CHARLES DE TOLNAY · HIERONYMUS BOSCH

Hieronymus Bosch

BY

CHARLES DE TOLNAY

AN **Artabras** BOOK

REYNAL AND COMPANY
in association with
WILLIAM MORROW AND COMPANY, INC.
NEW YORK

THE PHOTOGRAPHS IN THIS VOLUME ARE BY MAX SEIDEL, MITTENWALD

TO LUDWIG VON FÜLEP
FOR HIS EIGHTIETH BIRTHDAY

ISBN 0-517-255251

ORIGINALLY PUBLISHED IN GERMAN BY HOLLE VERLAG GMBH, BADEN-BADEN,
COPYRIGHT © 1965 BY HOLLE VERLAG
FIRST PUBLISHED IN THE UNITED STATES IN 1966

PRINTED in JAPAN

CONTENTS

Introduction to the Work of Hieronymus Bosch

Youth

Roots

Towards 1475, at the time when Hieronymus Bosch's career as an artist was just beginning, the masters of Bruges, Ghent, Louvain, Haarlem and Delft were painting according to the old principles established at the beginning of the century by the Master of Flémalle and Jan van Eyck. The paintings of these masters were imbued with the solemnity of divine service and so inspired the faithful to humble devotion and mystic exaltation of the soul. The viewer is raised into a higher sphere where the language of the feelings is conventional and finds no words with which to attain self-knowledge and the conscious experience of the real world.

Hieronymus Bosch was the first to break through this noble convention; his pictures are directed to the intellect and help the viewer to form an independent opinion of mankind and the reality of things. With Bosch art begins to shake off the tutelage of the Church.

The sources reveal that Hieronymus Bosch was born in 's Hertogenbosch to a family of painters and worked there from 1480 to 1516. Towards the end of the fifteenth century 's Hertogenbosch was a wealthy and populous commercial city, but in the field of art it could not compete with the major centres. To the present day historians have been unable to accept the idea that such a universal and sovereign art as that of Hieronymus Bosch could have sprung from the local tradition of 's Hertogenbosch; they have sought the roots of his artistic upbringing in Brussels or Antwerp, Bruges or Tournai, in Delft, in Haarlem or in German art. But in Bosch's first works we find no direct connexion with the great schools of painting of the epoch. Paradoxical as it may seem, the first versatile painter open to the influences of the world whom the Netherlands had produced since Jan van Eyck really did spring from the artistic milieu of a provincial town.

This apparent contradiction resolves itself when we recall that, owing to its conservatism, the art of 's Hertogenbosch remained closer to Gothic universalism than that of the great art centres, each of which cultivated its own style from the second quarter of the fifteenth century onwards. Consequently 's Hertogenbosch was better suited than any of those centres to the development of an independent spirit in keeping with a universal outlook.

APPX. PL. 116 In 's Hertogenbosch stood the most important Gothic church in the whole country: the cathedral of St John, the only church not built of brick in the regional style, which with its stone material and soaring structure conformed to the principles of French Gothic. Four of the numerous paintings that once decorated the pillars of the choir still bear witness to the fact that here the tradition of fresco painting lived on. The *Tree of Jesse*

which was probably painted between 1390 and 1400, preserves, in the elegant lineation of the figures and the almost calligraphic arabesques of the tree-trunk, the musical character of the monumental religious style of the fourteenth century. The two frescoes of St Nicholas on one side and of SS James and Peter on the other belong, with the vase-like silhouette of the robes, the rich play of the trimmings and the heavy folds of the soft and clinging materials, to the late medieval style which probably originated in the Paris court and between 1400 and 1420 made its way to the other great European courts, such as those of Dijon, Verona and Prague.

APPX. PL. 59

APPX. PL. 61

APPX. PL. 60

A fourth fresco, dated 1444 and possibly the work of a grandfather of Hieronymus Bosch, Jan van Aken († 1454), is of particular significance for us. It represents *Christ on the Cross* with the Virgin, St John and donors. We can see from the sharp angles of the outlines and the numerous breaks in the drapery that the artist was familiar with the innovations of Jan van Eyck; but he remained faithful to certain Gothic elements, such as the brocade fabric of the background and the bent body of Christ, which resembles that in the *Tree of Jesse* and is still far removed from the frontal and axial posture of the body which had become widespread in the great Netherlands art centres since the beginning of the fifteenth century. Moreover we see here, instead of the full, deep colours of the van Eyck brothers, Gothic azure blue and pale pink tones that fail to reproduce the varying qualities of the fabrics. It is surprising to discover that this fresco served Hieronymus Bosch as inspiration for his *Crucifixion* (formerly in the Franchomme Collection, now in the Brussels Museum): we find in the latter the same silhouette of Christ, the same head-cloth worn by Mary, the same types of face and the same light scale of colours.

APPX. PL. 58

CRUCIFIXION

PLATES PAGES 286–289

It must have been works of art such as these with which Bosch was familiar and which enabled him to take up a free and independent position vis-à-vis the epoch-making advances of the van Eyck brothers. By gradually setting free provincial Dutch painting from the techniques and stylistic elements of the Flemish tradition embodied by the van Eycks, and being the first to draw inspiration from the indigenous spirit of his country, Hieronymus Bosch created an art that heralded the great national Dutch school of the seventeenth century.

The flat landscape of Holland with its infinite horizons seemed to him particularly well suited to his vision of the world. This world unfolds itself in a sweeping scene of hitherto unknown breadth, through which wafts a breeze never felt before, no longer hemmed in by the traditional backcloth and wings of rocks and hills.

Mirrors of the World
(The Biblical and the Profane)

Whereas Hieronymus Bosch's contemporaries were content to solve formal problems within the framework of the old religious themes, Bosch from the beginning set himself new tasks; to him art was a language which he used to express a view of the world, and his pictures are open books that address themselves to all the viewer's spiritual faculties. Such an appeal is warranted by the spread of a more objective way of thinking, less subject to the authority of the Church, which had existed for about a decade, since the appearance of the first incunabula. A comparative study enables us to date a group of six pictures as belonging to Bosch's early period by virtue of a certain stiffness of movement, the angular folds of the drapery and the hesitancy of the brushwork, in spite of their evident stylistic innovations. It is desirable to consider these six paintings together. Even in the three pictures with biblical themes, however, not to mention the three secular works, the artist has evolved new ideas.

ADORATION OF THE MAGI

PLATES PAGES 79–80

APPX. PL. 72

The *Adoration of the Magi* in the Johnson Collection in the Philadelphia Museum of Art, to judge by the grouping of the figures and also by certain details, seems to have been inspired by Dutch miniatures of around 1440 which, like Bosch's picture, do not exhibit the general composition, the rich garments and the splendour of the three wise men's retinue characteristic of the official art of the period, an art typified by the Hugo van der Goes' Montfort Altar. But Bosch goes even further than his models; united by the magic power of the star, a theme whose unexpected reappearance emphasizes the miraculous quality of the event, the five figures convey the impression of members of an esoteric religious community. Hieronymus Bosch has placed Joseph between the Virgin and the three wise men, without, like his predecessors and contemporaries, leaving an empty space in the centre of the composition; he has combined the group into a unity and screened them from the world, i. e. from the landscape, by the poor, dilapidated, badly weather-beaten stable. The moss-covered straw roof, from which the skeleton framework of beams projects, radiates the whole dismal transience of things; the flat marshy landscape with the quiet little town on the horizon, symbol of the indifferent everyday world, breathes a deep melancholy. The shepherds, the first harbingers of this world, understand nothing of the miracle and, paying no heed to the sacred event, greet the oxen and asses in the stable. We can guess what Bosch wishes to express by this: the earth is a spiritual desert

PLATE PAGE 80

in which Jesus appears only to the initiate, as the manna fell only for the chosen people, an idea which the artist emphasizes by representing in the embroidery on King Caspar's

sleeve the gathering of the manna – according to some preachers of the period, a typological model of the Epiphany. In the lower left foreground stands a small bare tree, symbol of winter and the death of nature, while in the upper parts of the picture, closer to Christ, the new life of spring is already sprouting – an indication that with the advent of Christ on earth redemption and a new life after death and decay are certain. This basic idea may have led Bosch to clothe all the main figures in pink, the colour of hope and of spring. This is no longer an illustration of the biblical story, but an 'eternal allegory' (to use Sebastian Franck's expression) of the present world, and hence topical.

This conception appears in even more marked form in the *Marriage at Cana* in the Museum Boymans-van Beuningen, Rotterdam. The erect posture of the guests, rigid-looking in their parallelism, is in conformity with tradition and recalls the *Last Supper* by Dirk Bouts in Louvain. But with their bizarre airs, strange costumes and disquieting or comical expressions the guests are nevertheless an astonishing gathering. MARRIAGE AT CANA

PLATES PAGES 70–77

In the background a magician, magic wand in hand, performs his office in a 'chapel' decorated with pillars before a sideboard that serves as an altar: he is bewitching the food, making a pair of fire-tongs shoot out of the beak of a swan and streams of poison spurt from the mouth of a wild boar and using his magic power to change the cherubim that decorate the capitals of the columns into demons, one of which is aiming an arrow at the other, who is managing to escape through a hole in the wall. In the foreground the stout coarse-looking host is pouring water into the jugs. But the miracle is to be sought elsewhere; for Christ, paying no attention to the host, is blessing a goblet that a strange child-like figure dressed as an officiating priest is holding aloft in the axis of the picture. All this becomes understandable when we recall that from the second half of the thirteenth century onwards the Church regarded all magic as heresy and every magician as a tool of Satan. Apart from Mary, who is pointing out the Saviour to the timid bride, and the man on Christ's left, who seems to represent the pious donor, the remainder of the guests seated at table are all heretics who are regaling themselves with the poisoned food and drink; this is proved by the crescent, the symbol of heresy, which garnishes the lusciously prepared swan. Bosch contrasts the false miracle of the magician with the true miracle of Christ: the transubstantiation of the wine into the blood of Christ is taking place without the knowledge of the company, who are entirely given over to the pleasures of the table. The artist may have been thinking of the passage in the Bible that says: 'Ye cannot drink the cup of the Lord, and the cup of devils: ye cannot be partakers of the Lord's table, and of the table of devils' (I Corinthians x, 21).

A slight asymmetry in the composition here serves the painter's purpose. The diagonal that runs across the picture enables the artist to emphasize the focal points: lower right and upper left the bewitched food and drink, in the centre the goblet containing the blood of life. The didactic tendency and the critical acuity of this work are mitigated by the sovereign humour with which Bosch depicts his figures' evil, while the eye is delighted by the bright and joyful palette, in which a gentle pink, a carmine red and an iridescent olive-green predominate.

In its general arrangement the picture *Ecce Homo* in the Städelsches Kunstinstitut, ECCE HOMO

Frankfurt-on-Main, likewise conforms to tradition, although the omission of the folds and the details of the garments, which are kept as undisturbed surfaces, permit us to look upon this picture as the last work of the early biblical group. The weightless figures of the multitude gain in frightening unreality through the fact that they threaten to burst the picture-frame, grow out to infinity and become a vision of the whole of mankind. We shall better apprehend the cruel and demonic faces of these spectators who, with visible anticipatory delight, are demanding the Crucifixion, if we pay heed to the symbolic indications provided by Bosch: the toad engraved on the shield, the idol on the head of the bridge and the crescent on the red flag of the town hall. The painter is numbering all these people in the army of the Devil. This intention is reinforced by the atmosphere of the little town enveloped in sulphur fumes, where vacillating shadows wander aimlessly about the main square before the town hall.

Christ is bending down from the platform, on which Pilate and his executioners are displaying Him to the people, in an unfamiliar attitude, looking out over this world of the Devil with an expression of profound compassion. Here He is not merely the mute 'Man of Sorrows'; He is once more aware of the whole misery of the human condition. The parallelism between the two diagonals formed by the upper part of Christ's body and the heads of the spectators underlines the interrelation between the two attitudes. From all this it is easy to understand why Bosch put in the mouths of the two donors, who formerly occupied the left foreground and were later painted over, the words 'Salva nos, Christus redemptor'. This is the desperate cry for help of a world delivered up to Satan.

Pursuing aims similar to those evident in the first biblical works just dealt with, in his earliest profane works Bosch strives for an even more direct portrayal of everyday reality. Here too, in a certain sense, there is the same moral instruction directed to the individual conscience, instruction that no longer calls for an ideal conduct of life in conformity with the traditional ideas of the Church, but opens one's eyes to the grievous condition of human society. Following a tradition common in the didactic poetry of the Middle Ages, he does not depict evil confronting good in tragic conflict, as in the Psychomachies, but presents it as ridiculous.

In the exquisite, smooth, enamel-like way it is painted, the *Cure of Folly* in the Prado recalls the pictures of the Master of Flémalle. Despite the audacity of the conception Bosch is far from having achieved complete mastery of his media and is still in many respects tied to tradition: the naive characterization of foolishness by symbolic attributes, the schematic composition, the lack of relatedness of the figures to each other and to the landscape, the stiffness of their movements, the angular folds of the drapery, as well as the role of the full red, the luminous deep blue, the pure white and the grey in the colour scheme are sufficient grounds for placing the picture in the early phase of Bosch's work.

The inscription *Meester snyt die keye ras – Myne name is Lubbert das* states the theme: the futility of all worldly healing arts, an idea propagated by didactic poems (e. g. Brant in Chapter 55 of his *Ship of Fools*), moral sermons (such as those of Geiler of Kaisersberg) and proverbs.

With the encouragement of a monk and a nun, a corpulent citizen is offering his

forehead for an operation by the charlatan. He is in no way perturbed by the fact that the doctor is using the funnel of wisdom as a head-covering while the nun is putting the book of medical knowledge to the same senseless use.

As regards the circular shape of the picture, we shall see in the course of our study that in Bosch's work the tondo form always indicates the terrestrial globe; here the wheel and gallows in the background, as symbols of the wickedness of the world, point to the meaning of the wide and empty Dutch landscape, whose barren and uniform character – an innovation in art – is particularly well suited to the suggestion of universality. Thus in a unique, fortuitous section of landscape the artist captures an essential trait of the universe as a whole.

Up to now the *Seven Deadly Sins* in the Prado, originally the decoration on a table-top, has been regarded as a late work, on account of the surprising realism of its scenes. But the division of the landscape into parallel areas, the broken folds of the drapery, the bright colours in the style of the Haarlem school – the luminous bright blue of the sky, the olive-green of the meadows, the pink of the garments – and finally the uncertainty of the drawing are sufficient evidence that this is the work of a beginner.

SEVEN DEADLY SINS

PLATES PAGES 58–69

The *Seven Deadly Sins* are detached from the context of the medieval system of virtue. Having been secularized, the abstract concepts are no longer personified, but are represented by apparently random scenes from everyday life. The thoughts and actions of the figures are directed towards unsuitable goals, and the resulting unbalance of the moral order creates the comic effect. In their totality these extracts from life form the broad border of a disc to which, by the appropriate use of chiaroscuro over the whole surface, the artist has given the appearance of a glass sphere – obviously a symbol of the earth. The centre is occupied by a unique representation of the Eye of God: the risen Christ seems to be reflected in a gigantic blue pupil, encircled by a bright pink cornea, enlivened by golden rays. The inscription *Cave, cave, Dominus videt* is in keeping with the idea, propagated by didactic poems such as Freidank's *Bescheidenheit*, that nothing is hidden from the Eye of God.

In order to appreciate the innovations introduced by Bosch let us compare this picture with the miniatures of the *Virtues and Vices* in the MSS of St Augustine's *City of God*, which are preserved in the libraries of Ste Geneviève in Paris and at The Hague and date from about the same period. In these the apparent realism of the scenes is merely an illustration of moral fables, and the division into individual pictures follows the style of the mysteries. The point of departure of the miniature-painter remains medieval abstraction; Bosch's is direct and critical observation of everyday life.

APPX. PL. 70

A brawl between drunken peasants on the fresh green meadow in front of an old, dilapidated tavern in the midst of an idyllic landscape of astonishing simplicity is a genuine 'instantaneous photograph' of *Anger* in action and replaces the usual allegorical figure of *Ira* with its attributes. We surprise *Pride* in the semi-darkness of a room furnished in bourgeois style in which a well-to-do middle-class woman with her back to the spectator is complacently admiring herself in a mirror held by a small devil. In *Lust* an elegant gathering accompanied by its fool is giving itself up to the pleasures of a meal out of doors.

PLATE PAGE 62

PLATE PAGE 63

PLATE PAGE 64

PLATE PAGE 65
PLATE PAGE 66
PLATE PAGE 67
PLATE PAGE 68

Accedia, that strange apathy which the Middle Ages ascribed particularly to melancholy minds, is represented by a monk who has fallen asleep in front of a fire. In his dream his uneasy conscience is showing him the faith that he has neglected. *Gluttony*, a manifest forerunner of Bruegel's *Well-stocked Kitchen*, shows gluttons in a tavern, both the figures and the utensils symbolizing the vice. In *Avarice* a dishonest judge is being bribed by the rich man while at the same time taking money from the poor man. *Envy* shows a quarrel between neighbours in the street of a small town. In all these pictures the vice appears *a posteriori* in random scenes taken from life and not *a priori* as an allegorical personification.

The fatal consequences of a life lived in obedience to impulse, according to the inscriptions on the two scrolls of proverbs the source of all vice, are represented in the four corner medallions, which in part, contrary to what was usual, recall the Four Last Things.

CONJUROR
PLATES PAGES 86–89

The *Conjuror* in the Museum at St-Germain-en-Laye is later in date and more or less contemporaneous with the Frankfurt *Ecce Homo*. By comparison with the *Seven Deadly Sins* it exhibits an advance not merely in mastery of the media and certainty in observation, but also in knowledge of man as a social being. We seem at first sight to be looking at a humorous incident of a familiar kind: a conjuror with a crafty expression is making frogs jump out of the mouth of a simpleton who does not notice that meanwhile an accomplice of the conjuror is stealing his purse. The malicious and stupid expressions of the spectators betray at a glance their lack of inner resistance. Their ingenuousness, their credulity, their ludicrous gravity render the incident highly comical to us who can see through the game. In his composition Bosch creates an apparently paradoxical equilibrium between the isolated standing figure of the conjuror on the right and the group that he is holding in thrall on the left, with their mask-like faces. He does this with the compositional means of Italian Trecento fresco painting, particularly of those frescoes depicting miracles, on which the solitary figure of a saint standing out in profile against a neutral background balances the group of the healed and of the attentive spectators. Bosch attains the monumental simplicity of this style by closing off the horizon with a wall running parallel to the composition and so foregoing linear perspective. Nor has he allowed himself to be drawn into the excess of drapery folds in which the brushes of his contemporaries delighted. In the treatment of the garments he aims, on the contrary, at a unity that gives striking value to the local colour. The carmine red of the conjuror alone counterbalances the shimmering red of the tricked victim and the olive-green, grey and white of the other figures.

Just as the monumentality of execution reaches beyond the small format of the picture, so the artist's preoccupation reaches beyond the anecdotal subject matter: we no longer see isolated individuals forming a group, but a simple entity with many heads, a kind of helpless hydra subjected as a whole to the conjuror's power of suggestion, representative of mankind helplessly at the mercy of ridiculous magic.

PLATE PAGE 317
BELOW LEFT

From the sketch for this painting in the Cabinet des Dessins of the Louvre we can see the important step that Bosch had to take in order to free himself from the old Netherlands school tradition. The drawing, which Bosch probably designed for a tondo composition, gives no hint of the audacity of composition of the painting: the balance between the two

parts has not yet been attained, the group on the left still consists of an agglomeration of individual figures, as with Ouwater or Geertgen for example, and has not yet been fused into a single multi-headed creature. The garments still clearly show the characteristics of the current mode without any simplification, and the silhouette that creates the synthesis is absent.

Middle Period

The Suffering of the Redeemer

In the middle period of his creative life, lasting roughly from 1480 to 1510, Bosch liberated his style from the last traditional elements that still hindered his attempts to express in art his already universalist thinking.

But the works from this period with biblical themes are *classical* altarpieces in the full meaning of the term. By adopting from the altarpieces not merely the subject, but also the large format and the big statuesque figures, Bosch developed further, with greater solemnity but in simple terse language, the tendency contained in the Frankfurt *Ecce Homo*.

CRUCIFIXION
PLATES PAGES 286–289
APPX. PL. 58

We have already seen how strongly the *Crucifixion* in the Brussels Museum (formerly in the Franchomme Collection) is influenced by the old fresco in 's Hertogenbosch Cathedral dating from 1444. In the Brussels panel the hierarchical portrayal of the patron saint's intercession makes way for the representation of a spiritual drama, though a drama of a curiously sober nature. A sickly young man is deep in prayer. His black cloak and black and red leggings scarcely stand out from the austere pale and cold tones of the composition as a whole. Peter, his patron saint, who is standing behind him holding the keys of Paradise in his hand, is recommending him to St John, who in turn is recommending him to the Virgin. Through this exalted mediation the prayer reaches the Saviour, whose kindly expression promises that it will be heard. The donor no longer plays a passive role, but through his ardent prayer enters into a living intimate relationship with his patron saint. He is of the same physical size as the saint and appears with him on the same plane before the crucified Christ. Behind the sacred scene is the peaceful every day Dutch landscape with its dunes, its windmill and the big city on the horizon, reminiscent of 's Hertogenbosch, toward which an indifferent traveller is making his way.

CHRIST CARRYING THE CROSS
PLATES PAGES 290–291

Christ Carrying the Cross (formerly in the Escorial, now in the Royal Palace, Madrid) differs from contemporary Netherlands altarpieces in the sobriety and simplicity of the figures and the almost monochrome colour-scheme, in which grey predominates.

A cross of unusual size weighs heavily upon the Saviour, and yet it is not this burden that afflicts Him. His questioning gaze is directed towards the spectator and calls him to account for his association with the executioners and traitors – a gaze that strikes to the heart and is filled with compassion and reproach. Christ's pain finds an echo in the triangular group composed of the Virgin and John who is supporting her, both of whom are standing a little to one side in the background, exactly on the axis of Christ's head; the keynote, or focal point, which Bosch thereby gives the composition transcends the

20

historical event and lends it eternal significance. The executioners with their brutal faces no longer play the role of contrasting secondary figures usual in the Dutch and German tradition. They here become principal actors in the drama, in which – a hitherto unknown phenomenon in an altarpiece – the spectator, identified with the executioners, takes part directly. Christ is no longer suffering because of His martyrdom, but because of the demonic bewitchment of mankind.

The eternally unchanging alternative, before which Bosch sets the spectator, becomes even more apparent when he deprives the event of the spatial ambiance of the landscape, and thereby of its unique and fortuitous character, which is still so strongly in evidence in the Brussels *Crucifixion* and the *Christ Carrying the Cross* in the Royal Palace, Madrid. The artist was undoubtedly striving for this effect in the composition of the *Crowning with Thorns* in the National Gallery, London, and the Escorial, where the figures, depicted only half-length, are fixed upon the abstract background as though for all eternity. One is tempted to compare these works with the half-length pictures common towards the end of the fifteenth century in the Venetian school, a type of picture that soon also influenced Lucas van Leyden, Roymerswale and Hemessen. But Bosch's original intention was not the same as that of these artists. They wanted to break with Gothic verticality in order to give their works three-dimensional depth. Bosch, on the other hand, did not wish to be an innovator from the purely pictorial standpoint, but seems merely spontaneously, and perhaps under the influence of late Gothic Franco-Flemish half-length pictures, to have found the appropriate means of expression for his purpose.

In the London *Crowning with Thorns* the large figures, which fill almost the whole surface, stand out impressively from the cold grey of the background: the transparent white of the centre of the picture (Christ's mantle) is framed below by pink and carmine, above by olive-green and black. The figures, among whom we recognize some of the evil faces from the Escorial *Christ Carrying the Cross*. viz. the man with the big hat and the one with the fleshy nose, surround Christ like a pack of wild beasts; they are clinging to Him, forcing the crown of thorns on to His head, tearing off His mantle. With His sad, gentle eyes Christ is seeking those of the spectator, appealing to his conscience.

In the Escorial *Crowning with Thorns* Bosch, to give his idea even more powerful expression, returns to the half-length type of picture from the early fifteenth century, the tondo on a gold ground. Thus he proclaims even more clearly his independence of contemporary taste. The treatment of the figures, which are almost life-size, their masterly distribution around Christ, and the fine modelling of the faces, rich in nuances, herald the great style of the last period.

Christ sits motionless in three-quarter profile in His pink cloak, with His forehead bleeding under a tightly-plaited crown of thorns, and once more turns His suffering gaze towards the spectator. Fanned out around Him are the executioners to whose cruel faces Bosch has given the appearance and even certain features of wild beasts: the man with the tiger's whiskers on his upper lip resembles a carnivorous beast, the one with bared teeth a fox. The broad-shouldered man with the bull's dewlap, who is surreptitiously winking at the spectator, puts his foot on the bench on which Christ is sitting in order to press the crown of thorns

CROWNING WITH THORNS
PLATES PAGES 307–308

PLATES PAGES 290–291

21

still more firmly on His head. It is a strange coincidence that at this time, as his drawings show, Leonardo da Vinci was studying certain similarities of facial expression in men and beasts. But we must not seek any direct connexion between these scientific studies and the purely didactic caricatures in Bosch's *Crowning with Thorns*. The latter show no artistic affinity with the former and moreover have clear precedents in Bosch's own work.

The meaning of the tondo, in its circular shape a symbol of the terrestrial globe, is further emphasized by the fall of the apostate angels, whose grisaille figures fill the four black corners of the picture.

Hieronymus Bosch later adopts the 'half-figure' form with even greater audacity in some of his dream pictures, which we shall be able to understand fully only after an analysis of the works of his middle period, the great triptychs and pictures of ascetics.

Renunciation of the World
(The Great Triptychs)

When the artist reveals to us the evil of mankind in his portrayals of the anguish of Christ, does he not at the same time disclose the depths of his own heart? We know that Bosch was a member of the Brotherhood of Our Lady of 's Hertogenbosch, which had included laymen among its members ever since its foundation in 1318. The foundation statutes assigned to the brothers almost exclusively religious tasks, and especially veneration of the Mother of God; but in the fifteenth century charity also assumed an important place. Should we not see in this the influence of the Brethren of the Common Life, who in 1424 came to 's Hertogenbosch, there took the name of Hieronymites and for three years numbered among their disciples Erasmus of Rotterdam, who in more than one respect has affinities with Bosch? Without doubt they spread the spirit of the renewal of the religious life, which brotherhoods of this kind had been preaching, especially in the Netherlands, ever since the end of the fourteenth century.

A Netherlands preacher, Gerhard Groote, was the initiator of this movement, the importance of which cannot be overestimated since, born of the protest against the corrupt clergy and of the striving for a purer and deeper piety, it represented an important step along the road to the Reformation. The adepts of the *moderna devotio* sought salvation of the soul and fellowship with God without the aid of the official Church; they regarded themselves as the brethren of the true religion and openly dissociated themselves from those whom they called 'false brothers'. They rejected useless seclusion in monasteries in order to live and work in a world that no longer tempted them.

This definite item of information which we possess concerning the artist's life therefore casts an illuminating light on his frank judgement of human institutions and his sharp criticism of monks and ecclesiastical dignitaries which surprise us in his large triptychs, and are not to be explained either by heresy or by atheism. The astonishing freedom of the judgement which Bosch passes upon the clergy and the great ones of the world, even in his altarpieces, is no doubt also partially explained by the fact, attested by recently discovered documents, that as the husband of a wealthy patrician woman, Aleyt van der Mervenne, Hieronymus Bosch spent his life in a small castle near 's Hertogenbosch, in material independence. This may have further strengthened his innate tendency to spiritual independence.

Bosch's profound piety is the source of his view of the world; in panoramic compositions, for which the triptych is particularly well adapted, he presents us with a 'mirror of the

universe', as if it were the unreal realm of Maya; henceforth supported by a truly spiritua-
lized technique, the *alla prima* method of painting, he increasingly deprives his figures of
their own substance, so that they become phantoms, and fuses them with an equally imma-
terial, 'dissolved' landscape. Thus he creates a style which, while it reminds us of Impres-
sionism, is in his case chiefly determined by his own moral purpose.

HAY-WAIN

PLATES PAGES 116–133
Already in the *Hay-wain* in the Escorial the figures have become much smaller; they have
lost their weight and flit around the golden mass of the hay as simple, lively and joyful
dabs of carmine, pink, green, blue and grey on the blue background of a mirage. In its
general structure this triptych corresponds to the type of the *Last Judgement:* the contrast
between the left wing, where the Fall of man is shown against a background of the
Earthly Paradise, and the *Hell* of the right wing, as well as the symmetrical composition of
the centre panel with its seething mass of small figures above which the Lord occupies His
traditional place, quite obviously lend themselves to Bosch's intention of replacing the idea
of the transcendent divine judgement by the notion, popular in the late Middle Ages, of
immanent judgement as the consequence of man's sinfulness and foolishness.

PLATE PAGE 122
The artist seems to have been inspired by the Flemish proverb 'The world is a haystack
and each man plucks from it what he can.' Through a broad sunny landscape wrapped in
a thin blue haze rolls the huge hay-wain, the symbol of vanity. On its back it bears young
lovers, an alluring image of earthly joys. In their madness all mankind – monks, burghers,
peasants, the healthy and the sick – hurl themselves upon it: some fall under the wheels,
others try in vain to set a ladder up against it, and many actually fight ferociously for the
sake of a handful of hay. The great ones of the world, the Pope, the Emperor and the prin-
ces, follow the wagon in a solemn cavalcade. The wagon is drawn by human beings who,
as they approach Hell, are changing into beast-like demons. In the cloud-encircled disc of
the sun Christ appears. With hands raised in sadness He is the anguished witness of the
inescapable consequence of vanity, mankind's descent into Hell.

By making the triptych unusually high, Bosch gave his two wings almost the character of
frames; between them the centre panel is rather like a miniature within its ornamental
borders.

PLATES PAGES 118–121
The left wing is intended to remind the spectator of the biblical prefigurations of humanity's
present corruption. The portrayal of Adam and Eve's Fall is supplemented by the fall of
the apostate angels, depicted in an entirely new manner. This spinning swarm of angels
dropping out of the clear sky and turning into insects as they fall at once reminds us of the
famous *Fall of the Apostate Angels* painted more than half a century later by Bruegel the
Elder. It seems as though Bosch drew his idea from nature, from actual observation of
insects swarming round a light.

PLATES PAGES 130–131
The right wing leads us to the final stage in the fall of humanity. Bosch represents hell as
a burning landscape. The bridge over which the sinners have to pass, the man riding on
a calf and carrying a golden goblet in his hand -- the personification of the gravest of all
sins, the theft of consecrated objects – are taken from Tondalus's *Book of Visions.* Hybrid
beings, half men, half demons, are building a tower of vanity upon which the kingfisher
sits as the symbol of Vanity. On the other hand Bosch remains true to tradition when he

depicts a dog, a frog and a snake punishing the lechers. The dark silhouette of the ruin, outlined against the red background of the flaming sky and its rising pillars of smoke, is the great painterly climax of the work, the first attempt to achieve an effect which the artist later employed with great mastery.

The composition with small figures, as well as the technique employed in this triptych, are repeated in a group of works, some of them on a smaller scale, which were undoubtedly once parts of diptychs or triptychs and were produced at roughly the same period.

In the *Death of the Miser* in the National Gallery, Washington, which probably formed the left wing of an altarpiece, we find the theme of the upper left-hand corner medallion from Bosch's *Seven Deadly Sins*, which was inspired by the engravings of the *Ars Moriendi* and especially by the series of engravings executed by the Master E. S. But in the work of his maturity Bosch has freed himself more from his model and this picture is entirely different in its conception of space: Hieronymus Bosch returns to the then already outmoded type of composition created by the Master of Flémalle and re-adopted by Roger van der Weyden in some of his works; a kind of proscenium leads under an arch into a narrow and deep barrel-vaulted room. Bosch transforms the clear rational construction of the interior space, as it was usually portrayed by his precursors, into an irrational dream-like representation of people and things. What his work may lose in lucidity it gains in novelty of conception.

DEATH OF THE MISER

PLATE PAGE 91

PLATE PAGE 328

ABOVE LEFT

APPX. PL. 69

The dying man's salvation no longer depends, as in the *Ars Moriendi,* upon the victory of the angel or the demon, that is to say upon metaphysical beings fighting for a soul that is itself passive. It depends upon the responsible soul of the dying man himself, whose gestures express the conflicting impulses within him and hence the indecision in which, for Bosch, man always remains. This stands in contradiction to Italian humanism, according to which the human will is able to reach clear decisions.

In Bosch's picture the dying man hesitates to choose between the crucifix, upon which his inner gaze rests, and the money-bag, for which his hand is reaching; the vacillating soul cannot make use of its free will. We see the same dichotomy in the sanctimonious individual at the foot of the bed, whose left hand is letting the beads of a rosary slip mechanically through his fingers, while the right is filling the sack which the demon of avarice is holding out to him. The weapons and helmet in the foreground show us that this is at the same time a social satire directed against the nobility.

The light spiritualized mode of painting employed in the *Ship of Fools* in the Louvre lends this small picture the same evanescent character, the same impression of portraying an illusory world as the *Hay-wain.* The closely packed figures stand out as flat silhouettes without three-dimensional modelling from the greenish background of foliage and the misty landscape with its vague horizon. The effect of space is achieved exclusively by the contrast of light and colour values: the bright and cold grey tones that Bosch has chosen for the two main figures – that is to say, for the centre of the picture – even create a distance between the spectator and the whole group behind them with its warm and sumptuous lilac and Bordeaux-red. The artist brings the whole mastery of his palette to bear upon the shimmering silk in which he clothes the fool. A slight asymmetry in the tri-

SHIP OF FOOLS

PLATES PAGES 92–93

angle formed by the figures and the slant of the may-tree that serves the vessel as a mast creates an impression of continual rocking and swaying. The boat is being driven about aimlessly; forgetting his duty, the steersman has abandoned his helm to take part in the passengers' game around the cake. The picture's basic theme is probably inspired by the last chapter but one of Sebastian Brant's *Ship of Fools:*

Wir faren umb durch alle landt
All port durchsuchen wir, und gstadt
Wir faren umb mit großem Schad
Und künnent doch nit treffen wol
Den staden do man lenden sol
Unser umbfaren ist on end
Dann keyner weisz, wo er zu lend
Und hant doch keyn ruw tag, und naht
*Uff wiszheyt unser keyner acht.**

Corrupt humanity goes aboard a nutshell under the pink pennon of the crescent and, abandoning itself to the pleasures of gluttony, drifts towards its downfall. The clergy occupy

PLATE PAGE 315

the place of honour in this *scapha gustationis,* which was probably once part of a triptych

BELOW RIGHT

made up of other ships of fools depicting various sensual pleasures.

CHRIST CARRYING THE CROSS

If we consider the *Christ Carrying the Cross* in Vienna in this context, instead of with the

PLATES PAGES 99–103

group of biblical pictures, this is because, by virtue of its small format, it has affinities with the painting we have just been studying, and, like this and *Death of the Miser,* is linked by the small size of its figures to the *Hay-wain.* Moreover this picture, which calls to mind a mirage through its composition and mode of painting, contains a moral rather than a religious message.

Christ Carrying the Cross doubtless formed the left panel of a triptych, whose centre panel probably represented Mount Calvary and whose right panel may have depicted the *Deposition.* Chronologically they can be placed after the *Hay-wain,* whose bright and lively colours they recall, here enriched by iridescent reflections, and before the *Temptation of St Anthony* in the Lisbon Museum, with which they share the curving lines of the draperies. Christ, wearing sandals of thorns, staggers and bends beneath the weight of the Cross. He can no longer keep pace with the hurrying crowd, whose contorted faces betray a childish cruelty: the emblem of the toad on the heraldic shield tells us that this is the army of the Devil. Likewise victims of the crowd's malignancy, the two thieves are visible on the lower edge of the painting. They form the two lower angles of the triangle of which Christ is the

PLATE PAGE 102

apex. The unexpected apparition on the left lower edge of the small panel, a man whose penetrating eyes seek ours, emphasizes the arbitrary, almost medieval character of the step-like flat composition: this somewhat blunt face is none other than the artist's own.

PLATE PAGE 98

On the reverse Bosch has painted within a dark circle the Christ Child; pushing a walking-

* 'We travel around through every land / We seek through every port and every town / We travel around with great harm / And cannot reach / The shore where we should land / Our journeying is without end / For no one knows where we should land / And has not one peaceful day, one peaceful night / To wisdom none of us pays heed.'

frame with one hand and holding a toy windmill in the other, he is taking his first innocent step on the path through life. How this path ends for the believer, the artist tells us by the example of *Christ Carrying the Cross* on the front of the picture.

I am of the opinion that Hieronymus Bosch's second great triptych, the *Temptation of St Anthony* in the Museu Nacional, Lisbon, is to be dated in the last decade of the fifteenth century, when a rebirth of the Flamboyant style and a revival of the Gothic curve took place all over Europe. Hieronymus Bosch too must have been caught up in this current, and we may regard the Lisbon triptych as the first important example of its effects. TEMPTATION OF ST ANTHONY PLATES PAGES 134–157

In the centre panel groups of figures and landscape motifs glide along like dream images: set free from all weight, they are obeying the laws of a magical space in which the force of gravity is replaced by a mysterious power of attraction between objects. PLATE PAGE 136

Even the buildings seem to be floating, indeed rocking, on the surface of the water. In order to create this atmosphere of an aquarium peopled by fabulous creatures Bosch has boldly disregarded the laws of aerial perspective: he has audaciously filled the centre of the picture with an immaterial-looking cold tone, a silvery ash-grey, which he has surrounded by warmer and heavier tones – in the foreground by a dark brown that is carried over into the two side panels, in the background by a brownish-red and a bluish-green. Luminous patches of Bordeaux-red, carmine, deep blue, olive-green, pink, gold and white distributed in an artistic rhythm enliven the neutral grey and lend the strange vision the character of a brilliant festival.

The whole composition is given a curious unity by the dominant theme of the 'witches' sabbath' which is here for the first time, and at once with an unusual richness of motifs, introduced into the iconography of the *Temptation of St Anthony*. Such painters as Verbeck and Teniers, inspired by this work by Bosch, later revived this motif, but with a purely thematic or painterly aim.

The *Malleus Maleficarum*, published in 1487, teaches that in His anger at the depravity of men God permitted the Devil to found on earth the sect of sorcerers and witches. In the centre panel Bosch surrounds St Anthony with the adepts of this sect. They are overrunning the ruined castle which, according to tradition, the ascetic chose for his life as a hermit, while around the castle the scenes of the 'witches' sabbath' are taking place: the ride through the air, the gathering on the banks of a pond, the burning of a village, the pact with the Devil in the shape of a black mass read by a priest-demon with a pig's head, while in the foreground close beside the saint a young knight listens to the tempter's words of welcome. PLATE PAGE 137

In depicting the orgy of the 'witches' sabbath' Bosch has included many references to lust and gluttony. These references are almost always bound up with his implacable, ironic criticism of the corrupt clergy. His symbols – the simplest elements taken from all spheres of nature and everyday life – assume ever new forms; but the more fantastic they appear to us, the more forcefully we feel the reality behind them; apparently the play of pure imagination, they are striking illustrations of the vices. It is from this point of view that we must see the bulbous tower that has become the permanent kitchen of the monks and nuns, as well as the meaningful gatherings of monsters in the air and on the water; PLATE PAGE 154

finally, neither the sin of sodomy nor that of Lesbian love escapes the artist's irony. Assailed from all sides, the saint preserves himself from the evil world only by the firmness of his faith. In the darkest part of the picture, in the depths of the ruined castle, stands an

PLATE PAGE 141

altar with a crucifix and a burning candle. Christ, who is standing beside the altar like a priest and whose presence is revealed by the narrow ray of light cast by the evening star, points to the crucifix. The pictures that Bosch projects as though through a wall of glass

PLATE PAGE 139

upon the corner tower of the castle, are Old Testament scenes of faith triumphing over heresy. At the bottom we see the 'Return of the Spies from Hebron' with the bunch of grapes brought from Canaan; according to the *Biblia Pauperum* (Bible of the Poor), the prototype of baptism. It is followed by the 'Sacrifice of the Swan' before an idol, symbol of idolatry. The larger picture at the top combines the 'Expulsion of the Worshippers of the Golden Calf' and 'Moses receiving the Law on Mount Sinai', prefigurations of the overthrow of the idols and the descent of the Holy Ghost.

PLATES PAGES 134, 156
APPX. PL. 90

On the left wing of the triptych the painter, here following St Athanasius and the iconographic tradition of the Middle Ages, shows us St Anthony being tortured by the cruel demons; after being carried up into the air the saint, fainting and supported by his companions, is being taken back to his hut. But Bosch does not keep exactly to St Athanasius's text: the environs are peopled by the obscene dignitaries of the synagogue of Satan and

PLATES PAGES 135, 157

the hut assumes a strange, anthropomorphic shape. On the right wing St Anthony is turning away fearfully from the temptress, again a motif taken over from St Athanasius; but a fresh temptation offers itself to his gaze, a laid table, whose cloth conceals the demons from him.

Perhaps the painterly audacity of the work is best exemplified by the three landscapes in the background. The fire in the night on the centre panel, with its spurting sparks and the curiously harsh lighting of the forest glade, already anticipates the landscapes of Rubens. The landscapes on the side panels have the pallid unreality of dream pictures. On the left the blue water of the lake and the desolation of its barren banks form the setting for the despicable suicide of the human race. On the right between the mole and the little town occupied by the army of the Devil, whose houses shimmer in the air, there stretches a large space almost devoid of human figures.

The zigzag compositions of the side panels serve to elongate their proportions; moreover the distribution of their main figures, which are orientated towards the centre, draws attention to the centre panel. Here the viewer's eye is attracted to two semicircles, formed by the human figures and the groups of demons in the two halves of the picture. They run across the whole surface and St Anthony and Christ beside the altar are situated on their tangents. Despite their small scale and the restraint with which they are depicted, these two figures form the true pivots of the composition. Does not the secret of this equilibrium between the small figure of the saint and the wide, magic-filled space lie in the capacity of a soul to integrate a multiplicity of sensory impressions in its inner world? Bosch develops this capacity with increasing power: his later compositions never overstep the horizons of a thinking or dreaming soul.

The whole art of the Middle Ages was a representation of thoughts and feelings, and not

a picture of the visible world. At the beginning of the fifteenth century, a time when spiritualism was still holding its own in spite of the discovery of realistic means of expression, we meet, probably for the first time, pictures of man's inner world side by side with portrayals of man himself. One of the first known examples of this mode of representation is a woodcut from South Germany, executed in about 1430: it shows on either side of the crucified Christ the ardent and the absent-minded man, both in prayer; the lines that join the head of the former to Christ on the Cross demonstrate the direction of his thoughts; the spiritual aberrations of the man who is praying badly are also expressed by lines, but these join his head to six small pictures portraying the seven deadly sins. They represent the thoughts that fill his mind. But some miniatures of this period already show a less schematic representation of the inner life of the soul: in *Christ on the Mount of Olives* in the Book of Hours, illustrated by the Master of Magloire for the Duke of Bedford, we see the Stations of the Passion as mental visions of Christ, painted in blue ink in the sky above His head. Here Bosch's dream pictures are already contained in embryo.

APPX. PL. 114

APPX. PL. 112

In the *Ecce Homo* in Philadelphia Christ sees all the events of biblical history as though in a dream. The composition is only understandable if we bear in mind that the picture we have today is only a fragment of a panel that was originally about four times as large. Our picture is the left upper quarter, where the story of the Passion begins with the scourging and the Ecce Homo scene. In the two lower quarters, that is to say the former foreground, the Passion continues. It was probably a scene showing Christ carrying the Cross, made up of large half-length figures (a drawing made from the whole composition, which itself is now lost, is preserved in the Crocker Art Gallery, Sacramento, California). The background right (upper quarter) shows the hill of Golgotha, that is to say the final phase of the Passion. In the Philadelphia fragment the Son of man stands with closed eyes behind a curious balustrade, and all the figures surrounding Him are changing into spectres and bizarre insects. They are the tormentors that appear to Christ's inner eye, and as such in a guise very far from human, e. g. Pontius Pilate. They are so far removed from reality that they cease to be a direct threat to Christ's soul. Head-coverings and helmets and the forest of spears and other weapons proliferate like living plants, while the asymmetrical structure of the composition in two strips one above the other goes beyond a rational, realistic conception of space. At the same time, however, we must not forget that this is only a fragment.

ECCE HOMO
PLATE PAGE 104
ABOVE LEFT

PLATE PAGE 326

St Gregory at Mass on the reverse of the *Epiphany* in the Prado shows the saint kneeling deep in prayer in front of an altar, whose strongly three-dimensional pictures are coming to life for him. Round the Redeemer, who is looking at him full of gentleness, the angels are flying like moths drawn to a light, and painted figures that have become flesh play their parts in the Stations of the Passion; at the topmost point of the altar, which has turned into the hill of Golgotha, they actually step out of their frame and their silhouettes stand out against the star-dotted darkness that now fills the church.

ST GREGORY AT MASS
PLATE PAGE 295

Four small panels by Bosch are preserved in the Palace of the Doges in Venice. Now arranged in pairs side by side, but not in the original sequence, they depict on one side the wandering of souls to the *Earthly Paradise* and the *Ascent into the Heavenly*

Paradise, on the other side the *Descent of the Damned into Hell* and their arrival in *Hell*. The bold conception of these visionary pictures, in which space almost completely absorbs the figures, leads us to place them chronologically between the *Temptation of St Anthony* in Lisbon and the *Garden of Earthly Delights* in the Prado. In the *Earthly Paradise* the souls live in the company of the angels; one of the latter is taking under his protection the couple awaking on the shores of the blessed. At the foot of a hill the souls are giving themselves up to innocent amusements, while at its summit rises the Fountain of Life, too far from the souls' longing for them to be able to reach it.

On their *Ascent into the Heavenly Paradise* the souls leave the dark space of the universe and soar along a circular shaft that is already flooded by the everlasting light. Intoxicated with joy, they free themselves more and more from the laws of gravity, to obey the attractive power of the realm of light. On the first stage of the journey, the ecstatic soul is still supported by two angels; one angel is sufficient to lead it as soon as it has been struck by the rays of light, and finally it enters alone into Paradise, where it returns to its origin, the everlasting light.

In the *Descent of the Damned into Hell*, on the other hand, the souls, hurled by demons into the darkness of the abyss, sink slowly like drowning men into the bottomless depths. Are the burning landscape, the dark lake and the desperate cries of the martyred a nightmare of the soul that sits on the edge of the terrible place, tortured by a demon and resting its head in its hand with a gesture of melancholy?

Bosch replaces the Paradise and Hell of the Middle Ages, which were objective images of the celestial and infernal hierarchies, with subjective visions that correspond to the conceptions of the great mystics and exist only within the inner world of the soul. We feel here in visual art the poetic force that inspired a Dante.

With this group may also be numbered the two grisaille panels in Rotterdam depicting the *Flood* and *Hell*. In the *Flood* Bosch does not follow the iconographic tradition but goes straight back to the biblical text, which gives him a grandiose vision of an entirely new kind. Curiously, he chooses the point at which the waters have already receded from the earth and the ravaged soil is visible. On the bleak, barren, sandy promontories rising from the former seabed rotting corpses still lie. But the ark is stranded on the summit of Ararat, and like a winding river the animals are streaming down the mountain-side to spread life anew in the devastated valleys.

In the triptych of the *Garden of Earthly Delights* in the Prado, in which the symbol reigns, Hieronymus Bosch does not rest content with pictorial and literary tradition, or with his own imagination, but, anticipating psychoanalysis, uses the whole acuity of his penetrating mind to draw from his memory and experience dream symbols that are valid for all mankind. But to him they are not simple phenomena of psychic automatism, nor the pure play of the mind. The artist is not dominated by his subject matter but himself dominates it with sovereign authority, and in his hands the symbols become instruments which he uses for his own purposes. The specific meaning he gives them becomes intelligible only in the light of his basic theme: the nightmare of humanity. Bosch is simultaneously the dreamer and the judge of dreams, actor and stage-manager in one person.

EARTHLY PARADISE
PLATES PAGES 110, 111 LEFT

ASCENT INTO THE HEAVENLY PARADISE
PLATES PAGES 111 RIGHT, 112–115

DESCENT OF THE DAMNED INTO HELL
PLATE PAGE 109

FLOOD AND HELL
PLATES PAGE 105

GARDEN OF EARTHLY DELIGHTS
PLATES PAGES 202–247

Within Bosch's work the *Garden of Earthly Delights* is the most perfect expression of the Late Gothic current. The small figures that fill the whole surface of the centre panel are arranged PLATE PAGE 218 in the rhythm of a sumptuous decoration in keeping with the Flamboyant style and with the exuberance of a 'thousand-flower carpet'. Linked with the effect of the three superimposed but interconnected pictorial planes, peopled by these figures right to the horizon that is set far up near the top of the picture, is the illusion of a mirroring depth, a *fata morgana*, in which light blue, pale pink and olive-green play in luminous soft reflections.

In the foreground idyllic groups of men and women with delicate bodies gleaming like white pearls ceaselessly form and break up around an axis composed of scarlet coral. Mingled with the human throng are animals of unnatural proportions, birds, fishes, butterflies and also water plants, giant flowers and fruits. Nothing seems more chaste than the love-play of these couples. But just like psychoanalysis, the dream books of the time disclose the true meaning of these pleasures: the cherries, strawberries, raspberries and grapes that are offered to the human figures, and which they devour with enjoyment, are nothing but the godless symbols of sexual pleasure. The apple-boat that serves the lovers as a refuge is reminiscent of the female breast, the birds symbolize lewdness and ignominy, the sea-fish lust or anxiety, the shell is the symbol of the female. Bosch here paints a striking picture of repressed desires.

The artist's purpose is above all to show the evil consequences of sensual pleasure and to stress its ephemeral character: the aloe bites into naked flesh, the coral holds bodies fast, and the shell closes upon them. In the Tower of Adulteresses, whose orange-yellow PLATE PAGE 223 walls gleam with crystalline reflections, the deceived husbands dream amidst horns. The glass sphere in which a couple are caressing, and the glass bell that unites a sinful trio, illustrate the Dutch proverb: 'Happiness and glass, how soon they pass.'

The red arrow of the coral leads the eye to the middle plane of the picture where the PLATES PAGES 224–225 eternal circus of the passions follows the labyrinth of pleasures. The human figures are frenziedly riding fantastic or real animals, which they hold back or spur on according to the rhythm of love. The cavalcade circles around the Fountain of Youth, in which young Negresses mingle with fair-haired girls of milk-white complexion. Swans, ravens and peacocks, symbols of sensual enjoyment and vanity, settle on the heads of the bathers; some of them are wearing as a head ornament the pagan crescent.

On the uppermost plane the Fountain of Adultery rises in the midst of the Pond of Lust: PLATE PAGE 222 a steel-coloured sphere with cracked walls bearing a crown made up of a crescent and horns of pink marble, a glittering symbol of the heretical character of this sin and the dangers which it brings upon the world. The four Castles of Vanity, made up of plants, marble rocks, fruits and beads, gold and crystal, and peopled by acrobats and birds, tower up into the sky as monstrous blossoms of the absurd.

To an increasing extent master of his technique, Bosch makes the hollowness and fragility of transient things more and more palpably evident to us. He gives up the *alla prima* manner and models with a gentle chiaroscuro: flesh and marble are composed of the same living substance.

On the left wing the *Earthly Paradise* captivates by the purity and harmony of its colours. PLATES PAGES 205–217

Bosch has utilized the knowledge of natural history current in his day to gather together, for the creation of Eve, animals, plants and minerals from the various regions of the earth. Everything in this peaceful garden seems to breathe serenity and innocence, but in reality it is marked with the stigma of unnaturalness and corruption.

PLATES PAGES 216–217

The Eve whom the Lord is bringing to Adam is no longer the woman created from Adam's rib, but already the image of seduction, and the astonished look which Adam is giving her is a first step towards sin. The duality of the still pure man and the woman who carries

PLATE PAGE 207 RIGHT

within her the seed of sin is repeated behind them in the flora and fauna: the stunted palm, round which the serpent is coiled, standing on a curious orange-coloured rock, is opposed diagonally to the blossoming palm. A few spots spoil the pure picture of animal life: a lion is devouring a deer, a wild boar is pursuing a strange beast. Precisely on the axis of the

PLATE PAGE 206

composition there rises – neither plant nor marble – the Fountain of Life, a pink flower soaring Gothically upwards on the inky blue stones of a small island. At its tip it bears the scarcely visible sign of the crescent and in its core, like a worm, the owl, bird of mis-

PLATE PAGE 214

fortune. The four rocks that enclose this 'botanical garden' on the horizon are tall, fantastic aviaries; with their bizarre shape and the symbols with which they are decorated they form a skilful introduction and transition to the Castles of Vanity on the central panel.

PLATES PAGES 240–247

The panel showing *Hell* presents the third phase of the Fall. The earth itself has become a hell; the very objects that had been instruments of sin have become gigantic instruments of punishment. These chimeras of bad conscience, which enliven the night with hallucinatory clarity, possess all the special significance of sexual dream symbols: vase and lantern, knife and skates refer to the two sexes. Out of the barrel-organ, the mandolin and the harp Bosch forms an orchestra of instruments of vengeance that draw their harmonies from men's suffering. The hare, which so quickly digests the sinner it has devoured, combines lust with the fear of death. The gigantic ears are omens of misfortune; the huge key hanging from a staff, to which it has been attached by a monk, betrays the desire for marriage, which is forbidden to the clergy.

In the centre sits a white monster. Its wooden clogs, 'blue boats' of destruction, contain legs shaped like trees hollow to the bark, whose branches bore through its body, the broken

PLATES PAGES 241, 323

shell of an enormous egg. Its lecherous idiot's head bears a platform on which demons and witches are leading unnatural sinners round a huge bagpipe, emblem of the male sex. An inn is let into its rump above which flies the banner of the bagpipe; a witch is serving the sinners seated at table. Apart from them, a corpulent man in the attitude of melancholy sits with closed eyes above the abyss; when we recognize in his features the face of Hieronymus Bosch, the whole picture appears in a new light: the artist himself is dreaming this dream, his soul is the place of the thousand agonies and the thousand torments.

As a synthesis of all destruction, the vision of the world dissolving in flames illumines with a ghostly light the dark night of the background. Enormous conflagrations, before which rise the silhouettes of ruins, disclose the spectral shapes of clouds and mountains; the rays of their yellow fires cross one another in a flickering interplay, like searchlights directed upon the hurtling hosts of souls and demons.

The universal meaning of this 'Divine Comedy', which Bosch concludes with what is

perhaps the finest fiery landscape ever painted, is directly expressed on the reverse of the wings where it is introduced by a definition of the universe. The theme is the 'Creation of the World', for the representation of which the artist invents an essentially new iconography. The world, hitherto depicted as a little toy in the hand of God, covers almost the whole surface of these panels, and the small figure of the Creator, relegated to a corner, becomes of secondary importance. Bosch sees the universe as a transparent ball of glass in which reflections create the impression of roundness; within its womb rests the primeval landscape of the earth with its fantastic flora, surrounded, according to the medieval conception, by a belt of water; a pallid gleam as of moonlight illumines this mysterious vision of a world in which man has not yet found his place. With this unusual representation of the universe Bosch introduces into the history of art what is, so far as I know, the first pure landscape. Just as bold as Leonardo in his decision to depict our world without human figures, he differs from the Italian in that he was content to evoke the poetry of enigmatic nature, whereas his Italian contemporary sought, beyond this, to reconstruct the genesis of our world.

PLATES PAGES 202–203

A document preserved in the archives at Lille states that in the year 1504 Philip the Handsome commissioned a large *Last Judgement* from Bosch. The precision of this date renders improbable any hypothesis that a connexion exists between the king's commission and the *Last Judgement* in the Akademie der Bildenden Künste, Vienna, which has been regarded by some as the original and by others as a reduced copy. In fact both the style and the composition of this excellent copy of a lost picture by Hieronymus Bosch might well belong to a work forming the transition from the *Hay-wain* to the *Garden of Earthly Delights*.

LAST JUDGEMENT
PLATES PAGES 164–187

The combination of the themes of the fall of the angels, the creation of Eve and original sin shows in both composition and iconography a close affinity with the left wing of the *Hay-wain*. The elements that fill the centre panel are not yet arranged in the rhythm specific to the artist's Late Gothic compositions; but on the right wing the excessive proportions and the spectral character of certain dream symbols foreshadow the right wing of the *Garden of Earthly Delights*, without equalling it.

PLATE PAGE 170

In the centre panel Bosch humanizes the iconography of the *Last Judgement;* the divine judgement loses its importance and the human theme fills almost the whole picture. In the foreground of the earthly landscape tortures of the most varied kinds, inspired by the *Vision of Tondalus* and the *Shepherds' Calendar,* are being carried out with complicated appliances and machines; in the background the portrayal of a fiery landscape, and in the centre the small melancholy figure resting on his elbows on a rocky island (a depiction of the artist himself), anticipate the *Garden of Earthly Delights* to an even greater degree.

PLATE PAGE 174

Hence we might be more inclined to see a connexion between the Lille document and the Munich fragment of a *Last Judgement*. The elements that here combine to form a kind of fabric testify to such a refined art that we cannot date the work prior to the *Garden of Earthly Delights*, a view which is confirmed when we note the iconographic identity of individual motifs – a monster seen from the rear, legs bearing a head – with those of the late drawings preserved in Oxford, which may be preliminary studies. It seems too that Bosch was trying here to teach a lesson according to a higher morality: the vision of

LAST JUDGEMENT
PLATES PAGES 248–253

PLATE PAGE 321 MIDDLE

33

physical tortures is here replaced by a portrayal of the pangs of remorse of the resurrected; the mighty and the lowly of this world hide their faces in a gesture of despair or implore the Judge for mercy with looks full of terror.

The Ascetic Life

Whereas in his large triptychs and the paintings whose composition has affinities with them Hieronymus Bosch looks at the world from a distance, as though contemplating it from another planet, in his pictures of ascetics he shows the path trodden by Christ's followers and renunciation of the world through mortification. Since he was reviving asceticism, the ideal of the early Middle Ages, at a time when the omnipresence of nature could no longer be denied, he proposed an asceticism that could only arise and come to maturity in recognition of the futility of the world; in spiritual agreement with the Brethren of the Common Life, the new ascetic seeks 'to live and work piously *in the world*'; from a purely human viewpoint he is thus anticipating the ideas of the Reformation, which also taught an asceticism within the world, but at the same time he remains Catholic through the idea of mortification. But this type of ascetic – too far removed from renunciation and the mystic joys for Catholicism and too far removed from the earth for the Reformation – found no direct echo either in art or in religious life.

In respect of its artistic form the composition of the pictures of ascetics, which form a closed group, seems to be a compromise between the formula of the biblical pictures and that of the large triptychs: a single big figure dominates the whole foreground and stands out against a broad landscape.

St John on Patmos in the Berlin Gemäldegalerie seems to be related in colour scheme and execution to the *Hay-wain*. Only the division of the landscape distinguishes this picture from the engravings of the Master E. S. and Schongauer; the figure of the saint himself and his vision are directly inspired by them. Seated on a rise in the ground and separated from the world by a hill, the saint finds himself rewarded for his deep meditation by the apparition of the Virgin on the disc of the sun. An angel, painted in the blue and white colours of the sky, is showing her to him. Neither the demon who appears behind him, nor the disasters that can be seen in the background landscape – a burning ship, a shipwreck and gallows – can distract him from this consoling vision. But bad as the world may be, Bosch depicts it with love in the freshness of its spring. He brings St John's garment, in which pink is combined with the white of daylight, into harmony with the bright green of the meadows, the pale blue of the atmosphere and the transparent blue silhouette of the city on the horizon.

On the reverse, the terrestrial disc is seen floating in the night of the demon-populated universe. On its grey surface, illumined by an uncertain light, there follow one another

ST JOHN ON PATMOS

PLATES PAGES 255–263

APPX. PL. 94, 95

PLATES PAGES 256, 260–263

with a strange rapidity and without interruption, the Stations of the Passion, but each one has its own atmosphere. The cycle begins with the Mount of Olives and ends with the Sepulture. It is dominated by the bare peak of Golgotha, which rises, fanned by the damp cold wind of evening, from a broad flat half-flooded landscape. In the solitude of dusk a mother and her child, the last stragglers from the crowd, are hurrying home;

PLATE PAGE 263

abandoned by everyone, Mary and John remain behind to watch at the foot of the Cross. But the night of the Passion is followed by the day of the Resurrection: in the centre of the circle a smaller disc stands out in a diffuse light; on a rock towering up out of the water into the pearl-grey dawn sky sits the divine pelican feeding his young with his blood, a symbol of Christ's blood-sacrifice and hence of redemption.

ST JEROME

PLATES PAGES 264–267

The *St Jerome* in Ghent is an emaciated penitent; half naked, with closed eyes, he has cast himself on the ground, and so great is his ardour that he actually enters into God: on the crucifix that he is holding in his arms Christ is coming to life. Corrupted works of nature cover his grotto in utter confusion. A bucranium, a stone tablet resembling Moses' Tablet of the Law, a fragment of a human ear and other objects hard to define crown the grotto like unfinished phrases of nature. Beside this mysterious chaos the traditional lion becomes a small domestic animal. The objects scattered around the saint – the bishop's cloak and hat, the pomegranate and the fantastic plant – shine like rubies whose shimmer plays upon the dark velvet of the grass and the water and the crystal of the rock. This quiet harmony of deep red tones in a composition dominated by deep green anticipates Elsheimer and Rembrandt. In the background only a few houses and some almost imperceptible human shadows interrupt a landscape of bright lakes, dark hills and woods.

ALTARPIECE OF THE HERMITS

PLATES PAGES 268–272

The *Altarpiece of the Hermits* in the Palace of the Doges, Venice, represents on the left wing *St Anthony*, on the centre panel *St Jerome*, and on the right wing *St Giles*: three hermits who for Hieronymus Bosch, as in Jan van Ruysbroeck's *Book of the Highest Truth*, embody the three stages of mystic exaltation of the soul.

Certain motifs from the Lisbon altar have served as stimuli for the left wing, depicting *St Anthony*. At night, as a fire breaks out in the village, the saint moves like a sleepwalker towards the marsh, to draw water and still his thirst; at this moment there emerge all around him the images of his lusts and his bad conscience: a fish-demon pours wine into a jug, a naked woman appears behind a cloth, a dwarf demon reads the mass, and a demon with a peacock's tail ridicules his pride. These dwarfish monsters, whose garnet brilliance fascinates him, here merely illustrate the saint's sinful inclinations. There is no interconnexion between these individual figures, which stand side by side like the beads of a rosary; in order to understand them the eye and mind have continually to return to the saint, the key to a composition that is primarily didactic, although at the same time it represents a further step in the development of Bosch's ability to conjure up in paint the images of man's inner world.

Of an entirely different kind are the visions that appear to *St Jerome* in his dialogue with God: kneeling among the ruins of a pagan temple before an antique marble throne, emaciated, mirroring in his features all the tension of his spirit, he is not praying but warding off the contradictory visions that illustrate the drama of his inner life: as a symbol

of subservience to the world of the senses there appears at the foot of the throne the image of a peasant with his head in a beehive; above this, as the highest symbol of the liberation of the soul, are a picture of the 'Beheading of Holofernes' and, as a symbol of the strength bestowed upon him by his faith in Christ, a picture of a knight mounting a unicorn, and finally, even more real and almost within the ascetic's reach, the 'Crucified Redeemer'. The victory of faith over idolatry is represented by the fall of the idol; behind the saint in the iridescent crystal of the plinth, from which the idol has fallen, a heretical worshipper kneels before the sun and moon.

Behind the saint, in the centre of a forest pool, rises a kind of hut built of rocks and completely covered with moss, climbing plants and intertwined roots, a piece of untouched nature, whose mysterious, proliferating life thrusts forward right up to the ruins. On the roof can be seen a structure that creates the false illusion of a kitchen chimney emitting a cloud of smoke, perhaps a hint that the ascetic's thoughts are straying in the direction of earthly food. The pink patches of the hermit's cloak and hat form a subtle harmony with the olive-green of the landscape.

Well-being in this life and community with God are the themes of the *St Giles* panel, the third picture in the triptych of ascetics. In a grotto that serves him as a chapel, a tame deer at his feet, he is praying without the help of the book which lies unopened before him. Neither the arrow, which in accordance with the *Legenda Aurea* pierces his breast, nor the forest demon whose shaggy head appears in a hole of the grotto, nor the wild beasts disturb his inner peace. He is praying for the salvation of all sinners and on a parchment scroll we can read the long list of those whom the saint's intercession has helped.

The authentic Late Gothic style of the *St John the Baptist in the Wilderness* in the Museo Lazaro Galdiano, Madrid, shows the same stage of development as the *Garden of Earthly Delights*. Resting one elbow on a rock that dominates glades and woods, his eyes half closed, the ascetic seems to be dreaming the fabulous plant – the symbol of carnal joys – that is shooting up before him, like the root from the breast of Jesse, and the lamb to which his finger is unconsciously pointing. The painter thus again sets the saint before the alternative of the good and the evil path.

ST JOHN THE BAPTIST
IN THE WILDERNESS

PLATE PAGE 273

The lustre of the deep red and green tones is intensified by the proximity of the cold grey of the rock – a harmony whose whole wealth of subtle variations is reflected in the bowl of fruit, the symbol of nature and at the same time of evil.

The *St Christopher* in the Museum Boymans-van Beuningen in Rotterdam belongs by virtue of its composition, even though it has a different theme, to the group of pictures of ascetics. The saint, bowed down by his burden, is striding through the river with his knees bent and clutching the curving staff with both hands. Never had the saint's physical effort been portrayed with such intensity; in the words of Jacobus de Voragine, Christ weighs upon his shoulders like the whole burden of the world – in reality the artist has not placed the Child directly on the saint's shoulders, but has made Him float above them, a spiritual burden which the saint has accepted through his conversion. The large fish dangling from the saint's staff symbolizes the fast that follows the conversion, as related in the *Legenda Aurea*. At the same time it reveals the antithetical meaning common to the two

ST CHRISTOPHER

PLATES PAGES 278–281

scenes in the background: the hypocritical hermits fattening themselves at an enormous jug filled with meat and honey, and the hunter who is hanging on a tree a bear he has just killed.

The painter's complete mastery of his media leads to the assumption that the picture is later in date than the *Altarpiece of the Hermits*. Thanks to its Bordeaux-red tones the main figure stands out in strong relief from the blue background of the landscape, an aesthetic contrast that corresponds to the spiritual antithesis between the resolution and perseverance of the saint and the insecurity of the phenomenal world illustrated by the burning town. This coastal landscape provided Joachim de Patinir with the stimulus for his finest cosmic landscape pictures.

ALTARPIECE OF ST JULIA

PLATES PAGES 274–277

A special place in Bosch's work can be given to the *Altarpiece of St Julia* in Venice, which continues the series of the victory of faith. Although the composition of the centre panel shows a certain similarity to the artist's first biblical pictures, the wings are closely linked with the series of portrayals of ascetics that we have just been considering. Moreover the somewhat granular painting technique of the whole triptych is of the same character as

PLATES PAGES 276–277

and particularly reminiscent of the *Altarpiece of the Hermits*. The figure of St Julia on the cross dominates the composition of all three panels. It seems to be the power of faith alone, which is no longer a postulate but the inviolable possession of her soul, that is opening her arms. This power enables her to direct her gaze to the eternal kingdom and, as it were, raises her victorious body towards heaven. Her red garment flutters like a banner in the wind. The strength lent her by her sanctity radiates from the cross and strikes the dense throng at her feet like a thunderbolt: the governor and his counsellor and the pot-bellied

PLATE PAGE 275

notables are all the more dumbfounded because the heretics, utterly dismayed, are covering their faces, taking to flight or falling unconscious.

The landscapes of the two wings are further depictions of the evil world. The nocturnal conflagration of the city behind and above St Anthony has a more concrete, more human significance here; in its red glow the inhabitants, carrying the possessions they have hastily gathered together, are leaving their burning town, whose brown gables glint in the light of the flames.

The two figures in the foreground of the right wing are probably the slave-dealers who, according to legend, sold the saint to Eusebius. The harbour in front of which the artist has placed them might be the site of this action: Cap Corse. The memory of a terrible night still weighs heavily upon the pale grey dawn. On the sea-front the fishermen are resuming their daily labour and bringing a whale ashore. But a malefactor is attacking an unfortunate traveller, the wrecks of sunken ships project from the water, and the Devil's galley blocks the entrance to the harbour – witnesses to the terror of the night still visible in the gloomy reality of the morning.

Last Period

The Final Synthesis

During the first years of the sixteenth century a change of style took place throughout Europe. The Neo-Gothic was displaced by a synthetic monumental style: Leonardo, Michelangelo, Raphael returned to the masters of the Early Renaissance and sought their inspiration in the work of Giotto and Masaccio. At the same time and in an analogous manner Bosch's genius, in order to create the basis for a grand style, turned to Jan van Eyck and the Master of Flémalle, both of whom he had hitherto disregarded. Having reached this stage in his hitherto very largely individual evolution, the artist turned his attention to the same problems that were exercising the great minds of the time, in the north and in the south, and solved them in an analogous way. The various works which he produced from then on are closely related in style, as is particularly clear when they are compared with his early works. Bosch remained true to his own categories of pictures, but he rendered them more precise and used them to summarize his personal experiences in a final synthesis appropriate to his old age.

ADORATION OF THE MAGI

PLATES PAGES 296–305

Nothing is more characteristic of this than the triptych of the *Adoration of the Magi* in the Prado, the spiritual seeds of which are already contained in the Philadelphia panel of the same subject. The Virgin and Child are unequivocally inspired by Jan van Eyck's *Madonna of the Chancellor Rollin*, now in Paris: we see the same posture of the figure, the same movement and the same folds, framed by the same outline, in van Eyck's gorgeous *Regina Coeli* and Hieronymus Bosch's austere mother of God. The total composition, as has already been noted, derives from the *Nativity* by the Master of Flémalle in the Dijon Museum, whose panoramic landscape seen from a bird's-eye view could not leave Bosch unimpressed.

The sacred scene and the landscape of the *Adoration of the Magi* display both in the treatment of form and the contrast of colours the striking antithesis by means of which Hieronymus Bosch liked to express the duality of the eternal and the ephemeral. The voluminous figures in the foreground, confidently modelled in the flow of their wide soft folds, recall the style of Claus Sluter. The alternating tones of their local colours – red, mourning black, blue-black and pure white – give the foreground its rhythm. By contrast the stable and the whole landscape of the background are kept within the range of a soft beige and a light olive-green and are immersed in a silvery shimmer.

The adoration of the wise men has here the character of a liturgical act, in which the donors and their patron saints are taking part. Mary is at once throne and altar; Balthasar, kneeling at a respectful distance from this living altar, is depicted as an old priest who, assisted

by Melchior and Caspar, is performing the service. Through this identification with holy mass the biblical event gains the symbolic significance of the eternally-repeated celebration of the sacred sacrifice – a guiding idea which, as in the Philadelphia picture and others, is paraphrased in the small scenes that decorate various objects within the main picture. The embroidery on Melchior's cloak portrays, above Manoah's sacrifice, the Visit of the Queen of Sheba to King Solomon, the typological model of the Epiphany; the worship of an idol is depicted on the sphere that Caspar is bringing to the Child, but the pelican which crowns it recalls Christ's mission as the Redeemer; the goldsmith's work brought by Balthasar and lying on the ground beside a helmet decorated with the emblems of lust, has as its theme the sacrifice of Isaac, the typological model of the sacrifice of Christ. Strangely clad figures wait in the stable, as though in the wings of a stage, for the moment when they can take the place of the kings, to whose retinue they belong, in order to become the second link in a chain of everlasting adoration. The crown of thorns and the jewels of these newly-converted savages are doubtless a reference to the Stations of the Passion. There is nothing surprising about this interpretation of the Epiphany: did not the members of the Brotherhood of Our Lady regard themselves as the direct successors of the Three Wise Men through their special worship of the Virgin?

PLATE PAGE 299

PLATE PAGE 298 LEFT

Behind the miserable stable, whose eggshell-thin walls look as though they could not stand up to a breath of wind, and on the fragile straw roof, shepherds are hiding – nomads dressed in the colours of the steppes whose primitive faces betray dull curiosity. But to the profane world, which is looking on through their eyes, the meaning and essence of the event remain concealed: they can grasp what is happening only partially, and the roof beam that is collapsing above the divine group prevents them from coming closer. The sole exclusively humorous element in the picture –St Joseph drying the Christ Child's diapers at a fire of vine-twigs under a projecting roof of pale tiles – is inspired by the art prior to van Eyck.

Without forming a complete unity, the landscapes of the three panels possess an inner affinity: the coarse peasant dances on the left, the idol crowned with a crescent that points the way to a pagan Jerusalem, the wild hordes of riders and the dilapidated inn with the ambiguous symbol of the white swan in the middle, on the right the torture wheels, the bear and wolf attacking travellers, are variations on the theme of a world persisting in heresy.

Under the same clear sky, whose azure-blue pales away towards the horizon, the multiple faces of the earth are depicted on the three panels. On the left wing, between the glade in which the peasants are enjoying themselves and the large farm with its thatch roof, herds are grazing in the damp Dutch meadows. In the centre the familiar dunes assume the wild character of the desert. Its monotony is interrupted by wooded oases whose quivering foliage and lonely waters are steeped in mystery. The landscape of the right wing stretches out to infinity. Beyond the sandy shore extends the grey surface of a kind of estuary, in the centre of which a whole town with its towers, windmills, harbour and ships shimmers in the silvery mist of morning. Eye and spirit are again and again pulled away by the subtle and uncanny charm of this vast map of the world, only to return once more to pious consideration of the sacred scene in the foreground.

TEMPTATION OF ST ANTHONY

PLATE PAGE 306

The only picture of an ascetic that has come down to us from Hieronymus Bosch's last creative period, the *Temptation of St Anthony* in the Prado, is in every respect the consummation of the endeavours that were visible in earlier representations of the same subject. Here we see most clearly the means by which the artist achieves the 'grand style': he reverts to tradition and, like Geertgen before him, constructs a relatively restricted space bounded by a few important three-dimensional forms, which alone determine the pictorial planes and create the illusion of depth. He lends even greater emphasis to this impression by the device, already well known in Netherlands painting, of arranging a row of large trees along a diagonal of depth.

Nevertheless Bosch remains true to his method of seeing things from a bird's-eye view, but this time he utilizes all their three-dimensional potentialities. In earlier pictures the point of sight was high, so that the landscape appeared as seen from above. But the figures were constructed from a lower point of sight, as if seen from in front. Now for the first time Bosch seeks to reproduce people too as though seen from slightly above, thereby arriving at an artistically unified viewpoint that embraces both space and figures.

The luminous beige, the olive-green and the transparent blue form the soft and gentle harmony of this weightless world, whose elements, modelled with a fine *sfumato*, seem hollow and enveloped only by a thin membrane. In this idyllic peaceful decoration the little demons, the representatives of an unknown fauna, engage in harmless struggles; they are no longer materializations of the evil tendencies in the saint's soul, but little human peccadilloes that can no longer confuse him, caricatures without mystery and true forerunners of the demons of Bruegel. Crouched with the immobility of a statue in the hollow of his tree, this St Anthony, having reached his highest stage of wisdom, has become an insensitive rock: his eyes, the only thing about him still alive, gaze with superhuman intensity upon the things that pass all understanding.

In this last period Hieronymus Bosch, now certain of his mastery, gives even his biblical works the character of dream pictures. The *Christ before Pilate* in the Princeton Art Museum and the *Christ Carrying the Cross* in Ghent are rich in unusual inner life.

PLATES PAGES 307, 308

CHRIST BEFORE PILATE

PLATE PAGE 309

In contrast to the two pictures of *Crowning with Thorns* of the middle period – that in London and that in the Escorial – which, in spite of their innovations, remain true to the principles of Gothic, the *Christ before Pilate* surprises us through its similarity, in composition and in the plasticity of its figures, to the Venetian half-length figure pictures of the period. But Bosch is guided solely by his own intentions and we shall see that in the Ghent *Christ Carrying the Cross*, perhaps the last work of the artist to come down to us and the conclusion of his evolution, he reveals his whole individual personality.

CHRIST CARRYING THE CROSS

PLATES PAGES 310–311

Here all connexion with real space has been broken off. Lost among heads that rise up out of the night and are pressed together like weightless bubbles, Christ sleeps with closed eyes: He is dreaming this nightmare. In His motionless face only the drawn-down corners of the mouth betray the oppressive fear of going under and suffocating in this seething mass of familiar faces now menacing him. Round the bad thief in the right lower corner, who is filled with anger at their mockery, the executioners are exulting with sadistic joy. Left to a Dominican, who is admonishing him with wicked fanaticism, the good thief emerges

like a drowning man with green and rotted flesh, dead eyes and clammy wet hair. One of the executioners has seized the cross with both hands. He is pressing it down, and with it Christ, summoning up all the strength of his malice. The face of Veronica has been transformed into an uncanny wax mask. The artist's creative genius draws the apparitions from his dreams, and the misshapen creatures he invents stem from the encounter between the horrifying and the comical that plays such an important part in the theories of Freud.

Bosch expresses the impalpable character of his dream visions by a limited number of means: the most powerful is perhaps the repetition five times of a light, sharply defined profile, behind which appears a less light three-quarter profile, behind which in turn emerges a third, even darker full face. The group of three is a formula of Italian monumental art, invented by Giotto, revived by Masaccio and then by Raphael; Bosch takes it up and renders it even more effective by graduating the light content of the colours. Moreover, the principle of the repetition of the same motif in the same pictorial field is a remarkable anticipation of Mannerism.

The stillness in which this world of sleep is enveloped is intensified by the warm and peaceful splendour of the Bordeaux-red, the velvet-blue and the soft black; its mystery is deepened by the gentle charm of the in part iridescent colours, which in Veronica's head-veil change from soft blue to white and from white to golden yellow, or in the transparent crystal of the sugar-loaf-shaped head-covering of one of the executioners form a subtly variegated rainbow. Indissolubly intermingled, horror and dazzling beauty create that condition of tension between fear and pleasure into which dreams alone put and hold us.

If we conclude our study with the *Prodigal Son* from Rotterdam Museum, the only picture with a profane theme from Hieronymus Bosch's last period, we do so although this is not the master's last work, but because it expresses with rare power his final spiritual attitude towards human life. The graduation of the light values of the colours lends the tondo in its octagonal painted frame the character of a small convex mirror – for Bosch the mirror of reality.

PRODIGAL SON

PLATES PAGES 283–285

The artist remains faithful to the principle which he applied in the pictures of ascetics – that is to say, he designs the whole composition around a single figure that dominates the foreground. The irresolute posture and bewildered expression of this wretched wandering vagabond, grey before his time, might illustrate the verse which the melancholy situation of the human soul inspired Freidank to write in his *Bescheidenheit*:

> *I know not rightly who I am*
> *Nor whither I should go.*

In the soul of the Prodigal Son will and instinct are in conflict. He has to choose between debauchery and virtue. With its crooked roof, broken windows, loose shutters and the washing in the window, the White Swan inn with the jug on the gable makes a decayed impression, indeed has a positively dissolute appearance.

Thus it threatens to hold back the Prodigal Son, whose steps are already leading him to the entrance of his father's fields. At the very moment when he is about to pass through the gate, he turns his eyes away from it, his injured foot slows his step. With a hesitant hand, in which he holds his Sunday hat decorated with an awl, the sign of his shoemaker's

trade, he points out the right path; on his jacket hangs a popular good luck charm, a pig's foot. But attached to the ragpicker's basket on his back, in which he has stowed his possessions, are a wooden spoon, the sign of profligacy, and a cat's skin, in folk-lore a bringer of misfortune. Thus the symbols too are distributed according to the principle of good and evil on the front and back of the person. The evil symbols point to the left, where the house of ill repute stands, the good to the right, to his father's lands.

Breaking away from the iconographic tradition, which represents the *Prodigal Son* as either carousing in the brothel or kneeling penitently at his father's feet, Bosch has chosen this moment in the lost son's life, in order to be able to adapt the theme to the allegories of decision. The angels and the demons, the virtues and the vices, do not appear here personified; the dilemma is created by life in its reality. But the human soul is not yet strong enough to dispense with superhuman powers: devoid of faith, full of inner contradictions, undecided as to its goal, it wanders about in a world without God. Bosch's irony is mitigated by pity for man, who can find no moral home within himself. Hence Bosch remains standing at the threshold across which the path leads to the idea of the free will of autonomous humanistic man. But precisely because he does not portray man in his spiritual power and physical strength, like the Italians, but in his inner weakness and bodily fragility, his work is all the more poignant. In the Palace of the Doges in Venice, when one comes from the monumentality of the pictures by Titian, Tintoretto and Veronese, in their sumptuous gilded wooden or stucco frames, into the semi-darkness of the unornamented room in which Bosch's works are now exhibited, one sees with surprise that pictures which look like magnified miniatures lose nothing by the comparison. It is not only the delicate mastery with which Bosch deals with the atmospheric and light effects of landscape that enables him to confront these other artists on equal terms, but also the humility and timidity manifested in the language of his brush, and the ardent spirit that always touches upon the last things.

With a palette similar to that employed over a century later by Jan van Goyen, the young Aelbert Cuyp and the young Salomon van Ruysdael for their monochrome – beige, beige-grey or grey – landscapes, which are considered the classical expression of the Dutch atmosphere, Bosch achieves the highest degree of perfection with the simple means of his light and transparent brushwork. In the *Prodigal Son* the pure grey of the rainy sky, the beige-grey of the dunes and the groups of trees wrapped in silver-grey haze harmonize with the light grey of the main figure's garments and the straw-yellow of the back-basket, as well as with the pale lilac of its lid. Only the lively pink of the face and the hands stands out. The gloom and melancholy of all earthly life are evoked through the mood of a rainy day in a dismal landscape of sand dunes.

Technique and Style

Hieronymus Bosch's technique and style evolved neither from a school tradition which he took over or developed, nor from an alien technique which he made his own. They are the adequate and direct expression of his view of the world, a phenomenon that had not been repeated since Jan van Eyck. Jan van Eyck had given a picture of the totality of the world – a fundamental intention which became lost in his successors; under the influence of the late medieval panentheism he revealed in nature the work of divine creation, the *natura naturata*. In order to paint a world to which the act of the Redeemer restored its paradisial innocence, he created a technique and a style that made of it a cosmic gem; men and things, fauna and flora, are like precious jewels bathed in supernatural light and participate in the same condition of grace and peace.

Faced with a world that denies its metaphysical origin and does not yet seek any immanent meaning, Hieronymus Bosch invented another image: the world that had once been the home of the soul became alien to him. The gem changed into a deceptive veil, its divine lustre into vanity. Enveloping in mist that which had once been clear, rendering inconstant that which had once been lasting, and immaterial that which had once been palpable, the artist finally found the new face of the earth: a world that is merely an optical illusion. This is the reason why Hieronymus Bosch never strives for an objective description of things in themselves. Drawing and modelling also play only a very secondary role in his painting, which is based above all on the appropriate distribution and correct graduation of the luminosity of the colours. Thus the impression of space is created by several smooth colour values superimposed one upon the other in parallel zones and their artistic graduation determines the layers of space: the darkest tones dominate the lower part of the picture and they grow progressively lighter towards the horizon line, only to grow darker again in the sky. Through this procedure, by means of which Bosch for the first time represents a purely aerial perspective, the artist creates an extraordinary breadth and depth in a space that nevertheless remains visionary. It is also this parallelism of the zones of colour that gives the whole surface of the picture a rare degree of unity; the space depicted coincides strictly with this surface – that is to say, it does not, as later in Baroque, reach out into the space of the spectator. In this respect Hieronymus Bosch's painting, whose dematerialization anticipates the seventeenth century, remains true to the Middle Ages: devoid of the diagonals that enliven all Baroque compositions, it floats before the spectator like a mirage, without ever forcing its way into his real space. In the pictures with the small

figures there is no foreground. In the pictures with large figures the first zone of colour is formed either by the flat silhouette of these figures or by a single figure that forms a unity with the whole foreground; in these two cases the middle distance is missing and the figures stand out from the background with an often monumental impressiveness.

The colour scheme also serves to intensify this homogeneity. The colours never describe the actual substance of the object, its texture, but express a manifoldly varied substance specific to the colours themselves. His negative attitude to reality has driven the artist to the irrational play of iridescent tones or to the nuances of grisaille.

Light only serves to augment the insubstantiality of this mode of painting. For the most part diffuse, it places white or pink high-lights on the figures and objects of the foreground and lies like a silvery bloom on the background of the landscapes. In the late works a subtle chiaroscuro seems to drain things of their substance by creating transparent shadows. The artist replaces the individual representation of things by the direct reproduction of a total view, which he then, on the basis of his knowledge, modulates and enriches; this is why he used to execute his pictures in a single session, as was already noted by Carel van Mander. On the prepared white ground Bosch would sketch in the whole composition with his black chalk, over this he laid a thin layer of pale beige, on top of which he then carried out the painting with a pointed brush and transparent colours. Unlike his predecessors, whose enamel-like mode of painting caused the painting ground to disappear and was thereby admirably suited to express the static condition of things, Hieronymus Bosch's transparent, loose technique was the perfect means of revealing their state of disintegration. This also explains his negative attitude towards the achievements of the Italian Renaissance, namely the stabilization of space through linear perspective, the anatomical understanding of the human body, the language of gesture through which a now autonomous humanity expresses itself, the profane delight in ornamentation. But if Bosch does not use these achievements, on the other hand he himself surpasses the audacity of the Venetians by his purely optical conception of the universe. The creator of a style of his own, he stands isolated in his period.

THE DRAWINGS

PLATES PAGES 315–329 Prior to Hieronymus Bosch, Dutch artists demanded no more of the pen than the painterly possibilities afforded by the traditional technique of the silver point; they continued to reproduce the three-dimensional character of an object, light and shade and the qualities of materials by means of infinitely fine hatching. No longer using the silver point, but almost exclusively the pen, Hieronymus Bosch created through line a new calligraphy in which, for the first time in Dutch art, the object represented expresses at the same time the temperament of the artist. His drawings, at first consisting of almost straight lines with very little hatching, became during his middle period a bold calligraphy full of flamboyant

curves; in the drawings of his final phase, simplified synthesizing lines build up with a sure touch sketches modulated by powerful hatching and gentle dashes.

These drawings fall into three groups: the designs for paintings; the sketches, in which, mixing imagination with observation of nature, Hieronymus Bosch unites all the variations on a theme; and lastly drawings of a final character that are works of art in their own right, often bolder than many of the master's paintings. The drawing in the collection PLATE PAGE 331 BELOW belonging to the Museum Boymans-van Beuningen in Rotterdam, which probably illustrates the Dutch figure of speech 'That's a proper owl's nest', belongs to this last category. The section of a tree-trunk that fills the whole width of the sheet and stands out sharply from the delicate background, and the mysterious love-life of the owls which lodge in it, recall the art of the Far East, even if we accept Jakob Rosenberg's thesis that this drawing is only a fragment of a larger sheet.

Fame

The simultaneously provincial and universal art of Hieronymus Bosch was soon to enjoy great success. Even during the artist's lifetime it aroused the interest of the most exalted patrons. In 1504 Philip the Handsome ordered from Bosch a *Last Judgement;* in 1516 Margaret, Regent of the Netherlands, owned a *Temptation of St Anthony* which has today disappeared; his works soon found a place in the famous collection of Cardinal Grimani in Venice and a little later in the great collections at Antwerp. The Spanish king Philip II was a passionate admirer of Bosch's pictures and acquired for his Escorial the largest selection, which can also be considered the most happy choice.

During the sixteenth century and in the first half of the seventeenth, Hieronymus Bosch exercised a dominant influence on the painters of the whole of Europe. In his own country the young Lucas van Leyden, and in Antwerp Quentin Massys, could not escape it. Through the mediation of Jan de Cock, Antwerp Mannerism was enriched around 1520 by the bizarre elements that appealed to him in Bosch's work, while the important landscape painter Joachim de Patinir derived from Bosch the decisive formulas for his synthetic cosmic landscapes. The coarse *drôleries* of Jan Mandyn and Peter Huys were inspired by his scenes of hell. The luministic effects of certain fiery landscapes, e. g. those of Elsheimer and Jan Bruegel the Elder, owe a debt to Bosch. Thanks to the engravings of the first great Antwerp publisher, Hieronymus Cock, the influence of Hieronymus Bosch's art spread over the whole of Europe around the middle of the century. In the seventeenth century both Brouwer's and Teniers' work mirrored this influence in large measure. Without doubt the treasures of the Escorial inspired the palette and the composition of El Greco's first Spanish compositions. In France Callot emerged as the witty and elegant theatrical producer of the *Temptations of St Anthony* in his engravings. In Germany Lucas Cranach the Elder copied the *Last Judgement* (Berlin), and Altdorfer adopted Bosch's fiery landscape effects in some of his early pictures.

In Italy Hieronymus Bosch's work exercised no significant direct influence on the visual arts, although Giorgione's so-called *Raphael's Dream* is inconceivable without contact with Bosch's paintings. On the other hand the sixteenth-century writers Guicciardini, Vasari, Lomazzo and Baldinucci speak highly of Bosch and unanimously praise his great imagination. In Spain art-lovers, writers and churchmen discussed the meaning and importance of his work from the beginning of the sixteenth century to the end of the seventeenth. The artist's star did not wane until the end of the seventeenth century; but Bosch regained the

esteem of art historians during the closing years of the nineteenth century, and his influence was revived and became stronger than ever before in the art of Surrealism. With all these writers and painters, however, we find only one aspect of Hieronymus Bosch's work. His true glory consists in his having prepared the way for the two geniuses of Flemish painting, Pieter Bruegel the Elder and Rubens, by presenting a completely new picture of the totality of the world seen for the first time independently of religious postulates, and finally in the fact that he made Rembrandt possible by coming to grips with the secret forces of the soul and tracing the true mainsprings of the inner life in the depths of the unconscious.

CONCLUSION

Simultaneously attracted by the joys of the flesh and seduced by the promises of asceticism, too much of a believer to fall into heresy, but too clear-sighted not to see through the shortcomings of the clergy and the evils of the world, dazzled by the beauty and wonders of nature and unwilling to recognize their divine or human value, contenting himself with the *docta ignorantia,* Bosch lays bare the contradictions of his age and makes them the subject of his artistic production; in this he transcends a Sebastian Brant, a Murner or a Kaisersberg who, in their criticism of the world, entirely neglect the positive side. On the other hand the painter raises the everyday world to the level of high art and discovers in it an uncanny, though vain beauty; his discovery leads to a new sovereignty of consciousness, which is no longer bound exclusively to religious doctrines but strives for that independence of the mind which future generations were to achieve. In these unique paintings of the late Middle Ages, as in the late phases of all cultures, the truth of the inner world prevails over the lies of the outer. Already in the seventeenth century a Spanish contemporary of El Greco, Frey Joseph Siguença, could pass the following judgement on Bosch: 'The difference which, in my opinion, exists between the pictures of this painter and those of others lies in the fact that the others sought to paint man as he is outside – but he alone had the courage to paint him as he is inside.'

Preface to 1937 Edition

Facts relating to the human relations and spiritual strivings of Hieronymus Bosch, and evidence from which it would be possible to reconstruct the course of his artistic evolution, are extremely scanty. Hence any interpretation of Bosch must rest chiefly upon his pictures. This is undoubtedly the reason for the uncertain nature of all evaluations of this painter.

The earliest writers on Bosch – Lampsonius and Carel van Mander – confined themselves to the most obvious criterion, his subject matter; their view of Bosch as the inventor of fantastic *diableries* and scenes of hell, which still prevails among the general public today, was also supported by art historians down to the last quarter of the nineteenth century. Then, under the influence of the new realism that emerged in contemporary art, scholars revised this judgement. Justi, Schubert-Soldern, Glück, Schmidt-Degener, L. Maeterlinck, van Bastelaer, Gossart and Lafond based their interpretation on the other obvious aspect of Bosch's art, his realism. They saw in him the forerunner of modern realism. Starting from this premiss von Baldass arranged Bosch's work chronologically according to the progress of its realism, on the assumption that increased realism was the painter's main concern. Further, attempts have been made to apply the methods of historical pragmatism to the problem. Thus Dollmayr and Gossart sought the iconographical sources in old theological texts. Cohen and von Baldass believed that they could find the explanation of the artist's enigmatic style in the artistic traditions of the north. But none of them took proper account either of Hieronymus Bosch's creative invention, or of his personal intentions, which alone decided to what extent and for what purpose he made use of these traditions.

By contrast, this study seeks through an analysis of Bosch's work to clarify his artistic and spiritual aims and to determine his position in the history of art.

(1937)

In the twenty-nine years that have passed since 1937, when the above preface was published, many other works have appeared and enriched our knowledge of the artist. Chief among these are the two major surveys of Bosch's art produced by Ludwig von Baldass in 1943 and by Jacques Combe in 1946. Both employed the new approach to the artist and the

new findings contained in this book as their point of departure; but the two authors built upon this foundation in different directions. Baldass's book is valuable above all for the many detailed observations regarding technique and iconography to be found in his comprehensive catalogue of the works – revised, in the 1959 edition, by Gunther Heinz. Jacques Combe gives a general picture of the master written with great sensibility and literary skill. Our conclusions of 1937 – regarding the chronology, interpretation of the work, and the master's artistic and intellectual development – are not questioned.

In view of this, we felt justified in retaining the original text unaltered, apart from minor additions and corrections. On the other hand, the catalogue of paintings and drawings has been greatly extended and enlarged by the results of recent research, including that of the author. The new photographs of Hieronymus Bosch's works, made possible by the generosity of the publisher, were taken specially for this book.

<div style="text-align:right">

Charles de Tolnay
1966

</div>

The Paintings
and Drawings

THE CURE OF FOLLY

The inscription *Meester snyt die keye ras – Myne name is Lubbert das* ('Master cuts out the stones – My name is Lubbert das', i.e., gelded badger) states the theme: the folly and uselessness of all worldly healing, an idea widely propagated at that time in didactic poems, moral sermons and proverbs. A corpulent citizen, relying on the encouragement of a monk and a nun, offers his forehead to a charlatan for an operation. It does not bother him in the least that the doctor is wearing the funnel of wisdom as a head-covering or that the nun is making the same senseless use of a book of medical knowledge.

MADRID, MUSEO DEL PRADO.

Oil on wood. Height 48 cm, width 35 cm. Complete picture on facing page; details pages 54, 56 – 57.

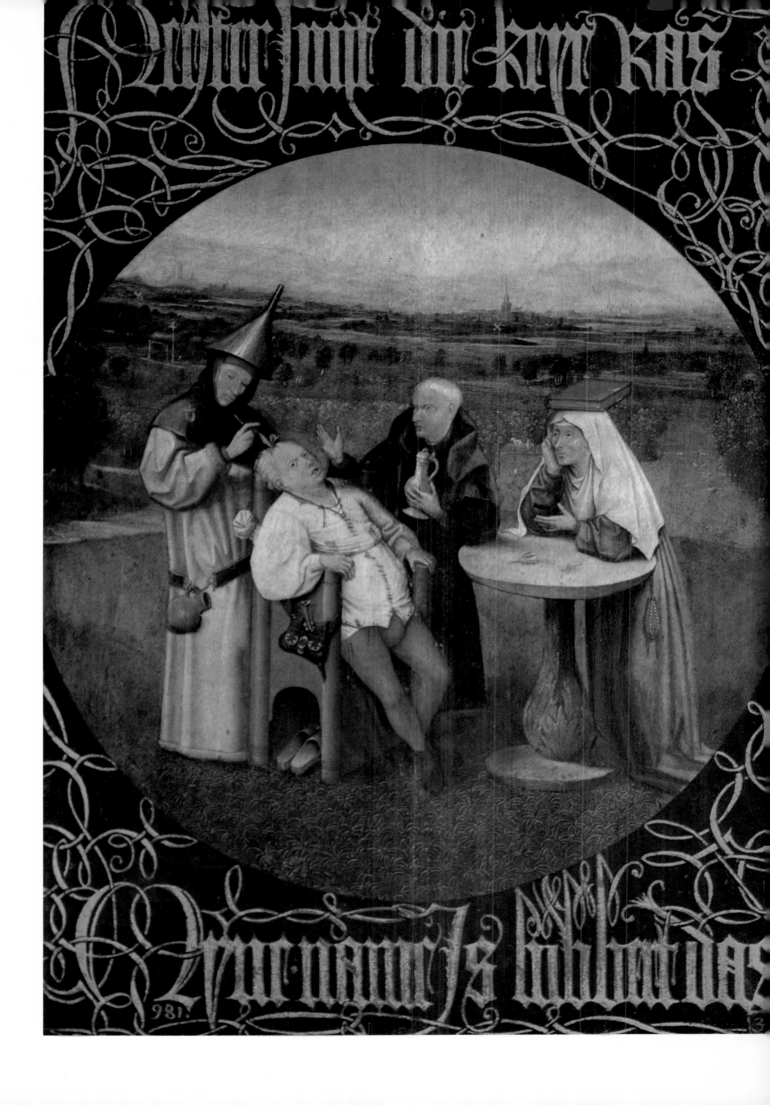

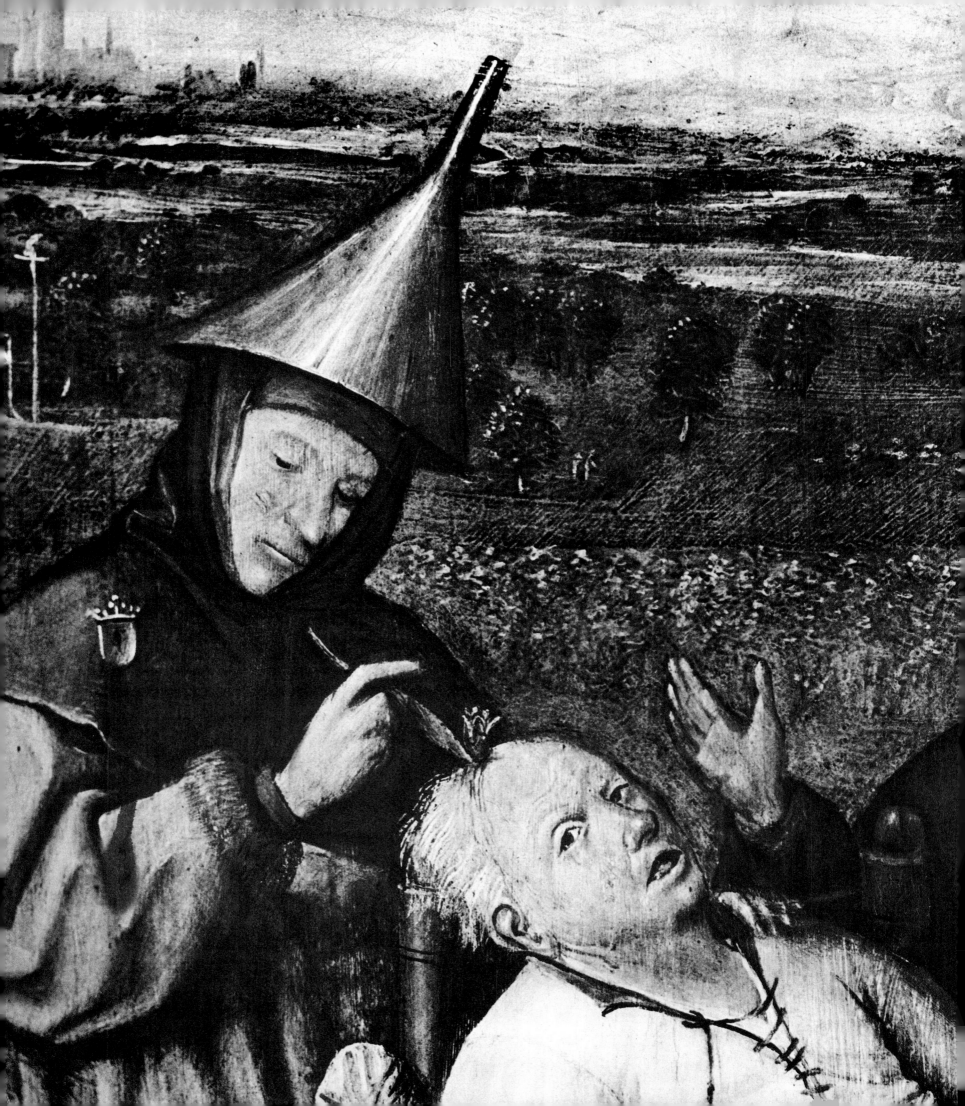

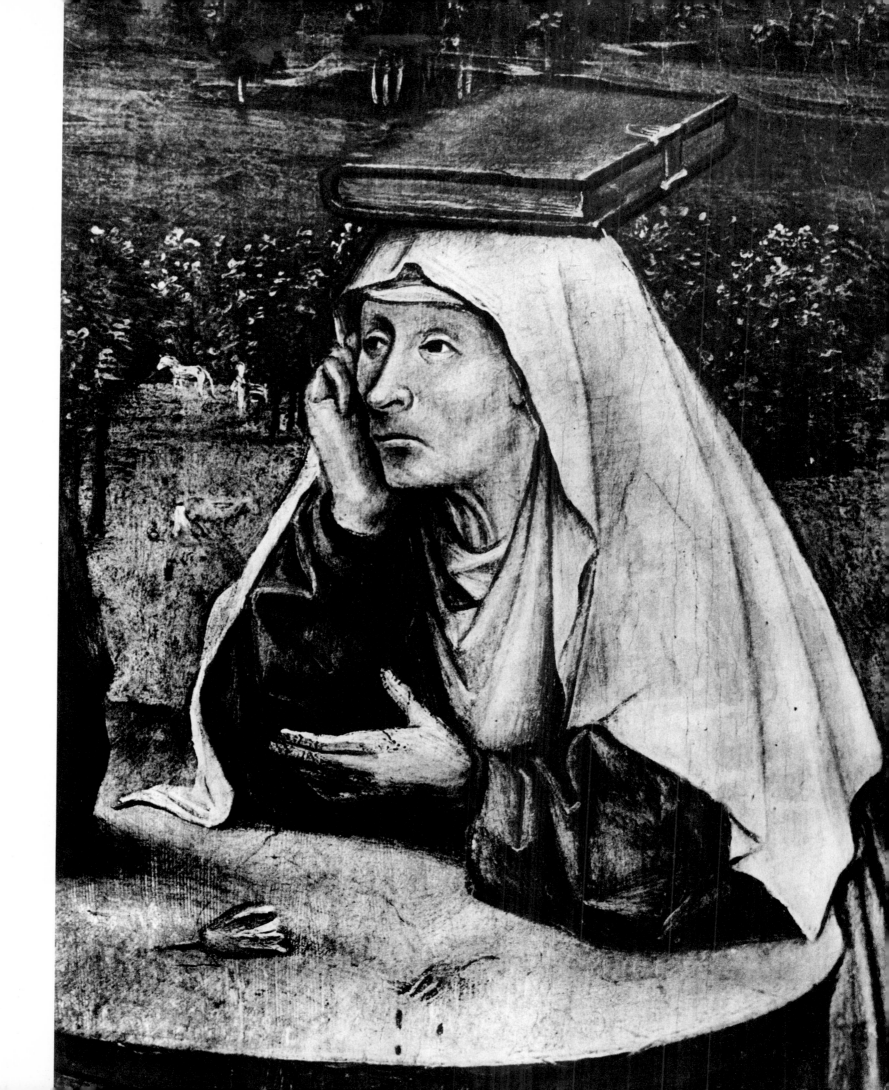

Gens absq̃ osilio ẽ et sine prudentia
virtus sapezẽt ⁊ intelligezẽt ac nouissĩa prouiderẽt

deutro. 32°

THE SEVEN DEADLY SINS AND THE FOUR LAST THINGS

The 'seven deadly sins' are taken from the medieval system of virtues. Here they are represented, not by personifications of abstract concepts, but by apparently random scenes from daily life. People's thoughts and actions are directed towards unsuitable goals, and the resulting unbalance of the moral order creates the comic effect. In the centre is an unusual version of the Eye of God; the inscription *Cave, cave, Dominus videt* is in keeping with the idea, common in didactic poems of the time, that nothing is hidden from the Eye of God. Painted table-top.

MADRID, MUSEO DEL PRADO (FORMERLY IN THE ESCORIAL).

Oil on wood. Height 120 cm, width 150 cm. Complete picture pages 60-61; details pages 58-59, 62-69.

Abscondã faciẽ mẽã ab eis : ⁊ ꝯsidezabo nouissĩa eoz

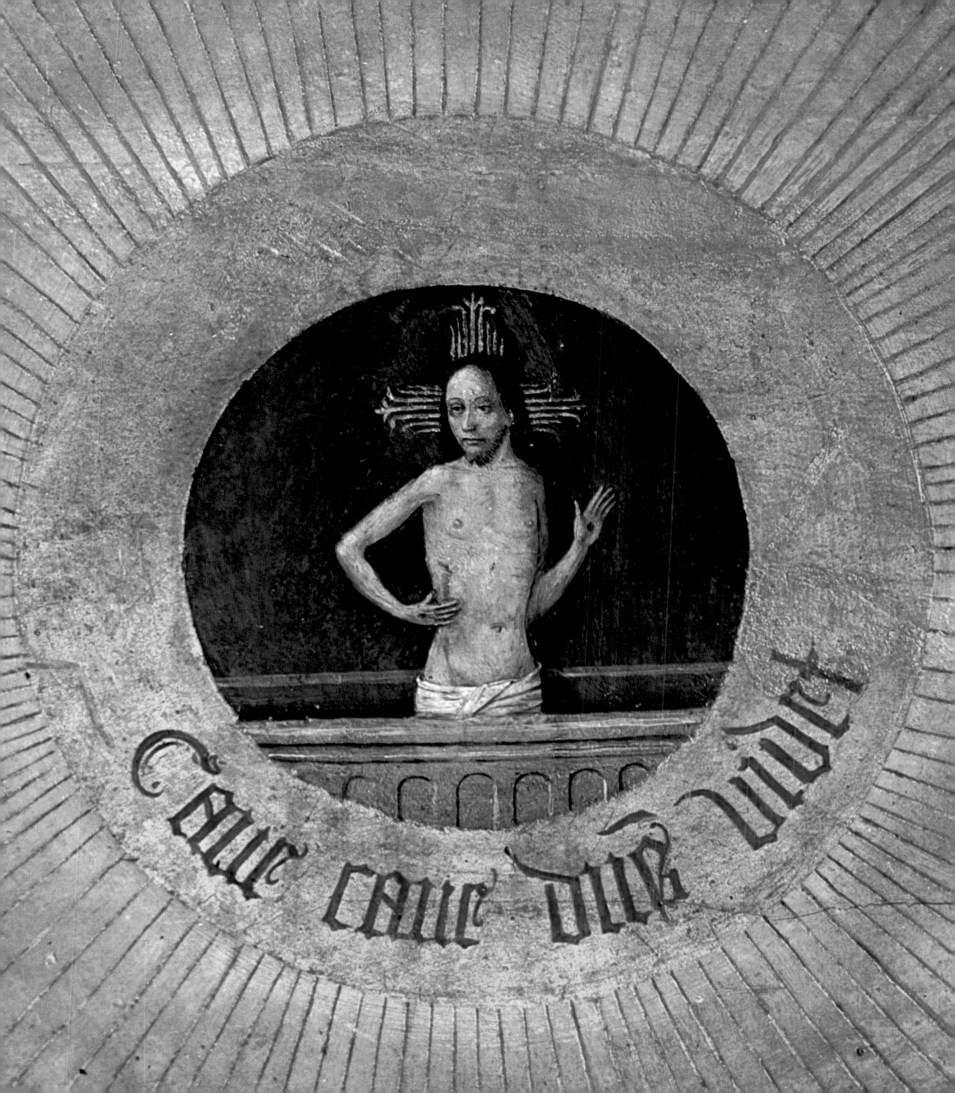

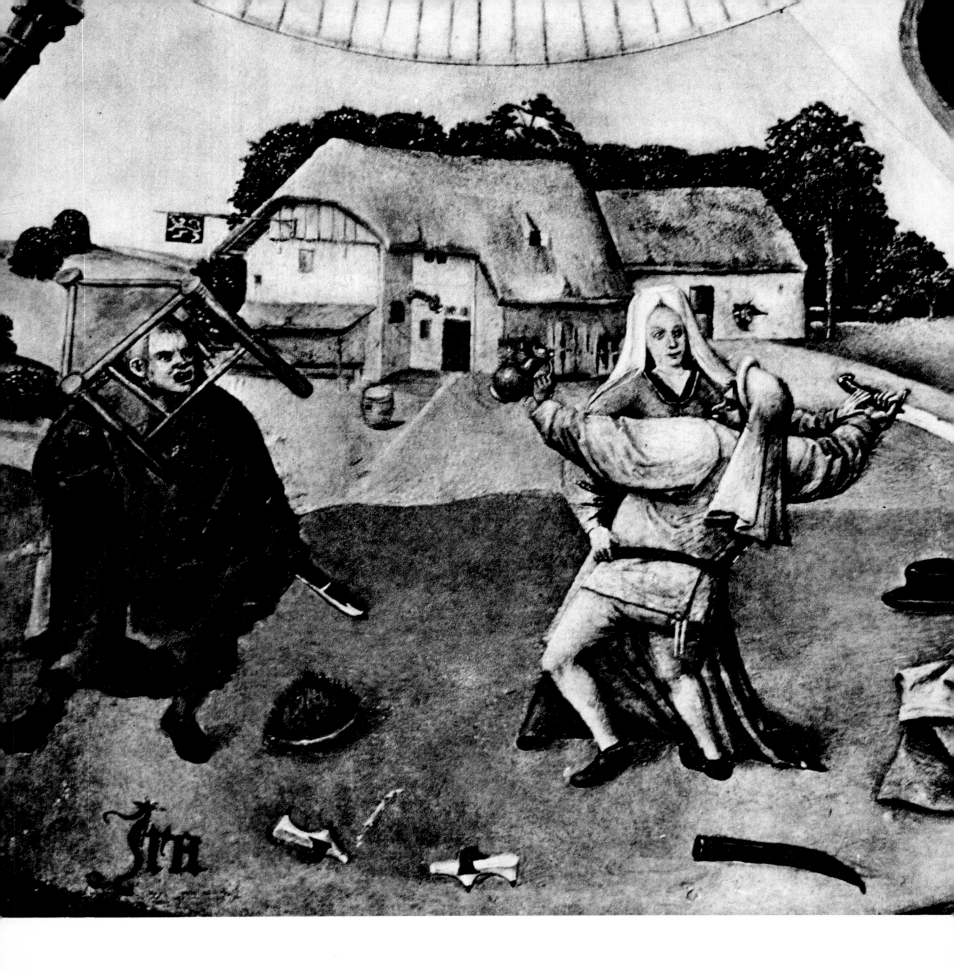

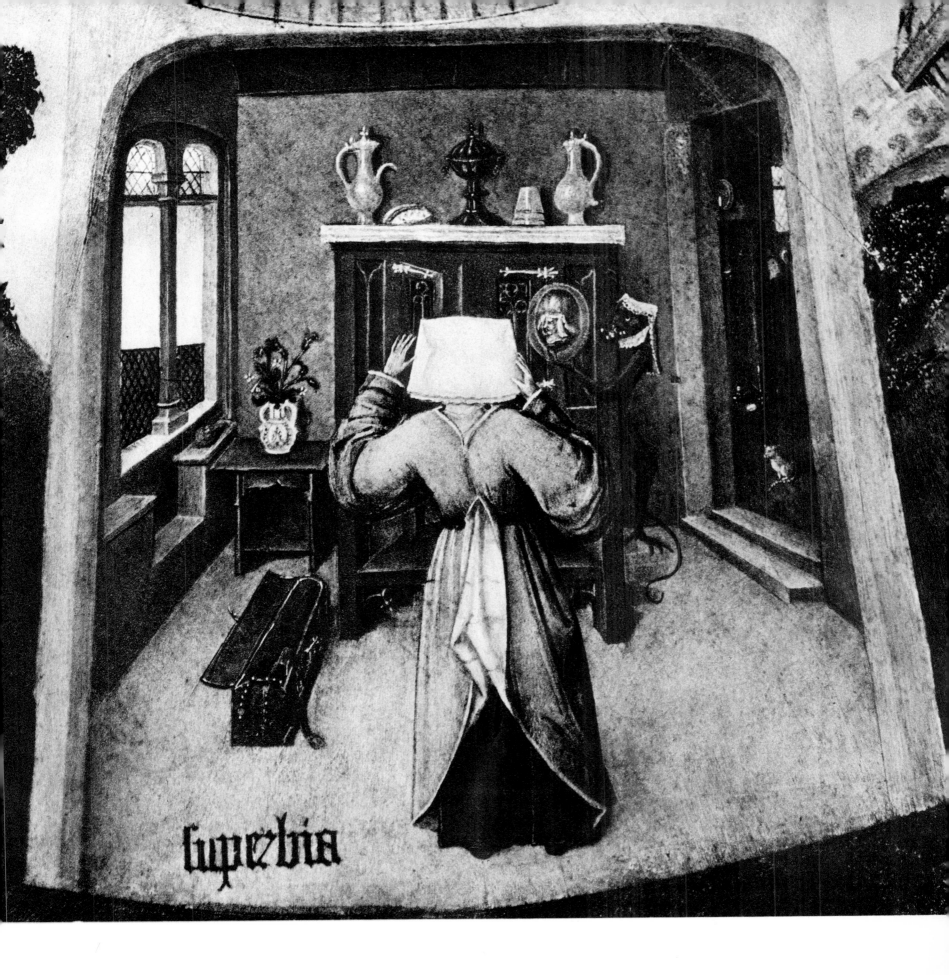

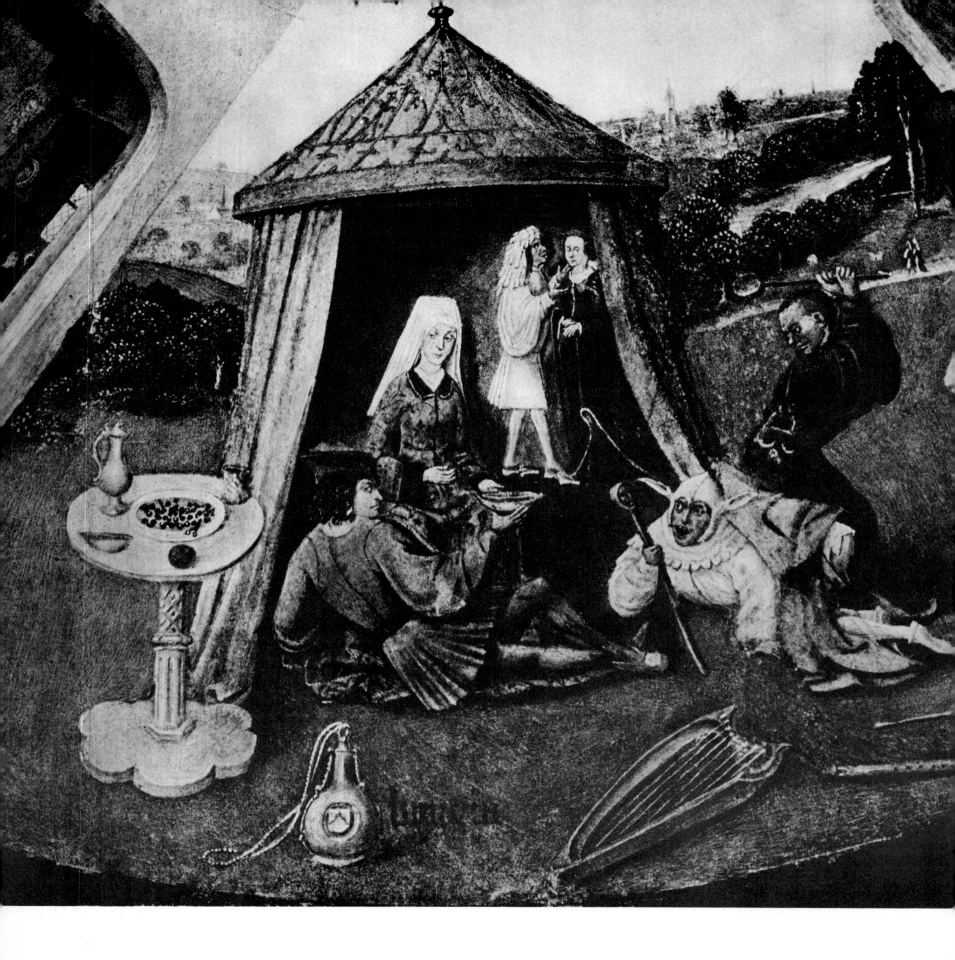

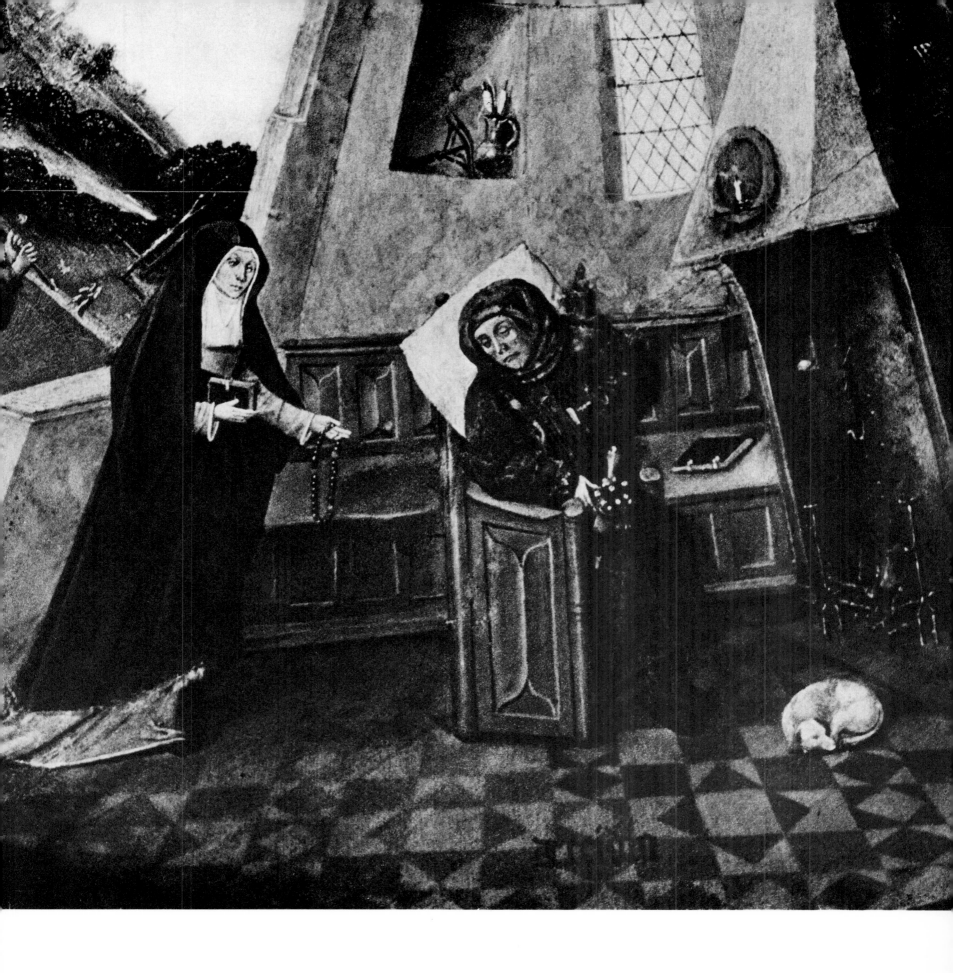

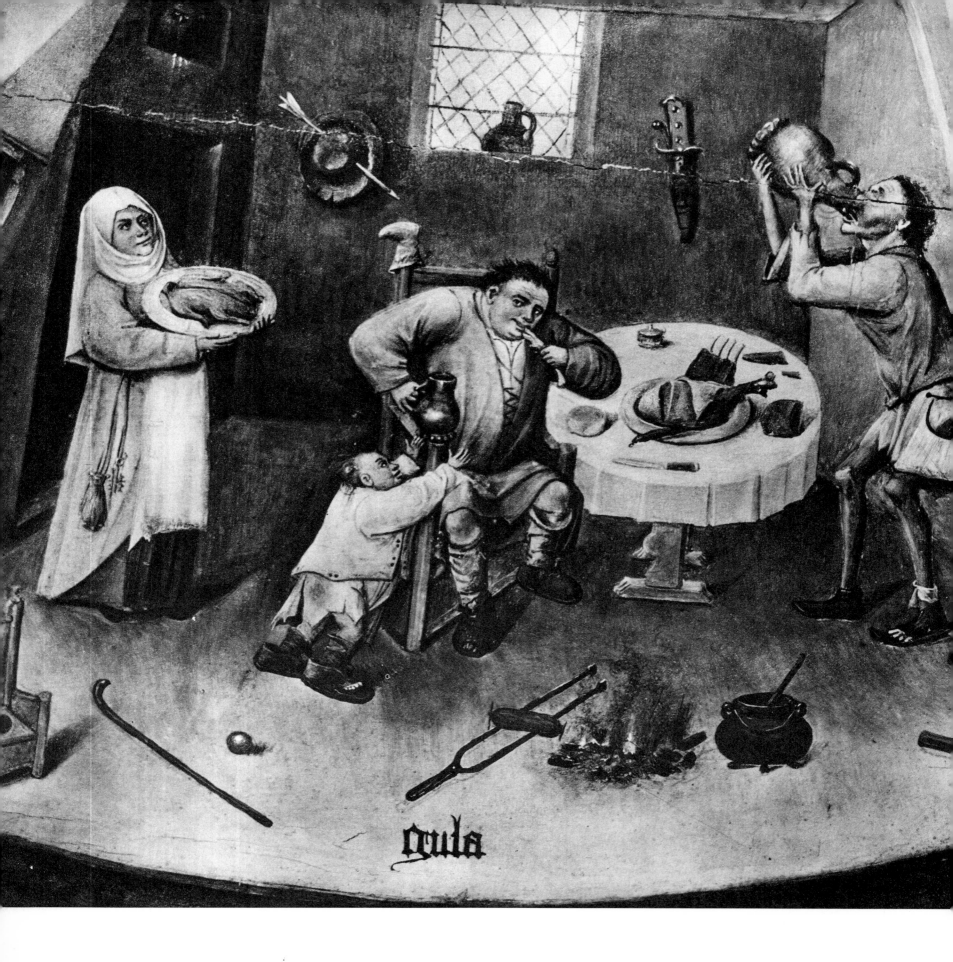

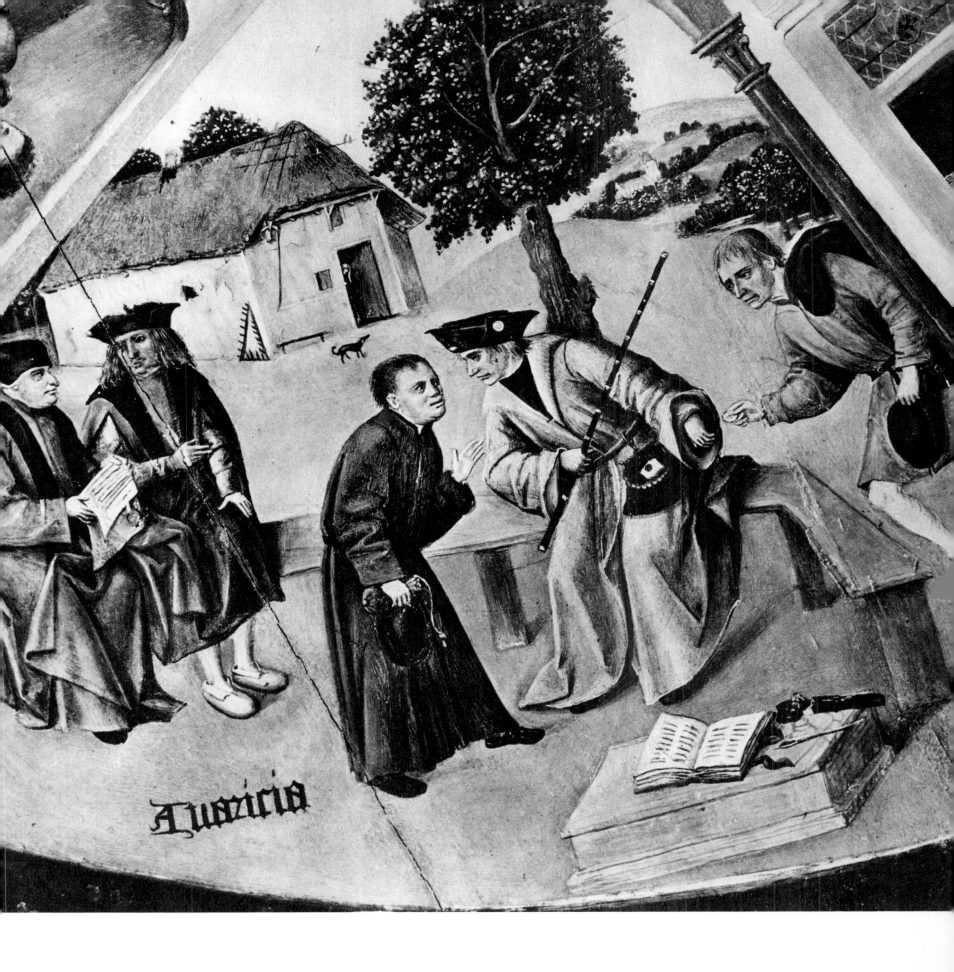

Auaricia

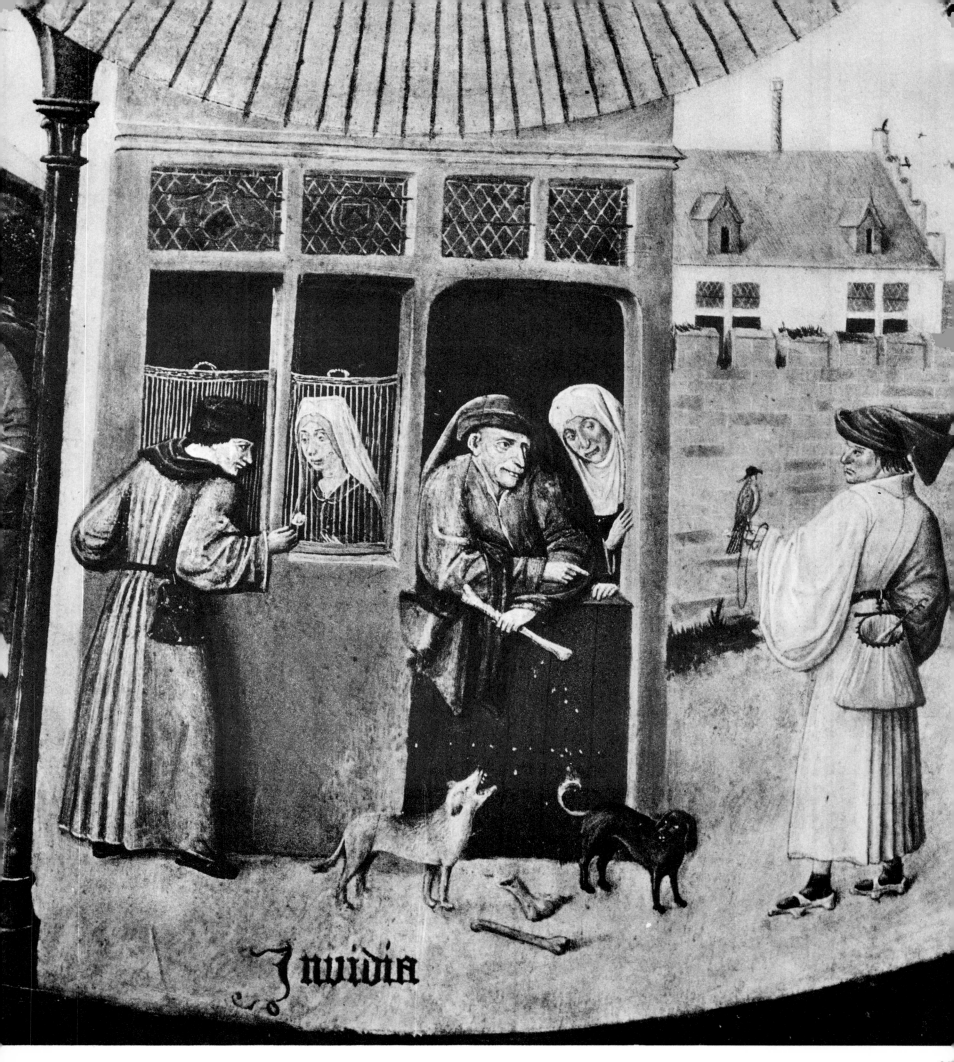

Invidia

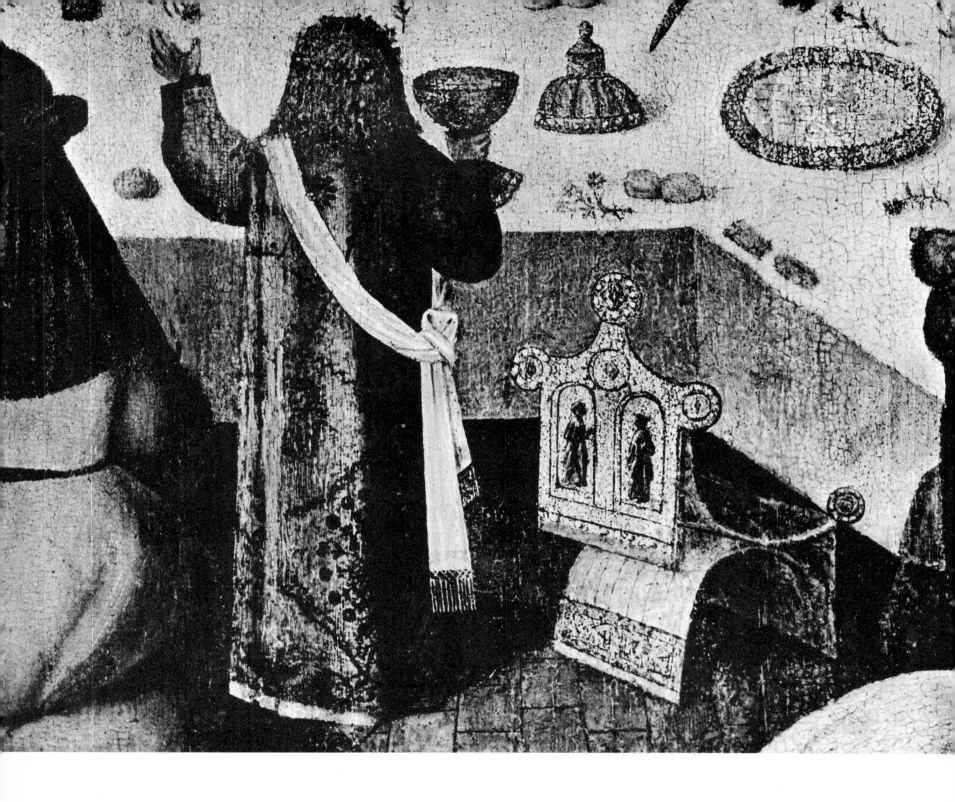

THE MARRIAGE AT CANA

The erect posture of the guests, seated parallel, gives the traditional impression of rigidity. With their bizarre airs, strange costume and disquieting or comical expressions, the guests are nevertheless an astonishing gathering. Apart from Mary, who is pointing out the Saviour to the timid bride, and the man on Christ's left, they are all heretics. The transubstantiation of the wine into the blood of Christ is taking place without the company's being aware of it.

ROTTERDAM, MUSEUM BOYMANS-VAN BEUNINGEN.

Oil on wood. Height 93 cm, width 72 cm. Complete picture page 71; details pages 70, 72-77.

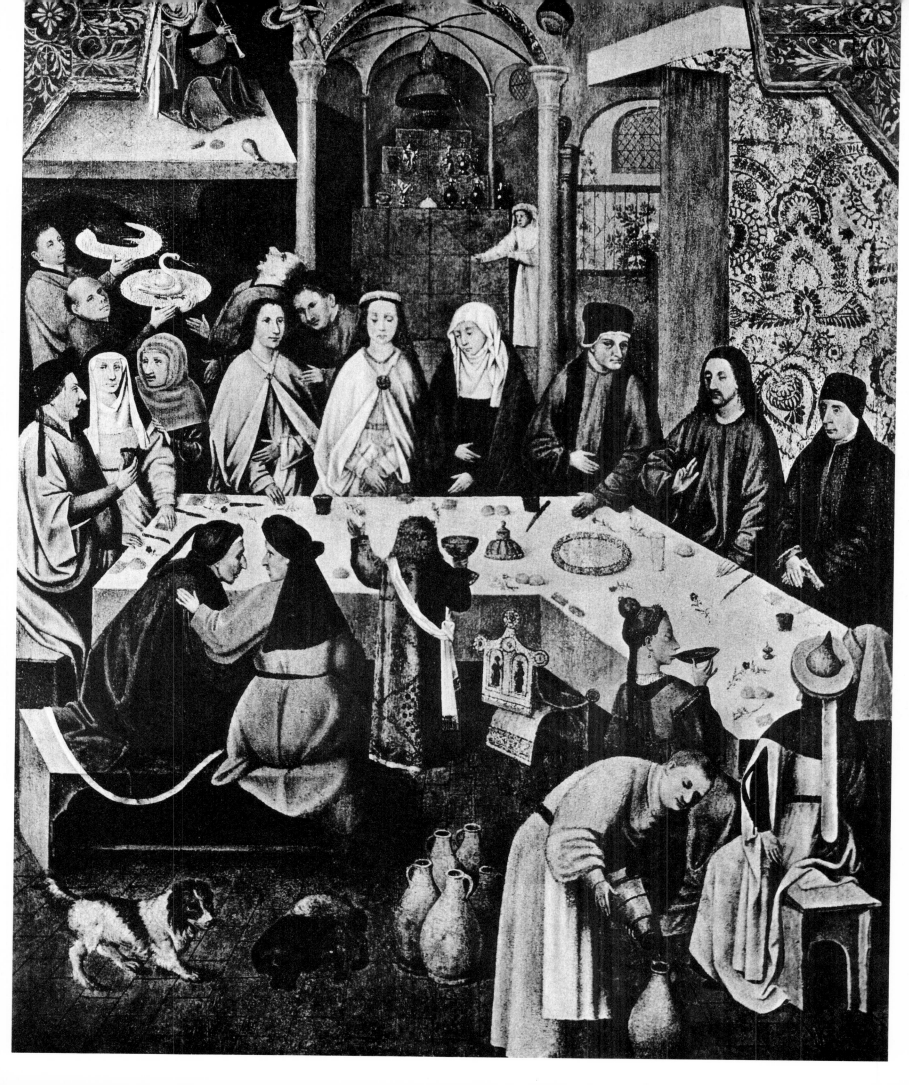

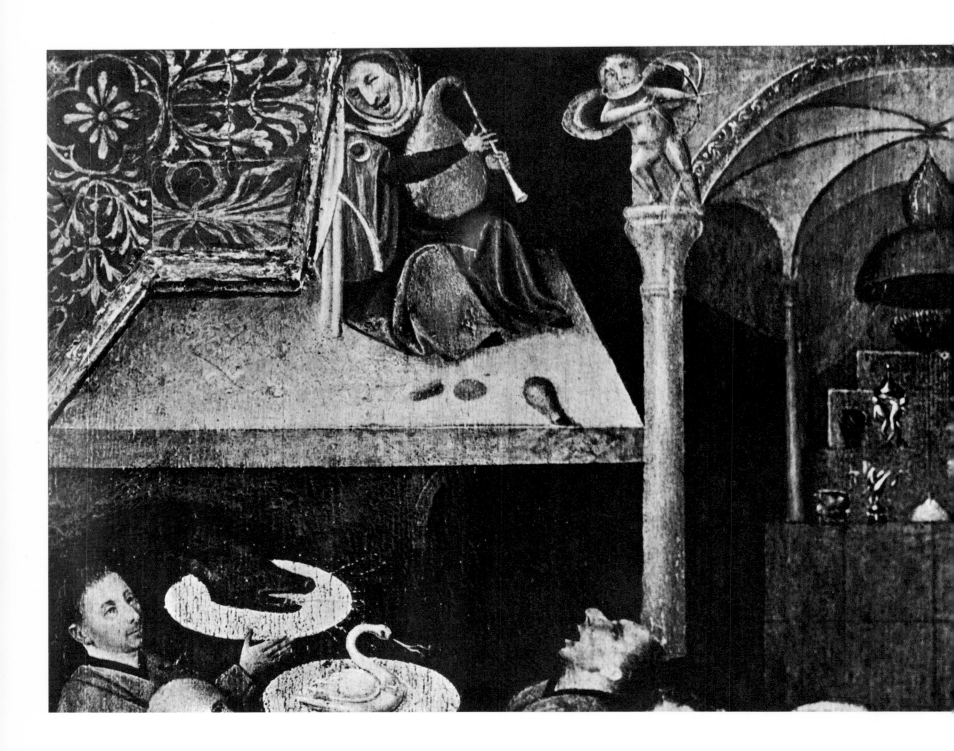

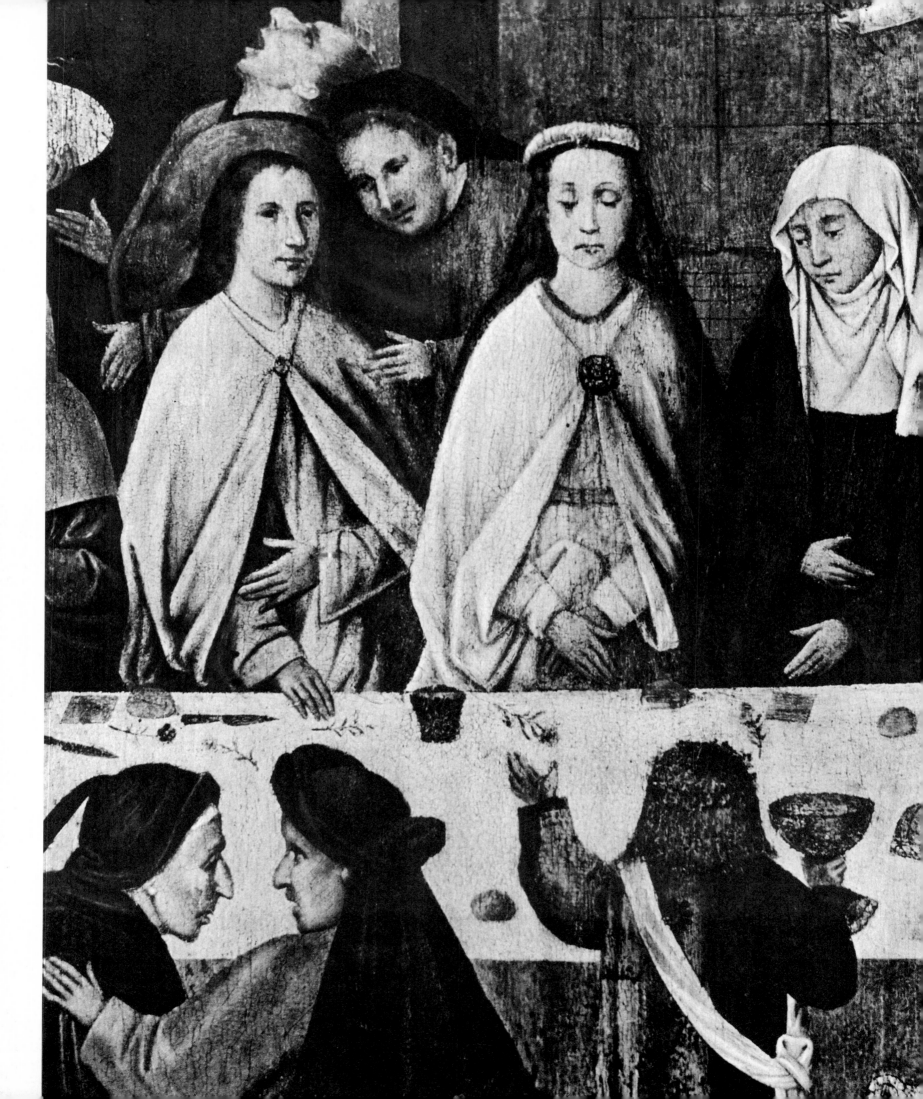

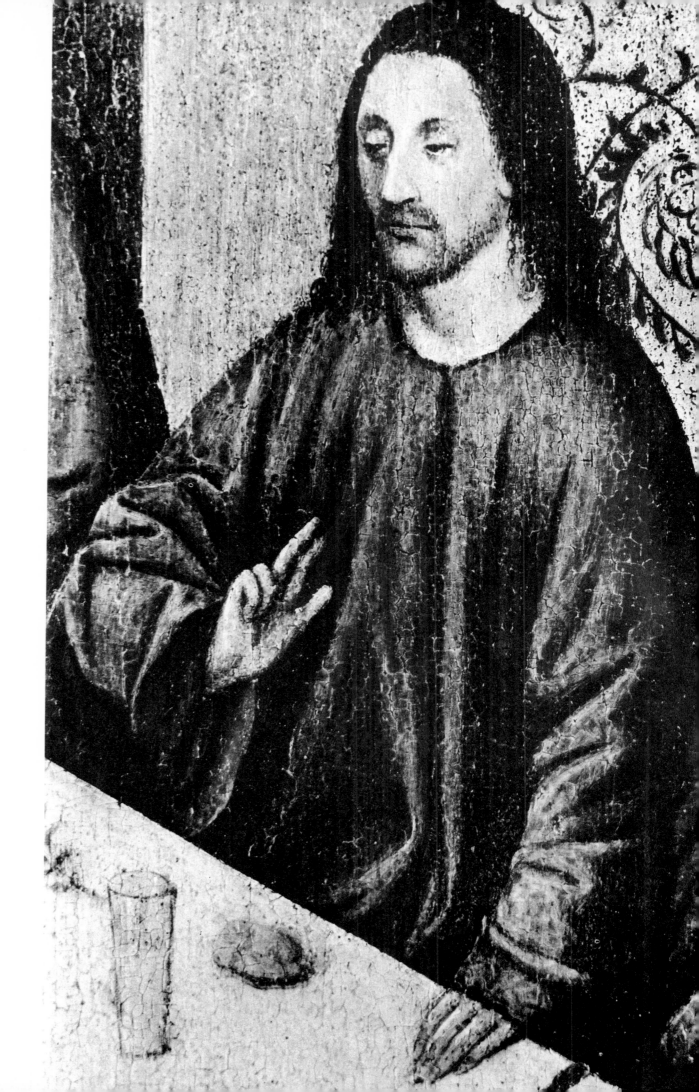

7

TWO HEADS, POSSIBLY OF HIGH PRIESTS

ROTTERDAM, MUSEUM BOYMANS-VAN BEUNINGEN.
Oil on wood. Height 14.5 cm, width 12 cm.

THE EPIPHANY (ADORATION OF THE MAGI)

United by the magic power of the star (a theme whose unexpected reappearance emphasizes the miraculous nature of the event), the five figures convey the impression of members of an esoteric religious community. Bosch has combined them into a group, and screened them off from the world, i. e. from the landscape, by the poor dilapidated stable, which suggests the dreary transience of things. The flat landscape with the quiet little town on the horizon breathes a deep melancholy; the earth is a spiritual desert, in which Jesus appears only to the initiate.

PHILADELPHIA, PHILADELPHIA MUSEUM OF ART, JOHNSON COLLECTION.
Oil on wood. Height 74 cm, width 54 cm. Complete picture page 79; detail page 80.

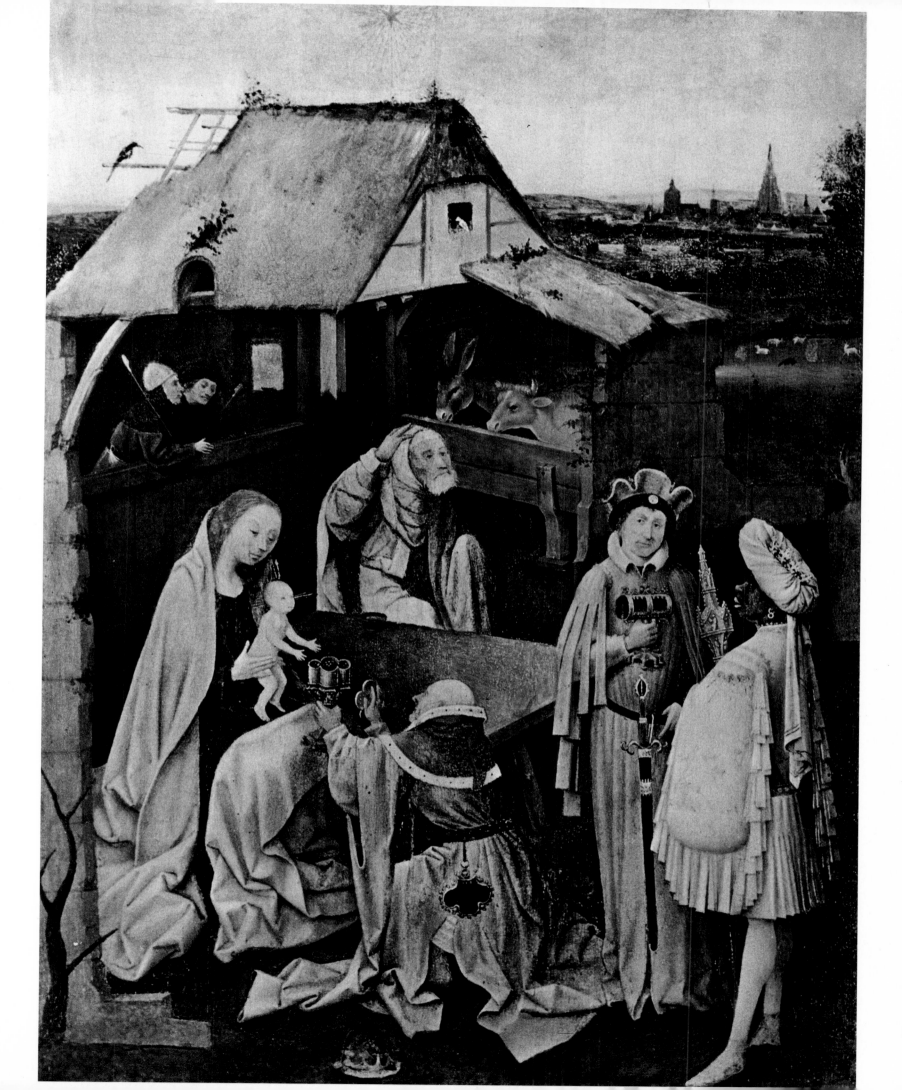

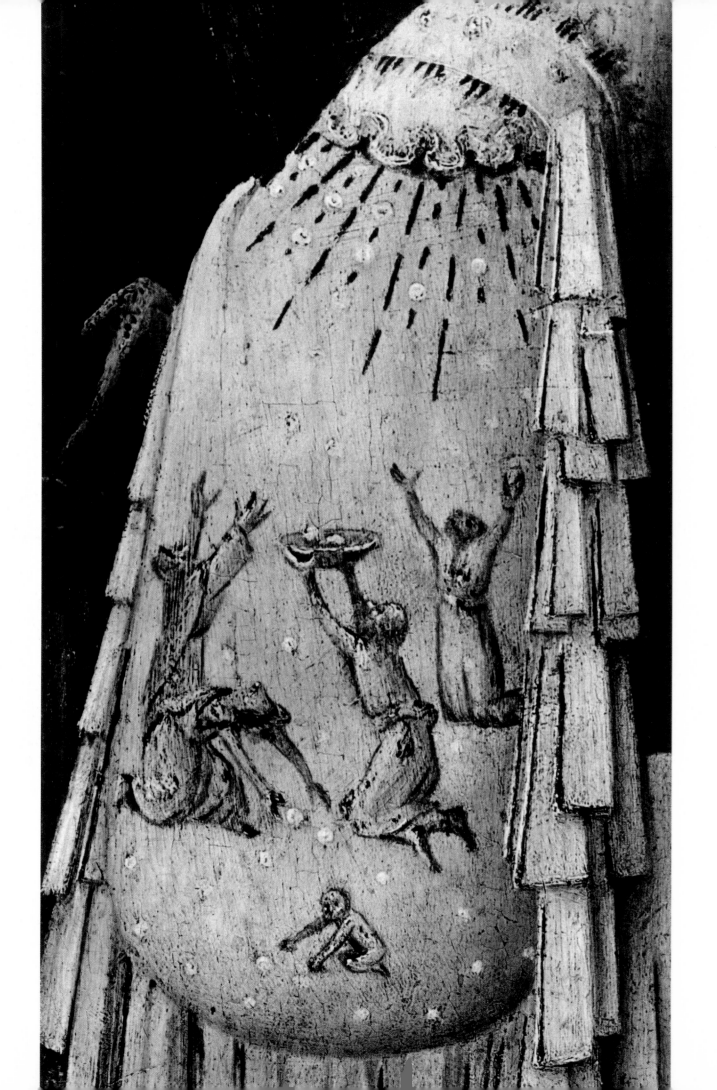

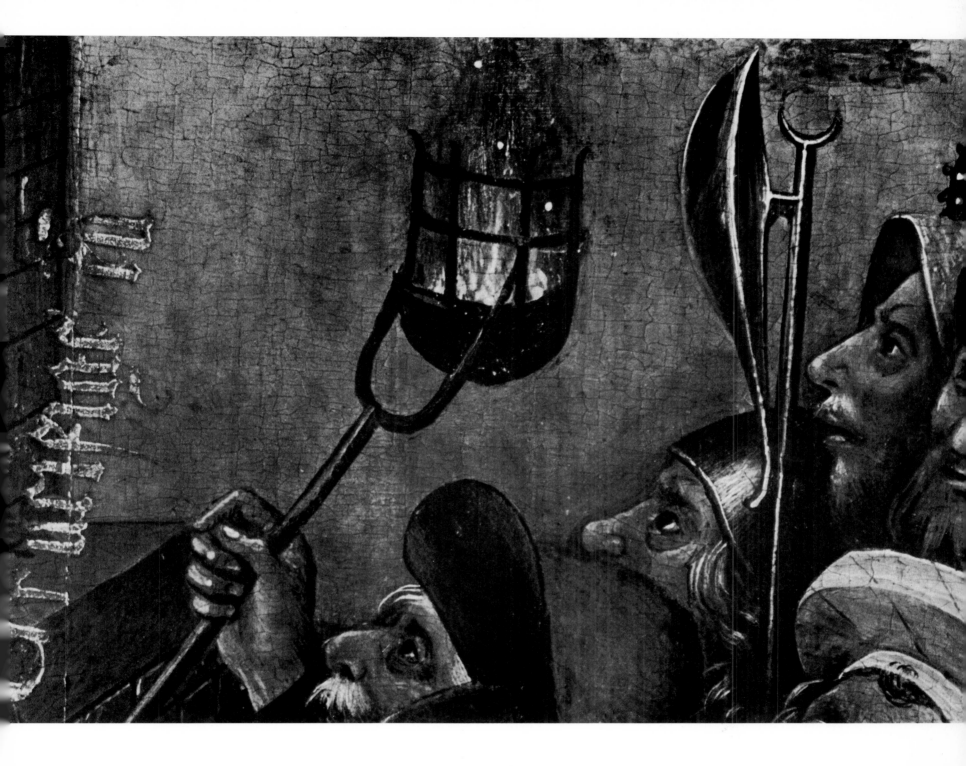

ECCE HOMO

From the platform on which Pilate and his executioners are displaying Him to the people, Christ is bending down, in an unfamiliar attitude, over this world of the devil and looking upon it with profound compassion. Here He is not just the mute Man of Sorrows, but is once again aware of the whole misery of the human condition. This explains why Bosch puts into the mouth of the two donors (formerly in the left foreground, now painted over) the words *Salva nos Christus redemptor* – the desperate cry for help of a world delivered up to Satan.

FRANKFURT-ON-MAIN, STÄDELSCHES KUNSTINSTITUT.

Oil on wood. Height 75 cm, width 61 cm. Complete picture page 85; details pages 81-84.

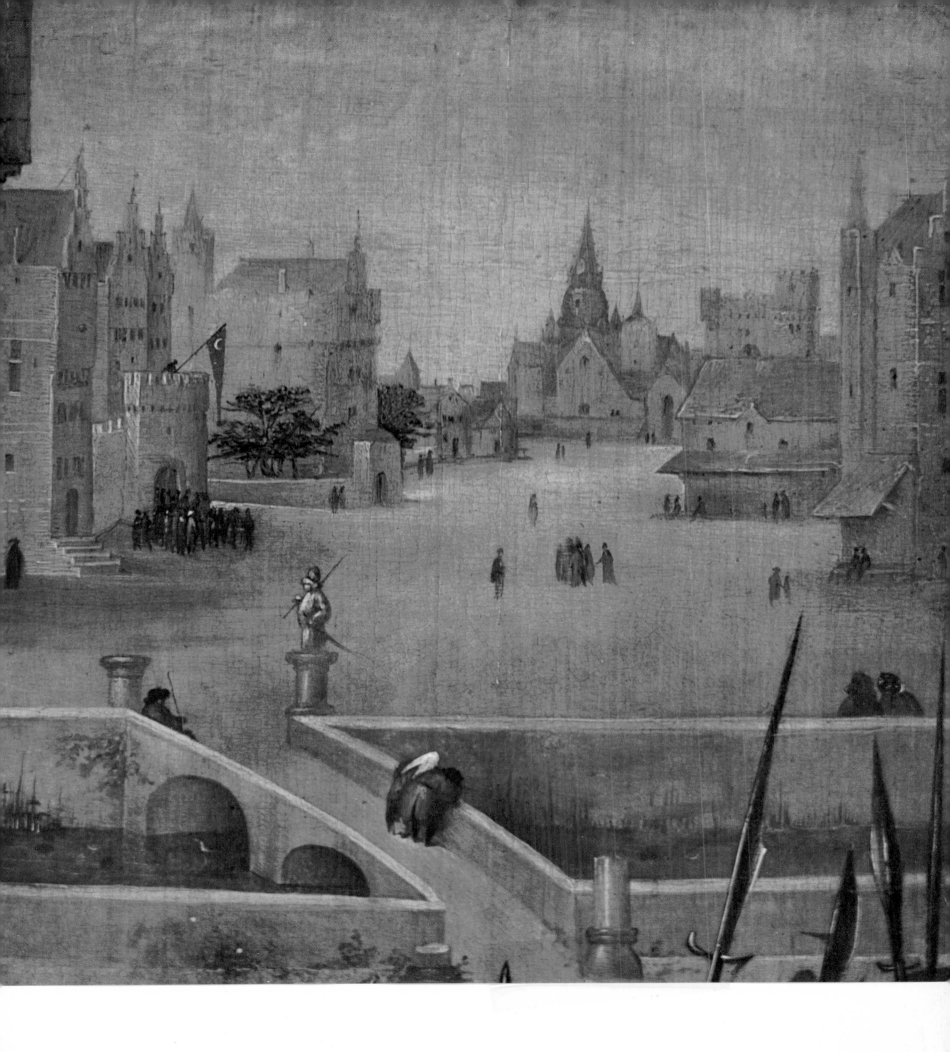

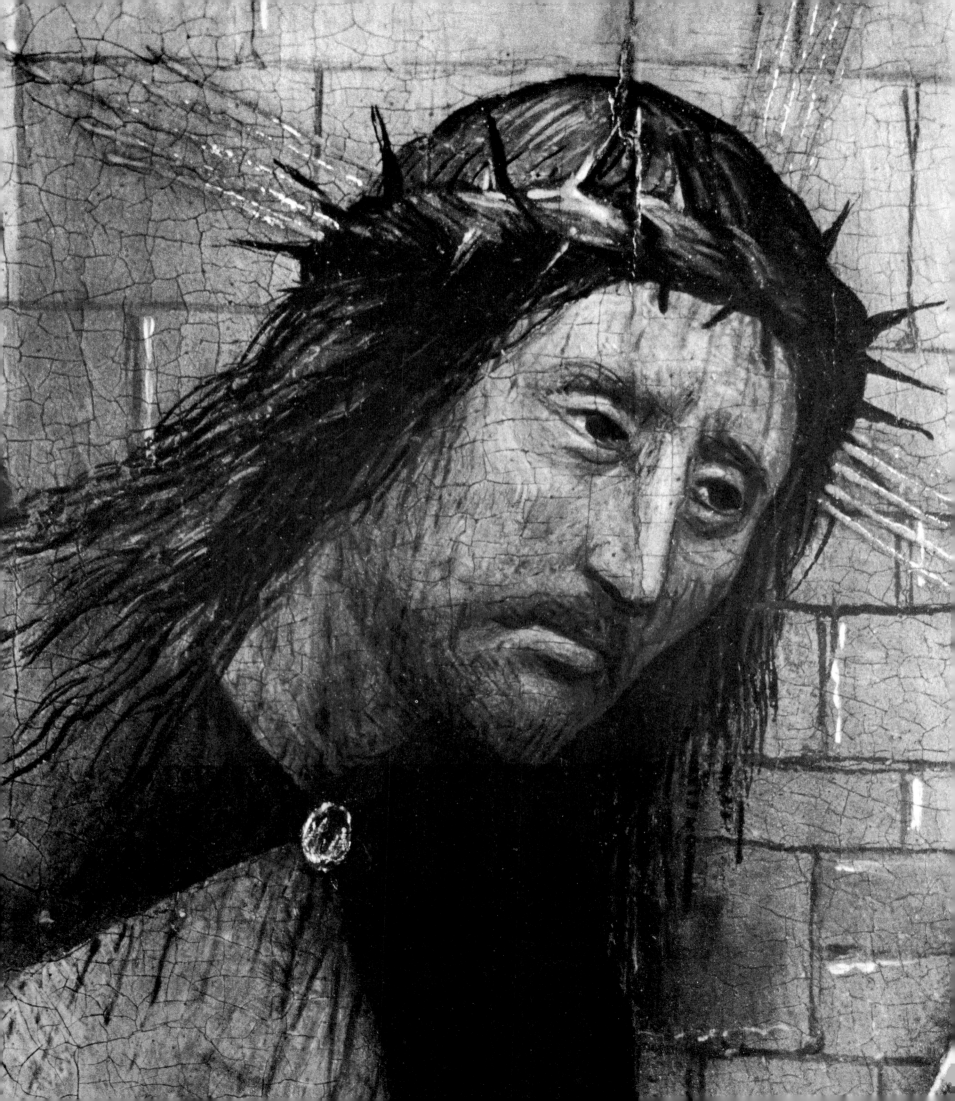

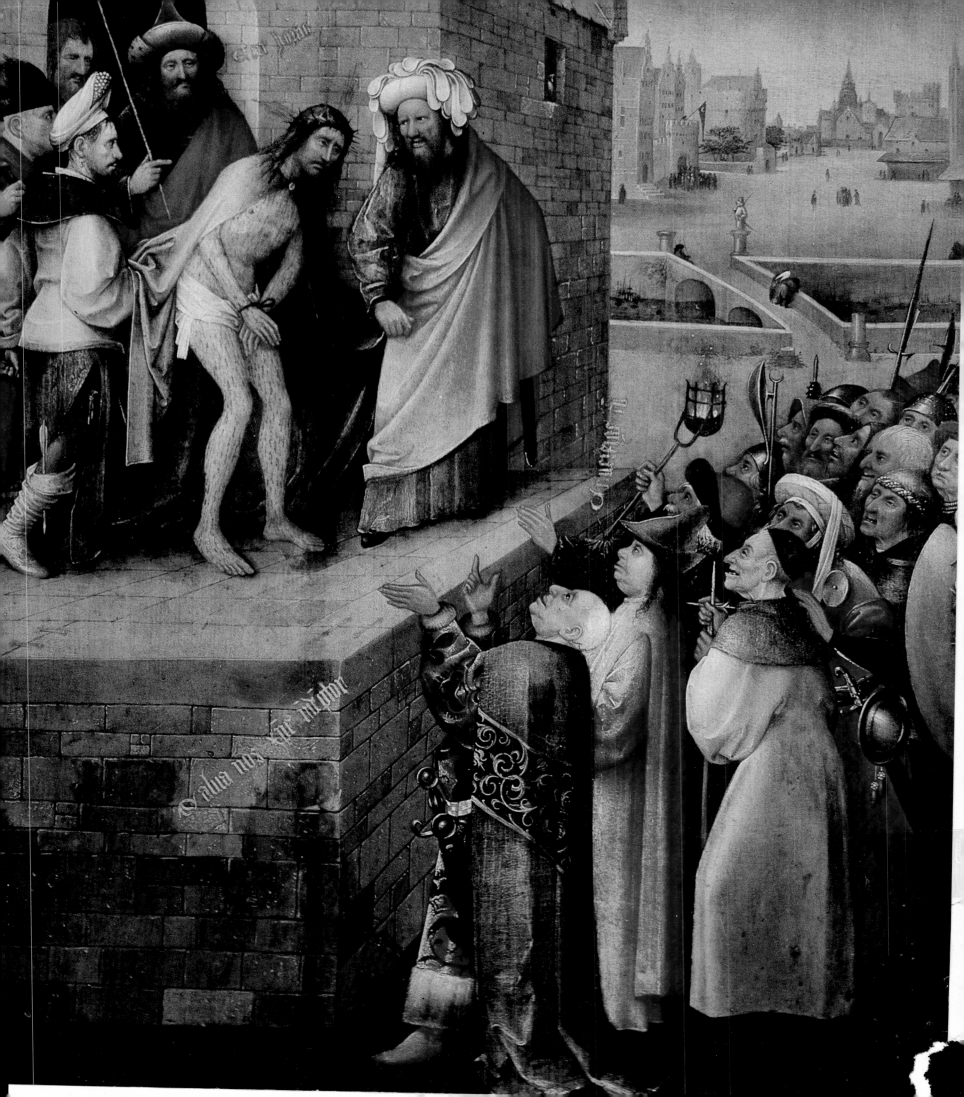

THE CONJUROR

At first glance this seems to be a humorous incident of a familiar kind: a conjuror with a crafty expression is making frogs jump out of the mouth of a simpleton, who does not notice that meanwhile an accomplice of the conjuror is stealing his purse. The spectators' ingenuous credulity, their ludicrous gravity, render the episode highly comical to us, who can see what is going on. But the inner purpose of the artist goes beyond the anecdotal subject. The group, all victims of the conjuror's power of suggestion, represents mankind, delivered over helplessly to ridiculous magic.

SAINT-GERMAIN-EN-LAYE, MUSÉE MUNICIPAL. *Oil on wood. Height 53 cm, width 65 cm. Complete picture page 87 (below): details pages 86, 87 (above), 88-89.*

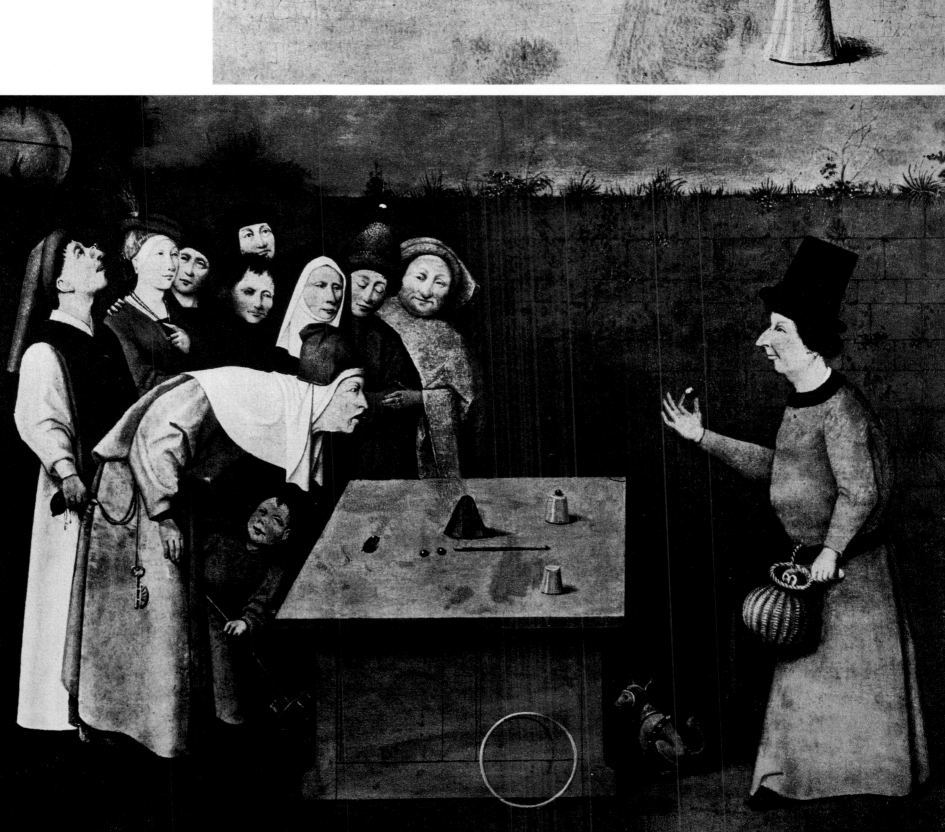

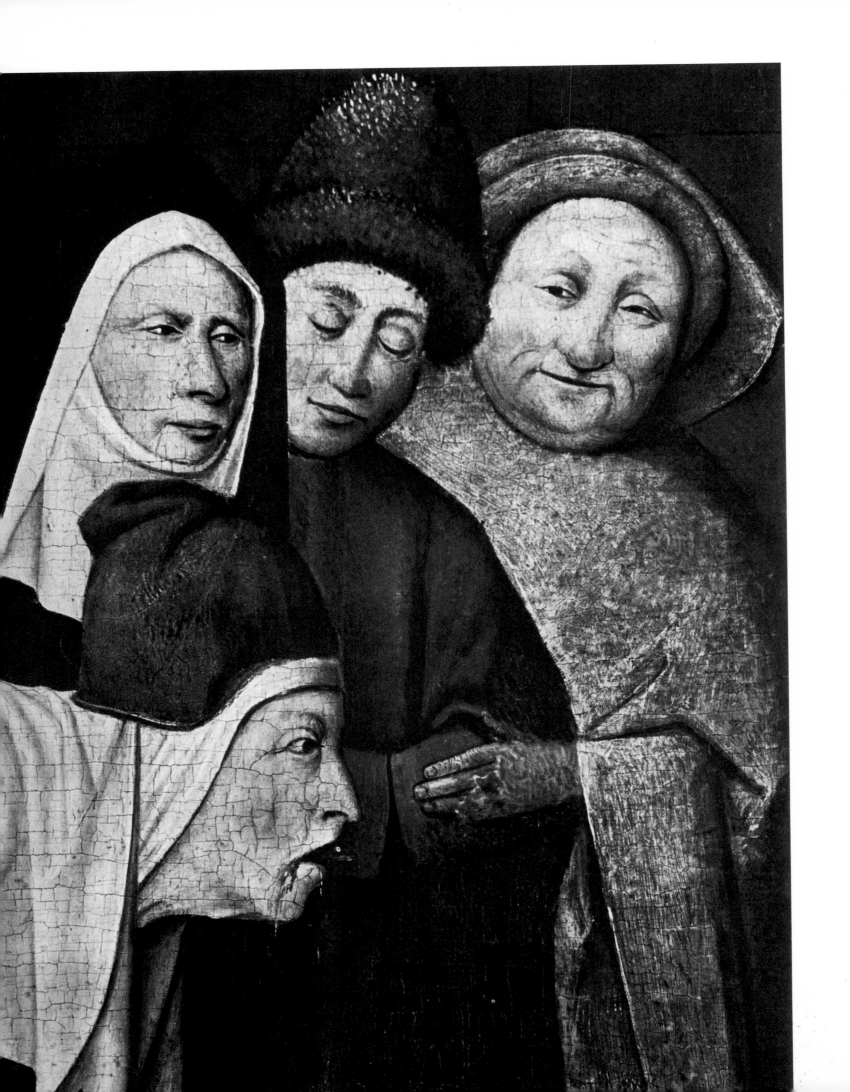

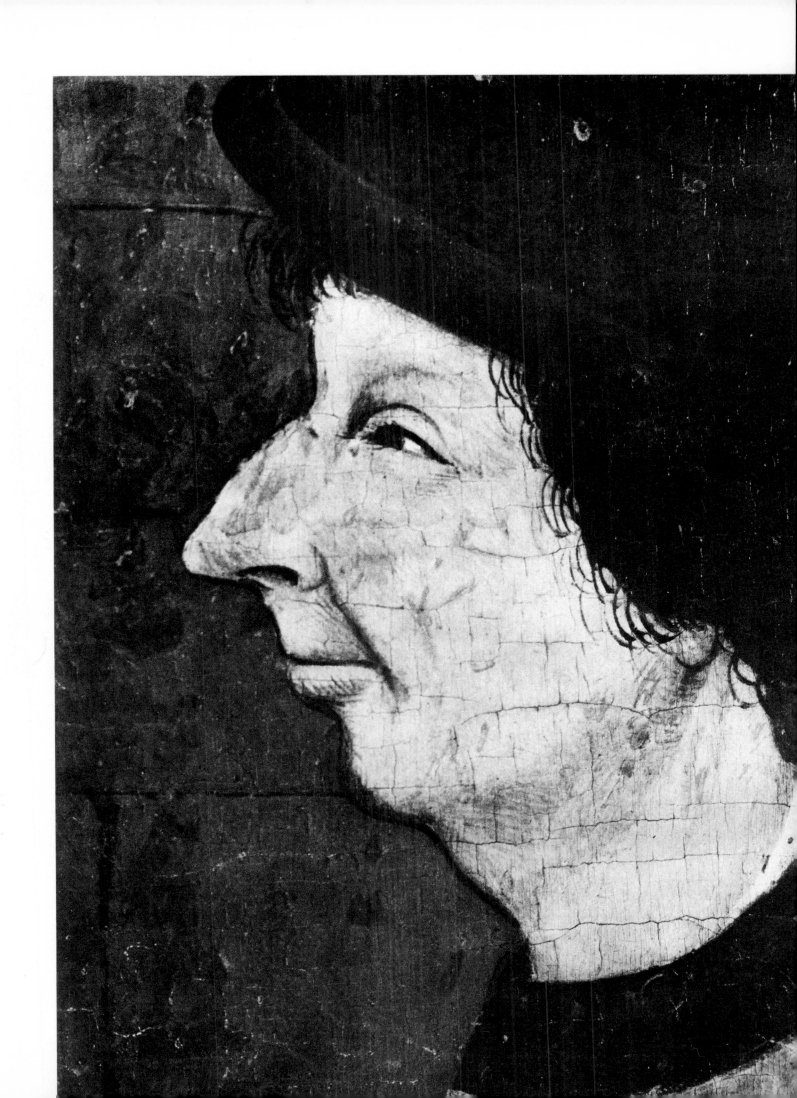

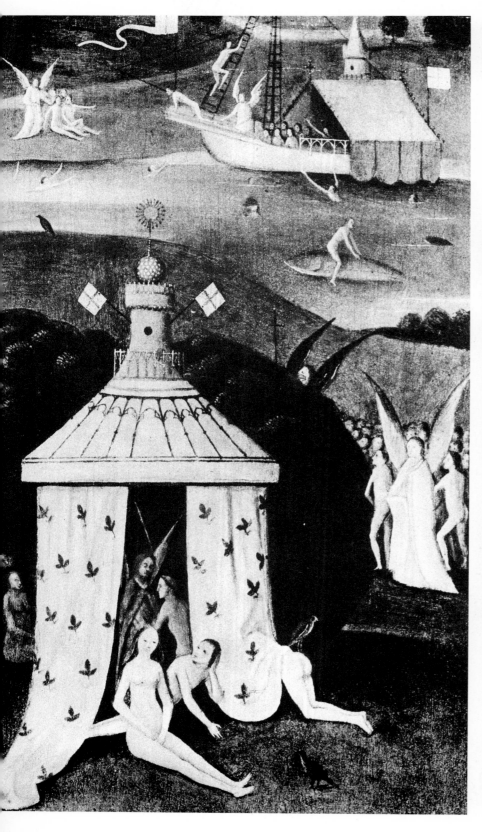 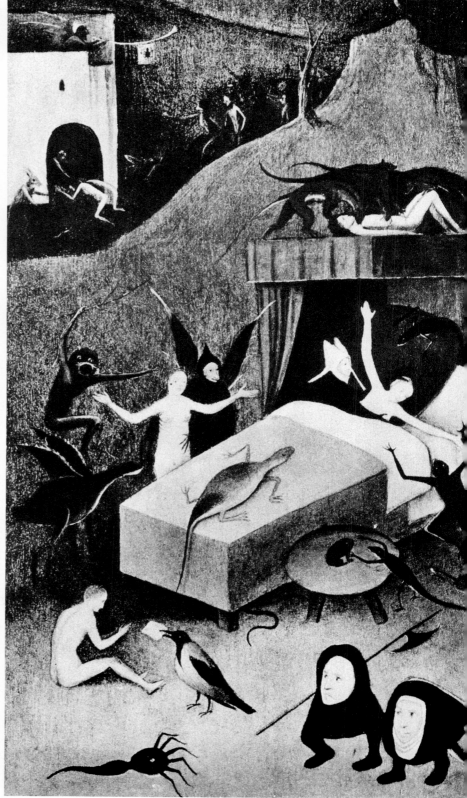

PARADISE and HELL: two panels

Both panels originally belonged to a triptych,
with the Last Judgement as the centre-piece.
NEW YORK, WILDENSTEIN GALLERIES.
*Oil on wood. Height 34.5 cm, width 21 cm and
height 33.4 cm, width 19.6 cm. Plates above.*

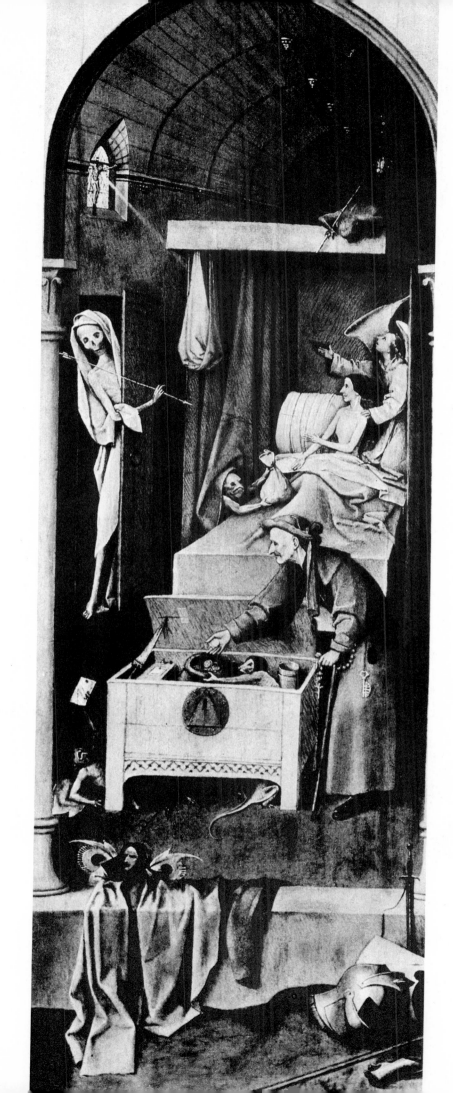

THE DEATH OF THE MISER

The dying man hesitates to choose between the crucifix, upon which his inner gaze rests, and the money-bag, for which his hand is reaching.

WASHINGTON, NATIONAL GALLERY.

Oil on wood. Height 92.6 cm, width 30.8 cm.

THE SHIP OF FOOLS

Under a pink pennon bearing the Crescent, corrupt humanity embarks in a nutshell and abandons itself to the pleasures of gluttony, unaware that it is drifting to its doom. The clergy occupies the place of honour in this *scapha gustationis*, which was probably once part of a triptych made up of other 'ships of fools' depicting various sensual pleasures.

PARIS, MUSÉE DU LOUVRE.

Oil on wood. Height 57.8 cm, width 32.5 cm. Complete picture page 93; detail above.

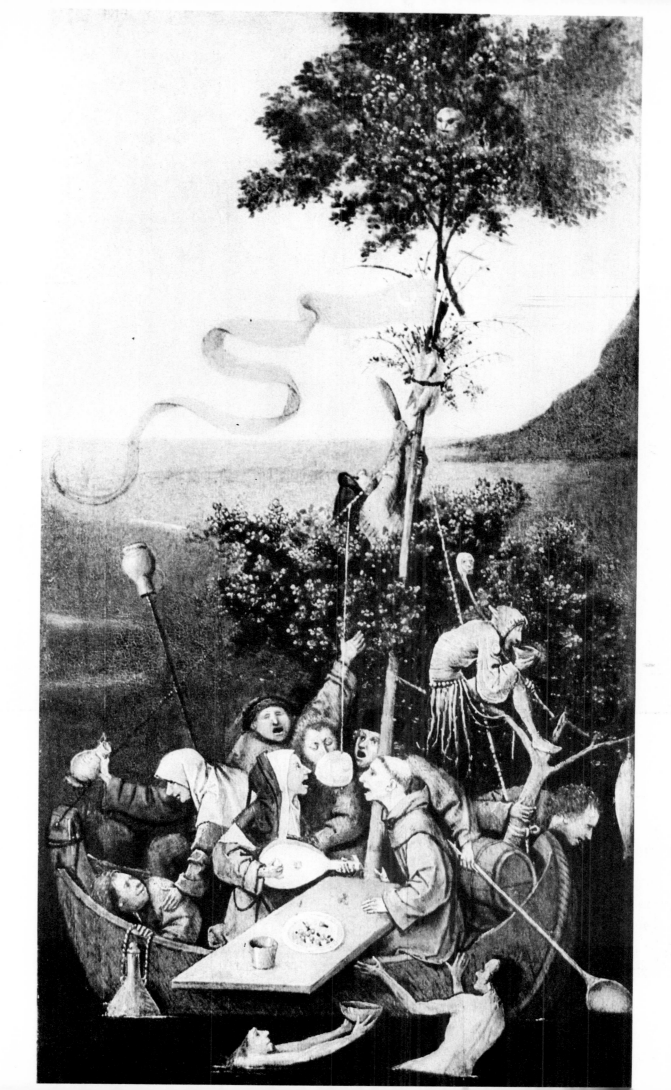

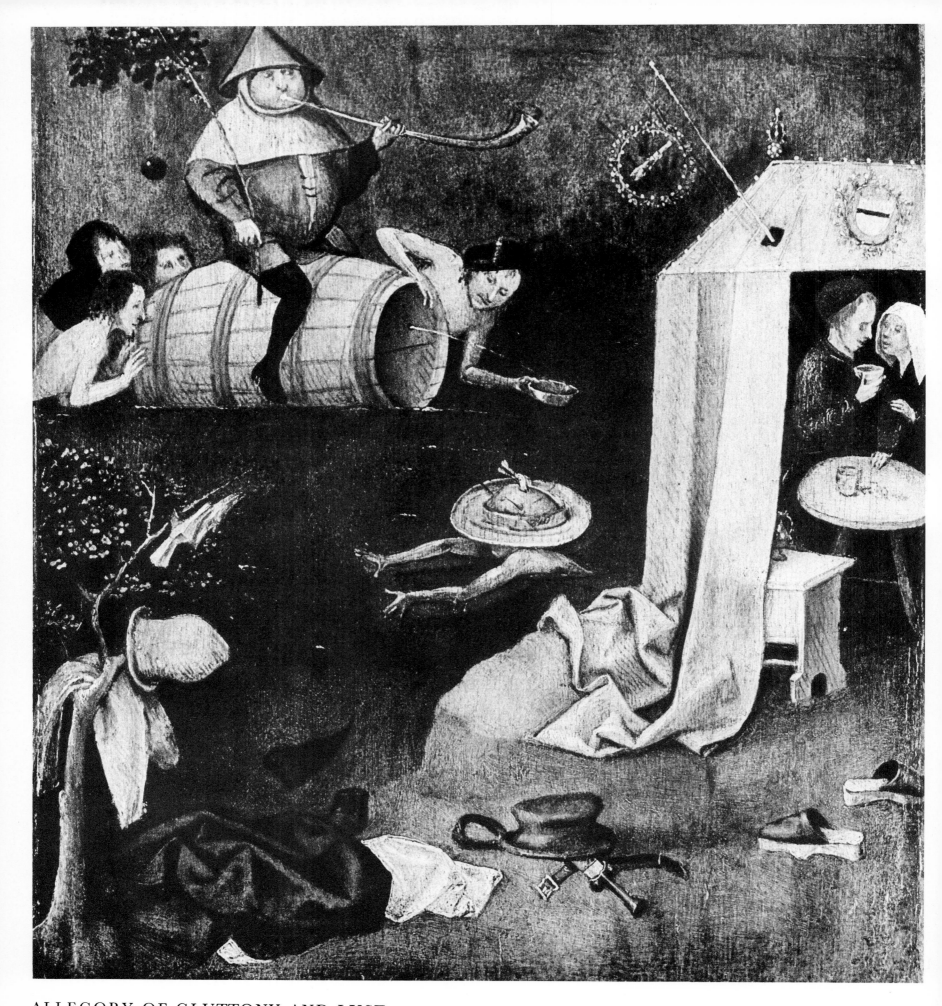

ALLEGORY OF GLUTTONY AND LUST

NEW HAVEN, YALE UNIVERSITY, ART GALLERY.
Oil on wood. Height 31 cm, width 35 cm.

HEAD OF A WOMAN (fragment)

ROTTERDAM, MUSEUM BOYMANS-VAN BEUNINGEN.
Oil on wood. Height 13 cm, width 5 cm.

THE ADORATION OF THE MAGI:
two panels (fragments)

Left: Detail from an Adoration of the Shepherds. *Right:* Detail of the retinue of the Magi.
PHILADELPHIA, PHILADELPHIA MUSEUM
OF ART, JOHNSON COLLECTION.

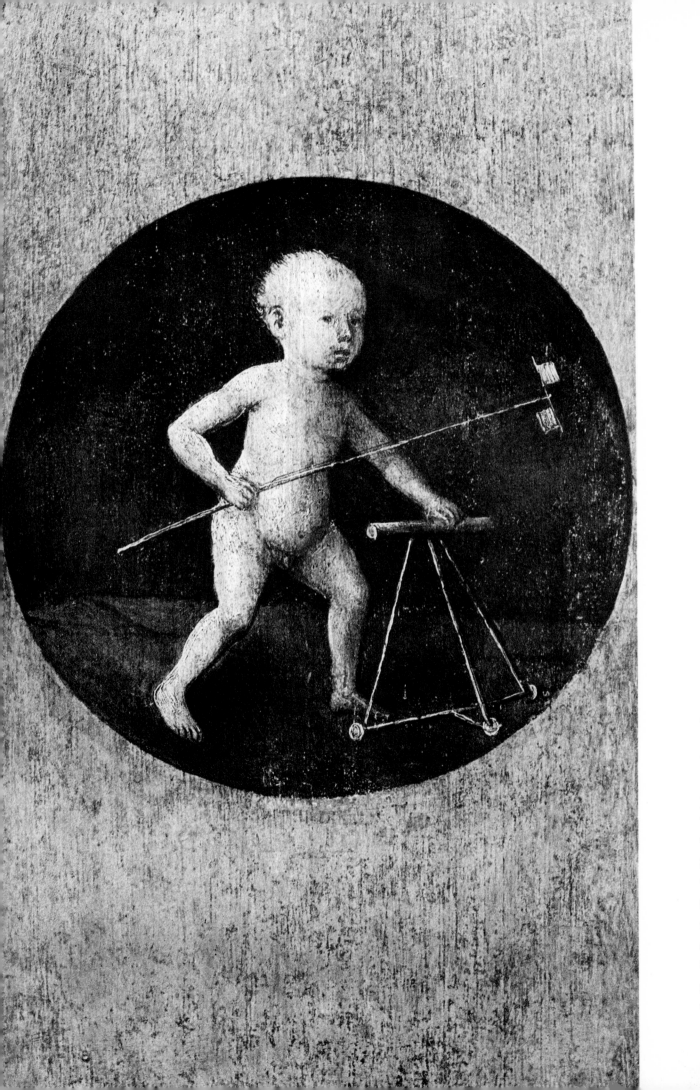

CHRIST CARRYING THE CROSS

On the reverse, in a dark circle, Bosch represents the Child Jesus, pushing a wheeled walking-frame with one hand and holding a toy windmill in the other – taking His first innocent step on the path through life. How this path ends for the believer, the artist teaches us by the example of *Christ Carrying the Cross* on the front of the picture. Christ, wearing sandals of thorns, stumbles, bowed down under the weight of the Cross; He can no

longer keep pace with the hurrying crowd, whose contorted faces betray cruelty; the emblem of the toad on the heraldic shield *(above right)* tells us that this is the army of the Devil.

VIENNA, KUNSTHISTORISCHES MUSEUM.

Oil on wood. Height 57.2 cm, width 32 cm. Complete picture of front page 99; details pages 100-103. Picture of reverse page 98.

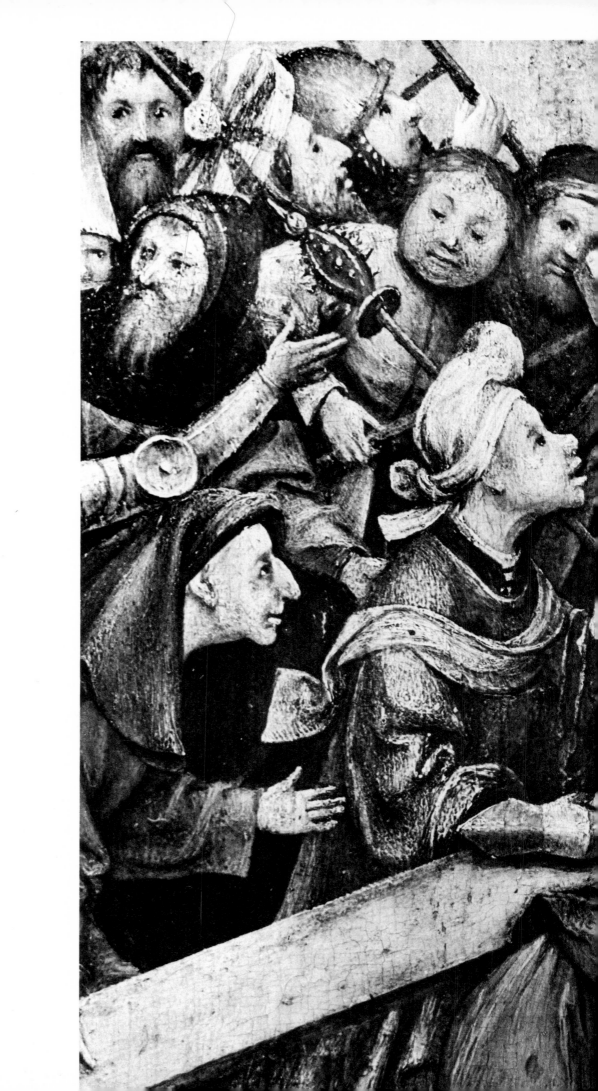

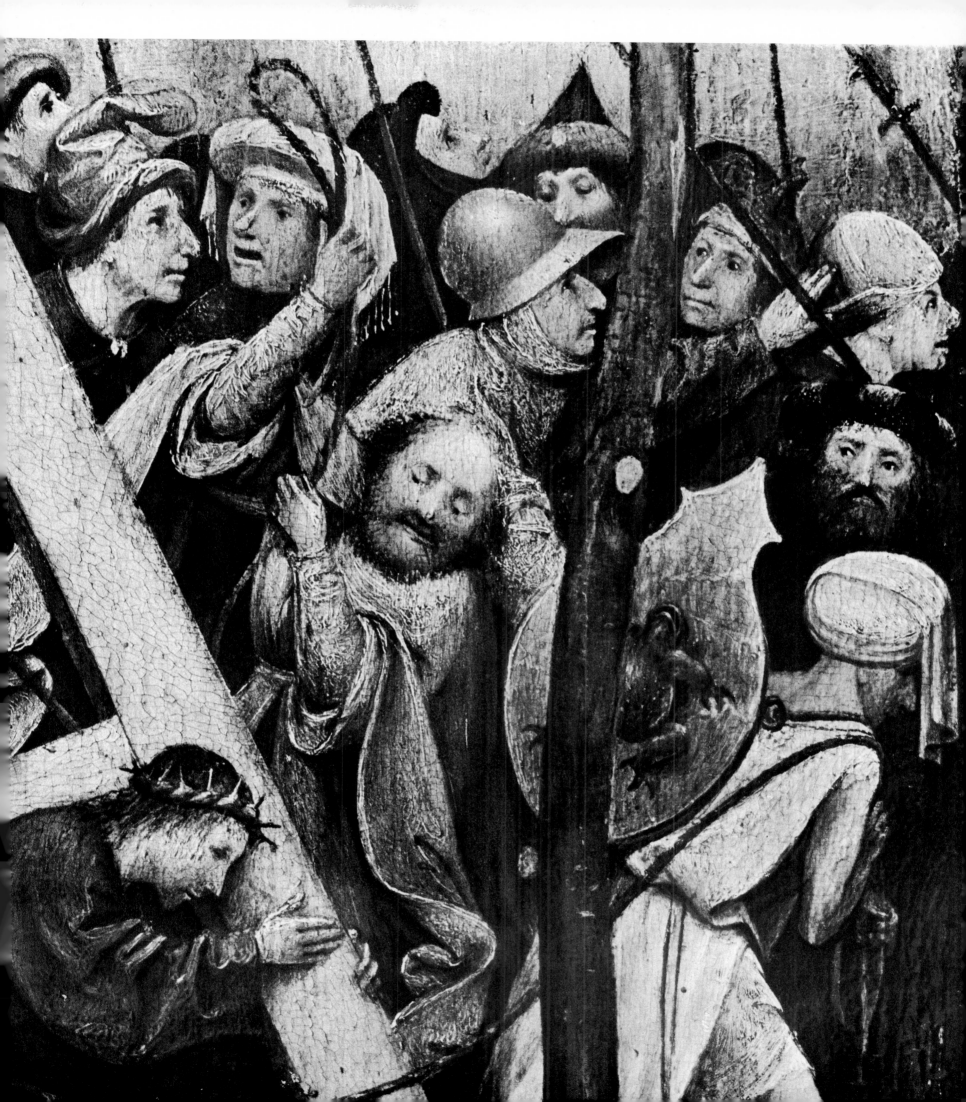

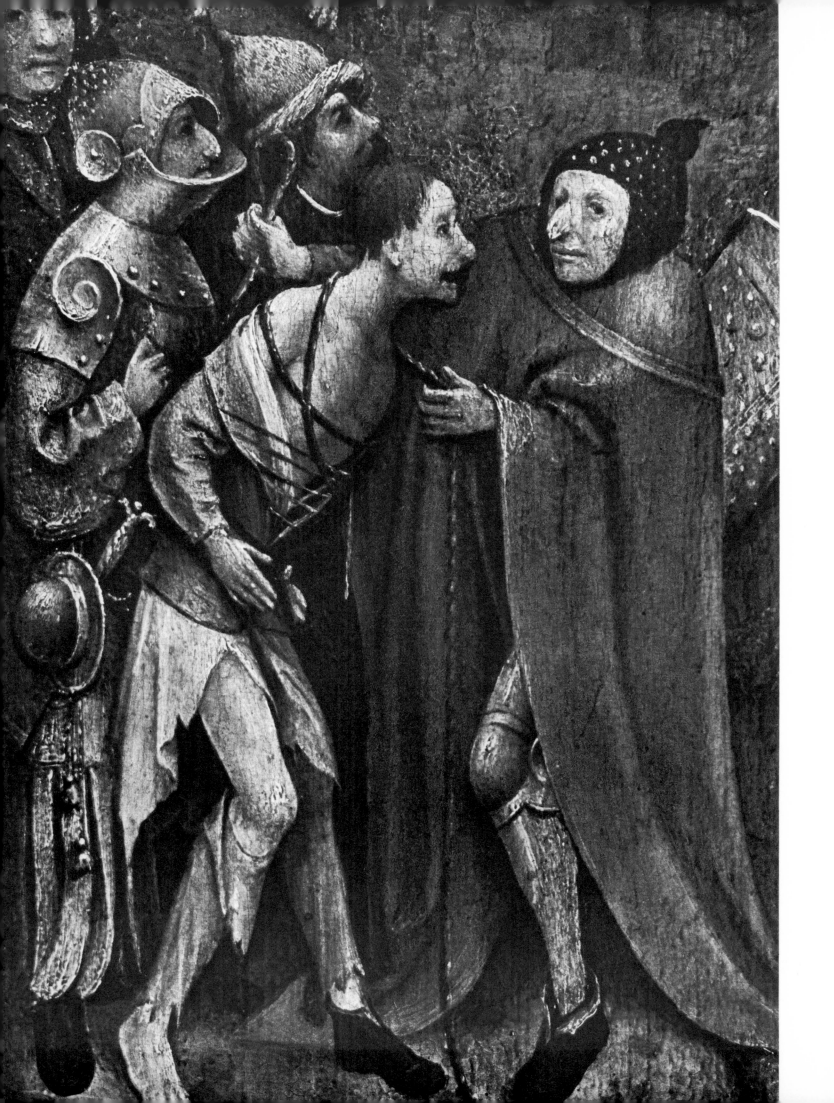

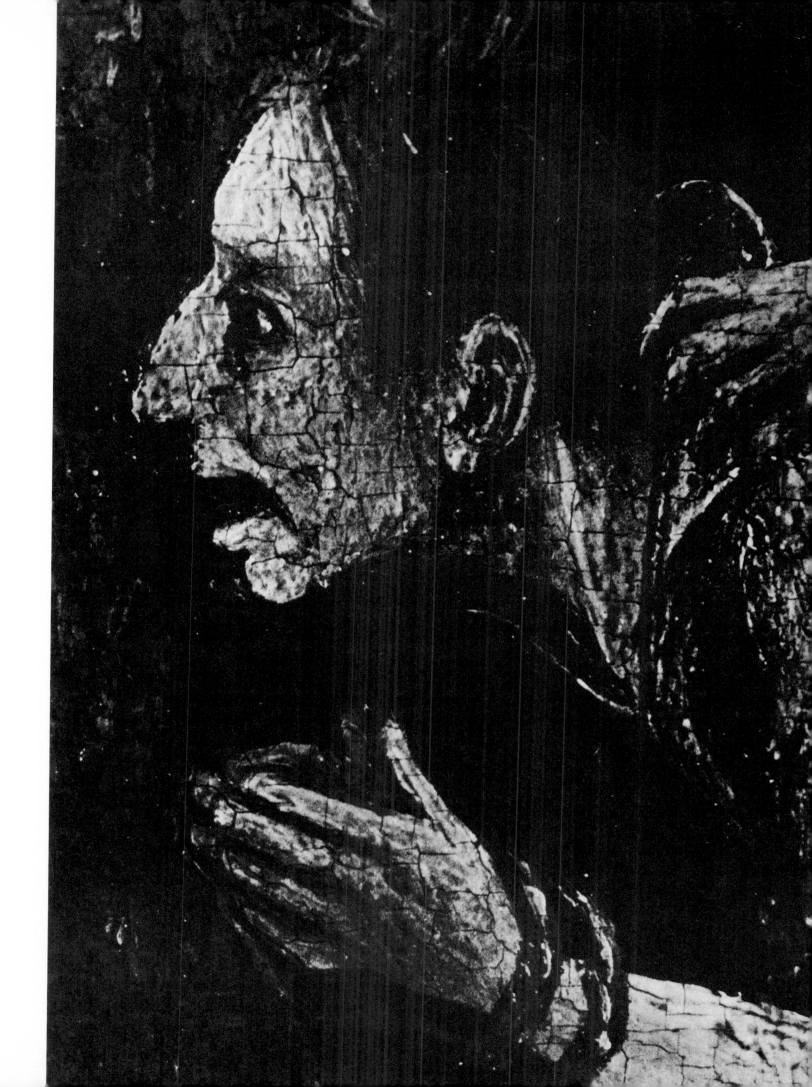

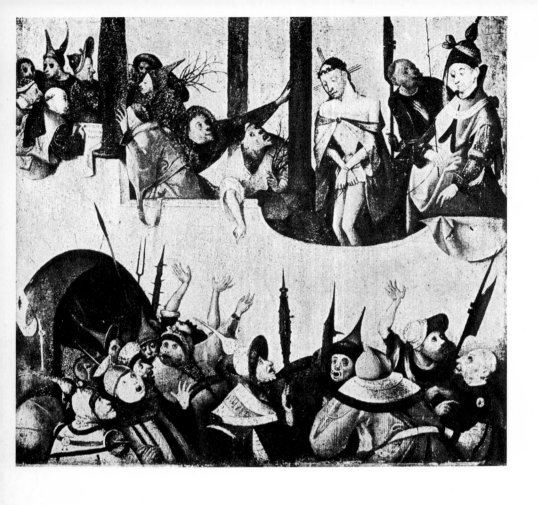

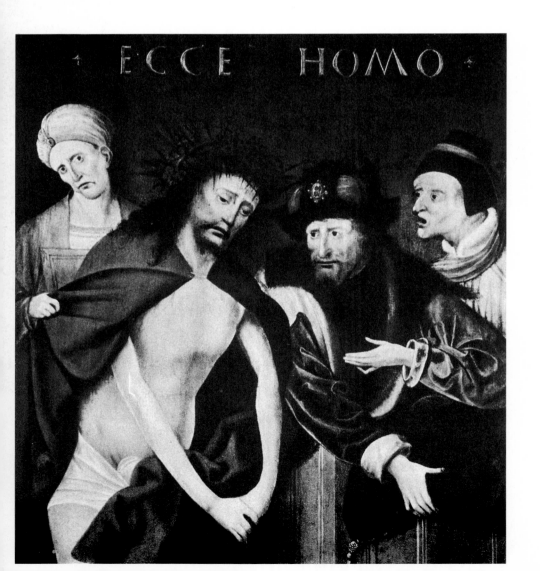

ECCE HOMO

Above left: This is only a fragment of a panel originally about four times as large, of which it is the left upper quarter.

PHILADELPHIA, PHILADELPHIA MUSEUM OF ART, JOHNSON COLLECTION.

Oil on wood. Height 50 cm, width 52 cm.

ECCE HOMO

Above right: Replica, with slight changes, of the picture above left.

INDIANAPOLIS, INDIANA, THE GLOWES FUND COLLECTION.

Height 66.2 cm, width 48.7 cm.

ECCE HOMO

SWITZERLAND, PRIVATE COLLECTION.

Oil on wood. Height 62.5 cm, width 53 cm.

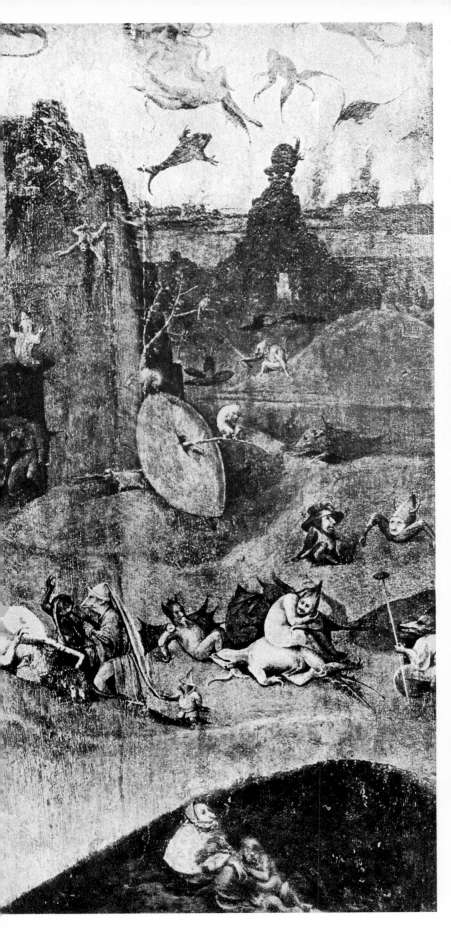
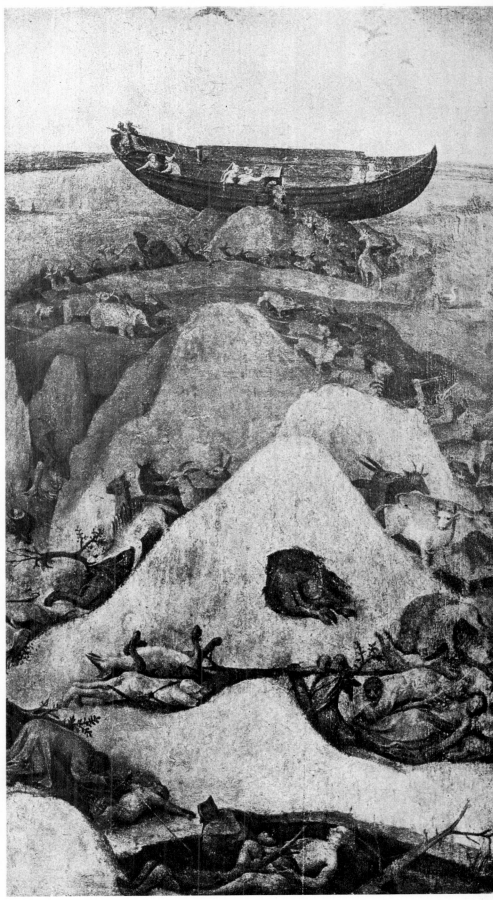

THE FLOOD and HELL

In the *Flood* Bosch does not follow the iconographic tradition but goes back directly to the biblical text, which inspires him with a grandiose vision of an entirely new kind. Curiously, he chooses the point at which the waters have already receded from the earth and the ravaged soil is visible. The rotting corpses are still lying on the bleak, barren, sandy promontories rising from the former sea-bed. But the ark is stranded on the peak of Ararat, and the animals are issuing

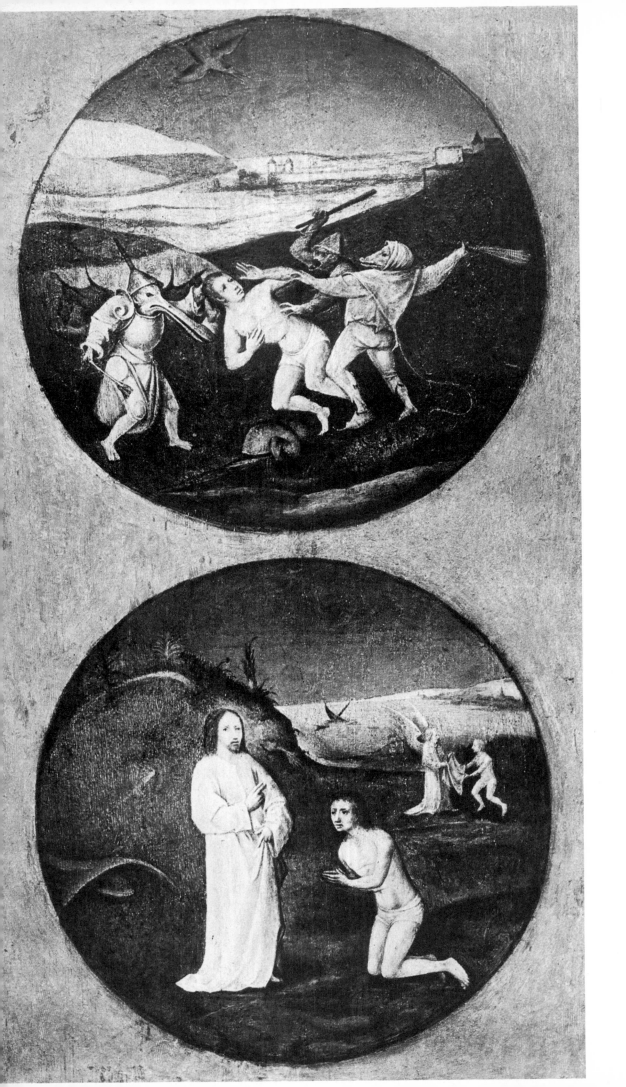

from it and winding in procession down the mountain-side, like a river, to spread life anew in the devastated valleys.

The interpretation of the landscape of *Hell* and the four tondi on the reverse is still a matter of dispute.

ROTTERDAM, MUSEUM BOYMANS-VAN BEUNINGEN.

Oil on wood. Height 69.5 cm, width 38 cm and height 69 cm, width 36 cm. Complete pictures of front page 105; complete pictures of reverse pages 106, 108; details page 107.

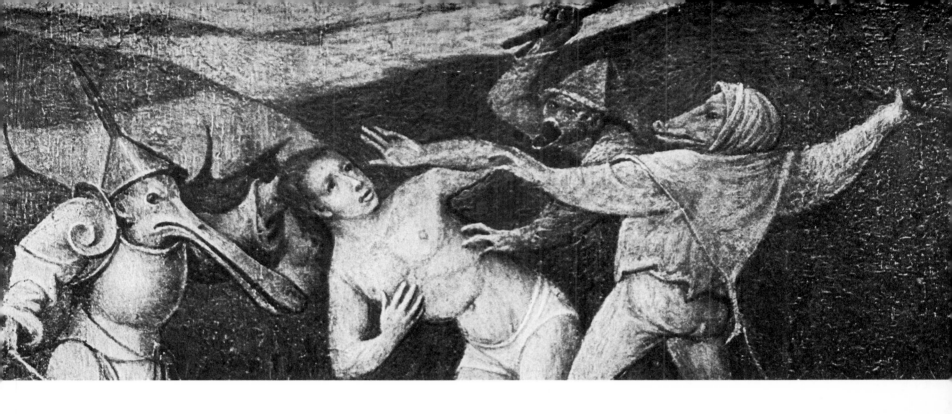

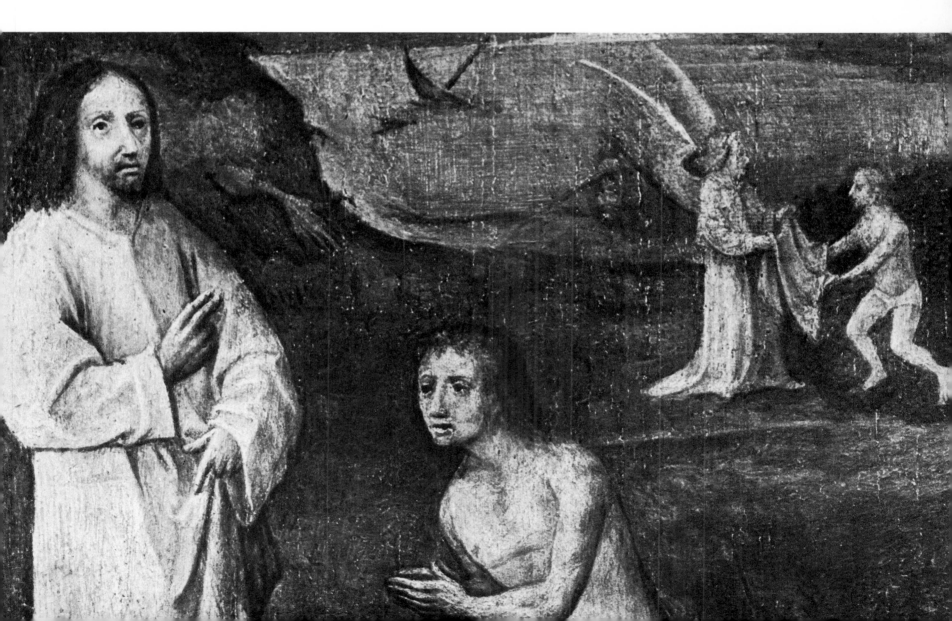

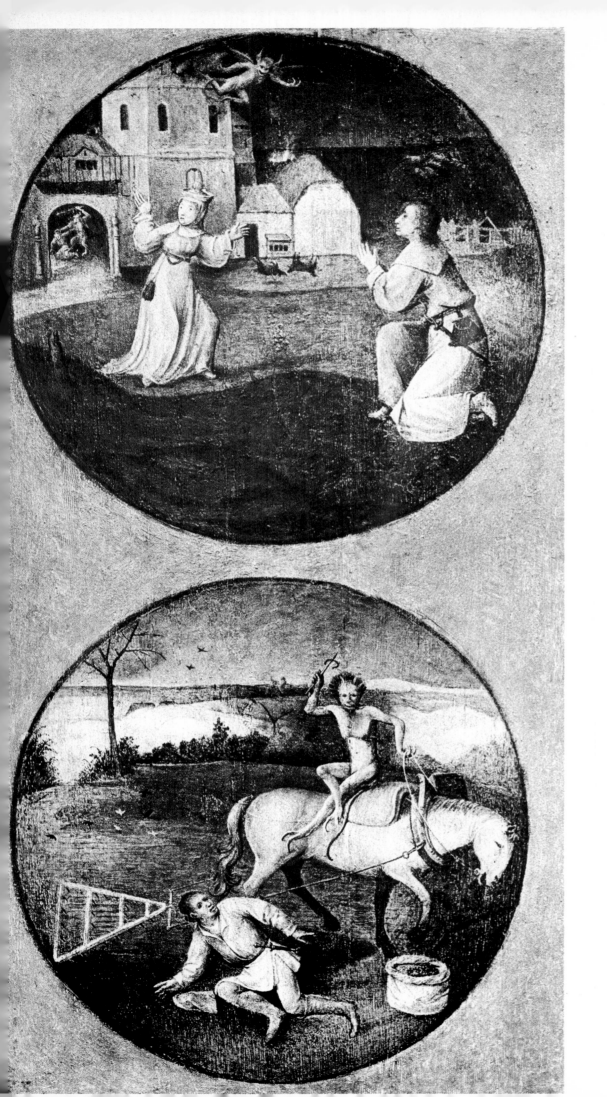

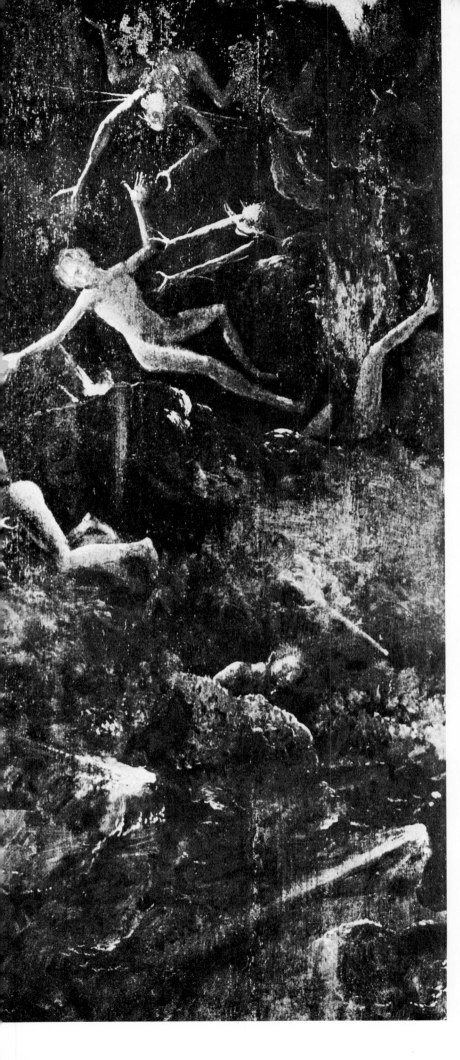
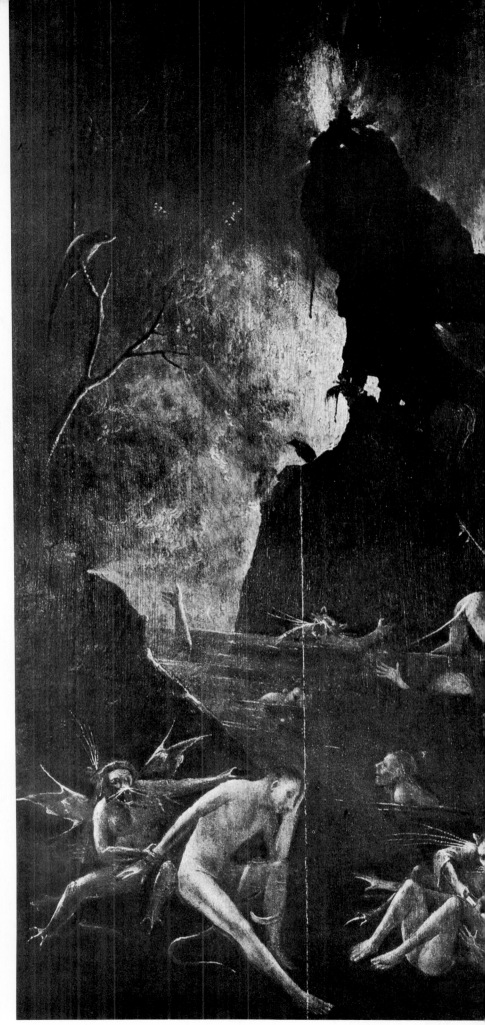

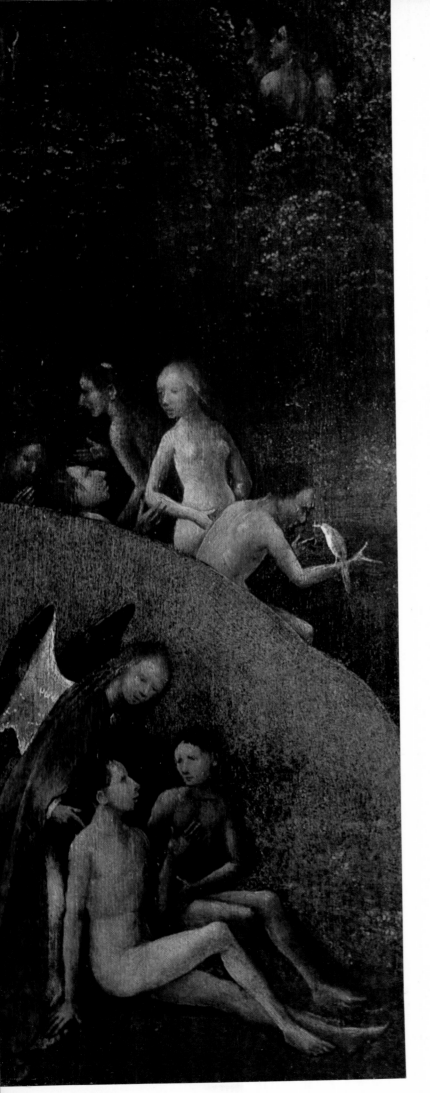

THE DESCENT OF THE DAMNED INTO HELL

HELL

THE EARTHLY PARADISE

THE ASCENT INTO THE HEAVENLY PARADISE

In their ascent into the heavenly paradise the souls are leaving the dark space of the universe and passing along a circular shaft which is already flooded with everlasting light. Intoxicated with joy, they are freeing themselves more and more from the laws of gravity and obeying the attraction of the realm of light. In the descent into hell, on the other hand, the souls, hurled by demons into the darkness of the abyss, are sinking slowly like drowning men into the bottomless depths.

Bosch replaces the medieval Paradise and Hell, which were objective images of the celestial and infernal hierarchies, with subjective visions that resemble the conceptions of the great mystics and exist only in the inner world of the soul.

VENICE, PALACE OF THE DOGES.

Oil on wood. Height 86.5 cm, width 39.5 cm. Descent of the Damned into Hell, page 109 (left); Hell page 109 (right); Earthly Paradise, complete picture page 111 (left), detail page 110; Ascent into the Heavenly Paradise, complete picture page 111 (right), details pages 112-115.

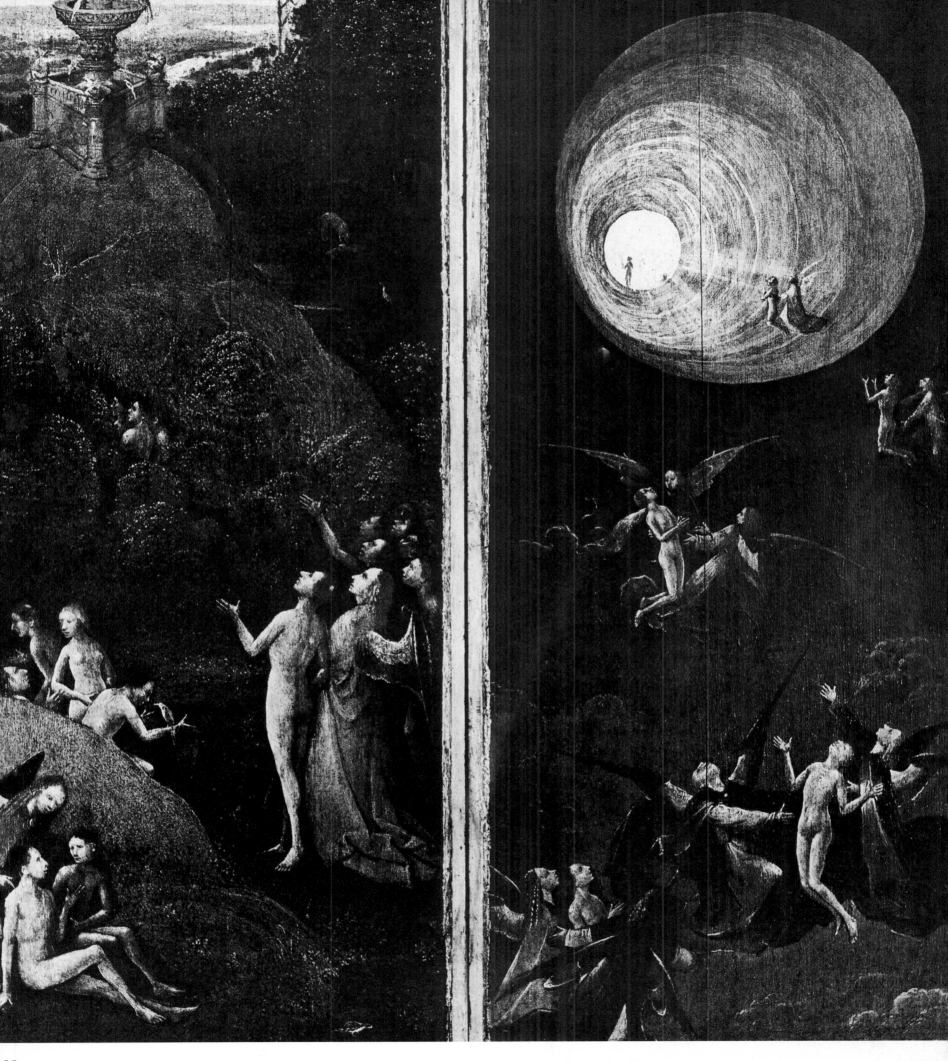

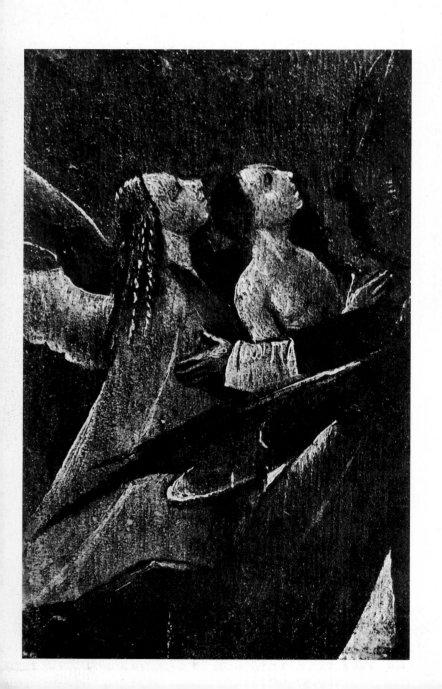

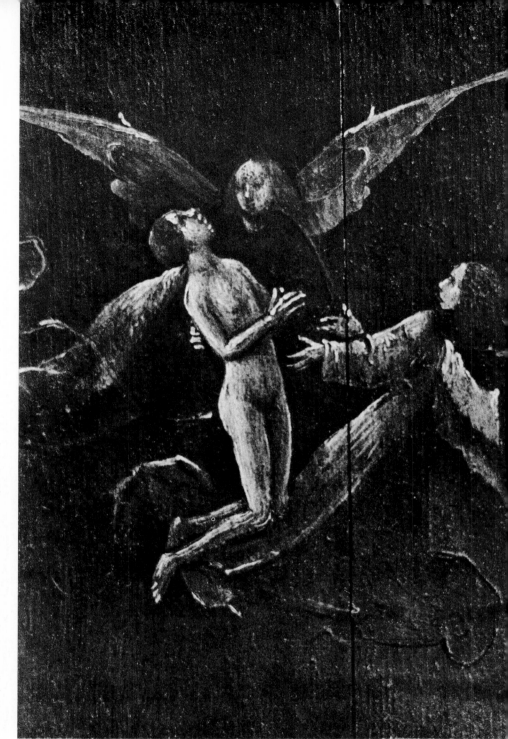

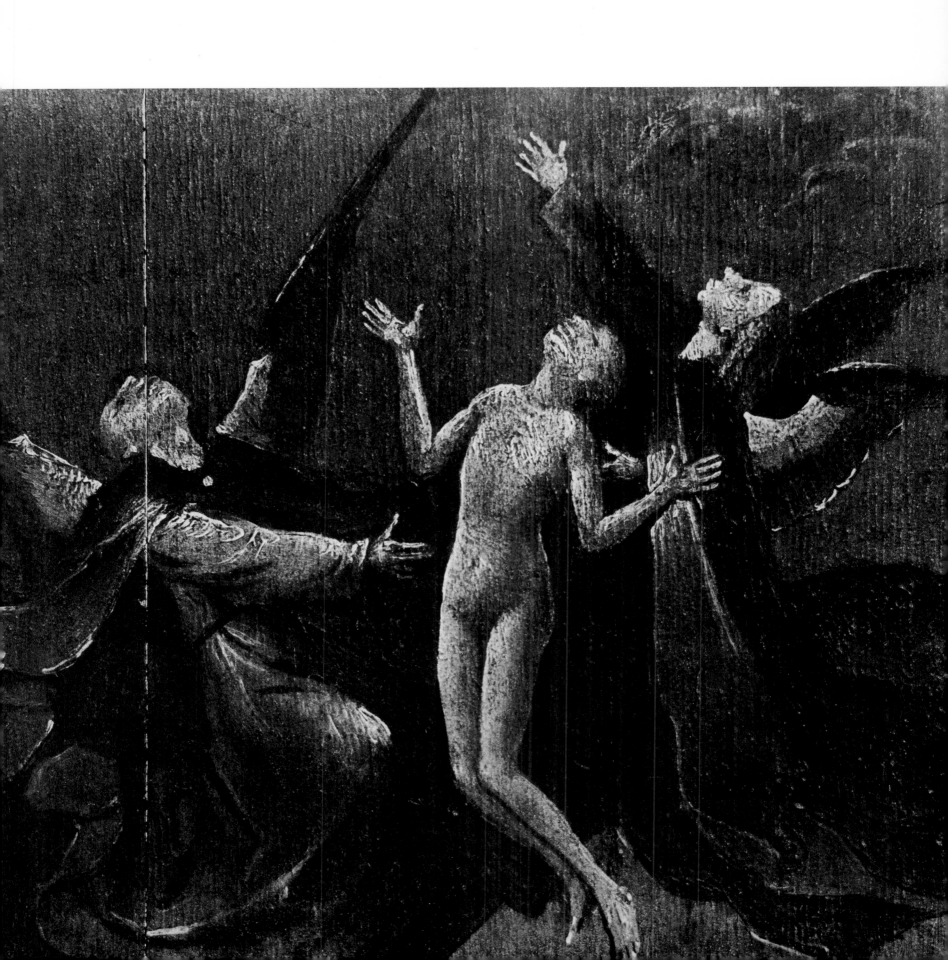

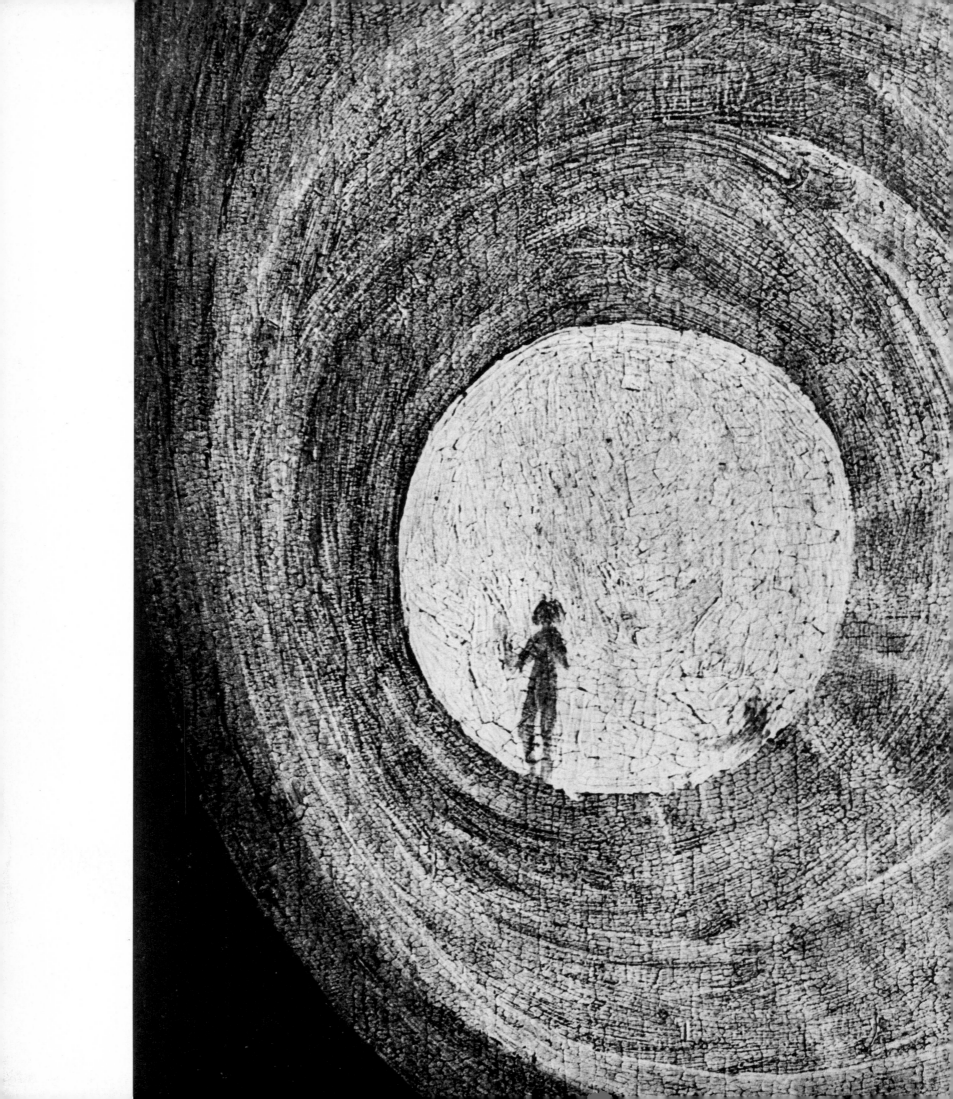

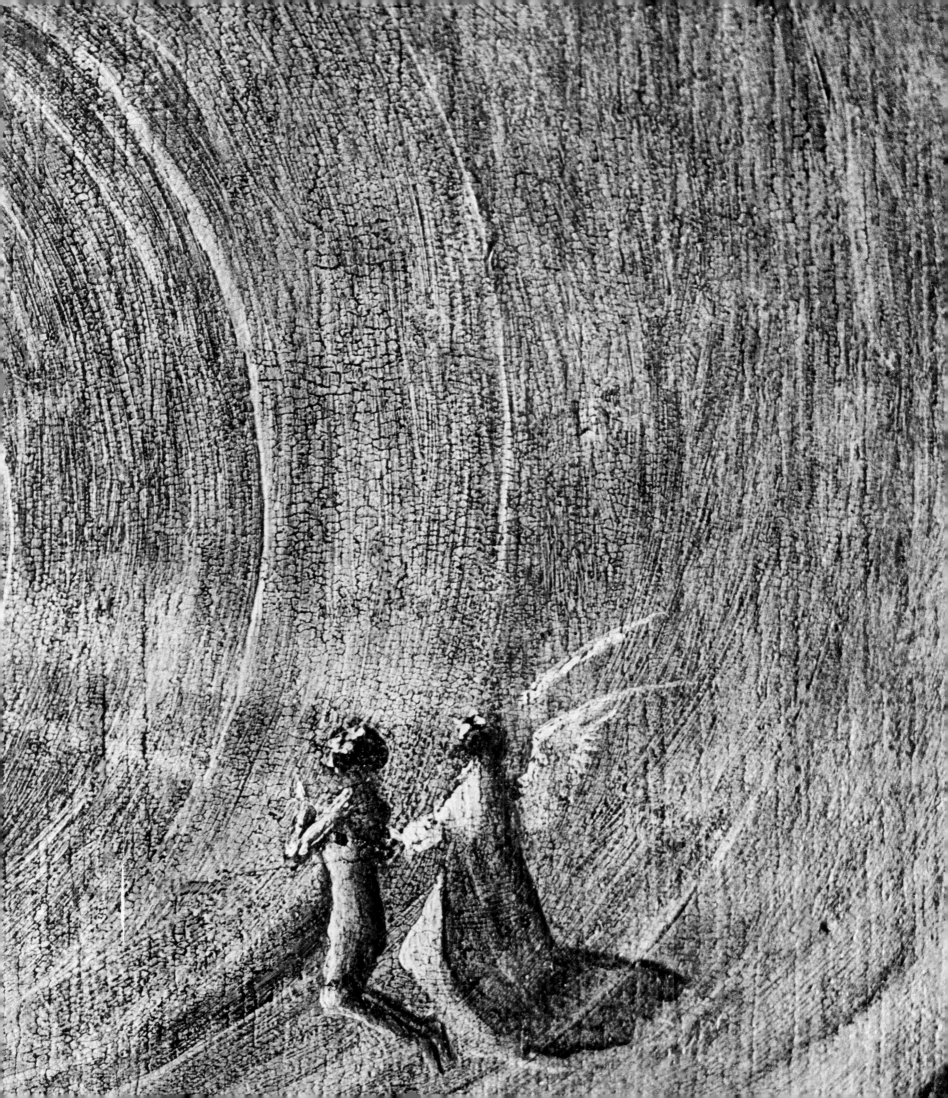

THE HAY-WAIN

Bosch's view of the world is inspired by profound piety. It discloses to us a 'mirror image of the universe' in pano-ramic compositions, for which the triptych form is particularly well adapted. When closed, the triptych shows a vagabond or wanderer passing through the wicked world. Signed.

MADRID, MUSEO DEL PRADO.

Oil on wood. Height 135 cm, width 100 cm; width of each wing 45 cm. Complete picture page 117; details page 116.

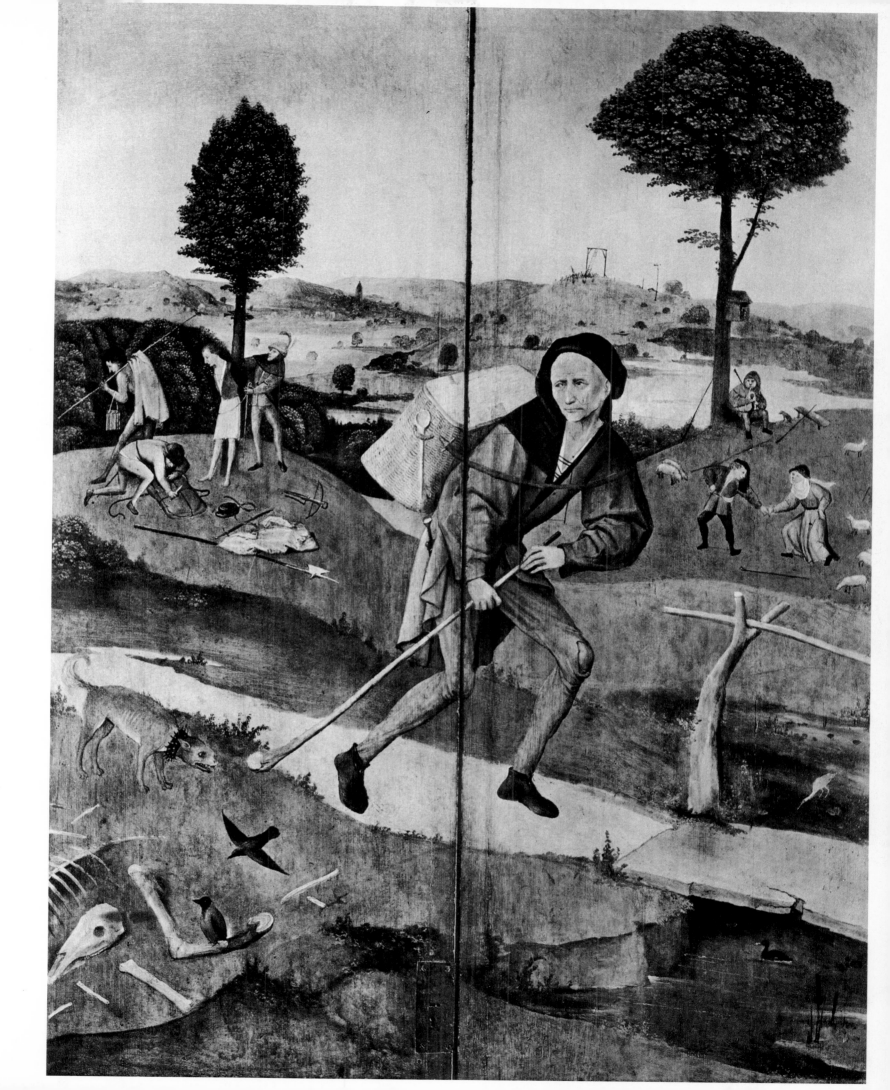

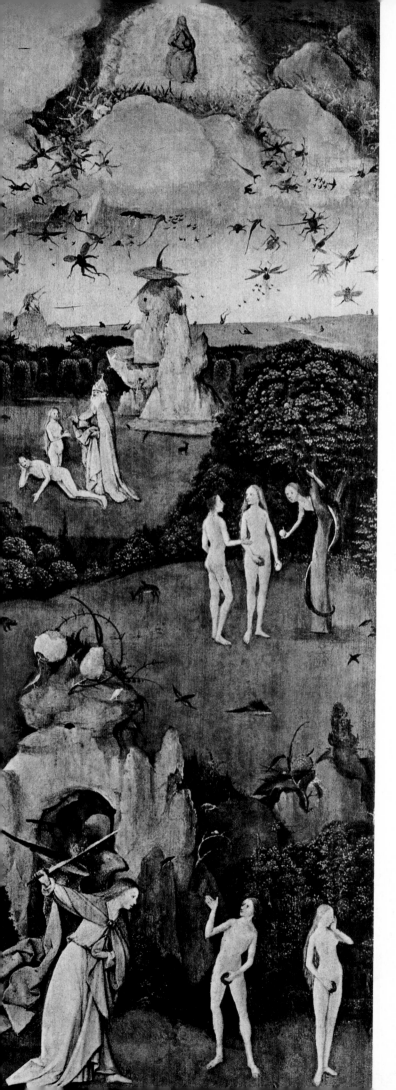

For the composition of the work as a whole the artist seems to have been inspired by the Flemish proverb 'The world is a haystack and each man plucks from it what he can.' The huge hay-wain, the symbol of vanity, rolls triumphantly through a broad sunny landscape veiled in a light blue haze. The great ones of the earth are following the wagon in a stately cavalcade. The wagon is drawn by human beings who, as they approach Hell, are changing into beast-like demons. In the cloud-encircled disc of the sun Christ appears. With hands raised in sadness, He is the anguished witness of the inescapable consequences of vanity, of mankind's descent into Hell. The left wing is intended to remind the spectator of the biblical prefigurations of mankind's present corruption; the right wing shows us the final stage in the fall of humanity.

The triptych with wings open page 119 (above right). Complete picture of the centre panel page 122; details pages 123-129. Complete picture of left wing page 118; details pages 119-121. Complete picture of right wing page 130 (left); details page 130 (right), pages 131-133.

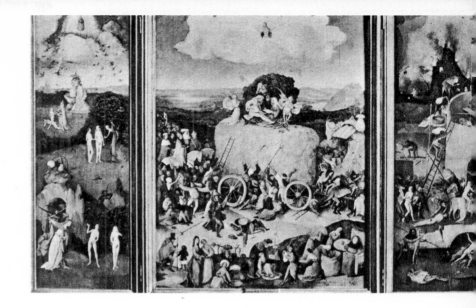

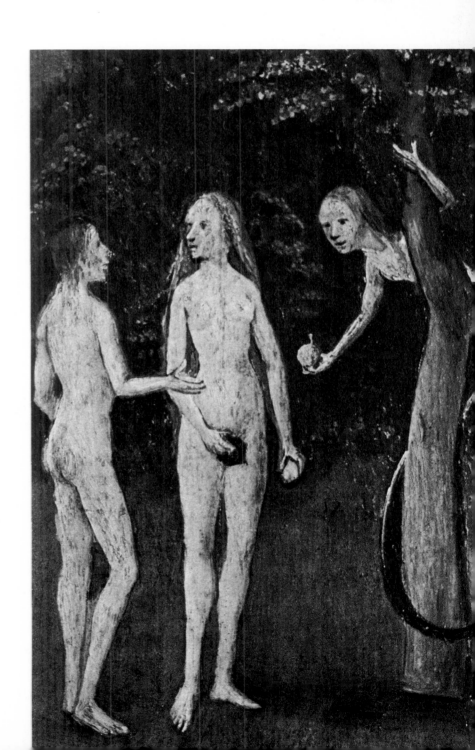

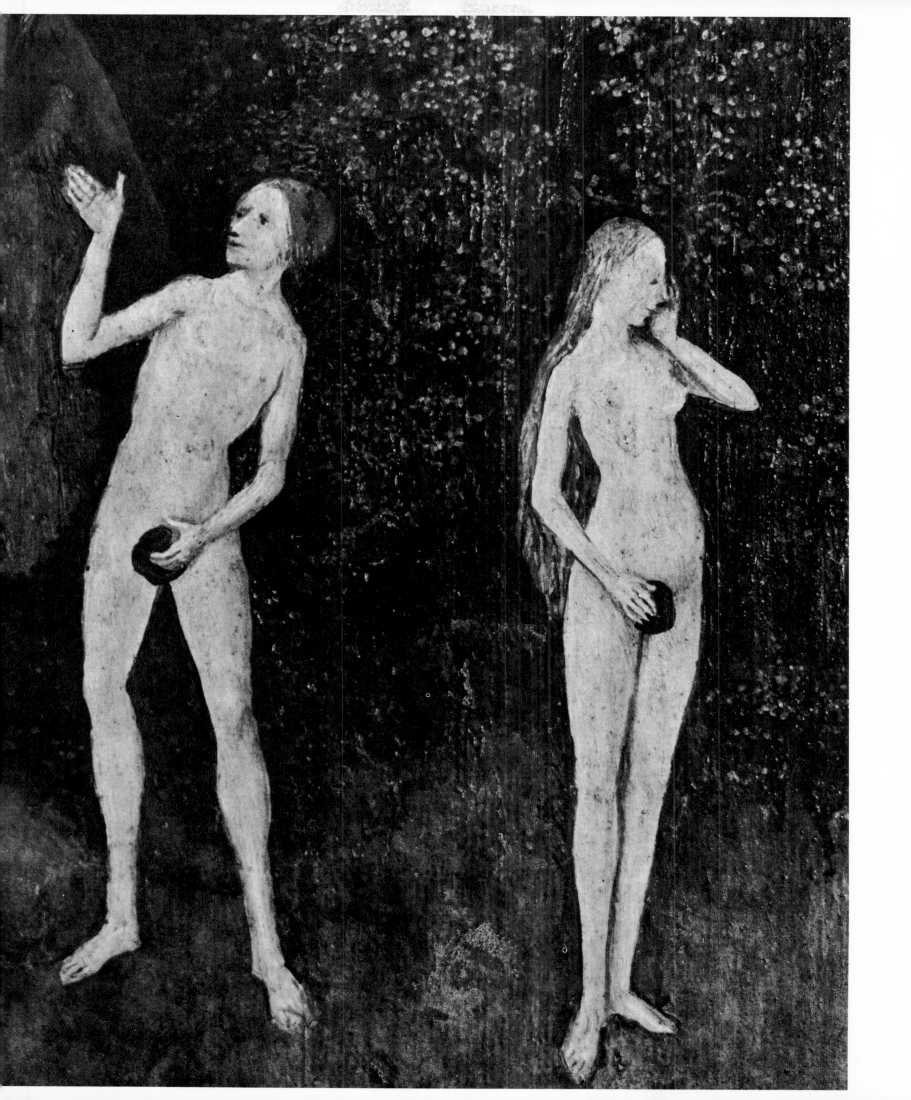

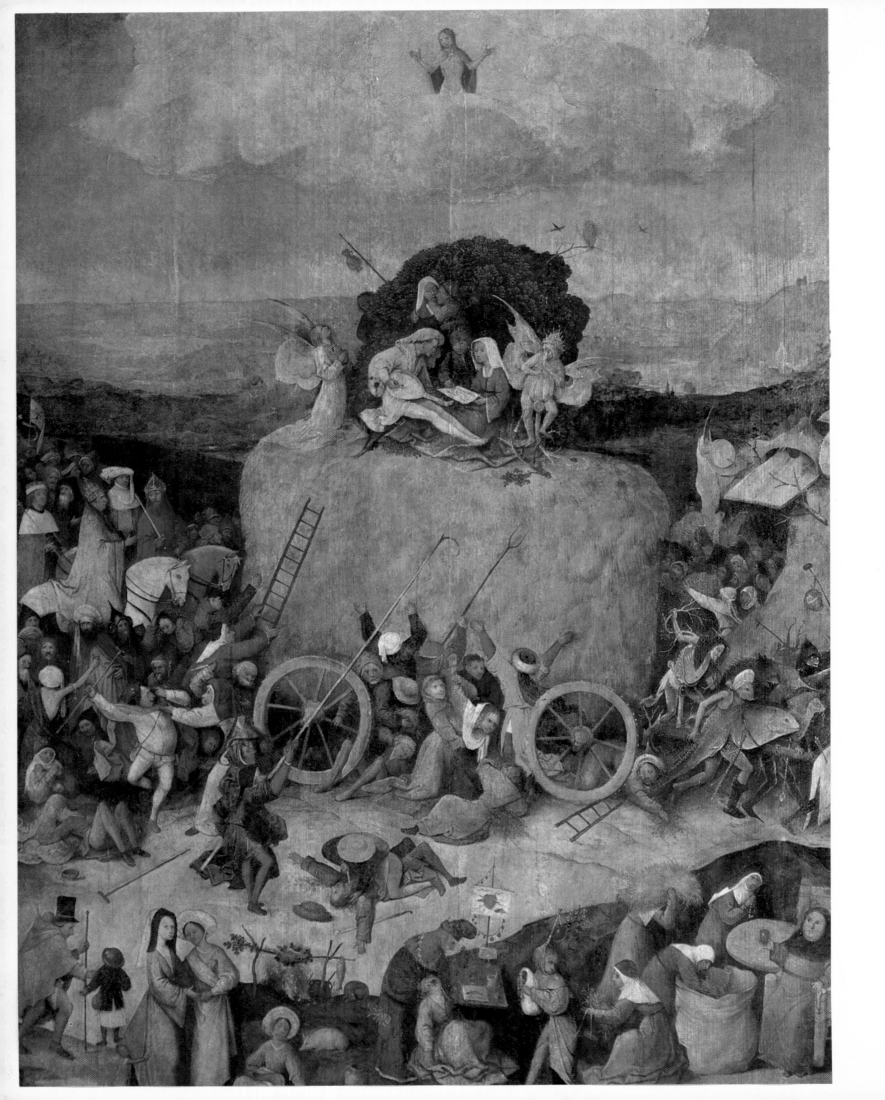

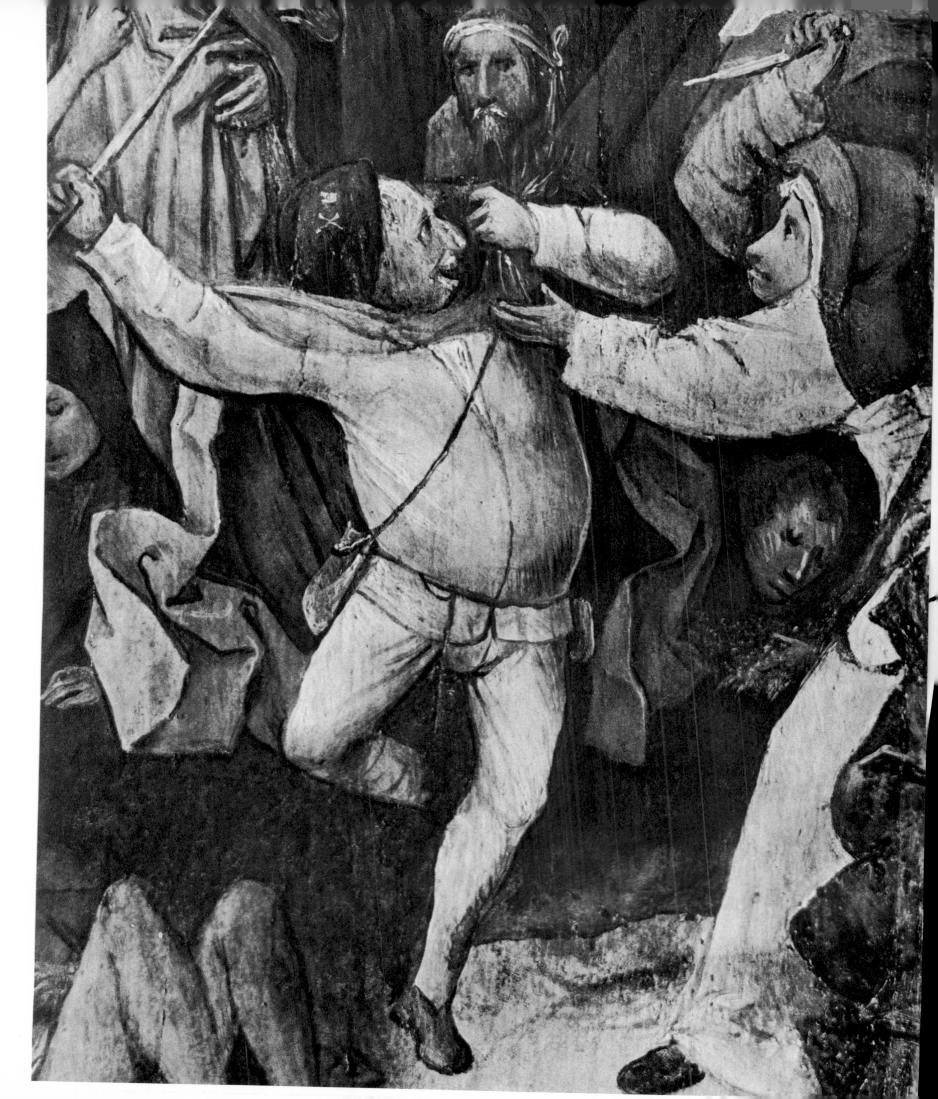

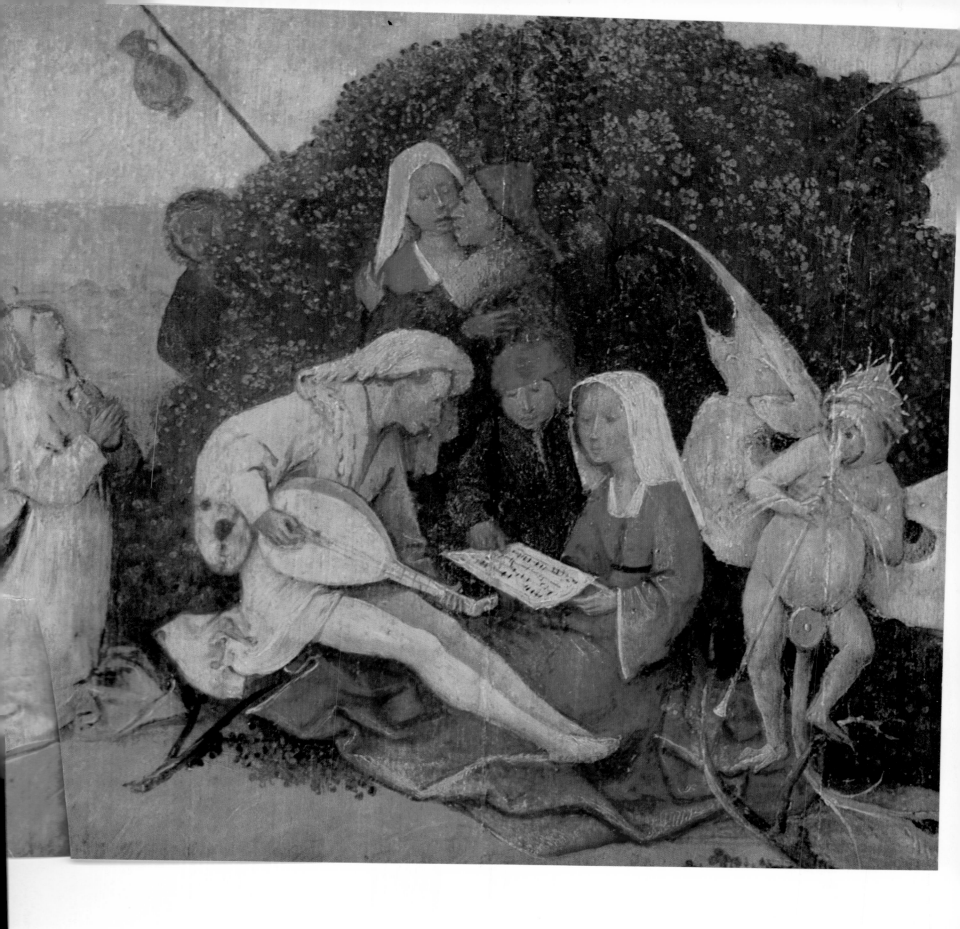

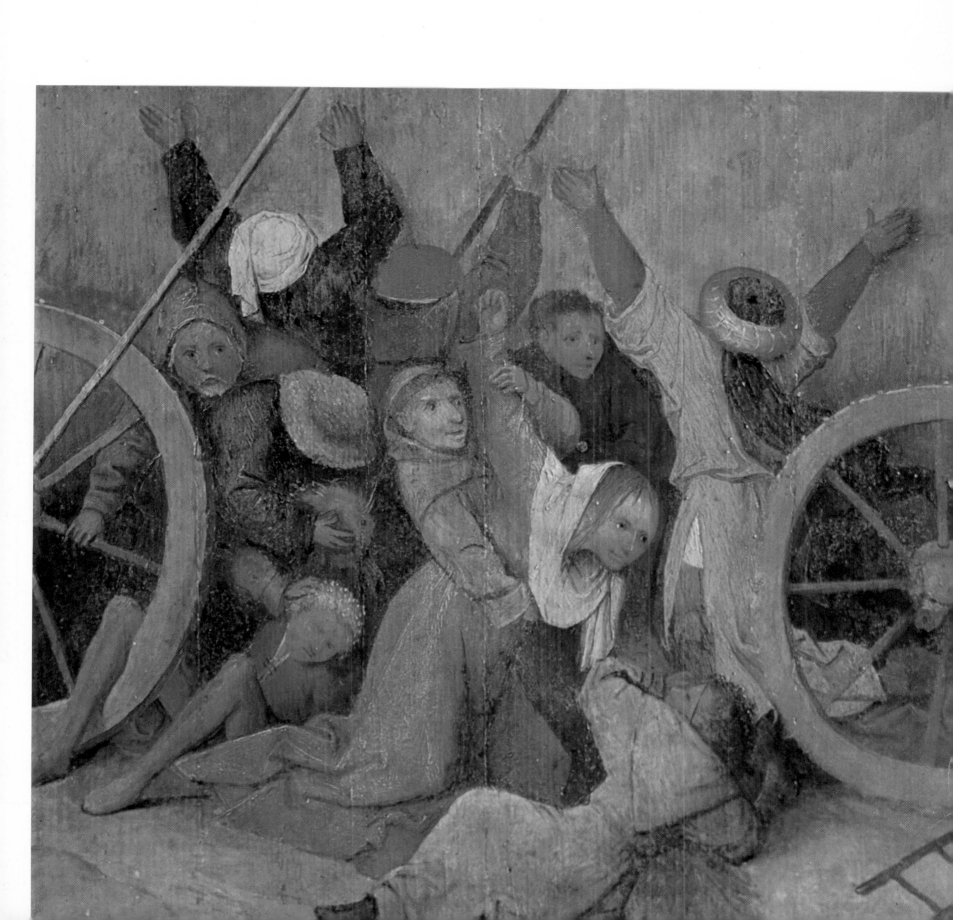

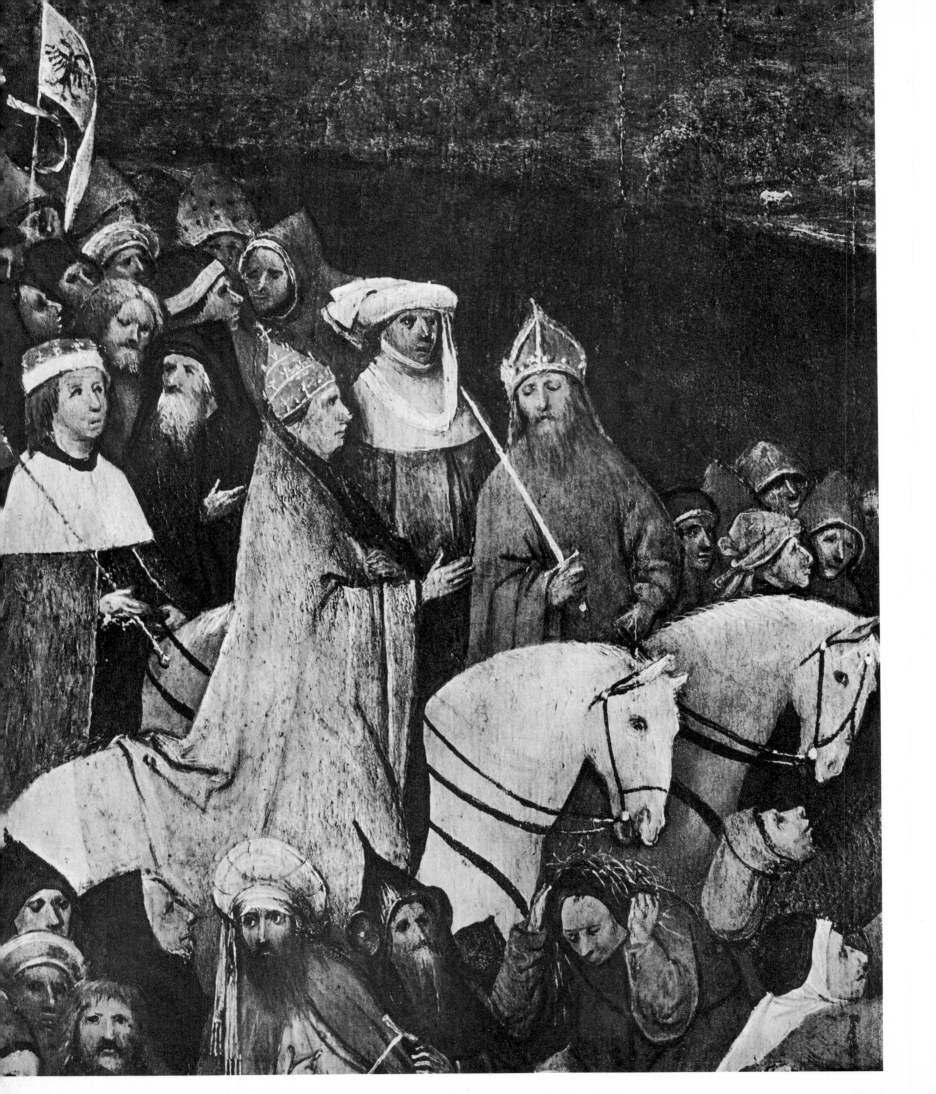

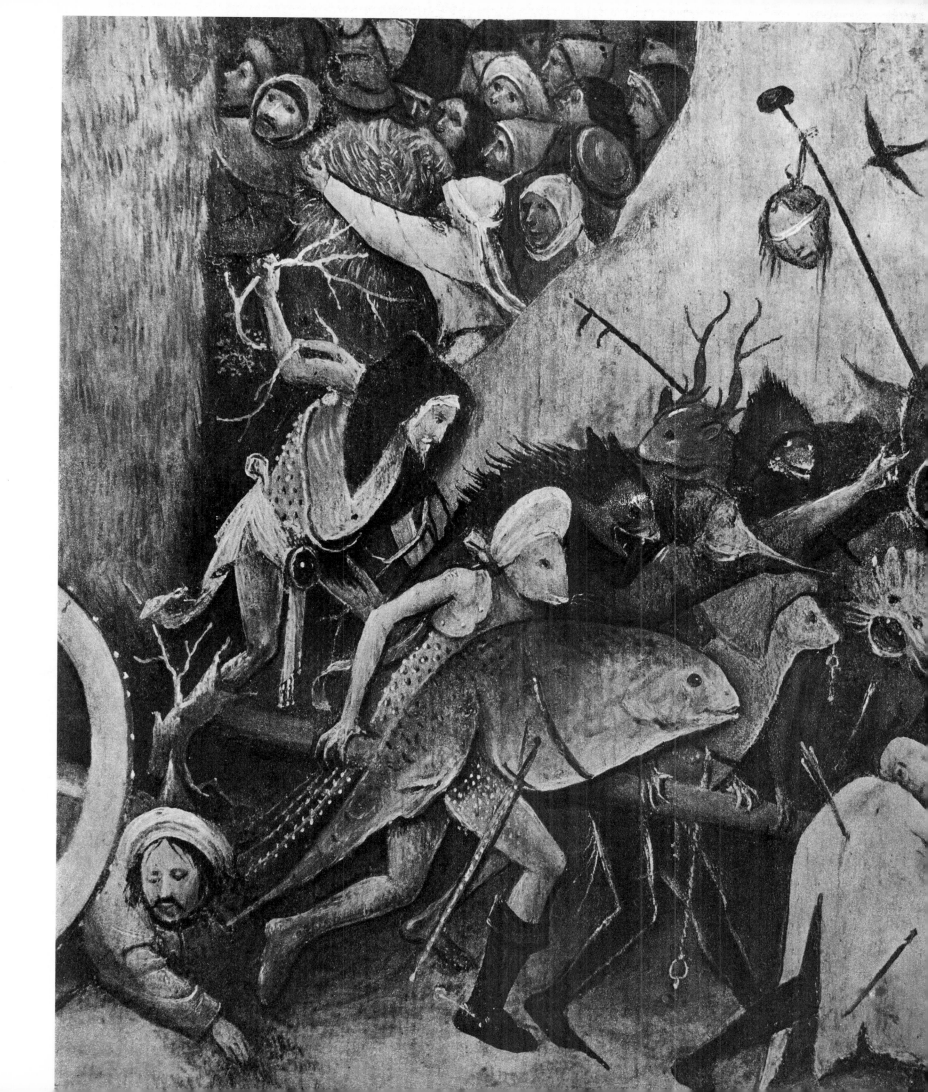

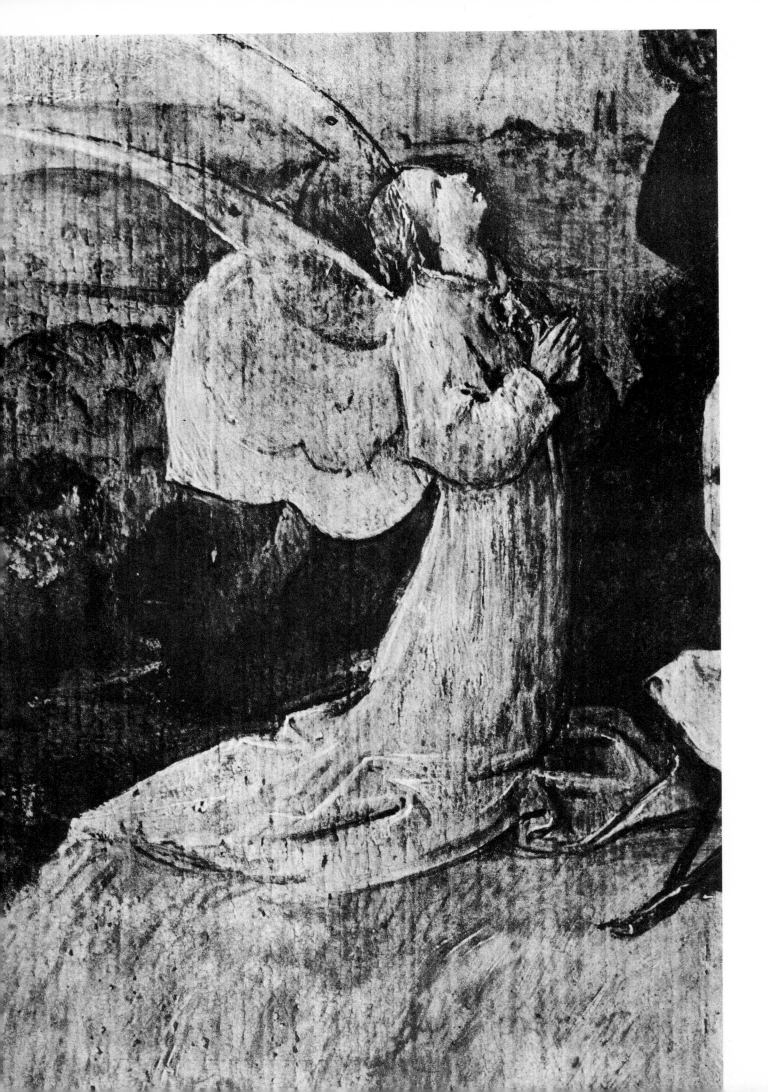

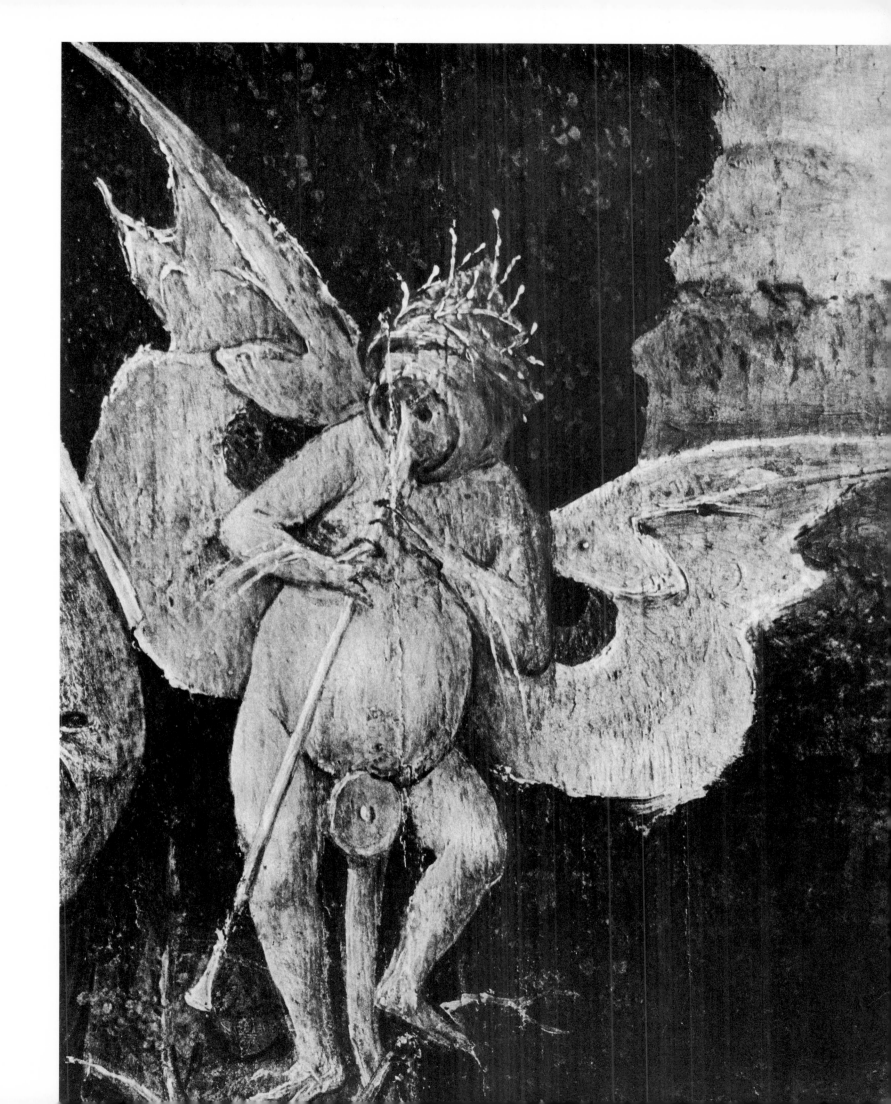

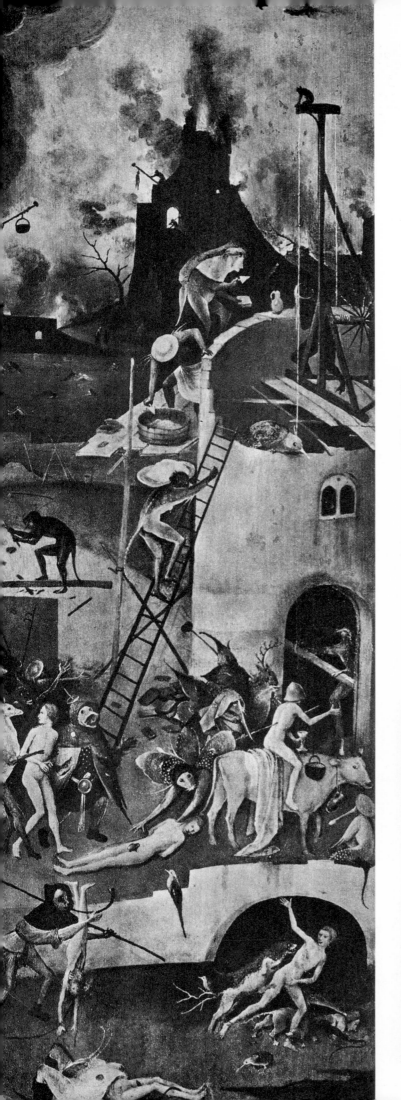
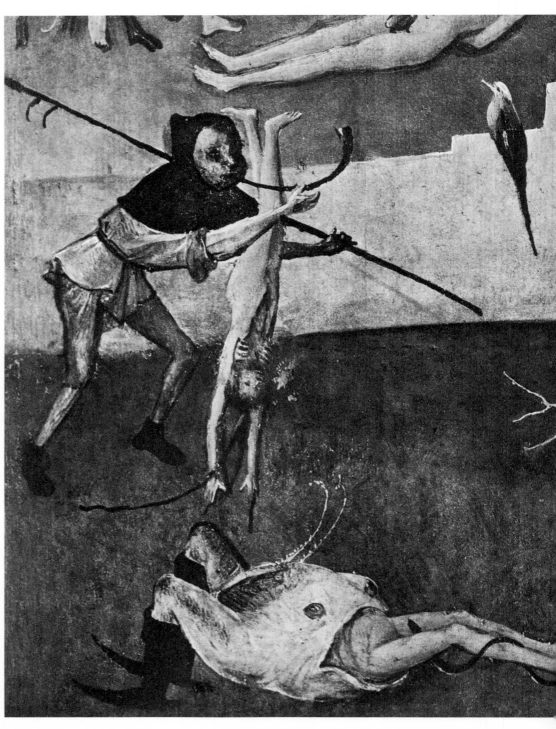

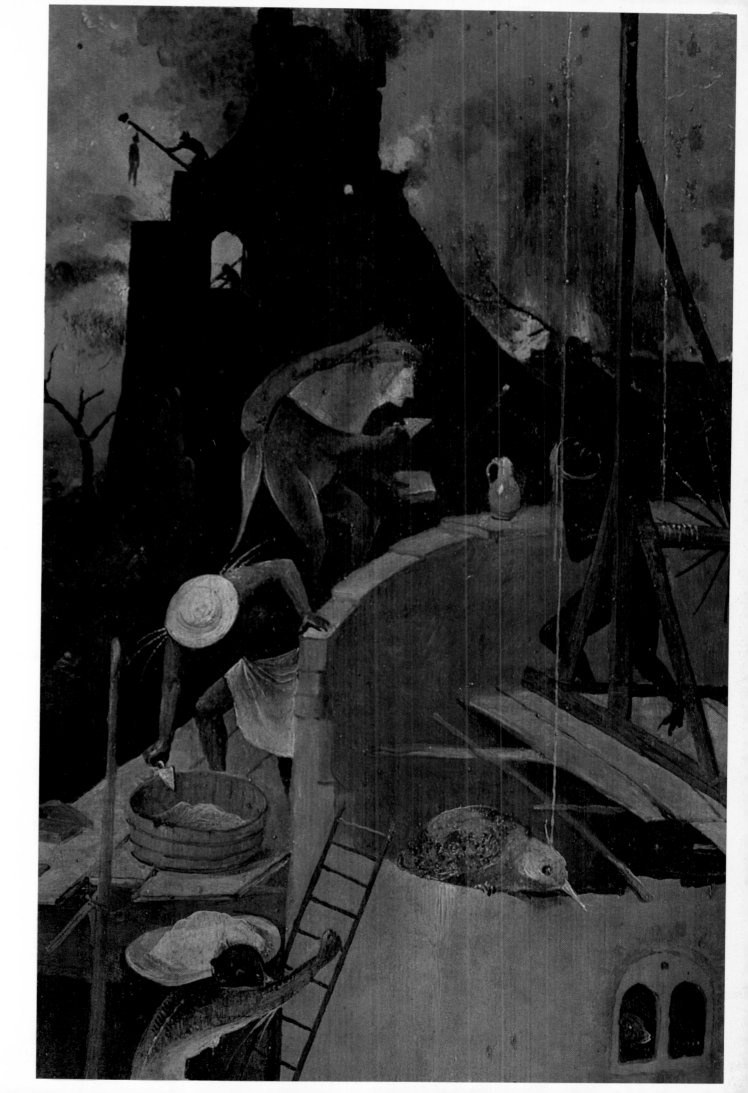

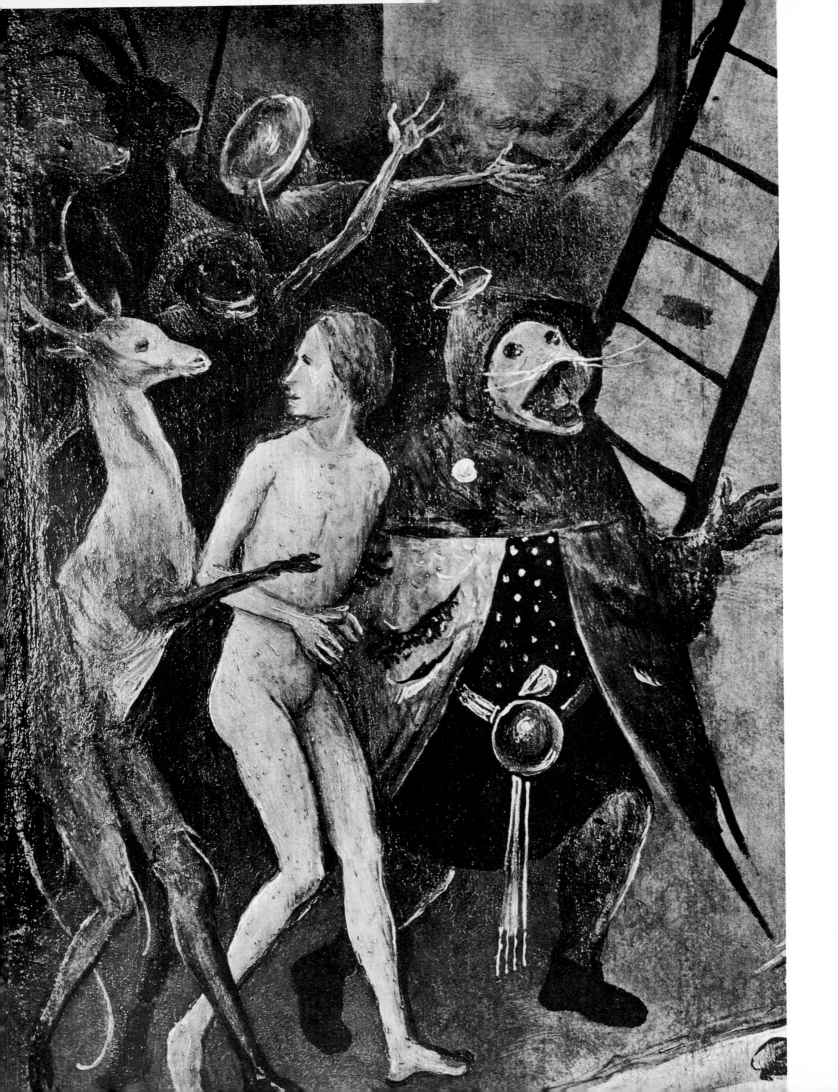

13

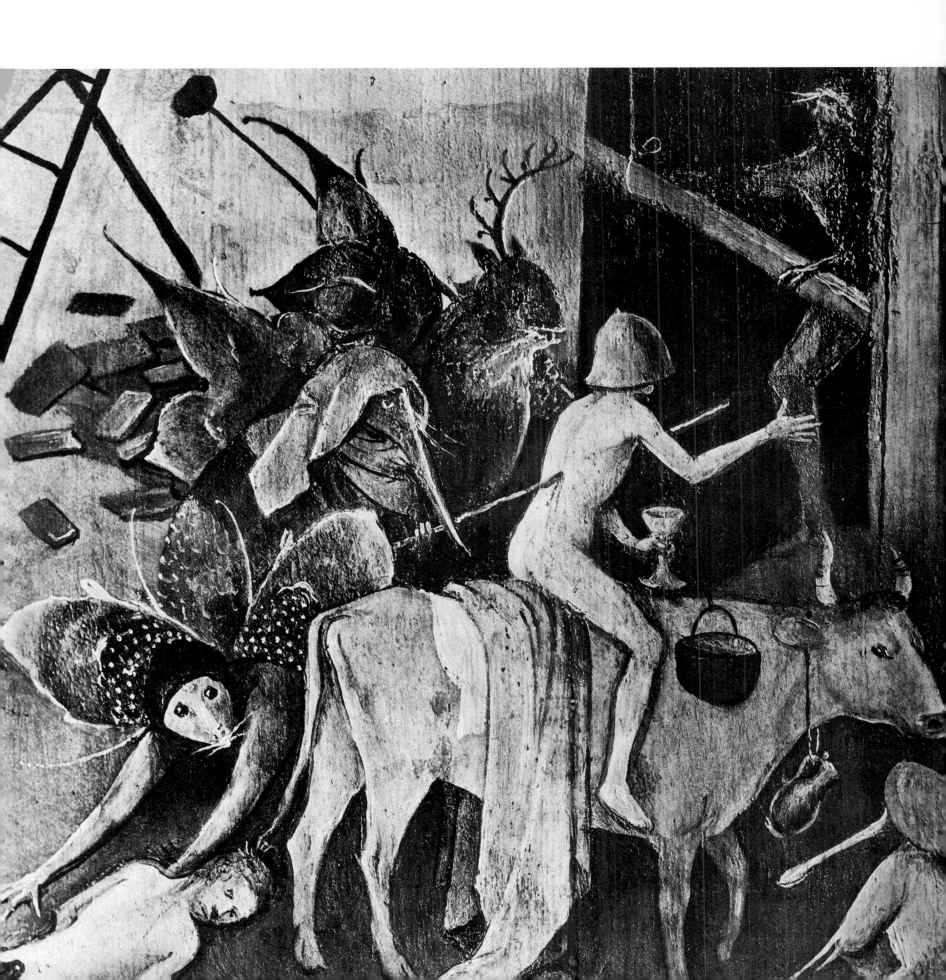

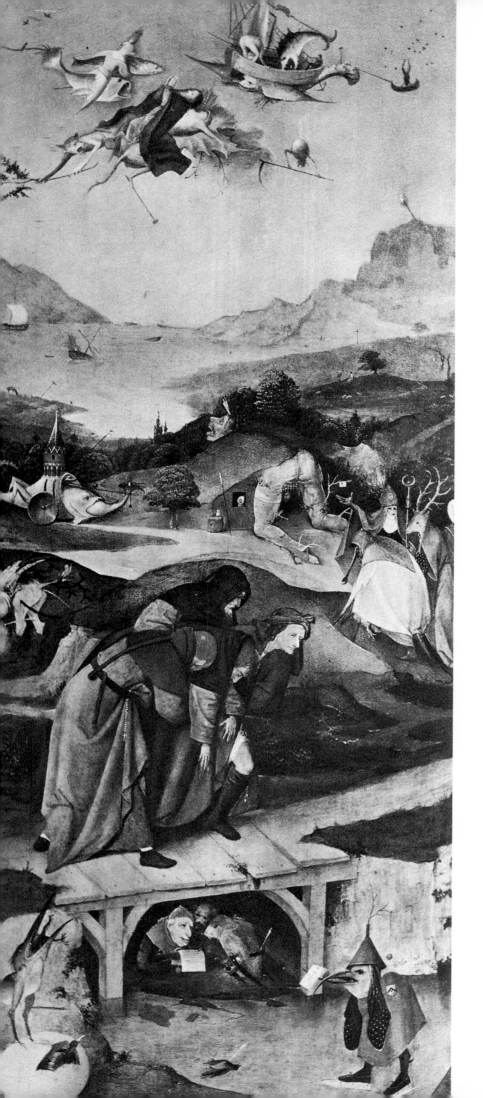

THE TEMPTATION OF ST ANTHONY

In the centre panel groups of figures and landscape motifs are gliding along like dream images; relieved of all weight, they are obeying the laws of a magical space, in which the force of gravity is replaced by a mysterious power of attraction between objects. The whole composition is given a curious unity by the dominant theme of the witches' sabbath, which is here introduced for the first time, with an unusual wealth of motifs, into the iconography of the Temptation of St Anthony. Assailed from all sides, the saint preserves himself from the evil world only by the firmness and fervour of his faith. In the darkest part of the picture, in the depths of the ruined castle, stands an altar with a crucifix and a burning candle. On the left wing the painter

shows us St Anthony being taken back to his hut, in a faint, supported by his companions. On the right wing he is turning away fearfully from the temptress, only to see a fresh temptation: a laid table, whose cloth conceals the demons from him.

LISBON, MUSEU NACIONAL DE ARTE ANTIGA.

Oil on wood. Centre panel: height 131.5, width 119 cm; each wing: height 131.5, width 53 cm. Complete picture of centre panel page 136; details pages 137-154. Complete picture of left wing page 134; detail page 156. Complete picture of right wing page 135; details pages 155, 157. Outer sides of wings pages 158-163.

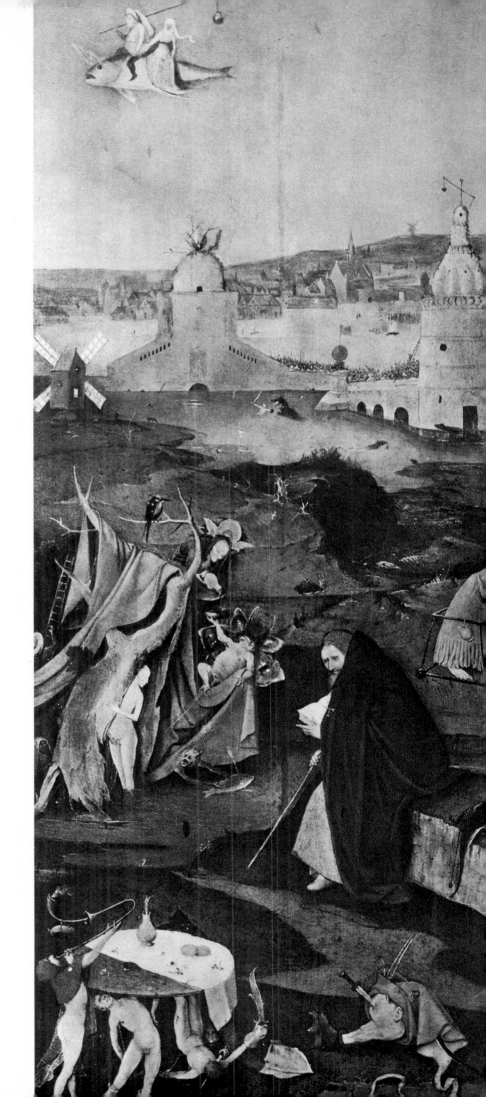

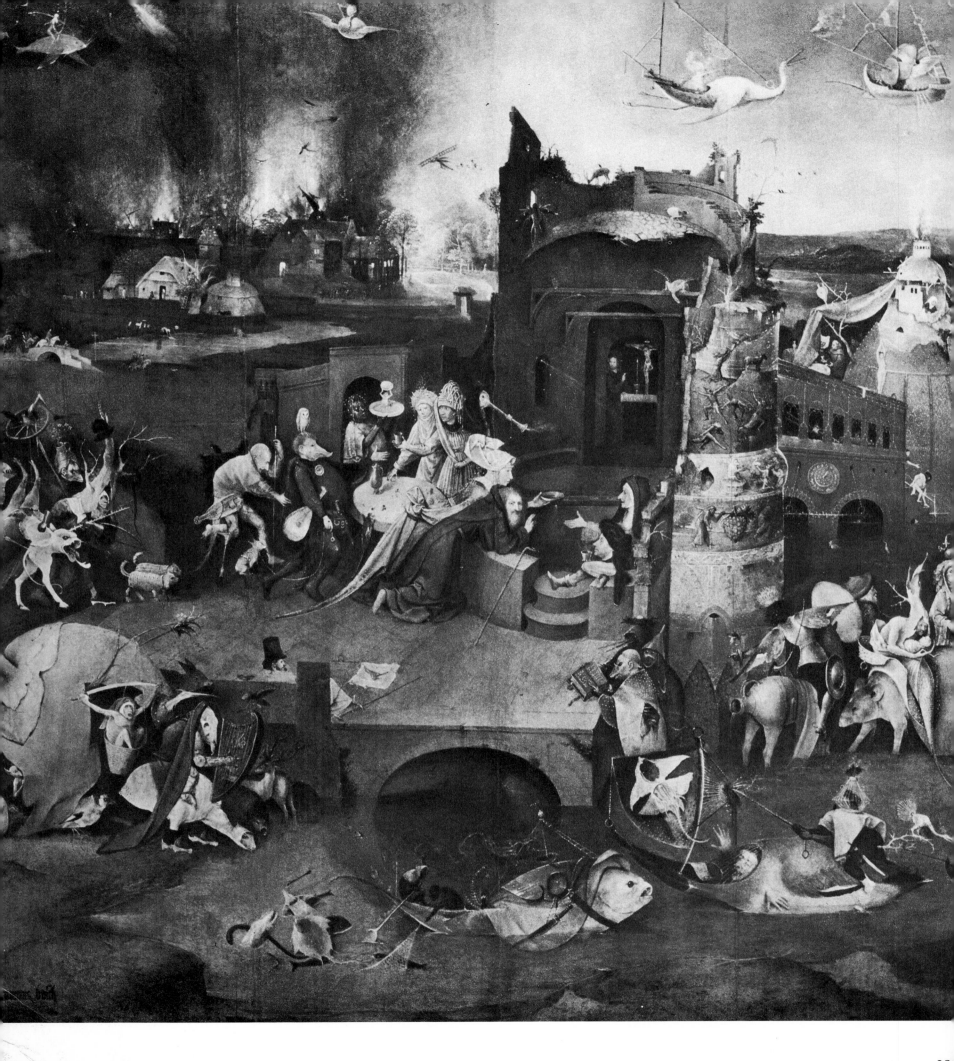

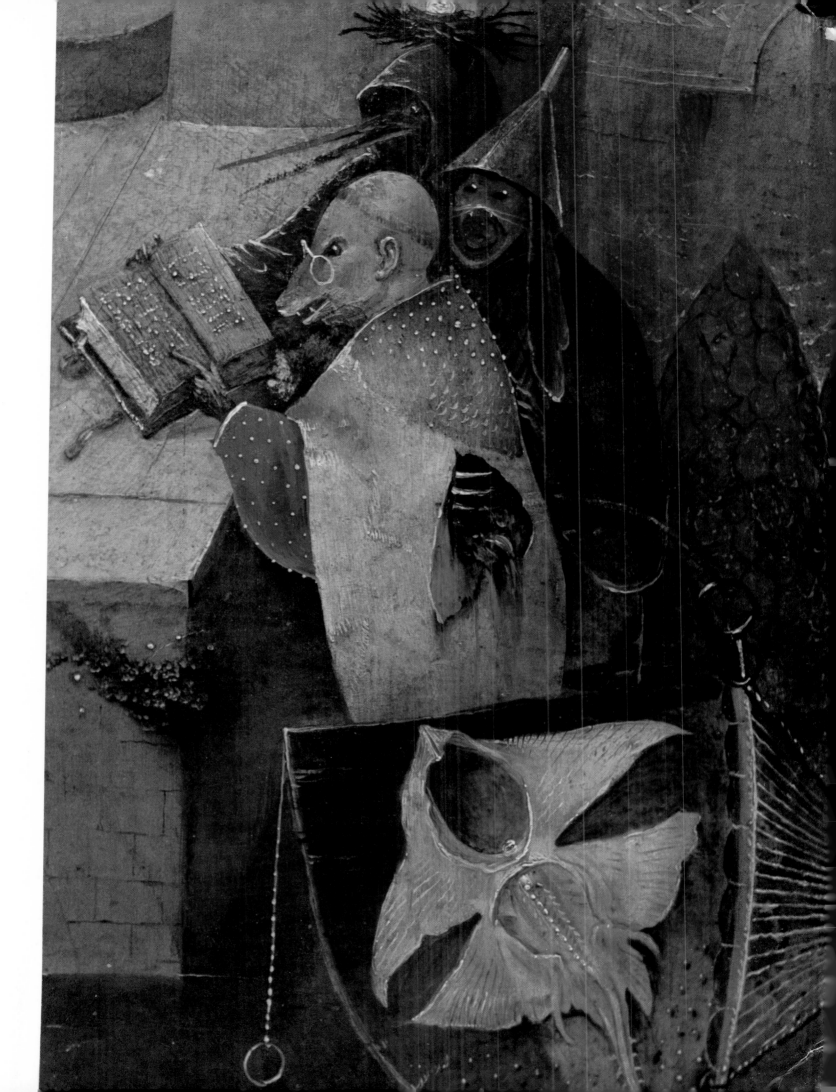

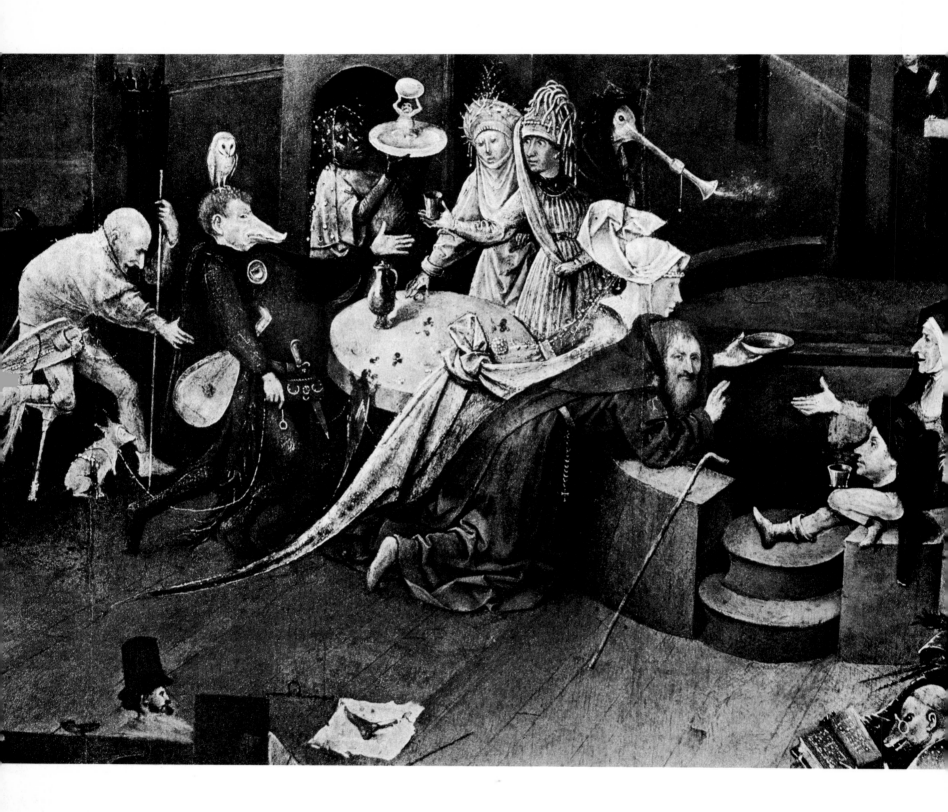

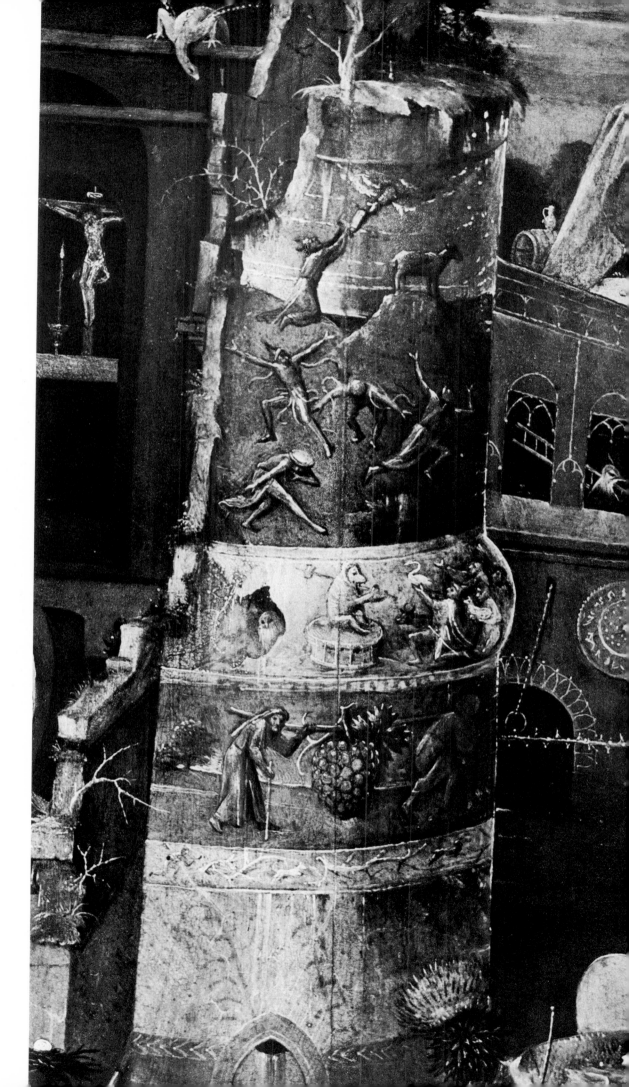

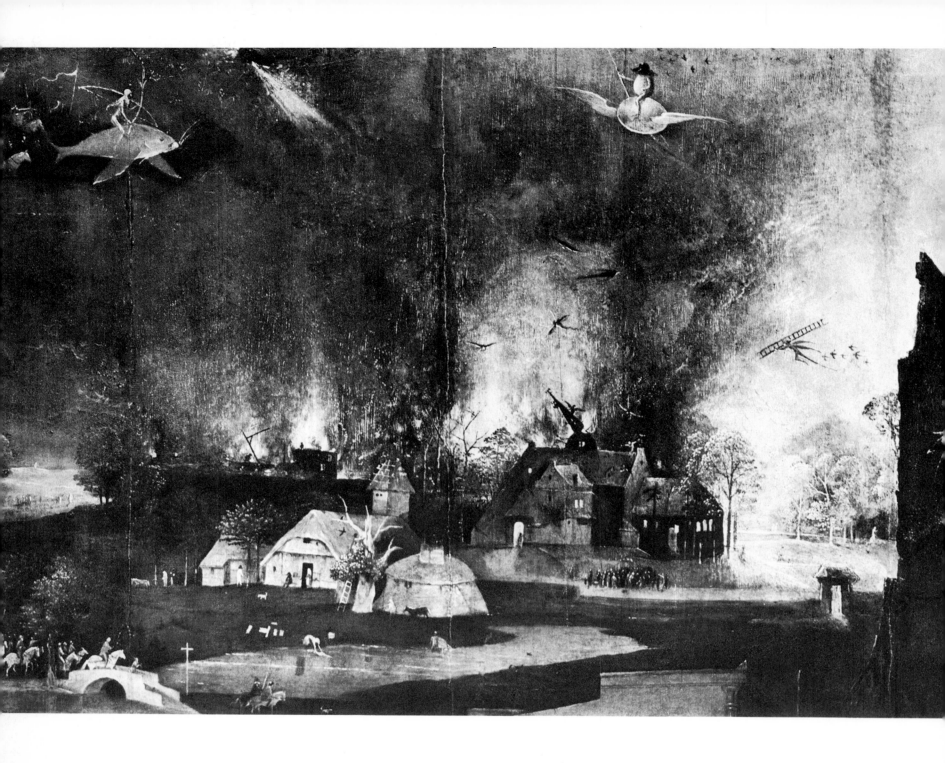

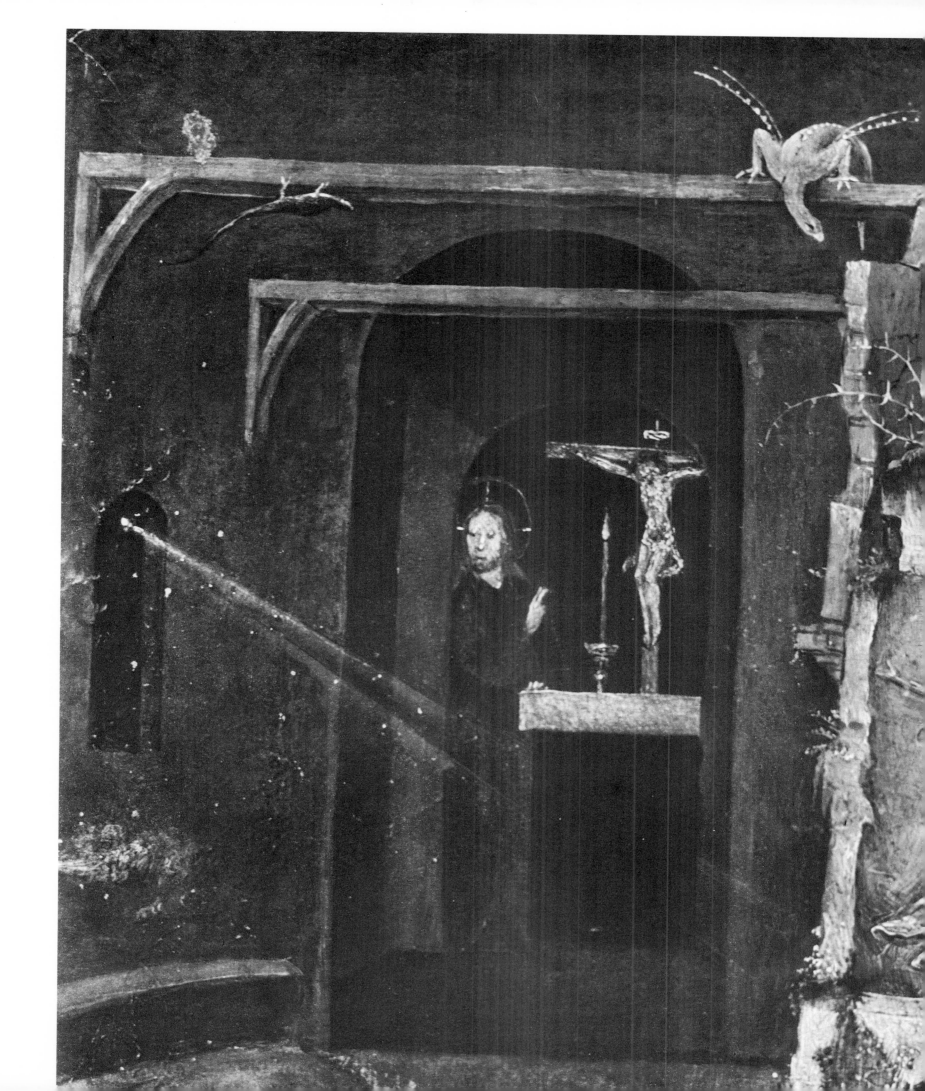

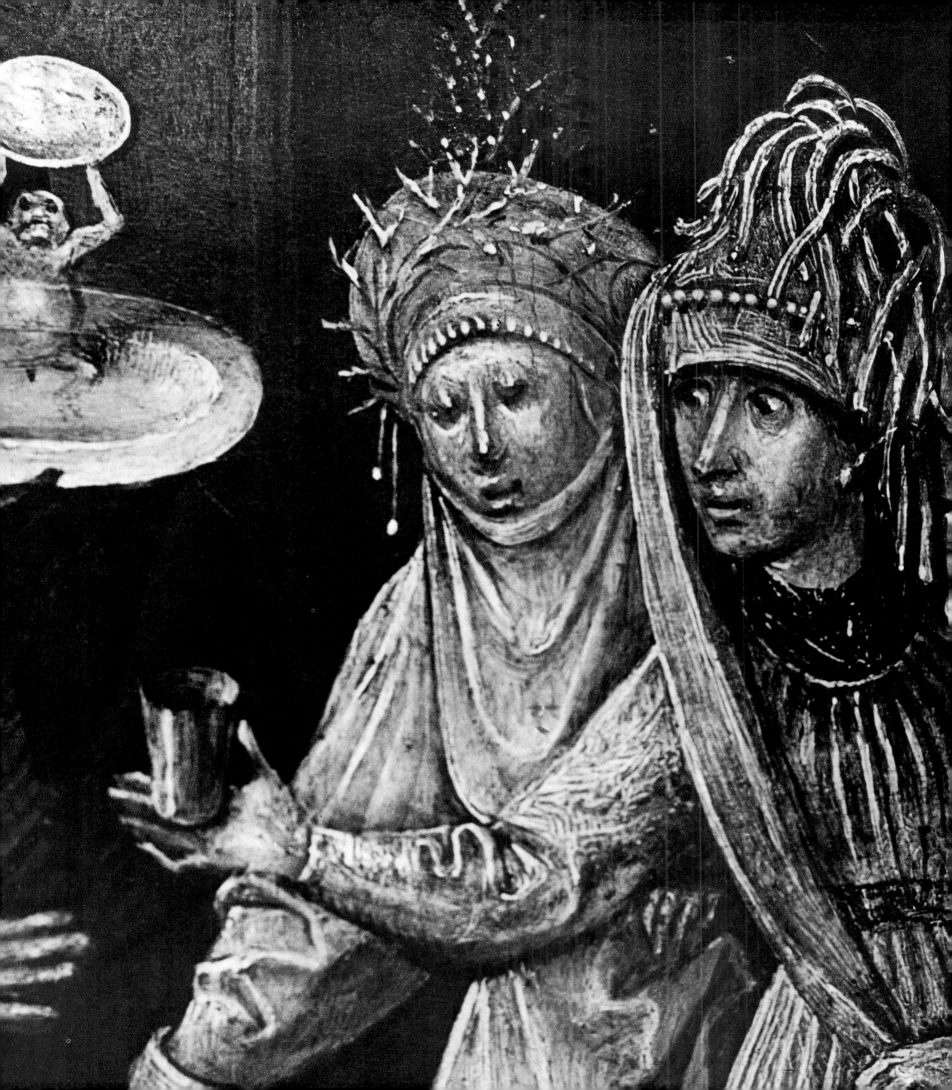

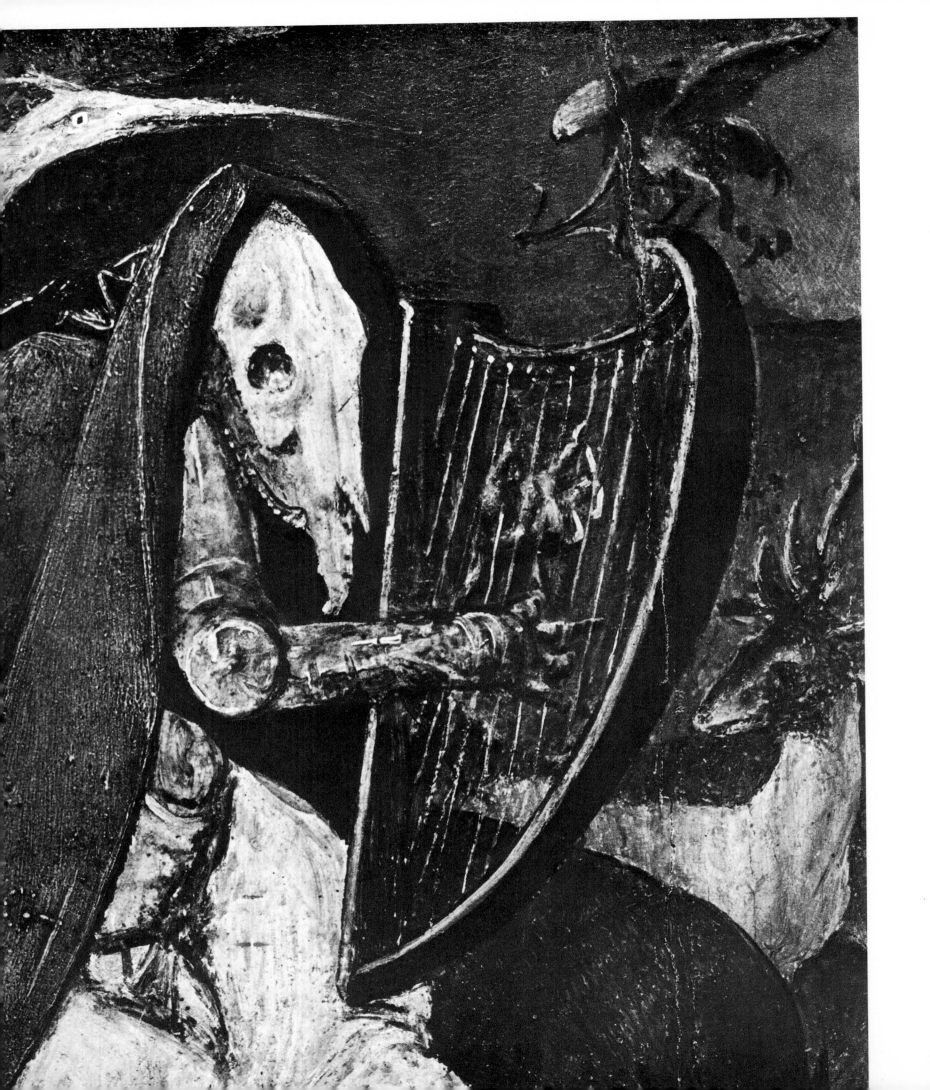

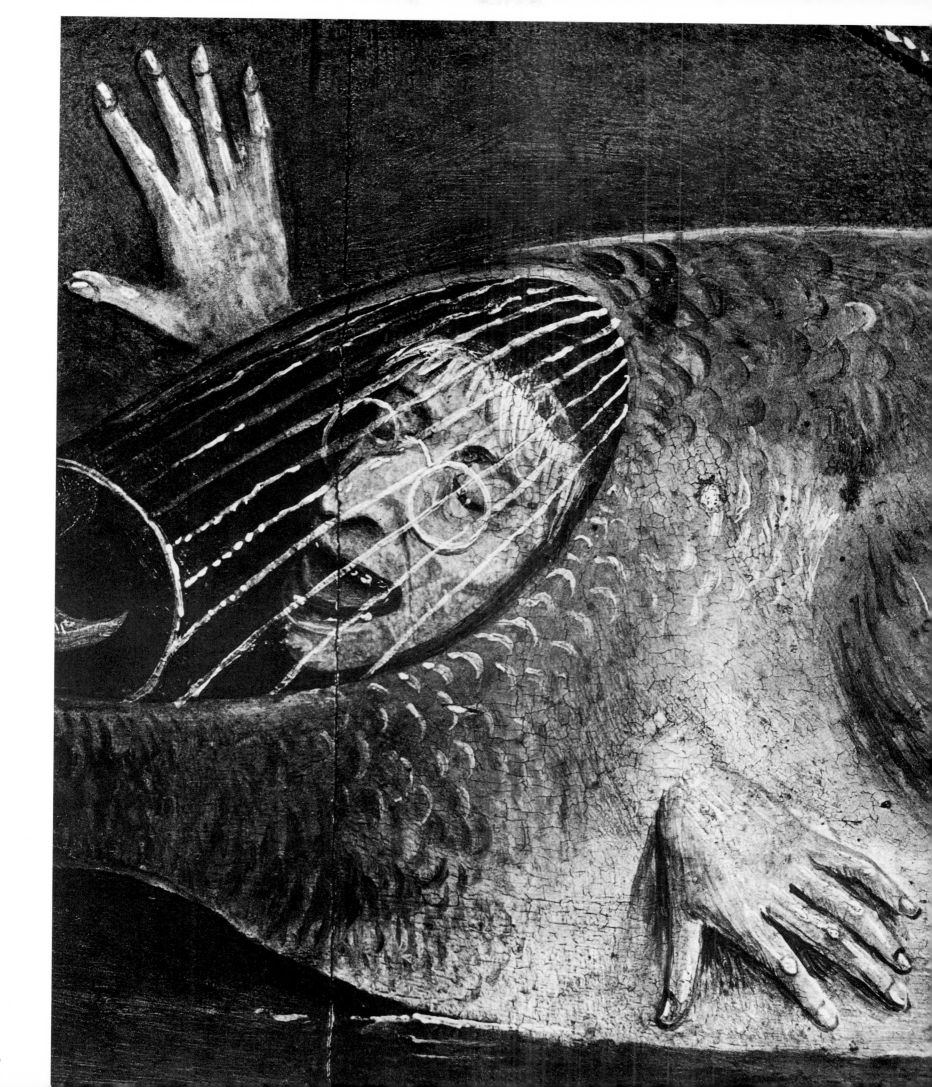

45

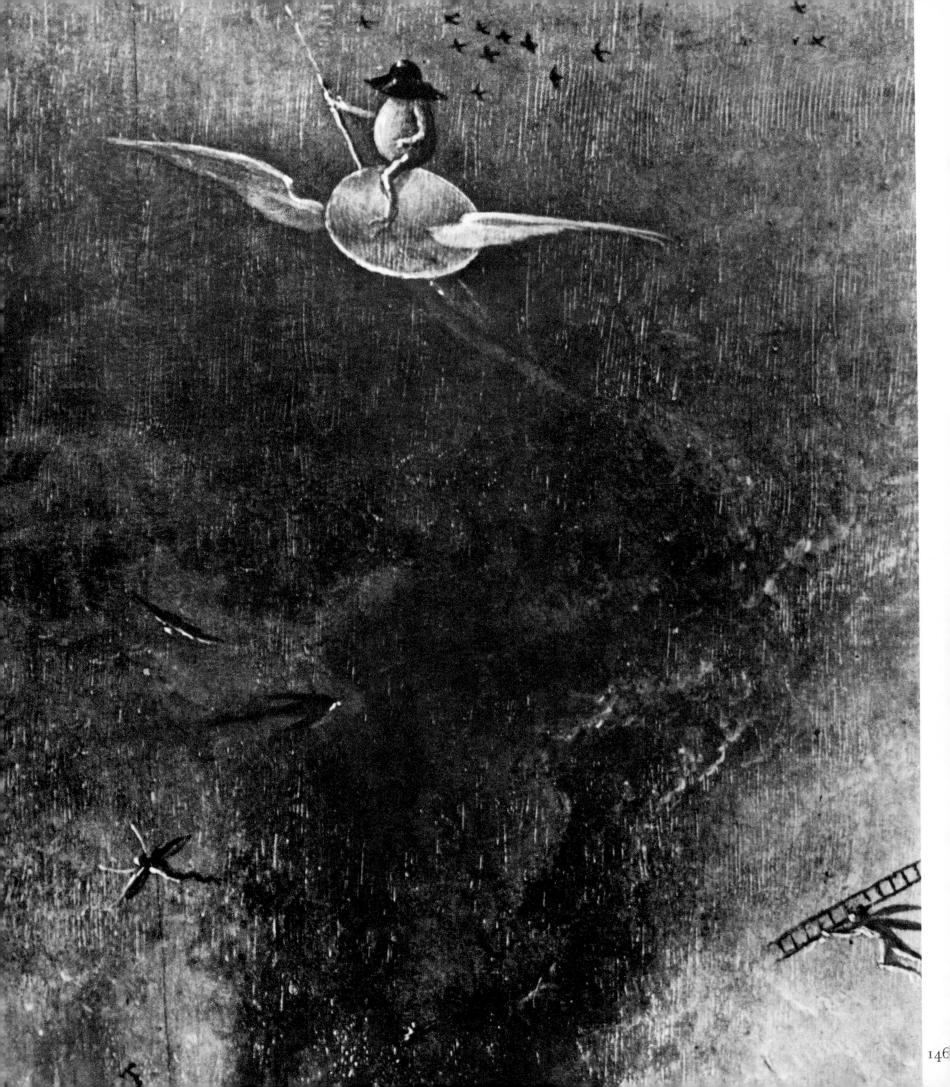

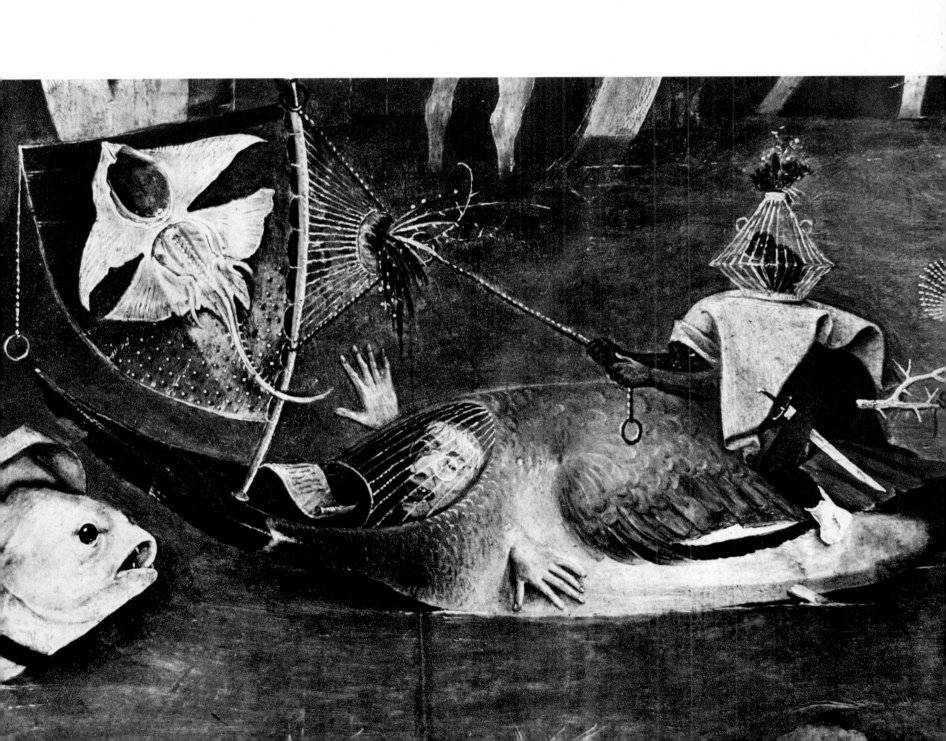

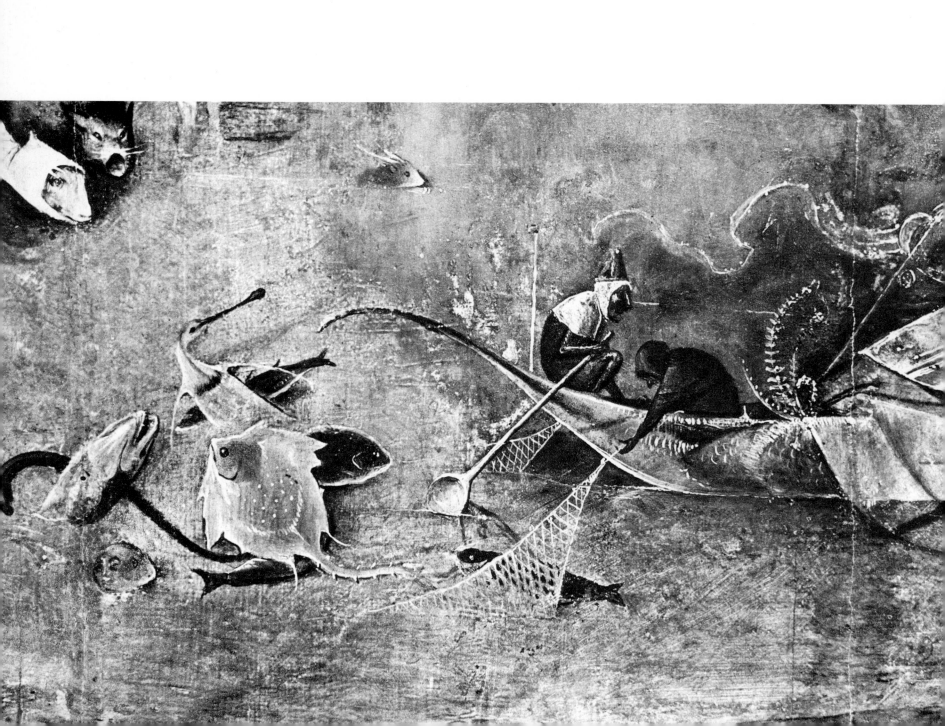

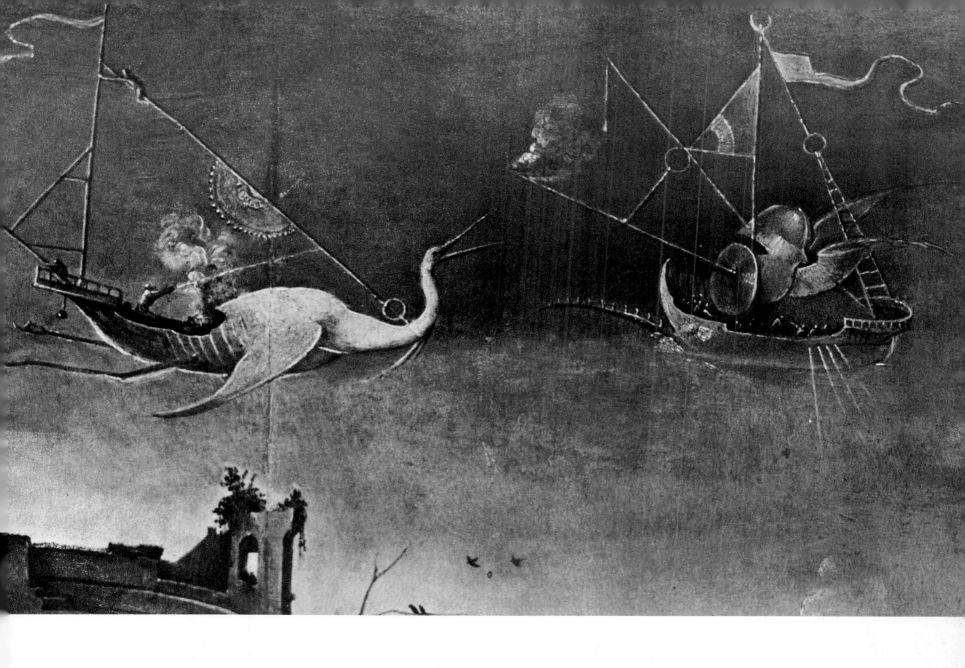

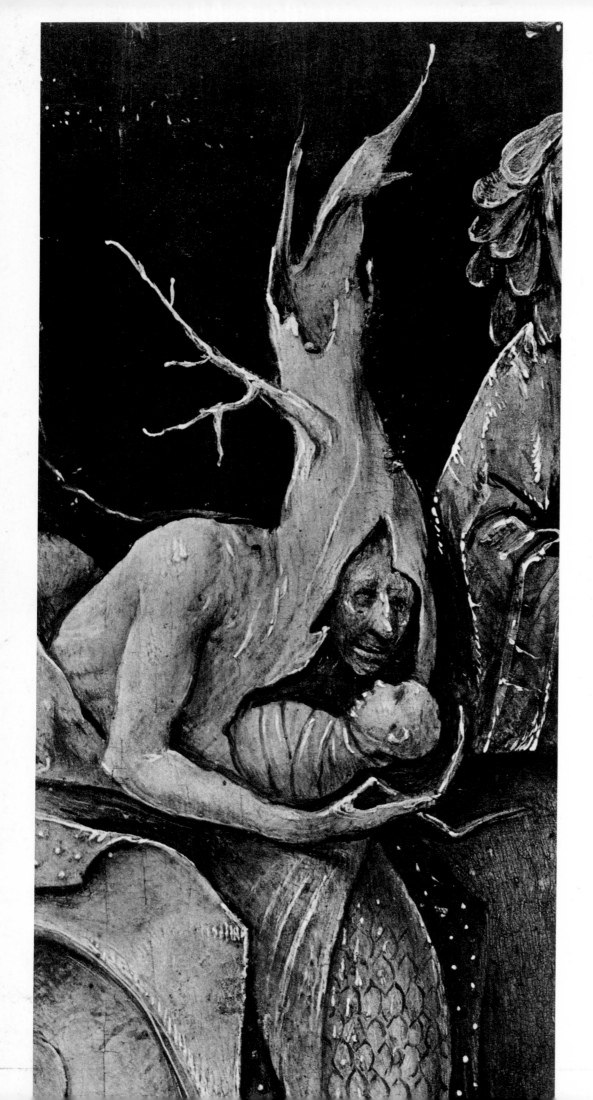

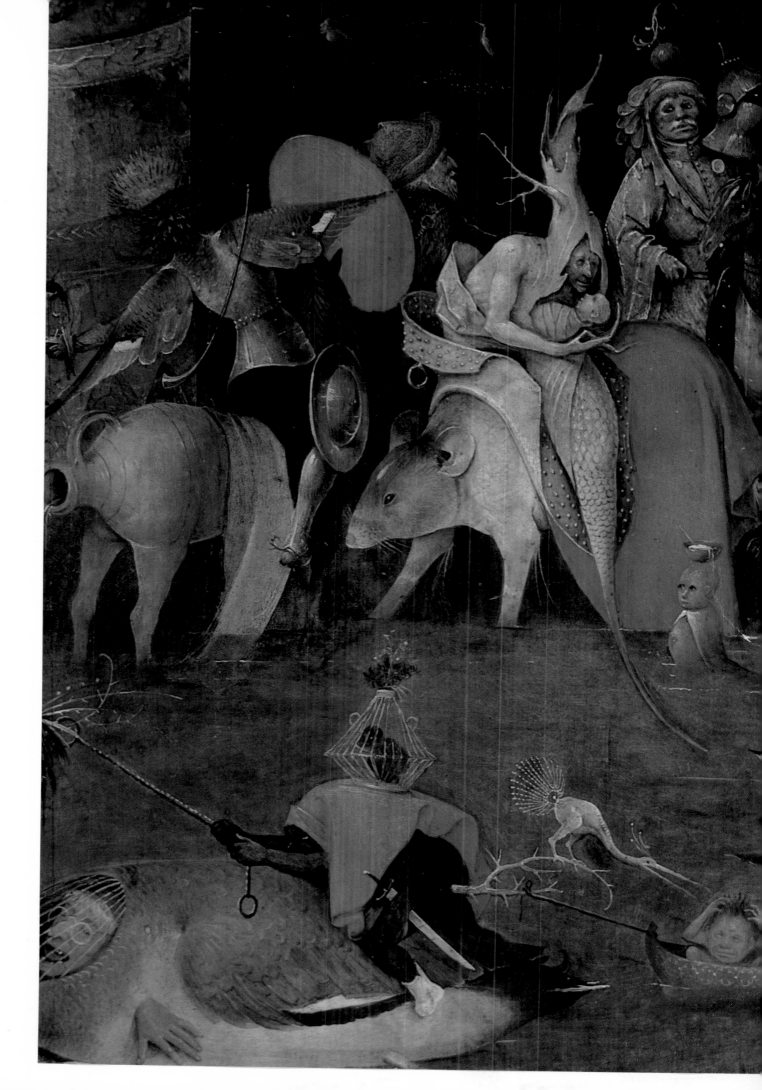

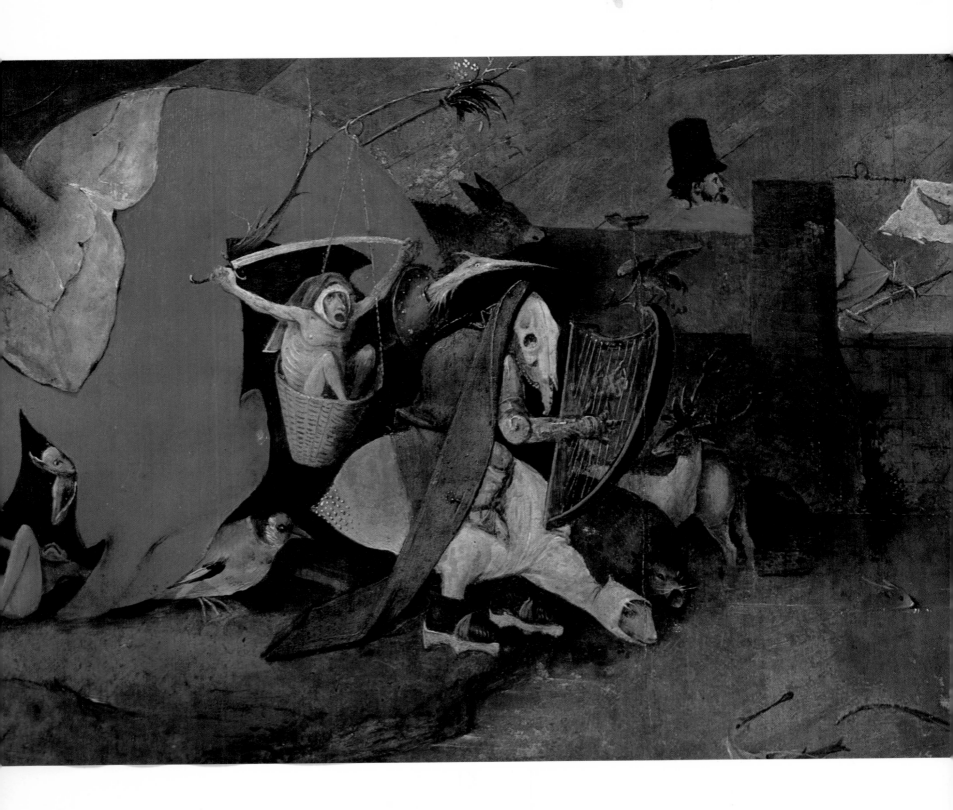

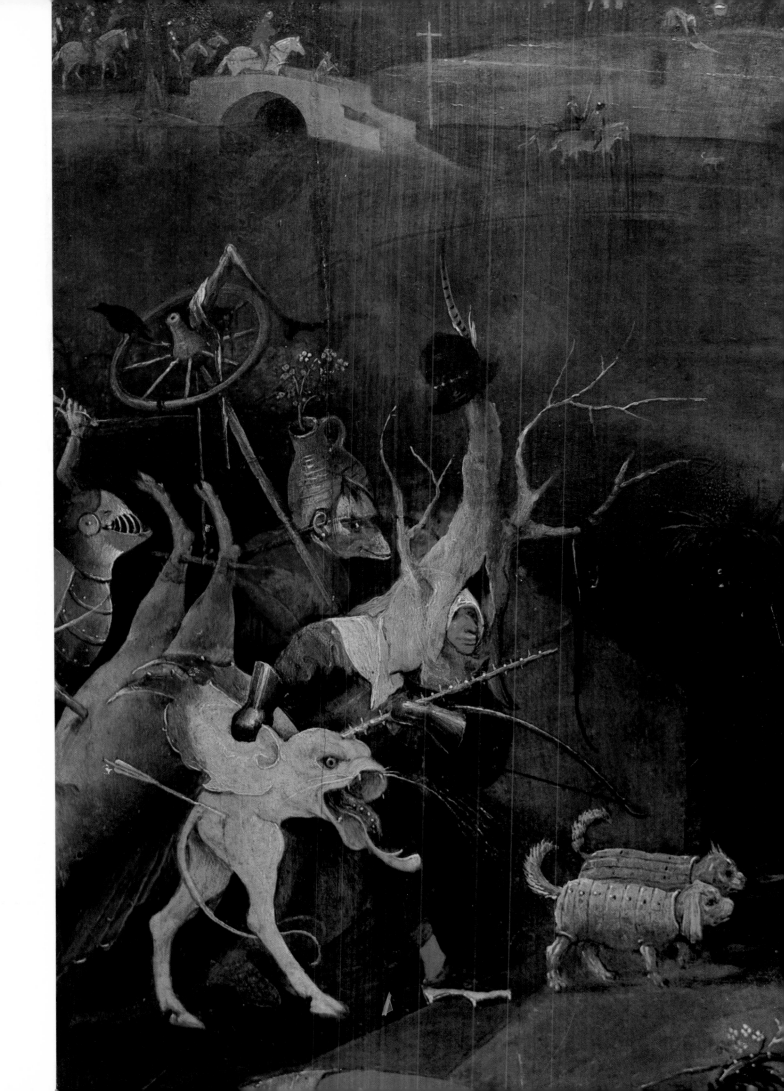

53

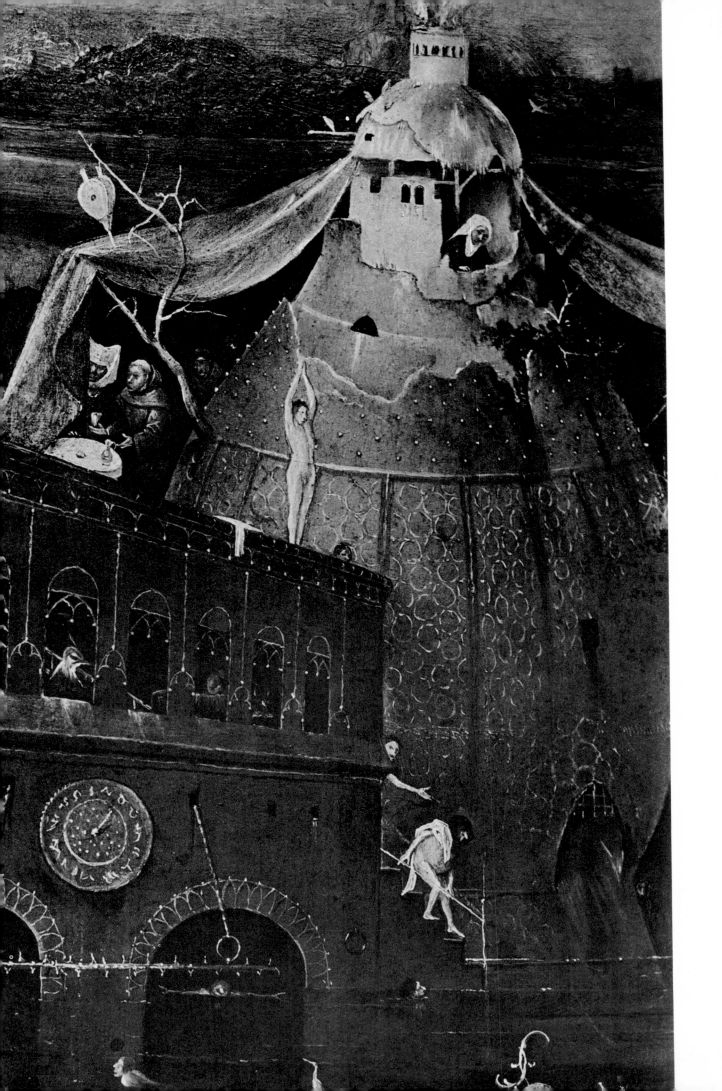

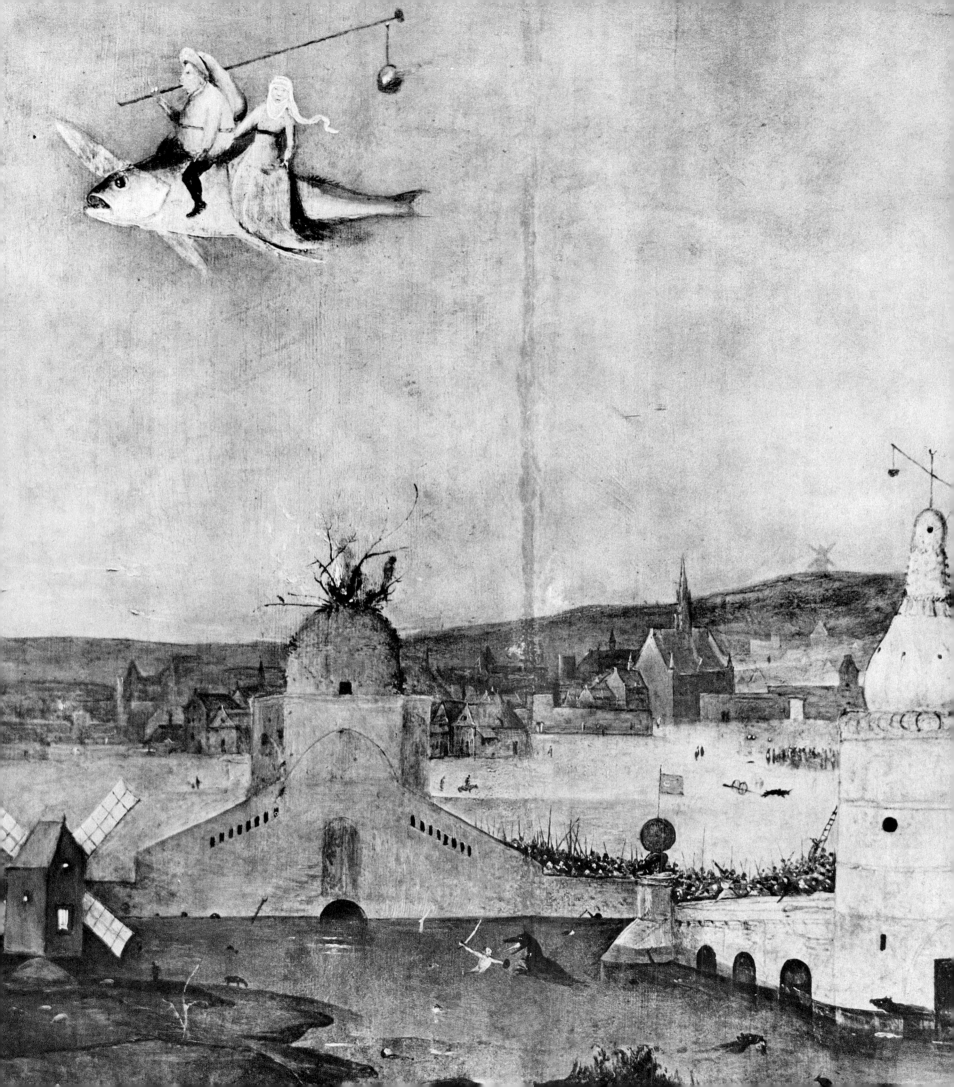

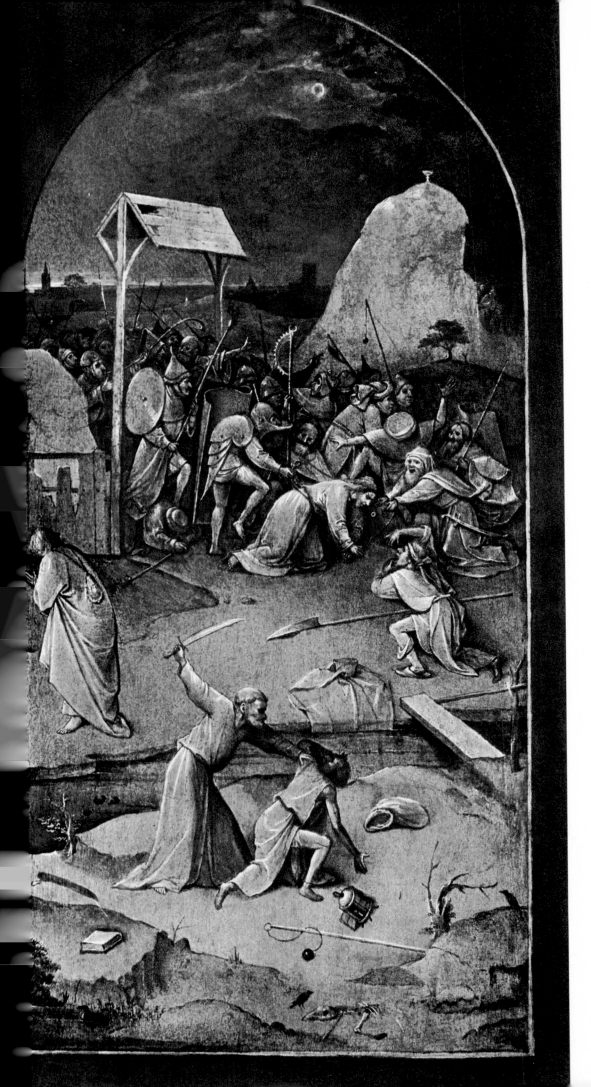

The Seizure of Christ and *Christ Carrying the Cross*.

Grisaille. Outer sides of wings of the St Anthony triptych. The entire altarpiece shows sinful mankind; when the wings

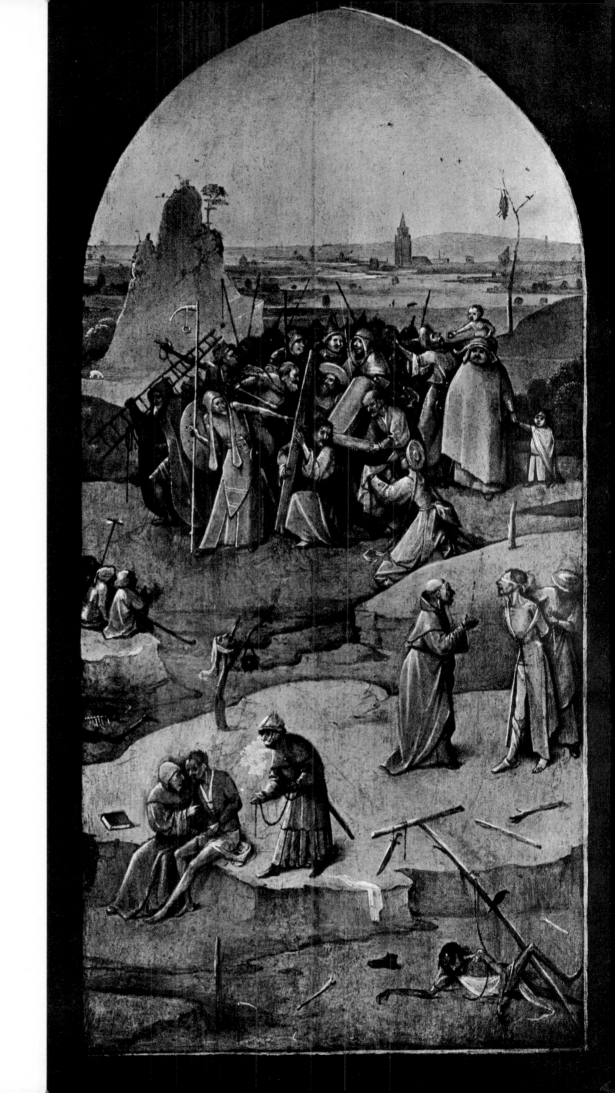

are closed, it represents, in two Stations
of the Passion, mankind's salvation.
Complete pictures of the wings pages 158-159.
Details from left wing pages 162-163; from
the right wing pages 160-161.

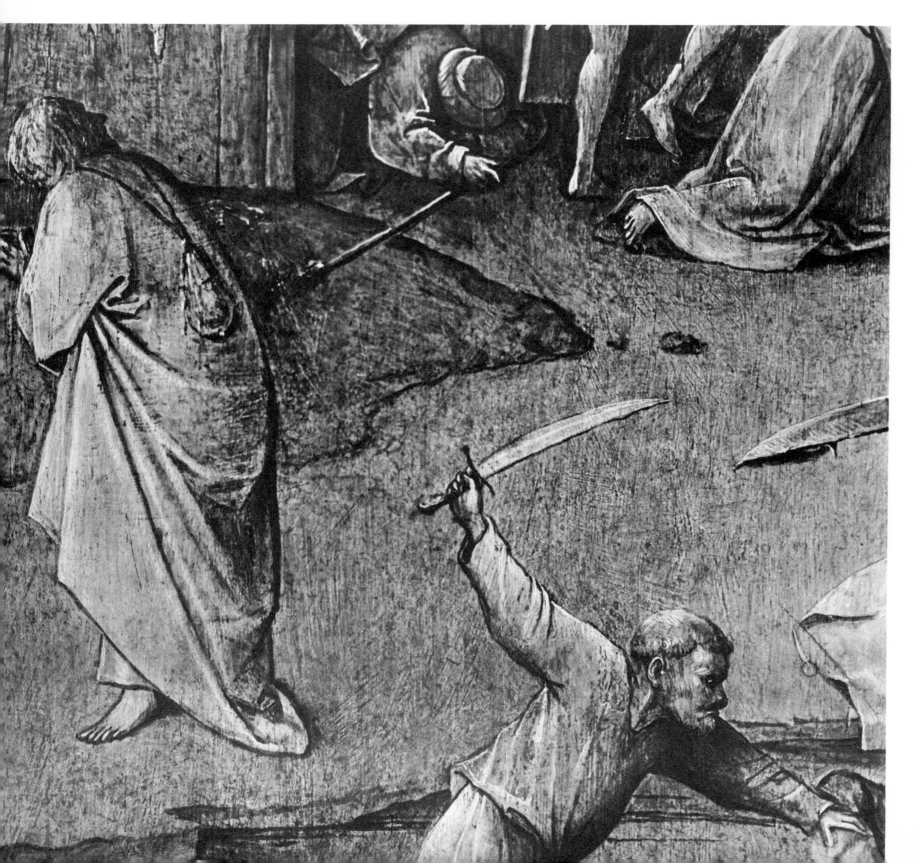

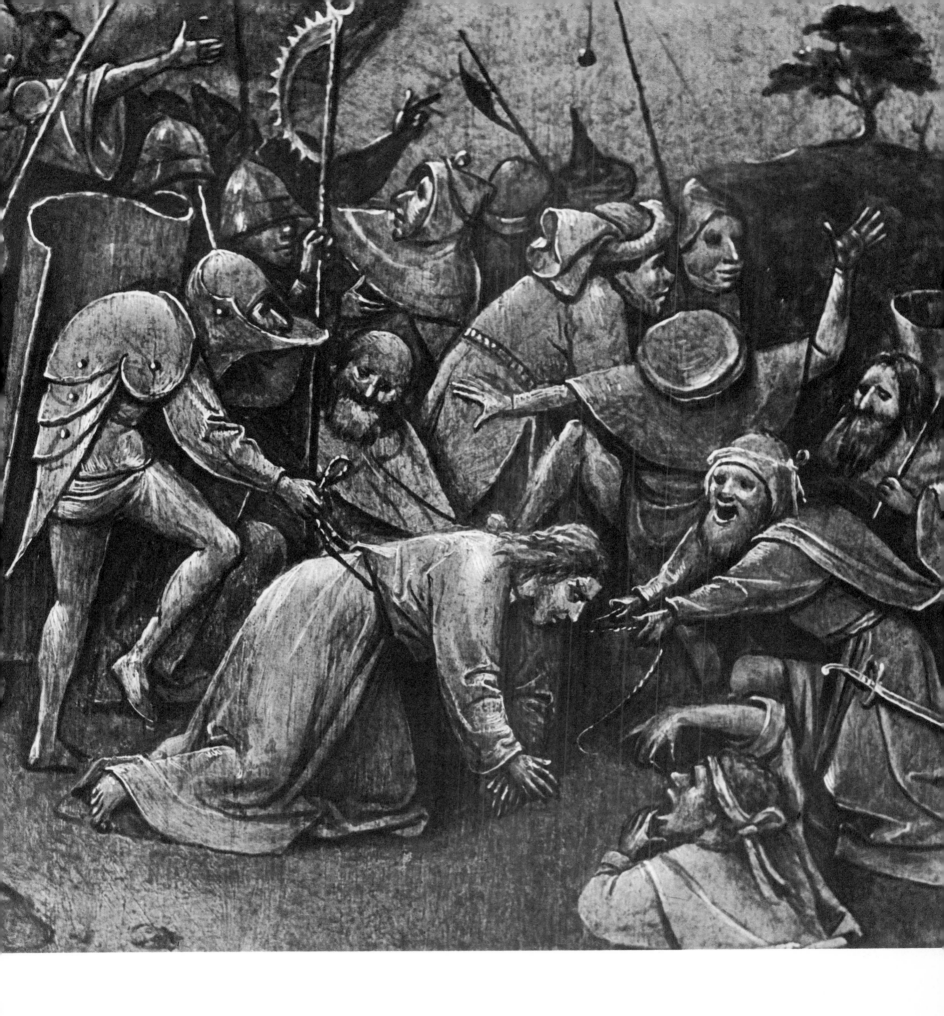

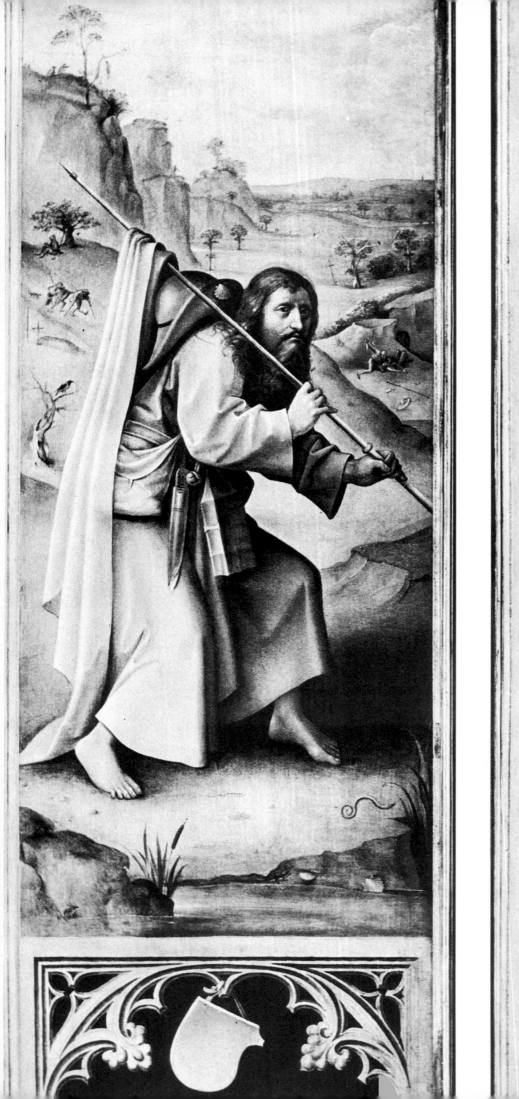
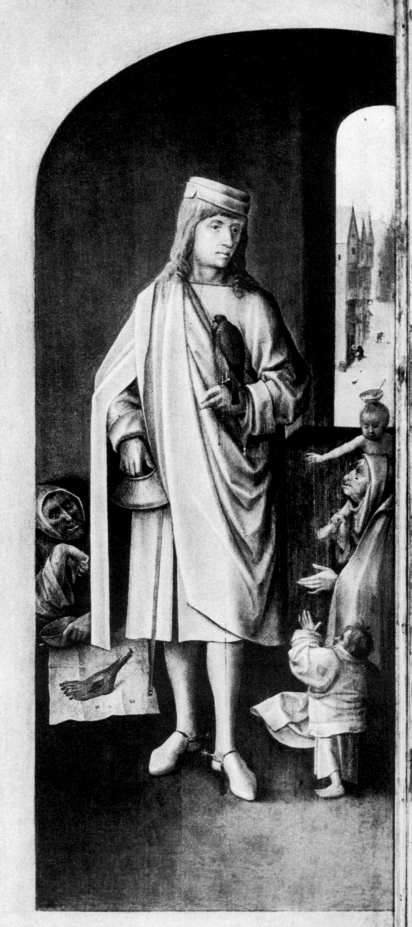

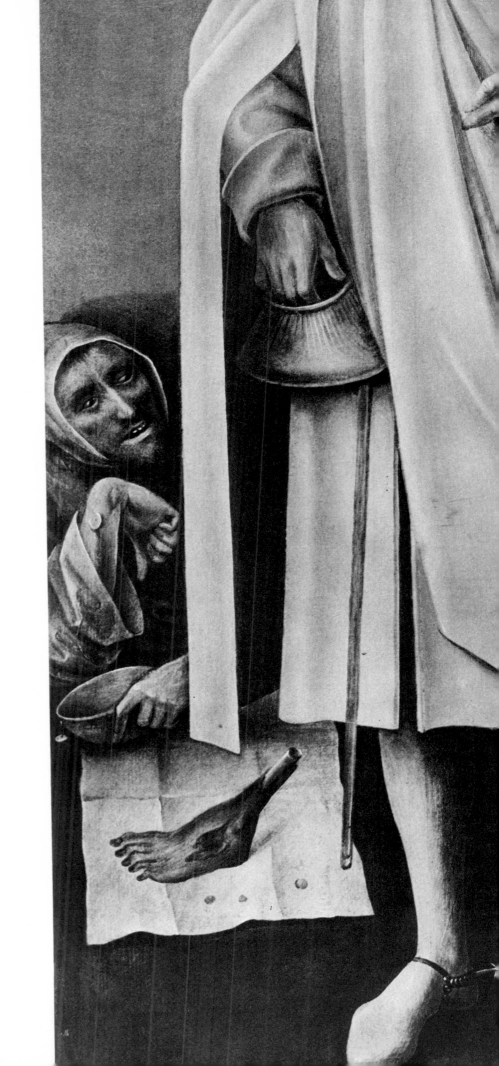

THE LAST JUDGEMENT

On the outer side of the two wings: St James of Compostela and St Bavo (grisaille paintings).

VIENNA, GEMÄLDEGALERIE DER AKADEMIE DER BILDENDEN KÜNSTE.

Oil on wood. Centre panel: height 163.7 cm, width 127 cm. Each wing: height 167.7 cm, width 60 cm. Complete picture of outer side of wings page 164. Details from left wing pages 166-167. Detail from right wing on this page. Complete picture of open altarpiece page 169. Complete picture of left wing page 170, details pages 168, 171-173. Complete picture of centre panel page 174; details pages 175-181. Complete picture of right wing page 182 (left); details pages 182 (right), 183-187.

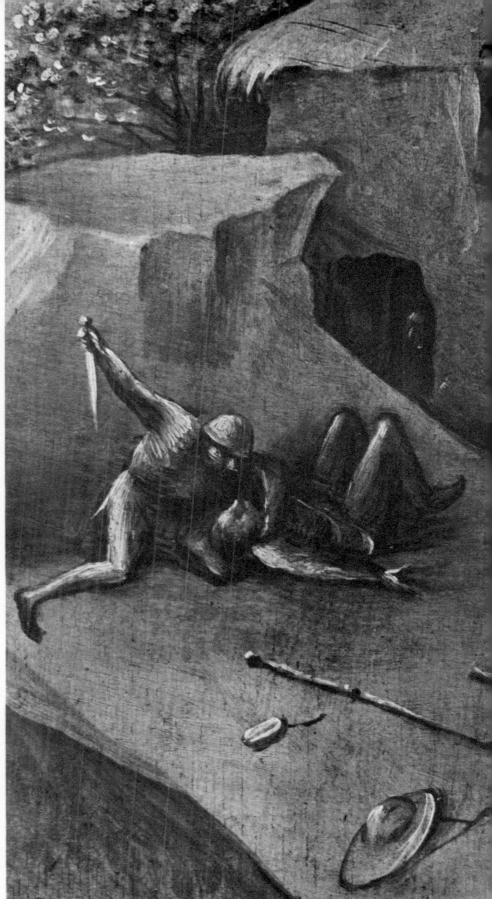

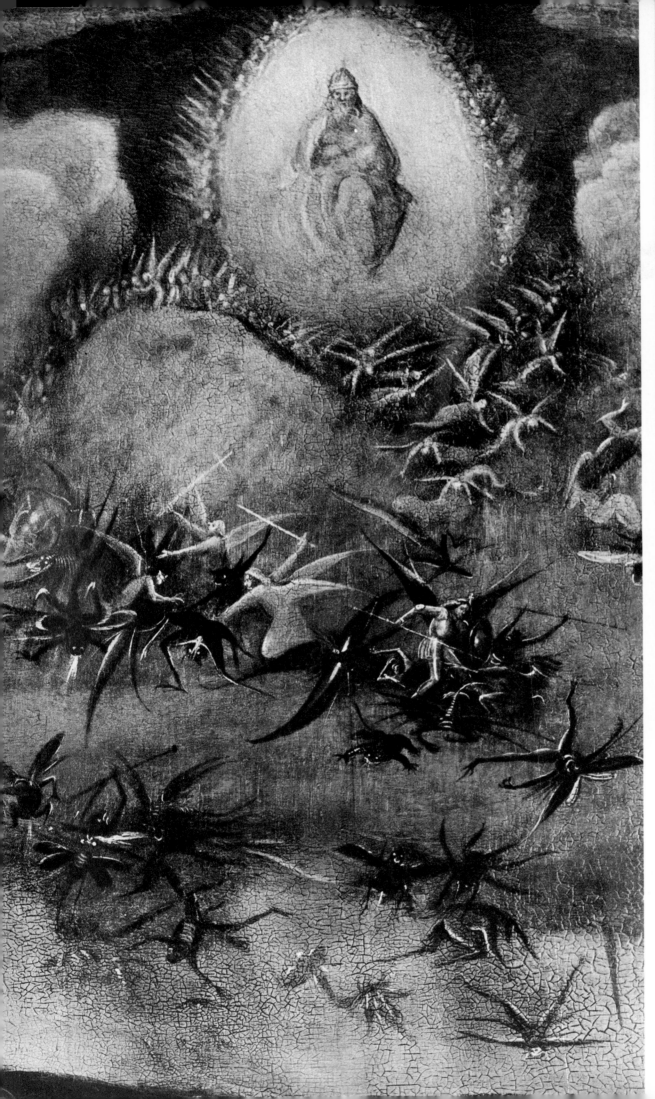

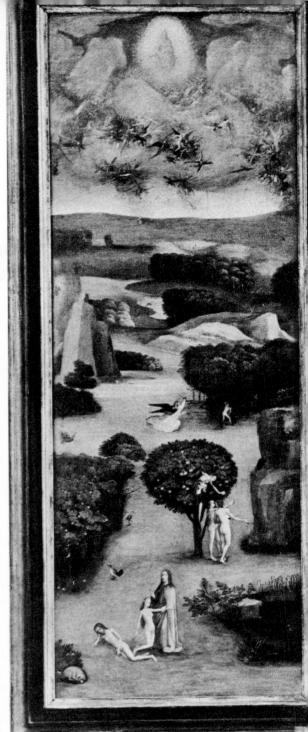

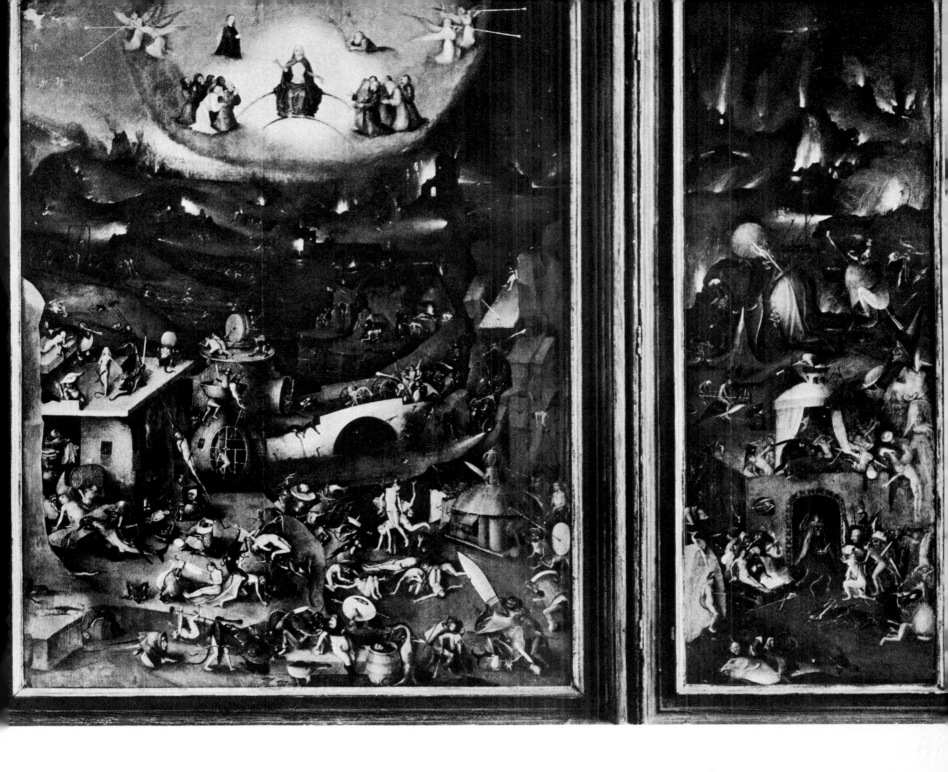

THE LAST JUDGEMENT

In the centre panel Bosch humanizes the iconography of the Last Judgement; the divine judgement loses its importance, and the human theme fills almost the entire picture. In the foreground of the earthly landscape tortures of the most varied kinds are being carried out with complicated appliances and machines; in the background is the portrayal of a fiery landscape, and in the centre, on a rocky island, is a melancholy little figure, resting on his elbows (a depiction of the artist himself). These anticipate the *Garden of Earthly Delights*. The combination of the themes of the fall of the angels, the creation of Eve and original sin shows a close relationship, in both the iconography and the composition, to the left wing of the *Hay-wain* (see plate on page 118). On the right wing, however, the exaggerated proportions and spectral character of certain dream symbols foreshadow the right wing of the *Garden of Earthly Delights* (page 240).

VIENNA, GEMÄLDEGALERIE DER AKADEMIE DER BILDENDEN KÜNSTE.

9

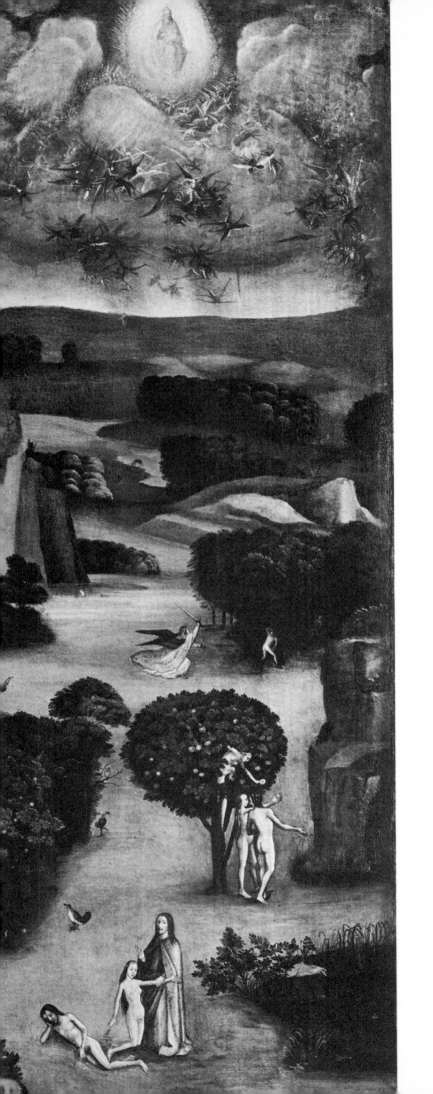

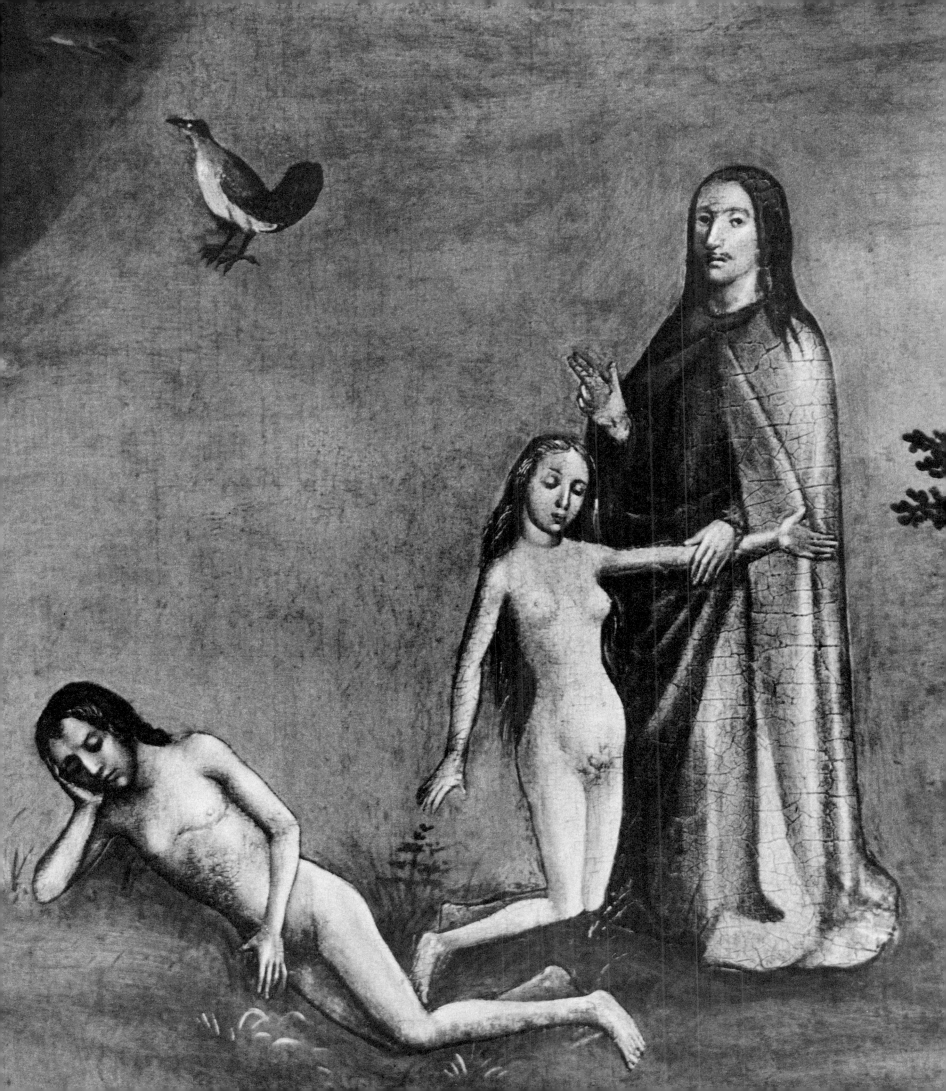

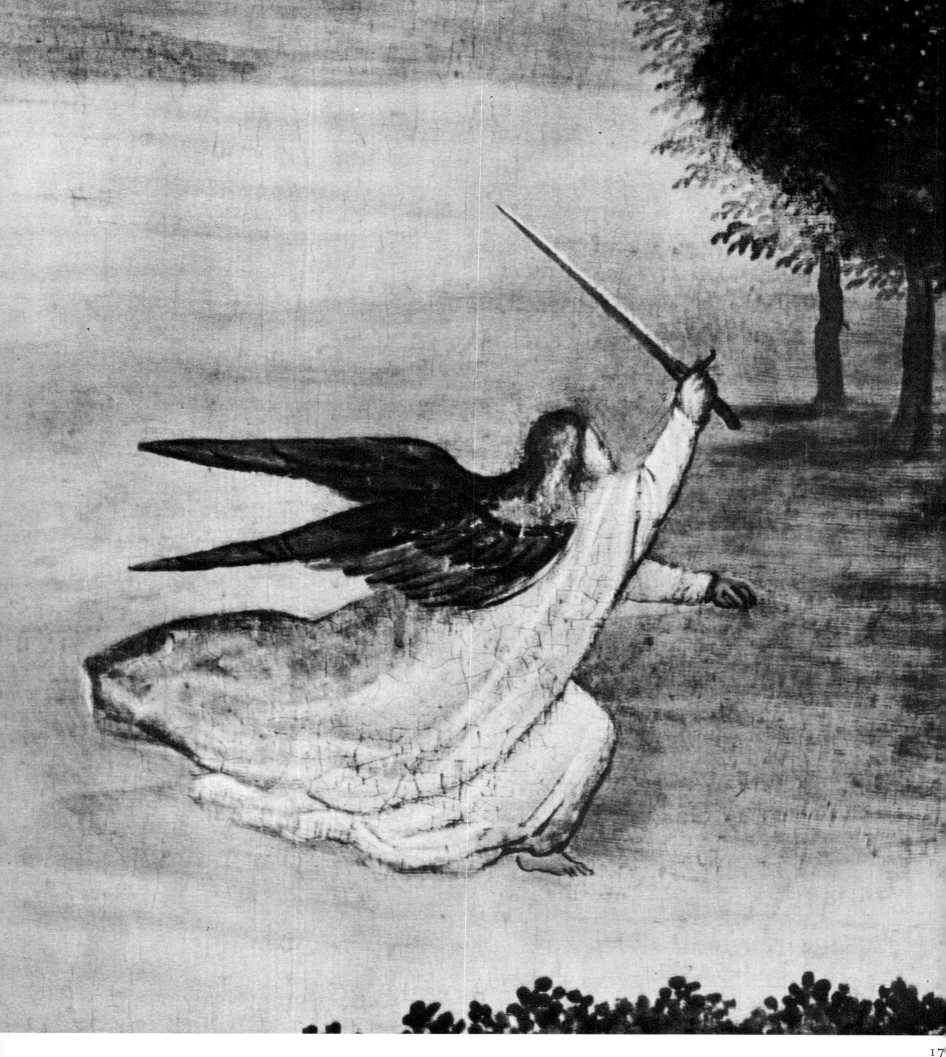

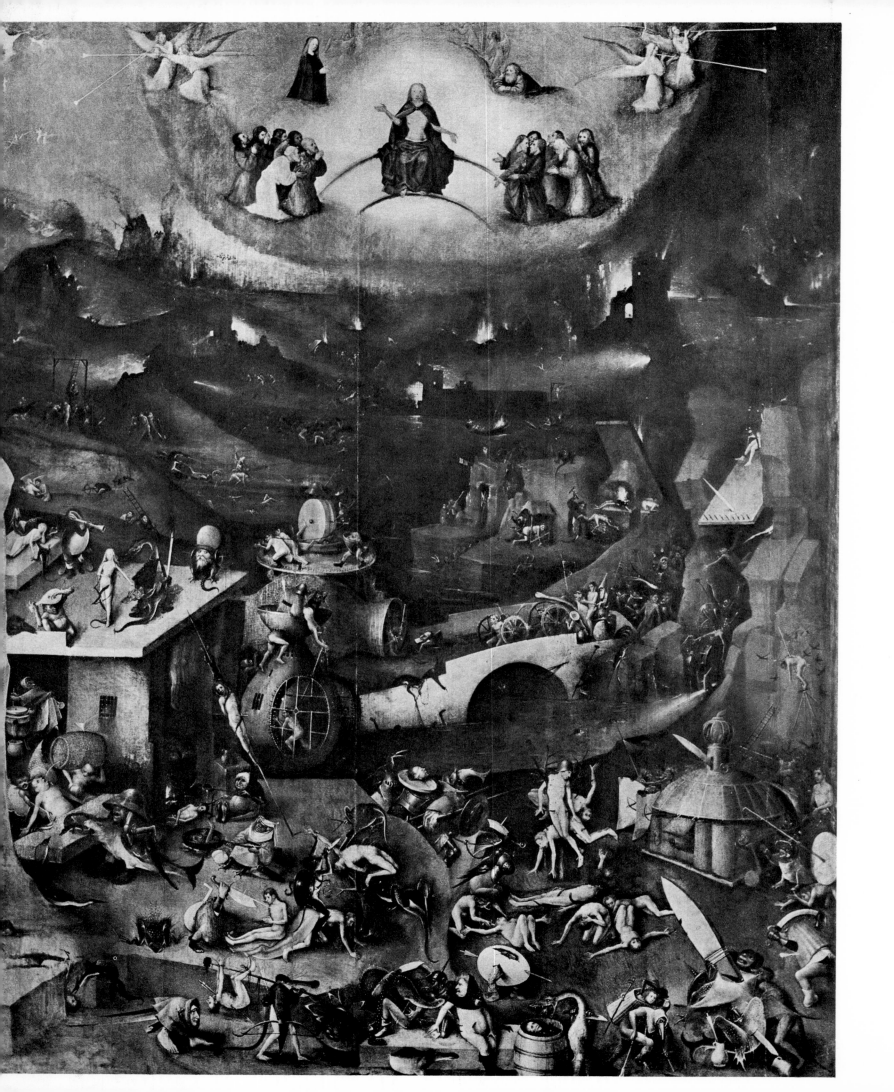

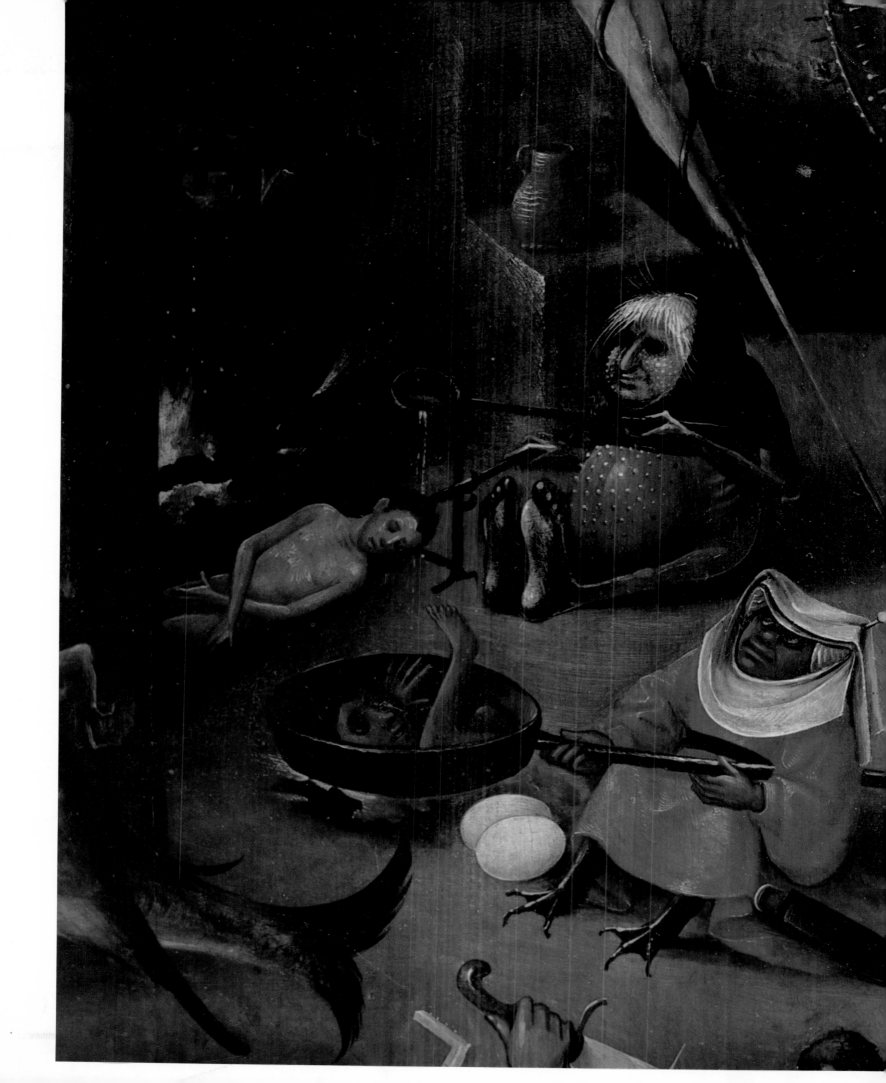

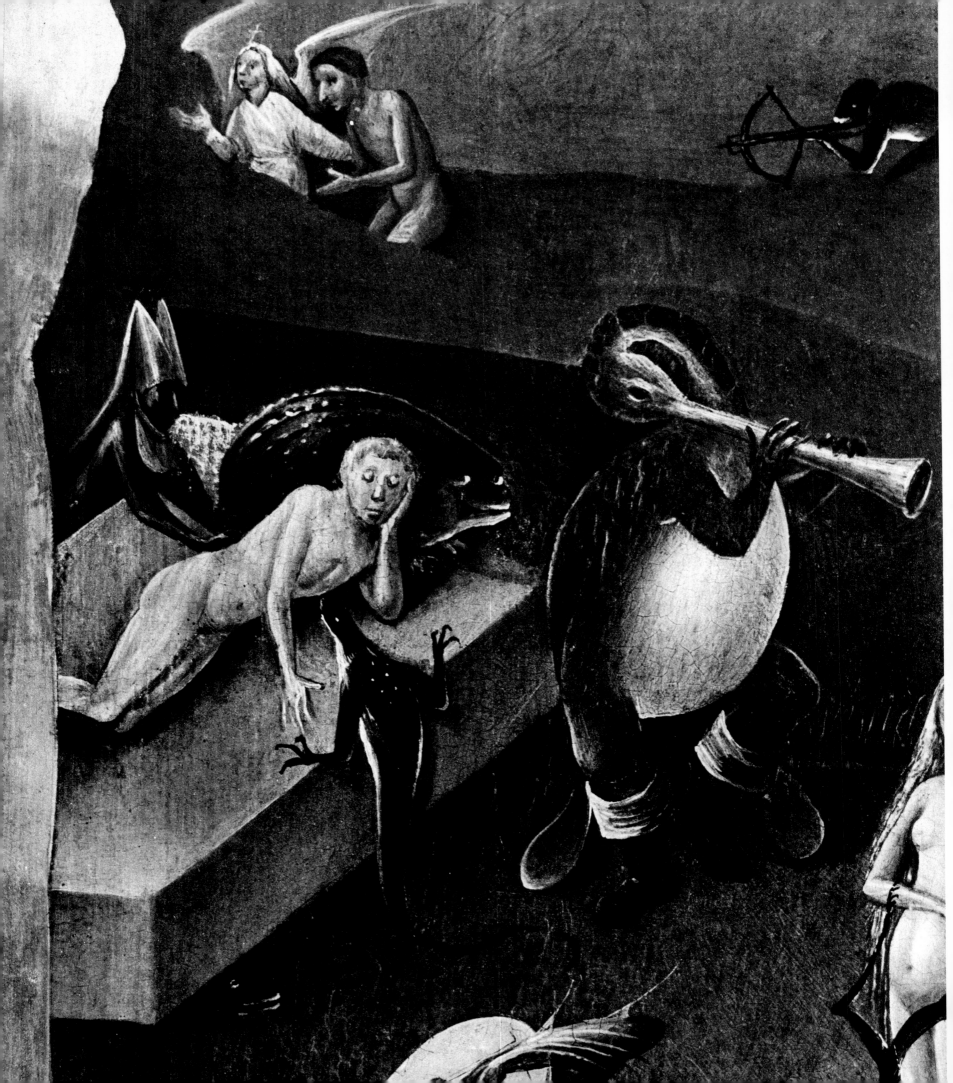

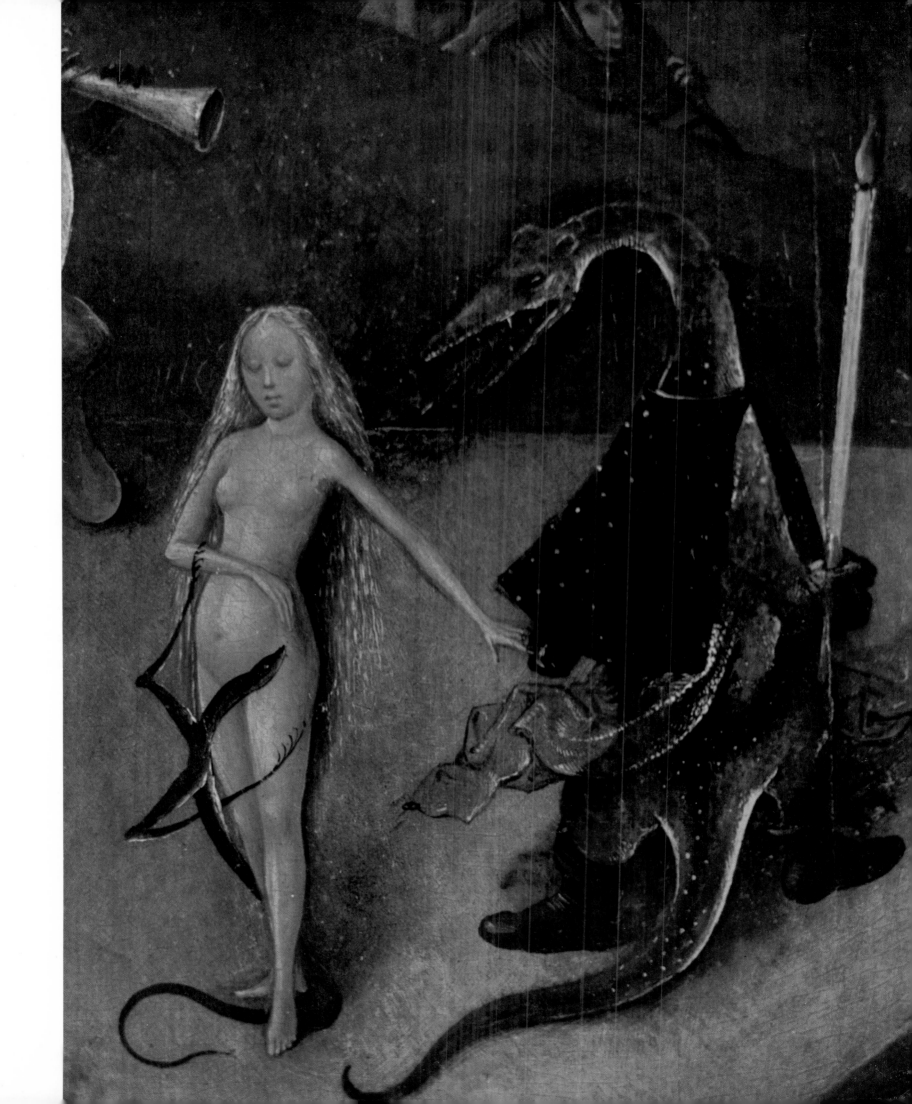

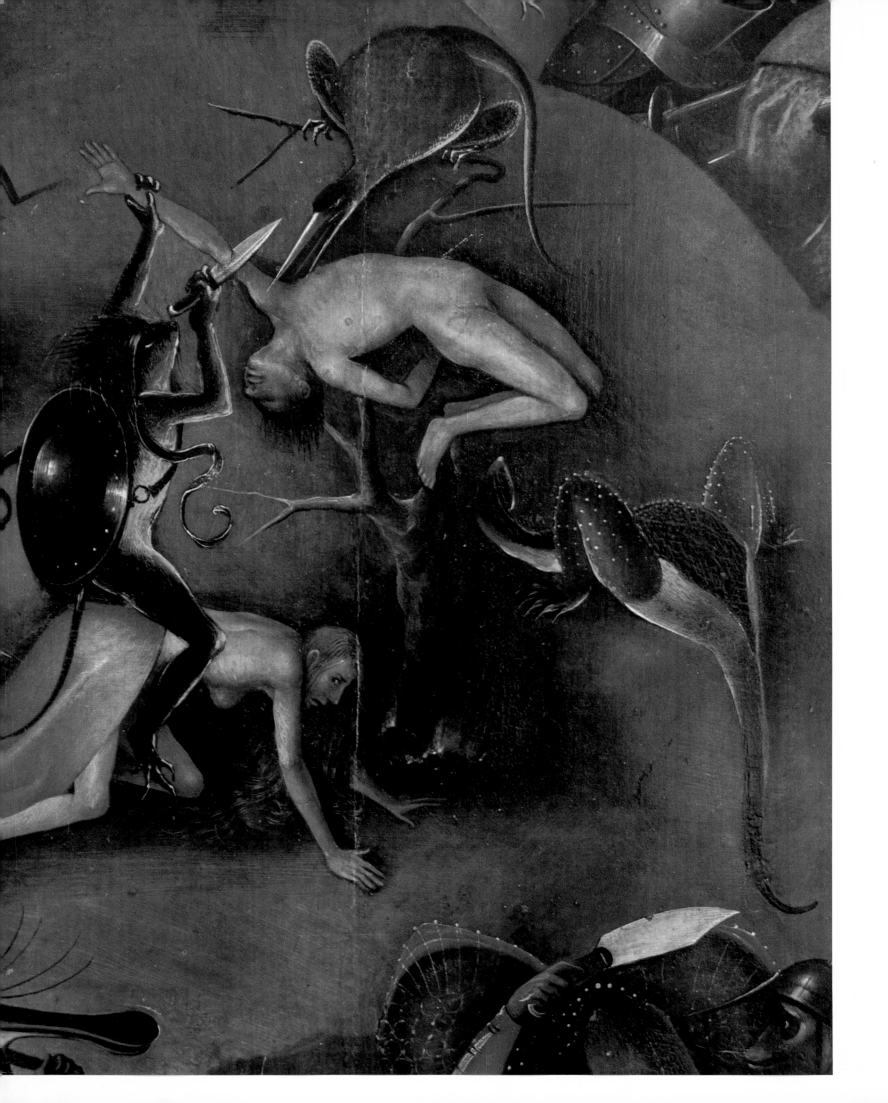

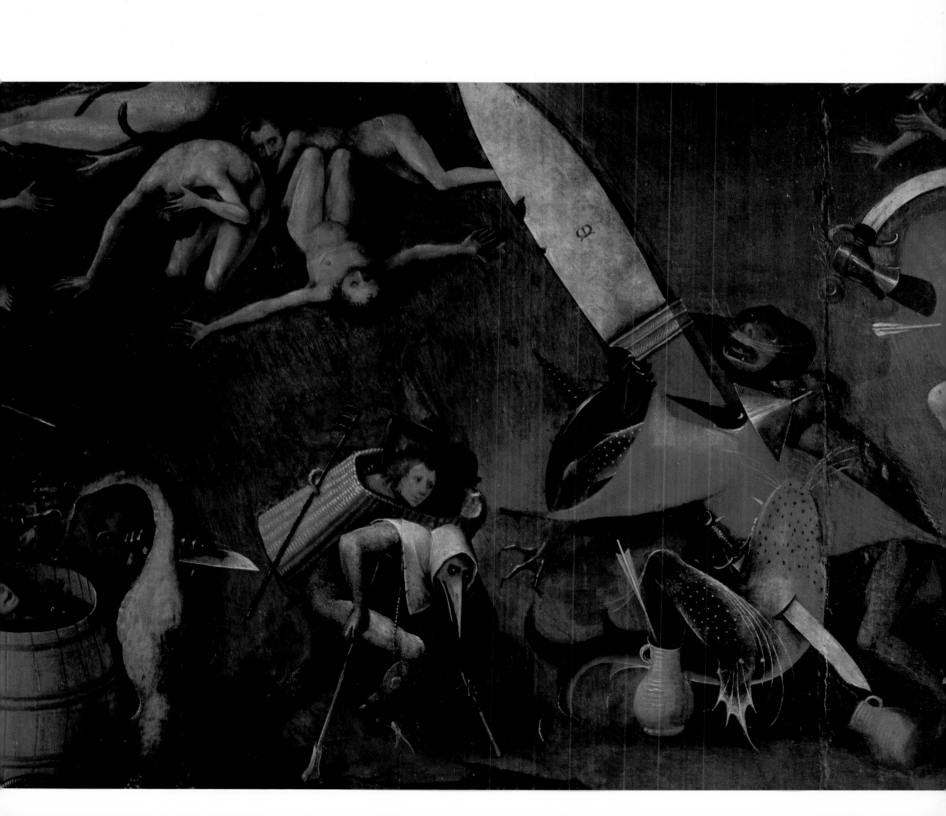

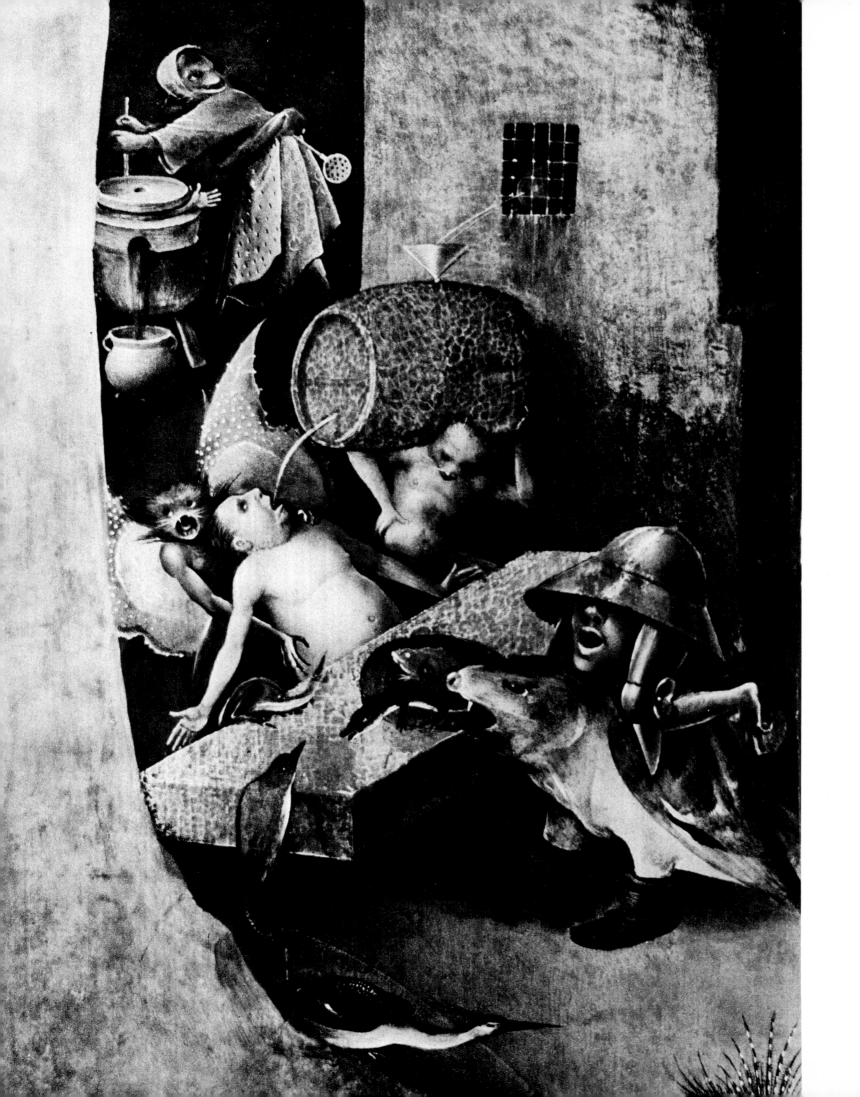

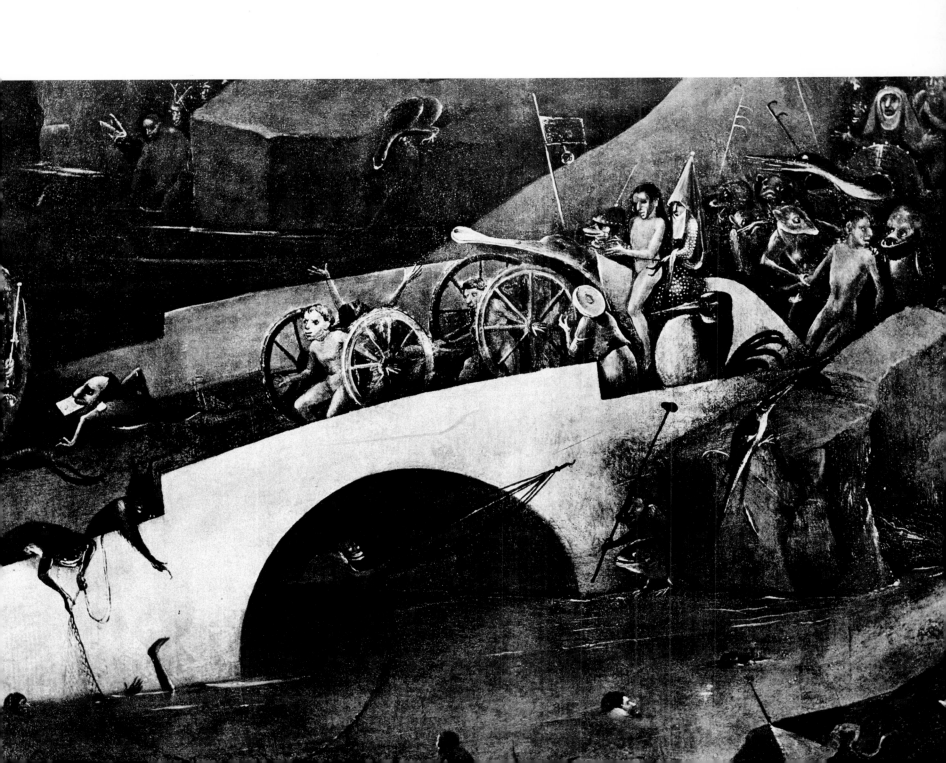

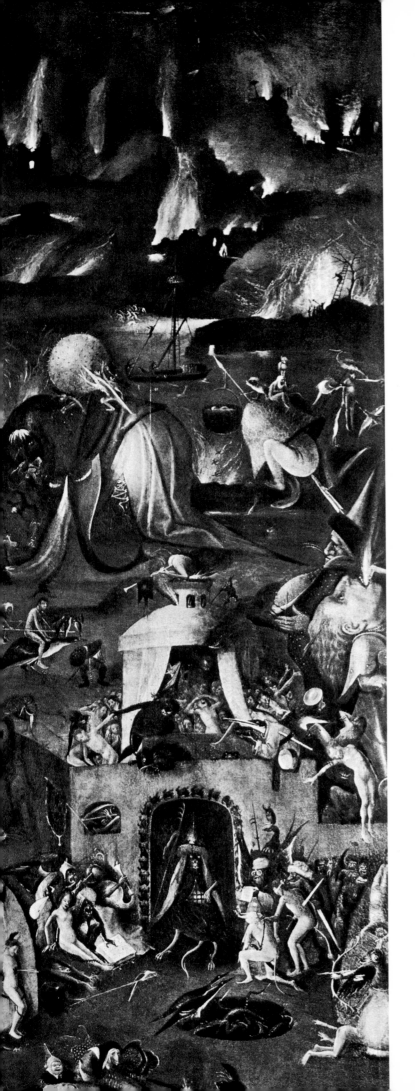
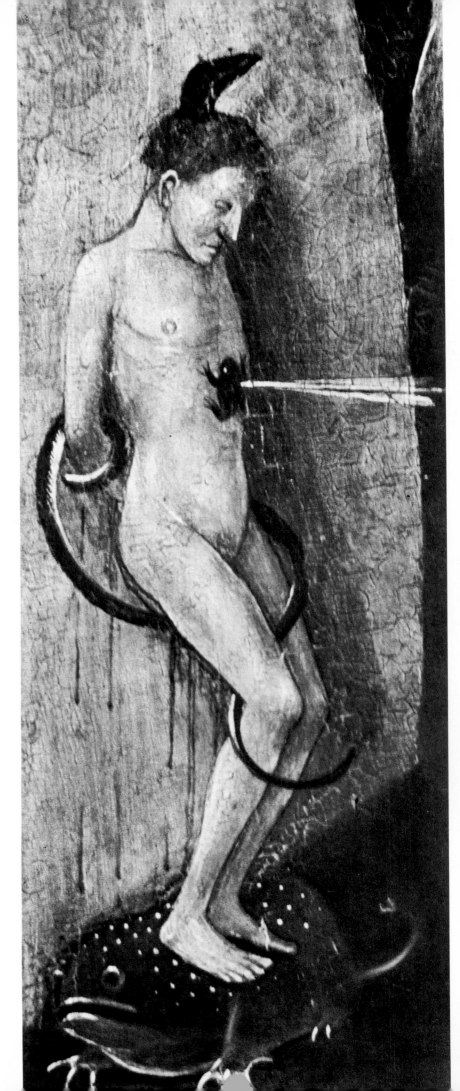

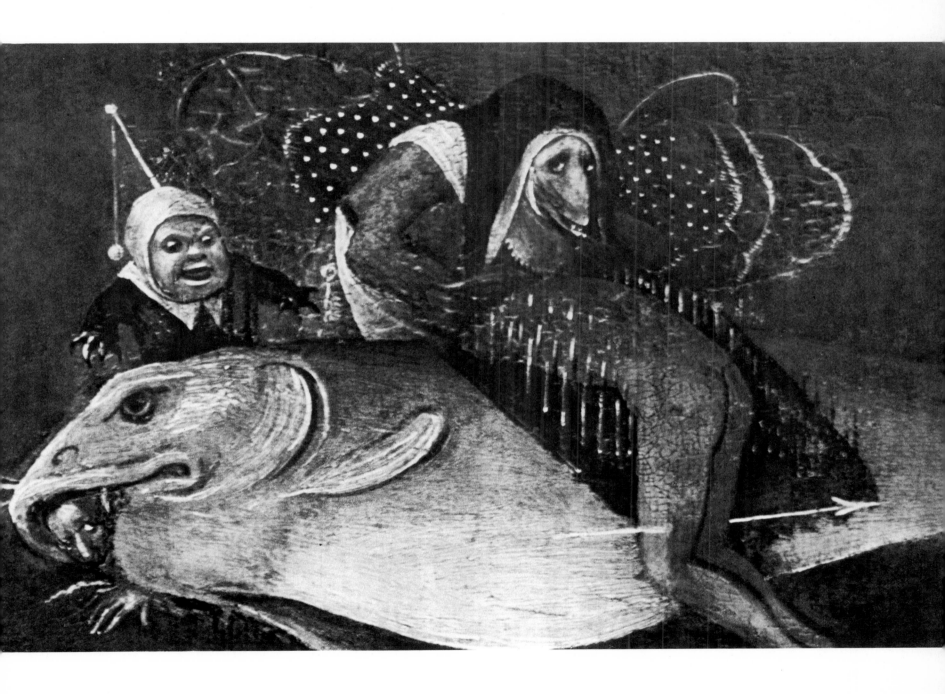

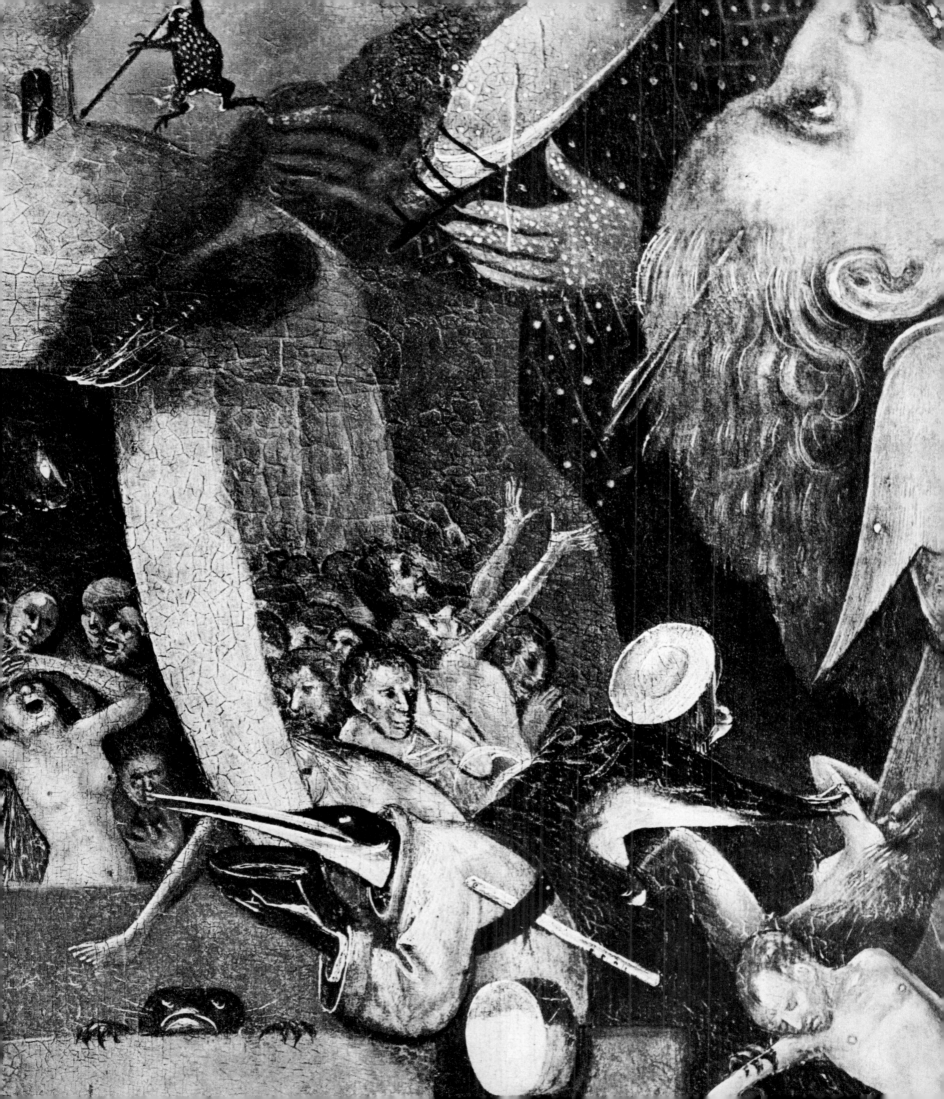

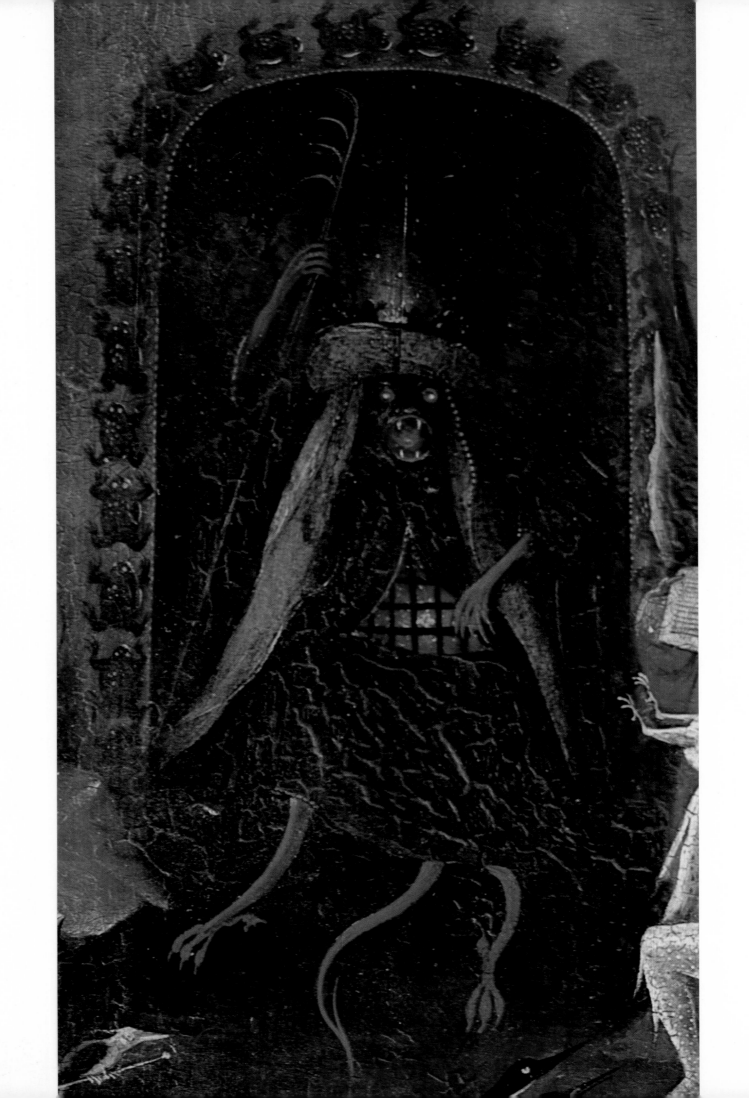

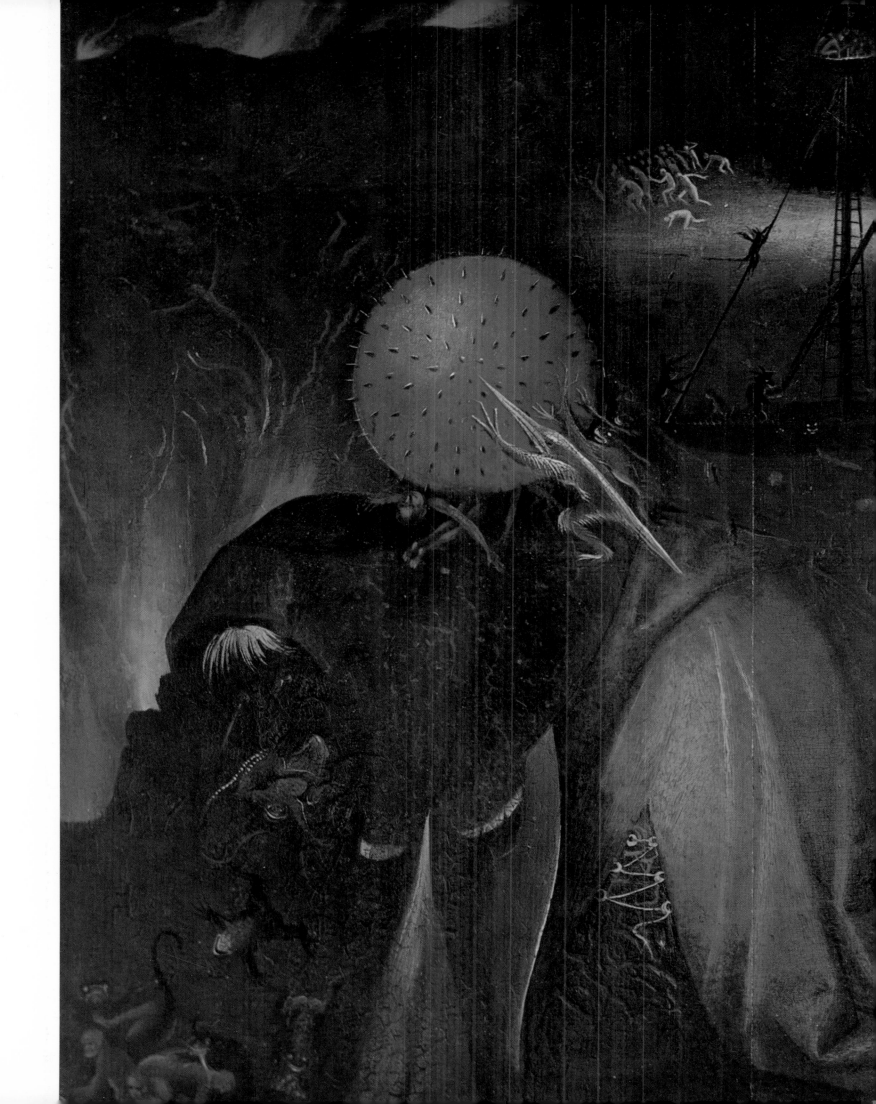

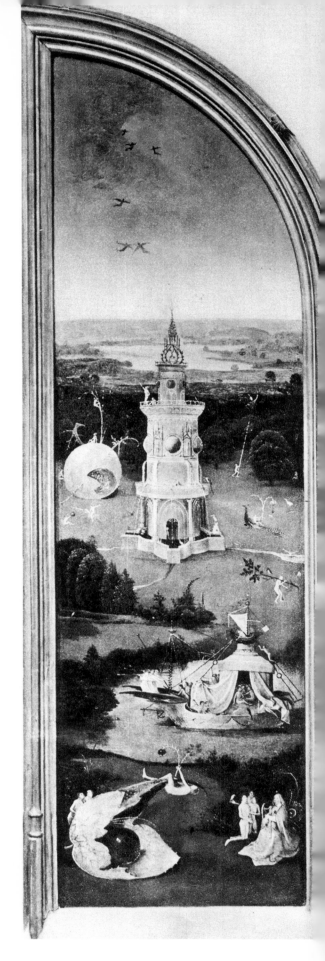

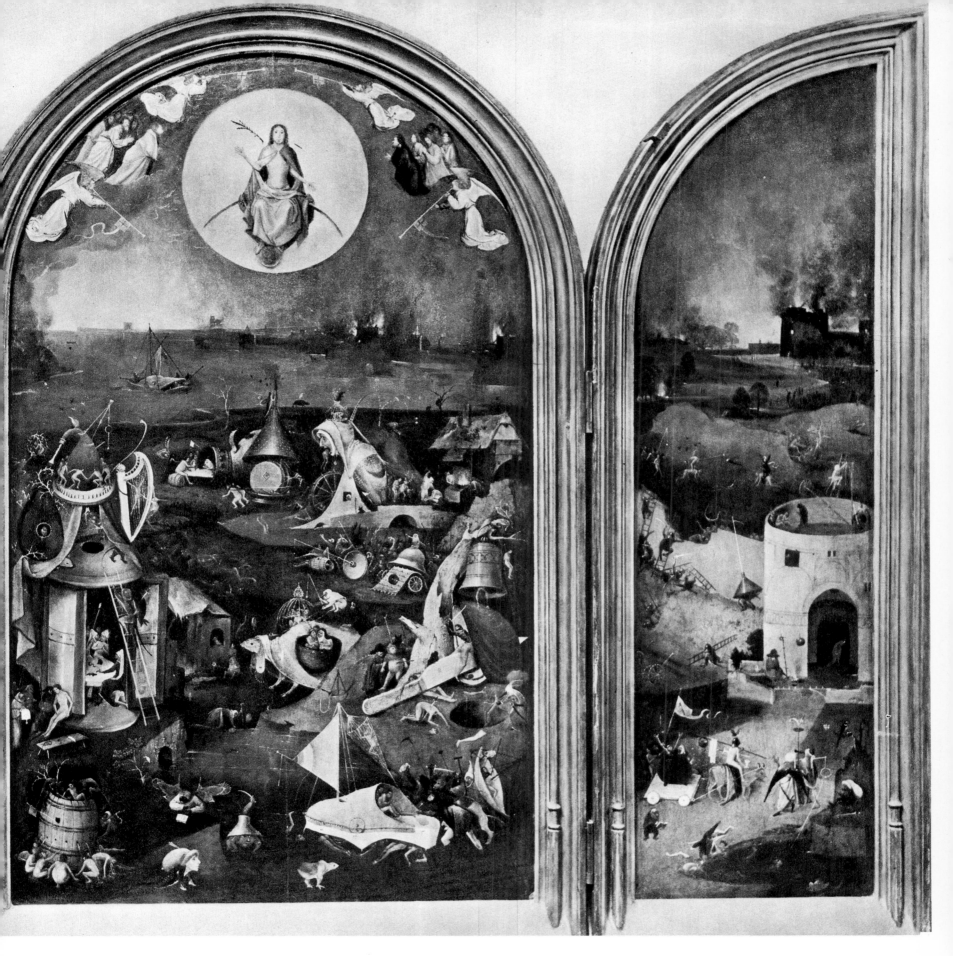

THE LAST JUDGEMENT

On the reverse of the wings (extreme left) is the *Crowning with Thorns*, in grisaille.

BRUGES, MUSÉE COMMUNAL DES BEAUX-ARTS.

Signed: Iheronimus Bosch. *Centre panel: height 99.2 cm, width 60.5 cm; each wing: height 99.5 cm, width 28.8 cm. Details from left wing pages 190-195; from centre panel pages 196-200. Detail from right wing page 201.*

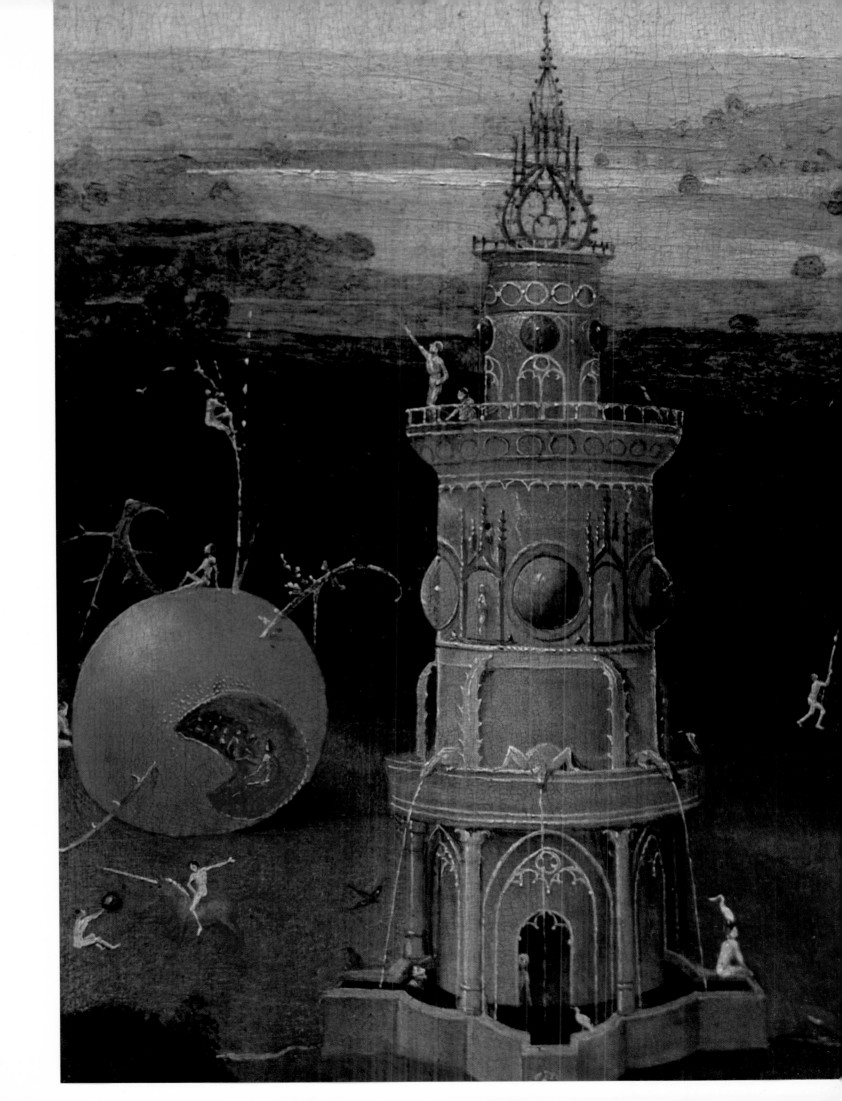

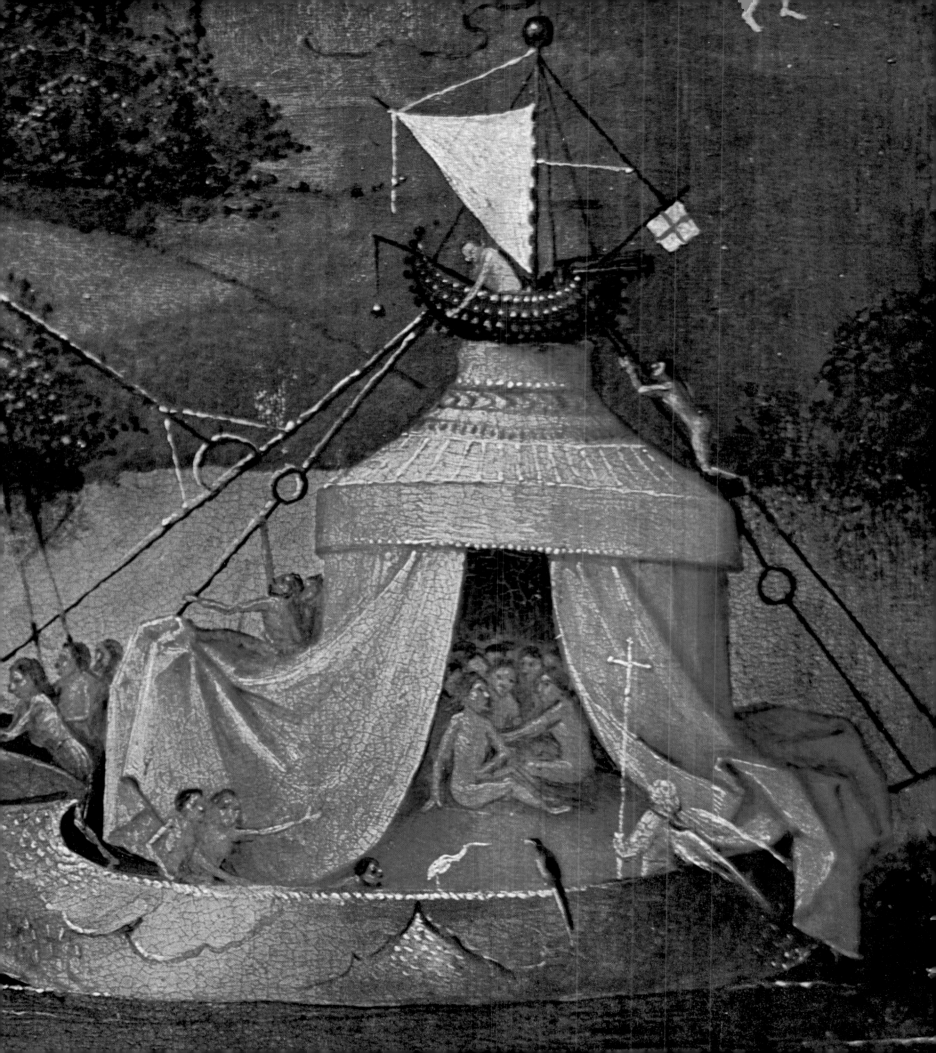

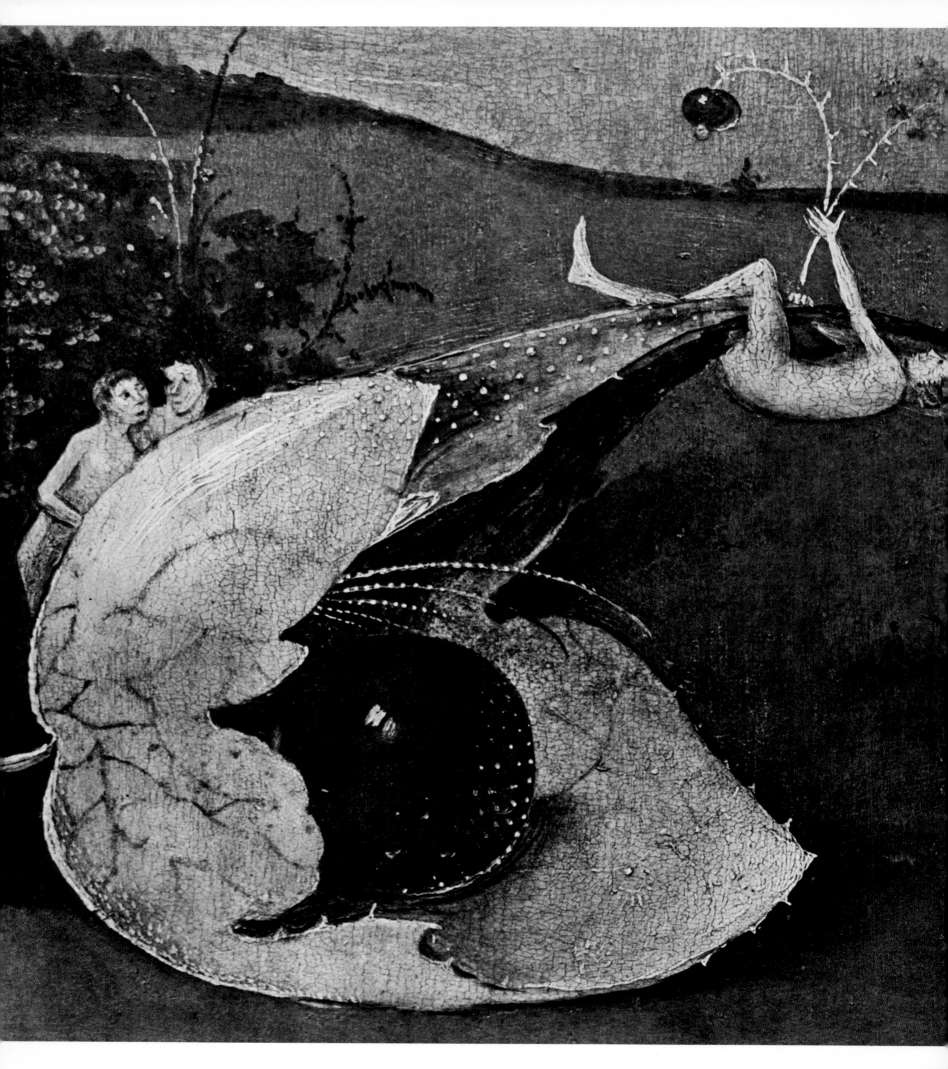

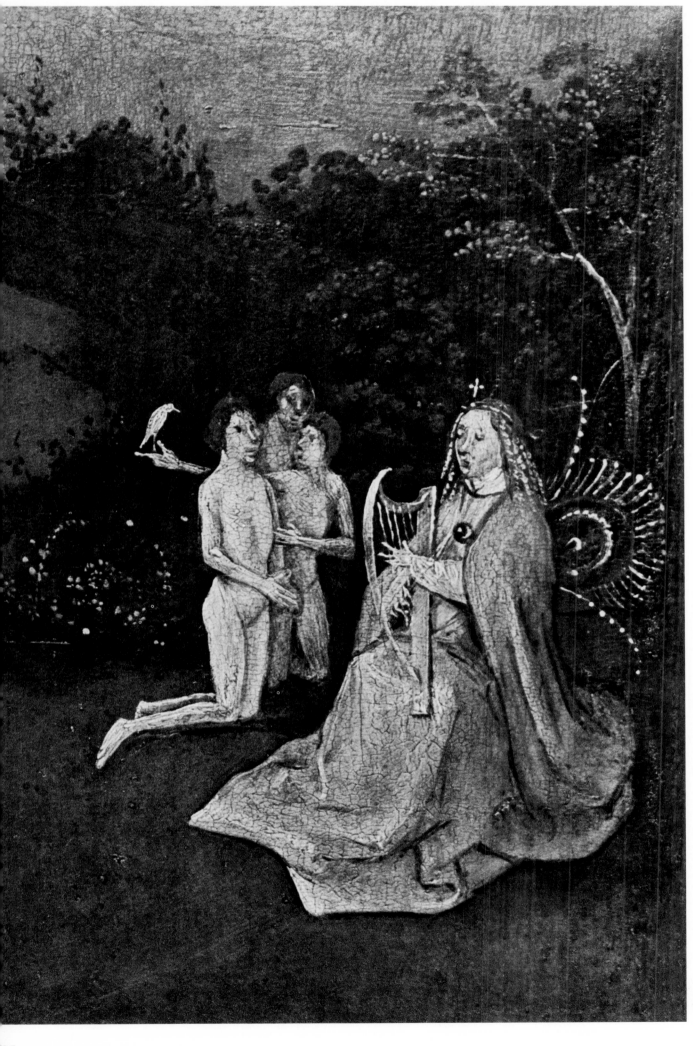

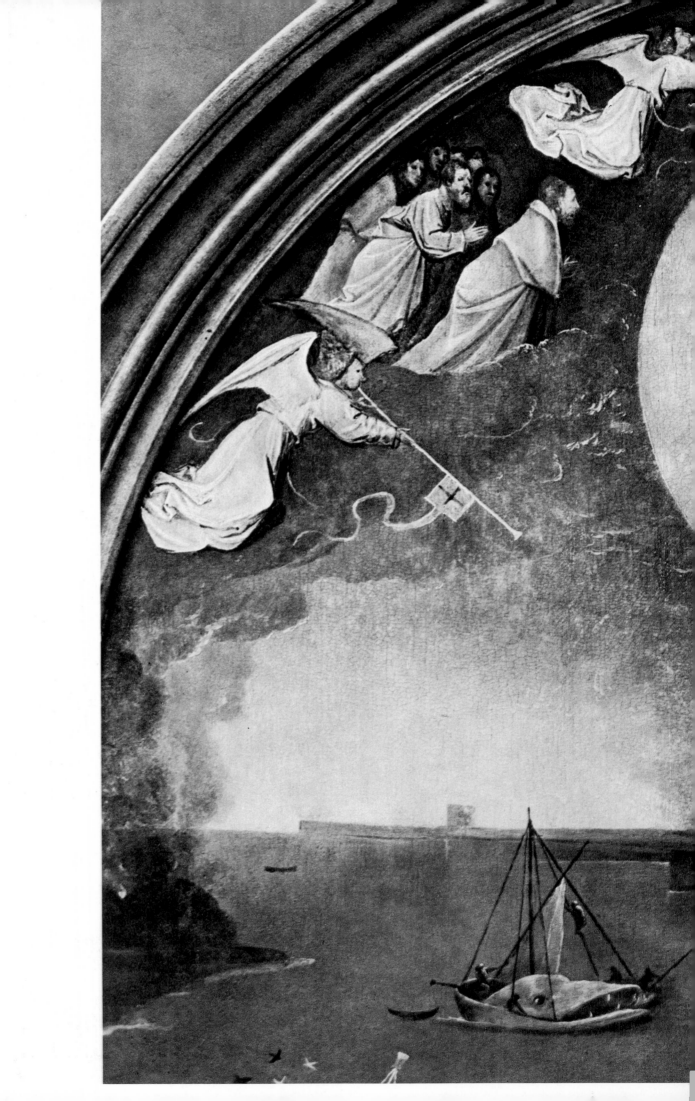

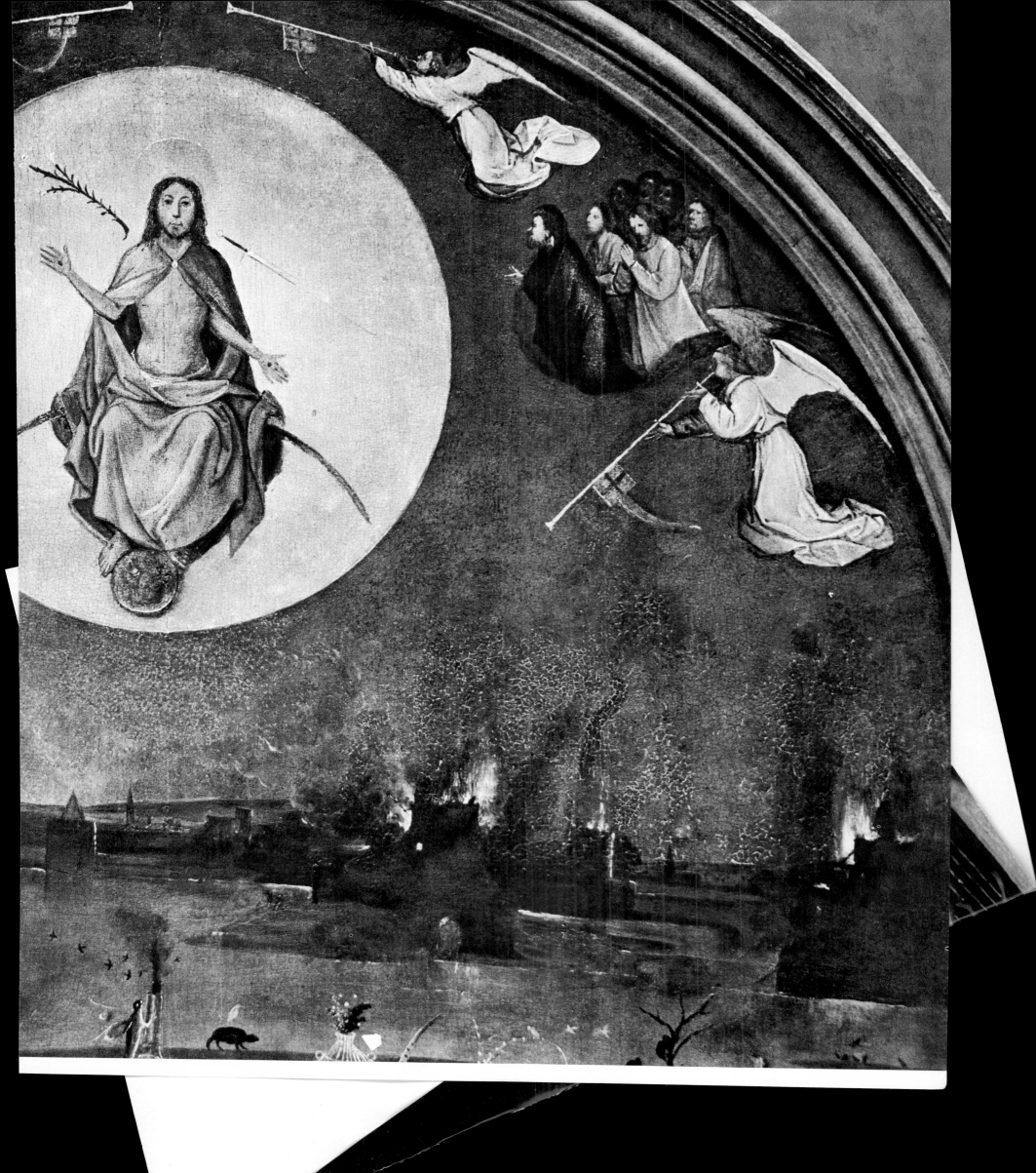

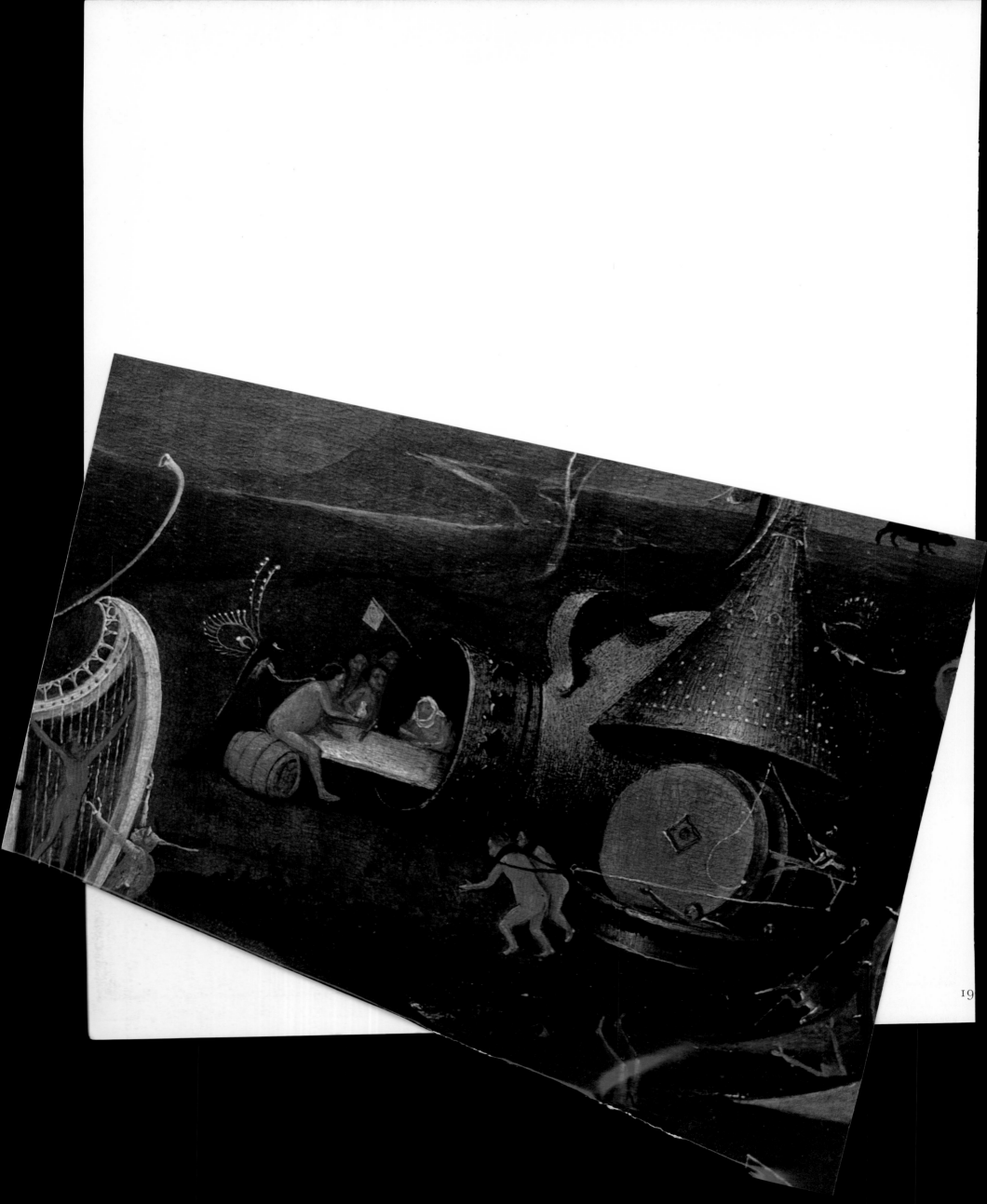

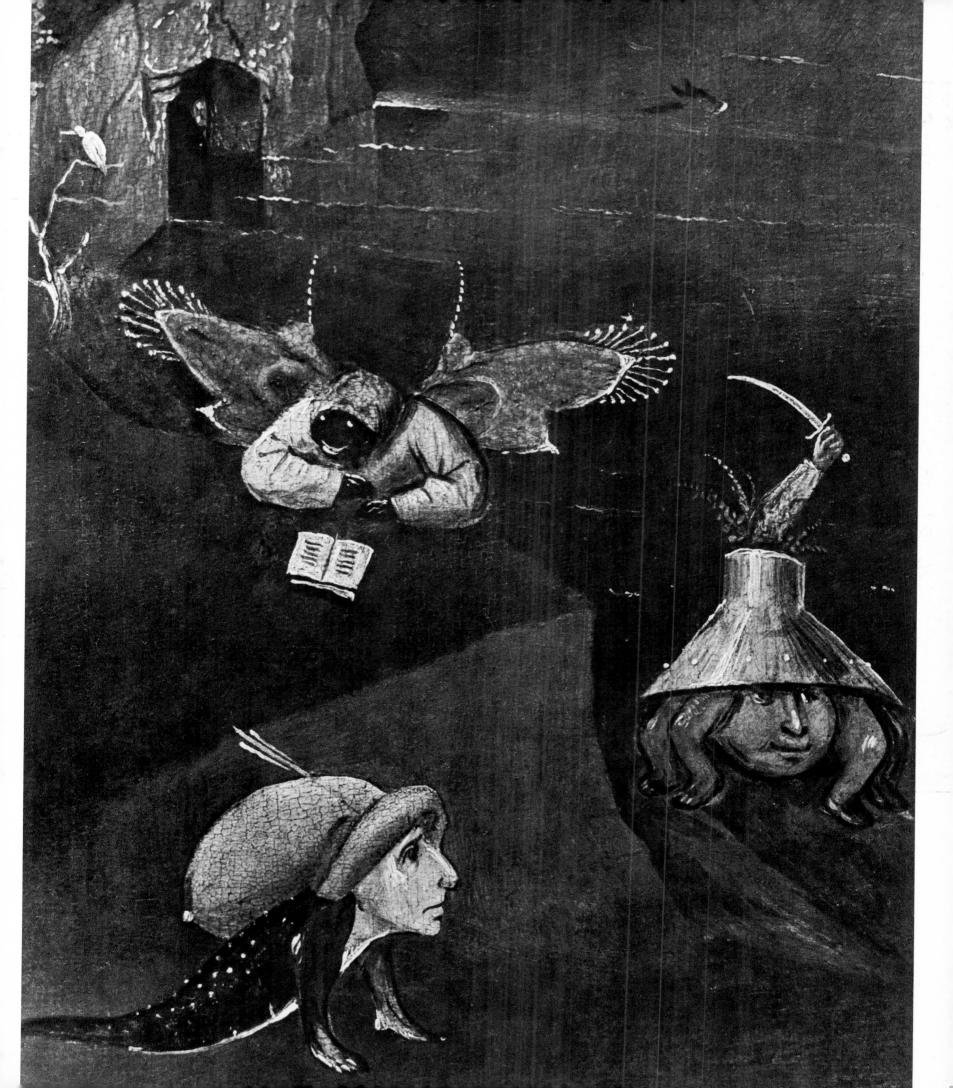

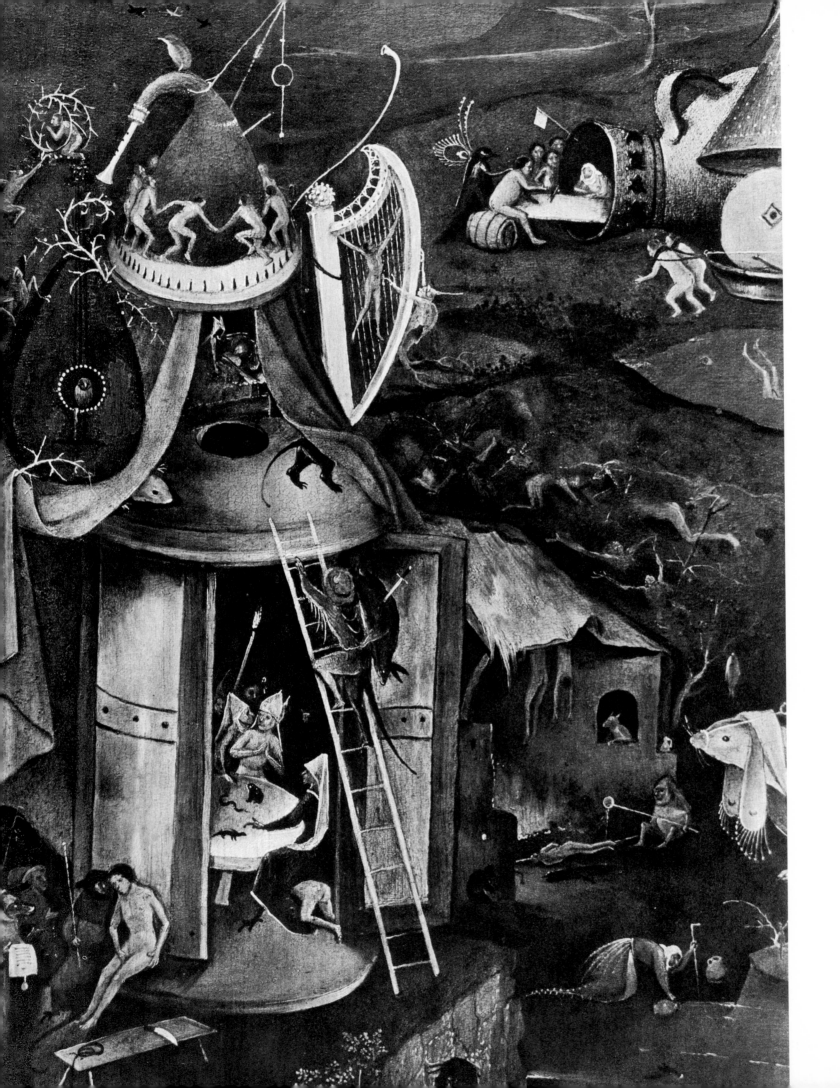

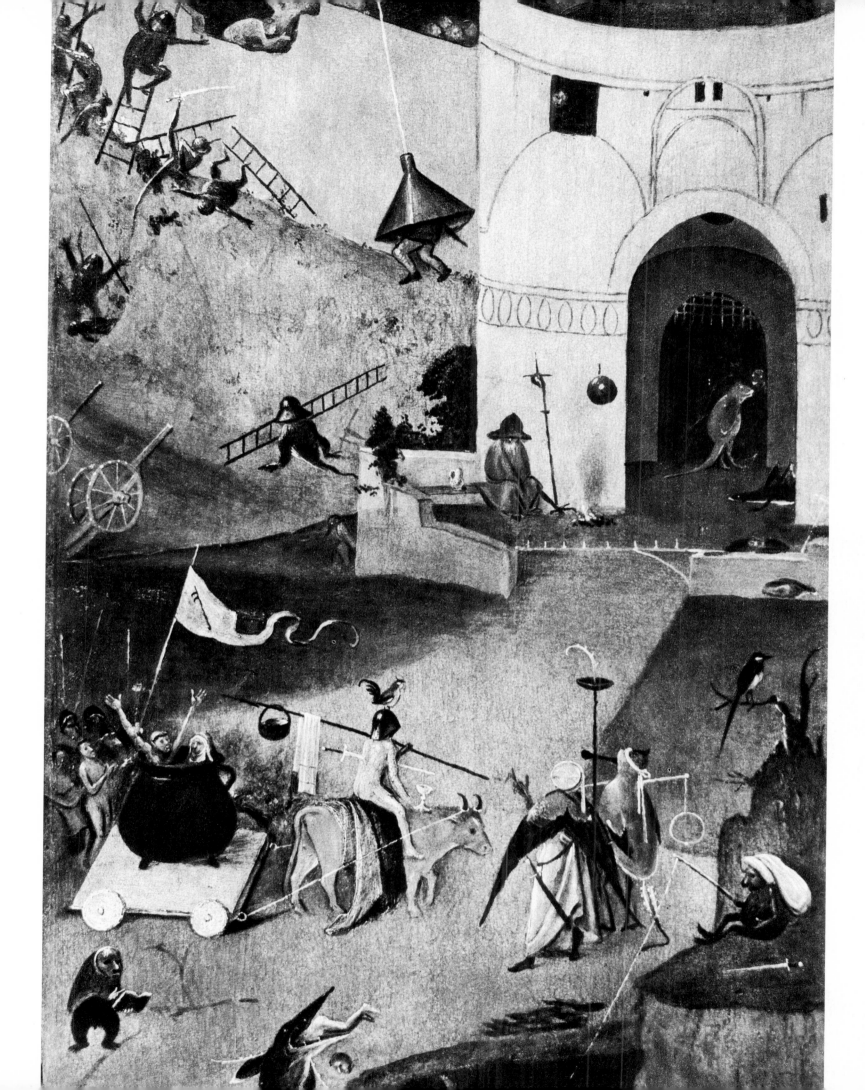

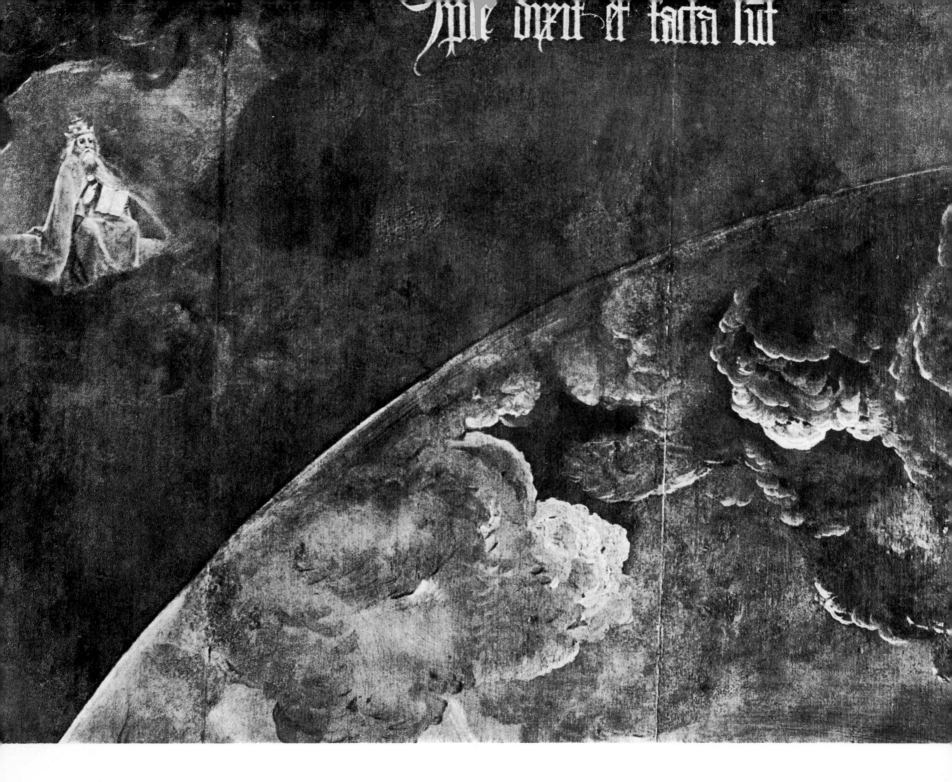

Ipfe dixit et facta lut

THE GARDEN OF EARTHLY DELIGHTS

Bosch does not rest content with pictorial and literary tradition, and uses the whole acuity of his penetrating mind to draw from his memory and experience dream symbols that are valid for all mankind. The specific meaning he gives them becomes intelligible only in the light of his basic theme: the nightmare of human life. Bosch is at once the dreamer and the judge of dreams, actor and stage-manager in one person.

On the outer side of the wings: *Creation of the World* (grisaille).

MADRID, MUSEO DEL PRADO (FORMERLY IN THE ESCORIAL).

Oil on wood. Centre panel: height 220 cm, width 195 cm; each wing: height 220 cm, width 97 cm. The triptych with wings closed page 203; detail page 202. The triptych open page 204. Complete picture of left wing page 205; details pages 206-217. Complete picture of centre panel page 218; details pages 219-239. Complete picture of right wing page 240; details pages 241-247.

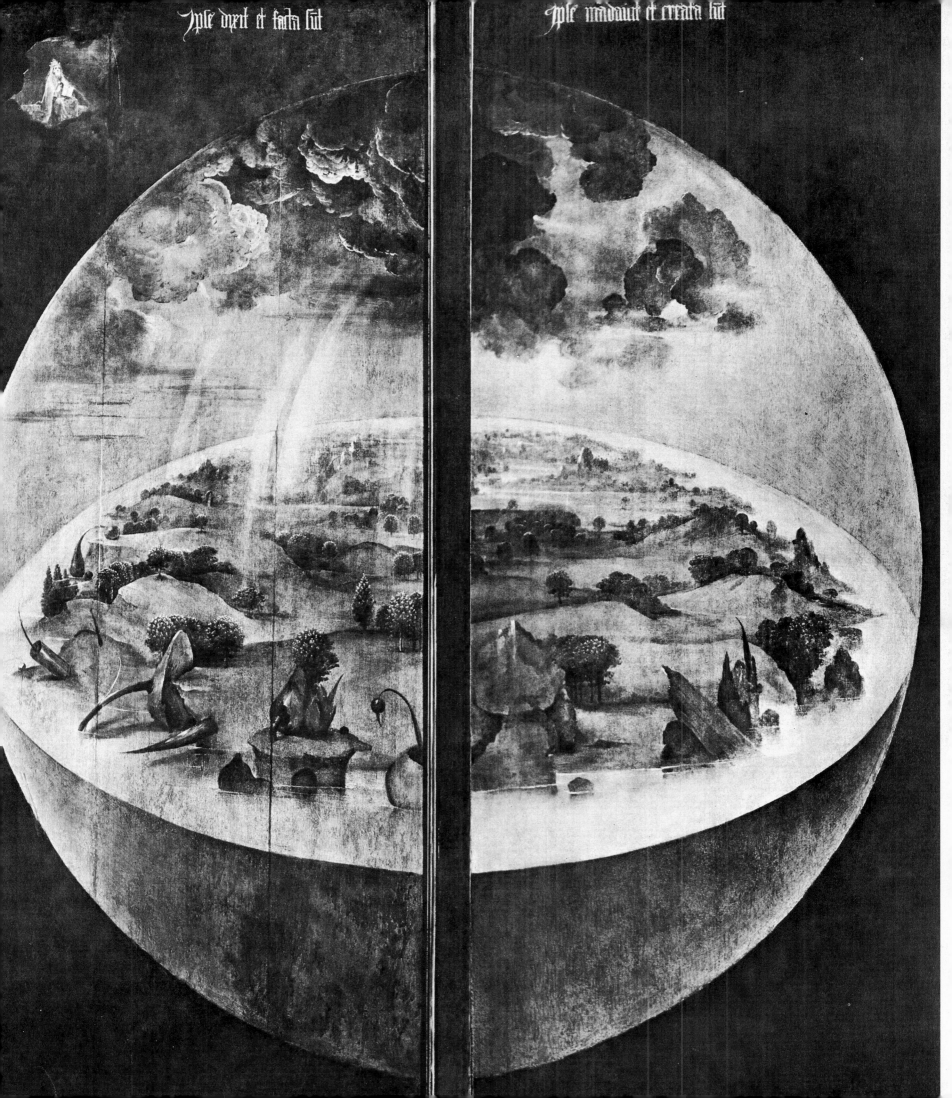

Ipse dixit et facta sunt

Ipse mandauit et creata sunt

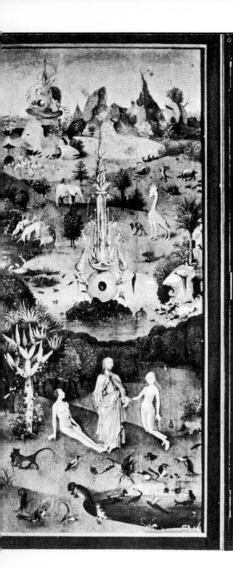
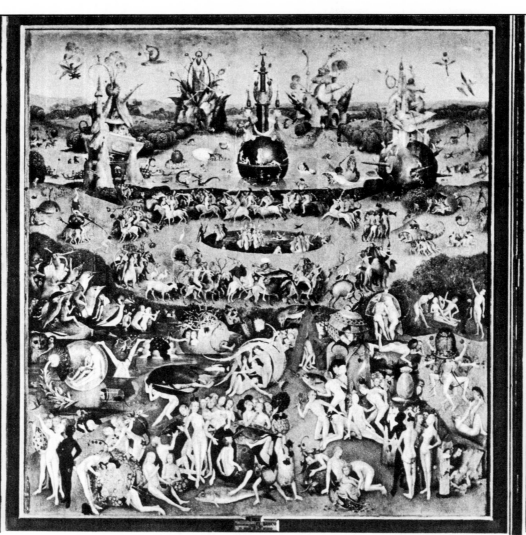
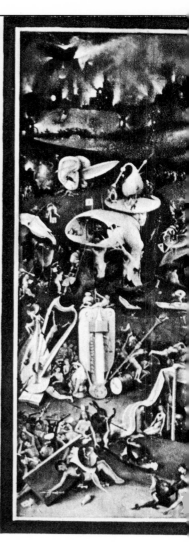

In the foreground of the centre panel is an unbroken series of idyllic groups of men and women whose delicate bodies gleam like white pearls. Nothing seems more chaste than the love-play of these couples. But the dream books of the time tell us the true meaning of their enjoyments: the cherries, strawberries, raspberries and grapes that are offered them, and which they eat with pleasure, are nothing but the godless symbols of sexual lust. Here Bosch paints a striking picture of repressed desires. In the middle plane the people are frenziedly riding fantastic or real animals, which they hold back or spur on according to the rhythm of love; the cavalcade circles around a Fountain of Youth. In the uppermost plane of the picture, in the midst of the Pond of Lust, stands the Fountain of Adultery. Increasingly master of his technique, Bosch makes us realize the hollowness and fragility of transitory things. On the left wing is the earthly paradise, fascinating in the purity and harmony of its colours. Everything in this peaceful garden seems to breathe serenity and innocence, and yet it is marked with the stigma of unnaturalness and corruption. Eve is already an image of temptation, and the astonished look that Adam is giving her is a first step towards sin. This is seen in the fauna and flora: a lion is devouring a deer, a wild boar is pursuing a strange beast. The right wing, Hell, depicts the third phase of the Fall: earth itself has become hell, and the very objects that had been instruments of sin have become gigantic instruments of punishment. As a synthesis of all destruction, the vision of the world dissolving in flames illumines with a ghostly light the dark night of the background.

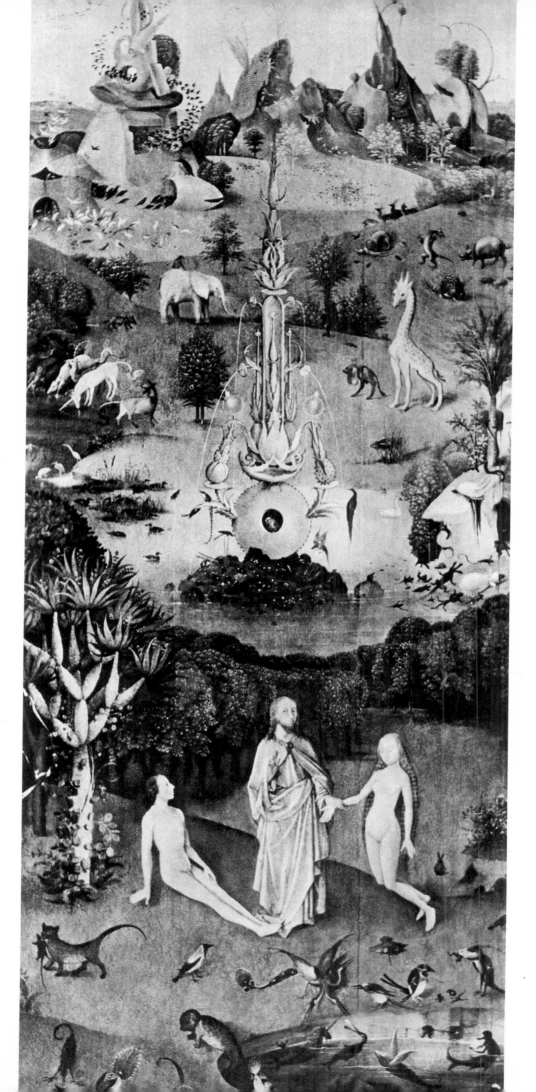

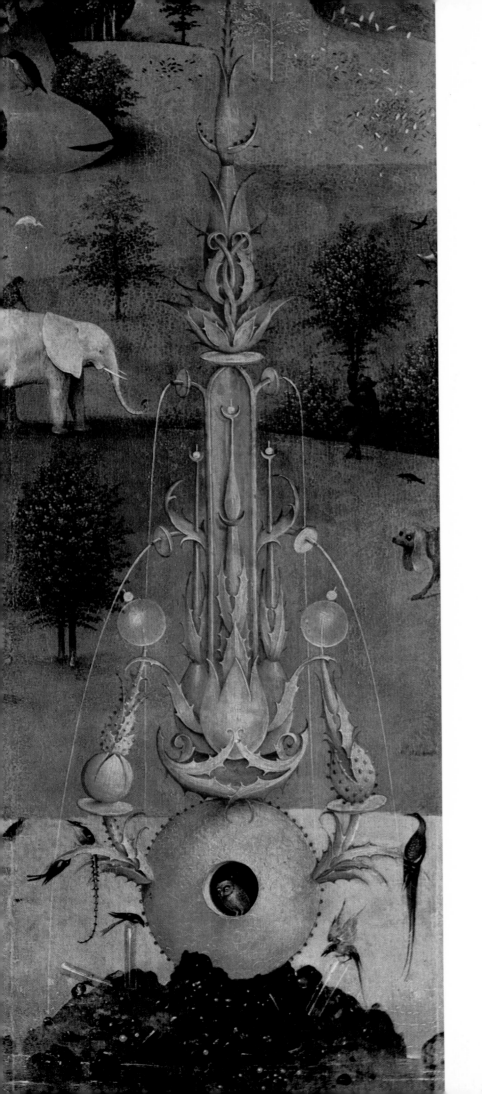

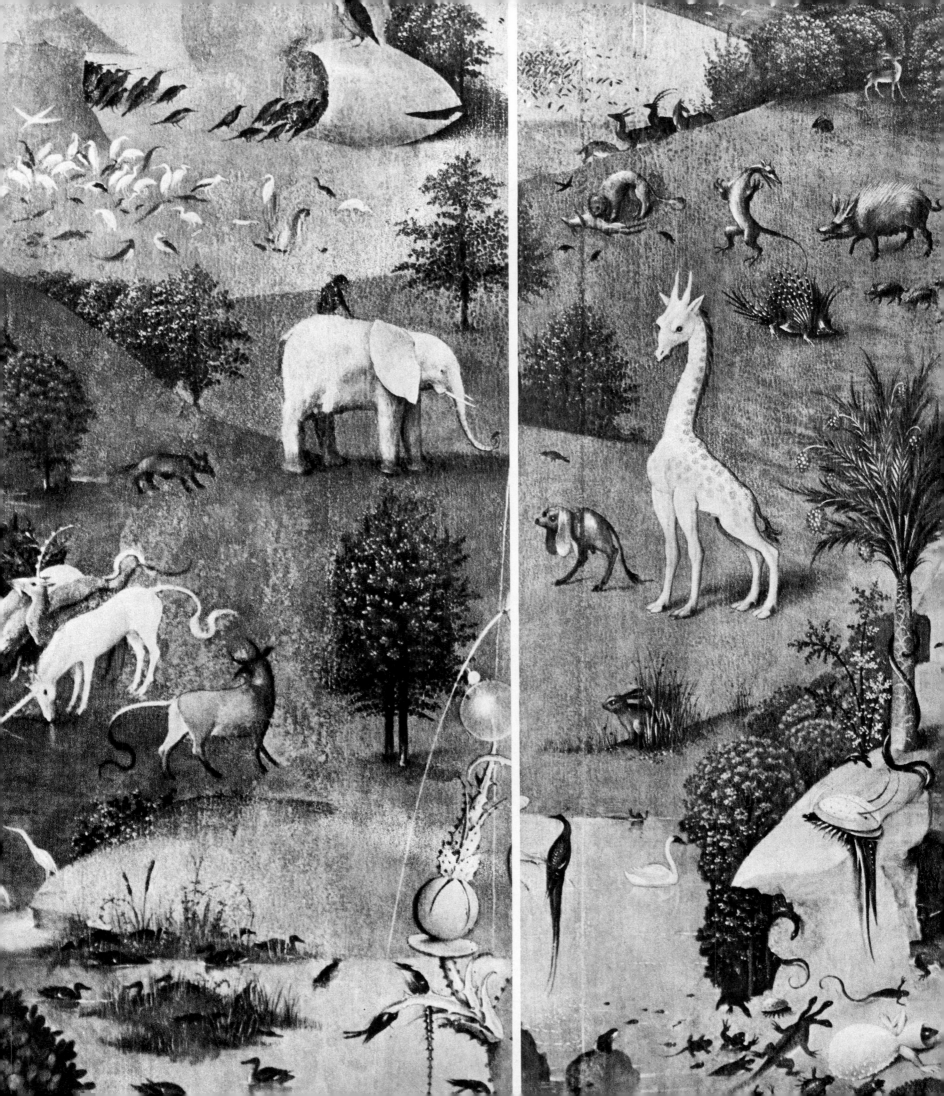

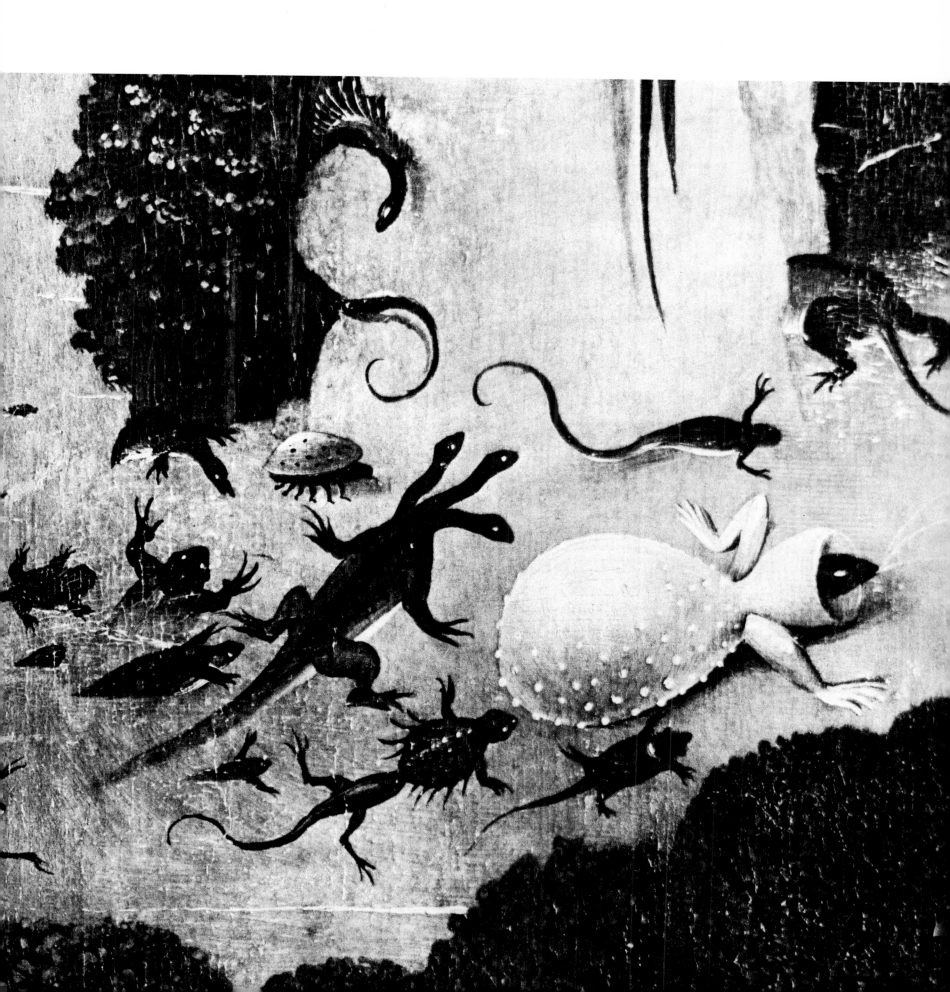

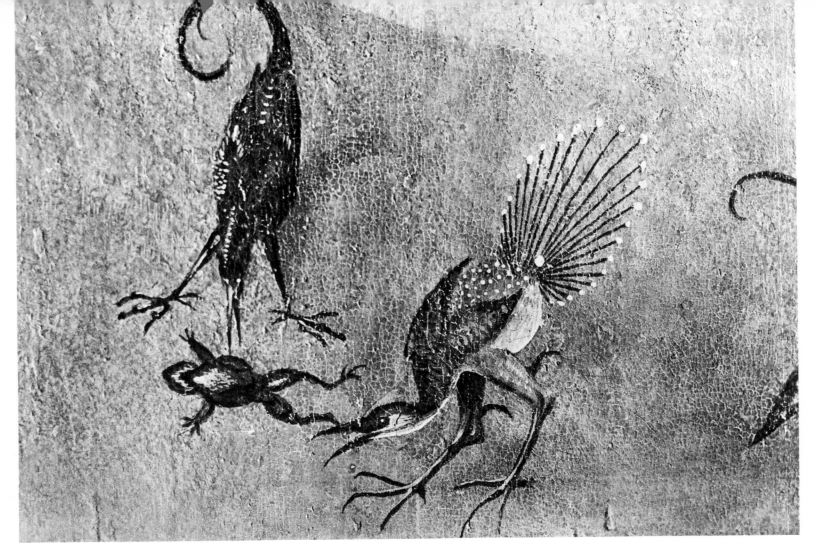

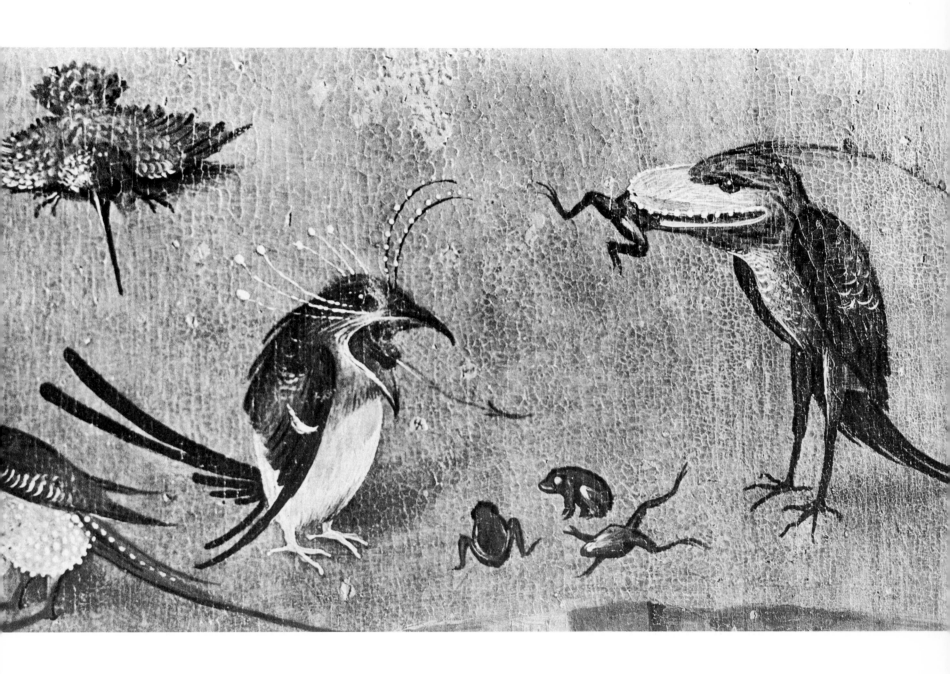

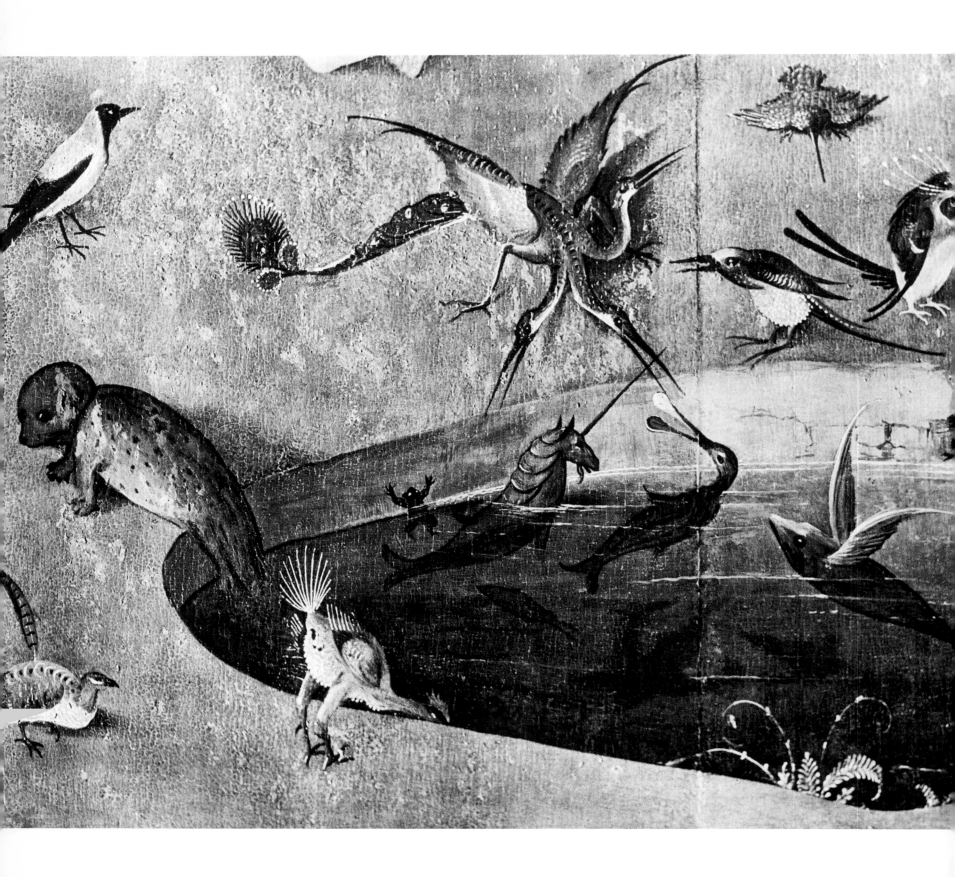

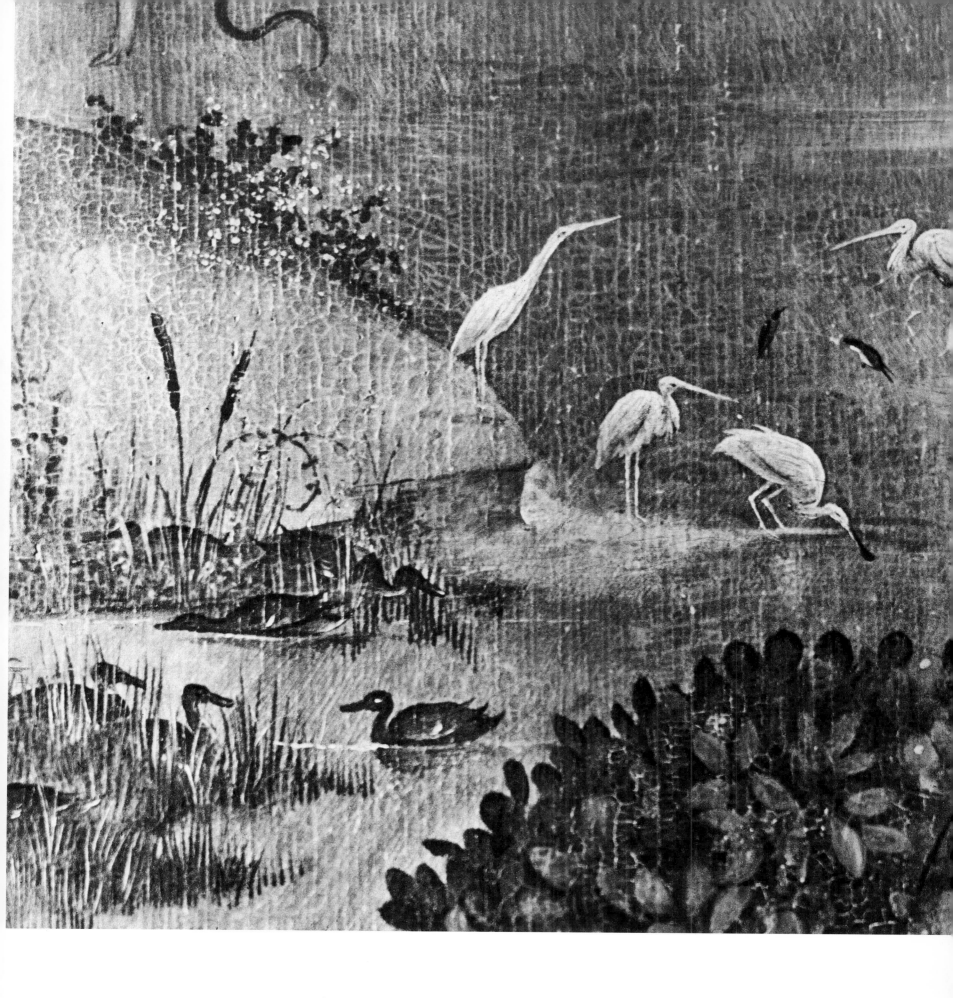

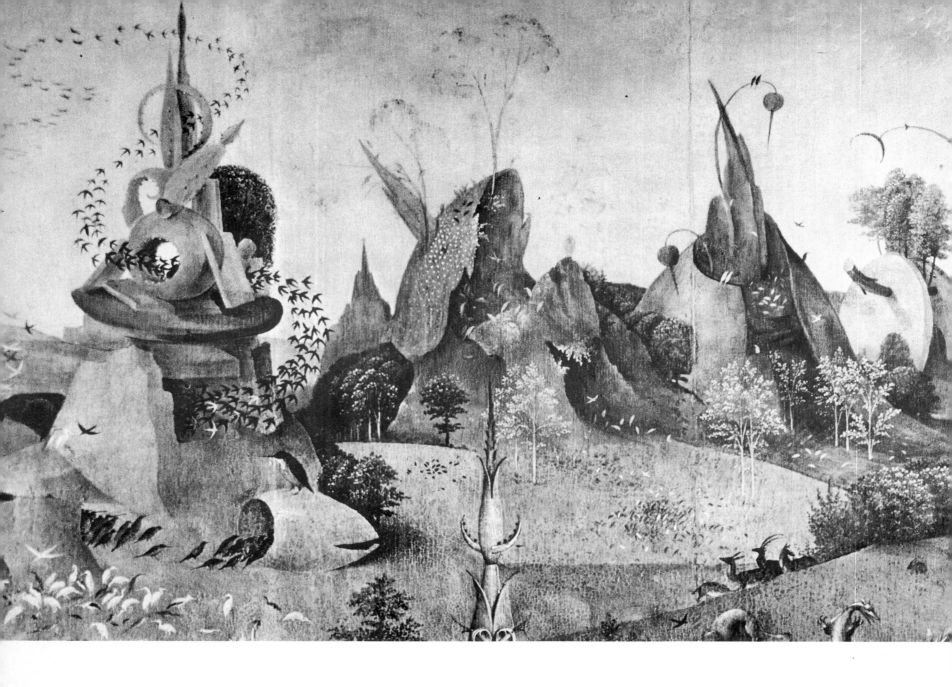

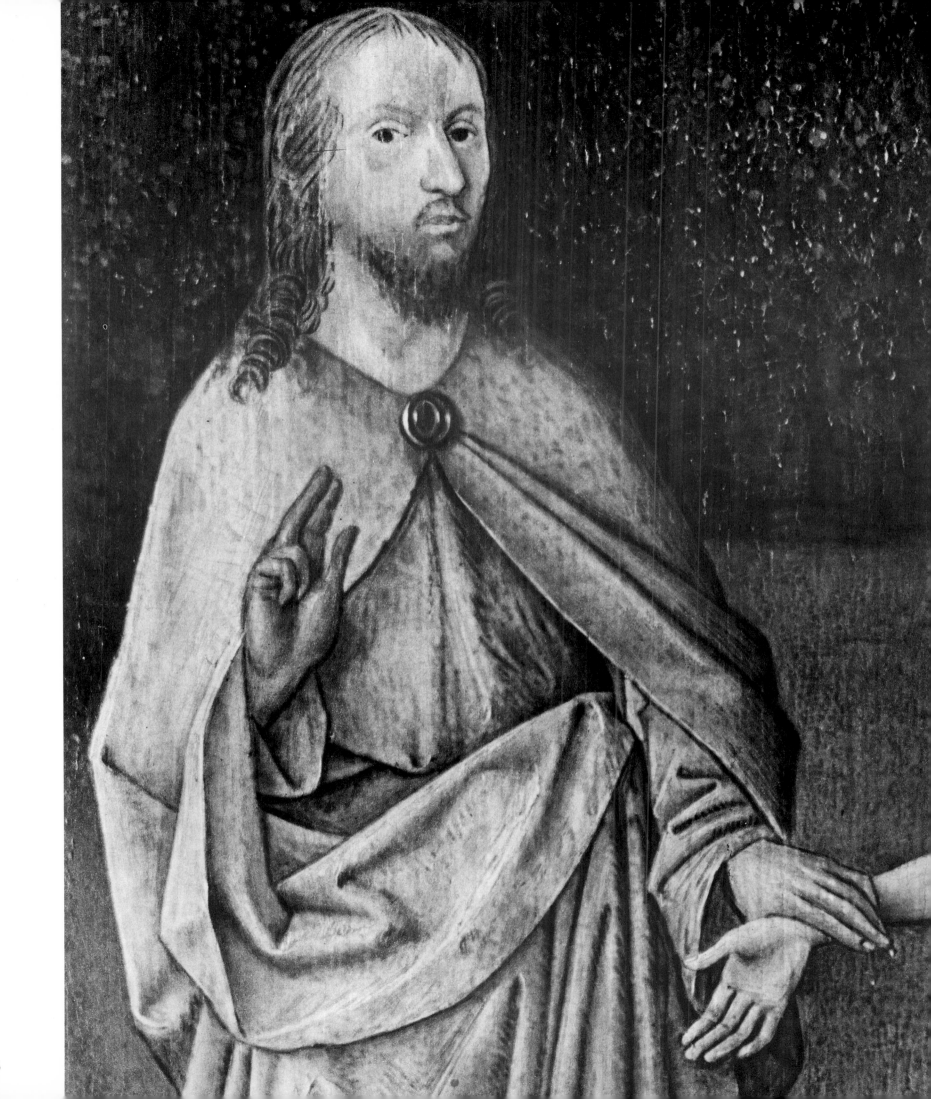

15

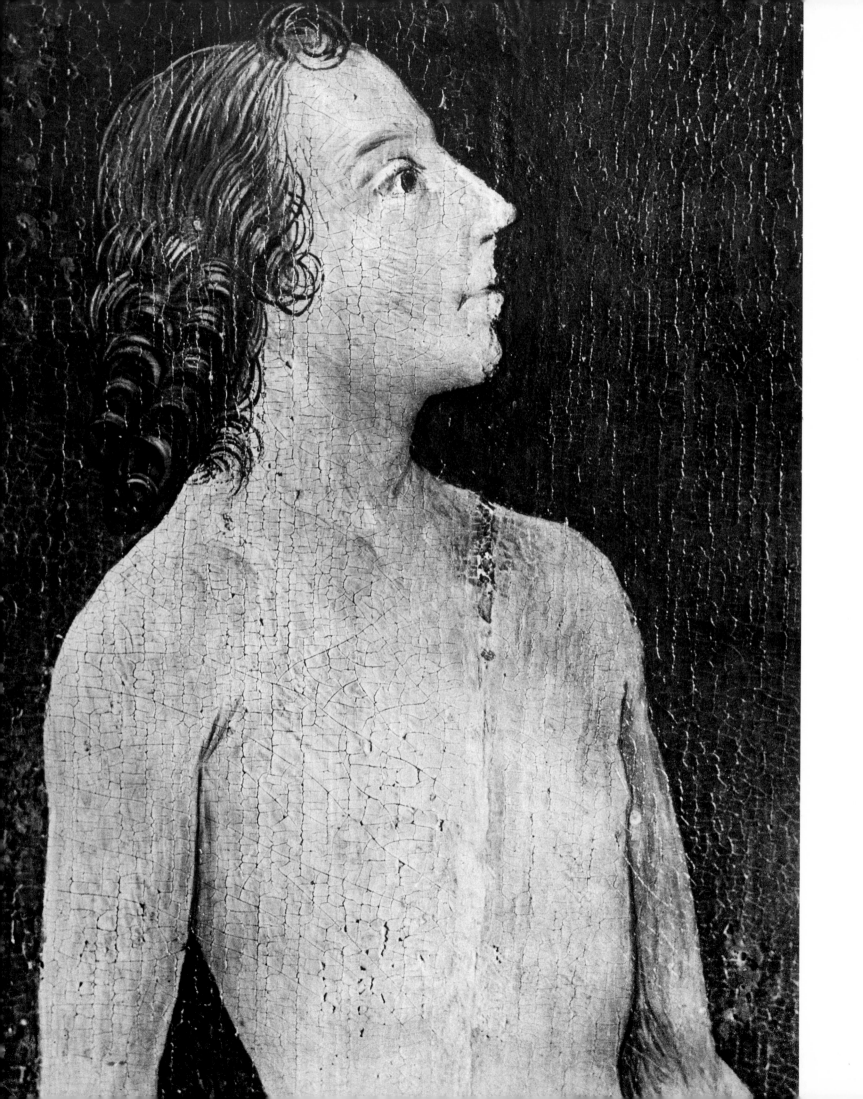

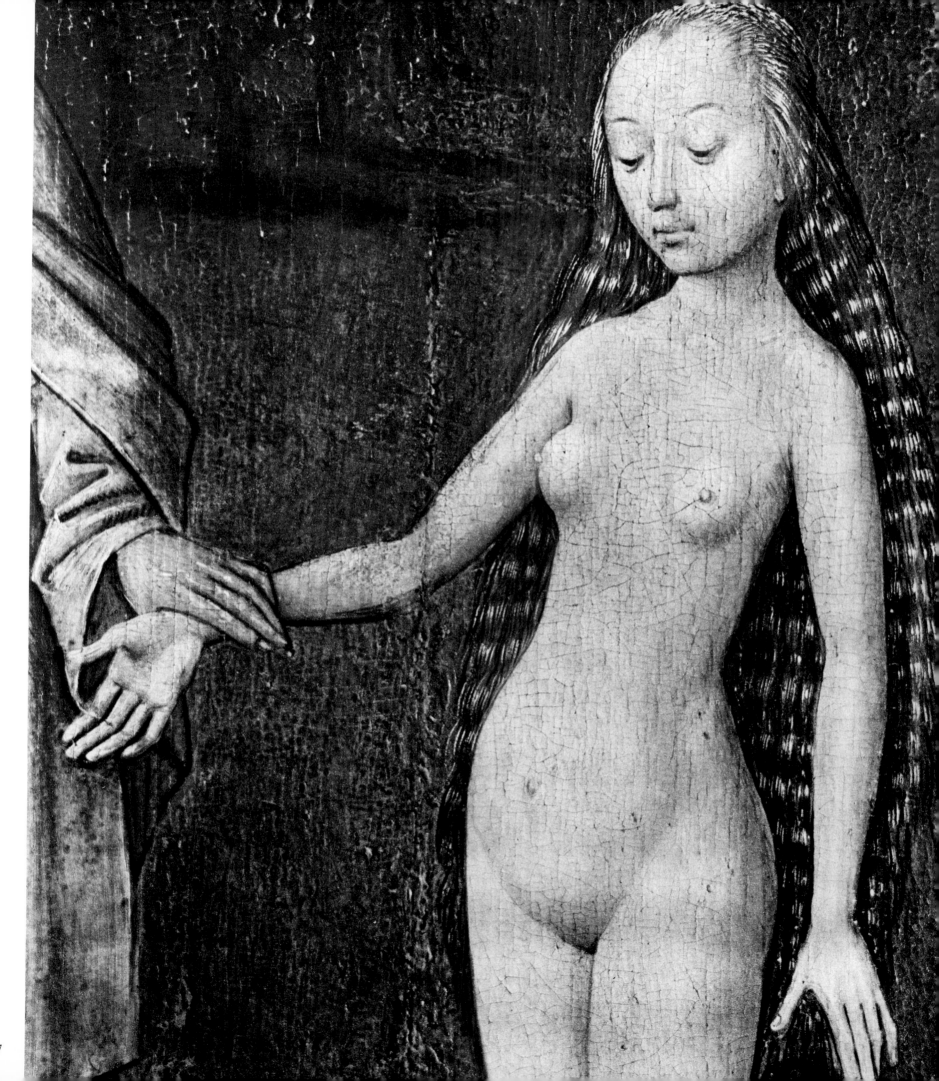

7

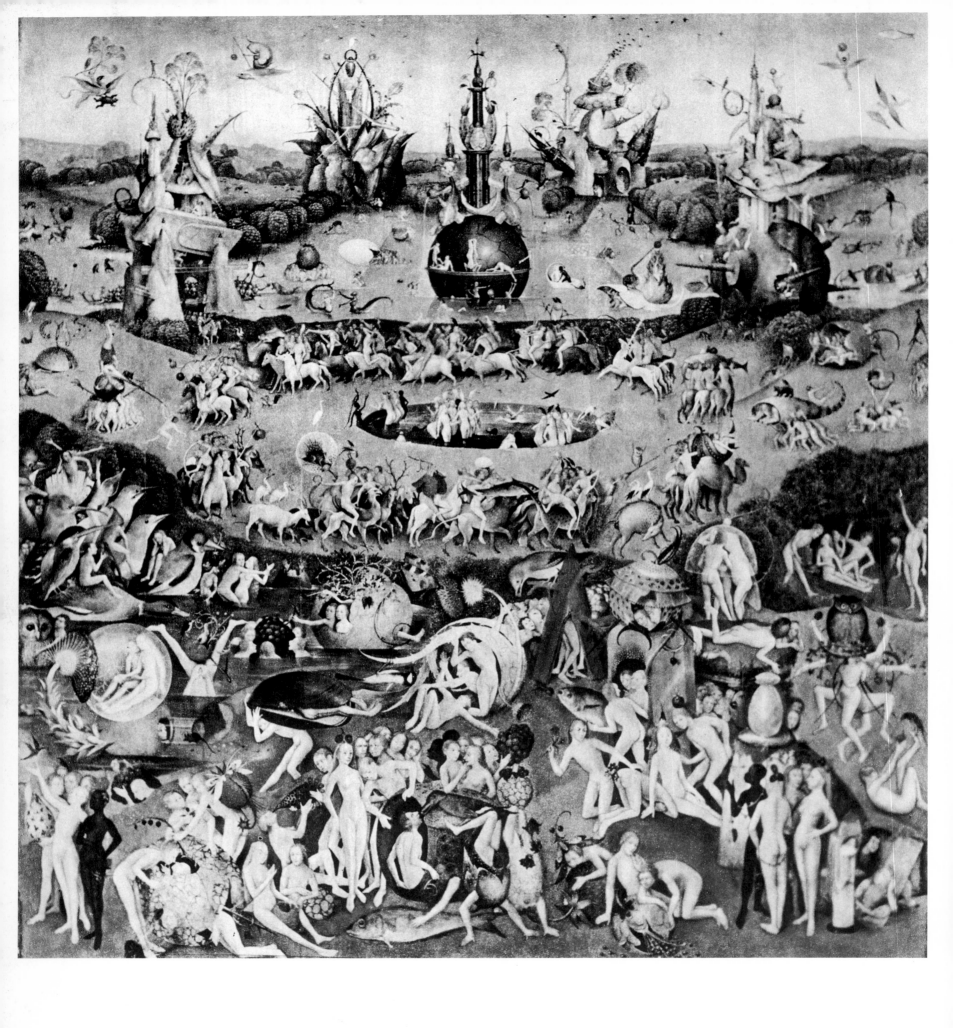

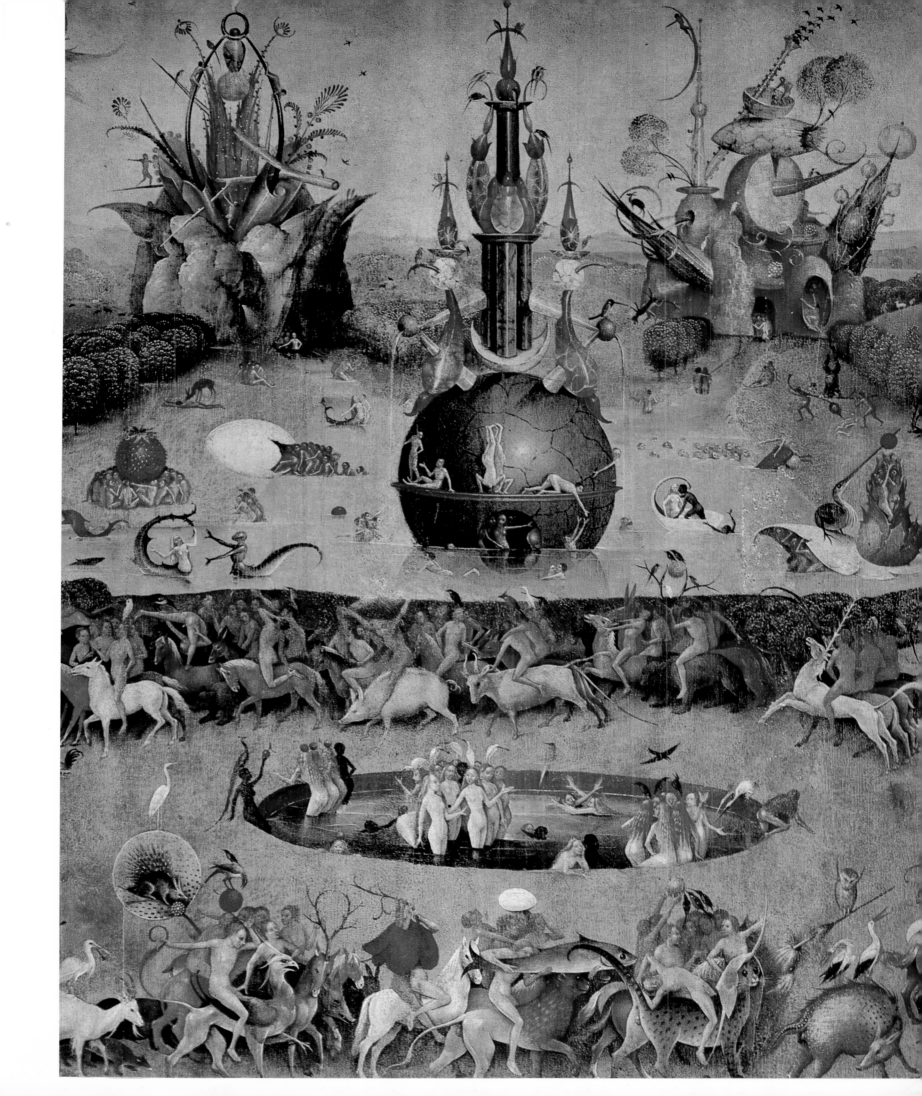

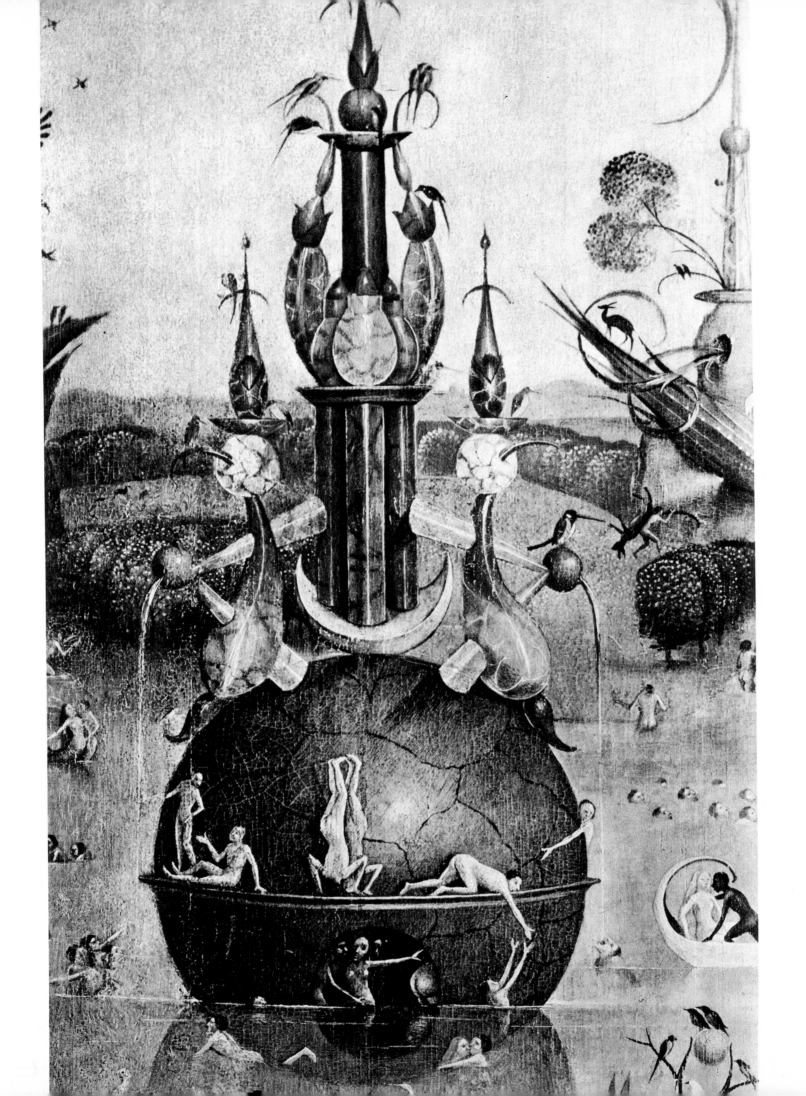

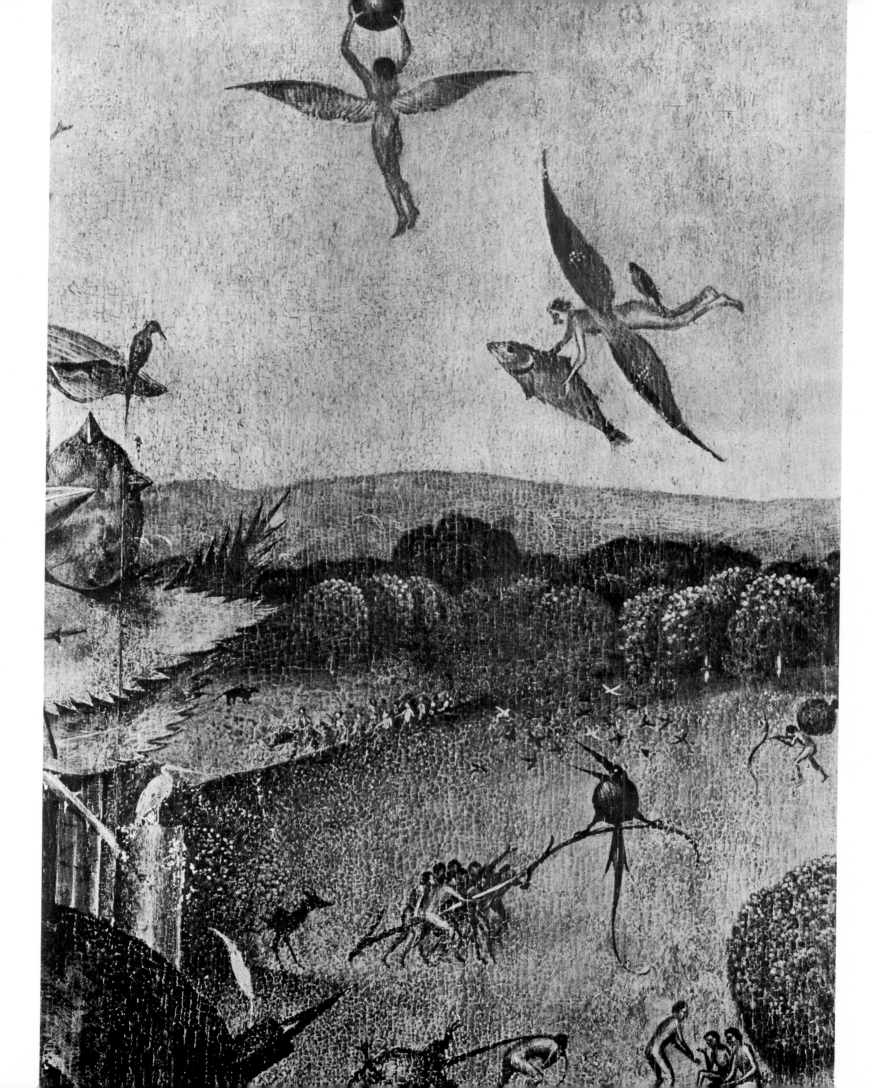

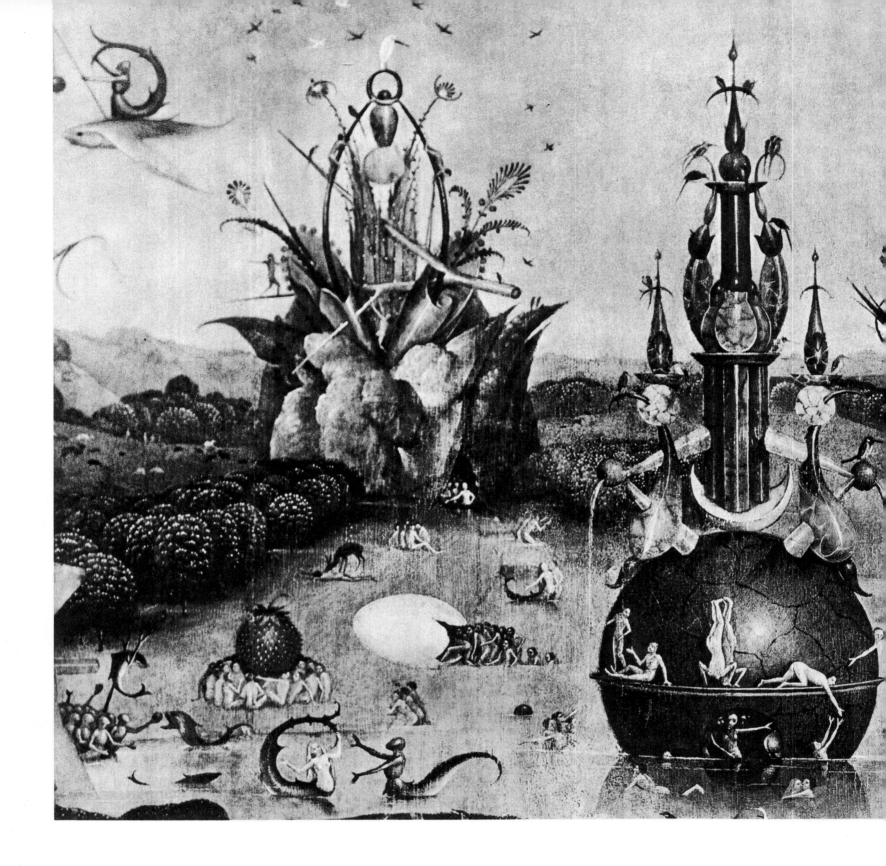

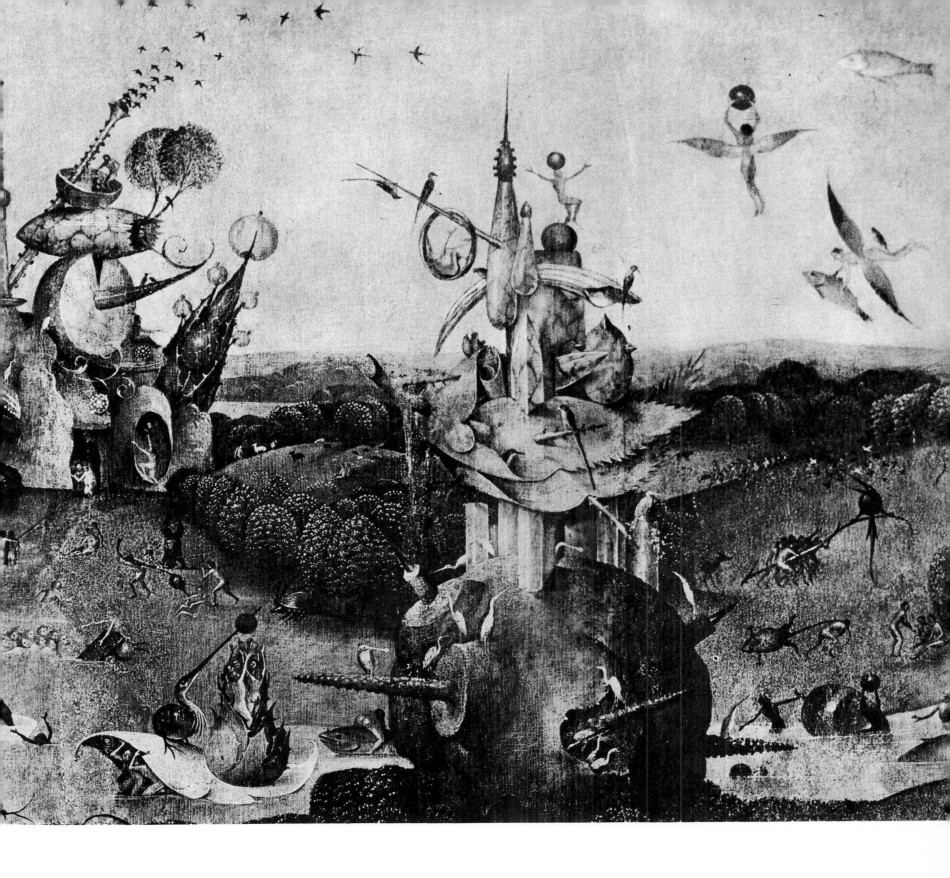

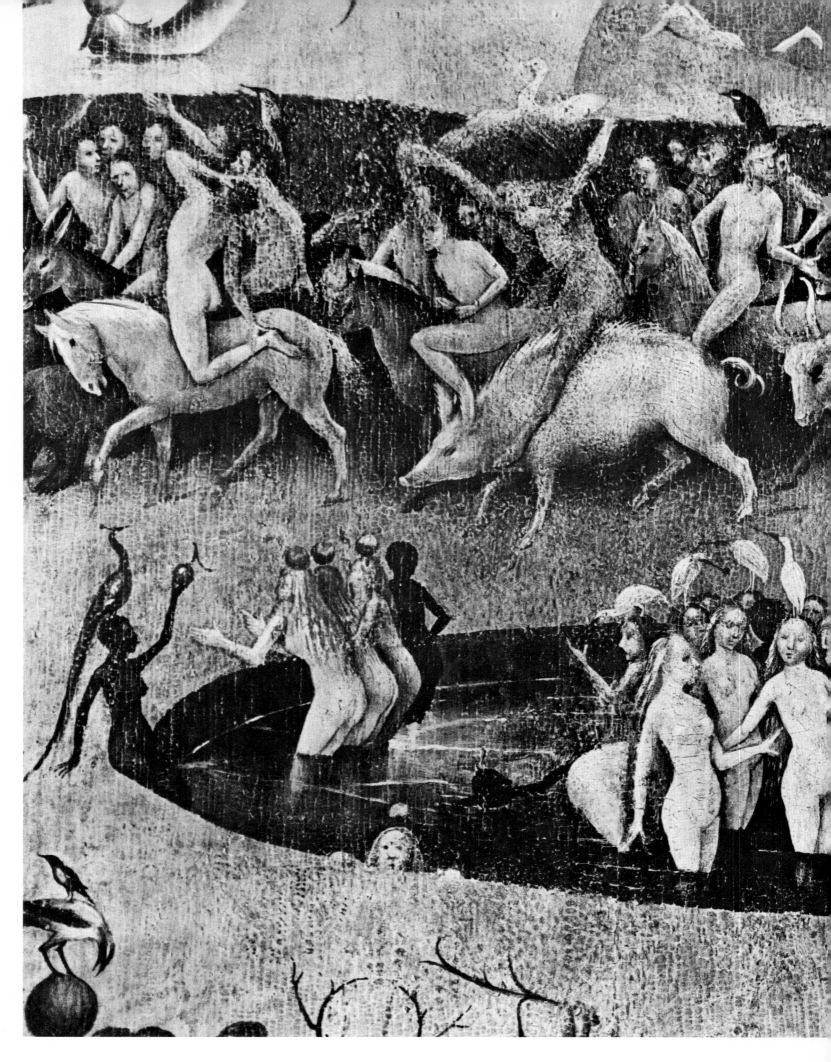

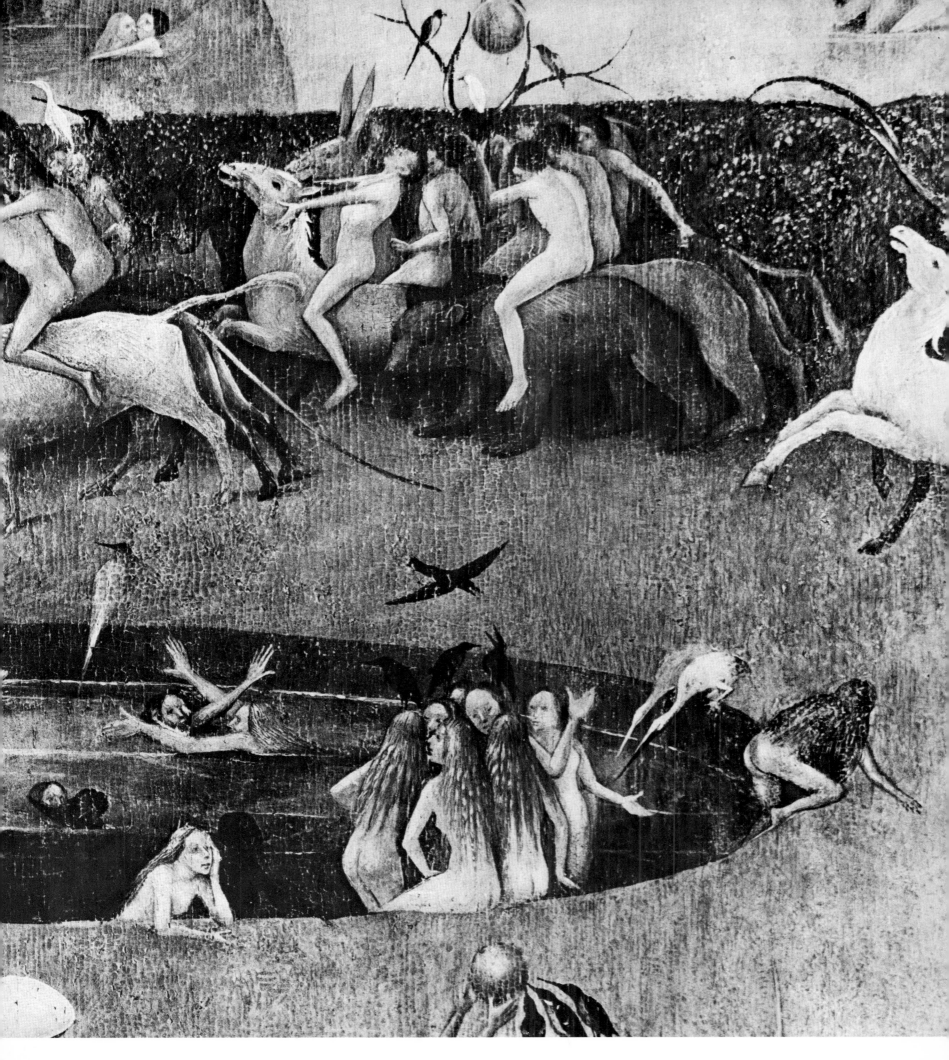

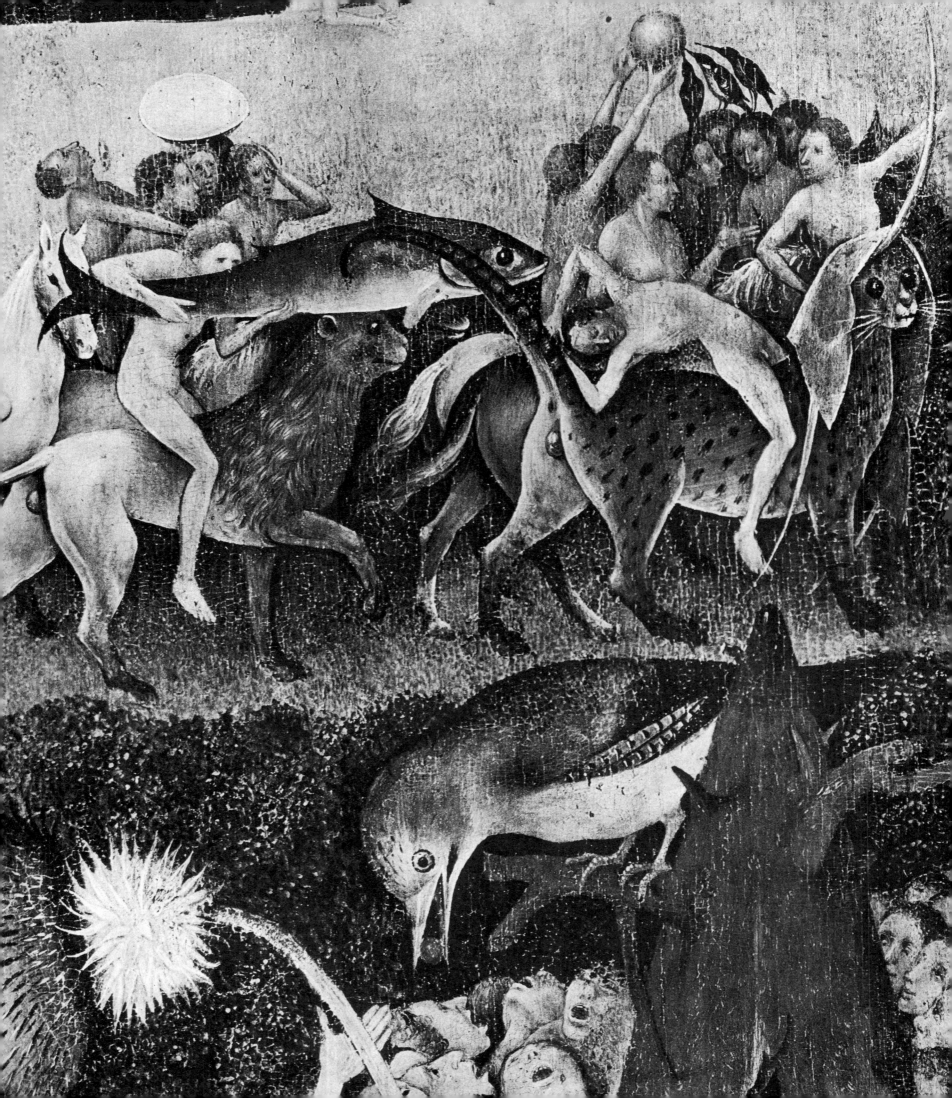

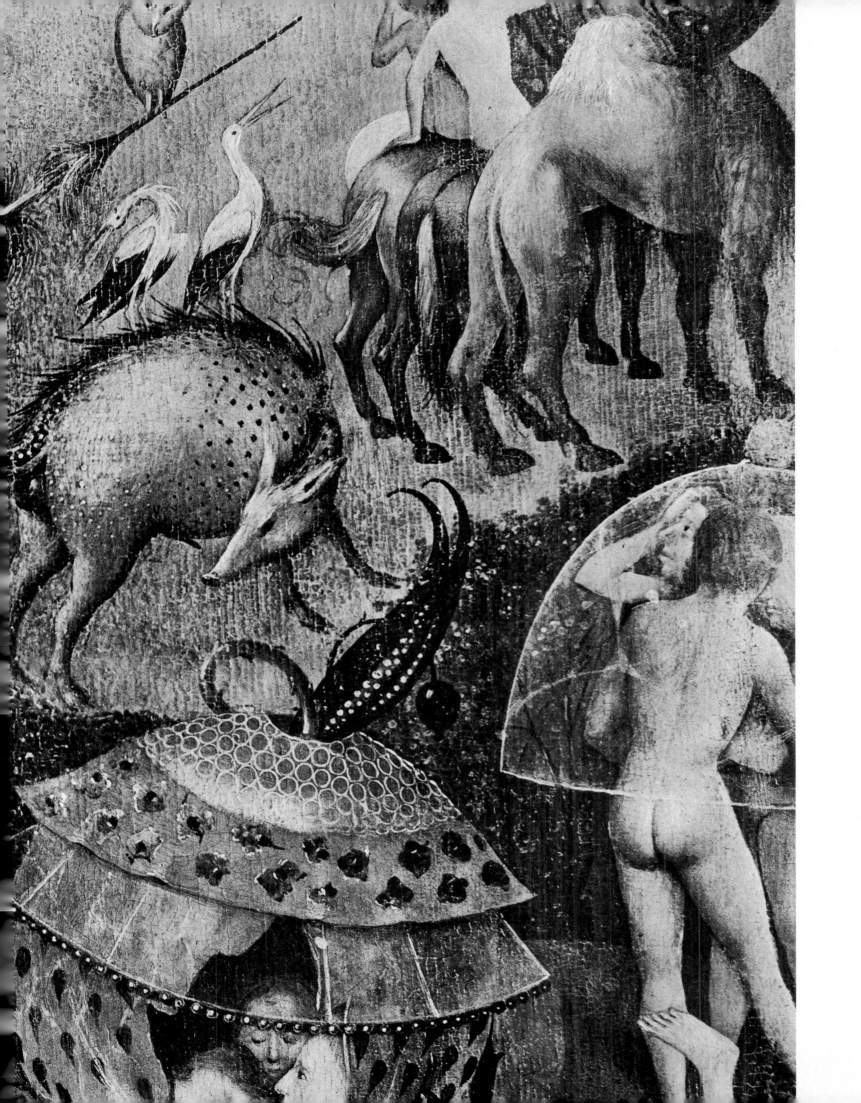

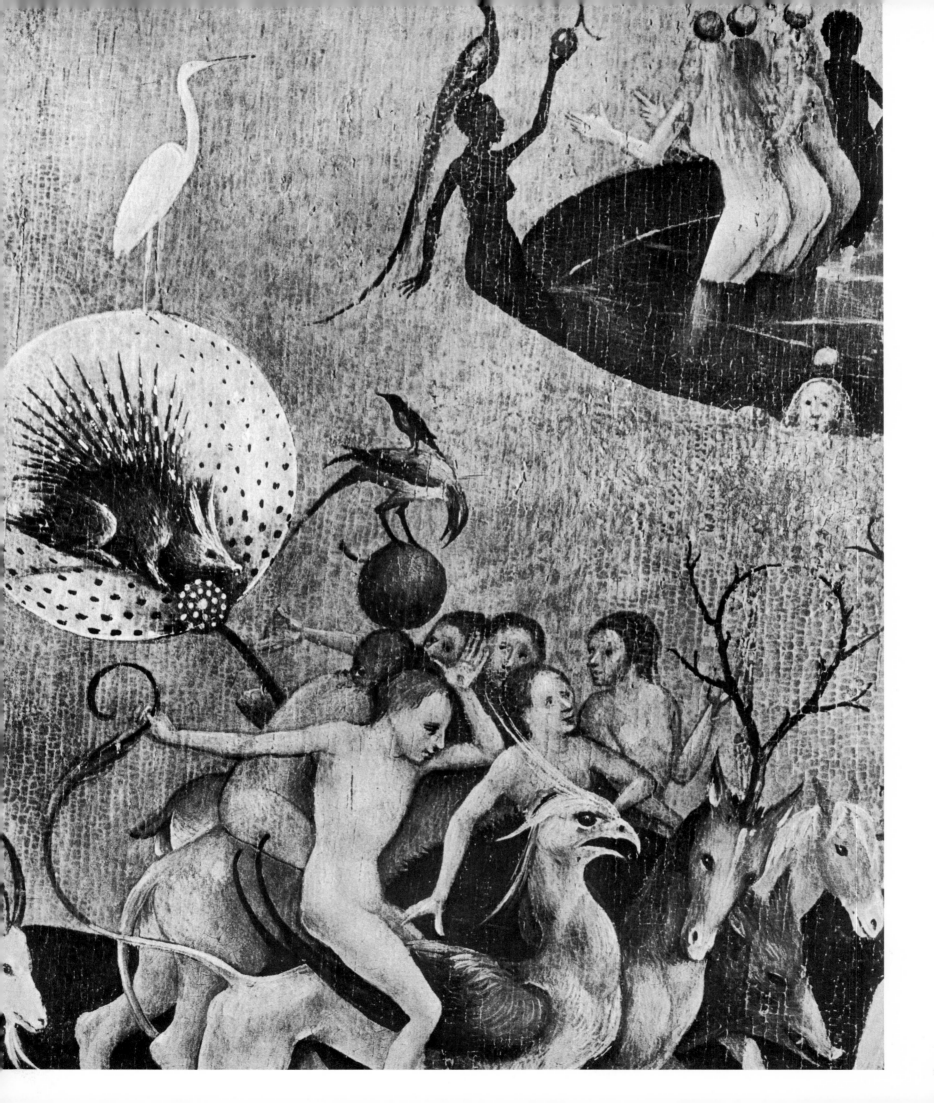

22

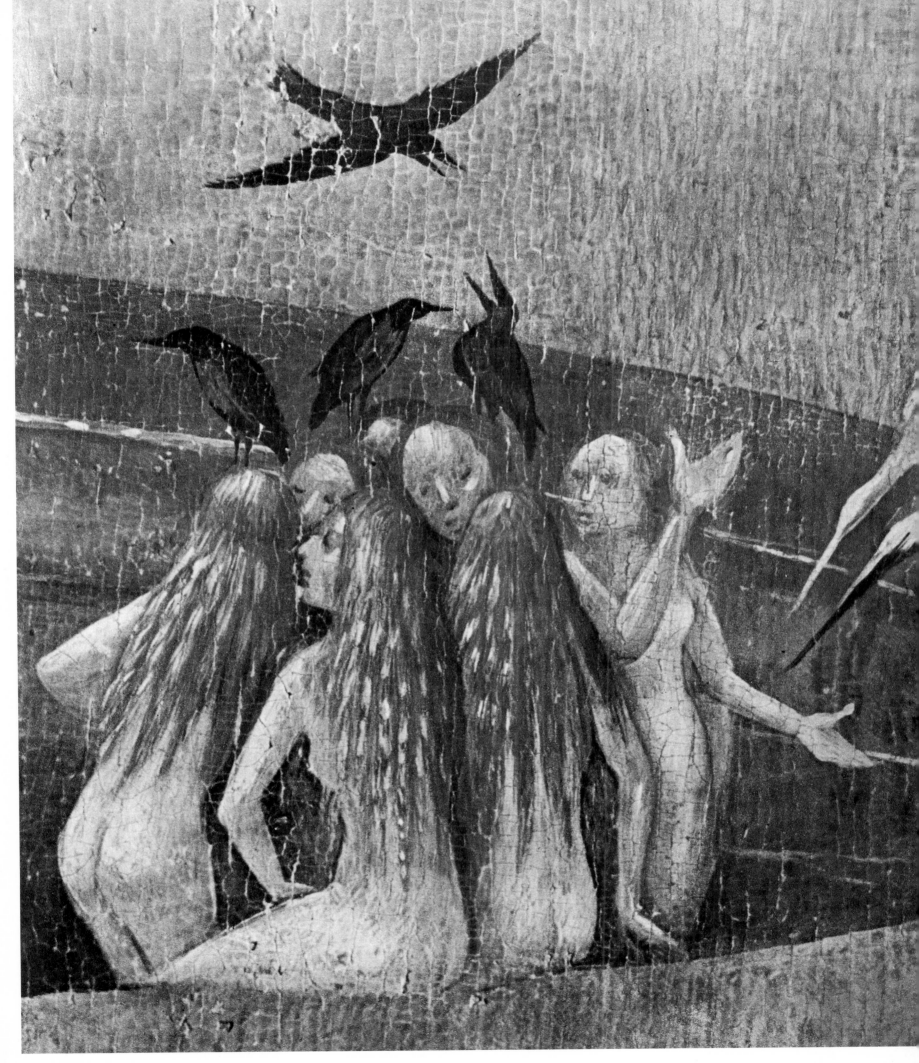

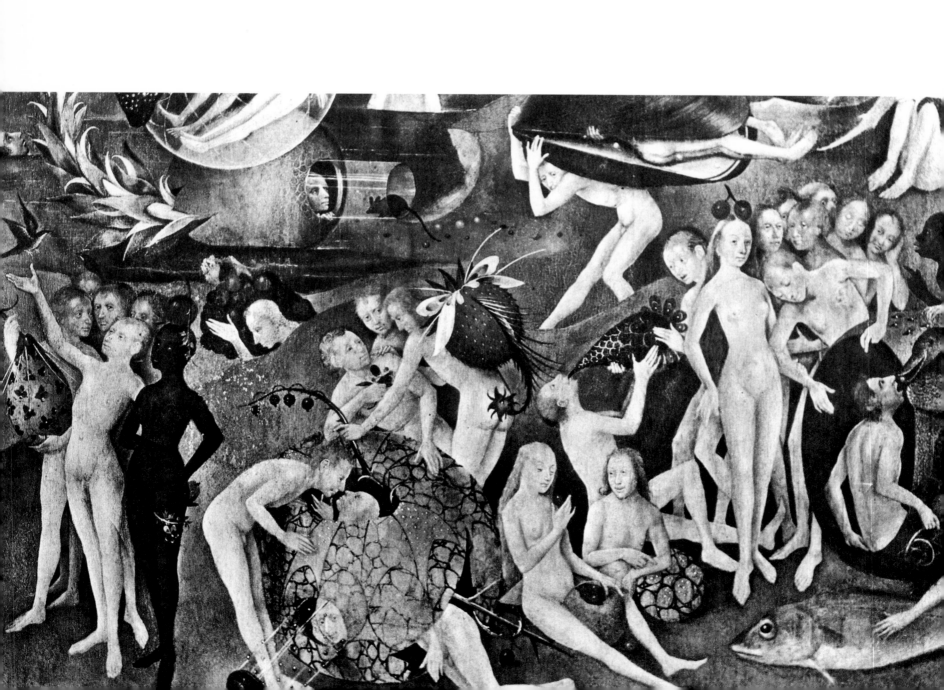

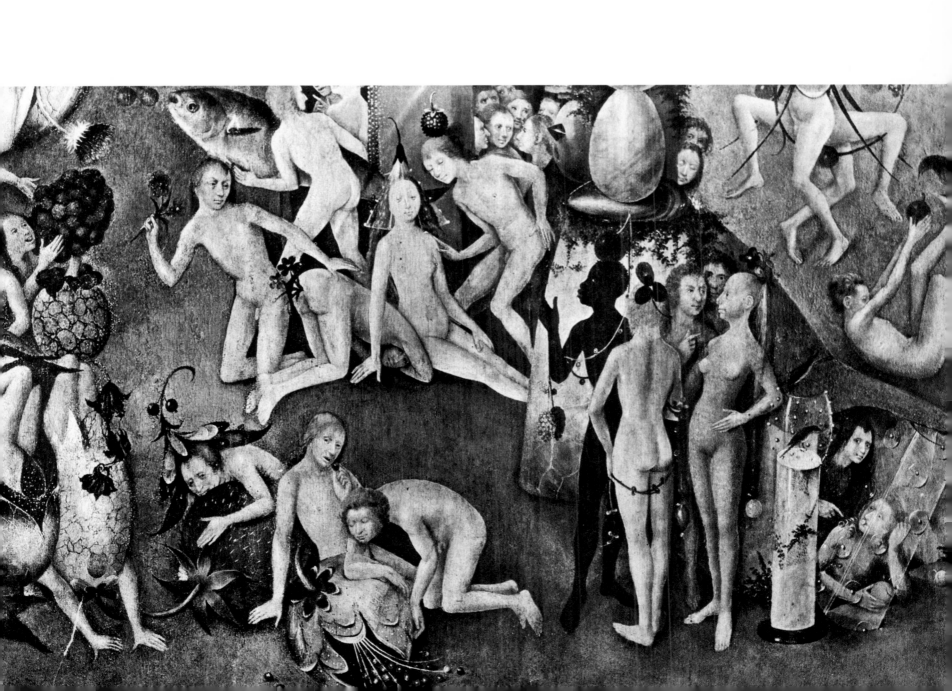

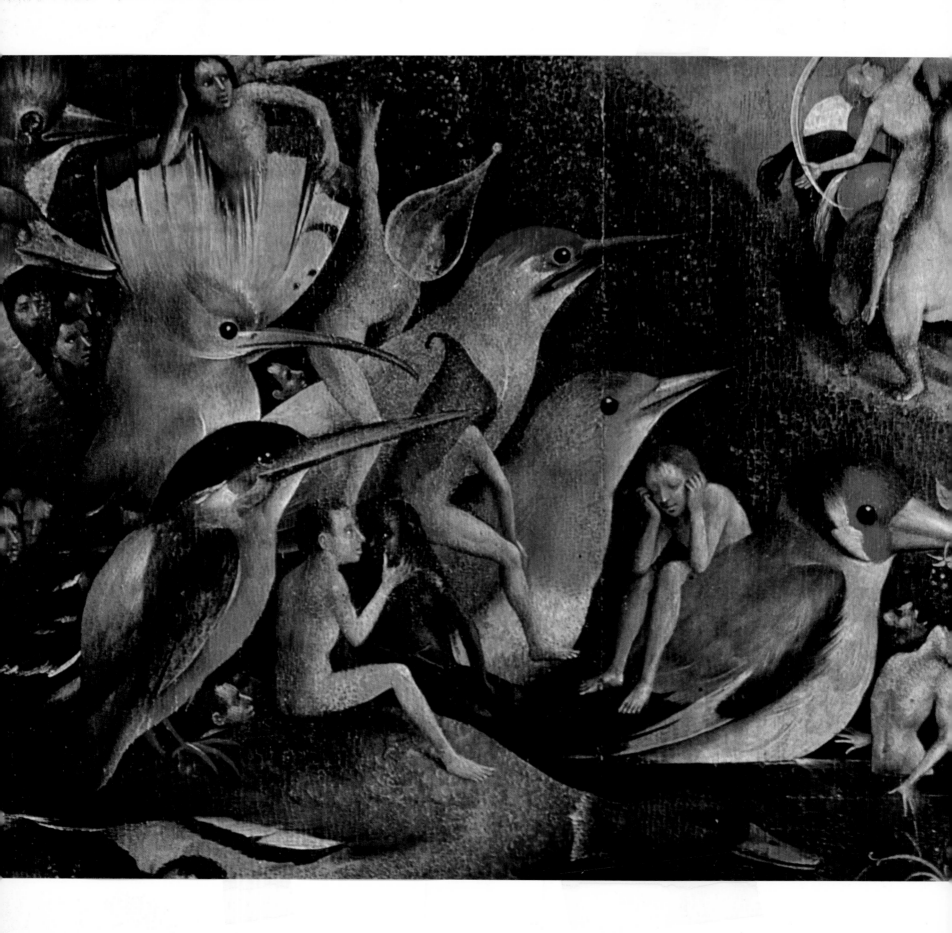

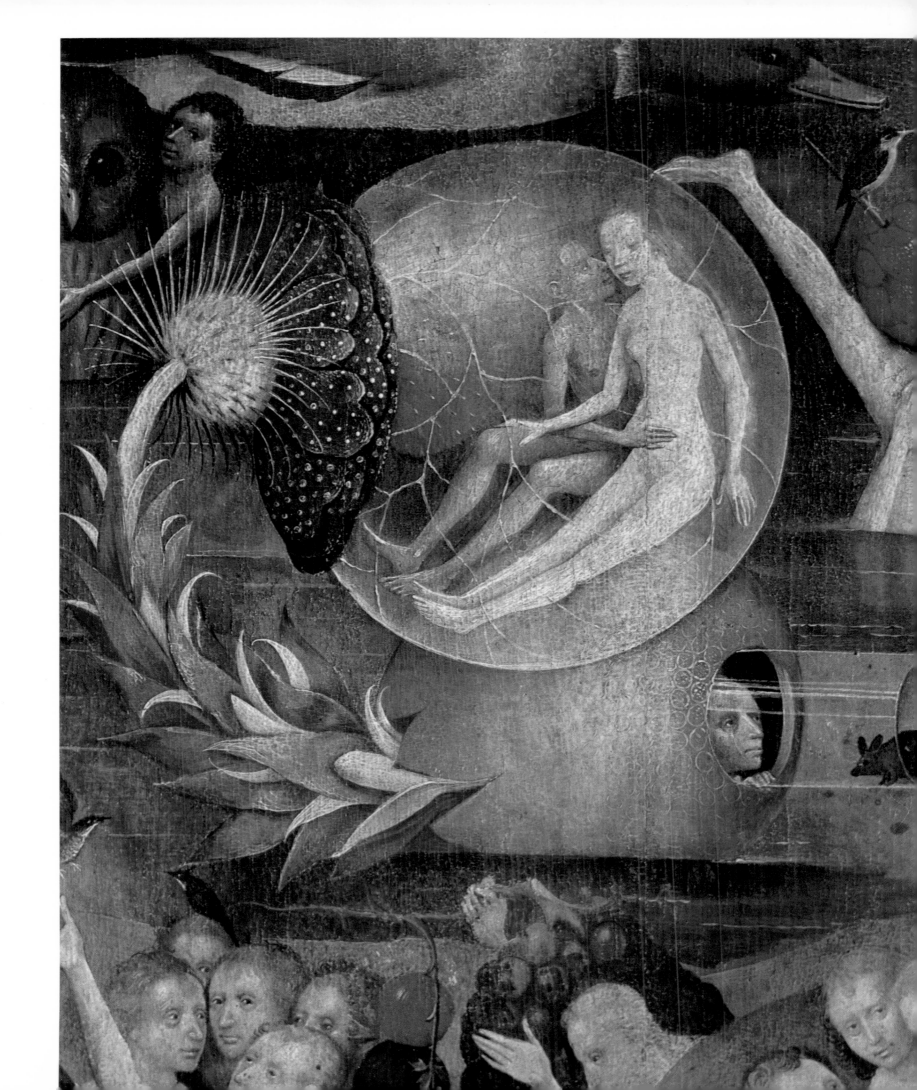

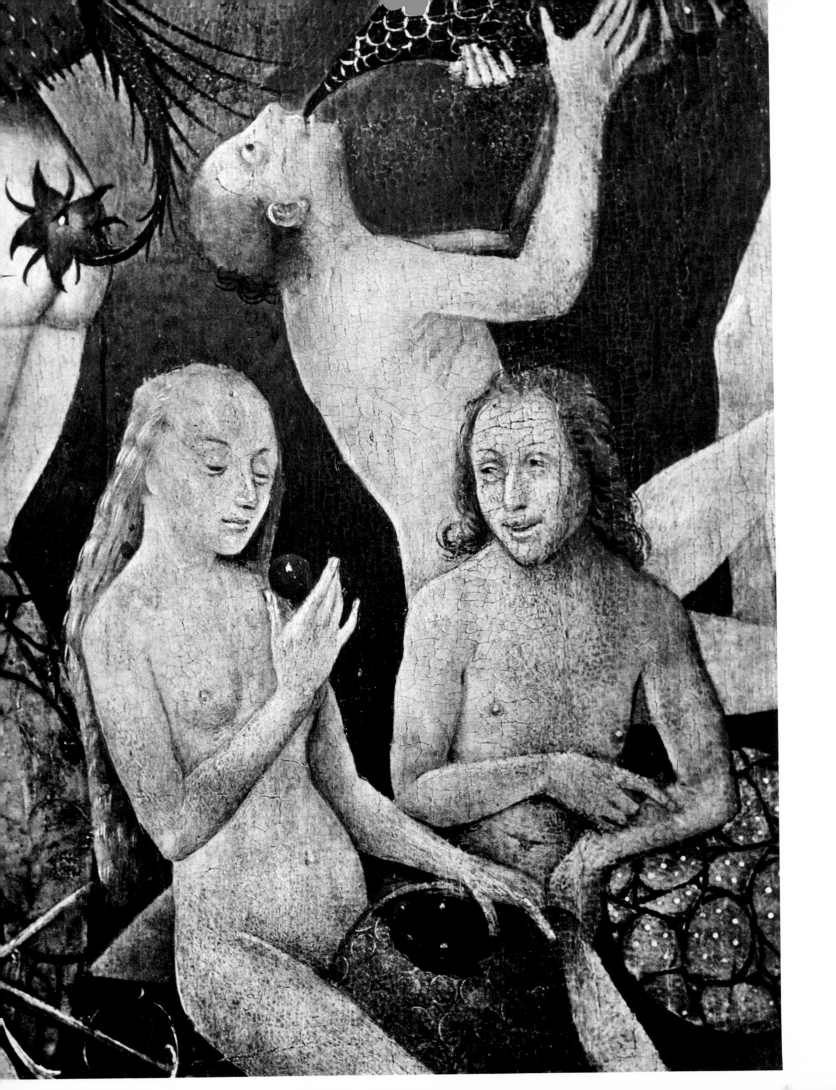

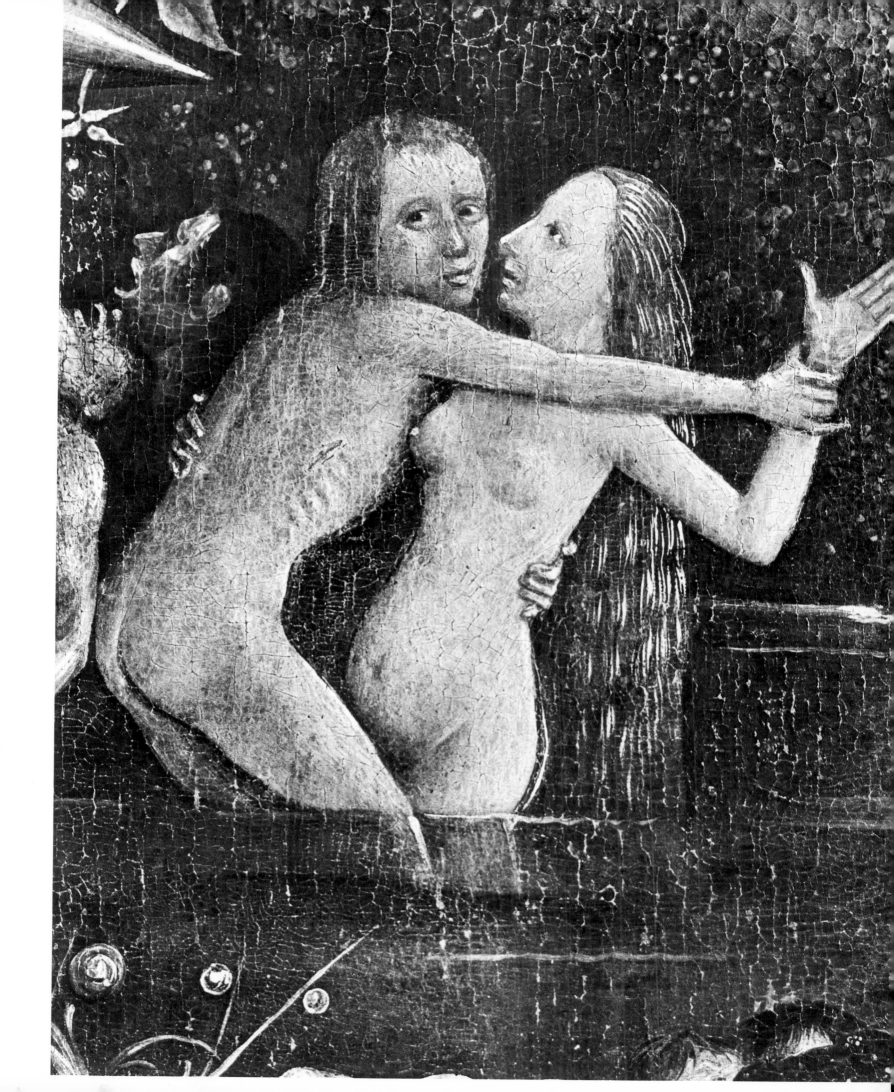

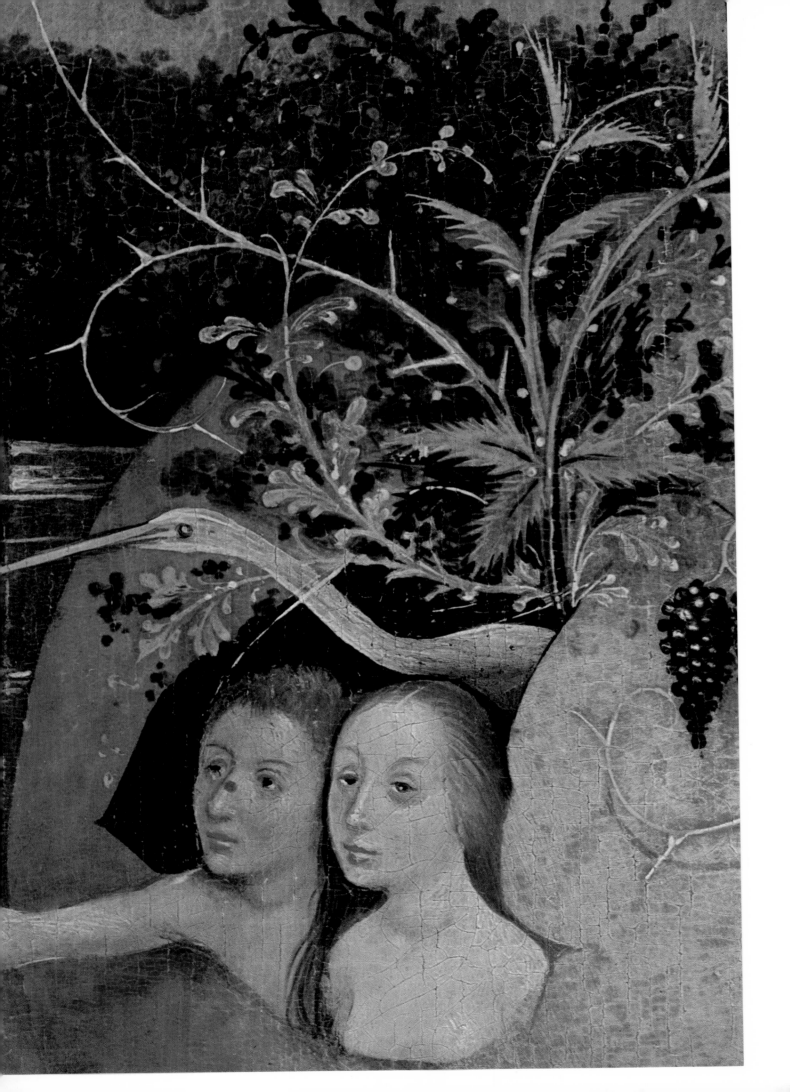

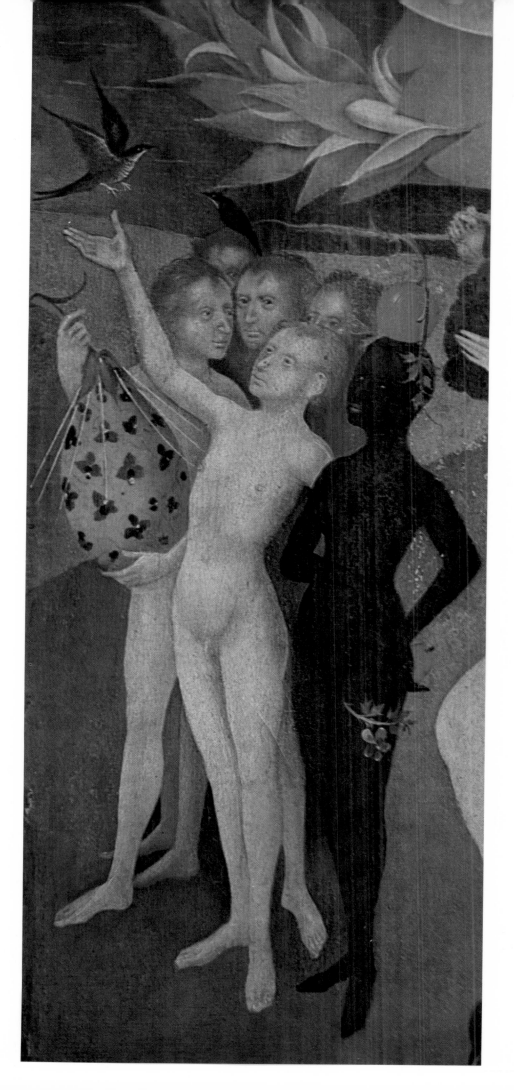

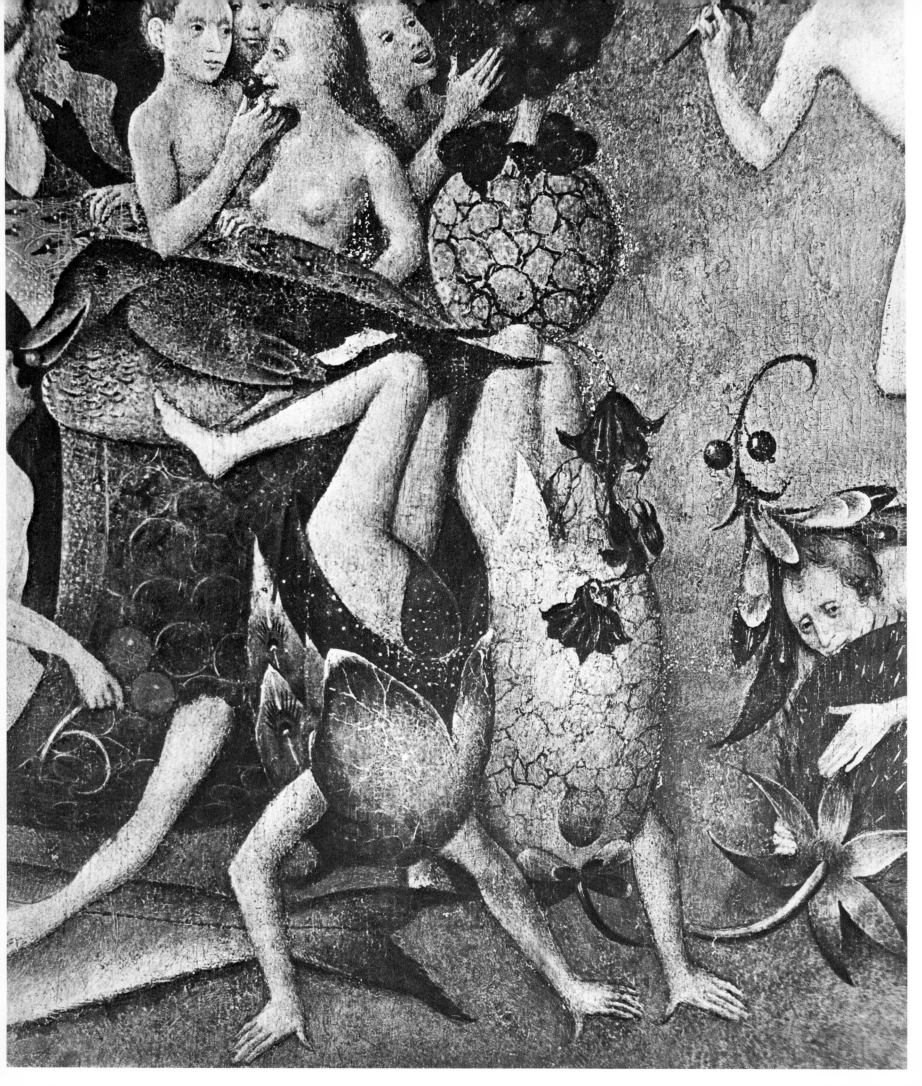

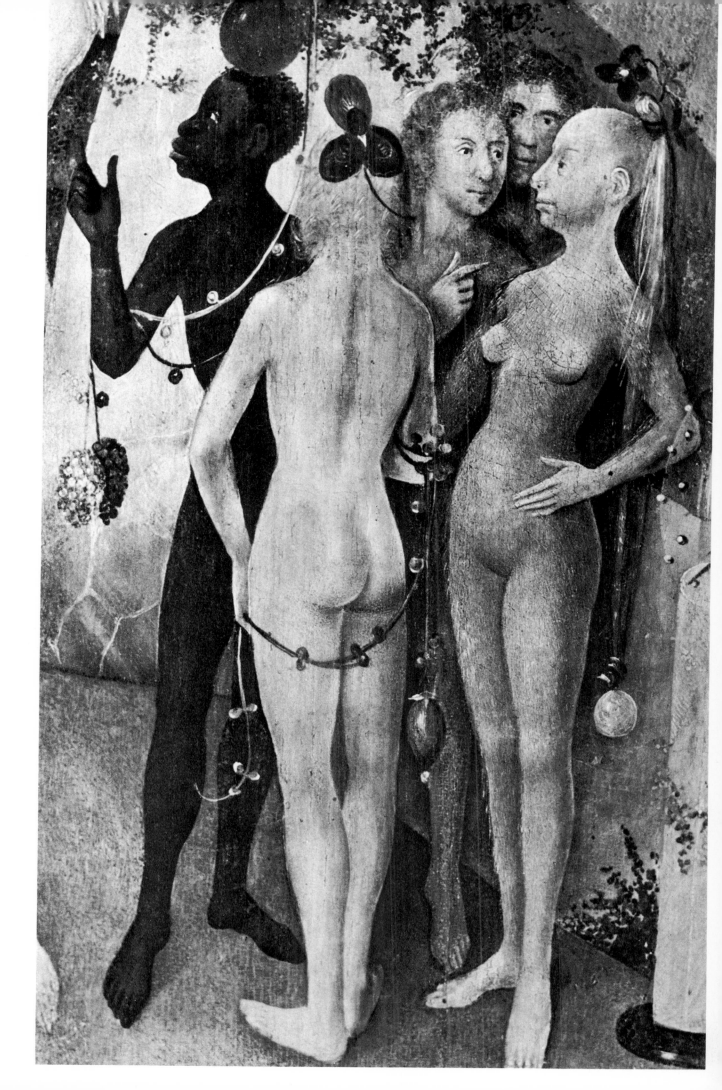

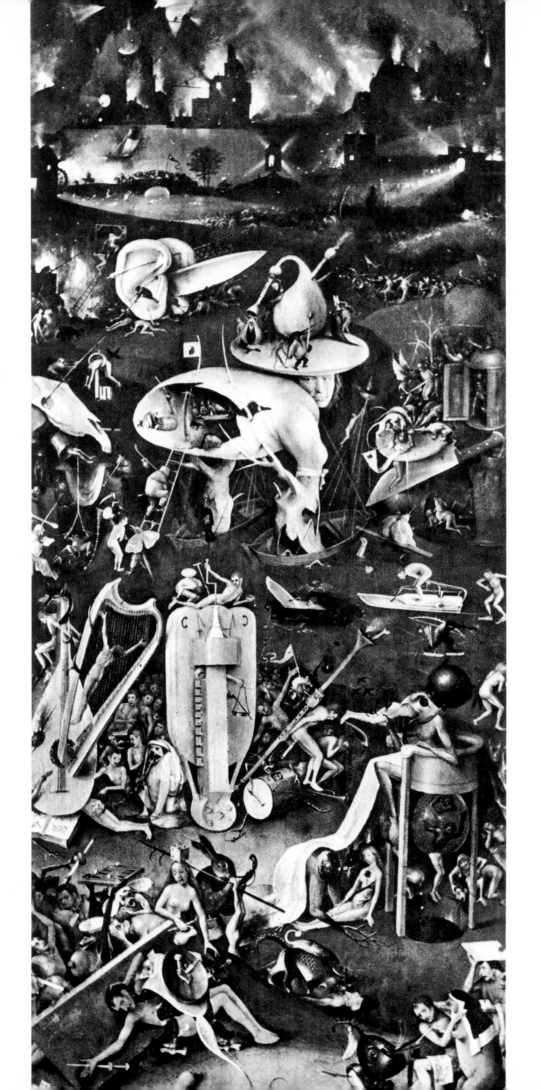

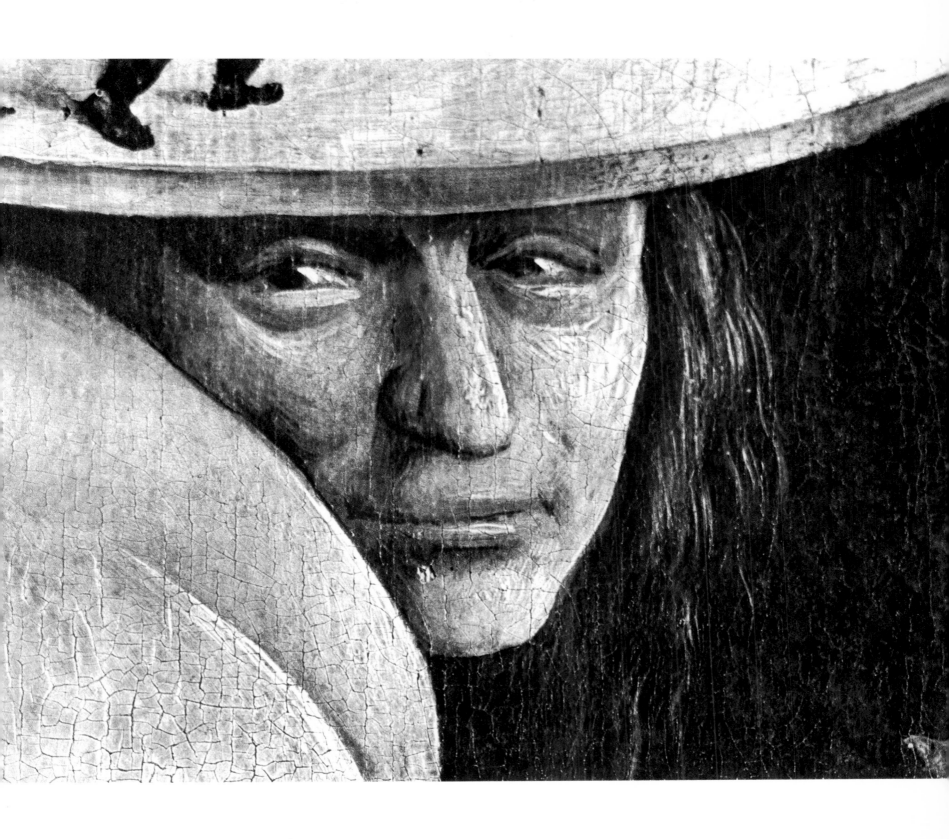

41

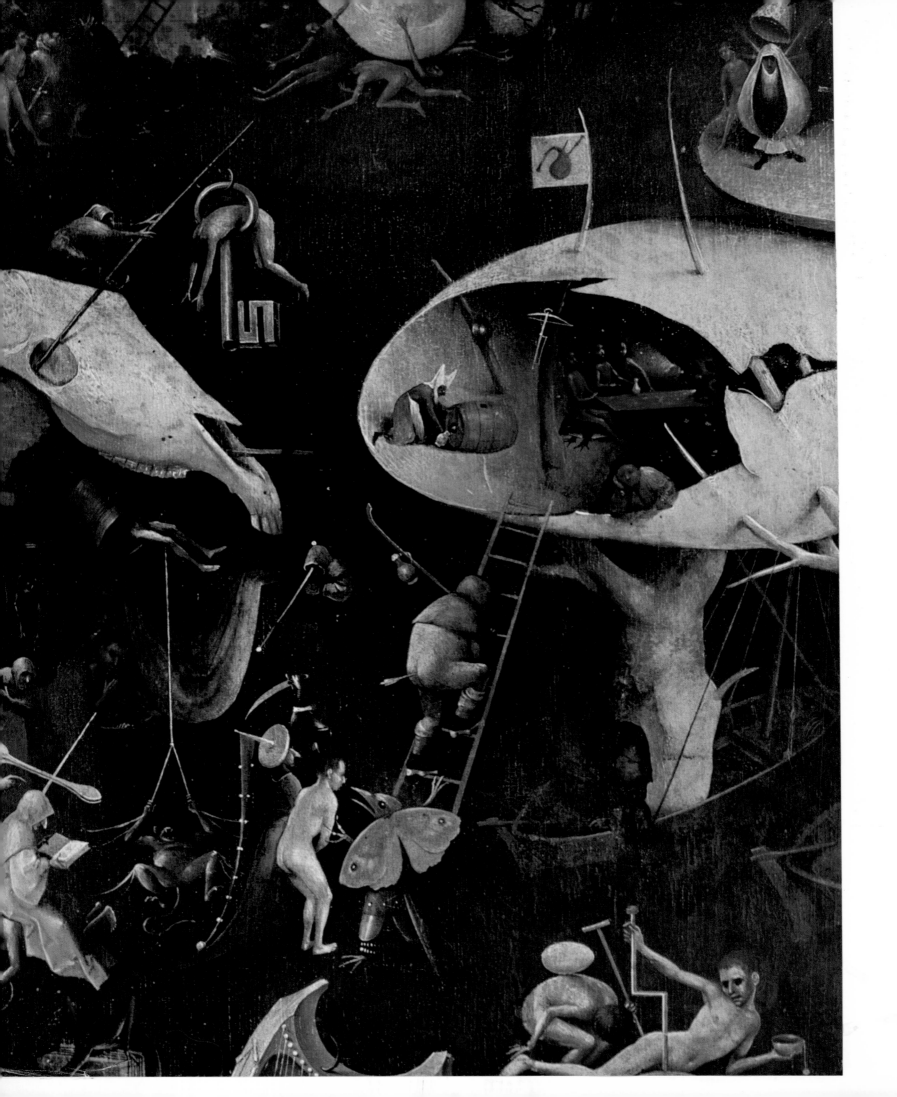

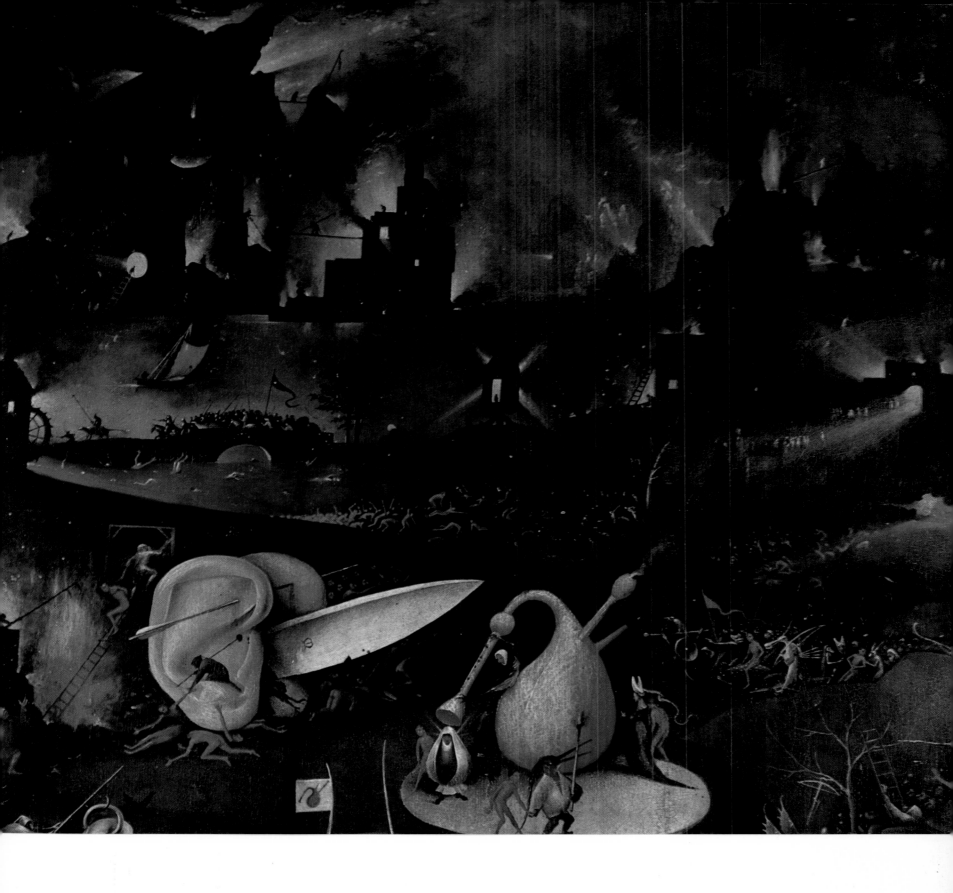

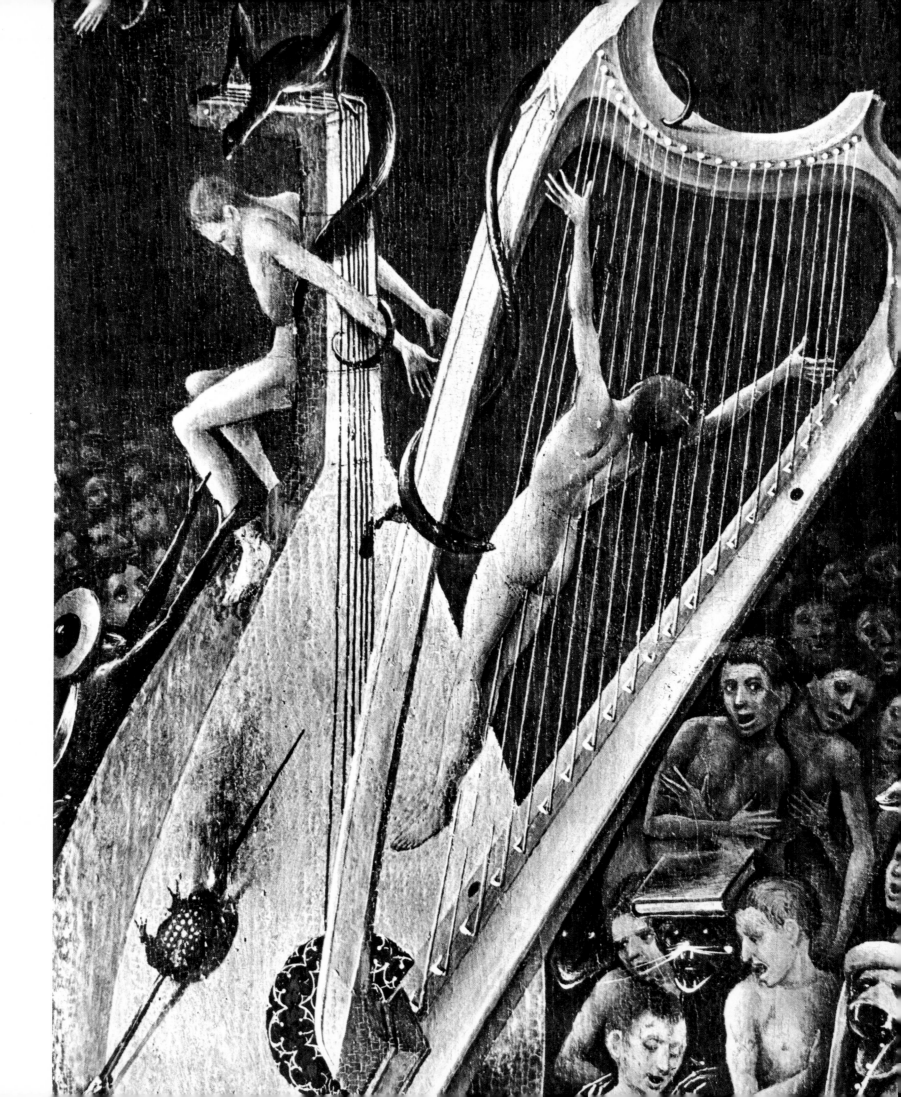

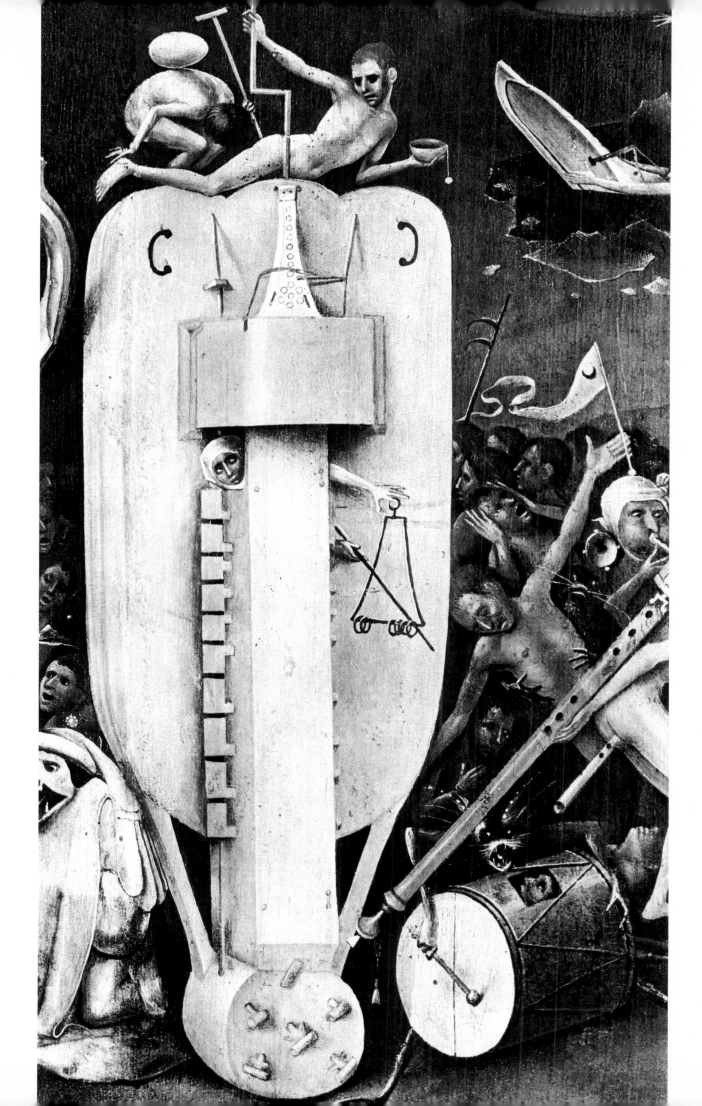

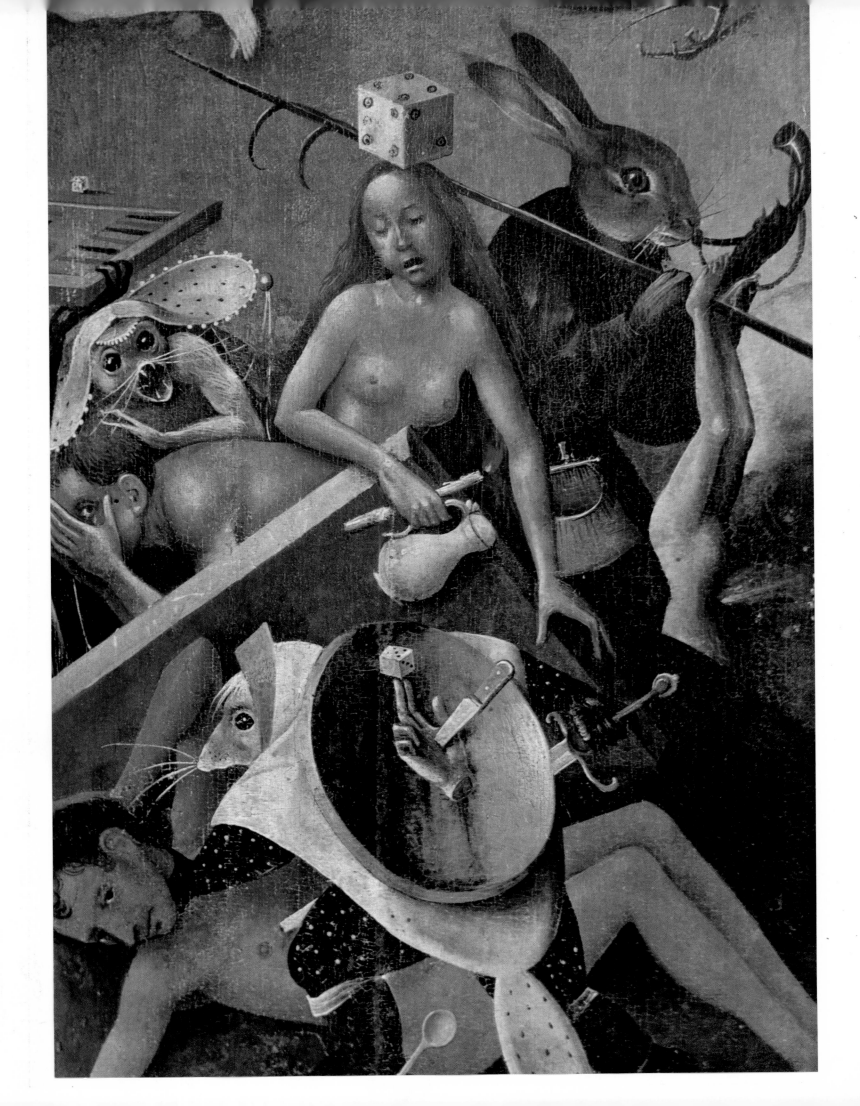

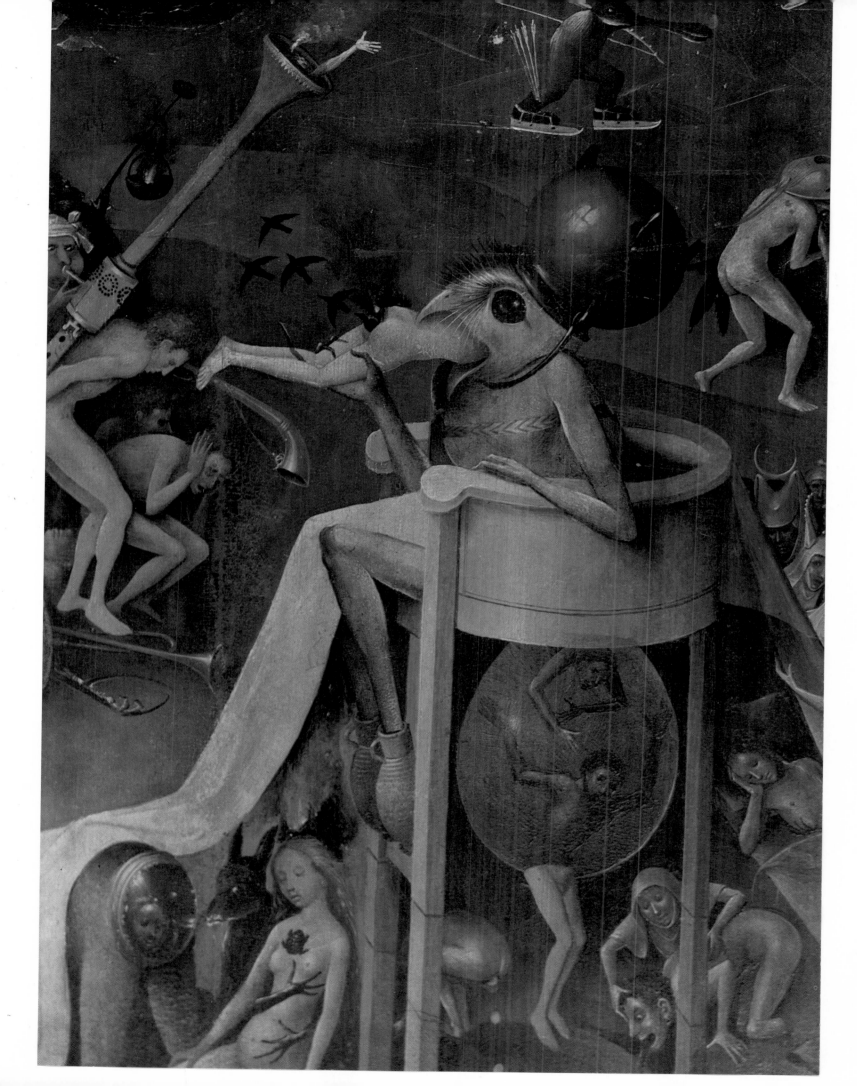

THE LAST JUDGEMENT (fragment)

Here Bosch seems to have wanted to give instruction according to a higher morality: the vision of corporal tortures is replaced by a portrayal of the remorse of the resurrected; the lowly and the mighty of this world are hiding their faces in despair, or with terrified countenances are begging the Judge for mercy.

MUNICH, ALTE PINAKOTHEK.

Oil on wood. Height 60 cm, width 114 cm. Complete picture pages 250-251; details on facing page and pages 252-253.

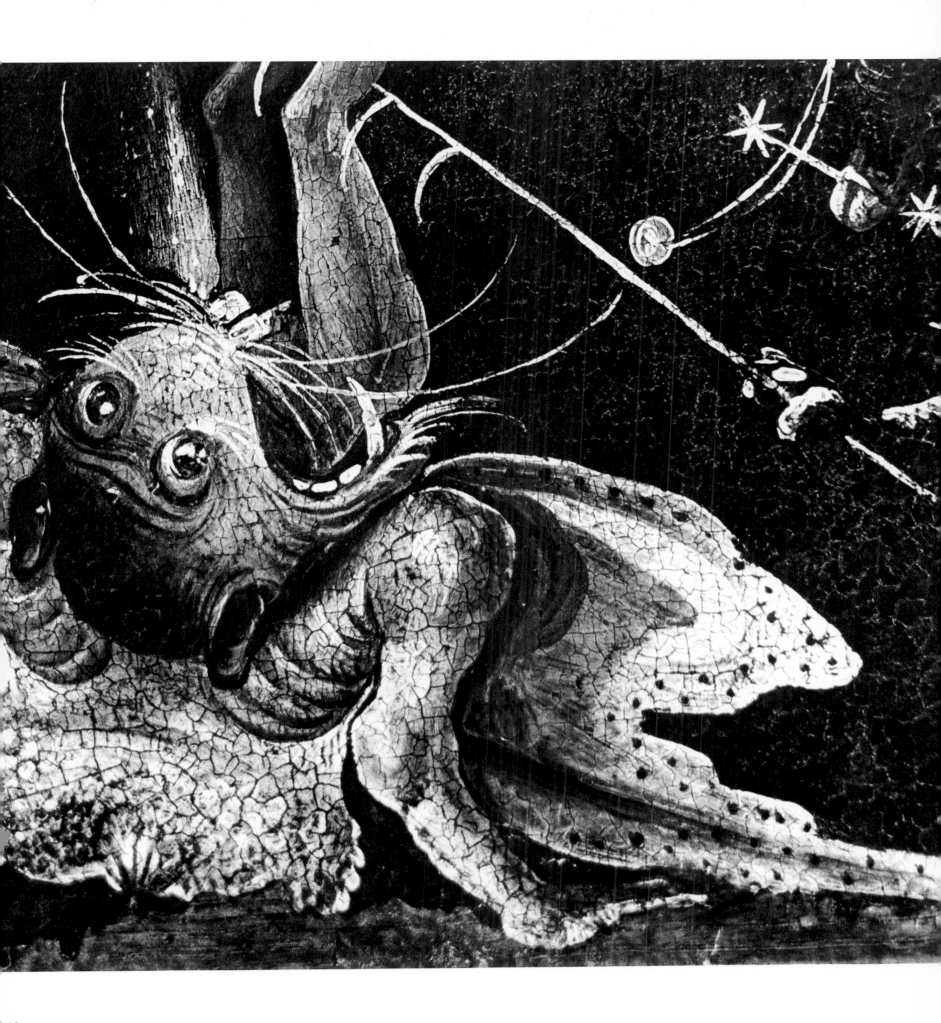

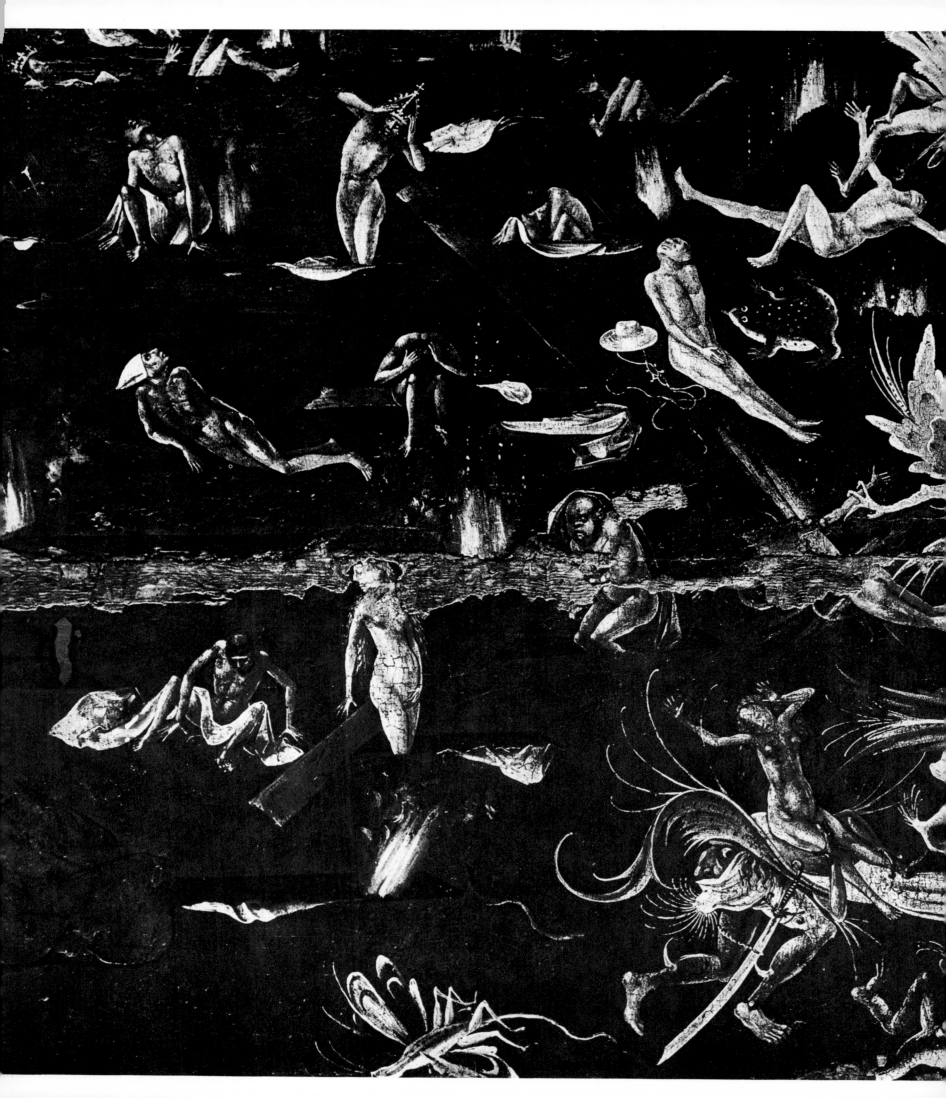

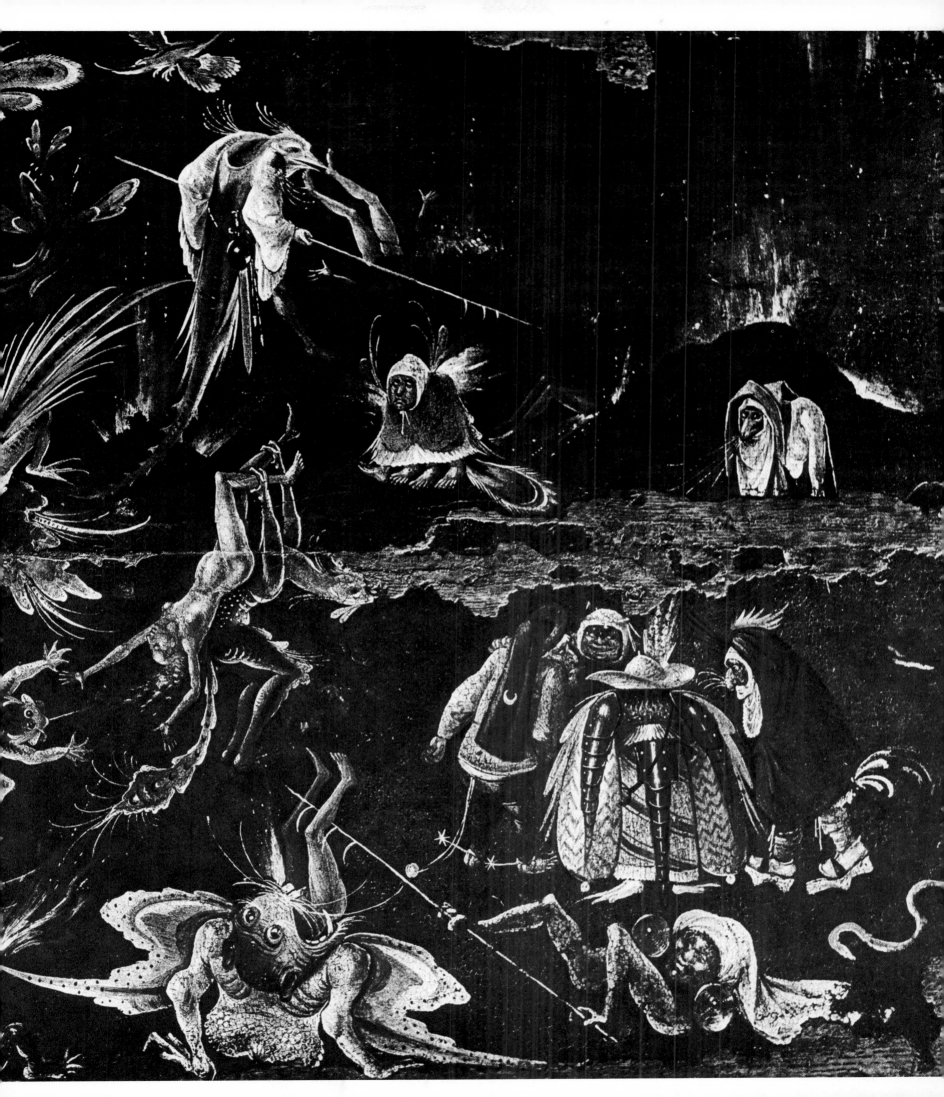

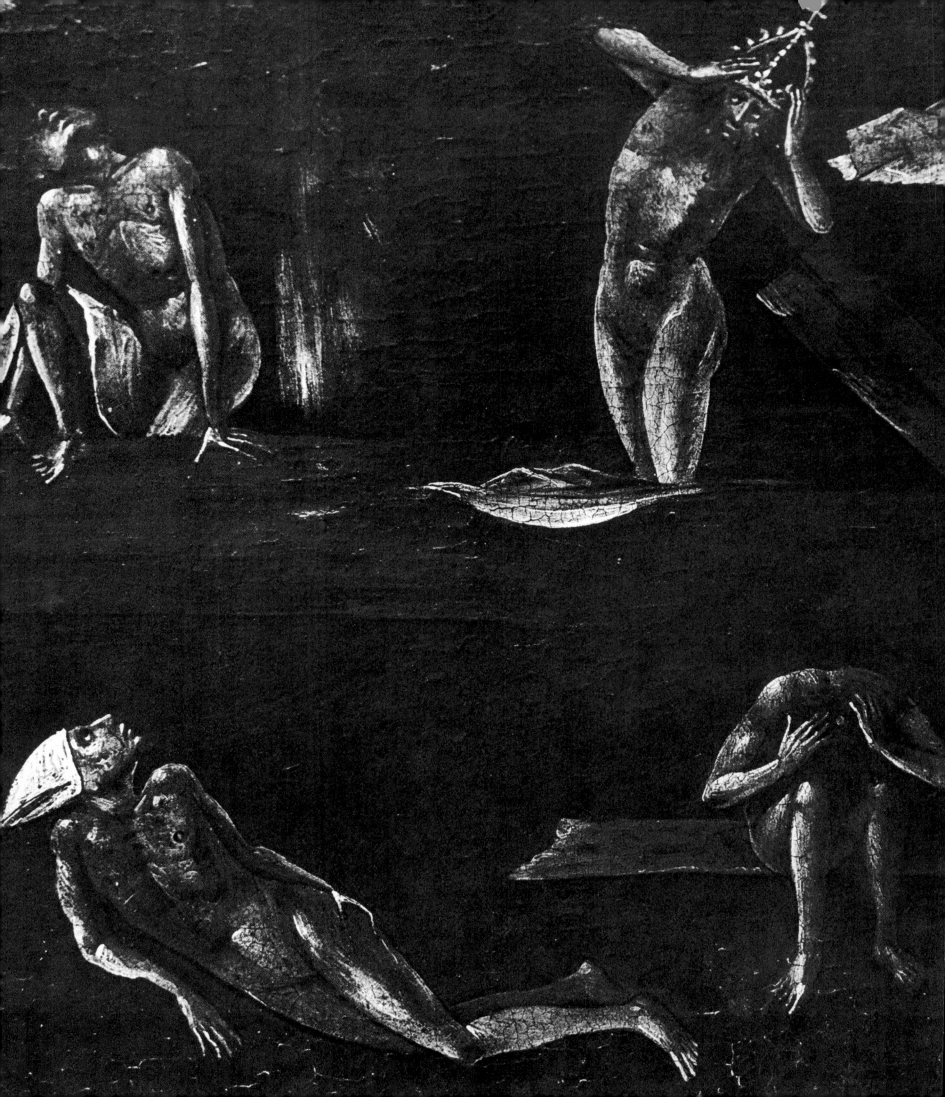

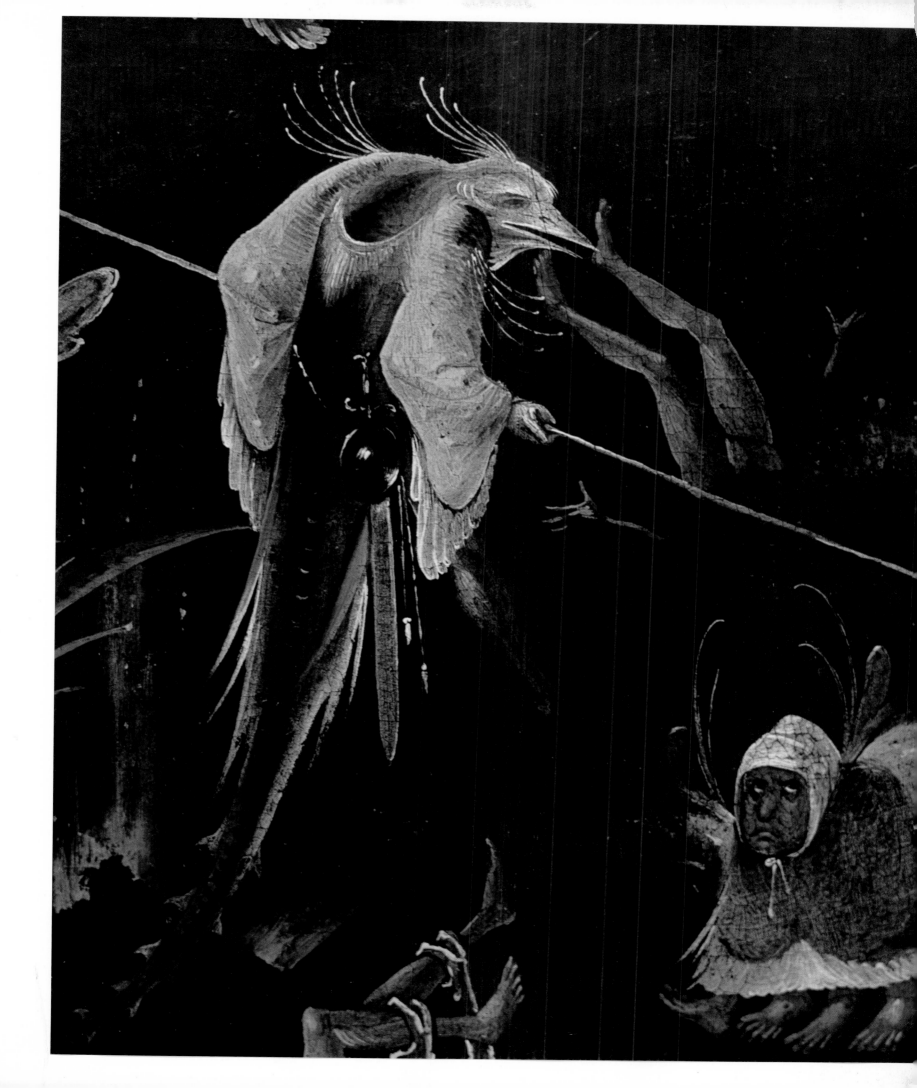

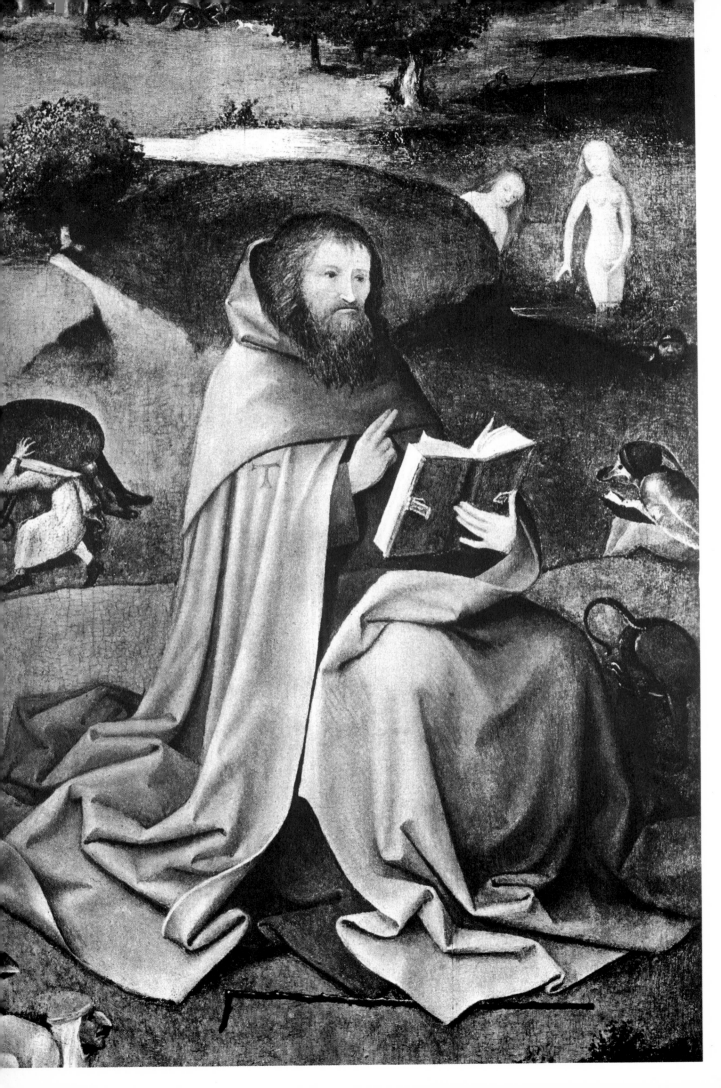

THE TEMPTATION OF ST ANTHONY

As Bosch revives the early medieval ascetic ideal at a time when the universality of nature could no longer be denied, he propounds an asceticism that can arise and come to maturity only in realization of the total insignificance of the world; in the purely human perspective, he thus anticipates the ideas of the Reformation.

NEW YORK,
WALTER P. CHRYSLEF.
COLLECTION.
Oil on wood.

ST JOHN ON PATMOS

The saint sits on raised ground, separated from the world by a hill; his deep meditation is rewarded by the apparition of the Virgin on the disc of the sun. Neither the demon that appears behind him, nor the disasters (a burning ship, a shipwreck and gallows) visible in the background landscape, can distract him from this consoling vision.

BERLIN-DAHLEM, GEMÄLDEGALERIE.

Height 63 cm, width 43.3 cm. Complete picture page 257; details pages 255, 258-259. Complete picture of reverse page 256; details pages 260-263.

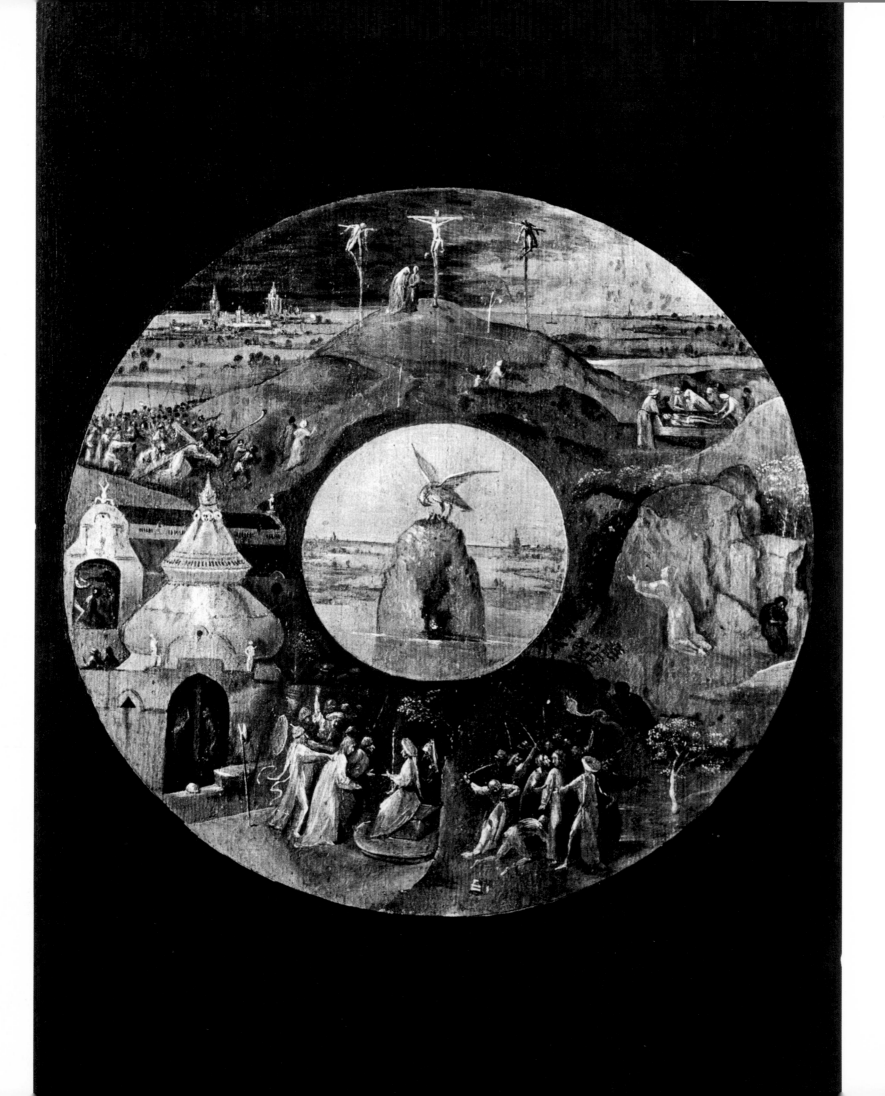

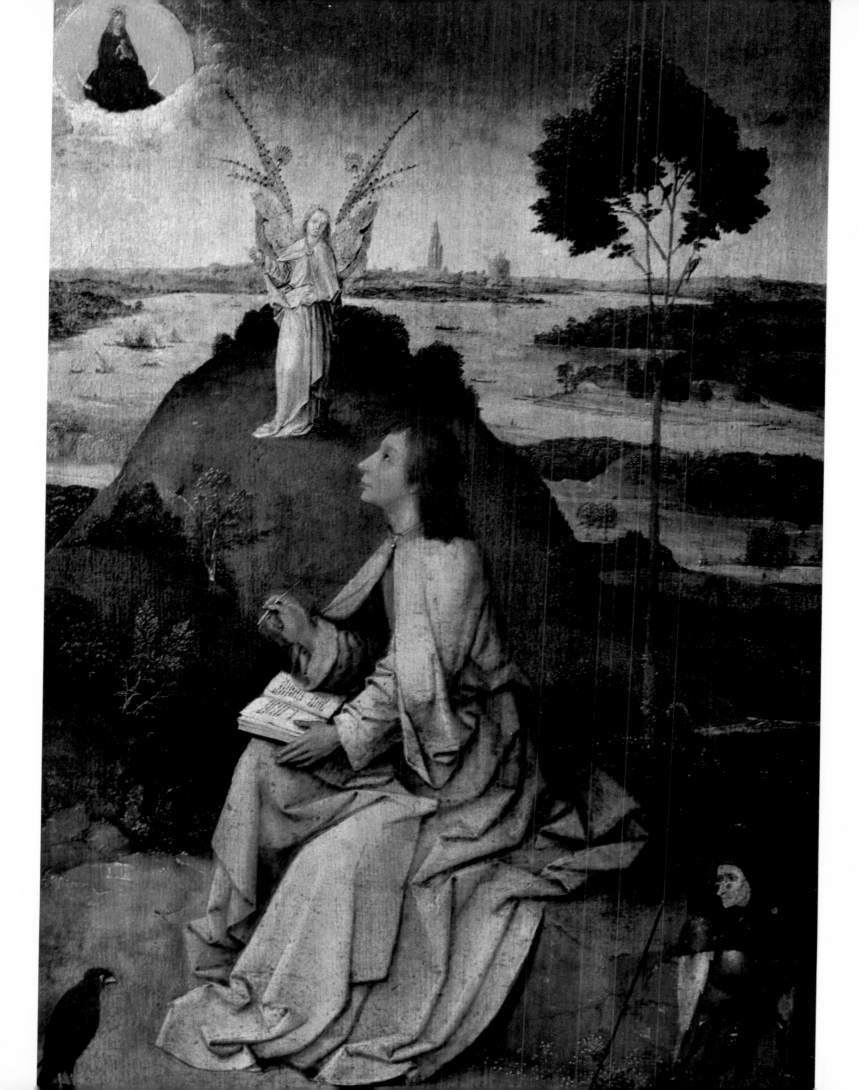

57

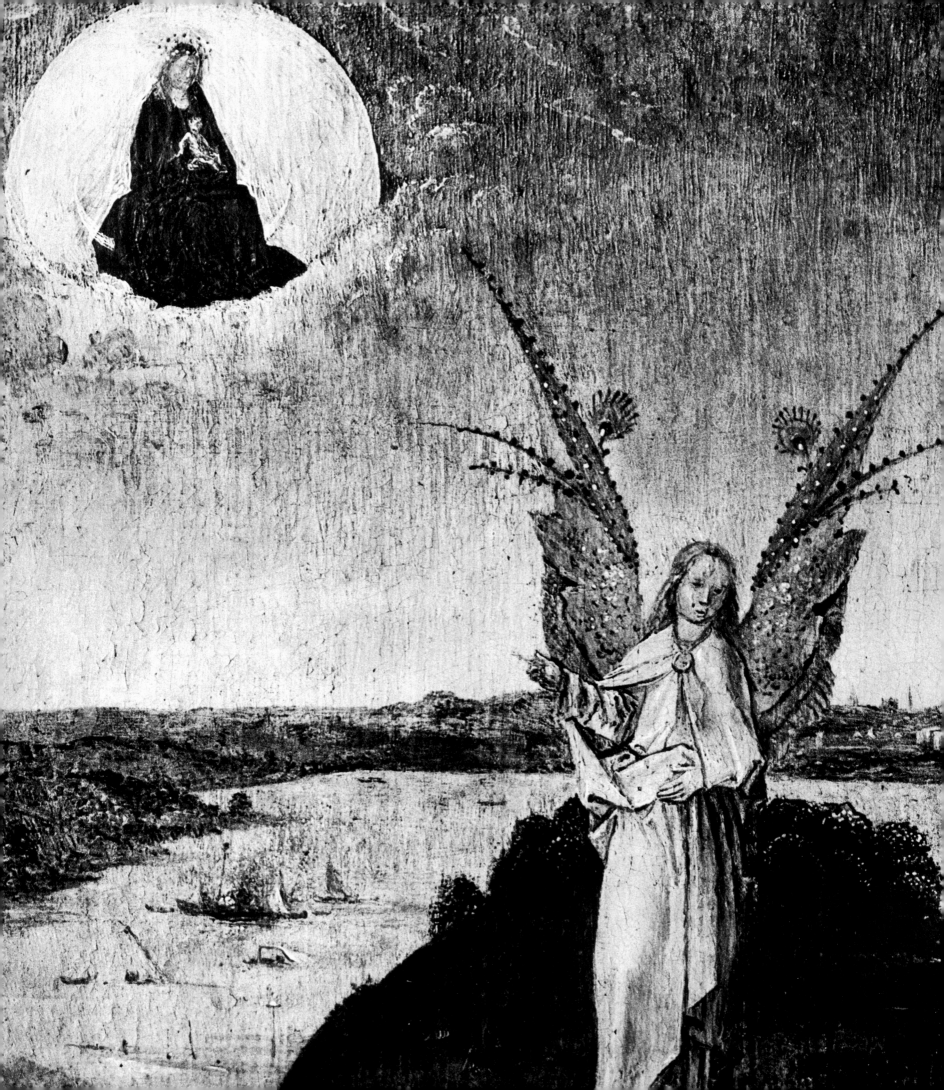

ST JOHN ON PATMOS (reverse)

On the reverse the terrestrial disc is seen floating in the night of the demon-populated universe. On its grey surface we see in sequence the Stations of the Passion: the cycle begins with the Mount of Olives and ends with the Sepulture. In the solitude of dusk a mother and her child, the last stragglers of the crowd, are hurrying home; abandoned by everyone, Mary and John remain.

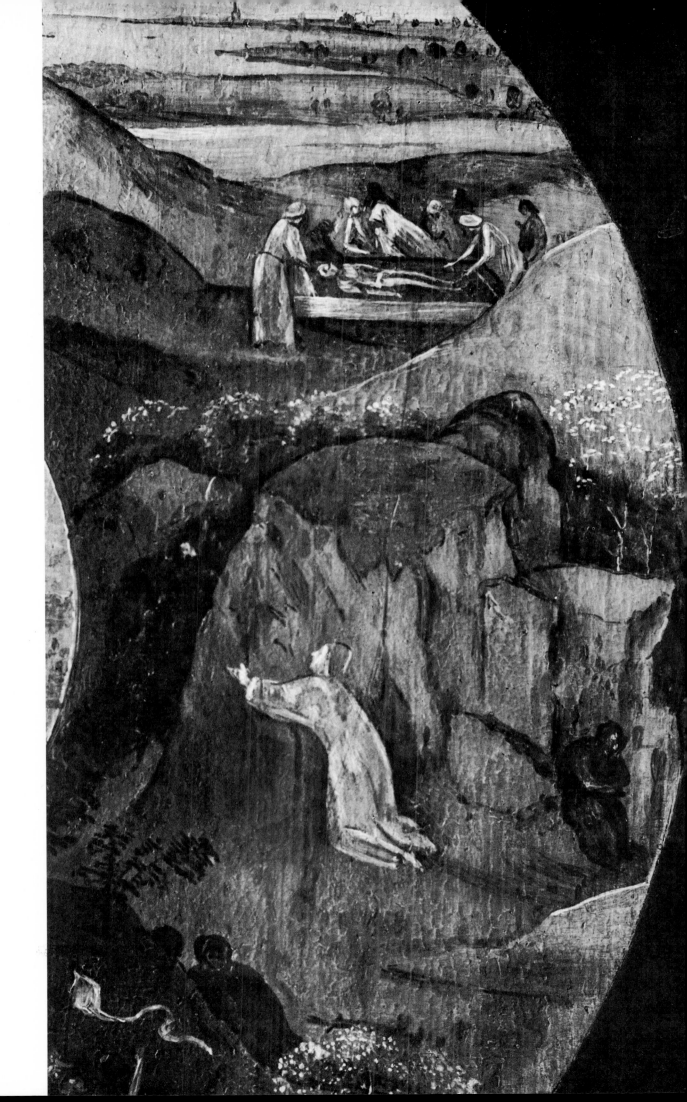

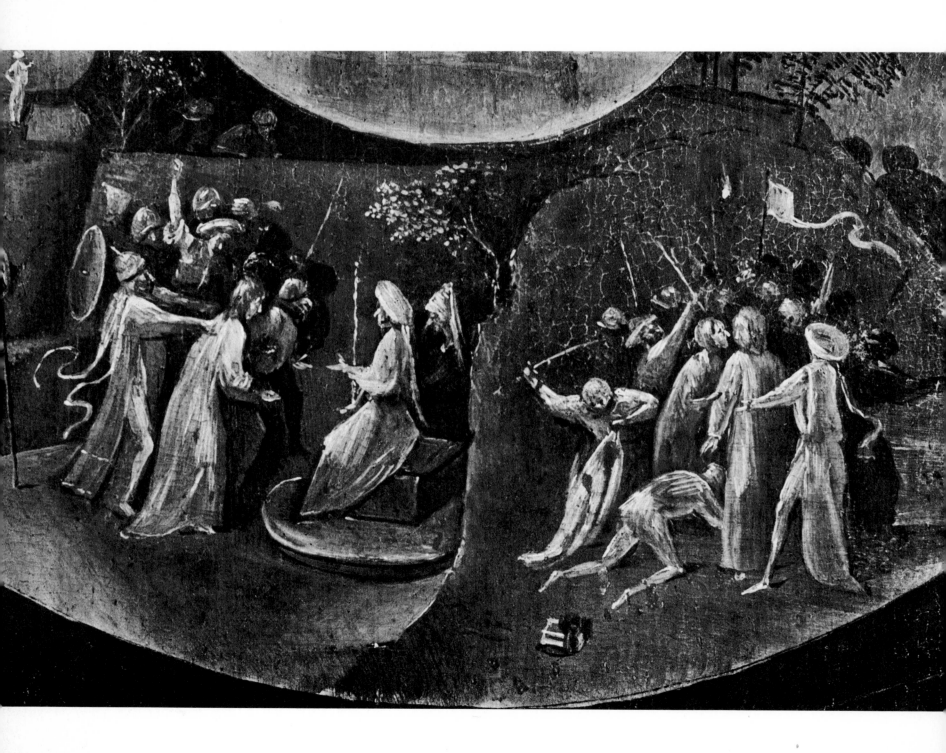

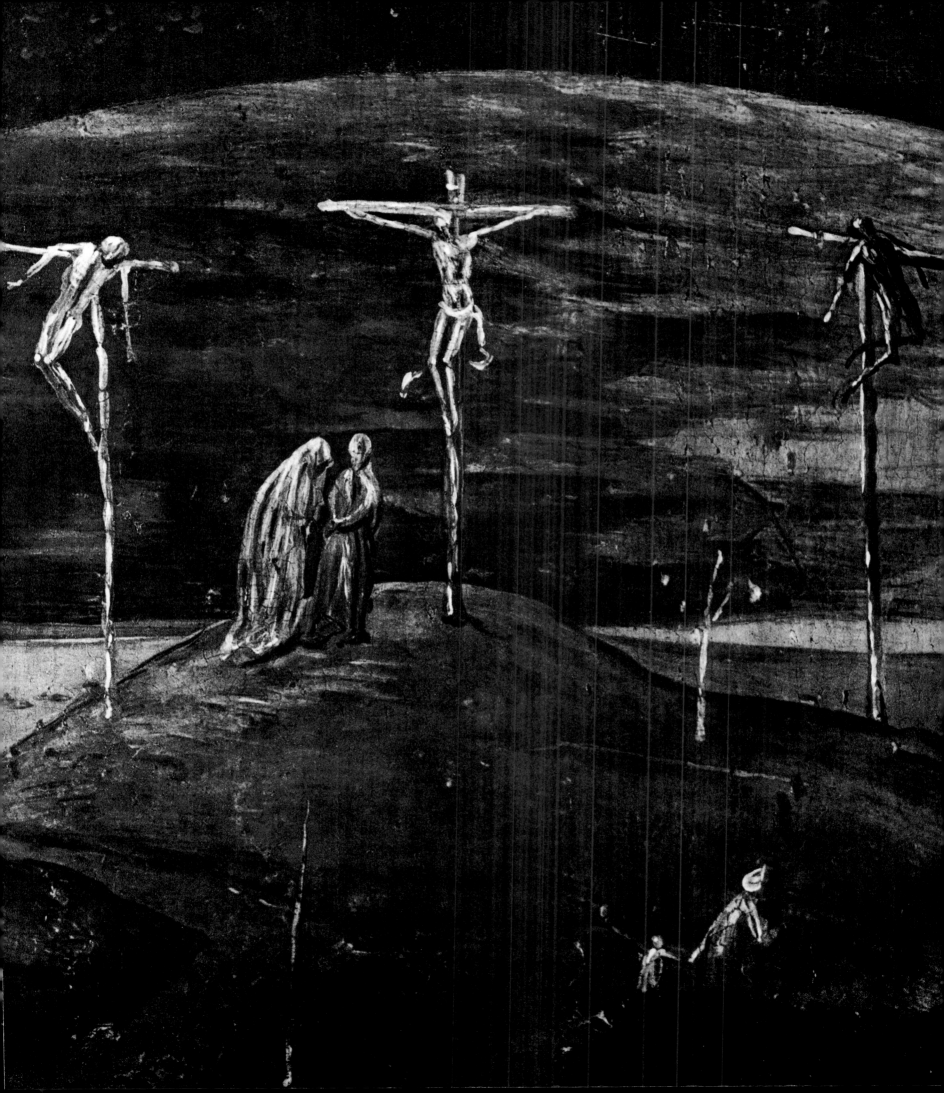

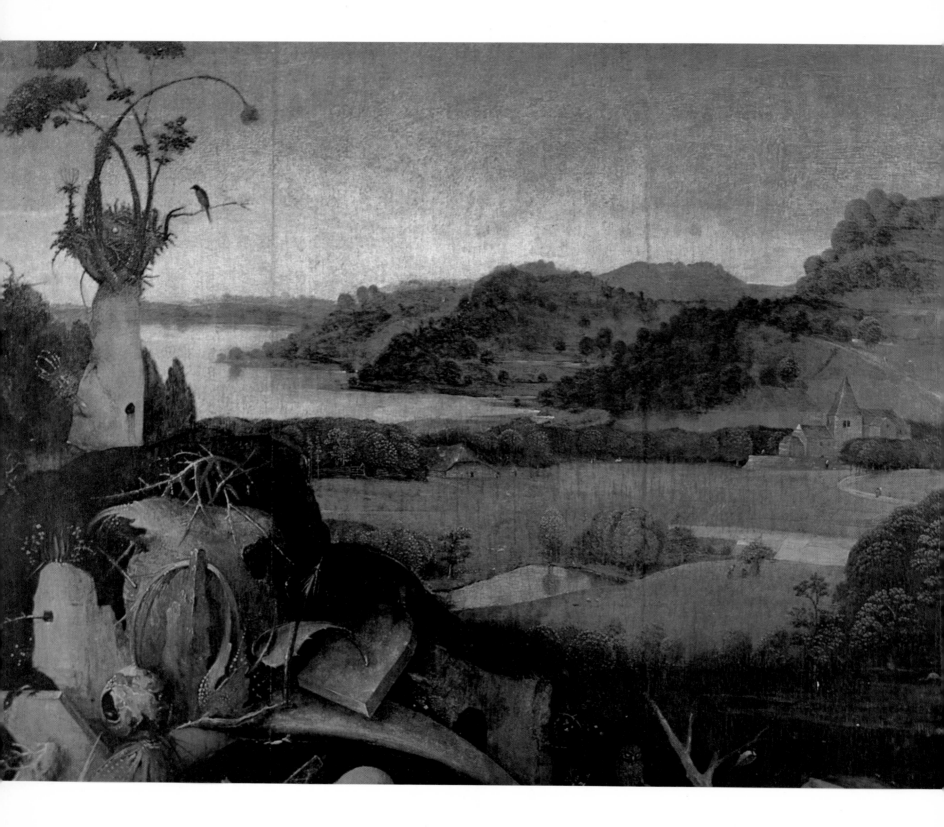

ST JEROME IN PRAYER

St Jerome is shown as an emaciated penitent. Half naked, with closed eyes, he has cast himself on the ground, and so great is his ardour that he actually enters into God: on the crucifix which he holds in his arms Christ is coming to life.

GHENT, MUSÉE DES BEAUX-ARTS.

Oil on wood. Height 77 cm, width 59 cm. Complete picture page 265; details pages 264, 266-267.

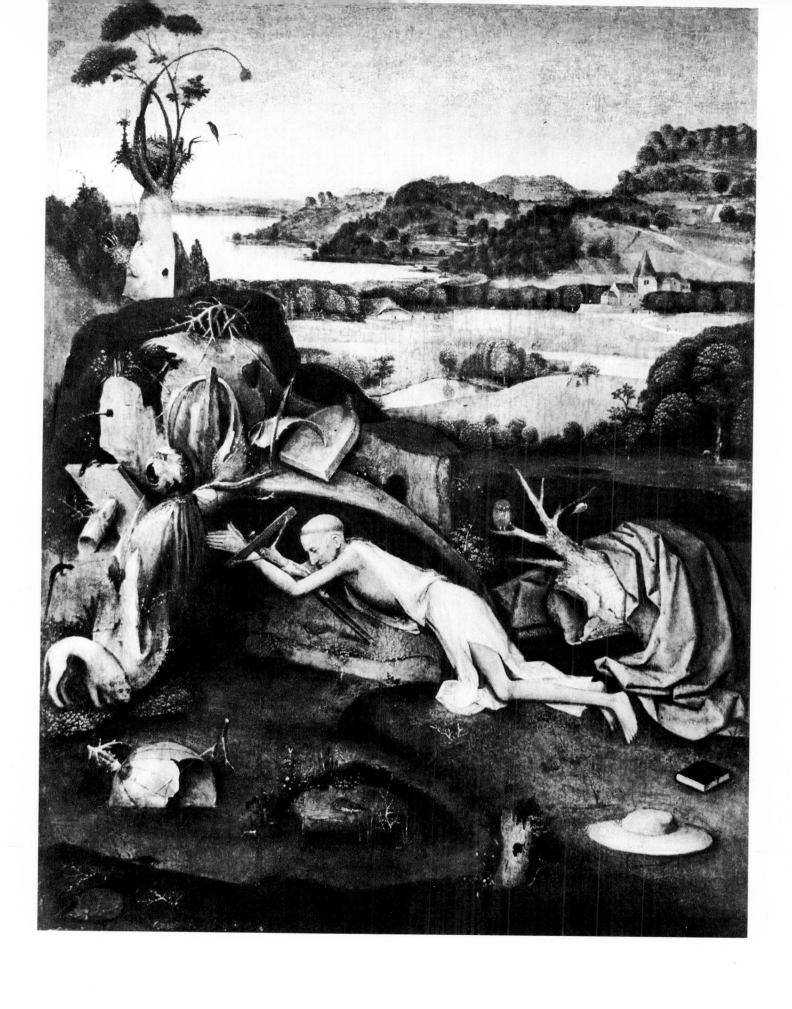

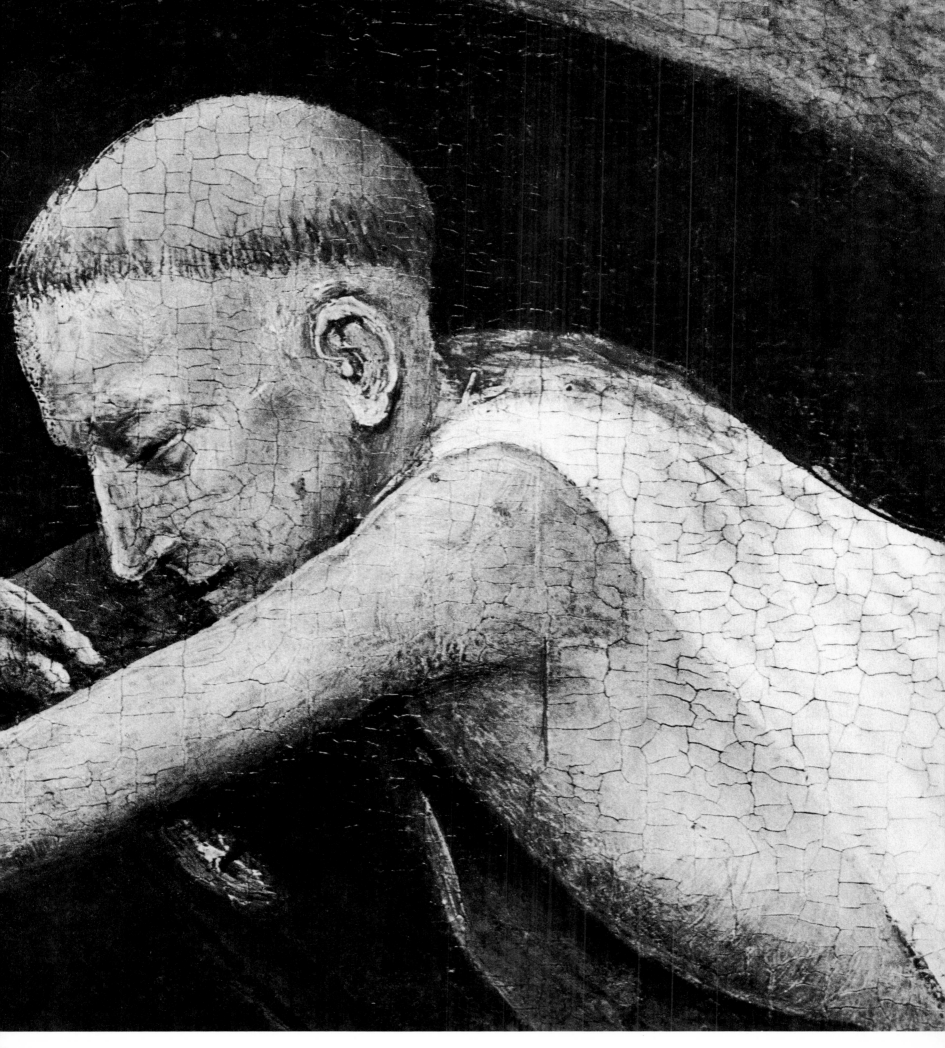

ALTARPIECE OF THE HERMITS

On the left wing is St Anthony, on the centre panel St Jerome and on the right wing St Giles: three hermits who for Bosch embody the three stages of the mystic exaltation of the soul. At night, as a fire breaks out in the village, St Anthony moves like a sleepwalker towards the marsh, to draw water and still his thirst; at this moment there emerge all around him the images of his lusts and his bad conscience.

St Jerome is seen kneeling before an ancient marble throne in the ruins of a pagan temple; emaciated, mirroring in his features all the tension of his spirit, he is not praying but warding off the contradictory visions that illustrate the drama of his inner life.

Well-being in this life and community with God are the themes of the St Giles panel. In a grotto that serves him as a chapel, a tame deer at his feet, the saint is praying, not using the book which lies unopened before him. He is praying for the salvation of all sinners; the long list of those whom the saint has aided by his intercession can be read on a roll of parchment before him.

VENICE, PALACE OF THE DOGES.

Oil on wood. Height 86.5 cm, width 60 cm; width of each wing 29 cm. Complete picture on facing page. Details from centre panel pages 270-272.

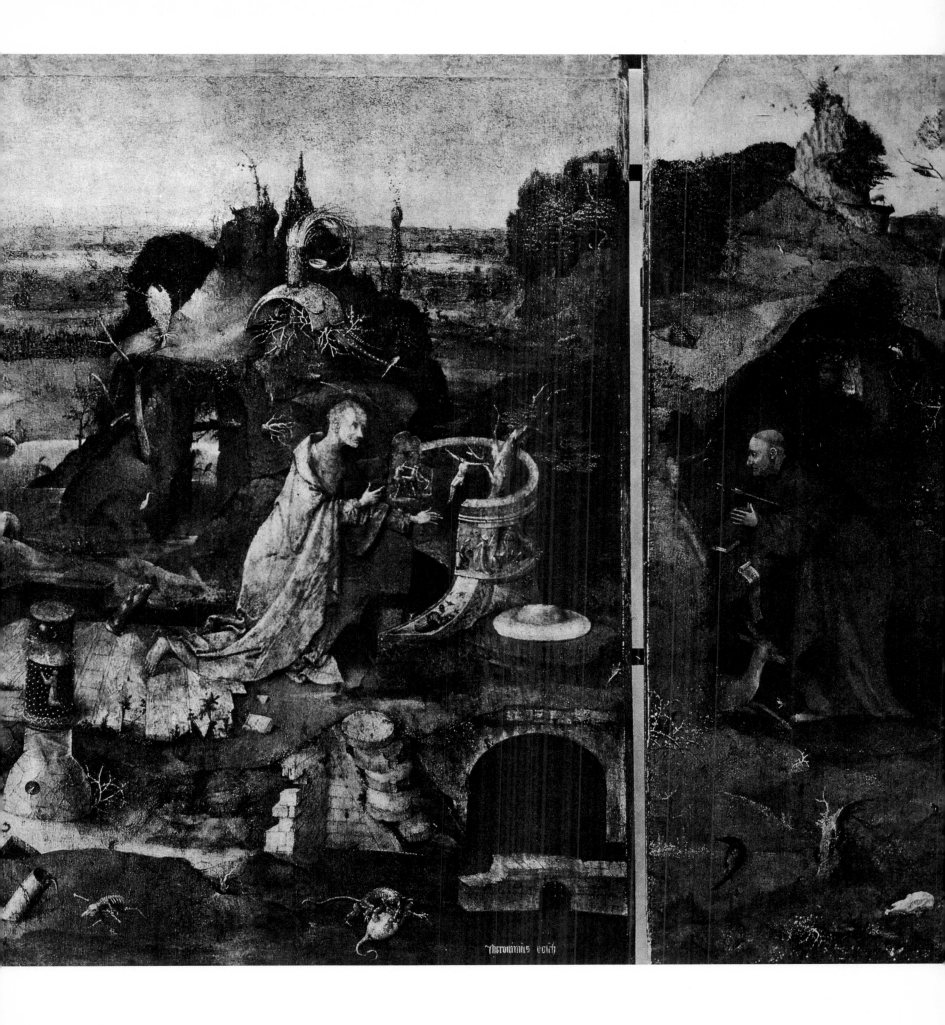

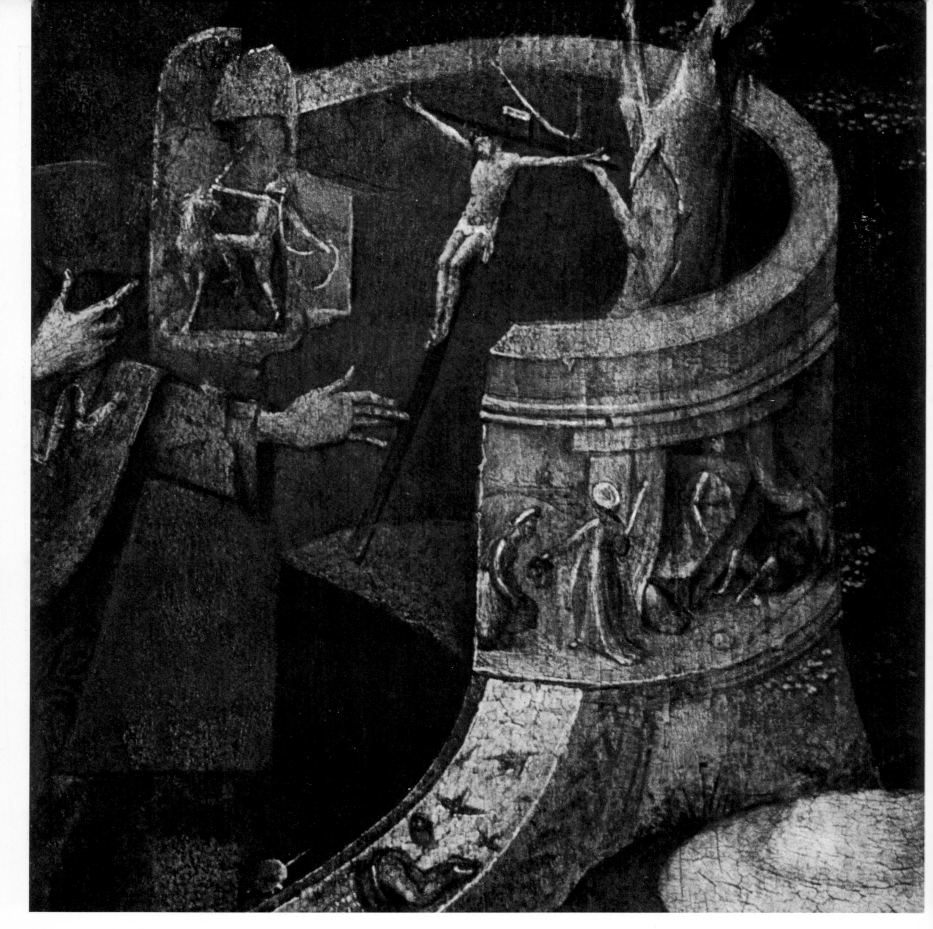

ST JOHN THE BAPTIST IN THE WILDERNESS

Resting one elbow on a rock, his eyes half closed, the ascetic seems to be dreaming the existence of the fabulous plant – the symbol of carnal joys – that is shooting up before him like the root from the breast of Jesse, and the Lamb to which his finger is unconsciously pointing. In this way the painter once again shows the saint faced with the alternative of the good and the evil path.

MADRID, MUSEO LAZARO GALDIANO.

Oil on wood. Height 48.5 cm, width 40 cm. Plate on facing page.

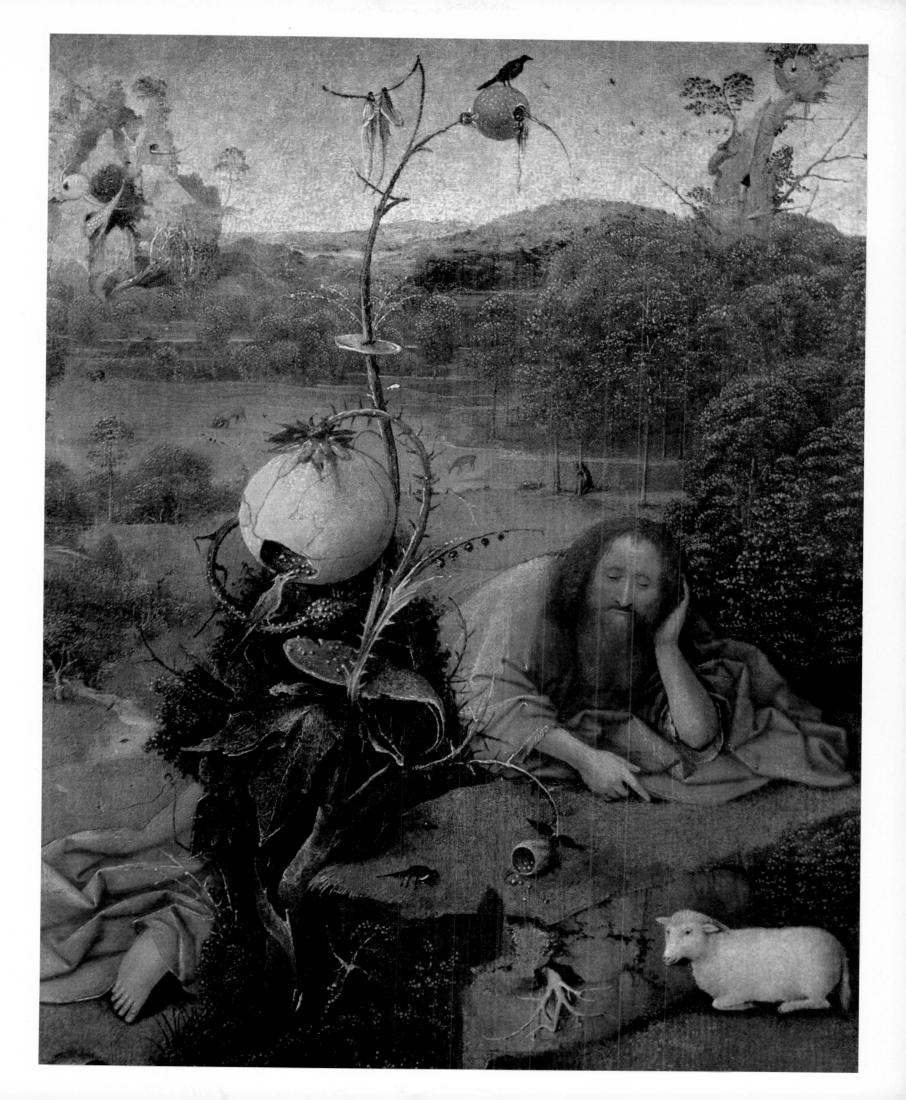

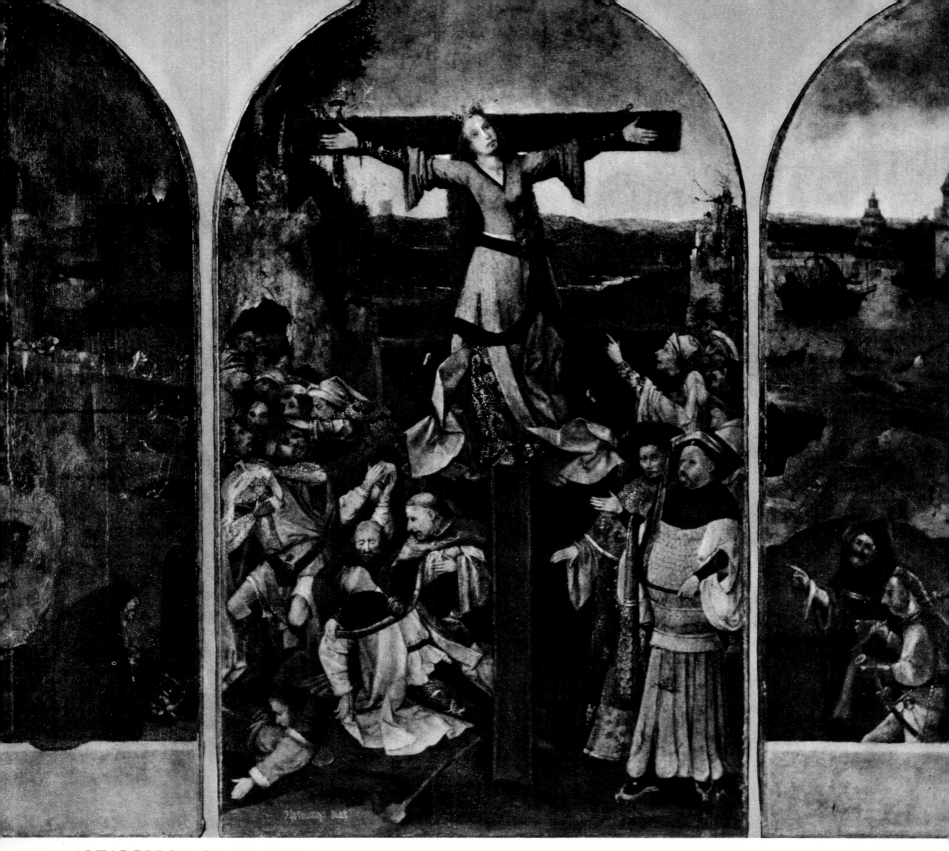

ALTARPIECE OF ST JULIA

The figure of St Julia on the cross dominates the composition of all three panels. Her red robe flutters like a banner in the wind. The strength that her sanctity lends her radiates from the cross and strikes the dense throng at her feet like a thunderbolt; the governor and the pot-bellied notables are all the more dumbfounded because the heretics, utterly dismayed, are covering their faces, taking to flight or falling unconscious. The landscapes of the two wings are further depictions of the evil world. The two figures in the foreground of the right wing are probably the slave-dealers who, according to legend, sold the saint to Eusebius. The memory of a night of terror still weighs heavily upon the pale grey dawn.

VENICE, PALACE OF THE DOGES.

Oil on wood. Height 104 cm, width 63 cm; width of each wing 28 cm. Details from centre panel pages 275-277.

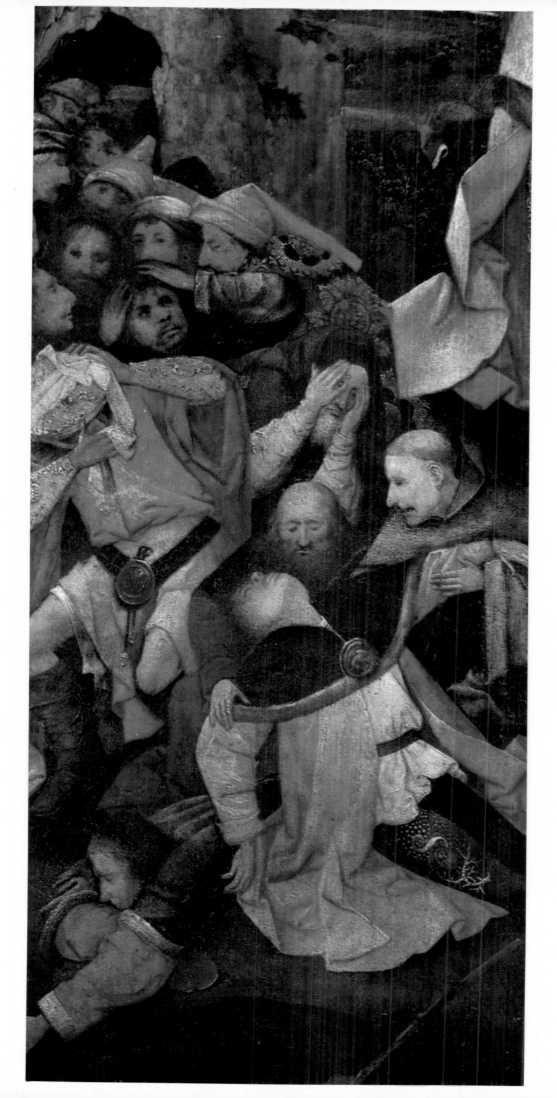

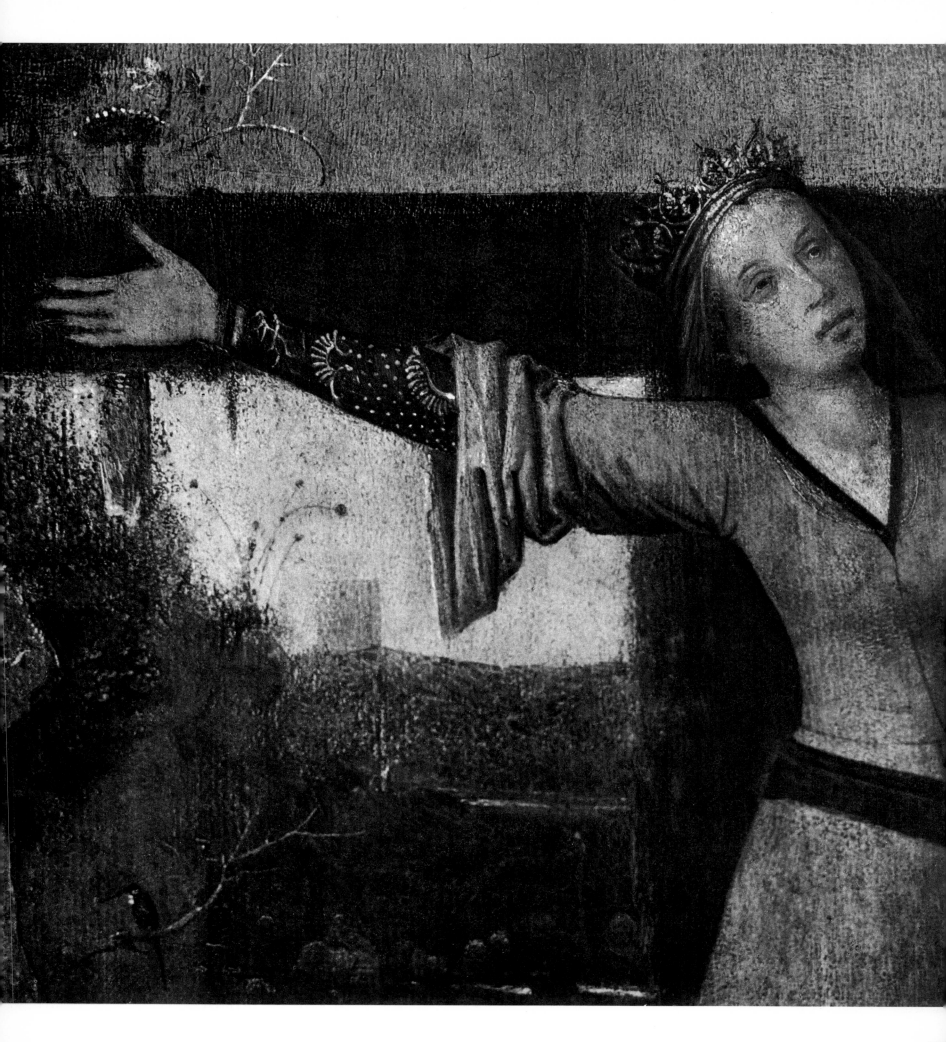

77

ST CHRISTOPHER

The saint, bowed down by his burden, is striding through the river with his knees bent and clutching the curving staff with both hands. Christ presses down on his shoulders as if with the weight of the world; the artist has not placed the Child directly on the saint's shoulders, but has made Him float above them – a spiritual burden that the saint has taken upon himself by his conversion. In the background the hypocritical hermits are feasting on meat and honey from an enormous jar; in contrast to them, the large fish dangling from the saint's staff symbolizes his conversion and fasting.

ROTTERDAM, MUSEUM BOYMANS-VAN BEUNINGEN.

Oil on wood. Height 113 cm, width 71.5 cm. Complete picture page 281; details pages 278-280.

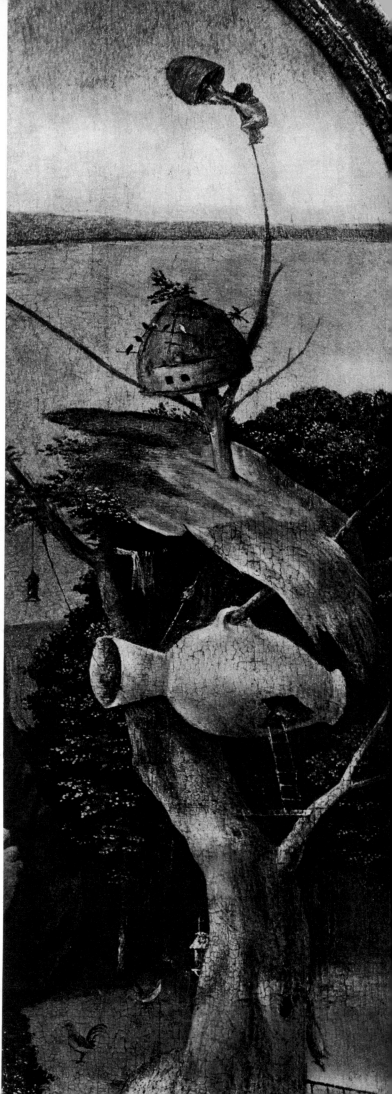

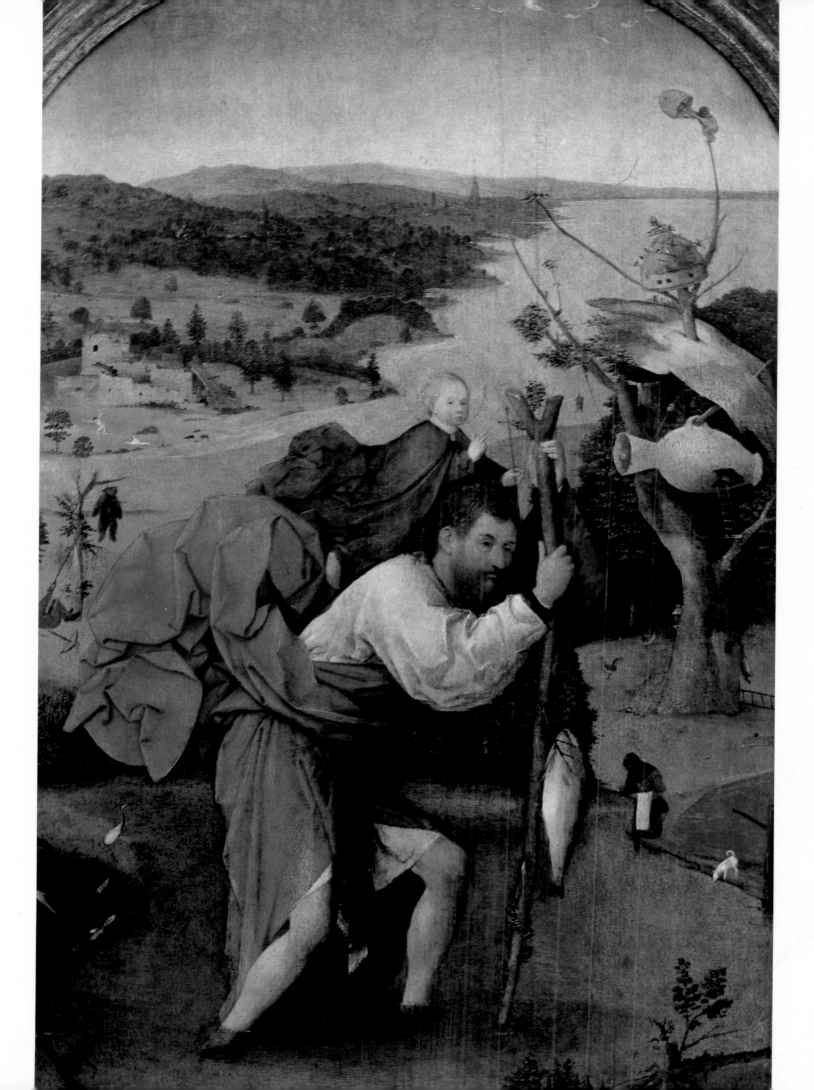

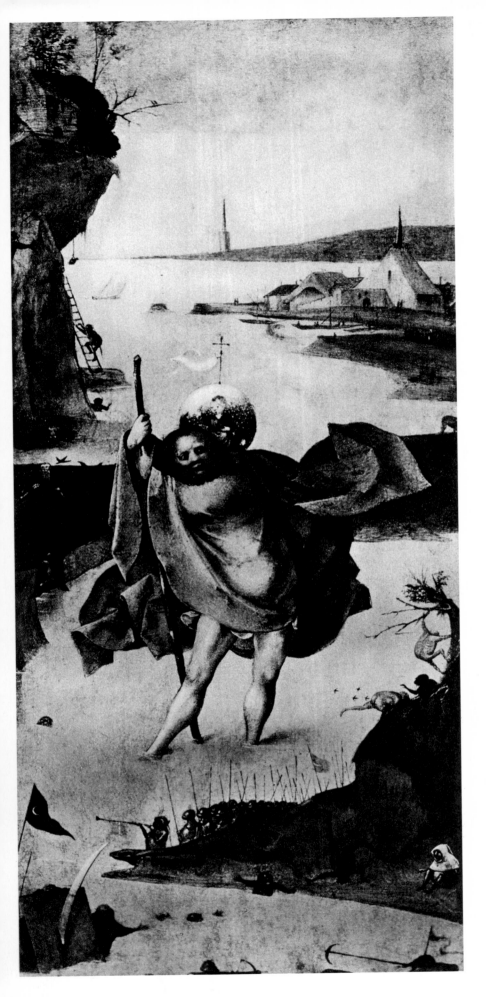

ST CHRISTOPHER

Oil on wood. Height 45 cm, width 20 cm.

THE PRODIGAL SON

In the soul of the Prodigal Son will and instinct are in conflict. He has to choose between debauchery and virtue. The White Swan inn, with its jug and its gable, threatens to hold him back. At the very moment when he is about to pass through the gate into his father's pasture, his injured foot slows his step. With a hesitant hand, in which he holds his Sunday hat, he points to the right path; from the front of his jacket hangs a good luck charm, a pig's foot. But attached to the ragpicker's basket on his back are a wooden spoon, the symbol of wastefulness, and a cat's skin, in folklore a bringer of misfortune. The evil symbols point to the left, where the house of ill repute stands, the good symbols to the right, to his father's lands.

Oil on wood. Diameter 71.5 cm. Complete picture page 283; details pages 284-285.

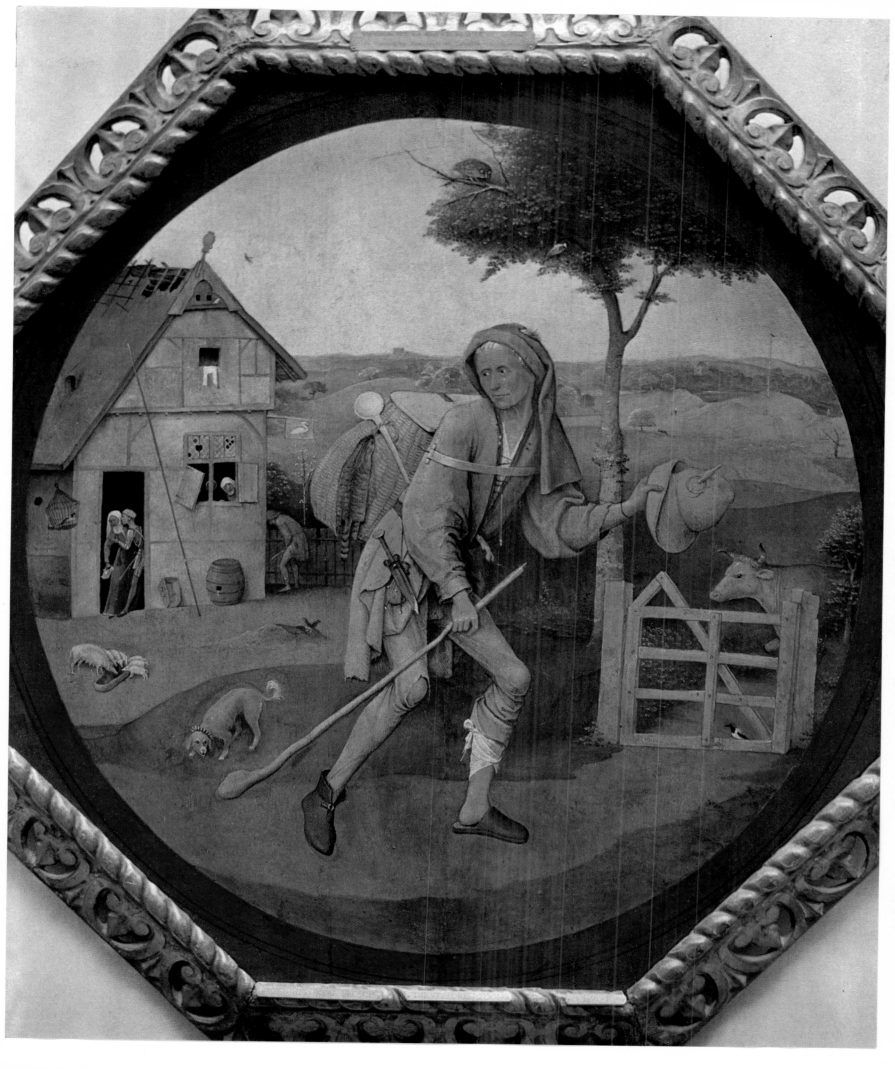

83

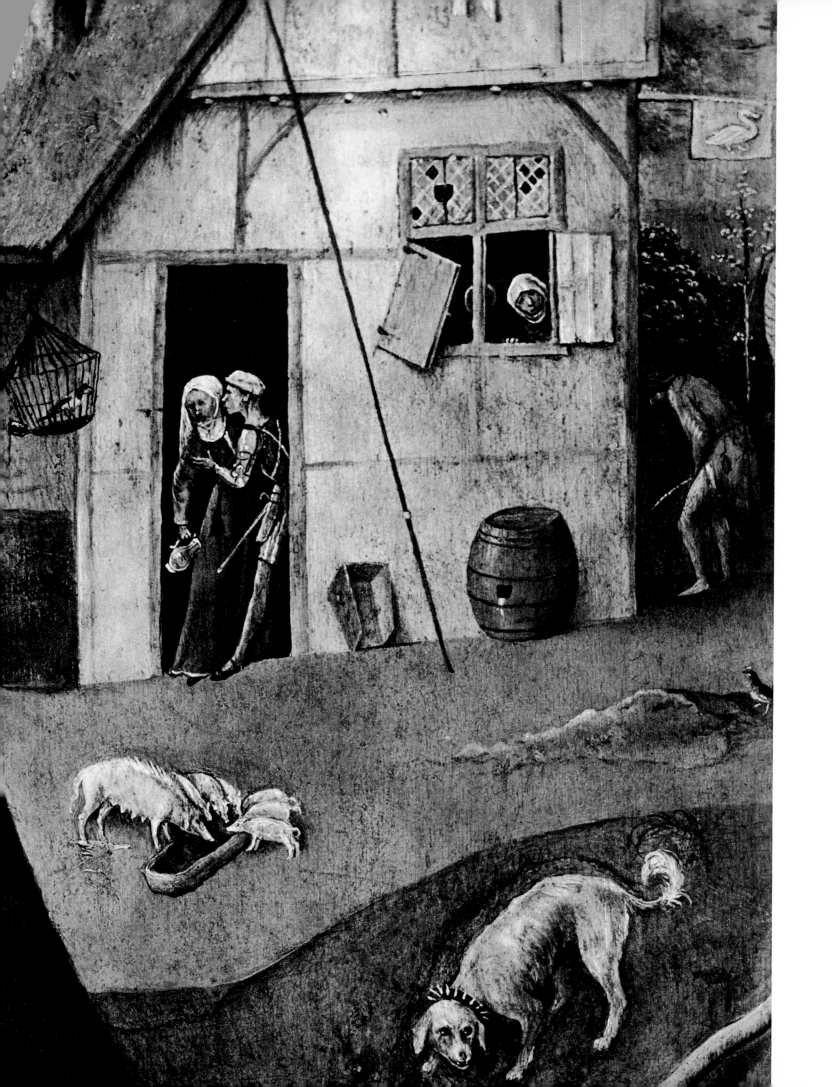

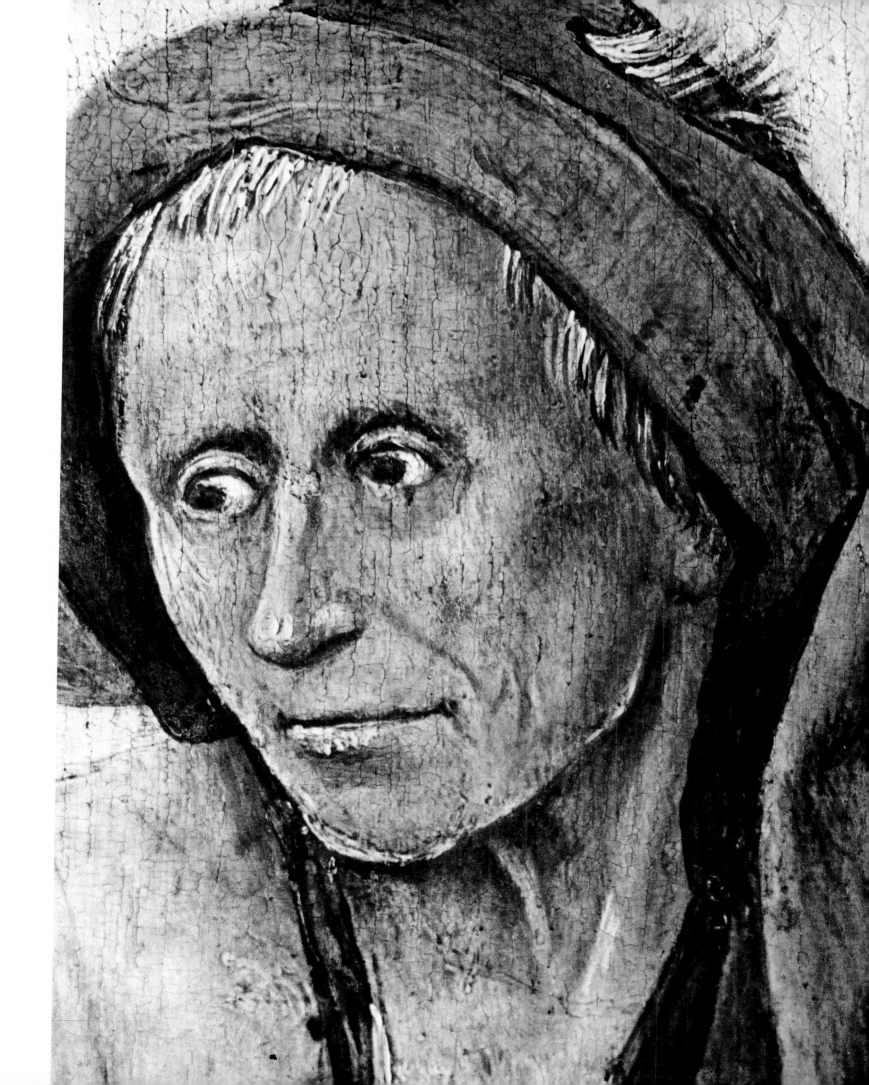

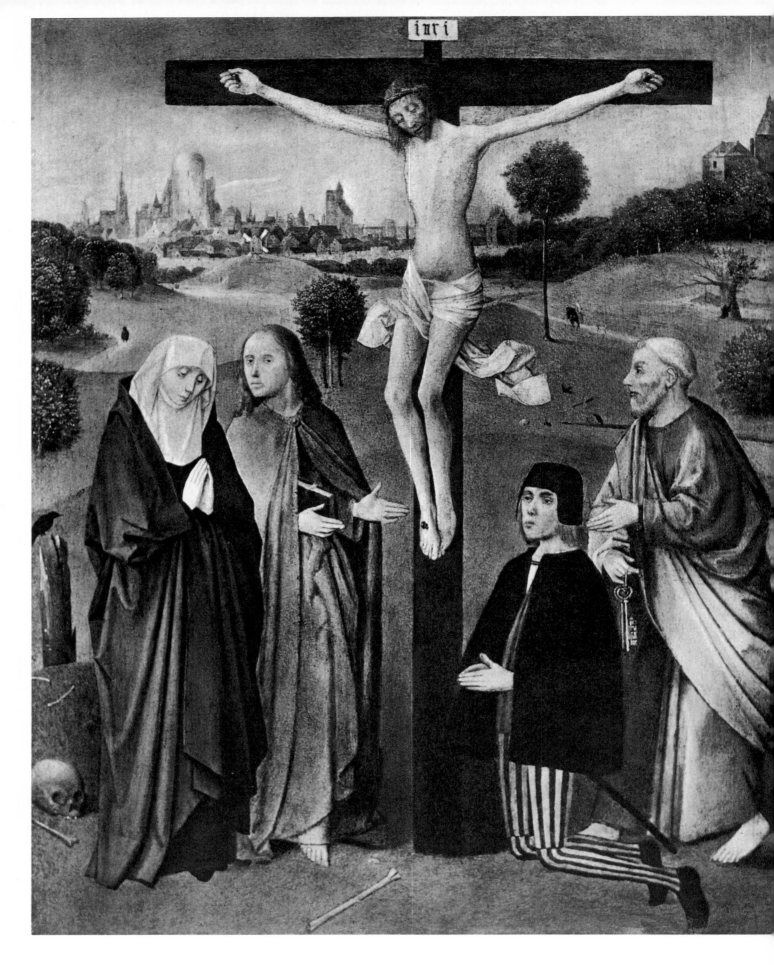

THE CRUCIFIXION

BRUSSELS, MUSÉES ROYAUX DES BEAUX-ARTS.
Oil on wood. Height 70.5 cm, width 59 cm. Complete picture above; details pages 287-289.

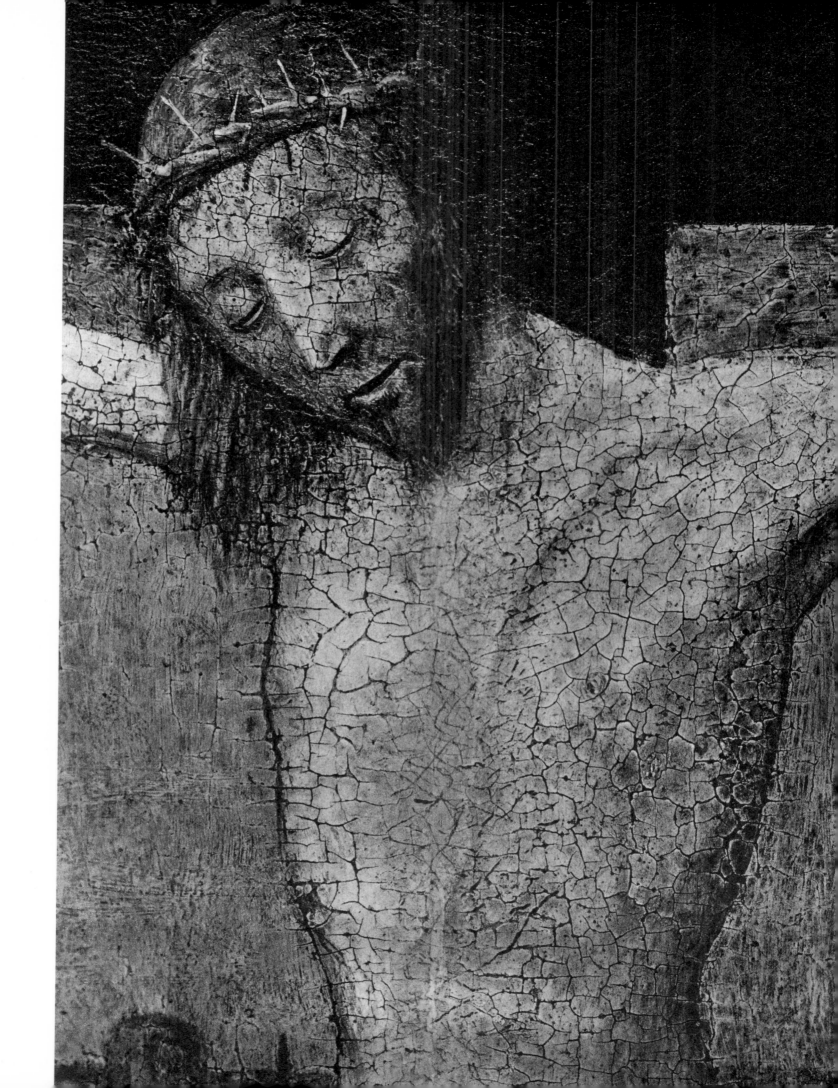

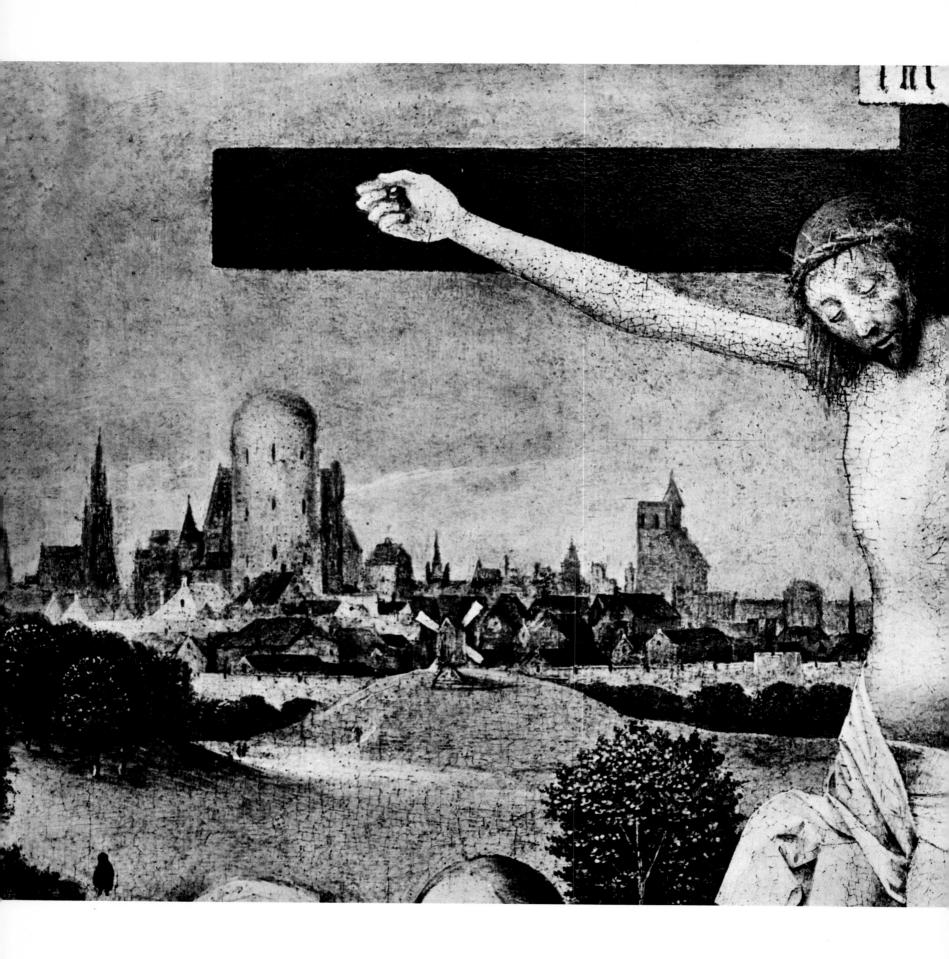

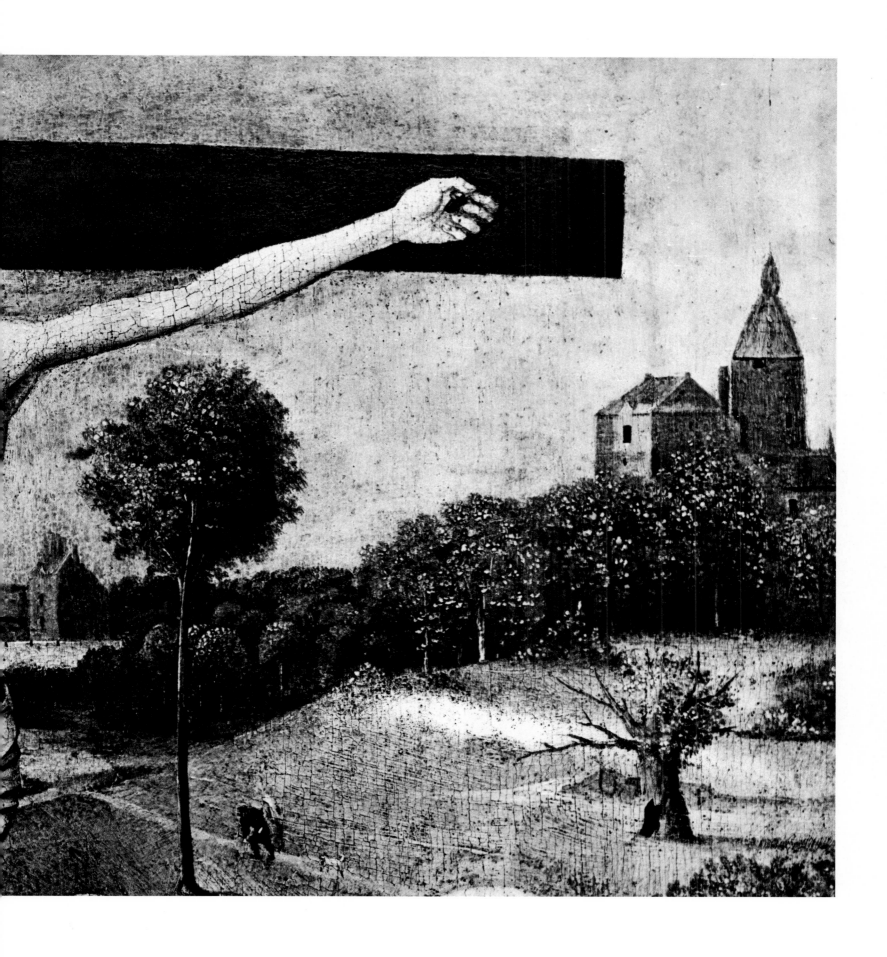

89

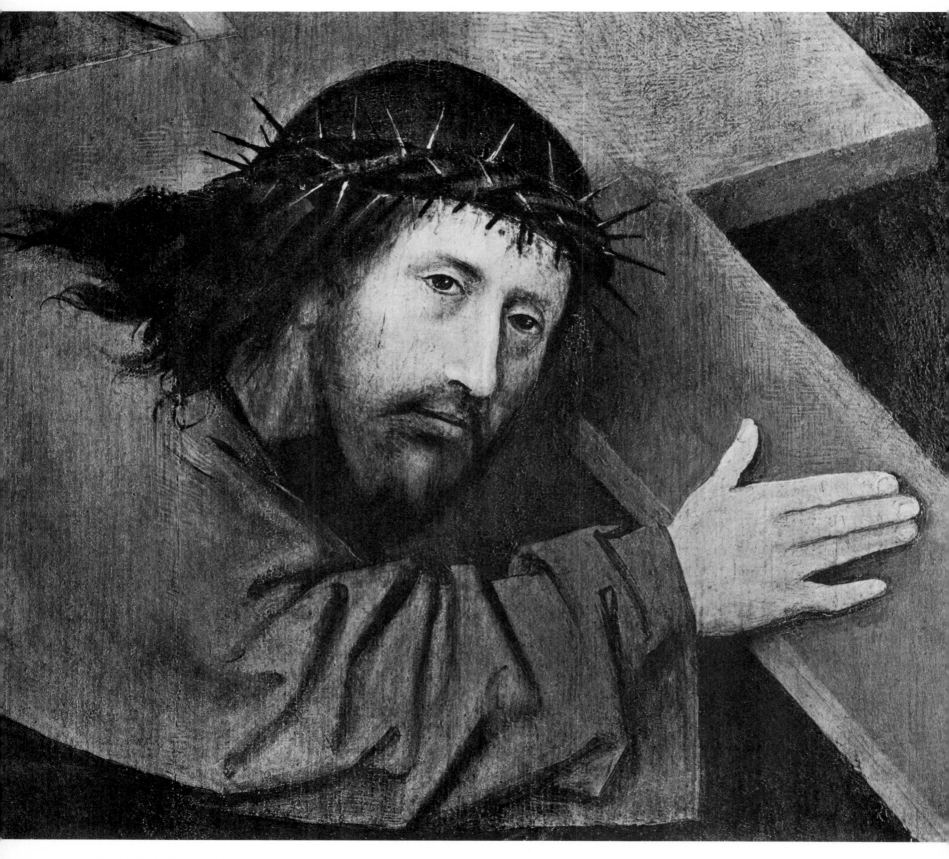

CHRIST CARRYING THE CROSS

A cross of unusual size weighs heavily upon the Saviour, and yet it is not this burden which afflicts Him. His questioning gaze is directed towards the spectator and calls him to account for his association with the executioners and traitors. These become the principal actors in the drama, in which the spectator, identified with them, takes part directly.

MADRID, ROYAL PALACE.

Oil on wood. Height 150 cm, width 94 cm. Complete picture on facing page; detail above.

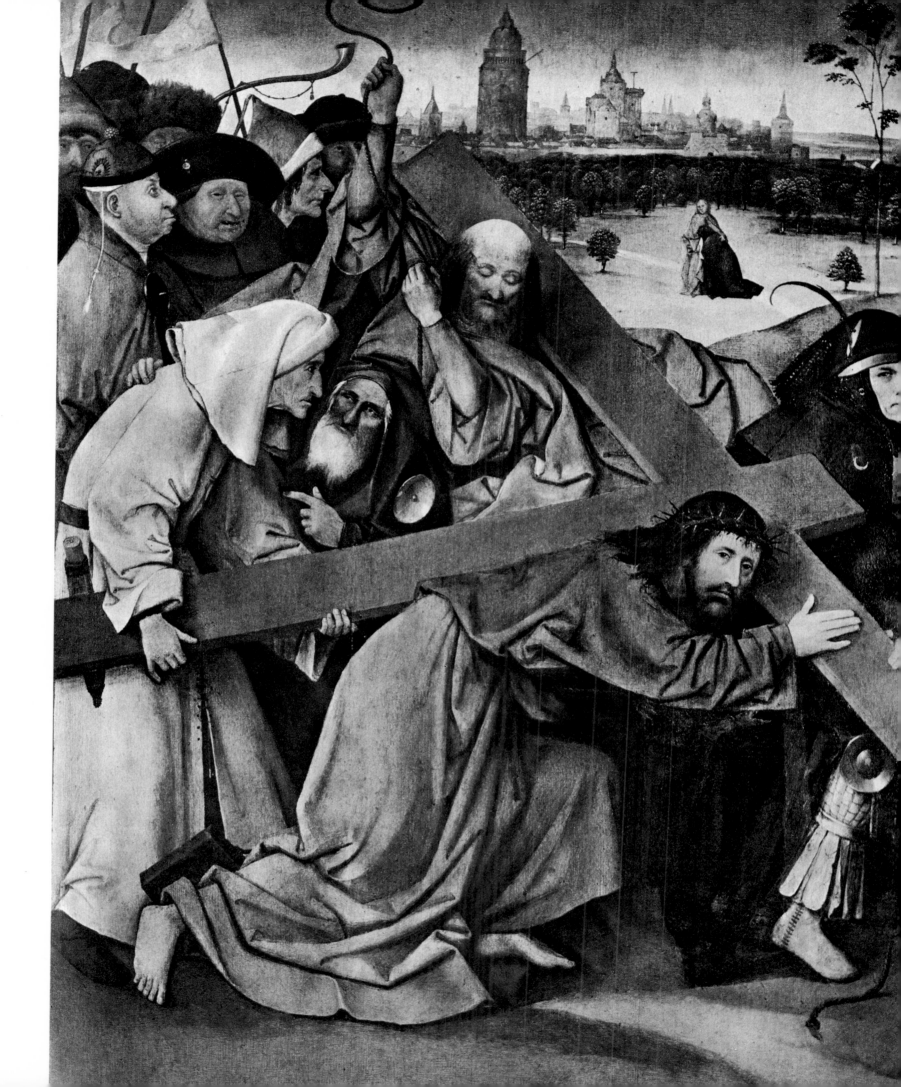

THE ADORATION OF THE SHEPHERDS

COLOGNE, WALLRAF-RICHARTZ MUSEUM.
Height 66 cm, width 43 cm. Complete picture on facing page; detail above and page 294.

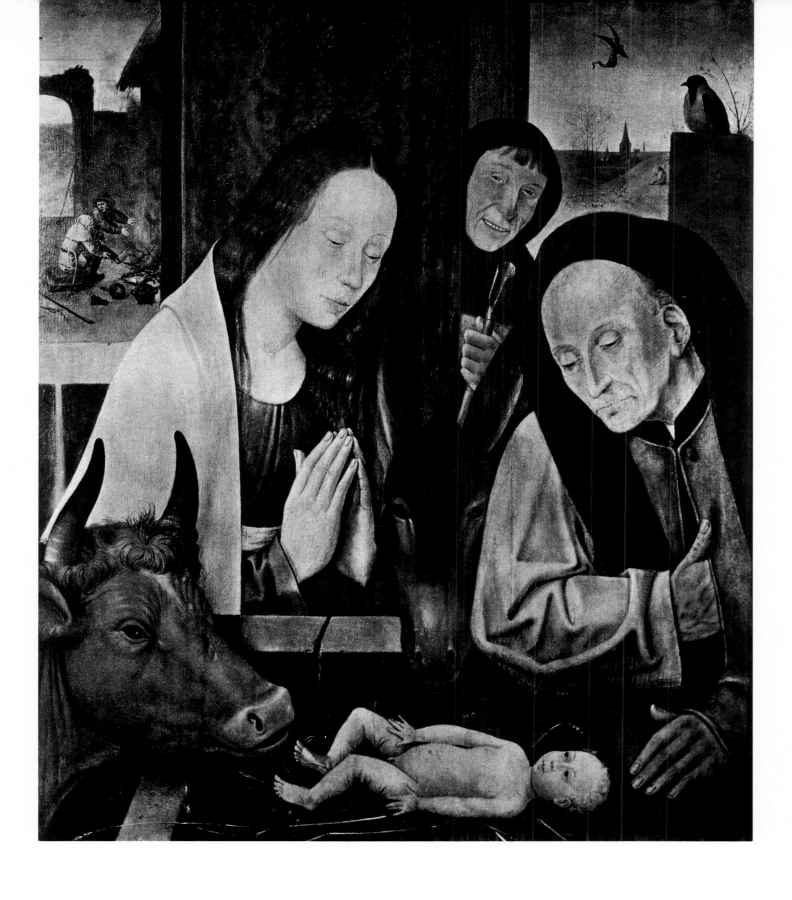

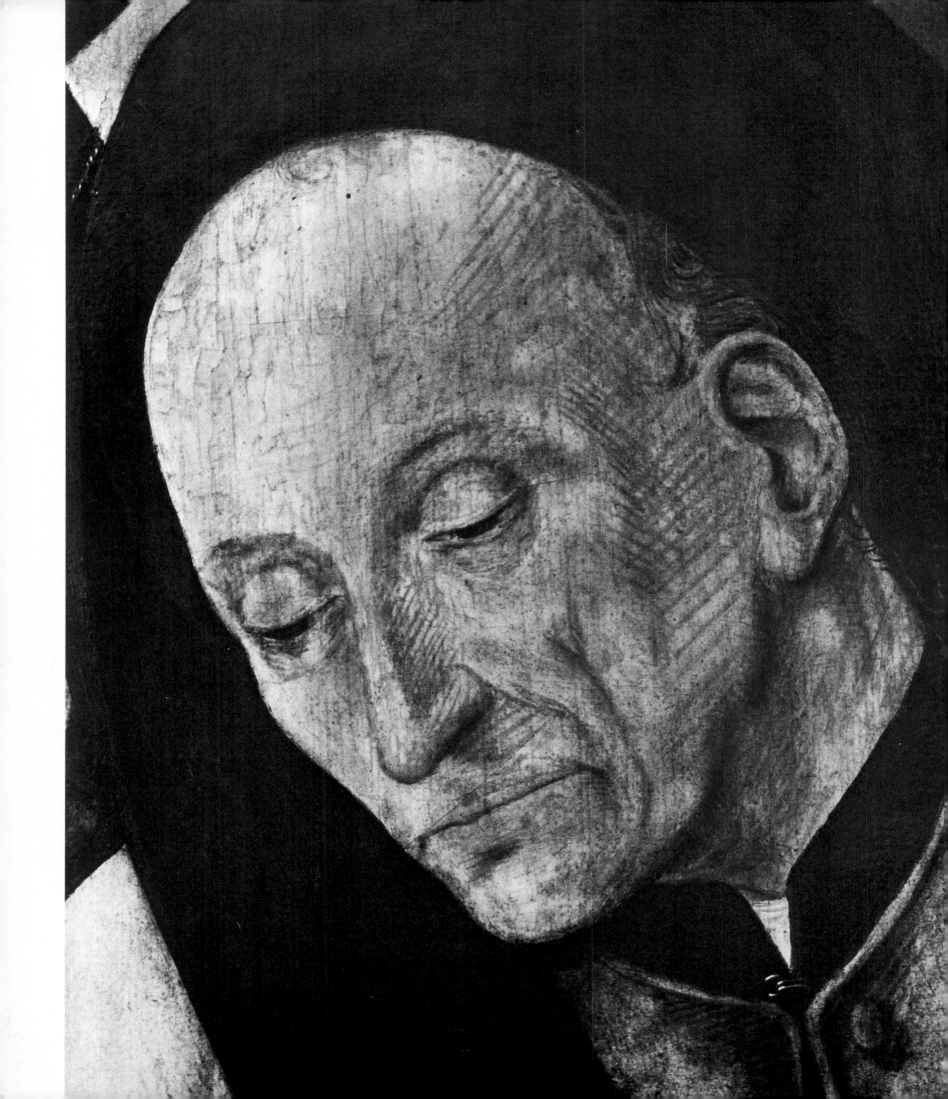

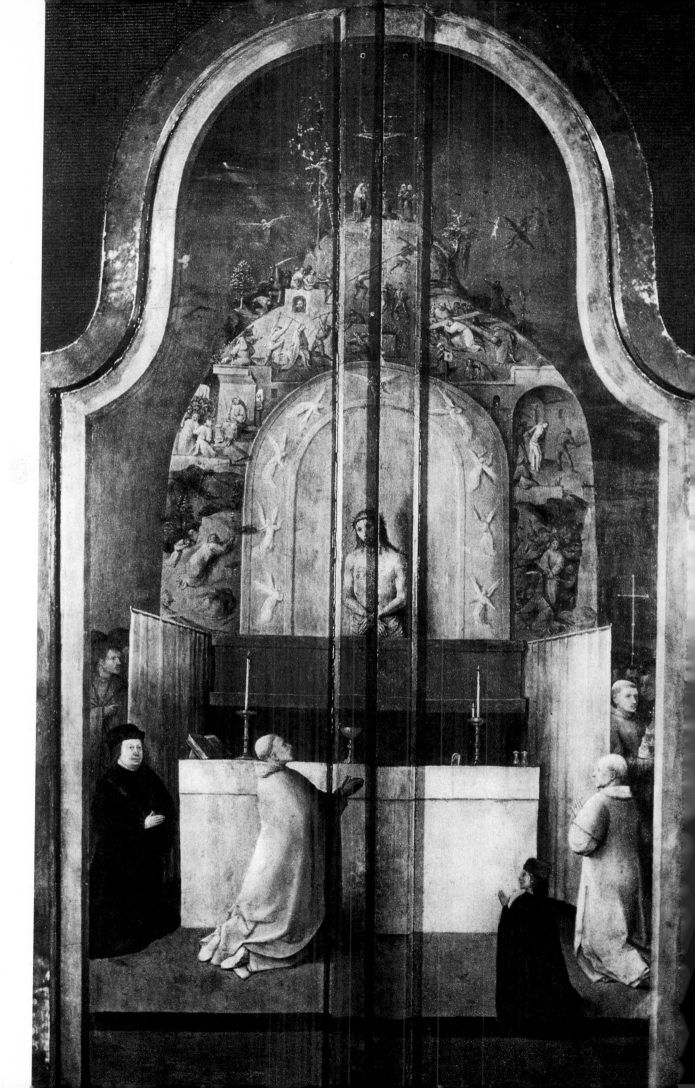

THE ADORATION OF THE MAGI
(EPIPHANI: altarpiece closed)

The mass of St Gregory on the outer side of the wings shows the saint kneeling, deep in prayer before an altar with painted scenes giving the illusion of depth, which come to life for him.

MADRID, MUSEO DEL PRADO.
Grisaille.

Oil on wood. Height 138 cm, width 72 cm; width of each wing 33 cm. Plate on this page.

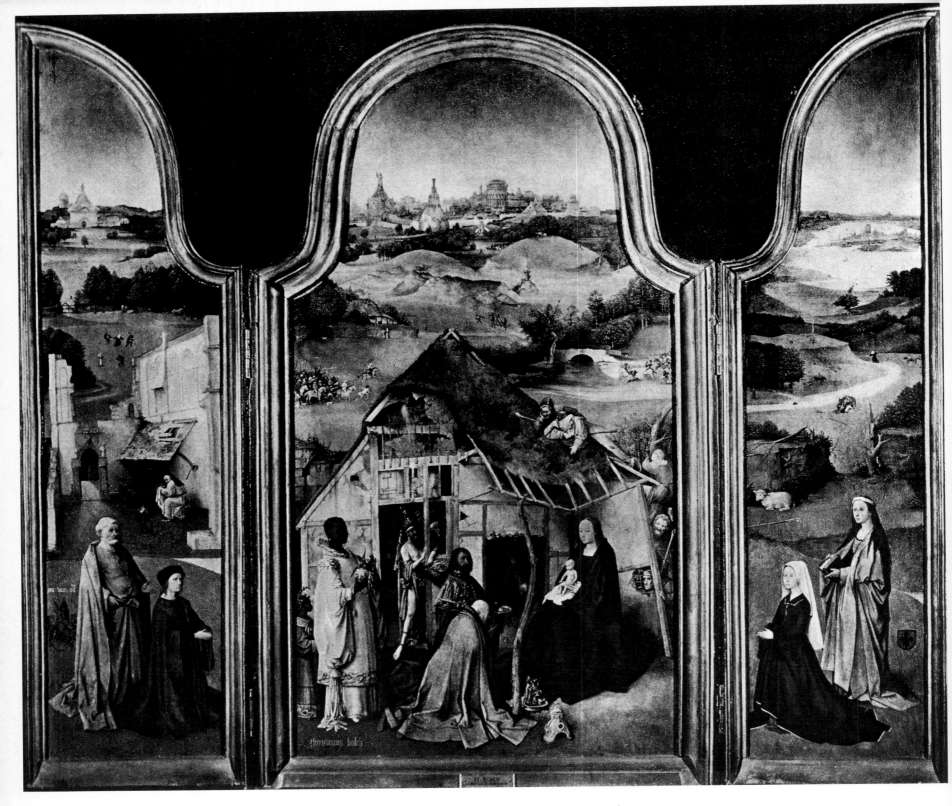

THE ADORATION OF THE MAGI (EPIPHANY: altarpiece open)

The Adoration of the Magi here has the character of a liturgical act, in which the donors and their patron saints participate. Mary is at once throne and altar; Balthasar, kneeling at a respectful distance from this living altar, is depicted as an old priest who, assisted by Melchior and Caspar, is performing the divine service. Through this identification with holy mass, the biblical event gains the symbolic significance of the eternal celebration of the holy sacrifice. The embroidery on Melchior's cloak depicts, above the sacrifice of Manoah, the Queen of Sheba's visit to King Solomon, the typological model of the Epiphany. On the sphere that Caspar brings the Child a pagan ritual is shown; but the pelican crowning it is a symbol of Christ's redeeming mission. The goldsmith's work brought by Balthasar, lying on the ground beside a helmet decorated with the emblems of lust, has as its theme the sacrifice of Isaac, the typological model of Christ's sacrifice. Under the same clear sky, whose azure blue fades into the horizon, the multiple faces of the earth are depicted on the three panels.

Complete picture above. Details from centre panel pages 297-304. Detail from right wing page 305.

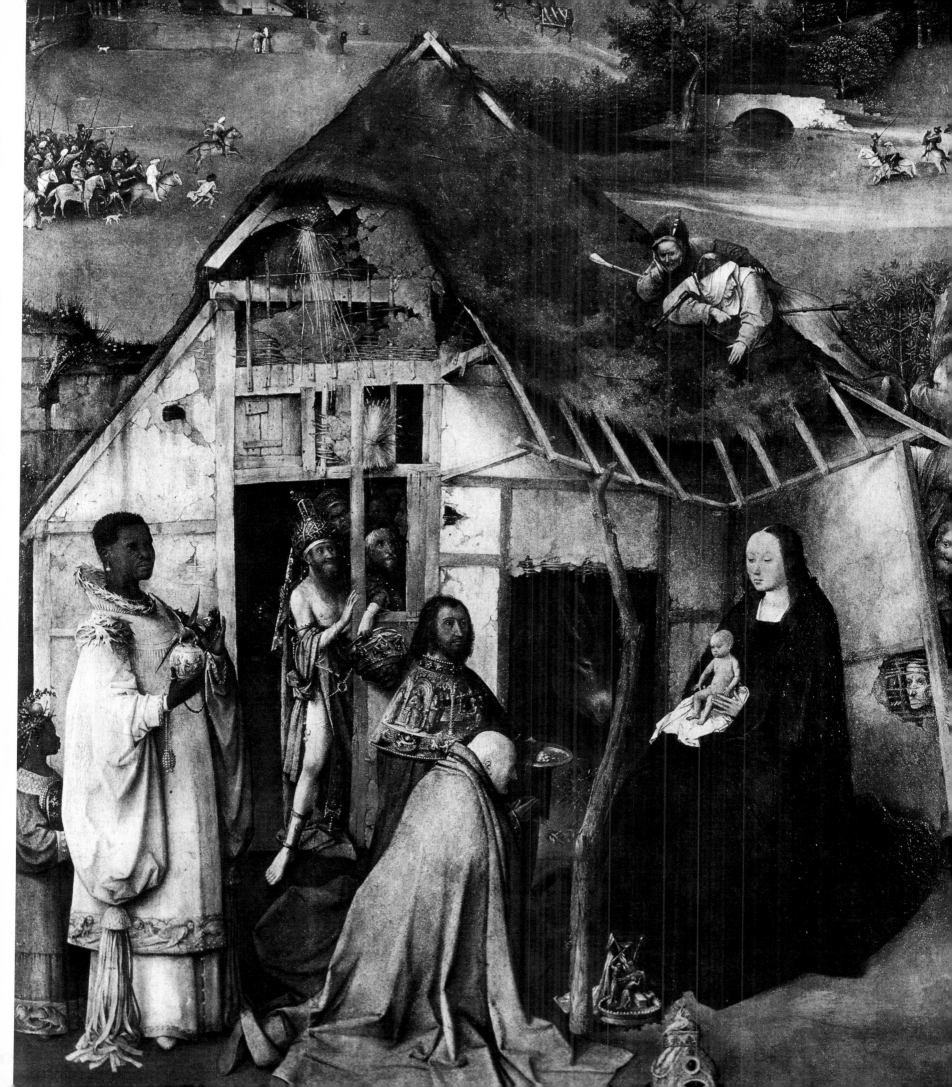

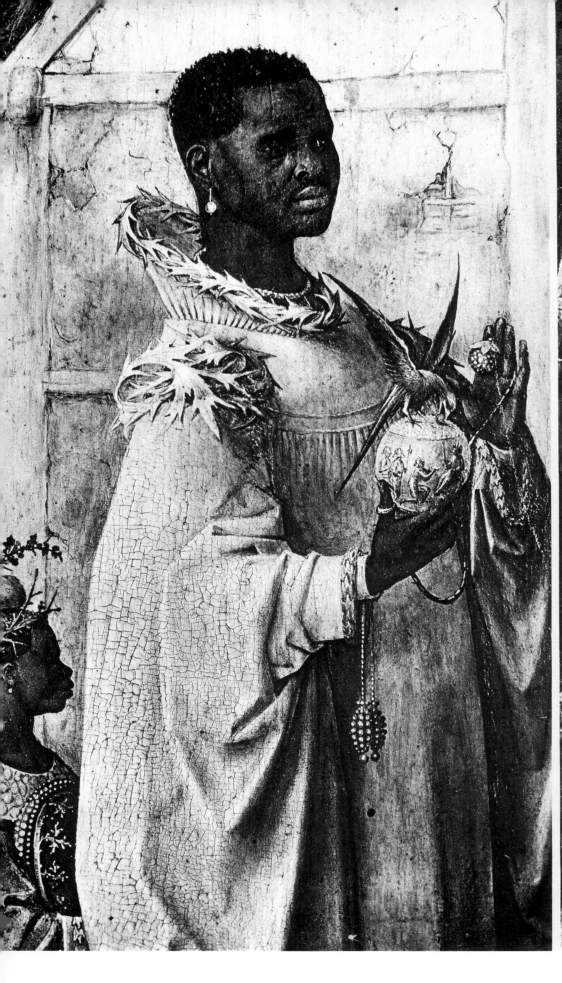
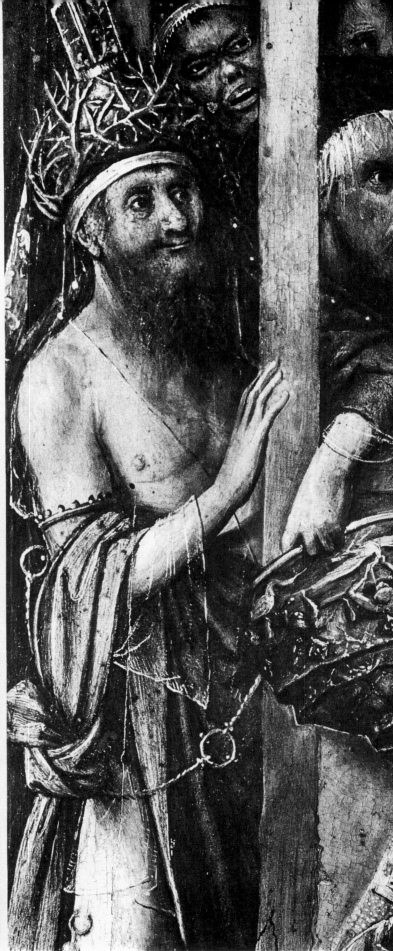

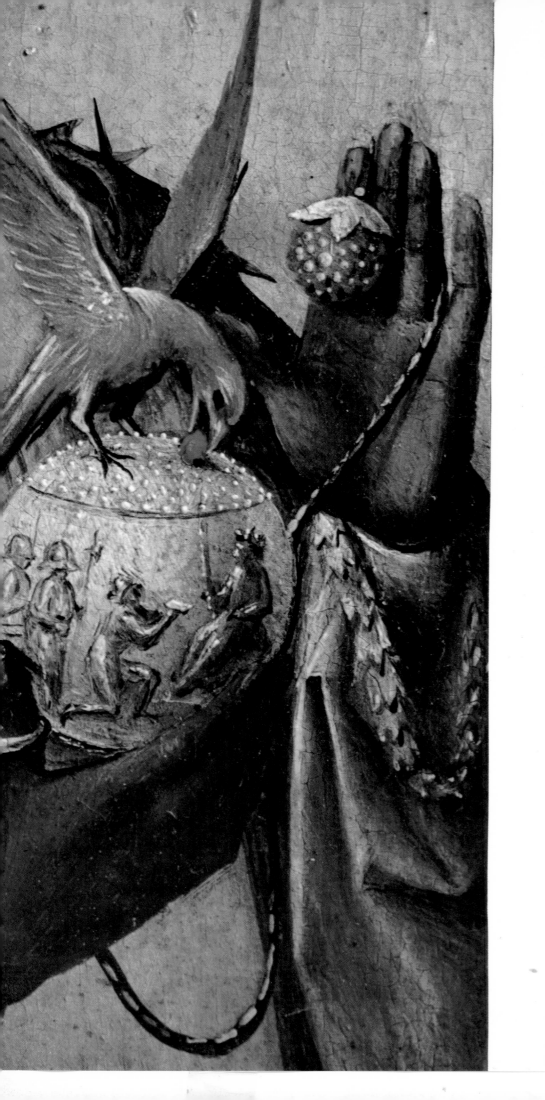

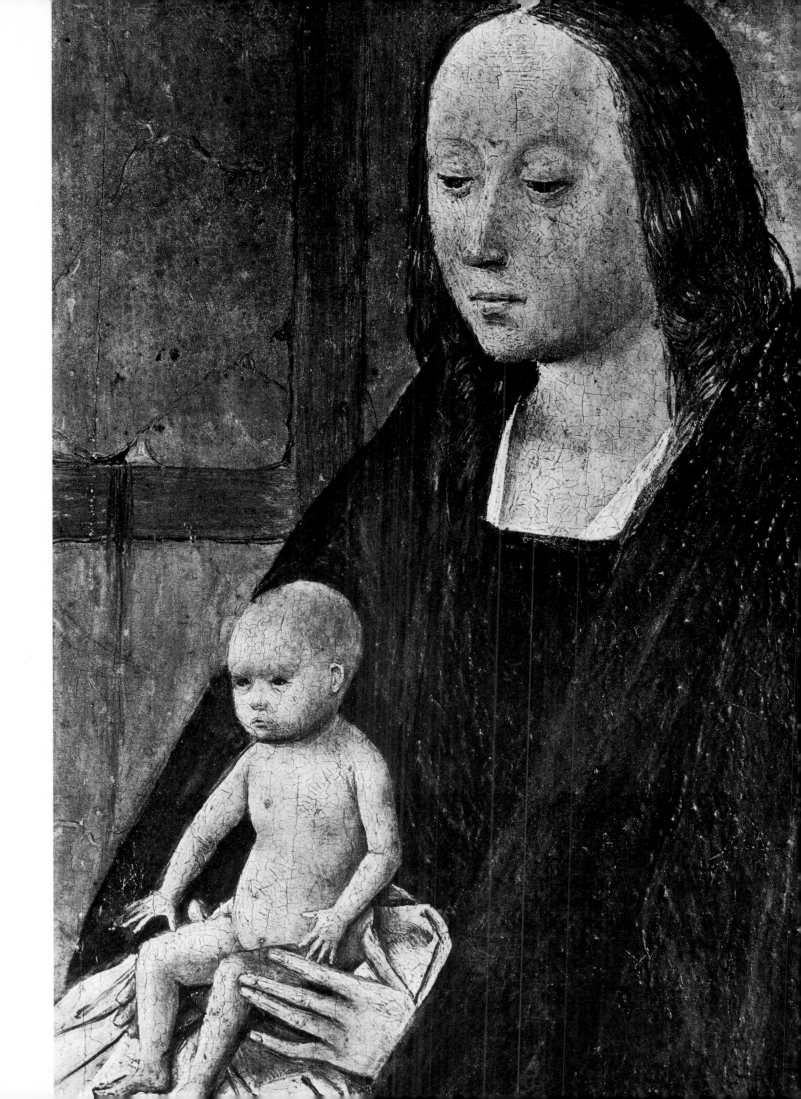

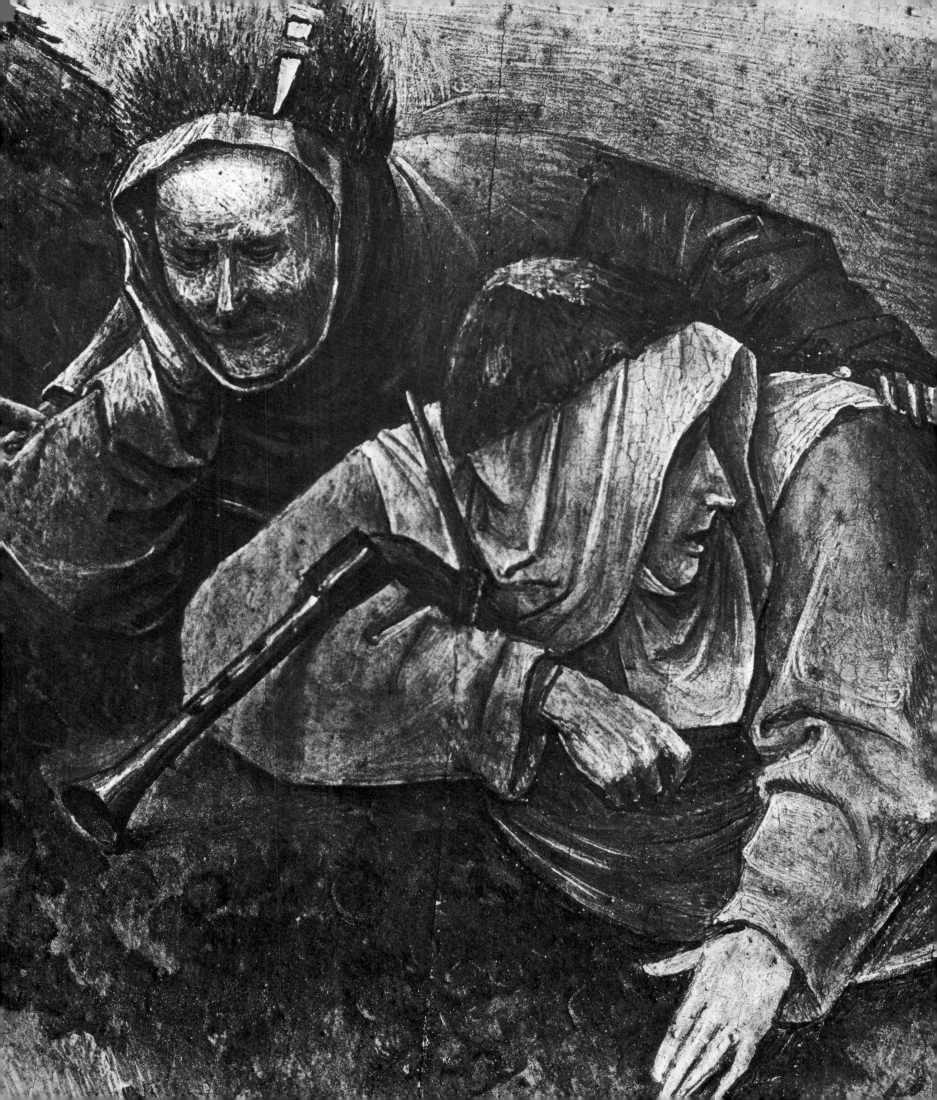

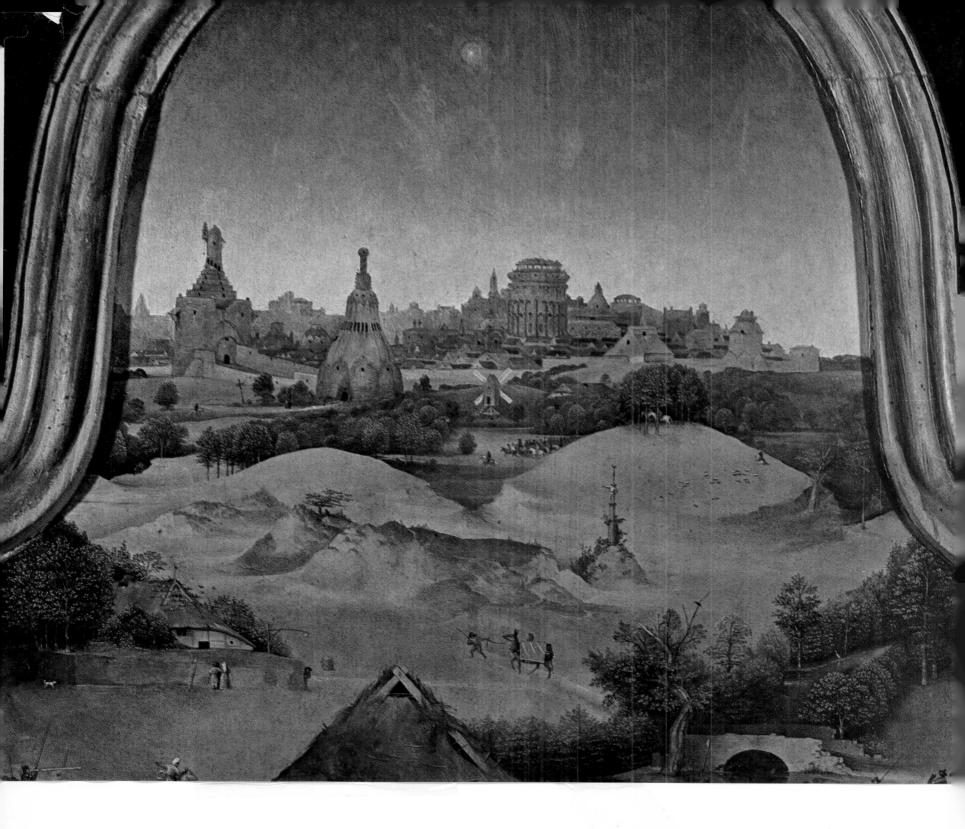

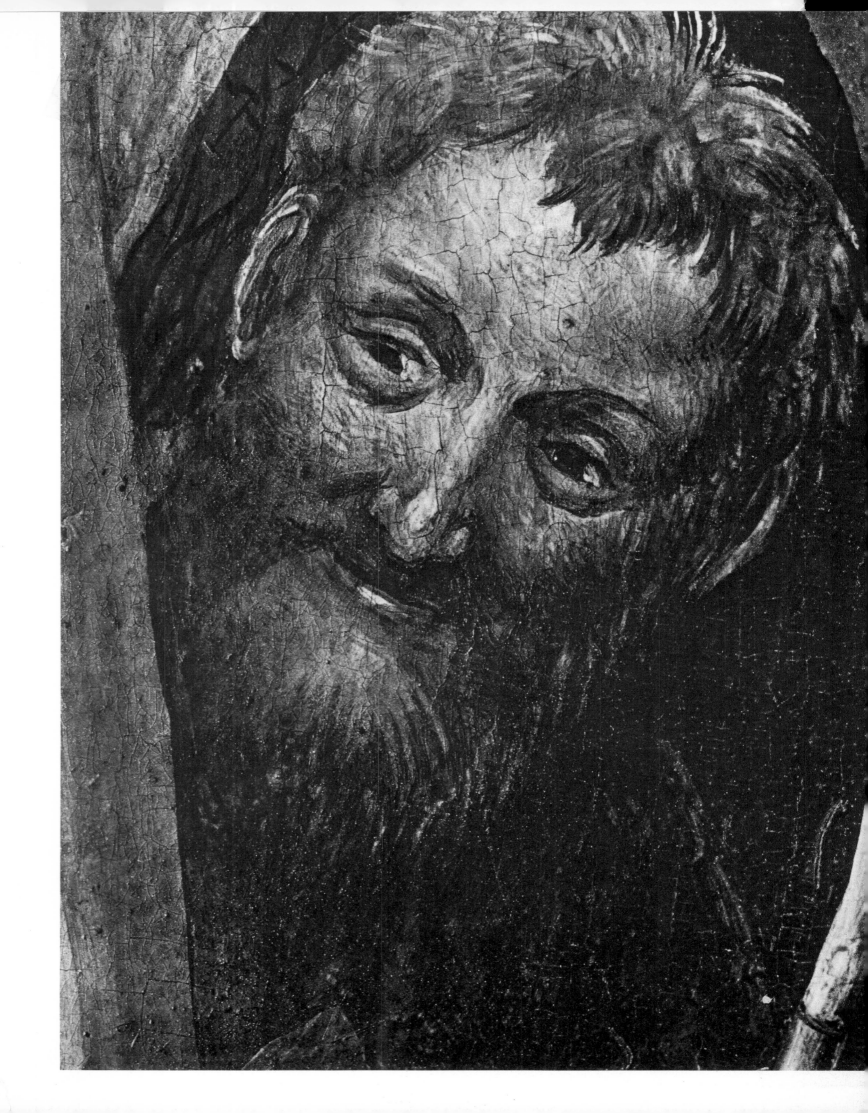

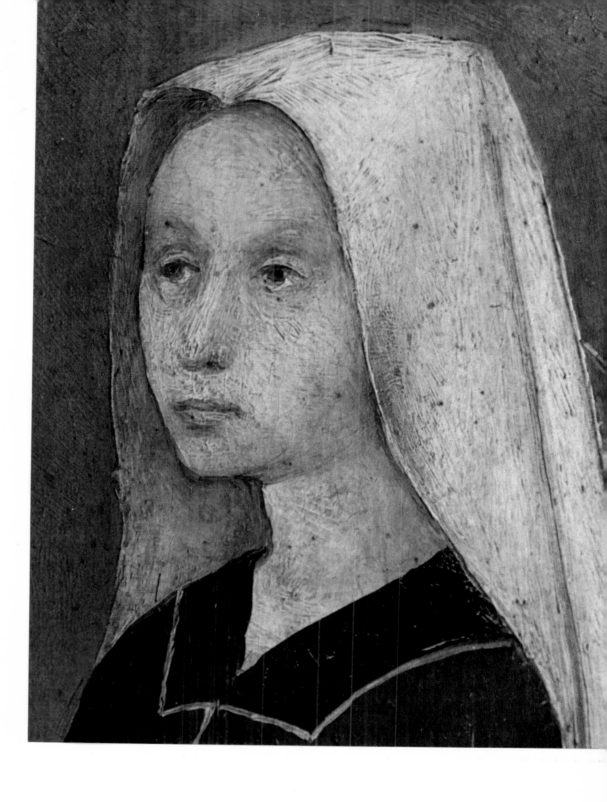

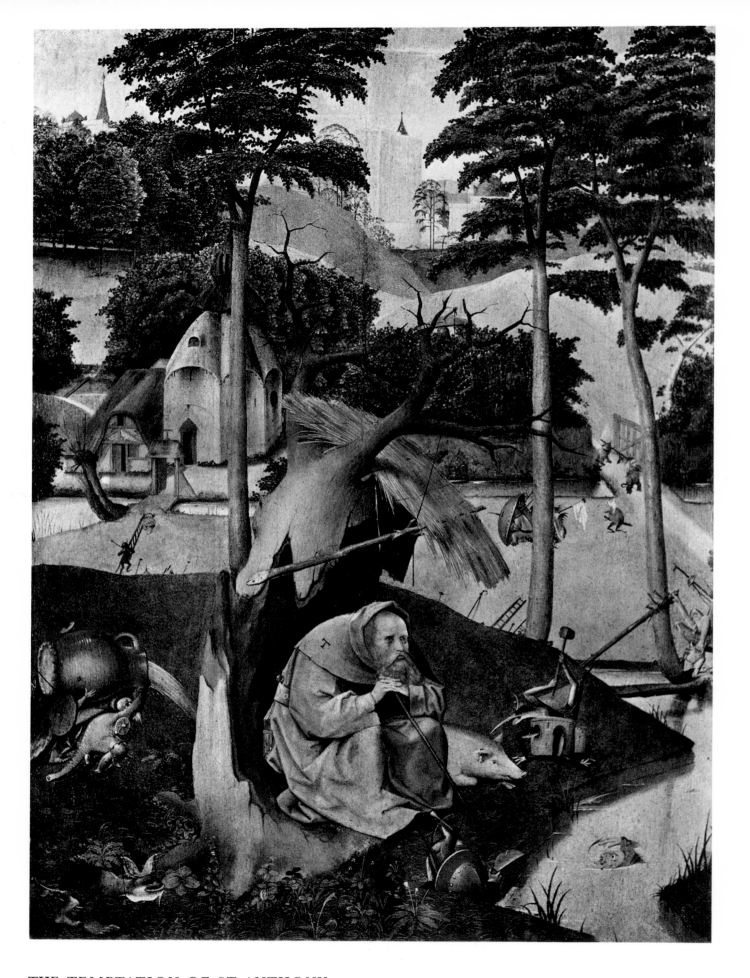

THE TEMPTATION OF ST ANTHONY

Crouched with the immobility of a statue in the hollow of his tree, this St Anthony, having reached the highest stage of wisdom, has become an insensitive rock: his eyes, the only part of him still alive, gaze with superhuman intensity upon 'the things that pass all understanding'.

MADRID, MUSEO DEL PRADO. *Oil on wood. Height 70 cm, width 51 cm.*

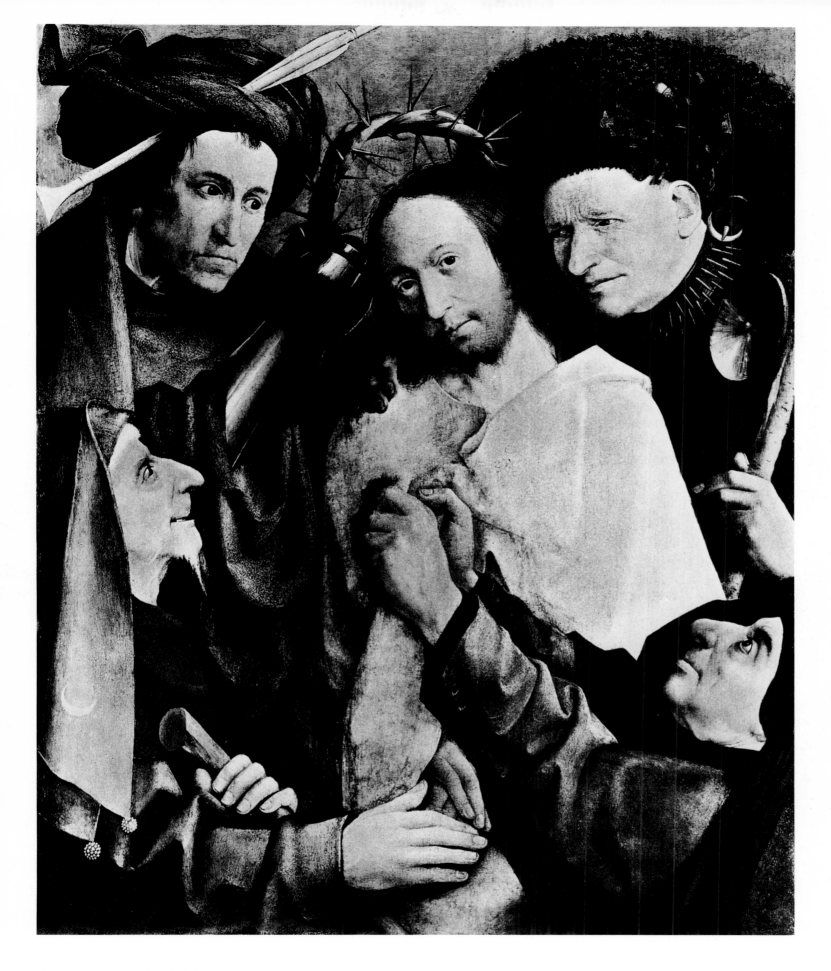

THE CROWNING WITH THORNS

The figures, among whom we recognize some of the evil faces from the *Christ Carrying the Cross* in Madrid (Plate page 291), surround Christ like a pack of wild beasts: they cling to Him, forcing the crown of thorns on to His head and tearing off His cloak. With His sad, gentle eyes Christ is seeking out those of the spectator and appealing to his conscience.

LONDON, NATIONAL GALLERY. *Oil on wood. Height 72.5 cm, width 58.5 cm.*

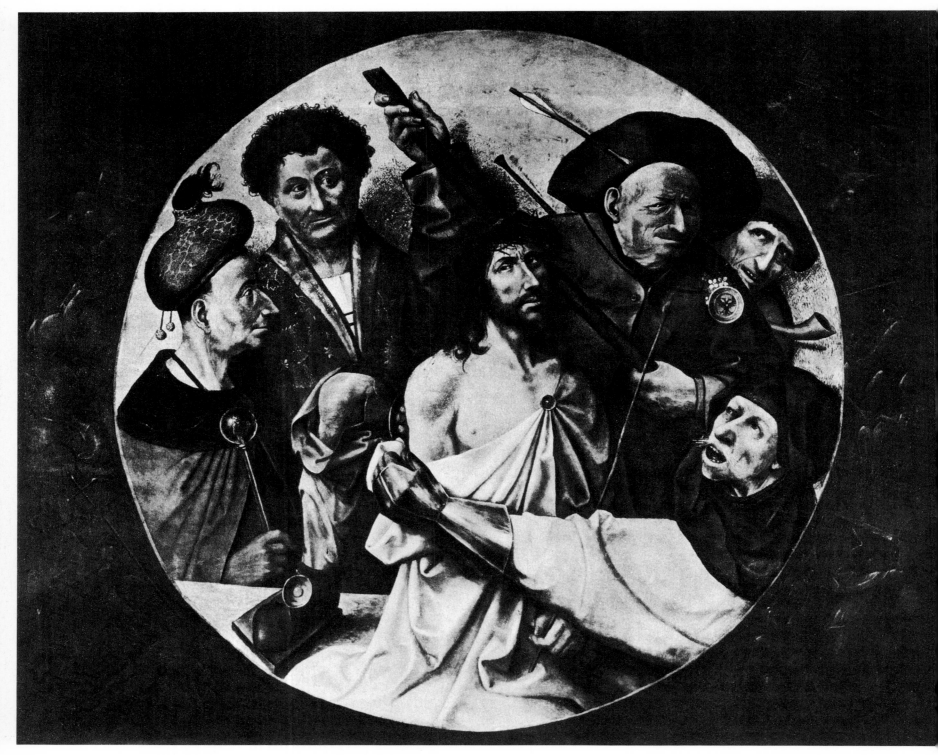

THE CROWNING WITH THORNS

Christ sits motionless in three-quarter profile in His pink cloak, with His forehead bleeding under a tightly-plaited crown of thorns, and once more turns His sorrowing gaze towards the spectator. Fanned out around Him are the executioners, to whose cruel faces Bosch has given the appearance and even some features of wild beasts. The broad-shouldered man with the bull's dewlap, winking slyly at the spectator, is putting his foot on the bench on which Christ is seated, in order to force the crown of thorns still more firmly on His head. The significance of the tondo, a symbol of the terrestrial globe, is further emphasized by the fall of the apostate angels, whose grisaille figures fill the four dark corners of the picture.

MADRID, ESCORIAL.

Oil on wood. Height 165 cm, width 195 cm.

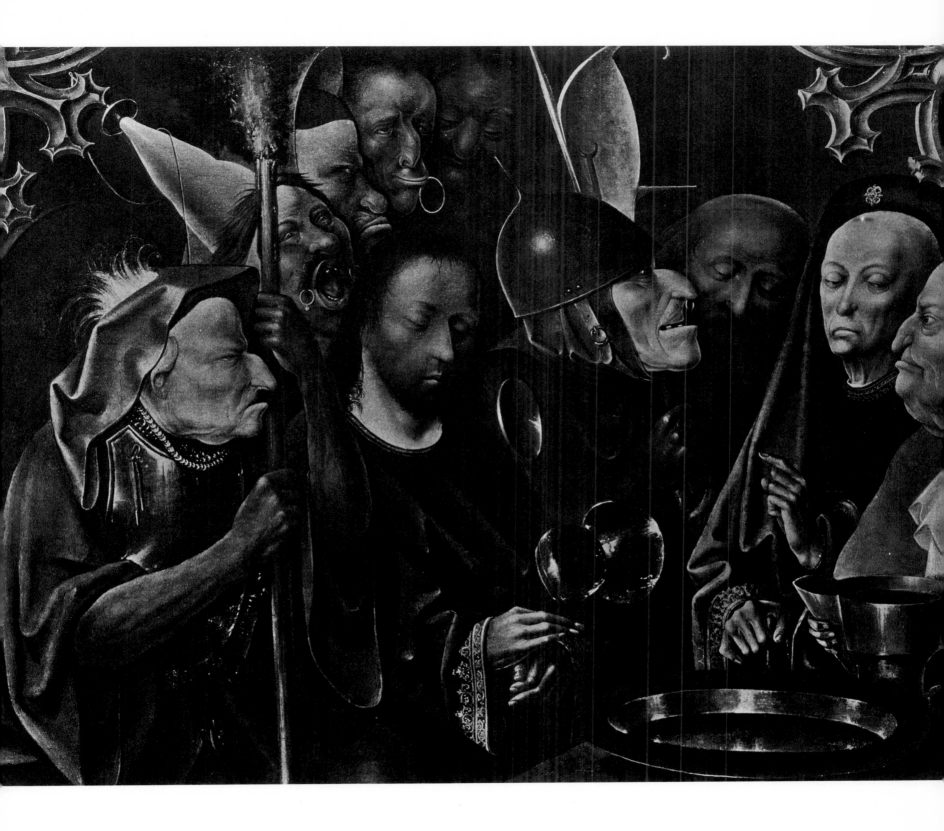

CHRIST BEFORE PILATE

PRINCETON, N.J., PRINCETON ART MUSEUM.
Oil on wood. Height 84.5 cm, width 108 cm.

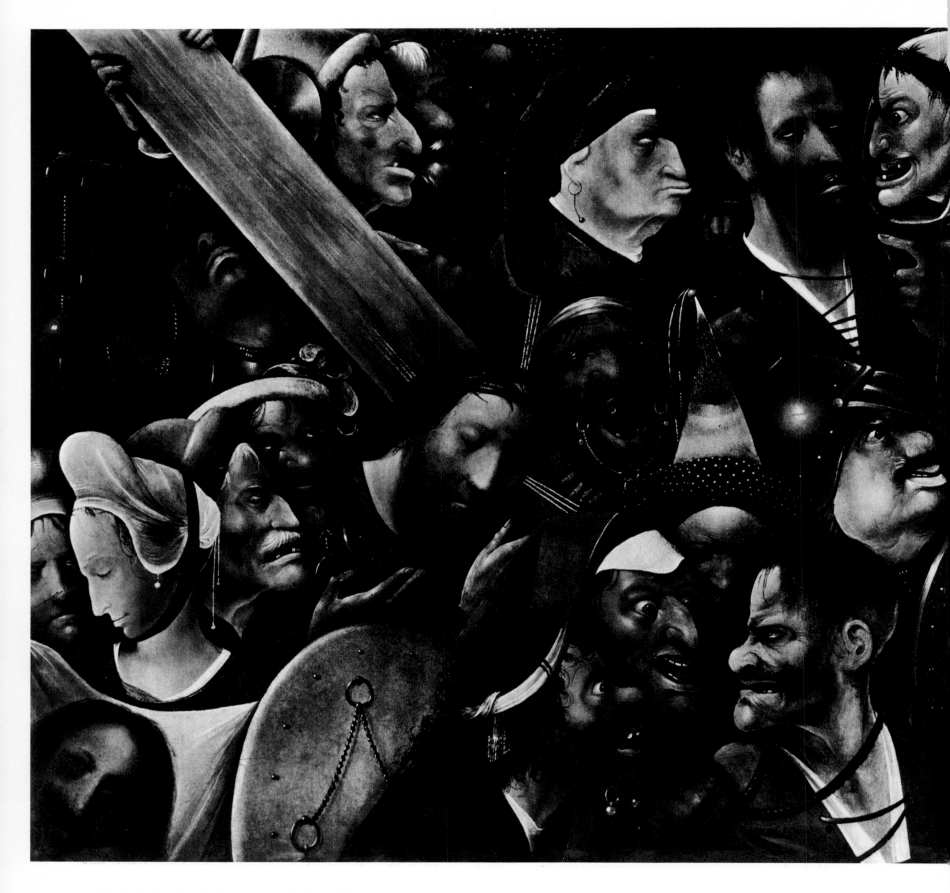

CHRIST CARRYING THE CROSS

Here Christ is shown without any distance between Him and man. Lost among heads that rise up out of the night, pressed together like weightless bubbles, Christ is sleeping with closed eyes and dreaming this nightmare. One of the executioners has seized the Cross with both hands and is pressing it down, and with it Christ, summoning up all the strength of his malice. The face of Veronica is transformed into an uncanny wax mask. The executioners

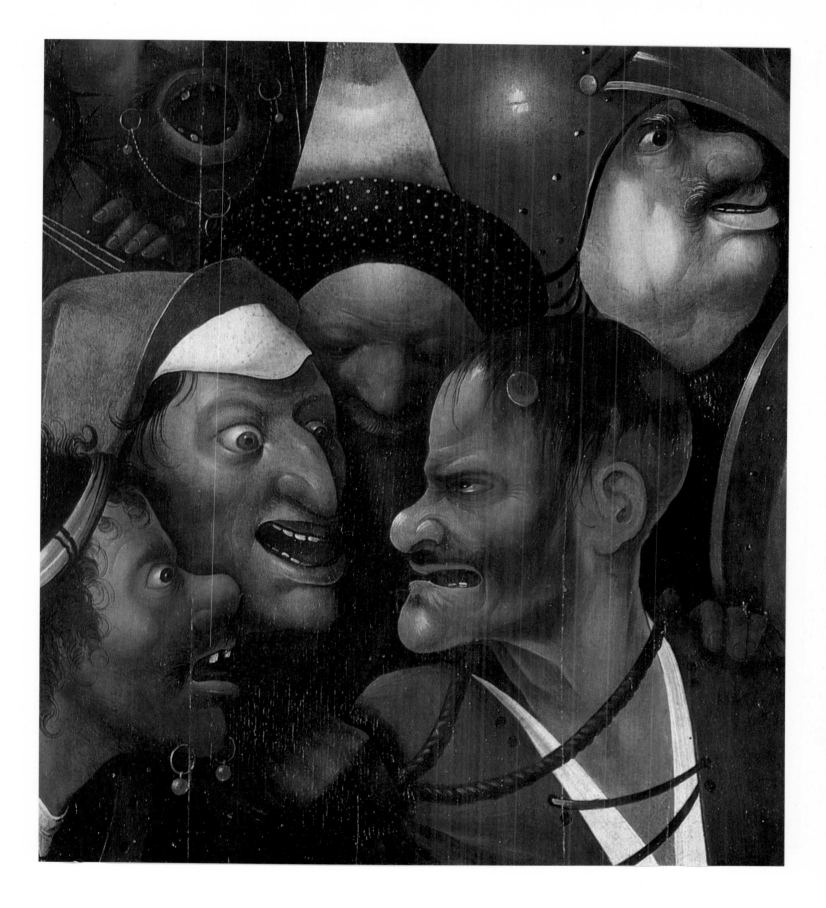

are exulting with sadistic glee over the bad thief, who is enraged at their mocking *(below right)*. In the upper right the good thief, delivered over to a Dominican who is admonishing him with evil fanaticism, staggers like a drowning man.

GHENT, MUSÉE DES BEAUX-ARTS.

Oil on wood. Height 76.7 cm, width 83.5 cm. Complete picture page 310; detail above.

THE VIRGIN AND CHILD and ST JOHN THE BAPTIST, standing

The figures imitate sculpture. With the exception of the heads and hands, they are in grisaille; the background is red. These figures were originally the folding cover panels of a large clock signed ISB.

'SHERTOGENBOSCH, CATHEDRAL.

Tempera on canvas.

DRAWINGS AND ENGRAVINGS

The numbers of the pictures refer to the Catalogue Raisonné of drawings in this work.

18 a

18 b

18 c

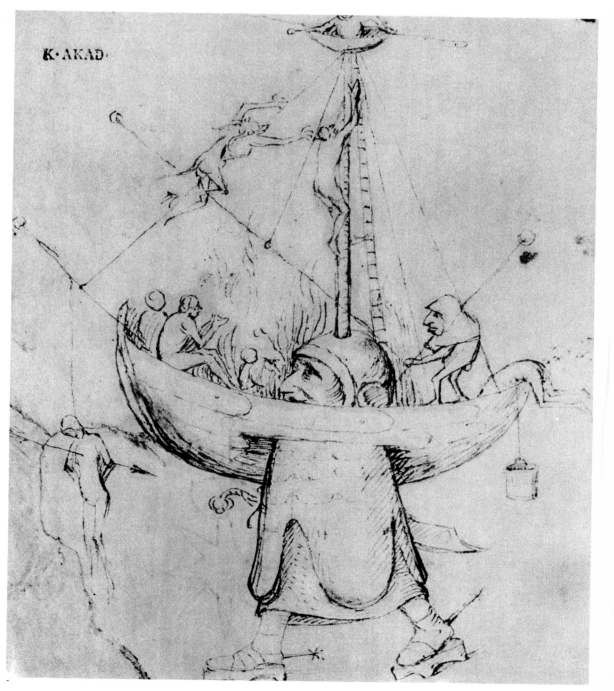

K·AKAD·

18 d

5

2

2

1 a

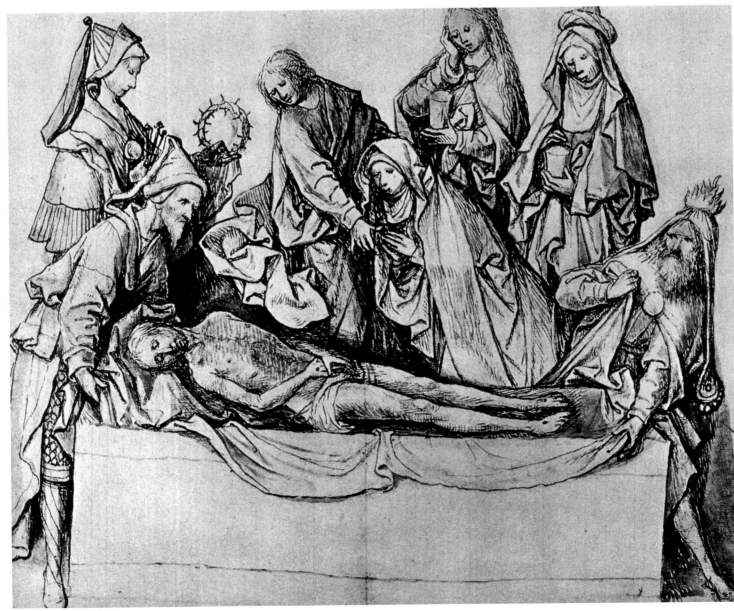

3

I

7

3

9

9

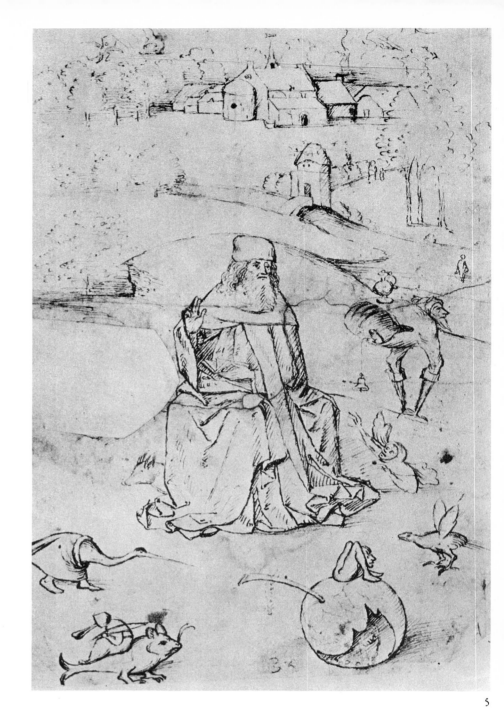

5

5

31

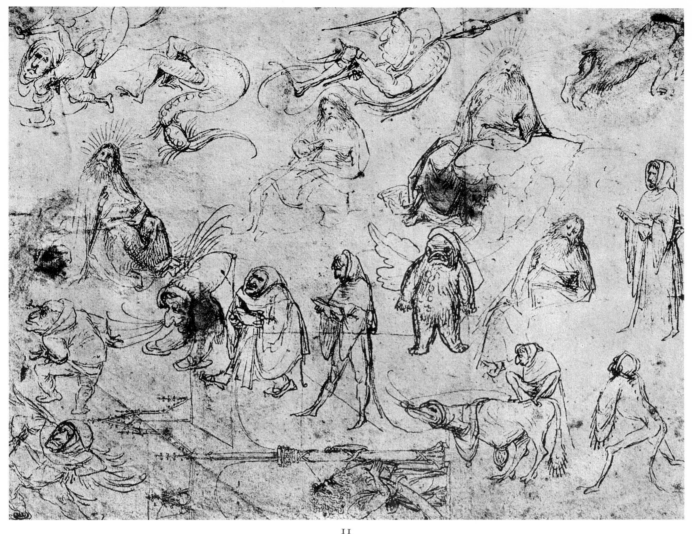

II

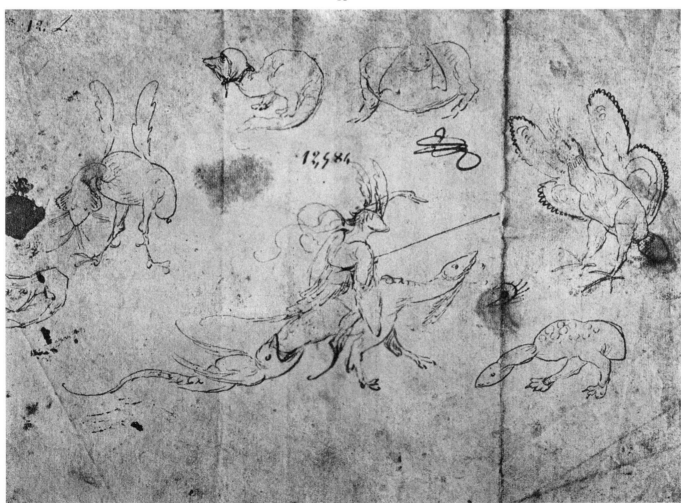

19

13 10

32

15

16

21

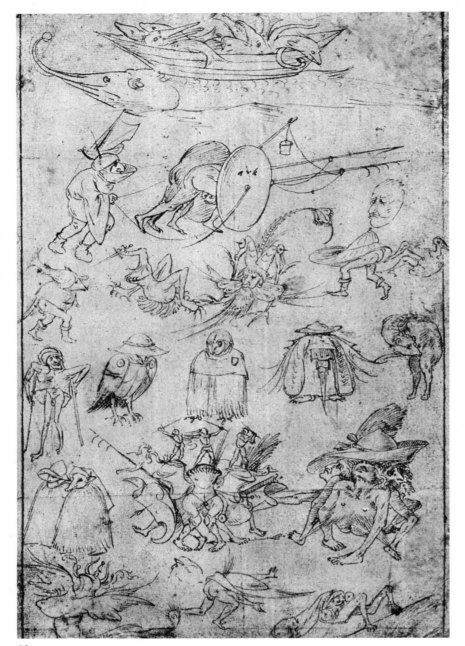

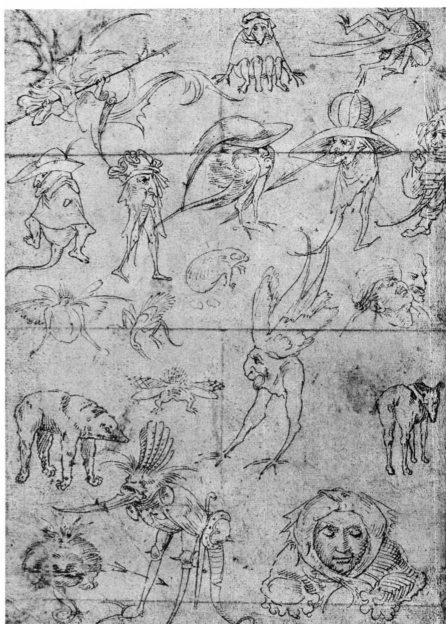

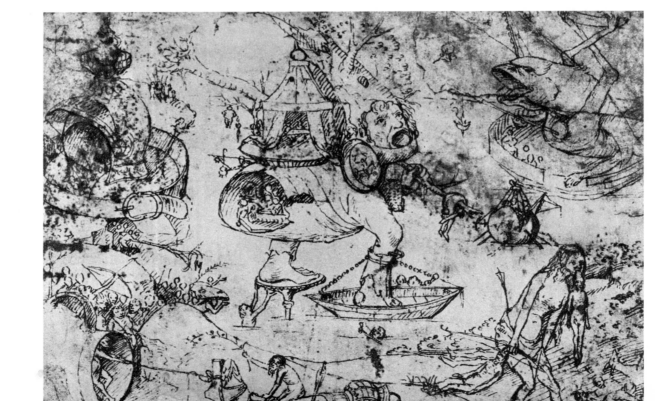

12

12

18 d

32

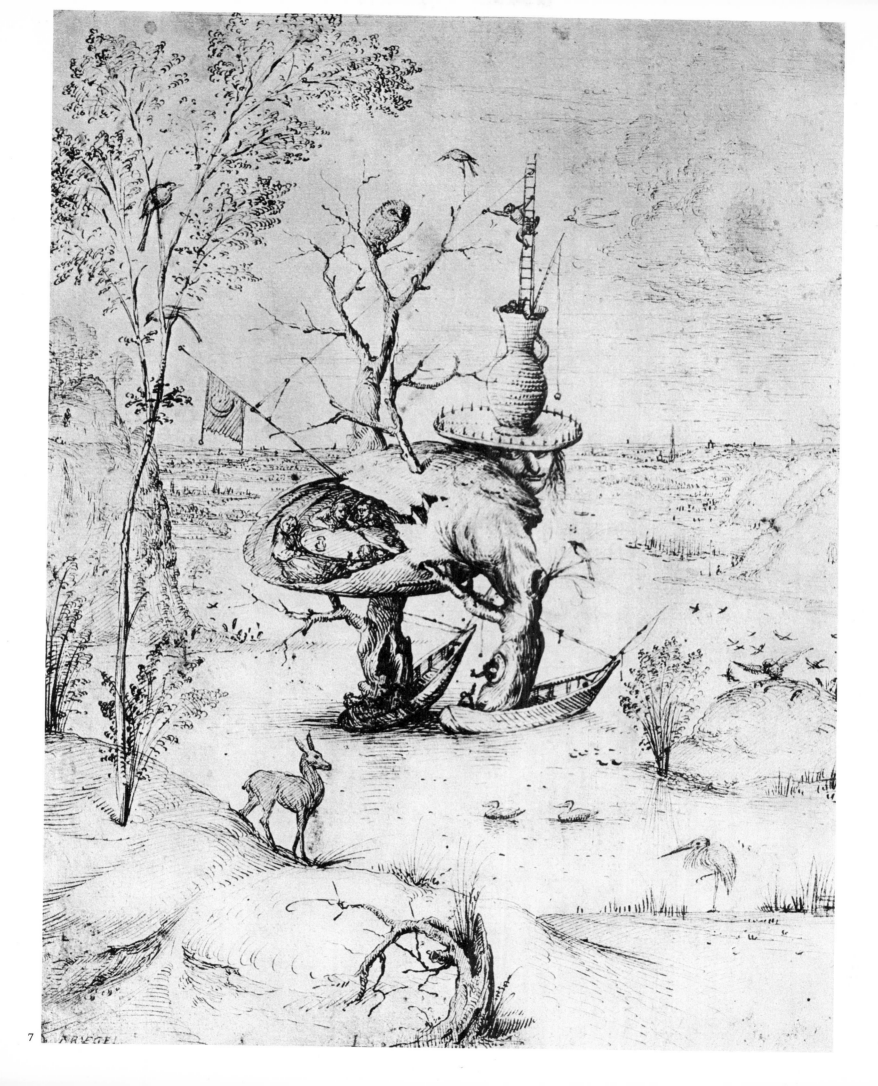

14 a

19 B.

336

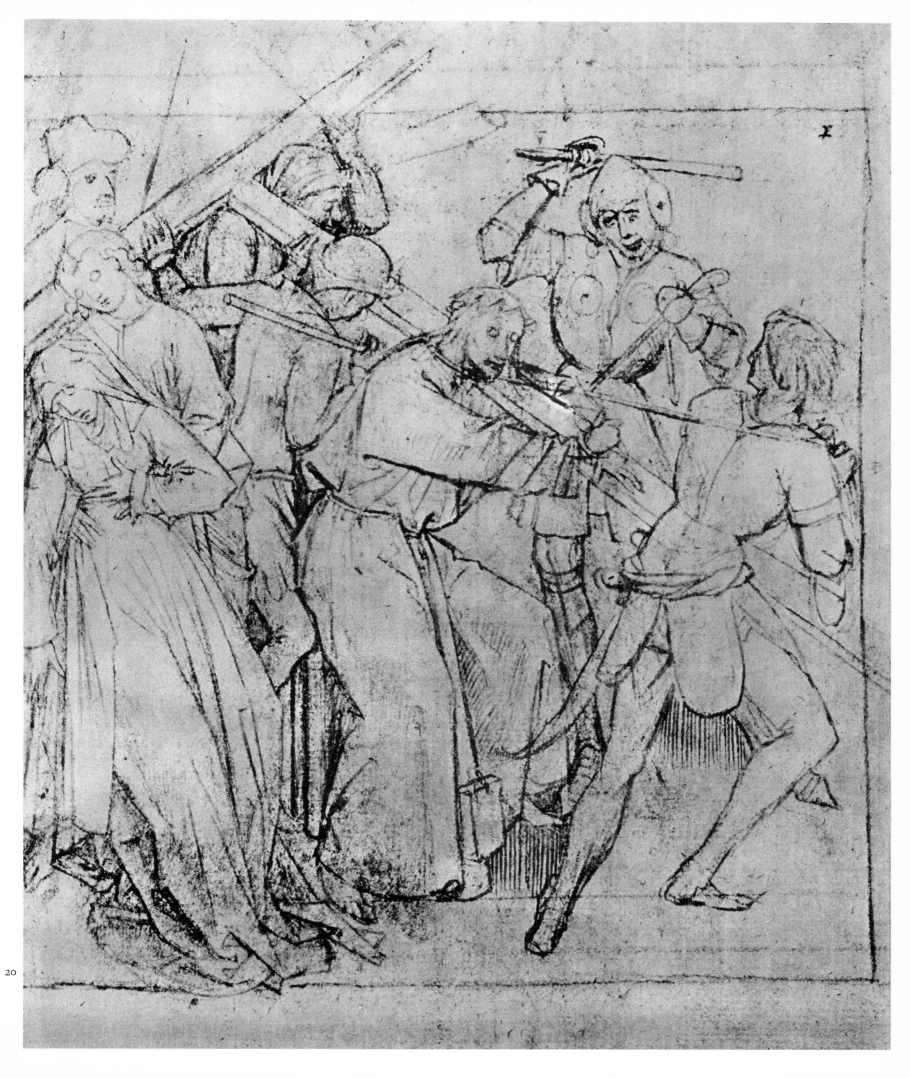

20

27

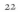

22

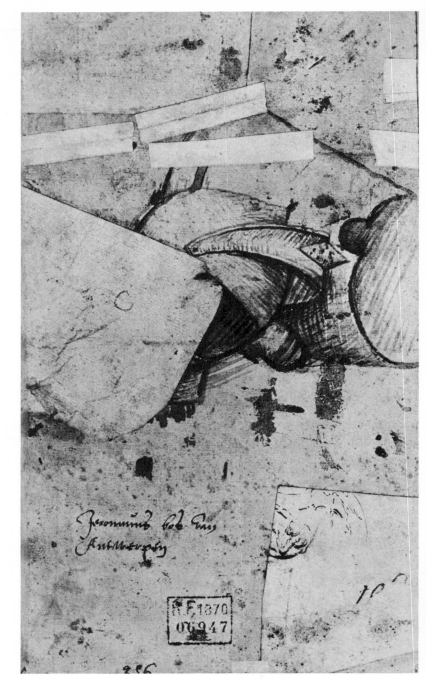

10 a

21 b

21 a

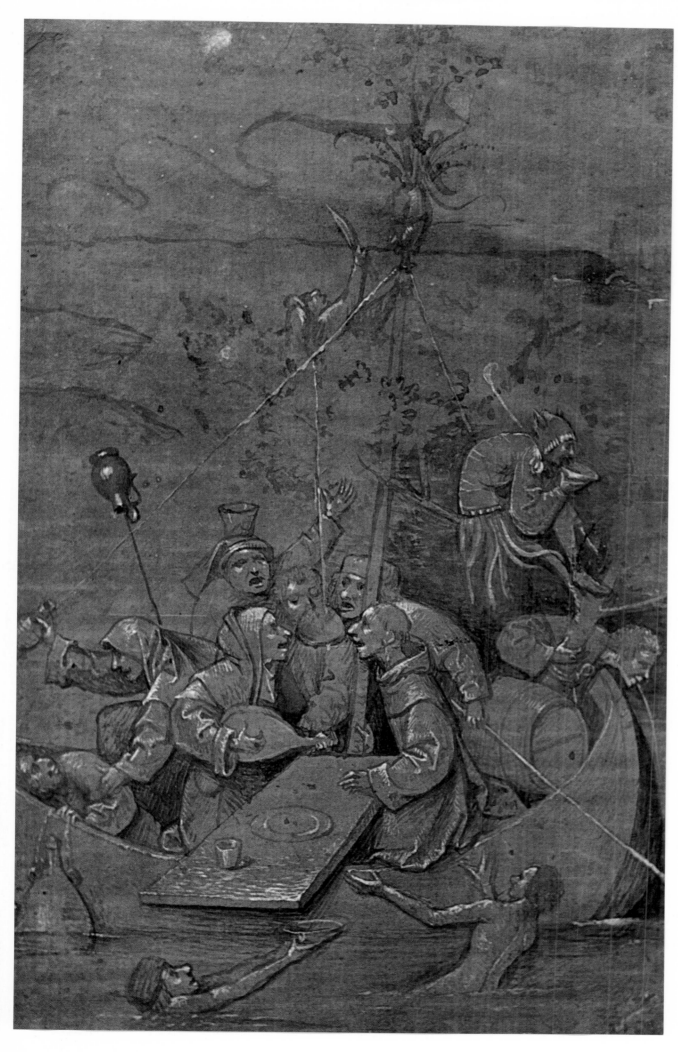

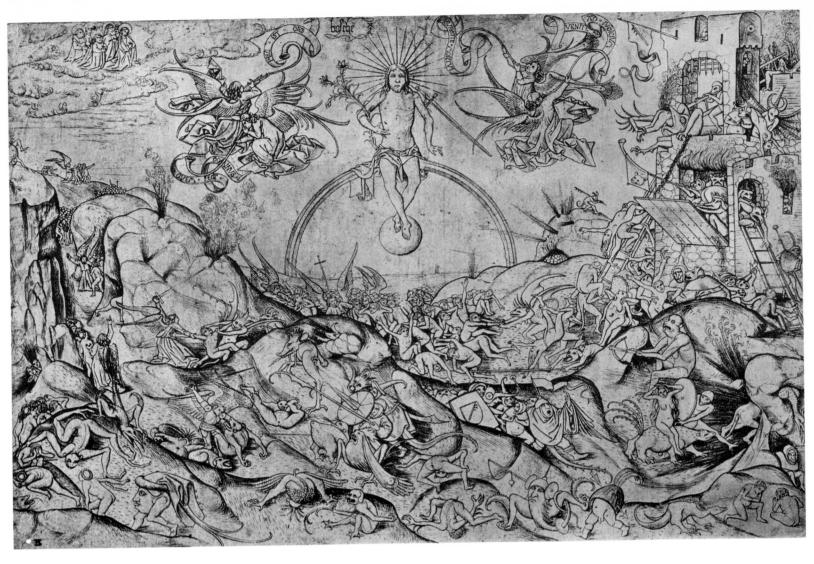

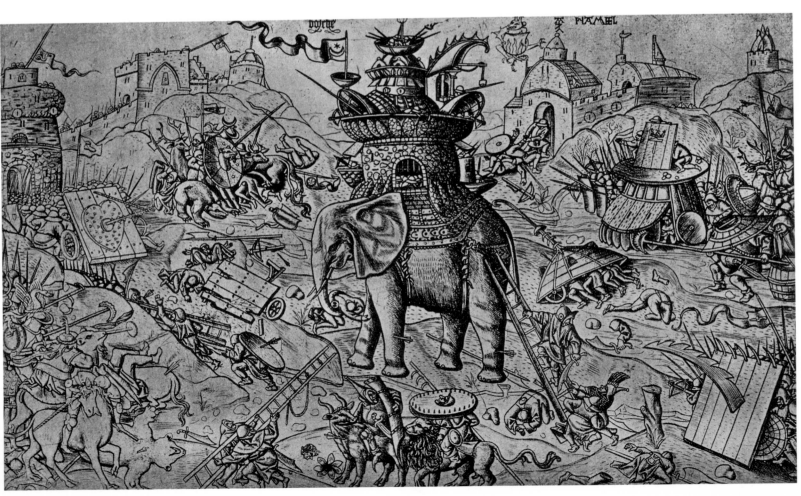

3

7

8

Catalogue Raisonné of the Works
of
Hieronymus Bosch

INTRODUCTION

In this catalogue our primary concern has been with the authentic works. However, we also mention in the same rubric some pictures that for the most part have hitherto been regarded as by the hand of the master: some are in our opinion especially faithful copies; others are works very close to his, whose originals, however, we were unable to examine.

The works have been grouped according to pictorial type and within these groups an effort has been made to list them in chronological order. For the artist's sources of inspiration and for comment on the works concerned, reference should be made both to the text and to the catalogue.

Nos. 7, 9, 11, 20 verso, 21, 27 and 33 of our catalogue do not appear in the catalogue of Max J. Friedländer, and Nos. (65), 66, 70, (71), (72), (74), 75, 76, (80), 86, (87), 88, 91, 94, (95), 96, 100, 107, (108), (112) and (113) of his catalogue appear in ours in the list of apocryphal pictures. We have placed in parentheses the numbers of those works that Max J. Friedländer himself regarded as dubious.

(We do not mention the copies that appear in the catalogue of Max J. Friedländer.)

The author would like to express his thanks here to Mr Jan Mosmans, Archivist of 's Hertogenbosch Cathedral, and to the late Mr H. J. M. Ebeling, Municipal Archivist of 's Hertogenbosch, for his kind assistance in undertaking research in the municipal archives, as well as to Messrs Diego Angulo Iñiguez (Madrid), Ludwig von Baldass† (Vienna), M. J. Friedländer† (Berlin), F. Koenigs† (Haarlem), Mme Suzanne Gruber (Paris) and Mr Johannes Wilde (London) for the information they have supplied me with. In addition, I am much indebted to Dr Ann E. Keep and to Dr Hans H. Hofstätter of Holle Verlag, for all manner of help in preparing the book so carefully; and to Mrs Howard Burns for correcting the final proofs. Finally, I should like to express my warmest thanks to Rina de Tolnay† for her understanding and support during the many years that I have been engaged on this work.

The notes to the pictures refer to pp. 9-49 of the main text; the number after the comma represents the line, counted from the top of the page.

AUTHENTIC PAINTINGS

A. Youthful Works

1. THE CURE OF FOLLY

PAGES 55-57

Madrid, Museo del Prado.
Oil on wood. Height 48 cm; width 35 cm. Unsigned.
Inscription: *Meester snyt die keye ras*
Myne name is Lubbert das.

PROVENANCE: The picture is described as 'a tondo, showing *Lubbert das*, the man having stones extracted from his head', in the dining-hall of the bishop of Utrecht, Philip of Burgundy, and is mentioned in 1524 in the inventory of the castle of Duurstede (cf. Roggen, 1939–40). The picture may be identical with the one that was later in the possession of Don Felipe de Guevara and was bought by Philip II in 1570. See Simança, *Nota de las pinturas compradas a Da. Beatriz de Haro y de Ladron de Guevara mujer é hijo de D. Felipe de Guevara en virtud del orden del SR. Rey D. Felipe II n°. 6 Cura de la locura.* Among the pictures that Philip II had sent to the Escorial in 1574 the picture is incorrectly mentioned, under no. 18, as a painting in tempera (see Justi, p. 143).

ATTRIBUTION: Justi, p. 129, was the first to attribute this picture to Bosch. H. Hymans, *G.d.B.A.*, x, 1893, p. 231f. Dollmayr, 1898, p. 297, questions the correctness of this attribution and propounds the hypothesis of an unknown master, to whom he attributes, in addition to the *Cure of Folly*, the *Last Judgement* in the Vienna Academy and the *Seven Deadly Sins* in the Escorial. L. Maeterlinck, *Le genre satirique dans la peinture flamande*, p. 232. Cohen, 1910, no. 18, quotes L. A. Scheibler: 'very nearly at his (Bosch's) level of development, but undoubtedly not by him.' Lafond, p. 85; Baldass, 1917, p. 178; Friedländer, 1927, pp. 101, 153, no. 109; Tolnay, 1937 and Combe, no. 1, consider the work an original.

The attribution of the picture to Bosch has recently again been called in question by Brand Philip (1958), Baldass (1959) and Boon (1960), although it has excellent evidence of origin (see above).

DATING: In ascribing this work to the beginning of the master's career, as we did as early as 1937, we go counter to views previously expressed: Baldass, 1917, p. 178, dates it later than the Frankfurt *Ecce Homo* and the Philadelphia *Epiphany*, but still in the master's youth. – Gossart, p. 80, and Demonts, p. 12, regard it as Bosch's last work, and all three base their judgements on the realism and the 'genre' nature of the painting. And yet the technique and style, which are closely related to the *Marriage of the Virgin* by the Master of Flémalle, for example, are clearly characteristic of a beginner. Would it be possible to explain the discrepancy between the landscape and the figures as arising from collaboration between the young artist and his grandfather or father, Jan or Anton van Aken?

In the Prado catalogue (1933) the picture is dated *circa* 1490, in accordance with Friedländer's view.

INTERPRETATION: *Lubbert das,* says Vermeylen, means deceived or gelded badger.

Actually the charlatan is not extracting from the patient's head the stone of folly, as would follow from the inscription, but a swamp tulip, a flower 'that is a symbol of money in thieves' cant' (Brand Philip, 1958). The scene signifies that the doctor is extracting money from his patient. A further allusion to this is the purse pierced with a dagger, hanging down at the patient's side.

Roggen (1939–40) believes that the picture represents a comedy scene of the period, and that the patient is a deceived husband. He refers to the story of Lubbert by J. van Doesborch (1528–30), in which Lubbert is a deceived husband. Bax (1949) mentions a similar scene, the Cure of Folly, represented in the Ommegang in Antwerp in 1563.

According to Fraenger, *Die Hochzeit zu Kana*, Berlin, 1950, the scene represents a ritual castration as practised by the Brethren of the Free Spirit, a heretical sect to which he believes Bosch belonged. Fraenger's interpretation was accepted by W. Hollmann in *Psyche,* IV, 1951, p. 234, and rejected by Bax, 1956, pp. 161 ff., Pigler, *Burl. Mag.,* 1950, and Brand Philip, 1958, pp. 41 ff., who propose an astrological interpretation, according to which our picture would represent the children of Mercury. Further,

337

Brand Philip is of the opinion that the element of air and the sanguine temperament are depicted, but she can adduce no evidence for the last point. The entire interpretation is dubious, since the planet itself is not represented. Brand Philip's hypothesis that this composition was part of a cycle of four tondi originally on the reverse of altarpiece panels, and that all were pictures of the children of planets, does not seem convincing. The other three compositions would be the *Charlatan* (which is, however, rectangular), the *Prodigal Son* (which is likewise a tondo, but much larger than the *Cure of Folly*) and a fourth picture that is no longer extant and which Brand Philip tries to reconstruct from engravings.

APPX. PL. I COPIES: Four copies of the *Cure of Folly* are known, reproduced by Brand Philip (p. 42f.). According to her, the variants go back to a lost original by Bosch, and are closer to Bosch's composition than the Prado painting, which she calls a pastiche dating from 1560–70. However, her stylistic arguments do not carry conviction; the panel in the Prado is a work of the 1480's. The copies may not be entirely independent of the Prado panel, in view of the similarity of the composition and the main figures. The figures added to the paraphrase in Amsterdam are obviously in a different style from those of Bosch. Possibly the other copies derive from the one in Amsterdam.

NOTES – P. 14, 40 The sermon of Geiler von Kaisersberg against ignorant physicians, published by J. Scheible, *Das Kloster*, Stuttgart, 1845, I, p. 524f.: 'Thou fool, why art thou proud of thy physic, by which thou art wounded. The virtues are a physic of the soul.'

P. 14, 40 We quote:

> Hij heeft den kei in 't hoofd;
> Hij moet van den kei gesneden worden

(see Harrebomée, *s. v.* kei).

P. 15, 5 Certain later pictures by Bosch will confirm our interpretation: in the *Seven Deadly Sins*, on the reverse of the *St John on Patmos* and on the reverse of the *Garden of Earthly Delights*, Bosch in each case gives this form of tondo the same universal meaning.

2. THE SEVEN DEADLY SINS

PAGES 58-69 Madrid, Museo del Prado (formerly Escorial).
Painted table-top.
Oil on wood. Height 120 cm, width 150 cm. Unsigned.
Upper inscription:
Gens absque consilio est et sine prudentia
Utinam saperent et intelligerent ac novissima providerent
(Deut. xxxii, 28–29).
Lower inscription:

Abscondam faciem meam ab eis et considerabo novissima eorum (Deut. xxxii, 20).
Inscription in centre of picture, under Christ:
Cave, Cave Dominus videt.

PROVENANCE: Mentioned under no. 8 among the pictures that Philip II had sent to the Escorial in 1574 (see Justi, p. 142). Siguença (op. cit.) describes this picture as being in the king's bedchamber in the Escorial, and mentions further that there was a companion picture, now lost, depicting the Seven Sacraments.

ATTRIBUTION: Don Filipe de Guevara, *Commentarios de la pintura*, ed. D. Antonio Ponz, Madrid, 1787, pp. 41 ff., attributes the picture to Bosch and not to an imitator, as Dollmayr erroneously holds. Schmidt-Degener corrects this error: *G. d. B. A.*, xxxv, 1906, p. 150, note 4. Justi, pp. 131 ff.: The four medallions in the corners are 'painted entirely in the manner of Roger and Memling. A hundred years seem to separate them from the other seven (paintings)'. Dollmayr, p. 296, attributes the picture to his Master 'M.'. Cohen, no. 8. Gossart, p. 60: The picture is by a Flemish contemporary of Pieter Bruegel the Elder. Lafond, p. 50.

DATING: Baldass, 1917, p. 193, who first tried to date the picture, regarded it as a work of the latest period and held that it contains the most perfect interiors and landscapes that the artist ever painted. Friedländer, pp. 102, 152, no. 104. On the contrary, as early as 1937 we recognized the picture as an early work, a view adopted by later scholars (including Baldass and Combe).

INTERPRETATION: The structure of the entire composition is reminiscent of pictures of the universe with its astronomical spheres, but in this case adapted to a special theme. Woodcuts depicting the vices, the virtues or the months were also composed on this pattern: cf. Combe, who refers to an Augsburg woodcut dated 1477; cf. also the woodcut in P. de Crescences, *Le liure des prouffitz champestres*, Paris, 1486. By using *sfumato* Bosch gives this circular composition a spherical effect, probably alluding to the terrestrial globe. The blue iris of the 'Eye of God' in the centre of the composition is converted into a symbol of the sun by centrifugal golden rays on a yellow-pink ground: an identification of Christ with the sun that goes back to the Bible.

Fraenger terms the table-top the 'table of wisdom', and sees it as a sort of Western mandala, a picture whose purpose was to evoke a contemplative mood among the members of the heretical sect of the Brethren of the Free Spirit, to which he thinks Bosch belonged. Fraenger surmises that the picture may have been commissioned by Jacob van Almangien and the table used ritually in

meetings of this sect. Bax, 1956, pp. 176ff., adduces arguments against this interpretation. No heretical elements can be found in the picture, and its moral content is very well suited to any burgher's house or to the Brotherhood of Our Lady in 's Hertogenbosch, of which Bosch was a member.

The slight differences in style and colouring between the tondi in the corners, which are in darker colours, with a Bordeaux-red predominating, and the tondo in the centre, which is painted in bright colours with soft fresh tones, can be explained by the fact that Bosch painted the four corner pictures somewhat earlier than the central one. In any case, it is our opinion that all the scenes are by Bosch himself.

APPX. PL. 69

The *Death* shown in the upper left corner is related to the representations of the *Ars Moriendi* by the Master E. S. Here the secularization of the theological concept is already noteworthy: a woman, the wife of the dying man, is seen in another room through a half-open door, counting on her fingers the coins that he is leaving. In the *Last Judgement* Bosch makes no distinction between the elect and the damned, while showing the desperation of the sinners and their prayers, now in vain. In the *Hell* the punishment of sins is systematized. This classification of punishments, inspired by the Apocalypse, is found depicted for the first time in Italy in the fourteenth century (Nardo di Cione, the *Hell* in Sta Maria Novella, Florence) and then in northern miniatures at the beginning of the fifteenth century (see Cheltenham Thirlestaine House, Ms Fr. 4417, repr.: A. de Laborde, *Les manuscrits à peintures de la Cité de Dieu de St-Augustin*, Paris, 1909, Plate 28). See also an Italian engraving of 1460, in which the punishments for Gula and Avaritia are the same as in Bosch. It is also possible, however, that Bosch's immediate sources were northern woodcuts in which the Italian iconography had already been adopted, as for example the *Calendrier du Berger* (cf. Combe). The *Paradise* is a sort of cloister in which men and women, strictly separated, devote their lives to meditation.

APPX. PL. 70

NOTES – P. 15, 27 We cite the *Bescheidenheit* of Freidank (Vridankes, *Bescheidenheit*, ed. Wilhelm Grimm, Göttingen, 1834, p. 2, v. 5):

> *Nothing is hidden from God,*
> *He sees through the gates of all hearts.*
> *Be it evil or good,*
> *What any man does in the dark,*
> *Or what he thinks in his heart,*
> *It will be brought to light.*

P. 15, 30 Cf. A. de Laborde, op. cit. (Plates LXX, LXXIV), about 1475.

3. THE MARRIAGE AT CANA

PAGES 70-77

Rotterdam, Museum Boymans-van Beuningen (formerly Haarlem, Koenigs Collection).
Oil on wood. Height 93 cm, width 72 cm. Unsigned.
The upper corners of the picture are cut away, probably at some later date.

PROVENANCE: It is not impossible that this work may be the picture 'in the manner of Bosch' mentioned in the Rubens inventory under the title of *Marriage Feast* (not *Marriage at Cana*, as G. Ring writes).

PRESERVATION: Heavily restored: almost all the heads are repainted. The dogs, lower left, are probably of the eighteenth century. The upper corners have been cut. Photograph prior to restoration: *Jahrbuch für Kunstwissenschaft*, ed. E. Gall, 1923, p. 310. Copy before restoration and mutilation, see Appx. Pl. 12, below right.

INTERPRETATION: Although both the dogs in the original as it stands were obviously added by a later hand (see text), it may be that there were originally two dogs gnawing bones, since this motif is traditional in the depiction of feasts and the lower left corner would be empty without them.

Apart from a possible influence by Dirk Bouts' *Last Supper* (cf. Baldass), we should like to point out that the L-shaped table in this picture and the distribution of the main figures, with Christ on the short side of the table rather than in the middle and the bride full-face in the middle of the long side, go back to the tradition of the Italian Trecento, originated by Giotto in his *Marriage at Cana* (Cappella Scrovegni, Padua). This compositional device was retained in the north during the fifteenth and early sixteenth centuries (e. g. the *Marriage at Cana* of a pupil of the Master of the Legend of St Catherine, Melbourne; cf. Friedländer, *Altniederländische Malerei*, Berlin, 1926, IV, Plate 48). In Gerard David's *Marriage at Cana*, Louvre, the table is parallel to the picture plane (as in Baldovinetti, Museo S. Marco, Florence), but the arrangement of the main figures is the same as in Giotto's fresco. In all representations of this theme except that of Bosch, the action of Christ is linked with the scene around the wine-jars, where the miracle of the transubstantiation of the water into wine is being performed. Only in Bosch's painting is Christ turning away from the jugs and toward the chalice that a child, a kind of officiating priest (a completely unusual motif in this connexion), is holding in his hands, in the central axis of the picture. In this way the biblical miracle is intentionally overshadowed by the miracle of the Eucharist. The importance of the ministrant child is

stressed by the little golden armchair which stands beside him, which is adorned with two sacred figures (probably prophets) and is much richer than the wooden seats of the other guests. May we not see in this figure an allusion to the young Church and to the Eucharist of the Mass performed by Christ as priest? The figure that we interpret as the magician could at the same time be regarded as the master of ceremonies, who also has a staff in his hands in some fifteenth-century miniature pictures of feasts (cf. Bax, 1949, pp. 183ff.). The figure is standing in front of a strange sideboard, reminiscent of an altar, which stands in a vaulted Gothic apse. On the sideboard we see a loaf of bread, wine-jugs and an oil-flask – all of them objects used in the Mass; we further find the statuette of a pelican, the symbol of Christ, and another statuette, probably representing St Christopher carrying on his back the globe of the earth crowned with a cross. All these objects are in conformity with Christian practice. On the other hand, the statuette of the two naked dancing figures probably signifies lust, and the object on the top of the sideboard, which Combe regards as a sea-urchin, seems to symbolize heresy. Good and evil are contrasted here, as in the main scene.

Fraenger, *Die Hochzeit zu Kana,* has given a detailed interpretation of the structure of this sideboard. He believes that the division of the base of the chest into twelve rectangles corresponds to the signs of the zodiac, and that the objects on the top are exclusively heretical and sexual symbols. According to him the picture represents the marriage feast of Jacob van Almangien and a Jewish woman, an interpretation already rejected, rightly in our opinion, by Bax, 1949, pp. 153ff. Fraenger's assertion that astrological signs appear in this picture and that the figures represent the children of the moon *(luna)* cannot be fully proved or fully disproved. It would explain the high point of view that the artist chose for the scene. We believe, however, that Bosch here created a moralizing genre scene cloaked in a biblical motif, and so confronted the viewer with the alternative of good and evil, between which he must choose.

The entire setting, which is not a space surrounded by walls, suggests a stage setting, and in the background are seen, behind a railing, the heads of two onlookers. In this way Bosch apparently seeks to stress the didactic nature of the scene.

APPX. PL. 12 COPIES: There is a drawn copy in the Edmond de Rothschild Collection in the Louvre (published by Boon, *Burl Mag.,* 1960, p. 452), to which the copyist has added a portrait of the donor, introduced by a saintly bishop, in the lower left corner.

COPY: See illustration: photograph of a picture whose owner is unknown to us; drawing, Edmond de Rothschild Collection, Louvre. APPX. PL. 11

BIBLIOGRAPHY: Pfister, *Belvedere,* IV, 1923, pp. 73ff. G. Ring, *Jahrbuch für Kunstwissenschaft,* ed. E. Gall, 1923, p. 310f., with a good reproduction made before the picture was restored. Baldass, 1926, pp. 103ff.: detailed analysis. Friedländer, pp. 94, 145, no. 73. *Commemorative Catalogue of the Exhib. of Dutch Art,* Burlington House, 1929, p. 1. T. Borenius, *Pantheon,* III, 1929, pp. 57, 134. *Verzameling F. Koenigs Schilderijen,* Museum Boymans, Rotterdam, 1935, no. 3. *Catalogue of the J. Bosch Exhibition,* Museum Boymans, 1936, no. 48a. Tolnay, 1937. Baldass, 1959, Fig. 109 and pp. 54f., 80, 243. Combe, Plates 7–9. See text.

NOTES – P. 13, 10 The picture in the Boymans Museum has suffered severely from its latest restorations. The upper corners have been cut, the dogs added in the left foreground, and almost all the heads repainted. (An idea of the original state of the picture can be obtained from a copy, otherwise mediocre, reproduced in this book.) APPX. PL. 11

P. 13, 12 Baldass, 1926, p. 104, has called attention to this relationship. It may be assumed that Bosch was directly inspired by a lost picture by the Master of Flémalle. In accordance with the compositional principles of this master the figures are relatively small, and the side walls of the space in which the scene takes place are not visible.

P. 13, 24 According to J. Hansen, *Zauberwahn, Inquisition und Hexenprozess im Mittelalter...,* Munich, 1900: 'From the second half of the thirteenth century onward it was regarded as scientifically proved that magicians were bound by a pact with the devil, which presupposed apostasy from the faith.'

P. 13, 29 As to the significance of the swan, Bosch may have had the old Flemish saying in mind: *De zwaan is wit van pluimen, maar haar vleesch is zwart.* Harrebomée, II, p. 189.

We shall see that this interpretation also applies to the swan featured as a heathen sacrificial animal in the Lisbon *Temptation of St Anthony.*

On the other hand, we also know from certain documents preserved in the Archives of the Brotherhood of Our Lady in 's Hertogenbosch that the members of the brotherhood were accustomed to assemble at banquets at which the flesh of swans contributed by the noblest brothers was eaten. Hieronymus Bosch himself took part in such banquets (see p. 407, Documents). A 'swan-eating' is mentioned in the accounts as early as 1384 (see J. C. A. Hezenmans, *De Illustre Lieve Vrouwe Broederschap in den Bosch,* Utrecht, 1876, pp. 58ff.). In 1396 an account PAGE 139

340

mentions a gratuity to 'the servant that brought the swan' and soon the senior members of the brotherhood were being called 'brethren of the swan' (Communication by Mr Mosmans based on unpublished documents). At one time the brotherhood was even given the strange name of 'Brotherhood of the Swan' ('Zwanenbroederschap'; see F.X. Smits, *De kathedral van 's Hertogenbosch*, Brussels, 1907, p. 47) and on their arms the swan figured above the lily. Did Bosch intend, in his *Marriage at Cana,* to make a satirical reference to the luxury of certain 'swan brethren'? P. 13, 31 In his Purgatory (xxii, 142) Dante already used the theme of the *Marriage at Cana* to contrast gluttony and faith.

3a. TWO HEADS, POSSIBLY OF HIGH PRIESTS

PAGE 78 Rotterdam, Museum Boymans-van Beuningen, no. 1177. Oil on wood. Height 14.5 cm, width 12 cm.

A small picture, published by Baldass, 1943, Fig. 102. In poor condition. It is in the style of Bosch's early paintings and closely related to the *Marriage at Cana.* The attribution cannot be dismissed out of hand, but cannot be proved definitely because of the poor state of preservation of the picture.

4. THE EPIPHANY (ADORATION OF THE MAGI)

PAGES 79, 80 Philadelphia, Philadelphia Museum of Art, Johnson Collection. Oil on wood. Height 74 cm, width 54 cm. Unsigned.

PROVENANCE: Collection of the Earl of Ellenborough. DATING: M. J. Friedländer, *Von Eyck bis Bruegel*, 1916, p. 74. Baldass, 1917, pp. 182ff., considers the picture to be a youthful work. Frank J. Mather, jr., *Art in America*, VI, 1917 (Dec.), pp. 3ff. Friedländer, pp. 91, 143, no. 67: 'Probably dates from his youth.' Combe, Plate 10. INTERPRETATION: The high vanishing-point, the hut set diagonally in the foreground and the view of a distant landscape in the background may have their origin, as we said, in a lost work of the Master of Flémalle, Robert Campin (cf. his *Nativity* in Dijon and Jacques Daret's *Epiphany*) or in miniatures of the first third of the fifteenth century, in which the arrangement of the figures is also like that of the Philadelphia painting. However, Bosch has expanded the hut by adding a shed, the wall of which extends to the right-

hand edge of the picture. In this way he gives it a double compositional function: the hut serves at the same time to combine into a unity the group of figures in the foreground and to screen them off from the outside world of the background. The artist was to repeat this scheme in his later *Epiphany* in the Prado.

The motif of the broken wooden post at the corner of the hut nearest the spectator likewise goes back to a tradition, as can be seen from a Dutch miniature in a Utrecht missal of about 1425–30, fol. 19 v., Walters Art Gallery, MS 174, Baltimore. This strange representation of the post may perhaps be explained as a compositional expedient, to break the vertical line before it cuts the figure of the kneeling king and, in Bosch's case, that of Joseph as well. Bosch gives a sort of justification to this trick by showing the irregular break; none the less, it is illogical from the static point of view and does not occur either in the *Epiphanies* of the great masters of the Netherlands School or in the later *Epiphanies* of Bosch himself. The fall of manna embroidered on Caspar's sleeve was regarded in the Middle Ages as the typological prefiguration of the Eucharist and as related to the Last Supper (cf. *Biblia Pauperum, Speculum Humanae Salvationis*). Perhaps Bosch's intention was to link this Old Testament scene with the Epiphany, and he may have taken the idea from John vi, 33, where 'the bread of God is he which cometh down from heaven, and giveth life unto the world', and from John vi, 35, where Christ says, 'I am the bread of life (manna): he that cometh to me shall never hunger; and he that believeth on me shall never thirst.'

PAGES 295-305

PAGE 80

This is confirmed by a sermon of Savonarola's ,'Sopra l'Evangelio che si legge nella Epifania' (in *Sermoni e Prediche*, Florence, 1846, p. 165), which says that the gathering of manna was often regarded as the prototype of the Epiphany. . . .*nasce in Betlem, la quale è interpretata casa di pane, questo è certamente quel pane, che discende dal cielo*. . . On the other hand in the *Biblia Pauperum* and the *Speculum Humanae Salvationis* the gathering of manna is seen as the prototype of the Last Supper (see E. Breitenbach, *Das Speculum Humanae Salvationis*, Strasbourg, 1930, p. 165).

The idea of inserting a leafless sapling in the lower left corner may be a further allusion to the spiritual desert of the world before Christ's birth, as well as to January 6, the Feast of Epiphany. But we can see that close to Christ, in the cracks of the split wall and on the roof, fresh green is sprouting – the new life budding with the presence of Christ.

A solitary bird is sitting on a bare rafter of the roof. It seems to look on indifferently at this drama of decay and rebirth. This is in itself a highly poetic new idea, that

may also have a deeper significance. One wonders whether this bird, a magpie, symbol of inquisitiveness and garrulity, may not have been thought of by Bosch as a sort of spiritual self-portrait. Half a century later Pieter Bruegel the Elder took this motif up again in his picture of *Autumn* (Vienna) and used it in the same sense. It is also possible that the bird is a reference to the words of the Bible (Ps. cii, 7): 'I watch, and am as a sparrow alone upon the house top.'

The identification of the Adoration of the Magi with divine service in the church is also new. This purpose of Bosch's may explain the gifts brought by the kings, which are no longer the usual chalices, cups or small chests, but a reliquary and an object that looks like a monstrance. Thus the Adoration of the Magi is conceived as an eternal ritual and prefiguration of the Mass, an idea to which Bosch also remained true in his last *Epiphany*, in the Prado.

A warm pink tone dominates the foreground, since the cloak of the Virgin, Joseph's garment and that of one of the standing kings are in that colour, as are the girdle and shoes of the Negro king. Bosch achieved freshness and beauty in this hue, which he treated not as a static local colour but as a living changing tint, which flows into a pinkish-white in the brighter parts and into a deeper pink in the darker spots; instead of passing from a locally established colour to the more shaded parts, as was the custom in the Netherlands School, Bosch tones his pink in either direction, toward the light or the dark. In a similar manner, the light-green garment of the kneeling king and the white one of the Negro king vary in tone. This colour conception, which was no longer usual in the Netherlands after the middle of the century, continues and brings to perfection the earlier colour scheme of the international style. In addition to this, the fact that Bosch used pink for so many elements in this picture can be linked with the subject that he wanted to express: it gives the whole scene a bright aspect and heralds a new spring, with the birth of Christ.

APPX. PL. 73 NOTES – P. 12, 15 This miniature (MS 12, fol. 77 v.) is a copy of a miniature in the breviary of Jean Sans Peur, London (fol. 199), and a drawing in silver point in the Kupferstichkabinett in Berlin, generally attributed to Hubert van Eyck or an unknown Dutch master. (See B. Martens, *Meister Francke,* Hamburg, 1929, p. 203 and Figs. 54–58).

P. 12, 17 In the two conventional types of Epiphany, one in which the Virgin is shown frontally, seated in the centre of the composition (Roger van der Weyden, Memling), and another in which she is depicted in profile in a corner of the picture (Hugo van der Goes, Bouts, Gerard David, Geertgen), the scene is always a

ruin and the retinue of the kings always appears, and two of the kings are kneeling. In Bosch's presentation the simple hut and the omission of the kings' retinue, with only one king kneeling, are elements taken directly from the Dutch miniature of 1438 which link it with the Middle Ages.

P. 12, 20 The evening star mentioned in the legend and always depicted in the Middle Ages is absent from all *Epiphanies* in Dutch art during the latter half of the fifteenth century.

BIBLIOGRAPHY: In addition to the literature on p. 341: Tolnay, 'The Paintings of H. Bosch in the Philadelphia Museum of Art', *Art International*, VII, 4, 1963, pp. 20ff.

5. ECCE HOMO

Frankfurt-on-Main, Städelsches Kunstinstitut. PAGES 81-85
Oil on wood. Height 75 cm, width 61 cm. Unsigned.

PROVENANCE: Maeterlinck (Ghent) and R. v. Kaufmann (Berlin) Collections. Acquired by the Städelsches Kunstinstitut in 1917.

PRESERVATION: The artist represented the donors in the lower left corner, and they are still recognizable in X-ray photographs; see A. Wolters, *Städeljahrbuch,* VII–VIII, 1932, pp. 228ff.

INTERPRETATION: The arrangement of the groups in the foreground follows a tradition that we know from various representations: e. g. a woodcut of the early fifteenth century, to which Combe was the first to draw attention; a Dutch drawing of about 1480 in Berlin; and APPX. PL. 74
the engraving of the same subject by Schongauer in Brussels.

The text of the inscription, which reproduces the words spoken by the donors, is: *crucifige eu(m)*. In certain works by the Master of Flémalle, e. g. the *Marriage of the Virgin* in the Prado, we already find similar grotesque and malicious faces and the gesture of an onlooker, putting his hand on a neighbour's back. Can the source of Hieronymus Bosch's inspiration once more have been a lost work by the Master of Flémalle? Here, as in the scenes with the devil, it is not necessary to adduce Schongauer's *Passion,* as Dvořák does, in order to interpret the work of Bosch.

Domien Roggen, in an article in *Nieuw Vlaanderen* on March 7, 1936, explains the caricature-like quality of Hieronymus Bosch's personages as mere imitation of the calfskin masks worn in 's Hertogenbosch at the great religious processions in late June or early July on the occasion of the annual *kermes*. Roggen also refers to some accounts showing that masks of this kind were bought

by the Brotherhood of Our Lady; the oldest one dates from 1368, the latest from 1475. But the meaning of these masks, which were intended to represent sacred persons – the three Marys, the Prophets and the Apostles – suggest that they were not supposed to be caricatures.

In addition to the symbols of demoniacal magic, already mentioned in the text, we find here the owl in the small window of Pilate's house and the crescent on the halberd.

COPIES: See Friedländer, p. 116, and Brockmann auction at Christie's, London, July 31, 1931.

A similar painting of the *Ecce Homo*, in part identical, in the Museum of Fine Arts in Boston, is in our opinion an atelier product; see under no. 5a.

BIBLIOGRAPHY: L. Maeterlinck, *G.d.B.A.*, XXIII, 1900, pp. 68ff. *Catalogue de l'exposition de Bruges*, 1902, no. 137. *Repertorium für Kunstwissenschaft*, 1903, p. 168. Cohen, no. 4. Lafond, p. 41. Dvořák, *Kunstgeschichte als Geistesgeschichte*, p. 178. Friedländer, pp. 91, 146, no. 77. A. Wolters, *Städeljahrbuch*, VII–VIII, 1932, pp. 228ff. Tolnay, 1937. Baldass, 1959, p. 244, Figs. 113, 120. Combe, Plate 14, p. 81.

NOTES – P. 14, 8 In a bull of Pope Gregory IX (1233) the toad is already mentioned as a sign of the Devil and magic. See: G. G. Roskoff, *Geschichte des Teufels*, Leipzig, 1869, I, p. 330, and Grimm, *Wörterbuch der deutschen Sprache*, 5, 2416ff.

5a. ECCE HOMO

. PL. 13-18

Boston, Museum of Fine Arts.
Centre panel: height 73 cm, width 58 cm.

INTERPRETATION: This is a second and in part different version of the Frankfurt *Ecce Homo*. It was acquired by the Boston Museum of Fine Arts and published as an authentic work by Bosch by H. Swarzenski in the *Bulletin of the Museum of Fine Arts in Boston*, LIII, 1955, no. 291; Panofsky agreed with Swarzenski's view in the *Bulletin des Musées Royaux des Beaux-Arts*, V, Brussels, 1956, pp. 95ff. Both authors believe it to be a later, more mature version of the Frankfurt panel, and Panofsky dates the Boston painting about 1500, 'perhaps even a little later'. The praetor's palace and the group of priests and officers at lower right are almost identical in the two versions (note that the owl in the little window is absent in the Boston version). Other figures, e. g. Pilate and the soldier next to him, wear the same clothing. In the square before the town hall in the background there is seen, in Boston, Christ carrying the Cross; this resembles the scene on the reverse of the Berlin *St John on Patmos* (Swarzenski). Some of the buildings on the square in the background are likewise almost identical, e. g. those on the right, and are only slightly simplified in the Boston picture. The canal with the bridge leading to the square is omitted in the Boston panel. The painting is badly worn and has been painted over in parts (e. g. Christ's arm and the head of the figure at lower left).

Panofsky (op. cit.) regards the Boston picture as 'of fundamental importance' from the iconological point of view. He thinks that Bosch 'revolutionized or counter-revolutionized accepted tradition by showing Christ full-face, thereby starting a development that led, by way of the Master of the Virgo inter Virgines and Lucas of Leyden, to its culmination in Rembrandt's 1655 etching.' According to Panofsky, Bosch's Christ is here shown *en face* instead of in three-quarter profile for the first time since Duccio, and in the centre of the scene for the first time since the mosaic in San Marco: it is not so much an Ecce Homo as an 'ostentatio Christi'.

According to C. Eisler, *Corpus: New England*, 1961, pp. 33ff., the Boston panel reproduces a lost copy of a frontal *Ecce Homo* by Bosch, which also served as a model for the Master of the Virgo inter Virgines. But I doubt the correctness of this interpretation, since I regard the Boston work as a combination of various compositions by Bosch. The Boston work is a pastiche, and heteroclitic in its composition as well.

As regards its authenticity, Colin Eisler (op. cit.) is more cautious than Swarzenski and Panofsky; he proposes a compromise solution, saying that 'some places betray help by assistants', while others, such as 'the heads to the right and left of Christ are so splendidly drawn' that they probably derive from Bosch himself. For my part, I believe that the entire panel is an atelier work, in which, as I have already remarked, a number of the master's compositions were used and in addition enlarged on by the assistant, e. g. the two figures in the upper left corner, which certainly do not derive from Bosch. But even in the portions that have been copied almost exactly, the expression of the faces lacks the animation of the Frankfurt original. It is clear that this is only a copy from the fact that the soldier's hand, which in the Frankfurt copy touches the back of another soldier, hangs in the air in the Boston version and does not touch his neighbour's back. Mistakes like this are typical of copyists' work. Also, the right hand of the soldier holding Christ's cloak seems to be reproduced erroneously. And how characteristic it is that he has forgotten to put in the owl! The colours of this badly preserved painting, among which pink, light blue, dark olive-green and white dominate, are obviously inspired

343

by the technique of the early Bosch. Since Panofsky himself admits that iconographically the composition must be dated after 1500, while the technique and colours imitate Bosch as of about 1480, the contradiction is evident.

The predella and side panels, which had previously been in storage, are now shown in the Museum. Swarzenski and Panofsky do not mention them. Colin Eisler, who was the first to publish them, says, 'they are certainly by assistants, probably done after Bosch's death.' He adds that 'in style they depend on works that are generally assumed to belong to the early part of the master's œuvre – the *Epiphany* in the Prado and the *Crucifixion* in Brussels.' According to Eisler they are of inferior quality.

It is my opinion, however, that the paintings on the side panels are of higher quality and better preserved than the centre panel, that they were made in Bosch's atelier while he was still alive, and that the plastic folds of the garments worn by the patron saints do not go back to Bosch's earliest style but to his maturity. (The *Epiphany* in the Prado mentioned by Eisler is not, as he believes, an early but a late work.) The folds of the bright red cloak of St Peter are almost the same as those of St Peter on the left inner wing of the Madrid *Epiphany,* apart from the fact that the latter is superior in execution. The cloak of St Catherine resembles that of St Agnes on the right wing of the Madrid *Epiphany.* The blue-grey atmosphere of the landscapes in the background of both panels is of high quality and very closely related to Bosch, but the bushes in the middle ground are summarily executed. The kneeling donor has on his cloak an emblem of the Brotherhood of Our Lady of 's Hertogenbosch: *sicut lilium inter spinas,* 'as the lily among thorns' (Song of Solomon ii, 2). The coat of arms has been identified as that of the van Oss family, prominent in 's Hertogenbosch from the fourteenth to the sixteenth century. Pieter van Oss was in charge of the hospital, and C. Eisler assumes that the child in swaddling clothes under the cloak of the donor's wife is an allusion to their care of foundlings. Another possibility is that it may refer to the picture of a child who died very young.

The use of gold, especially in the brocaded garment of St Catherine and the glorioles, is an archaizing trait.

As I see it, the outer sides of the wings have the highest quality of all the paintings of the triptych. The painterly character is more strongly developed, and they must have been done later than the inner sides. The elaborately executed pink cloak of St Mary Magdalene is worthy of the master. Remarkable are the changing colours, blue melting into pink on the sleeves, foreshadowing the coloration of Mannerism. If we compare the pink cloak of St John the Evangelist with that of the Virgin in the Franchomme *Crucifixion,* we see that the Boston panel is painted in a more advanced style. The emblem on the green head-covering of the male donor is again that of the Brotherhood: *sicut lilium inter spinas* (Song of Solomon ii, 2). On the green wall tapestry in the background is the motif of a swan among leaves like those of lilies, which likewise appears to go back to the Brotherhood, whose foremost members were called swan brethren, just as the Brotherhood itself was called the Brotherhood of the Swan (see above, p. 341). Following a Netherlands tradition, the architectonic stage extends beyond the frame. We see a niche with a wooden barrel-vault running parallel to the plane of the picture (cf. *Death of the Miser)*, whose stone frame, however, has the form of an ogee – a contradiction that does not surprise us in Bosch's school, since the master himself had no feeling for architectonic structure.

It is by no means certain that the pictures were originally intended as side panels for the Boston *Ecce Homo* painting. In the first place they are different in style and quality, and secondly they are smaller. Their landscapes do not harmonize with the centre panel. Colin Eisler is of the opinion that they may have been planned as complements to a *Crucifixion* or a *Crowning with Thorns.*

Be this as it may, the centre panel is only a pastiche painted in the atelier after pictures by the early Bosch. The side panels, better in quality, were executed in a more highly developed style and probably under the supervision of the master.

There is also in existence a predella with the *Arma Christi* (for the iconography of the *Arma Christi,* see R. Berliner, *Münchener Jahrbuch,* 3rd series, VI, 1955, pp. 35 ff.), which again is somewhat smaller than the centre panel. It is in a provincial Dutch style, probably also from 's Hertogenbosch, and not without painterly qualities. It was probably inspired by the early Bosch. On a warm brownish-beige background are Veronica's veil, four heads and the instruments of Christ's Passion. It is painted with soft strokes, the light being indicated by white colour. Colin Eisler regards the predella as superior to the side panels.

6. THE CONJUROR

Saint-Germain-en-Laye, Musée Municipal. PAGES 86-89
Oil on wood. Height 53 cm, width 65 cm. Unsigned.

PROVENANCE: M. Ducastel Bequest (1872).
PRESERVATION: Repainted in many places (e. g. the

hair of the child on the left; the table).

ATTRIBUTION: Having had several opportunities to study the panel afresh, I am inclined to regard it as an original. It must be the prototype of the four copies and the engraving published and discussed by Brand Philip, 1958, pp. 24ff. She rejects the painting in Saint-Germain-en-Laye as a copy, and not even a faithful one; she is of the opinion that the original was a tondo, with additional elements that can be seen in the copy in Philadelphia. On this basis she seeks to found her theory as to the lost original. But the added elements on the copy in Philadelphia obviously do not derive from Bosch but were invented by the copyist in the forties or fifties of the sixteenth century.

DATING: Baldass, who regarded this work as an original (1917, p. 194), ascribed it to the final phase of the master's development and called it 'the most mature of his small pictures'. In the latest edition of his book (1959) he regards the picture as a copy of an early work. But the affinity in colouring and execution, especially of the flat silhouettes, with the Frankfurt *Ecce Homo*, which is generally accepted as a youthful work, leads us to date the *Conjuror* from the same early period.

INTERPRETATION: The motif of the frog jumping out of the simpleton's mouth probably illustrates the popular expression 'to swallow a frog', meaning to show great credulity (Combe).

Credulity and curiosity had already been described as major sins by Pico della Mirandola in his work *In Astrologiam* (Basle, 1552, p. 411). Roggen (1936) cites the last two stanzas of a poem in the *Refreynenbundel* (Anthology) of Jan van Stijevoort:

> Sit ic dan alden dach inde mute
> Ende gaeic savonts ter merctwert ute
> Sien batementen daer mij therte nae haect
> En speelmtmer (speelt men er) dan enighe sotte clute,
> Daer gaet mihn troonge in sulcker ontslute
> Van lachene dat mijn stortgat splaect.
> Soe coemter ee guijt, die in mijn bors geraect
> Ende vloijt mij mijn noppen denct propelic daer.
> Ic lach ic en peijs niet wat hij maect,
> Mer al lachende worden mij mijn scijven ontscaect.

Finally, we refer to the sentence in Freidank's *Bescheidenheit* (p. 115), which gives an explanation of the frog: 'Woe to the frogs, when they go into the stork's house.' And in point of fact a stork is represented on the rear wall, to the left.

Fraenger *(Hochzeit zu Kana,* pp. 67ff.) interprets this scene as a sexual-satirical rendering of a ritual circumcision.

According to Brand Philip, this too is a picture of planet-children. The mountebank is a child of Luna, and the composition describes both the phlegmatic temperament and the element of water. But this interpretation is based on the additional elements of the Philadelphia copy, which dates from the middle of the sixteenth century, and not on the original.

COPIES: See Brand Philip, 1958, pp. 24ff. APPX. PL. 8, 9
SKETCH: In the Louvre: Drawing no. 19,197. See text. PAGE 317
BIBLIOGRAPHY: H. Hymans, *G.d.B.A.*, x, 1893, p. 234, BELOW LEFT
L. Gonse, *Chefs-d'œuvre des Musées de France*, 1900, p. 7.
F. Dülberg, *Frühholländer in Paris*, Haarlem, 1908, IV, Plate 7. S. Reinach, *Apollo*, Paris, 1905, p. 216, Fig. 381. Schmidt-Degener, p. 147: detailed analysis. G. Frizzoni, *Chronique des Arts*, 1906, p. 240. L. Maeterlinck, *Le genre satirique* ..., p. 233. Gossart, p. 63. Cohen, no. 12. Lafond, p. 77. Baldass, 1917, p. 194: 'the most mature of the small paintings.' Friedländer, pp. 103, 152, no. 105: 'Perhaps an old copy.' *De van Eyck à Brueghel* (catalogue), Musée de l'Orangerie, Paris, 1935, no. 4. Tolnay, 1937. Baldass, 1959, p. 224, Fig. 10. Combe, no. 16.

NOTES – P. 16, 26 We refer, for example, to Giotto's *Resuscitation of Drusiana* in the Peruzzi Chapel in Santa Croce, Florence.

P. 16, 32 See Schmidt-Degener, pp. 147ff.

6a. PARADISE AND HELL: two panels

New York, Wildenstein Galleries. PAGE 90
Oil on wood. Height 34.5 cm, width 21 cm and height 33.4 cm, width 19.6 cm.

PROVENANCE: The panels were formerly in the Bromberg Collection, Bremen. They were first published by Tolnay in the *Record of the Art Museum*, Princeton University, xx, 1961, no. 2, pp. 43ff.

PRESERVATION: Both panels have been cut at top and bottom. They originally belonged to a triptych with the *Last Judgement* as the centre panel.

ATTRIBUTION AND DATING: The whole work can be reconstructed with the help of a fairly exact early copy of the lost triptych, which was formerly in the L. Maeterlinck Collection, Ghent and was published by him in the *Revue de l'art ancien et moderne*, XXIII, 1908, p. 149. At that time he still had no knowledge of the two original fragments and attributed the triptych to Herri met de Bles. It was again published by Lafond, *H. Bosch*, 1914, APPX. PL. 77 as a work by Herri met de Bles. The side panels are from the end of Bosch's early period, as can be seen from the simplicity of certain motifs that recur in more developed form in some later works, and from the flat brush-strokes characteristic of the works immediately prior to the *Haywain*.

INTERPRETATION: With respect to their colour the two panels are conceived as a contrasting pair: the *Paradise* shows a delicate, cool, bright harmony in which the white of the tent with its blue floral decoration and the light pink of the angel's cloak and the canopy of the boat stand out against the soft, cold, greyish blue-green of the background. *Hell*, on the other hand, is dominated by a warm, brownish background (anticipating Pieter Bruegel the Elder), in front of which gleam the pink of the blanket and the dull grey-blue of the canopy of the bed. The figures are painted *alla prima* as flat silhouettes, with scarcely any modelling. A comparison with the motifs of Bosch's later representations of the Earthly Paradise and Hell is extremely interesting, and this theme has been dealt with briefly by Tolnay, *Record of the Art Museum*, Princeton University, 1961, pp. 43 ff.

The copy of the triptych is important in that it is the first example of Bosch's new conception of the Last Judgement, which is encountered in a number of his later triptychs treating this subject. The novelty becomes evident if we compare the copy with the early tondo of the *Last Judgement* on the Madrid table-top. The upper part is in keeping with the Madrid work and is a simple development of it; this portion is still tradition-bound. But below we see an infernal landscape from a high viewpoint. Instead of the usual 'resurrection of the flesh' Bosch presents a valley with a river, a bridge and some crags. The valley is teeming with small devils, monsters and naked human souls, who are tortured by every conceivable kind of infernal machine. The latter seem to be new motifs, since they do not occur in any previous Flemish *Last Judgement* and are apparently inspired by literary sources, such as the writings of the Prophet Enoch and to a greater extent the book of the *Vision of Tondalus* (cf. Dollmayr, 1898, and A. Ruegg, *Die Jenseitsvorstellungen vor Dante und die übrigen literarischen Voraussetzungen der Divina Comedia*, Einsiedeln, 1945). There we find descriptions of the valley, river, the bridge and instruments of torture. Tondalus' book was very fashionable in Bosch's time and was published in three contemporaneous Dutch translations: 1482, Antwerp; 1484, 's Hertogenbosch; and 1494, Delft. Several motifs of the lost triptych reappear in Bosch's later works, and we can note how the artist began with simple forms and only gradually arrived at more complex ones. In this way we are able to follow the organic evolution of the master's conceptions. Bosch treated the subject of the Last Judgement at least seven times, and if we include the related triptychs (the *Hay-wain* and the *Garden of Earthly Delights*) nine times. These paintings can be classified into four groups:

A. Those that depict the resurrection of the flesh are the earliest and latest treatments: the table-top in Madrid and the Munich fragment.

B. These represent, instead of the resurrection of the flesh, the battle in a valley between angels and devils for human souls. The outcome of the struggle seems uncertain. Both compositions belonging to this type have been lost and are known only from engraved copies, one by Allaert de Hameel and one by Hieronymus Cock. In the latter the frame is given as well, presumably to emphasize that this was a reproduction of a painting. Although Bosch's style is here completely translated into the language of the mid-sixteenth century, we may assume that the elements of the composition go back to him.

C. Here the Last Judgement again occurs in a landscape, but a nocturnal one with a stream and a bridge in the middle ground and with burning ruins scattered in the background. In the foreground and middle ground are a number of instruments of torture. This type includes the lost triptych, a copy of which was formerly in the Maeterlinck Collection, and the two fragments of the original side panels in the Wildenstein Galleries. This composition directly anticipates the one in the Vienna Academy, so far as the centre panel is concerned. A third triptych of this type, and the most developed, is in Bruges.

D. To this type belong the *Hay-wain* and the *Garden of Earthly Delights*: two triptychs, one relatively early, the other late, both derived in their structure from the triptychs of the Last Judgement (cf. the wings), while the Divine Judgement is lacking on the centre panel. (It is of interest to note that Leonardo, a contemporary of Bosch, likewise omitted the Divine Judgement in his representations of the end of the world.)

All the triptychs discussed must be read from left to right and not beginning from the middle, as in earlier Netherlands depictions of the Last Judgement in triptych form. Bosch's triptychs show progressive stages in the downfall of the world as an immanent natural process, and there is a causal necessity in the three consecutive acts of the drama.

B. COMPOSITIONS WITH SMALL FIGURES FROM THE MIDDLE PERIOD

7. THE DEATH OF THE MISER

PAGE 91

Washington, National Gallery.
Oil on wood. Height 92.6 cm, width 30.8 cm. Unsigned.

PROVENANCE: Baron van der Elst (to 1951); Samuel H. Kress Collection.

PRESERVATION: The preliminary sketching of the composition with black chalk is still clearly visible. A few details have been painted over, possibly by Bosch himself, and are still visible through the paint: a rosary on the wall in front and a jug below the standing figure. The picture is relatively well preserved, with the exception of the upper corners, which have been repainted. It was cleaned and restored in 1937. Today I should date the picture in accordance with nos. 8, 9 and 10.

PAGE 328
ABOVE

ATTRIBUTION: The drawing *Death of the Miser* on grey paper in the Louvre (Inv. no. 6947), executed with a fine brush and heightened with white, is by the same hand as the drawing of the *Ship of Fools,* also in the Louvre, and considered by Popham and Boon to be an original by Bosch. I still maintain that this must be a copy, because the facial features lack detail whereas the drapery is reproduced pedantically. The draughtsman has altered the position of the door and set it in the middle of the left wall, so that the figure of Death has come closer to the dying man. It looks as though a later hand has added, in the empty space next to the door, the knight's helmet, lance and glove that were formerly in the lower right corner.

INTERPRETATION: The tonality, with its pale light tints, almost resembles a grisaille; only the bright red of the bed and the olive-green clothing of the figure at the foot of the bed stand out from the foreground. This suggests that it was the reverse of the left wing of a lost triptych. The other outside panel may have depicted another scene of the *ars moriendi*. When the altarpiece was open, the centre panel probably showed a *Last Judgement* and the wings *Paradise* and *Hell,* so that the ensemble was a representation of the Four Last Things.
The old man at the foot of the bed, who is often taken to be a second representation of the dying man, is probably a further illustration of irresolution: with his left hand he is praying with the rosary, but with his right he is putting money into the purse held by a small devil in the chest. For similar chests in miniatures, see Bax, 1949, p. 244. This therefore repeats the theme of the main scene: the choice between good and evil.

BIBLIOGRAPHY: Mentioned by G.Glück in his *Bruegels Gemälde* (1st ed.), Vienna, 1932, p. 57, and Baldass, 1935, p. 89, note 7. First published by Tolnay, 1937. Friedländer, Leyden, 1937, XIV, p. 101, but here described incorrectly as a grisaille. Baldass, 1959, p. 229. Combe, no. 32.

NOTES – P. 25, 10 For the engravings of the *Ars Moriendi* of Master E.S., see Lehrs, *Repertorium für Kunstwissenschaft*, XXII, 1899, pp. 458ff.; ibid., *Geschichte und kritischer Katalog der deutschen, niederländischen, französischen Kupferstiche im XV. Jahrhundert*, Vienna, 1910, II.

APPX. PL. 69

8. THE SHIP OF FOOLS

Paris, Musée du Louvre.
Oil on wood. Height 57.8 cm, width 32.5 cm. Unsigned.

PAGES 92, 93

PROVENANCE: Gift of Camille Benoît (1918).

PRESERVATION: The branch tied to the masthead in the Louvre painting has been enlarged by a later hand. In the original execution the foliage has highlights, which are lacking in the added portions. The copy, a drawing in the Louvre, does not show the enlargement, and X-ray photos prove that this is a later alteration.
The panel is cut off at the bottom, but nevertheless we do not believe that the part cut off contained the *Gluttony* now at Yale (see below).

PAGE 329

DATING: The dating of the Louvre panel is still in dispute. Baldass, 1959, dates it around 1500; Edouard Michel, *Louvre Catalogue*, and H. Adhémar, *Corpus: Louvre,* I, 1962, regard it as one of Bosch's last works (about 1510–16). We believe, on the contrary, that on account of the flatness of the figures, the broken folds of the drapery and the nature of the treatment, which is rather painterly than plastic, it must be ascribed to an earlier date, viz. the *Hay-wain* period or even a little earlier.

INTERPRETATION: In all likelihood this painting was a wing of a diptych or triptych, whose other panels may

PAGE 315
BELOW
have represented other ships of fools (Demonts). Bosch's sketch in the Vienna Academy may have been a study for the right wing. The painting in the Louvre would then represent the fools' paradise and the Vienna drawing the fools' hell.

The origin of the theme can be found in contemporary literature. It is apparently earlier than Sebastian Brant's *Narrenschiff*, which was first published in 1494; the idea was already known in 1413, as is apparent from the poem 'Blauwe Schuit' by J. van Oestvoren, where a monk and a nun are mentioned in connexion with a ship of fools. However, Bosch's boat is not blue, and hence Bax calls the painting in the Louvre the 'Lichte Schuit', the bright ship. The theme of the ship itself is present in didactic literature from the fourteenth century. See, for example, *Das Schiff der Flust* by Heinrich Teicher, about 1360, and the *Blauwe Schuit* by J. van Oestvoren, 1413 (both published in the critical edition of Sebastian Brant: Friedrich Zarncke, *Narrenschiff*, Leipzig, 1854, pp. LXff.). D. Th. Enklaar, *Tijdschrift voor Geschiedenis*, XLVIII, 1933, pp. 37, 145, gives precise data on the origin and meaning of the 'blauwe schuit' (blue ship). It was the name of a kind of guild, a gay company that gathered to make fun of the mighty ones of this world. Enklaar further emphasizes that a number of H. Bosch's figures were inspired by the poetry of J. van Oestvoren.

APPX. PL. 81

Demonts, pp. 1 ff., interprets the maypole as the biblical tree of knowledge, and thinks he recognizes a skull in the carnival mask that hangs from it. He links the work by Bosch to the first woodcut in the little book by Jodocus Badius [Josse Bade], *Stultiferae naviculae seu scaphae fatuarum mulierum, circa sensus quinque exteriores fraude navigentium* (1498). But here the symbolic tree is characterized as such by the snake and the proximity of Adam and Eve; Bosch, on the other hand, refrains from any biblical allusion.

The painting in the Louvre has recently been thoroughly treated by H. Adhémar, *Corpus: Louvre*, I, 1962, pp. 20ff. According to her this is a satire on drunkards and monks, showing how the dissolute clergy let the ship of the Church drift and neglected the salvation of souls.

PAGE 329

The drawing of the Ship of Fools in the Louvre, which Popham and Boon consider an original, is in our opinion only an early copy. The faces have lost sharpness and delicacy. On the other hand, even the minor folds of the drapery in the original painting are copied exactly (see also our remarks on the drawing of the *Death of the Miser* in the Louvre).

Other renderings by Bosch of the Ship of Fools, now lost, are known to us from copies. These are (1) H. Cock, an engraving of 1559, showing the company in a boat with the inscription 'Blue ship' and representing lust; (2)

APPX. PL. 6

APPX. PL. 7
H. Cock, an engraving of 1562, showing the company in an enormous conch, which obviously has erotic connotations; (3) two copies of paintings after the same composition, but with variations in details, one in Lille and the other in a private collection in Senlis, in which the company is sitting in an egg, which presumably symbolizes the world. According to Brand Philip (reported by H. Adhémar, op. cit.) the *Ship of Fools* in the Louvre and the *Gluttony* at Yale are both fragments of a large dismembered picture describing the month of May or Spring. The difficulty is that the *Ship of Fools* has been cut down only at the bottom, while the *Gluttony* has been cut off at the top and on the right and must therefore be the lower left portion of a composition that was originally larger. According to Charles Seymour Jr the Louvre and Yale paintings were originally placed one above the other and together had the same dimensions as the *Death of the Miser* in Washington. He supposes that they were wings of a lost triptych. Seymour overlooks the fact that the colours of the Washington painting are completely different from those of the Louvre and Yale works. Further, the copy of the Louvre painting, i.e. the drawing in the Louvre does not contain any part of the *Gluttony* and shows that the part cut off was only a narrow strip.

APPX. PL. 4, 5

PAGE 94

PAGE 91

Finally, according to C. Eisler, *Corpus: New England*, p. 48, it may be that 'the painting in Yale may have been below and to the right, with the Louvre fragment above it, perhaps somewhat further to the left.' But it is evident that the Yale picture must have been the lower left portion of an originally larger composition (because it has been cut down at the right), whereas the Louvre painting is a complete unit by itself, apart from the narrow strip cut off at the bottom (cf. the drawing in the Louvre). For this reason none of the three hypotheses seems convincing to me and I still hold that the *Death of the Miser* in Washington and the picture in the Louvre belong to two different triptychs. Even though the style of the *Gluttony* is closely related to that of the *Ship of Fools*, it cannot have belonged to the same ensemble.

BIBLIOGRAPHY: Lafond, p. 79. Demonts, pp. 1 ff.; detailed analysis, suggested dating after 1500. *Louvre Catalogue*, 1922, no. 61. Friedländer, p. 152, no. 106. C. Brière-Misme, *La peinture au Musée du Louvre (Ecole Holl.)*, II, 1929, p. 2. D. Th. Enklaar, *Tijdschrift voor Geschiedenis*, XLVIII, 1933, pp. 145 ff. *De van Eyck à Bruegel*, [Catalogue] Musée de l'Orangerie, 1935, no. 2. *Catalogue of the J. Bosch Exhibition*, Museum Boymans, Rotterdam, 1936, no. 52. Tolnay, 1937. Baldass, 1959, p. 226. Combe, no. 47. H. Adhémar, *Corpus: Louvre*, I, 1962, pp. 20ff.

NOTES – P. 26, 5 Text of chap. 108 of 'Das Schluraffen Schiff', cited after F. Zarncke, p. 104:

Wir faren umb durch alle landt
All port durchsuchen wir, und gstad
Wir faren umb mit großem Schad
Und künnent doch nit treffen wol
Den Staden do man lenden sol
Unser umbfaren ist on end
Dann keyner weisz, wo er zu lend
Und hant doch keyn ruw tag, und naht
Uff wiszheyt unser keyner acht.

P. 26, 16 This hypothesis was first formulated by Demonts, pp. 6ff.

9. ALLEGORY OF GLUTTONY AND LUST

PAGE 94Yale University, Art Gallery, Rabinowitz Collection. Oil on wood. Height 31 cm, width 35 cm. Unsigned.

PROVENANCE: Clay auction, Christie's, London, May 11, 1928, no. 31. Malmedé Gallery, Cologne. Silbermann Gallery, New York. Rabinowitz Collection, Long Island.

The coat of arms on the roof of the tent is that of the Bergh family, which was very prominent in 's Hertogenbosch and the Hague (C. Eisler). Baldass thinks it possible that the fragment belonged to a larger painting depicting the *Seven Deadly Sins* and suggests identifying it with a picture mentioned in the inventory of an Antwerp collection from the year 1574.

PRESERVATION: This is a fragment that has been cut at the top and on the right and, as was noted above (p. 348), did not originally have the width of the *Ship of Fools* in the Louvre and could not have formed its lower part.

DATING: This fragment is from the period of the *Ship of Fools* in the Louvre. Bruegel must have known this work: his Carnival figure in the painting *Carnival and Lent*, Kunsthistorisches Museum, Vienna, seems to be inspired by the main figure of this fragment.

INTERPRETATION: Charles Seymour Jr., *The Rabinowitz Collection of European Paintings*, Yale, 1961, p. 36, calls the picture the 'allegory of intemperance'.

The picture was recently treated in detail by C. Eisler, *Corpus: New England*, 1961. The shield projecting from the roof of the tent, a round crown with a pig's foot in the centre, seems to be an allusion to lust.

The fat figure riding on a cask from which wine is spurting, a sort of god of drunkenness or a 'mock Silenus' (Seymour), directly anticipates the Carnival figure in Bruegel's *Carnival and Lent* in Vienna. Bax, 1949, pp. 199, 214, tries to interpret all sorts of objects (the tent flap, the slippers, the spoon etc.) as symbols of forbidden love.

These may be rather far-fetched interpretations, and the meaning of the painting is clear even without them.

BIBLIOGRAPHY: *Catalogue of the J. Bosch Exhibition*, Museum Boymans, Rotterdam, 1936, no. 51, where the picture was exhibited for the first time. First published in Tolnay, 1937. Lionello Venturi, *The Rabinowitz Collection*, 1945, p. 63f. Ch. Seymour, p. 36. Baldass, 1959, p. 228.

9a. HEAD OF A WOMAN (fragment, in profile)

Rotterdam, Museum Boymans-van Beuningen, no. 2439 PAGE 95
(no. 5 in the catalogue of the van Beuningen Collection). Oil on wood. Height 13 cm, width 5 cm. Unsigned.

Of good quality, painted without any modelling, reminiscent of the heads of the *Ship of Fools* in the Louvre.

10. CHRIST CARRYING THE CROSS

On the reverse: the child Jesus playing with a toy wind- PAGES 98-103
mill and a walking-frame (black tondo with grisaille painting) on a red rectangular background.
Vienna, Kunsthistorisches Museum.
Oil on wood. Height 57.2 cm, width 32 cm. Unsigned.

PROVENANCE: Purchased in 1923 from Goudstikker, Amsterdam.

PRESERVATION AND RECONSTRUCTION: The painting was cleaned in the mid-thirties. Under the parts that had been painted over it was discovered that the cross of the good thief originally extended upwards to the edge of the picture and that there was a third cross lying on the ground; a broad landscape had been painted over by sky; finally, the last restorer repainted the peak of the cap of the soldier with the shield, at lower left. The painting, whose upper portion had previously had the form of a quadrant, was later shortened by about 20 cm; 2.5 cm was also cut off at the lower edge.

According to Baldass, 1935, pp. 87ff., the original size was 97 × 31 cm.

This painting seems to have been the left wing of a small triptych, whose centre panel probably depicted Golgotha and the right wing, the Entombment of Christ. (These three scenes are also found juxtaposed on the reverse of the PAGE 256
St John on Patmos in Berlin.) The preliminary drawing for the Entombment scene may possibly have come down to us in the sheet in the British Museum recently disco- PAGE 316
vered by Popham. The Vienna painting has been cut BELOW
off at the top, where it originally terminated in a quarter-circle (Baldass).

349

DATING: Generally regarded as a youthful work; Baldass, 1935, puts it at about 1480.

INTERPRETATION: The theme was treated relatively seldom in fifteenth-century Netherlands painting, which preferred static to animated scenes. In the thirteenth and fourteenth centuries Christ bore the Cross on His shoulder as an attribute (often the Cross was small), so that the upper portion of the Cross was above His head. This conception made it possible to represent Christ erect and dignified; it was probably conceived by Giotto (Padua) and adopted by his pupils and Sienese masters of the Trecento, from whom it was taken in turn by the Franco-Flemish masters of the latter half of the fourteenth century, who spread it throughout Europe in the first two decades of the fifteenth century. Jan van Eyck too followed this tradition in a lost work of which a drawing in the Vienna Albertina is a copy. Allaert de Hameel's *Christ Carrying the Cross* in the Brussels Museum adopted it, and we know that Allaert de Hameel, who was one of the architects of the 's Hertogenbosch Cathedral, must have known Bosch.

There is another version by Jan van Eyck, also lost, copies of which exist in Budapest and New York, in which the tip of the Cross is near the head of Christ; Simon of Cyrene carries the main weight of the Cross like a servant helping his master. For van Eyck the subject is almost a pretext to present a cavalcade of splendidly clad knights and soldiers; the entire work shows a courtly conception. Bosch relied on this type in depicting the Cross, which however he made considerably larger in relation to the scale of Christ's figure, so that it seems gigantic and bears down on His back with all its weight. The cross-arm is now no longer above Christ's head but directly behind it. Another innovation is that no one helps Him, not even Simon of Cyrene, who only touches the Cross. The apparent urgency of the procession as it hastens forward, and the scourging of Christ with a rope to make Him keep up with the crowd, are likewise new elements. Bosch's conception is closer to the German school of the early fifteenth century than to the Netherlands tradition; one is reminded of the *Carrying of the Cross* by Meister Franke in Hamburg and even more strongly of the one by Multscher (1437) in Berlin. The ugly heads of the crowd around Christ, although less expressive, are also to be found in German paintings. What is new is the human way in which Bosch tells the tragic tale: the colours recall those of gay meadow flowers.

In the idea of presenting a confessor next to one of the thieves, an innovation that Bruegel was to adopt, Bosch seems to have wanted to link the biblical event with his own times, and this may also be why he depicted himself as a witness of the scene. The entire conception seems to lay bare the human situation that is expressed in the popular saying, 'we have each our cross to bear.' This interpretation of the painting as a symbol of man's course through life seems to be confirmed on the reverse, which presents a black circle on a red ground, enclosing the grisaille figure of a small child, perhaps Jesus, who is learning to walk and has a paper windmill on a staff in His hand: the symbol of the beginning of His path through life. This theme is also found in Italy: for example, on the reverse of a 'Desco da parto', New York Historical Society (probably the infant St John the Baptist as a child with a windmill); or *Infantia* by A. Federighi, 1475, one of the Seven Ages of Man on the floor of the south transept of Siena Cathedral.

The same subject, the Child Jesus playing with a toy windmill and with His walking-frame, is also found in an anonymous painting from the northern Netherlands, dating from 1500 and preserved in the Rijksmuseum, Amsterdam, no. 43a.

COPIES AND PARAPHRASES: A *Christ Carrying the Cross*, tempera on canvas, first shown as no. 63 at the Hieronymus Bosch exhibition in Rotterdam, was in the Arnot Gallery in London in the nineteen-thirties. This picture, which is in a very bad state of preservation, seems to us not to be by the hand of the master: the Italianizing style of the monument in the centre and the very broad spatial conception lead us to date the painting between 1530 and 1540. See Baldass, 1935, p. 89, note 8, who however takes the picture to be an original by Bosch. Another copy, which can be dated to the middle of the sixteenth century by its style, was formerly in the Weinberger Collection in Vienna. (See Bibliography.) A further copy in Friedländer, p. 147.

BIBLIOGRAPHY: Baldass, 1926, pp. 107ff. Friedländer, pp. 92, 147, no. 83. W. Ephron, *Hieronymus Bosch: Zwei Kreuztragungen*, Zurich, 1931: an unsuccessful attempt to present the copy in the former Weinberger Collection as an original and the painting in the Vienna Museum as a copy. See the controversy: *Weltkunst*, 1931, no. 31, p. 6 (Baldass); *Belvedere* X (II), 1931, p. 107 (T. Strzygowski); *Belvedere*, X (II), 1931, p. 114 (W. Ephron); *Pantheon*, VIII, 1931, p. LXV (Winkler); *Repertorium für Kunstwissenschaft*, LII, 1931, p. 223 (Glück); Baldass, 1935, pp. 87ff. *Catalogue of the J. Bosch Exhibition*, Museum Boymans, Rotterdam, 1936, no. 28. Tolnay, 1937. Baldass, 1959, p. 244. Combe, no. 42.

NOTES – P. 26, 25 See Baldass, 1935, p. 89.

P. 26,30 The same kind of sandals, *prikkelplank*, are seen in a miniature of about 1470 in the Bodleian Library, no. 3083, likewise depicting Christ carrying the Cross.

P. 26, 37 This composition in zones, as well as

the style of the drapery, suggests certain miniatures of the late fourteenth century, e. g. the *Christ Carrying the Cross* by Jacquemart de Hesdin, Bibliothèque Royale, Brussels, MS 110600, and the *Temptation of St Anthony* dating from the beginning of the fifteenth century and known by a copy preserved in the Escorial and published by W. Schöne in *J.d.p.K.*, LVII, 1936, pp. 57ff.

P. 26, 37 Johannes Wilde was the first to call attention to this self-portrait of Bosch. See also Baldass, 1926, p. 109.

11. ECCE HOMO

PAGE 104 BELOW LEFT Swiss private collection (formerly Rudinoff Collection, Vösendorf).
Oil on wood. Height 62.5 cm, width 53 cm. Unsigned.

This painting was first published and attributed to Bosch by Benesch (*Mélanges Hulin de Loo*, 1931), who regards it as a complete painting and dates it to the last period. Having had an opportunity to see the picture, I agree with Benesch in regarding it as an original. However, I believe that it is a fragment of a larger painting; that the inscription at the top, which gives the work a finished appearance, is a later addition, since the letters are not Gothic, as they are elsewhere in Bosch, but Roman; and that the picture is from Bosch's second period. As Benesch has shown, the painting goes back to a woodcut from Dürer's *Great Passion* B. 9, which dates from 1497–8. This enables us to date Bosch's picture somewhat later, and to supplement the fragmentary composition by means of Dürer's complete woodcut. Bosch took three of four figures from Dürer but translated them into his own language. Dürer's plastic, rather harsh treatment has become a soft painterly one. In showing Christ's body leaning further forward, Bosch gave His silhouette an expression of greater pain. If the missing portion is reconstructed according to Dürer's woodcut, then Bosch followed the conception of his own early *Ecce Homo* in Frankfurt. The refinement of the painterly language and the vigorous curves, which correspond to the late Gothic style, are characteristic of Bosch's work in the last decade of the fifteenth century.
BIBLIOGRAPHY: Benesch, *Mélanges Hulin de Loo,* Brussels-Paris, 1931, pp. 36ff. Tolnay, 1937.

12. ECCE HOMO

PAGE 104 ABOVE LEFT Philadelphia, Philadelphia Museum of Art,
Johnson Collection.

Oil on wood. Height 50 cm, width 52 cm. Unsigned.

DATING: In our opinion the painting dates from the second period and already shows the late Gothic curves. Baldass, 1959, dates the panel as belonging to the earliest period, prior to the Frankfurt *Ecce Homo*. Benesch, *Mélanges*, p. 38, dates the picture from the time of the Vienna *Christ Carrying the Cross*.
INTERPRETATION: The composition is entirely different from the two other versions of the *Ecce Homo:* that in PAGE 85 Frankfurt (no. 5) and that in a Swiss private collection (no. 11). It is conceived as a flat frieze before a golden background. A balcony with an irregular parapet extends the entire width of the picture, and Christ appears a little to the right of the central axis. At upper left is a cluster of people who seem to be holding a meeting, possibly those who had just carried out the scourging (see the scourge in the hand of one rogue). The excited throng of priests and soldiers presses together directly below Christ, other figures are pouring out through the dark archway on the left, and the crowd seems to be constantly swelling.
This small panel is only a fragment of a larger one that no longer exists, as is evident if one takes the picture out of its frame and sees that the right-hand edge has been cut irregularly. There is a drawing after Bosch PAGE 326 in the Crocker Art Gallery in Sacramento, California, in which we see, in the foreground, Christ as a half-figure carrying the Cross and in the left background (as Seymour Slive observed) an *Ecce Homo* that is similar to, though not identical with, the painting in Philadelphia. In the drawing the scene is laid in the open loggia of Pilate's house and the figures of Christ, Pilate and the soldier next to Pilate are almost identical with those in the painting. The group of priests and soldiers below and in front of Christ here stands out behind the contour of a hill, and differs somewhat from the group in Philadelphia. In the right centre of the drawing we see Judas hanging and a vulture devouring his corpse; a little nearer the foreground is the Virgin, who has sunk to the ground and is being comforted by St John, kneeling beside her. Behind them stand three soldiers, and it is safe to assume that further to the right in the complete drawing Golgotha with its three crosses could be seen. The copyist of the drawing was a rather poor artist and probably not very accurate. Nevertheless, the sheet gives information about the total composition of the original to which the Philadelphia fragment once belonged. It can be assumed that the latter is one-fourth the size of the original, and formed its upper left quarter. In it Bosch represented various Stations of the Passion in chronological sequence: the scourging of Christ, indi-

cated by the column and the whips in the hands of the soldiers, has just ended and the judges have assembled to read the sentence of Crucifixion. In the scene directly beside the column, Christ is already being presented to the people by Pilate. The scene with Christ carrying the Cross must have been shown next, by means of half-figures in the foreground, as in the drawing. The continuation of the story must have been shown in the right background, with the Crucifixion. That our picture actually is a fragment of the left side of the complete work is shown by the vanishing-point, which is not on the central axis of the painting but at its extreme right, i. e. on the original central axis of the entire picture, as can be seen from the foreshortened perspective of the arcade and parapet. Similar representations of the Passion, with small scenes in the background and a large one in the foreground, are not uncommon in Netherlands painting of the fifteenth century, e. g. the Master of the Turin *Adoration* in Philadelphia. With the exception of Christ, the bodies, faces, garments and head-coverings of the figures are distorted and transformed into those of insect-like beings, and it is no accident that a beetle appears as an emblem on the banner at lower left, and on the shoulder of one of the soldiers at lower right. Their arms and hands are like the limbs of insects, and the cudgels and halberds are stylized so that they look like antennae. One gets the impression of an army of noxious insects. They move about quickly and seem to be agitated like insects swarming around a light. In the middle of this excited throng Christ stands, with bent knees and bowed head, His wrists bound not with fetters but with a thin cord. This is probably the artist's way of saying that he is a prisoner of spiritual, not physical bonds. The strange transformation of men into insects indicates that the artist intended to describe them not as people taking part in a historical event but as phantoms, as Christ felt them to be at this moment of His Passion. Christ's eyes are closed; it is His inner visions that surround him. The artist identifies himself with Christ's inner life and describes the figures in His hallucinations rather than external events.

Although visions and dreams had been depicted prior to Bosch, e. g. in miniatures by the Master of *Mary of Burgundy,* Bosch seems to have been the first to express the transformation of internal images into hallucinations and dreams. Literary descriptions of this phenomenon exist, e. g. in St Augustine's *Confessions,* where the inner images are described as 'empty phantoms'.

The Philadelphia *Ecce Homo* is executed in a flat, enamel-like technique, in which individual brush-strokes can no longer be distinguished; this is one reason for assigning it to the second period. Both zones are dominated by light splashes of cinnabar, which pale into white where the light strikes them and contrast with patches of dark blue and dark green. The interplay between these two different colour values gives a vivid rhythm.

BIBLIOGRAPHY: Claude Phillips, *Burl. Mag.,* XVII, 1910, p. 321. Lafond, p. 43. Baldass, 1917, pp. 178ff.: A youthful work. *Katalog Valentiner,* II, no. 352. Friedländer, pp. 91, 146, no. 78. Benesch, *Mélanges Hulin de Loo,* p. 38. Tolnay, 1937. Benesch, p. 244. Combe, no. 43. Tolnay, 'The Paintings of H. Bosch in the Philadelphia Museum of Art', *Art International,* VII, 4, 1963, pp. 25ff.

12a. ECCE HOMO

Indianapolis, Indiana, The Clowes Fund Collection. Height 66.2 cm, width 48.7 cm.

PAGE 104 RIGHT

This is an almost identical second version of the Philadelphia painting (no. 12), in which however the composition is more complete. At the bottom there is a horizontal parapet, which is lacking in Philadelphia, and the composition is treated as a whole rather than as part of a larger work. There are small differences present, for example in the direction of the cudgels and halberds in the lowest portion: in Philadelphia the halberd and cudgel in the middle point toward Christ and the soldiers beside the column; in Indianapolis they point toward the column (in Philadelphia too there was originally a column behind the soldier, but it disappeared in the process of cleaning). The individual heads are more expressive in the Philadelphia version and show a sharply-defined psychological tension, while in Indianapolis they become rounder and softer, lose their tension and have a somewhat empty effect. All in all, the quality of the Indianapolis work is equally outstanding, and its state of preservation even slightly better than that of the Philadelphia panel, but there is no doubt that the latter was done first, and that the Indianapolis version must be a replica of it. (When I saw the original of the Indianapolis version in 1940, I thought it possible that it too was a work by Bosch, but today I incline to the view that it is an excellent atelier copy.)

13/14. FLOOD and HELL

On the reverse: four medallions with biblical scenes (grisaille).
Rotterdam, Museum Boymans-van Beuningen.
Oil on wood. Height 69.5 cm, width 38 cm and height 69 cm, width 36 cm. Unsigned.

PAGES 105–1

PROVENANCE: Koenigs Collection, Haarlem. Count Chiloedes Collection, Madrid.

These two panels were discovered in Spain by M. N. Beets of Amsterdam; the upper portion has been cut off. On the reverse of each are two medallions, probably illustrating biblical sayings, but their interpretation is not yet definite.

These panels must originally have been parts of a triptych. Curiously, the front and reverse of both panels are painted in grisaille. We do not know the reason for this. Fraenger, *Die Hochzeit zu Kana,* is of the opinion that it was the sombre subject that led Bosch to paint them in monochrome. We should prefer to take it that the central portion of the altarpiece was a sculpture or a relief in wood and that Bosch completed the altar with these side panels. Documents exist showing that the altarpiece of the Brotherhood of Our Lady in one of the chapels in 's Hertogenbosch Cathedral was a triptych of this kind, with only the side panels painted by Bosch.

Fraenger (op. cit.) seeks to identify these panels with a triptych '*Sicut erat in diebus Noe*', 'But as the days of Noah were, so shall also the coming of the Son of man be' (Matt. xxiv, 37 and Luke xvii, 26–27). This triptych was acquired for Archduke Ernst shortly before his death in 1595 by Gramaye, the author of *Taxandria* (1610).

INTERPRETATION: If we study the compositions on the front and reverse, the landscape in *Hell* seems to have been the left panel and the *Flood* the right one, as Baldass, 1959, and Fraenger, (op. cit.), stated.

The interpretation of the landscape in *Hell* is still in dispute. According to Fraenger, it may represent the decadent race of Nephilim shortly before the Deluge. The centre panel may have represented the Flood itself or the Coming of the Son of God after Matthew xxiv, 37–39, and the right panel shows Noah's ark stranded on the peak of Mount Ararat. Bax holds that the left panel depicts the fall of the apostate angels, but this hypothesis does not seem credible in view of the other paintings by Bosch on this subject, on the left wing of the *Hay-wain* and of the Vienna *Last Judgement,* which differ so greatly.

In the Noah's ark panel the animals issue forth in pairs, one male and one female, an allusion to the fruitfulness of the new life on earth. The figures in the ark itself are likewise represented in pairs: Noah and his three sons with their wives. In Fraenger's view this scene is a biblical allegory of the catastrophe in the life of Jacob van Almangien, who according to him lost his wife and child by drowning and was himself saved only with difficulty. He considers the entire work an *ex voto* in memory of Jacob van Almangien's wife and child. There is no foundation for this hypothesis, since nothing is known about any such event and Fraenger deduces it exclusively from the picture.

The four tondi in grisaille on the reverse have not been elucidated for certain either. According to Baldass the upper left picture is an illustration of Luke xvii, 31: 'In that day, he which shall be upon the housetop, and his stuff in the house, let him not come down to take it away'; according to Fraenger the reference is to Matt. xxiv, 43. Baldass believes the lower left picture may be an illustration to the next sentence in Luke xvii, 31: 'And he that is in the field, let him likewise not return back'; according to Fraenger it refers to the parable of the sower. According to Baldass, the upper right picture may represent Luke ix, 24; 'For whosoever will save his life shall lose it...' (the preliminary drawing for the infernal beast is preserved in Berlin). Typologically this composition is reminiscent of the *Temptation of St Anthony,* in which he is flogged by demons. Baldass holds that the lower right picture illustrates the next sentence in Luke ix, 24: 'But whosoever will lose his life for my sake, the same shall save it'; Fraenger holds that it refers to Matt. xxii, 44, the Coming of the Son. The design of the composition is reminiscent of the Creation of Adam.

BIBLIOGRAPHY: Friedländer, p. 143, no. 64: 'Distinctive conception, certainly by Bosch. As to the execution I have no opinion to offer.' *Verzameling F. Koenigs schilderijen,* Museum Boymans, Rotterdam, 1935, nos. 4-5. *Catalogue of the Amsterdam Exhibition,* Rijksmuseum, 1929, no. 10. *Catalogue of the J. Bosch Exhibition,* Museum Boymans, 1936, nos. 58, 59. Tolnay, 1937. Baldass, 1959, p. 231. Combe, nos. 53-54.

15/16. THE DESCENT OF THE DAMNED INTO HELL – HELL – THE EARTHLY PARADISE – THE ASCENT INTO HEAVENLY PARADISE

Venice, Palace of the Doges.
Oil on wood. Height 86.5 cm, width 39.5 cm
(each panel). Unsigned.

PAGES 109–115

PROVENANCE: These panels might be identified as those that were in the possession of Cardinal Grimani in Venice in 1521 (La tela dell'Inferno; la tela dei Sogni), and which are mentioned by the Anonymous Morelli: *Notizie d'opere di disegno,* ed. G. Frizzoni, p. 196.

INTERPRETATION: These panels seem to have formed part of an altarpiece, probably a triptych or a polyptych, and apparently were either placed side by side, or with the *Heavenly Paradise* above the *Earthly Paradise* and the *Descent of the Damned* above the *Hell.* It is possible that

originally they were broader, and that the lost centre panel represented the Last Judgement. This arrangement corresponds to the iconography of the earlier representations of Heaven and Hell, except that there the two scenes of Paradise and Hell were combined in the same panel. Such a disposition, with a large centre panel and four smaller panels, two pairs one above the other forming two side panels, is found in Dirk Bouts' altarpiece in Louvain (Baldass, 1959, p. 28, accepts this arrangement).

The *Earthly Paradise* already shows signs of corruption (on the right a lion is devouring another lion). In this way Bosch shows that degeneration begins even in the Earthly Paradise, an idea that he was to resume in the

PAGE 205

left panel of his *Garden of Earthly Delights*.

The flight of the souls up to the Heavenly Paradise through the space of the universe shows the light coming like silver rays from a blue-grey circular tunnel. This tunnel is divided by nuances into sections that may signify the heavenly spheres. In earlier representations

APPX. PL. 84, 85

(e. g. Taddeo Bartoli, Neri di Bicci, Anonymus, Berlin and Breviarium Grimani, Venice) the eight heavenly spheres were always shown frontally and were not so deep. The idea, however, seems to be the same.

The tunnel reminds us of the so-called 'column of praise' in Manicheism, which symbolizes the journey of the souls of the dead into the kingdom of heaven. This 'column' is a tube, through which souls and prayers pass, as in Bosch. (On the 'column of praise', cf. Puech in his note in *Annuaire du Collège de France*).

In the *Descent of the Damned into Hell* Bosch reduced the number of figures, as compared with earlier representations by Jan van Eyck, Dirk Bouts and Memling, to such an extent that the dark empty space of the universe became the most important theme in his painting.

In the *Hell* Bosch depicts, instead of the traditional crater (cf. Bouts, Louvre), a dark landscape lit up by phosphorescent yellow and red flames reflected in the water.

BIBLIOGRAPHY: *Kunstchronik*, XXI, 1886, p. 298. Dülberg, *Frühholländer in Italien*, Haarlem, 1906, III, Plates VIII–IX: he doubts the authenticity of the picture. Cohen, no. 22. Baldass, 1917, p. 178: 'strongly archaistic'. Friedländer, p. 149, no. 89. Tolnay, 1937. Baldass, 1959, p. 231. Combe, nos. 38, 39.

NOTES – P. 30, 8 What a contrast between this spiritualized *Earthly Paradise* and the one by Dirk Bouts in the Lille Museum, which is so realistic!

P. 30, 15 Another example of an *Ascent into the Heavenly Paradise*, but to an objectively depicted Beyond, is the Rhenish drawing from the end of the fifteenth century in the Kupferstichkabinett in Berlin, published by Winkler, *Wallraf-Richartz-Jahrbuch*, new series, I, 1930, pp. 123ff.

P. 30, 18 The theme of the burning lake in the landscape in the *Hell* is derived from Rev. xxi, 8.

P. 30, 24 Dante's Paradise is the immaterial 'realm of light'. See Dante, *Paradiso*, 30, v. 38ff. Dante also develops the idea of the angels vanishing at the advent of light from the higher regions (*Paradiso*, 30, v. 1ff.). The conception of the German, Netherlands and Italian mystics: Meister Eckehart (*Schriften*, II, p. 10), J. van Ruysbroeck, *Das Reich der Geliebten* (ed. F. M. Huebner, pp. 10ff.), Pico della Mirandola, *Heptaplus* (ed. Basle, 1601, p. 13), is in conformity with that of Dante and anticipates that of Bosch; the latter was the first to embody such a conception in the visual arts.

C. THE GREAT TRIPTYCHS

ES 116–133

17. THE HAY-WAIN

On the outer side of the wings: *A Vagabond.*
Madrid, Museo del Prado.
Oil on wood. Height 135 cm, width 100 cm; width of each wing 45 cm. Signed.

PROVENANCE: Mentioned among the six paintings purchased by Philip II from D. Felipe de Guevara. Sent to the Escorial in 1574, as no. 9; see Justi, p. 142.
DATING: Until the publication of the first edition of this book in 1937 this painting was regarded as a masterpiece of the artist's last period, and dated about 1510. See Baldass, 1917, p. 190, who relies on the head-covering of the woman sitting on the wagon for his dating of the *Hay-wain.* This argument is invalid, since this head-covering had been in use from the second quarter of the fifteenth century onward: see, for example, the portrait of Elisabeth Burlunt in Hubert and Jan van Eycks' altarpiece in Ghent. The triptych may date from 1485–90 – that is to say, it is not a late work; compare the figures in the foreground with those of the *Seven Deadly Sins,* which are almost identical in style. And compare the *Prodigal Son,* a work of the artist's last period, with the outer side of the *Hay-wain,* which anticipates it, to realize the distance between the two works. In 1959 Baldass accepted our view.
INTERPRETATION: The question whether the version in the Prado or the one in the Escorial is the better has still not been decided. Formerly, the Escorial picture was regarded as the original, and Baldass has recently (1959) returned to this view. In the first edition of his book (1943) he considered the Prado version as qualitatively superior. Baldass' main argument for the Escorial version is that it exhibits many corrections; he notes that in the Prado picture the contours were at first left empty and only filled in later. But the fact should not be overlooked that the colours did not follow exactly the drawing of the silhouettes and that the brush-strokes show greater spontaneity than in the Escorial painting. Furthermore, the palette is brighter and fresher. The wings of the Prado version appear to be superior to the centre panel, the signature of which seems to imitate that of Bosch. The *Vagabond* on the outer side of the wings is of higher quality in the Prado painting than the one in the Escorial. One might ask whether the centre panel of the Prado painting is not a replica of the lost original.

For interpretation of the hay, see L. Lebeer and J. Grauls, 'Het Hooi en de Hooiwagen in de Beeldende Kunsten', in *Gentsche Bijdragen,* v, 1938, pp. 141 ff. The authors here publish an engraving by Bartolomeus de Momper dated 1559 and entitled *Al Hoy,* and come to the conclusion that the hay-wagon is 'a symbol of the transitoriness and greed for vain earthly riches'. See also P. de Keyser, in *Gentsche Bijdragen,* VI, 1939–40, pp. 127 ff. and J. Grauls, 'Ter Verklaring van Bosch en Breugel', in *Gentsche Bijdragen,* VI, 1939–40, pp. 139 ff. We learn from the text of the *Ommegang* (1563) that the hay-wagon is a satire on the egoism of avarice. Pigler, *Burl. Mag.,* 1950, pp. 132 ff., regards the centre panel of the triptych as an illustration of the Prophet Amos ii, 13–14. But for Bosch it is not the weight of the hay that is central, but its being dragged along.

APPX. PL. 86

The proverb that we have adduced as a possible source (see text) seems to fit better, although no version of it is known earlier than 1823 (cf. Grauls); but this does not preclude its having been used prior to this. In addition to pride and avarice, the centre panel also alludes to gluttony and lust.

The universal significance of the whole scene was fully recognized in the middle of the sixteenth century, as is shown by a tapestry in the Royal Palace in Madrid, in which Bosch's composition is enclosed within the crystal ball of the world floating on the ocean.

APPX. PL. 88

The composition is undoubtedly inspired by the *Trionfi,* but the Italian heroic conception is translated into a rustic idiom and treated satirically.
The Vagabond or Wanderer on the reverse, making his way through the wicked world, is a first version of the composition of the *Vagabond* in Rotterdam. The little rustic bridge may be an allusion to Psalm xxv, 4. Brand Philip, 1958, pp. 1 ff., regards the picture as a warning to the public against evil and deceitful characters and sees this vagabond, incorrectly we feel, as an 'infernal figure'.
An earlier description of the *Hay-wain* is found in *El Teatro Moral* by Ambrosio de Morales (cf. A. M. Salazar, 'El Bosco y Ambrosio de Morales', in *Archivo Español de Arte,* XXVIII, 1955, no. 110, pp. 117 ff.
COPIES: See Friedländer, p. 154.

APPX. PL. 87

BIBLIOGRAPHY: Justi, p. 132. Dollmayr, p. 343. Maeterlinck, *Le genre satirique dans la peinture flamande,* 1907, pp. 236 ff. *Zentralblatt für kunstwissenschaftliche Literatur,*

1909, p. 259. Cohen, no. 9. Lafond, p. 48. Baldass, 1917, p. 190, dates the picture about 1510 from the costumes worn. Baldass, 1926, p. 116: the Vagabond on the reverse may be inspired by the engraving the *Great Garden of Love* (L. 215) by the Master E. S. Friedländer, pp. 106, 153, no. 111, says of the reverse: 'perhaps atelier work'. Tolnay, 1937. Baldass, 1959, p. 229. Combe, nos. 18–31.

NOTES – P. 24, 11 Except in representations of the *Last Judgement*, this type of painting, with many small figures, disappears from Netherlands art after the middle of the fifteenth century, whereas it had been widespread there in the first half of the century. The most famous examples are: the *Christ Carrying the Cross* of Jan van Eyck, the original of which is lost and a copy of which is in the Budapest Museum; the two side panels of the altarpiece, depicting *Golgotha* and the *Last Judgement,* have been attributed successively to Hubert van Eyck, Jan van Eyck and Ouwater, and were formerly in the Hermitage and now in the Metropolitan Museum; and the famous miniatures, formerly in the Trivulzio Collection in Milan and now in the Palazzo Madama in Turin, likewise attributed to Hubert van Eyck (or Ouwater).

P. 24, 15 In R. Stadelmanns' *Vom Geist des ausgehenden Mittelalters*, Halle, 1929, p. 229, there is a subtle analysis of the concept of 'decadence', the spiritual intricacies and the joy in negation that are so characteristic of the mentality of the fifteenth century; at that time metaphysics itself was based on the certainty of a progressive decline of the Church.

P. 24, 16 *De werelt is een hooiberg; elk plukt ervan wat hij kan krijgen* (See Harrebomée, *s. v.* 'hooiberg'). Until now the picture has been regarded as an illustration of the words of Isaiah, 'All flesh is grass, and all its goodness is like a flower in the fields,' or of the words of David, 'The grass dries and the flower droops' (see Siguença, Appendix [8], and Justi, p. 132). The proverb that we quote is better suited to the theme and to the rustic character of the picture.

P. 24, 19 A kneeling angel is praying next to the young man. A devil is blowing a trumpet beside the girl; according to Siguença the trumpet is a symbol of fame. His tail of peacock feathers, in any case, suggests a personification of vanity.

P. 24, 22 In the foreground, in addition to a tooth-puller, we see nuns packing hay into a large sack, and a monk drinking wine.

P. 24, 24 They are actually wearing animal masks on their human heads.

P. 24, 31 The harmonious figures of Adam and Eve, so different from the representations of Adam and Eve in van Eyck, may perhaps be explained as due to the influence of very early fifteenth-century miniatures, e. g. the *Expulsion of Adam and Eve from the Earthly Paradise* in the *Très riches Heures* at Chantilly.

P. 24, 40 The first Dutch edition of this book was published in 1472 by Mathys van der Goes, under the title *Het boek van Tondalus Visionen*. It was published in 's Hertogenbosch in 1484 by Gerardus Leempt and in Delft in 1495 by Kerstiaen Snellaert. A critical edition was published in Ghent by R. Verdeyen and J. Endepols in 1914, under the title *Tondalus' Visionen en St Patricius Vagevuur*.

Of this panel Siguença writes: 'New rooms and dwellings for the sinners are being built; [Bosch] thus shows that there is no place left for the newcomers,' and later, that the stones used to erect the building are 'the souls of the damned'. These two remarks seem to us erroneous, since this tower, which the devils themselves are building and which the kingfisher characterizes as the tower of vanity, cannot be regarded as a prison – besides it is not built of stone but of plaster.

18. THE TEMPTATION OF ST ANTHONY

On the outer side of the wings: the *Kiss of Judas* and PAGES 134 *Christ Carrying the Cross* (grisailles).
Lisbon, Museu Nacional de Arte Antiga.
Oil on wood. Centre panel: height 131.5 cm, width 119 cm; each wing: height 131.5 cm, width 53 cm.
Signed on the centre panel, lower left: Jheronimus Bosch.

PROVENANCE: Perhaps one of the three *Temptations of St Anthony* that Philip II sent to the Escorial in 1574. Purchased from the Portuguese painter Damiano de Goes for 100 cruzados between 1523 and 1545. Gift of King Manuel to the Portuguese nation.
PRESERVATION: The lower portion of the centre panel is badly damaged (the bridge, the pomegranate, the water and the sky). The picture was cleaned and restored for the exhibition in Amsterdam.
DATING: Until 1937 this picture was dated to Bosch's last period. See Baldass, 1917, p. 192. – Baldass based his view on the alleged continuity of the landscape, whereas the colouring and composition show a clearly marked separation between the ruins in the middle ground and the landscape of the background. A *sfumato* that yet does not subdue the colour scale, and the late Gothic treatment and distribution of the forms indicate that, as we showed in 1937, this is a work of the artist's middle period. Baldass, 1943, and Combe, 1946, have accepted our dating. The reverse in grisaille depicts the *Kiss of Judas* on the left and *Christ Carrying the Cross* on the

right; to some degree they are reminiscent of the corresponding grisailles on the reverse of the Berlin *St John on Patmos*. The scene of the *Kiss of Judas* is laid in an impressive moonlit landscape; the chalice on the crag to the right alludes to the Passion of Christ on the Mount of Olives. In the *Christ Carrying the Cross* certain figures, such as Veronica, foreshadow the style of the Antwerp mannerists of 1520; in this the technique of the artist can be studied especially well, because of the corrections, still clearly visible (the heads of the Franciscan and the bad thief etc.).

INTERPRETATION: As regards the literary sources, Bax, 1949, is of the opinion that Bosch used the Dutch translation of the *Legenda Aurea,* published in Gouda in 1478, and the Dutch translation of the life of St Anthony by St Athanasius, Zwolle, 1490.

From the standpoint of composition, the wings with their relatively large figures and the landscape in the background are conceived after the type of Bosch's paintings of ascetics. But in the centre panel with its small figures in a large landscape, where even the main figure is set in the middle ground, the artist employed the compositional pattern of his paintings representing a résumé of the universe (e. g. the Prado *Hay-wain* and Vienna *Last Judgement*). It may be assumed that Bosch chose this mode of composition because it corresponded to his intention to represent here more than an episode out of the life of the saint: namely, the world dominated by the Devil and the situation in it of the human soul, represented by St Anthony. Bosch gave the scene a unity by showing us a heretical ritual, a sort of black mass and 'witches' sabbath', whose protagonists symbolize the sins of mankind. In fact, originally even more sins were depicted: an X-ray photograph shows that there was a figure with a mirror, obviously Pride, in the group behind the saint, which Bosch himself painted over. But within this general framework it seems to have been Bosch's prevailing idea to show St Anthony faced by the alternative of Christ or Satan, 'true reality' or 'empty phantoms', as St Athanasius says. The saint is between a figure with staff and tall hat, who seems to have conjured up all his witches to the sabbath and whom we interpreted in 1937 as a magician, and a small shrine with its tower in ruins, in which Christ Himself appears, pointing to a crucifix on an altar. In this way temptation by evil and salvation through Christ are juxtaposed. To emphasize this alternative, Bosch shows visionary pictures on the wall of the tower, two of which are typological prefigurations. The Tables of the Law herald the coming of the Holy Ghost. Moses' reception of emissaries from Hebron with grapes from the Promised Land anticipates the baptism of Christ. Three other visions are symbols of heresy: a swan

sacrificed to an idol of an animal, the worship of the golden calf and demoniacal animals below. These scenes are not conceived of as reliefs (as some authors assume) but as the saint's hallucinations, and seem to be made of a gleaming transparent substance, like horn or glass. Two of these scenes are light green and one pink. They are embodiments of the saint's desire for true faith to triumph over heresy. The monstrous creatures are described by St Athanasius as 'no more than empty phantoms, which disappear in the face of the Cross as though they had never existed'. This may be the reason why Bosch painted them as weightless, shimmering, seemingly empty apparitions.

The most recent detailed treatment of the iconography is by Bax, 1949, and fully confirms our earlier interpretation of 1937. Our assumption that the rites of sects of sorcerers and witches played a part in Bosch's inventiveness has found support in the statements by Bax and Cuttler that the marine monsters, the whale and the sawfish, symbolize the Devil and in the Middle Ages were associated with sorcerers and witches. The flying ship on the back of a monster at the top of the left panel may go back to medieval animal pictures (Bax, 1949; Cuttler, *Art Quarterly,* 1957). The fish, i. e. the Devil, carries the practitioners of magic on its back. Cuttler comes to the conclusion that 'Bosch wished to scourge magic by means of the flying groups of his Lisbon triptych', and Bax showed that Bosch took the bestiaries as his main source. Cuttler, *Art Bull.,* 1957, uses the work of previous authors (Tolnay; 1937; Bax, 1949; Pigler, 1950) to elucidate further details but seems to have gone astray in his conception of the triptych as a whole. Many of his interpretations are unconvincing: for example, on the left wing, the hut whose roof is formed by the body of a man kneeling in the middle ground is for him and Bax a brothel and the woman in the window is a whore. However, they overlook the fact that this is the saint's hut, which in his tortured vision has changed into a brothel or a tavern of ill repute. The obscene posture of the kneeling man is an evident allusion to lust (onanism) and the head pierced by an arrow indicates folly and self-destruction. According to Cuttler, the latter motif has a parallel in an astrological manuscript, which however has nothing to do with Bosch's characterization. The monster with a bagpipe to the left is in Cuttler's view only a motif generally used in comical illustrations, but he ignores the highly expressive meaning of this figure as a sexual symbol. Bax's interpretation of this figure as *peccatum contra naturam* seems closer to the truth. The fish with a scorpion tail and grasshopper legs, devouring another fish, is according to Cuttler a symbol of envy and according to Bax one of hypocrisy, but actually it is

another obvious symbol of lust. The grasshopper legs look like those of the man on his back, so that the tower becomes a phallic symbol, but at the same time the fish is lying on its belly, so that the image has a double function with sexual overtones. The 'friend' who with two Antonites is leading the saint back to his hut after his fall is regarded by several authors (cf. Bax, 1949, p. 20, notes 17–19) as a self-portrait of Bosch. The interpretation of the bird demon with a letter in its beak is still a problem. The almost illegible inscription on the letter has been read as 'graso' (Combe), 'oisuif' or 'oisuy' (Cuttler), or 'protestatio' (Bax). We consider it to be a letter of indulgence.

According to Bax the centre panel is an illustration of a legend related in the *Vitae Patrum* which, however, is found neither in St Athanasius nor in the *Legenda Aurea*; but the elements of the painting, with the exception of the water in the foreground, which also plays a part in the 'witches' sabbath', do not correspond to this notion. According to Cuttler 'the origin and meaning' of the principal scene behind St Anthony 'have escaped the eyes of previous authors'. He seems to have overlooked our 1937 text, in which we already interpreted the scene as an initiation into the sect of sorcerers and witches. Following Pigler, Cuttler believes that its sources are astrological prints of about 1460, representing the children of Luna, Saturn, Jupiter, Mars and Venus. The white woman in the middle he takes to be the Moon herself. But she exhibits none of the attributes that suggest this, and could just as well be a priestess of the sect. Without going further into Cuttler's other dubious identifications, we should like to deal with his interpretation of the ruined tower. According to him it represents 'the incompleteness and error of the Old Testament' and should be regarded as the image of the Synagogue; actually, however, it is the abandoned fort on the Nile to which, according to Athanasius, the saint had withdrawn. It is no wonder that Cuttler sums up his interpretation of the entire Lisbon triptych by saying that it is 'moralizing in aim... a pictorial attack on popular superstitions'. That is to say, he considers it a negative message, in contradiction to our conception, that it is a picture of the entire world under the spell of the Evil One, and at the same time a diagram of the human soul torn between the temptations of the flesh and the striving for salvation.

Bax (1949) made the interesting observation that the mother with the child riding on a giant rat recalls the iconography of the Flight into Egypt, and the three knights the three kings, but in reverse. The figures coming from the left are held by Bax to be personifications of sins. Combe sees in them allusions to the con-

cepts of alchemy, e. g. in the motif of the egg. The kitchen of the monks at the right is for Bax a brothel. The right wing represents scenes of temptation after the *Vitae Patrum* (Bax).

The altarpiece as a whole shows sinful mankind; when the panels are closed, it shows salvation in two Stations of the Passion.

It is possible that the altarpiece was created for an Antonite hospital; the monks may have brought the patients before this triptych in the hope of a miraculous cure (Bax, Baldass). This would explain the sign of blessing being given by the saint.

COPIES: The best known are in Friedländer, p. 149f. In addition we may mention the Stallforth auction, Munich, Helbing, October 1, 1919; Paris, Drouot, April 28, 1930; Bechstein auction, Berlin, Wertheim, December 11, 1930. APPX. PL. 2

BIBLIOGRAPHY: Siguença, see Appendix. Justi, p. 135. Dollmayr, p. 292. Cohen, no. 14. Lafond, p. 69. Baldass, 1917, p. 192: a late work. Dvořák, *Kunstgeschichte als Geistesgeschichte*, p. 176: he sees an influence of Schongauer's *Temptation of St Anthony* (B. 47). Friedländer, pp. 97, 149, no. 90. José de Figueiredo, *Revue Belge d'archéologie et d'histoire de l'art*, III, 1933, pp. 10ff. Exhibition *De van Eyck à Bruegel* [*Catalogue*], Musée de l'Orangerie, Paris, 1935, no. 1. *Catalogue of the J. Bosch Exhibition*, Museum Boymans, 1936, no. 56. Tolnay, 1937. Baldass, p. 240f. Combe, nos. 55–75.

NOTES – P. 27, 26 The *Malleus Maleficarum* gives us full details of this sect. The bull of Innocent VIII against the sect appeared in 1484. For all matters relating to sorcery, see especially: J. Hansen, *Zauberwahn, Inquisition und Hexenprozess im Mittelalter*, Munich, 1900. – id., *Quellen und Untersuchungen zur Geschichte des Hexenwahns*, Bonn, 1901.

P. 27, 29 St Athanasius, *Vie de St Antoine*, literal translation of Greek text by Charles de Remondange, Mâcon, 1874: *Antoine... rencontra au delà du Nil un fort abandonné, et que le temps avait rempli de serpents – il y fixa sa demeure ... il trouva de l'eau dans l'intérieur du fort et s'y retira comme au fond d'un sanctuaire.*

P. 27, 35 For the liturgy of the 'witches' sabbath', see Bourneville and A. Teinturier, *Le Sabbat des sorciers,* Paris, 1882. Görres, *Christliche Mystik*, IV, pt. 2, p. 280ff. Grillot de Givry, *Le musée des sorciers, images et alchimistes*, Paris, 1929.

P. 27, 40 These symbolic demons do not appear in the traditional iconography of demons, which are always in anthropomorphic or zoomorphic form. As examples in Netherlands art prior to Bosch, we mention the miniatures of the *Last Judgement* in the Missal of St Eulalia in Barcelona Cathedral (see Soulier, *La Cathédrale de Barce-* APPX. PL. 79

lone, Plate 13) and the *Last Judgement* attributed to Hubert or Jan van Eyck, formerly in the Hermitage and now in the Metropolitan Museum. These embodiments of sin are products of the infamous love of the sabbath.

P. 28, 1 Already in this work certain motifs can be interpreted as dream symbols, indeed in precisely the same sense given them by psychoanalysis – a science that Bosch foreshadowed, as we shall see in analysing the *Garden of Earthly Delights.* In the *Temptation of St Anthony* the fish are female symbols; the monsters whose forms so weirdly anticipate dirigibles are male organs; the child that Bosch has inserted in the lower right portion of his picture would seem to refer to obsession by the sex organs. See Freud, *Traumdeutung,* Vienna, 1900.

P. 28, 5 The ray of light and the apparition of Christ to the saint are taken from St Athanasius, *Vie de St Antoine,* op. cit., p. 19: *Cependant le Seigneur n'oubliait pas la lutte de son serviteur, il vint à son secours. Antoine, levant les yeux au ciel, crut voir le toit s'entrouvir et un rayon de lumière descendre jusqu'à lui . . .*

P. 28, 13 For this interpretation of the Expulsion of the Worshippers of the Golden Calf see: *Biblia Pauperum,* ed. Cornell, p. 259, no. 10. For the Moses receiving the Law on Mount Sinai, a prefiguration of the Descent of the Holy Ghost, see Breitenbach, *Das Speculum Humanae Salvationis,* p. 242.

APPX. PL. 80

P. 28, 16 The episode of St Anthony tormented by demons and carried home by his companions is taken from the *Legenda Aurea* (ed. T. de Wyzewa, pp. 87ff.). We refer to the scene in the curious early fifteenth-century miniature in the British Museum (no. 29433, fol. 89). According to Dvořák (p. 176) this was influenced by Schongauer's famous engraving (Fig. 47). Actually, the two compositions present no marked similarity, and Bosch seems to have been inspired directly by the legend. The engraving that Dvořák cites in support of his thesis and attributes to Bosch is in point of fact by Jan de Cock.

APPX. PL. 101

P. 28, 19 The monster playing the bagpipe behind the saint and his companions is an allusion to unnatural vice (see analysis of the right panel of the *Garden of Earthly Delights,* p. 33). In the foreground, under the bridge that the saint is crossing with his companions, demons are carrying sheets of parchment that may possibly be indulgences – a satirical reference to the Church's traffic in them.

P. 28, 21 St Athanasius, op. cit., pp. 13ff. The theme of the temptress was to see a great development in the psychological and profane thinking of humanism, and to be conceived in a very different spirit. See, for example, the Prado *Temptation of St Anthony* by Patinier.

19. THE LAST JUDGEMENT

PAGES 164–187

On the outer side of the wings: *St James of Compostela* and *St Bavo* (grisailles).
Vienna, Gallery of the Akademie der Bildenden Künste. Oil on wood. Centre panel: height 163.7 cm, width 127 cm. Each wing: height 167.7 cm, width 60 cm. Unsigned.

PROVENANCE: Collection of Archduke Leopold Wilhelm, where the picture was listed as an original by 'Hieronimo Bosz'. Purchased by Count Lamberg at the end of the eighteenth century.

PRESERVATION: Numerous portions retouched in the foreground of the sky in the centre panel, of which 4 cm have been cut off from the top. The wings, uncut, are in a poor condition. Toward the end of the sixteenth or in the seventeenth century they were painted over. See R. Eigenberger, *Die Gemäldegalerie der Akademie der Bildenden Künste in Wien.* A recent restoration of the triptych has revealed some of the overpainted portions of the centre panel.

ATTRIBUTION: H. Hymans, *C. v. Mander,* Paris, 1884–5, supposes that this is a smaller copy of the *Last Judgement* that Philip the Handsome commissioned from Bosch in 1504, which measured eleven by nine feet. Glück, 1904, p. 181, revives this hypothesis of Hymans' and points out that the shields on the reverse of the wings have no coats of arms, which would be understandable in the case of a copy. Baldass, 1917, p. 189, likewise regards the painting as a copy. On the other hand, M. J. Friedländer, *Von Eyck bis Bruegel,* Berlin, 1921, p. 81, and Friedländer, p. 148, no. 85, see it as an original. R. Eigenberger, *Die Gemäldegalerie der Akademie . . .,* Vienna, 1927, pp. 47ff.: 'The question of whether this is a copy or an original in large part by the hand of the master, i. e. a replica executed by the master himself, is still not definitively solved.'

In view of the many corrections discovered during the picture's recent restoration, R. Eigenberger favours the hypothesis of authenticity, but the stiffness of the calligraphy, the ungainly draughtsmanship of the figures and the lack of expression in their faces cause us to have serious doubts; cf. Tolnay, 1937. Baldass, 1959, also regarded this large triptych as genuine. In the last *Katalog der Galerie der Akademie in Wien,* 1961, Mrs Poch-Kalous published it as an original painting by the master and supports her opinion (p. 57) by the fact that many corrections were found after the painting was cleaned, and that high painterly qualities were revealed. Parts of the inside of the wings were painted over in the eighteenth century.

As I see it, however, even the best portions are lifeless in comparison with Bosch's originals, and I hold to my opinion of 1937 that this seems to be an excellent copy. In all probability it was prepared for Philip the Handsome, like the *Last Judgement* mentioned in the 1504 document, but that was much larger. It may be a copy of reduced size. The probability that it was prepared for Philip the Handsome is reinforced by the fact that a Burgundian and a Castilian saint are shown on the outer side of the wings: St Bavo and St James of Compostela – allusions to the Burgundian duke and his wife, Isabella of Castile (cf. Glück). In my opinion the triptych should be given a date later than the *Hay-wain* and even than the Lisbon triptych, but earlier than the *Garden of Earthly Delights*. (Poch-Kalous dates it prior to the Lisbon altarpiece.) Baldass, p. 232f., now regards the picture as an original; Combe, nos. 33–40, considers it a good contemporary copy.

COPIES: see Friedländer, p. 148.

ADDITIONAL BIBLIOGRAPHY: Th. Frimmel, *Geschichte der Wiener Gemäldesammlungen*, IV, pp. 43, 151. G. F. Waagen, *Handbuch der deutschen und niederländischen Malerschulen*, Stuttgart, 1862, I, p. 150.

NOTES – P. 33, 31 Themes derived from the Vision of Tondalus. Centre panel: the diabolical farrier at work (Ch. VIII). Right wing: the round building in the form of an oven (Ch. VI). Themes derived from the *Grand Calendrier des Bergers*: centre panel: the wheels, punishment for the haughty; the slaughterhouse, where the hot-tempered are suspended; the table of the gluttons (see Dollmayr, p. 342).

20. THE GARDEN OF EARTHLY DELIGHTS

PAGES 202–247

On the outer side of the wings: *Creation of the World* (grisaille).

Madrid, Museo del Prado (formerly Escorial).

Oil on wood. Centre panel: height 220 cm, width 195 cm; wings: height 220 cm, width 97 cm. Unsigned.

PROVENANCE: The first known owner was Prior D. Fernando of the Order of St Ivan, who died in 1595. The picture then came into the possession of Philip II and is mentioned in the inventory of July 8, 1593 among the works transferred to the Escorial, as *una pintura de la variedad del mundo*.

PRESERVATION: Parts of the painting, especially at the places where the wood panels meet, have flaked off and were renewed at the last restoration.

DATING: Formerly the picture was regarded as the masterpiece of Bosch's youthful period, and dated 1485 (Baldass, 1917, pp. 184, 190). He based his judgement on the apparently 'archaic' representation of the stepped planes, on what he regards as an advance in the treatment of space, and on the realism of the *Hay-wain*. But this successful rhythmical disposition of the diverse elements over the entire surface must be recognized as remarkable in its originality and novelty; moreover, the painting technique surpasses in perfection not only the *Hay-wain* but also the Lisbon *Temptation*, and its *sfumato* indicates the painter's last period. Our 1937 dating of the triptych as a late work has been accepted by all subsequent authors: Baldass, 1959, even regards it as one of Bosch's last works.

INTERPRETATION: Bosch conceived the three panels as a kind of unity, even if not a literal one. The forms on the horizon seem to describe a semicircle in perspective, encompassing the entire triptych and probably alluding to the terrestrial globe. Within this unity the panels are differentiated according to the scheme of the *Last Judgement*.

On the outer side of the wings, which were first published in Tolnay, 1937, we see the following inscription at the top:

> *Ipse dixit et facta sunt,*
> *Ipse mandavit et creata sunt.*
> (Ps. xxxii, 9; Ps. cxlviii, 5.)

The crystal ball in which we see the primeval landscape of the earth on the third day of Creation already shows, by the strange plants and crags, the earth's later corruption and its transient existence, which is also hinted at by the fragility of the crystal ball. A similar representation of the earth in a transparent ball with a landscape inside it is seen on Bosch's earlier table-top in the tondo of the *Last Judgement,* where Christ is enthroned on a glassy globe of this kind, and is already to be found in various works, e. g. the reverse of a medallion by Pisanello (Bax, 1949) or the French miniature from about 1445 in the *Livre des Merveilles du Monde*, Morgan Library, New York (461, fol. 67 v.).

Bosch may originally have intended to show on the left wing, not only the creation of Eve but also the fall of man and the expulsion from Paradise, as he did on the left wing of the *Hay-wain* and in the *Last Judgement* of the Vienna Academy. The sketch of the *Temptation of Eve* on the reverse of the drawing formerly in the Le Roy Bacchus Collection, Berkeley, California, may have been a preparatory sketch for a scene that he later omitted. The Creation of Eve does not correspond to the iconographic tradition, in which God brings forth Eve from Adam's rib; here God is showing the newborn Eve to Adam, who looks at her in admiration; the scene is not

PAGE 325
ABOVE LEFT

APPX. PL. 82

unlike that in the British Museum miniature MS 18880, fol. 14, where however the iconological type corresponds to representations of a wedding. The fall of man is shown in the centre panel, where in the lower right corner we can recognize Adam in an animal skin and next to him Eve.

The triptych, which was formerly regarded as a sort of didactic sermon against the lusts of the flesh (Sigüença), has recently been given a new interpretation by Fraenger, *Das Tausendjährige Reich,* Coburg, 1947. According to him it is a message of the positive path to attaining full harmony between the human soul and nature, and represents Paradise as it was before the Fall and as it will be once more under the laws of the heretical sect of the Brethren of the Free Spirit. It shows sacred prostitution according to the doctrines of Gnosticism. It was commissioned, according to Fraenger, by the Grand Master of the sect, whom he recognizes in the only clothed figure, wearing an animal skin (Adam), in the lower right corner. Later, Fraenger identifies this Grand Master as Jacob van Almangien. His interpretation has been rejected by various authors, e. g. Bax, 1956, von Holten and van Puyvelde. There is no evidence to show that Bosch or Almangien belonged to the Adamite sect, nor that this sect still existed during Bosch's lifetime, nor that Almangien commissioned the triptych. When Fraenger asserts that all Bosch did was to carry out exactly the commission of the Grand Master, he is limiting the artist to the role of mechanical illustrator and indirectly denying his creative genius. Fraenger does not see the anguish in the faces of the figures indulging in debauchery and ignores the significance of the outer side of the wings as a symbol of the world's fragility.

In our opinion this is neither a simple didactic sermon (Sigüença) nor a positive apotheosis of free love, as Fraenger asserts; it is an encyclopedia of love and at the same time a representation of the sweetness and beauty of mankind's collective dream of an earthly paradise that would bring fulfilment of its deepest unconscious wishes, while at the same time it shows their vanity and fragility (for analogies in Italy, cf. A. Chastel, *Art et humanisme à Florence au temps de Laurent le Magnifique,* Paris, 1959, pp. 393ff.). This paradise contains the germs of its own destruction. The idea that here Bosch consciously represented a dream of mankind appears to be supported by the substance of which this world is made, which seems to be horn. According to Macrobius (in his commentary on Cicero's *Somnium Scipionis),* 'dream allows the eyes of the soul to glimpse some rays of truth... we see the dream through a veil that is of the nature of horn, which can be made thin and transparent.' According to Virgil the substance of dream is either ivory (deceptive dreams) or horn (true dreams); the two gates of Hades consist of these materials. Out of these substances Bosch has built his world; the crags seem to be made of horn, and the sinuous figures of ivory.

Bosch seems to have been a well-educated man – even, according to Bax, a *rederijker* (a kind of master singer) – and it is very likely that he knew of Macrobius' dream theory and its classifications (ch. III). It is precisely where Bosch continues the ancient science of dreams that he comes closest to modern interpretations of dreams by psychoanalysis (Freud, *Vorlesungen zur Traumdeutung)* and modern depth psychology (Jung, *Wandlungen und Symbole der Libido).* As we have seen, many of his motifs are dream symbols of sexual desires, which Bosch could in part find in early keys to the interpretation of dreams (cf. text), of which there were publications in the late fifteenth century, and which, as Bax has shown, go back in part to poetical metaphors that appeared in book form only after Bosch's death, e. g. in Jan van Stijevoort's *Refreynenbundel,* 1524. As yet no literary source for the triptych as a whole has been found, but for the centre panel Bosch may have used the description of the fourth heaven in the Apocalypse of Baruch, ch. 10. 'I saw a great level plain and in its middle a lake full of water and on it were many birds of all kinds, but different from those that we have here... and all these birds were larger than those we know here on earth. And I asked the angel: "What kind of plain is this? What kind of lake is this and what kind of flock of birds around it?" And the angel said: "Listen well, Baruch: the plain that surrounds the lake with all its wonders is the place where the souls of the just are and live together in choirs. And the water is the water that the clouds contain, to rain down on the earth and let the fruits ripen." And I said to the angel of the Lord: "What kind of birds are these?" And he said to me: "They are those that praise God always with their songs."' Many elements of this description apply to Bosch's *Garden of Earthly Delights,* but the meaning of the whole is different, since in Bosch there is present the additional significance of corruption. Other accounts that may be mentioned as parallels are a description of the Isles of the Blessed in the apocryphal prophet Enoch and the medieval Irish poem of Imram Brain. In the latter the mountains of glass and the buildings inside the earthly paradise are rotating structures.

As regards the right wing, the literary source seems to have been the *Vision of Tondalus,* to which Dollmayr (1898) had already called attention and which Bosch may have known through a Dutch translation of 1484. It may have inspired the idea of hell as a place of contrast between fire and ice, as well as the principal figure, a blue-coloured monster with the head of a bird (accord-

ing to Fraenger, Satan) who devours the souls of the damned and lets them pass through his body (cf. Roggen, *Nieuw Vlaanderen,* March 7, 1936; R. von Holten, in *Konsthistorisk Tidskrift,* XXVIII, 1959, pp. 99ff.). The idea of a man being transformed into an animal or an object that played a part in his sins goes back to a medieval tradition and is expressed, for example, in Dante's *Inferno,* where the avaricious are changed into coins and the thieves into reptiles. It has already been mentioned in our text that musical instruments have a content of sexual symbolism. The man using the lever of the instrument resembling a barrel-organ has been identified by Bax as a beggar holding in his hand the sign by which beggars were known after 1459; this supports our hypothesis that sinners were punished by means of the objects with which they had sinned. Although more space is given to the punishment of lust than the other deadly sins, they are not missing. In part they can be identified by a comparison with the *Hell* tondo on the Madrid tabletop, on which Bosch elucidates by inscriptions the punishment of the various sins. It is not hard to recognize Pride with its mirror, Anger in the lower left foreground, and Avarice or Envy in the group in the lower right corner in the figure next to the lantern (Baldass). The damned soul in the group in the lower right corner has been interpreted by Combe as signing a pact with the Devil.

Benesch believes that the face of the tree-man in the middle ground is a portrait of Bosch himself; in our opinion, the self-portrait is the man leaning out of the tavern in an attitude of melancholy (cf. text). Key and bagpipe are allusions to the male and female sex organ respectively (Bax).

Fraenger regards the infernal landscape in the background as being at the same time a representation of the four elements, the windmill denoting air. Many of the individual motifs can be found in earlier manuscripts, but they are all isolated. Bosch may have consulted in

APPX. PL. 91

manuscripts the miniatures of the *Livre des Merveilles du Monde* (e. g. Morgan Library 461, about 1445; cf. N. Calas in *Life,* November 15, 1949), in which can be found a giant snail with a pair of lovers inside it (fol. 78 r.), exotic and fantastic animals (fol. 4 r.) and the theme of

APPX. PL. 93
APPX. PL. 98

the giant ears (fol. 26 v.).

The acrobats have a prototype in, e. g., the *Book of Hours* of Arras, about 1310 (Morgan Library 754, fol. 61 r.), and in a manuscript in the British Museum (Add. MS 36,684). On the acrobats in Bosch cf. I. Mateo, in *Archivo Español de Arte,* XXXIII, 1960, pp. 427ff. The motif of the giant egg with a male figure inside it is an age-old symbol of Eros; cf. C. Ramnoux, *La Nuit et les enfants de la Nuit dans la tradition grecque,* Paris, 1959, pp. 200ff. The fantastic rock formations in the back-

ground are interpreted by Fraenger as sexual symbols (phallic forms combined with crystalline female symbols). According to Combe, they contain allusions to alchemy. However, Bosch seems to have been the first to unite all these motifs in a connected paradisiac landscape, and by means of them to conjure up the vanity of human desires.

COPIES: The best known are indicated in Friedländer, p. 153. To these can be added the following. A copy of the centre panel in W. M. Newton, 1921. Four copies reproducing certain motifs of the Hell in a different landscape: the first, Fussac Fievez auction, Brussels, December 14–15, 1923; the second, Dorthmuth auction, Christie's, July 13, 1928; the third, Vasto auction, Canessa, Naples, December 10–19, 1928; the fourth, Maison Schulthess, Basle, 1936; a copy in a tapestry in the Royal Palace in Madrid. There is also a copy of the centre panel on canvas in the Budapest APPX. PL. 39–4 Museum; A. Pigler, *Catalogue,* 1954, no. 1323 (reference indicated by Dr Iván Fenyö). A copy of the reverse, in the Prado (Catalogue 1933: no. 2053), 186 × 77 cm.

BIBLIOGRAPHY: Sigüença, see Appendix, pp.384ff. Justi, p. 133. *Repertorium für Kunstwissenschaft,* XXVI, 1903, p. 169. Maeterlinck, *Le genre satirique dans la peinture flamande,* p. 238. Cohen, no. 10. Lafond, p. 45. Baldass, 1917, pp. 184, 190: a youthful masterpiece, about 1485; a quarter-century earlier than the *Hay-wain.* Dvořák, *Kunstgeschichte als Geistesgeschichte,* p.176: stresses the similarity of the tropical tree with the one in Schongauer's *Flight into Egypt.* Friedländer, pp. 104ff., 153, no. 110. Tolnay, 1937. Baldass, 1959, pp. 234ff. Combe, nos. 93–109.

NOTES – P. 30, 37 'The development of symbols is not a matter of chance..., but follows laws and leads to typical and general forms, which go beyond the limits of time and space, beyond the concepts of sex and race and even beyond the limits of the great linguistic families.' See O. Rank and H. Sachs, *Die Bedeutung der Psychoanalyse für die Geisteswissenschaften,* Wiesbaden, 1913, pp. 11ff.

P. 31, 1 This late Gothic trend spread to the whole of Europe in the last quarter of the fifteenth century. It appears simultaneously in Florence with Botticelli and Filippino Lippi, in Venice with Crivelli and Vivarini, in Germany with Schongauer and in Flanders itself with Justus van Gent.

P. 31, 15 These fruits have the same meaning in the keys to the interpretation of dreams known in antiquity. See Artemidorus, *Les jugements astronomiens des songes,* Troyes, 1634, p. 20: *Pèches, cerises et autres tels fruits... signifient voluptez déceptives (quand on songe les manger en saison).* Grapes have the same significance in fifteenth-century dream books. See *Les songes de Daniel Prophète,* printed about 1482 by Fromolt, Vienne (Dauph.), a basic work for that period, published in four languages at that time and

reproduced in facsimile by Maurice Hélin, Paris, 1925, with the title *La clef des songes*. In his work *Vorlesungen zur Einführung in die Psychoanalyse*, Vienna, 1933, pp. 167ff., Freud makes clear the scientific value of this symbolic language.

P. 31, 16 A symbol that is very widespread in folk literature. See Grimm's *Wörterbuch der deutschen Sprache*, I, p. 533. 'In speech and poetry the breasts of women are referred to as apples, e. g. by Fischart.' This meaning is confirmed by psychoanalysis. See Freud, op. cit. *(Vorlesungen)*, p. 168: 'the breasts... which like the larger hemispheres of the female body are represented by apples, peaches, fruit in general.'

P. 31, 16 See *Les songes de Daniel Prophète* for the meaning of 'shame' – in addition, the meaning of 'lust' for the bird is a common one in popular speech. See F. Kluge, *Ethymologisches Wörterbuch der deutschen Sprache* (6th ed.), p. 409.

P. 31, 16 Artemidorus, op. cit., tells us that in the dream books of antiquity fishes signified enjoyment and pleasure. In *Les Songes de Daniel Prophète* (p. 58) we see that in the fifteenth century salt-water fish denoted anxiety.

P. 31, 17 In popular speech, see Grimm, op. cit., VI, 2732c. As dream symbol, see Freud, op. cit. *(Vorlesungen)*, p. 167.

P. 31, 22 We cite some Netherlands proverbial expressions in which the special and extended sense of horns is found:

> *Jemand hoornen opzetten.*
> *Hij is een hoornendrager.* (Harrebomée, I, 152, 5.)
> *Zij zet hem hoornen op.* (Harrebomée, I, 334, 20.)

P. 31, 24 Bruegel was to illustrate the same proverb in his drawing *Lust* and in his painting the *Dulle Griet*.

P. 31, 25 Is this coral on the 'Vurige Doorn' (thorn of fire) a play on the name of the Society of Rederijkers in 's Hertogenbosch?

P. 31, 32 An idea taken from the *Garden of Love*. See A. Kuhn, *J. d. a. K.*, XXXI, 1913–14, pp. 1ff., for 'Illustrationen des Rosenromans'. As Dvořák remarks, the griffin in the middle ground appears to be influenced by an engraving by Martin Schongauer depicting a griffin.

APPX. PL. 92

P. 31, 15 A thorn of gold, crystal or horn pierces the four structures at their tips, to stress the vanity of their splendour. The 'castle' at the extreme left is built of pink rocks held together with bars of crystal; its roof is of pearls and is crowned with a thorny flower. The castle at the extreme right consists of an enormous dark blue pomegranate flower and is covered with marble and pink leaves. A velvet-blue crag, convoluted gold leaves, peacock feathers and a giant earring pearl are the compositional elements of the left background; in the right background there are pink crags bearing a little ship.

P. 31, 42 Bibliography on the *Earthly Paradise:* Franz Kampers, *Mittelalterliche Sagen vom Paradies*, Cologne, 1894; Arturo Graf, *La Leggenda del Paradiso terrestre*, Turin, 1878; G. Oppert, *Der Presbyter Johannes in Sage und Geschichte*, Berlin, 1864. At the beginning of the sixteenth century the same attempt is found on some maps of Persia – e. g. oriental flora and fauna are assembled on a sheet of the Miller Atlas, 'La Perse et les régions voisines', Paris, about 1516, Bibliothèque Nationale.

P. 32, 10 For the two trees of the *Earthly Paradise*, see Kampers, *Mittelalterliche Sagen vom Paradies*, Cologne, 1894. Dvořák (p. 176) remarks that the palm-tree in the left foreground is borrowed from Schongauer's *Flight into Egypt*.

APPX. PL. 82

P. 32, 12 Compare the miniature of the *Earthly Paradise* in the British Museum (MS 18880, fol. 14), whose composition in stepped planes, incidentally, is not unlike that of Bosch's *Earthly Paradise*. (Justi believes that a giant strawberry forms the foundation of the fountain of life – actually, this foundation is of the same material and has the same tone as the entire structure.)

P. 32, 21 Vases and lanterns are dream symbols of the female organs, knives and skates of the male. (See Freud, *Die Traumdeutung*, p. 316; Rank and Sachs, op. cit., p. 18.) We may also mention the severed head, a symbol of castration. The severed foot is a symbol of the male organ. Finally, the ladder is a symbol of the sexual act. (See Freud, *Traumdeutung*, p. 316). The large letter 'M' engraved on the giant knife in the background has been interpreted by Glück, *Zeitschrift für bildende Kunst*, new series, VI, 1895, as the signature of Jan Mandijn, by Dollmayr, p. 296–7, as that of Jan Mostaert, and finally by Th. Frimmel, *Geschichte der Wiener Gemäldesammlungen*, 1898, I, p. 461, as the sign of a cutler of 's Hertogenbosch, whom Bosch banishes to hell, a hypothesis later adopted by Glück, 1904, pp. 174ff. and Gossart, p. 57. These interpretations have little credibility, and this large 'M' must be seen either as an allusion to the male sex, which the symbol denotes unequivocally, or to the universality of the symbolism, as 'M' denotes *mundus*. Thus Bosch's knife, which bears the emblem of the world, ought to be related to the giant knife in Bruegel's drawing the *Big Fish Gobble up the Little Ones*, in the Vienna Albertina.

P. 32, 23 All these instruments are phallic symbols. See Freud, *Die Traumdeutung*, pp. 316ff.

21. THE LAST JUDGEMENT (fragment)

Munich, Alte Pinakothek.
Oil on wood. Height 60 cm, width 114 cm. Unsigned.

PAGES 248–253

PROVENANCE: Possibly a *Last Judgement* commissioned by Philip the Handsome in 1504. 1822, Staatsgalerie, Nuremberg. 1877–1920, Germanisches Nationalmuseum, Nuremberg. Since 1920 in storage at the Pinakothek, Munich. In 1934 rediscovered by Buchner.

RECONSTRUCTION: The picture must have formed the lower right portion of a panel originally about twice as wide, since the piece of drapery at lower right belongs to St Michael weighing souls in a balance, as Baldass, 1959, p. 29, has shown. According to Baldass, the entire width of the painting must have measured 250 cm. Baldass accepts our dating to the later period, roughly that of the *Garden of Earthly Delights*.

The devil seen from the rear, right, and the monster below him are both anticipated in the sheet of sketches with monsters in Oxford.

BIBLIOGRAPHY: E. Buchner, *Münchner Jahrbuch*, XI, 1934 –6, pp. 297 ff. Tolnay, 1937. Baldass, 1959, p. 234. Combe, nos. 87–92.

D. COMPOSITIONS WITH LARGE FIGURES

21a. THE TEMPTATION OF ST ANTHONY

PAGE 254

New York, Walter P. Chrysler Collection.
Oil on wood. Height 41.25 cm, width 26.25 cm.
Unsigned.

PRESERVATION: The painting was originally somewhat larger, and has been cut down at the top, perhaps also at the bottom.

ATTRIBUTION AND DATING: The picture was attributed to Bosch for the first time by C. de Tolnay and published in *Art in America*, XXXII, 1944, pp. 61 ff. It is a relatively early work, probably just prior to the Berlin *St John on Patmos*.

INTERPRETATION: In the foreground St Anthony is sitting in an idyllic landscape and meditating over his open prayer-book. As he concentrates on his prayers, temptations appear around him in the form of small figures, and we may assume that the artist intended the difference in size to indicate that they are the 'inner visions' of the saint and not real beings. St Athanasius calls the temptations 'empty phantoms'. Three of them allude to lust, and three seem to be social satires (cf. Tolnay, op. cit.). A number of motifs anticipate later works by Bosch. The conch was later used by the artist in the *Garden of Earthly Delights;* the naked woman bathing is repeated on the left panel of the Venice *Altarpiece of the Hermits*. The bird-demon reading the mass is an allusion to the black mass. The fire, a traditional attribute of the saint, either because he had the power to heal the disease known as 'St Anthony's fire' or because he had the power to avert fire, is an element of the landscape, in which appear a house burning and demon-like firemen rushing to put out the fire. The idea of developing an attribute in this way may derive from Bosch's method of seeing everything through the eyes of the saint; to St Anthony in his waking dream the little fire evidently appears as the burning of his own house.

The cool silver-grey of the saint's mantle dominates the centre of the picture and contrasts with the warm brown tones of the hills around and behind him. The patches of vermilion, pink and green are kept to the sides. The prayer-book is bound in dark-green velvet. The few flecks of bright colour are subordinated to the delicate harmony of grey and brown, anticipating a colour scheme to which the master remains true in his Lisbon altarpiece. The compositional type goes back to earlier Flemish and Dutch representations of the solitary saint meditating in a landscape (e. g. Geertgen Tot Sint Jans, *John the Baptist in the Wilderness*, Berlin; D. Bouts, *St John on Patmos*, Rotterdam). New aspects are the spiritualization of the forms, as manifested in the treatment of the surface, and the identification of the artist's spiritual viewpoint with that of the saint. The drawing in Berlin representing St Anthony has the same composition, but seems to be less fully developed. In it the buildings in the background are not yet seen through the eyes of the saint but with an external eye. It is of interest to note that in his last painting on this subject, in the Prado, Bosch returned to his earlier conception, with a dominant figure in the foreground; but by now the conception of form and space aims at plastic and spatial effects that are not present in his youthful work. The visual consequences of a high viewpoint are carried through logically in the later painting; the sitting position of the saint is here individualized, and expresses fear.

22. ST JOHN ON PATMOS

On the reverse: Scenes of the *Passion* in a medallion (grisaille).
Berlin-Dahlem, Gemäldegalerie.
Height 63 cm, width 43.3 cm. Signed, lower right: Jheronimus Bosch.

PAGES 255–263

PROVENANCE: W. Fuller Collection, Milan.

INTERPRETATION: The devil-beetle to the right of the saint is using a rake to try to steal the ink-bottle on the ground next to the saint; that is, he is trying to disturb his meditation, but the symbolical eagle of the saint watches over him (Revelation, xxii, 14–15). Bax, *Oud Holland*, LXVIII, 1953, pp. 200 ff., makes reference to a Dutch miniature of 1443 in the Royal Library in The Hague, in which the motif of the ink-bottle is already present. According to E. Redslob, *Die Gemäldegalerie Berlin-Dahlem*, Baden-Baden, 1964, p. 203, the *Legenda Aurea* would have required Bosch to depict the saint's domestic animal, a partridge, rather than the eagle.
According to Fraenger, *Hochzeit zu Kana*, p. 24 f., the picture illustrates Rev. xxii, 2, and the saint is a portrait of Jacob van Almangien. However, no portrait of this personage is known.

PAGE 255

BIBLIOGRAPHY: G.F.Waagen, *Treasures of Art in Great Britain*, London, 1854, III, p. 5. *Amtl. Berichte aus den kgl. Kunstsammlungen*, Berlin, 1918, XXXIX, col. 35–36. Cohen, no. 2. Baldass, 1917, p. 178. J.Six, *Amtl. Berichte aus den kgl. Kunstsammlungen*, Berlin, 1918, XXXIX, col. 261–70. Dvořák, *Kunstgeschichte als Geistesgeschichte*, p. 139: the first to stress the relationship of this painting to the *St John on Patmos* by Schongauer (B. 55). M.Konrad, *Wallraf-Richartz-Jahrbuch*, III–IV, 1926–7, p. 141: points to the similarity between St John and one of the figures of the *Last Judgement* from Diest (Musées Royaux, Brussels) but this is probably fortuitous. Friedländer, pp. 98, 151, no. 101. P.Wescher, *Zeitschrift für Kunstgeschichte*, II, 1933, p. 101: believes that he recognizes a view of Nijmegen in the town in the background. Tolnay, 1937. Baldass, 1959, p. 239. Combe, nos. 82–84, dates the picture to the period of the *St John the Baptist* in the Museo Lazaro Galdiano, Madrid.

NOTES – P. 35 *Non sumus religiosi, set in seculo religiose videre nitimur et volumus* (Letter of Petrus Dieburg, 1490, see Barnikol, op. cit.).

APPX. PL. 94

APPX. PL. 99

P. 35, 21 Dvořák (p. 178) was the first to call attention to this relationship to Schongauer. The type seems to derive from Netherlands art, e. g. the *St John on Patmos* by Dirk Bouts, Rotterdam. On the other hand, the similarity between the person of St John and one of the apostles of the *Last Judgement* from Diest, now in the Brussels Museum, to which Martin Konrad points (*Wallraf-Richartz-Jahrbuch*, III–IV, 1926–7), is probably accidental.

23. ST JEROME IN PRAYER

PAGES 264–267

Ghent, Musée des Beaux-Arts.
Oil on wood. Height 77 cm, width 59 cm. Unsigned.

PROVENANCE: Acquired for the museum in 1908 by Hulin de Loo.

INTERPRETATION: The reclining posture of the half-naked saint appears to be an innovation by Bosch, since up to that time in representations of St Jerome chastising himself the saint had been shown kneeling, as in Bosch's *Altarpiece of the Hermits* (e. g. the St Jerome of Gerard David in the Städelsches Kunstinstitut, Frankfurt-on-Main). The strange shapes into which the natural rocks are transformed remind us of an ox skull, symbol of death, and Moses' Tables of the Law; but the latter are in disorder, perhaps to indicate misuse of the laws, or merely symbols of the distraction of his spirit.

COPIES: A copy of the rocks on the right panel of the triptych in the Bruges Museum, no. 209.

BIBLIOGRAPHY: Baldass, 1917, p. 186: produced between the first and second period. Friedländer, p. 151, no. 97. *Catalogue de l'Exposition du Jeu de Paume*, Paris, 1923, no. 28. *Catalogue de l'Exposition flamande à Londres*, 1928, no. 110. *Catalogue of the J.Bosch Exhibition*, Museum Boymans, 1936, no. 50. Tolnay, 1937. Baldass, 1959, p. 238. Combe, no. 113.

24. ALTARPIECE OF THE HERMITS

PAGES 268–?

Venice, Palace of the Doges.
Oil on wood. Height 86.5 cm, width 60 cm; width of each wing 29 cm. Signed, lower right: Jheronimus Bosch.

PROVENANCE: Mentioned by A.M. Zanetti, *Della Pittura Veneziana*, Venice, 1771, p. 491: *Nella istessa stanza dell' Eccelso Tribunale sono ... S.Girolamo nel mezzo ed altri santi dai lati*. In 1893 transferred by Dollmayr from the store-rooms of the Kaiserliche Galerie, Vienna, to the exhibition rooms. Since 1919 in the Palace of the Doges, Venice.

PRESERVATION: Damaged; the landscape and sky of the centre panel have been painted over. The head and chest of St Jerome have been retouched. The altarpiece, which originally terminated in a semi-circular or keeled arch, has been cut down at the top. In fact, the upper corners of the centre panel have been filled in so as to form a rectangle.

DATING: To judge by its style, this altarpiece is later than the Ghent *St Jerome* and earlier than the *St John the Baptist* in the Museo Lazaro Galdiano, Madrid.

INTERPRETATION: We have here a further development of the idea of representing the world not only from an external point of view but an inner one, corresponding to the visions of the hermit. St Anthony is surrounded by apparitions that distract his soul, and the artist presents the intricate paths of his unconscious associations in a way similar to that in St Augustine's *Confessions* (x, 30) (cf. E. v. Kahler in *Merkur*, 1962, p. 705f., who makes reference to this passage in the *Confessions*).

The images that appear around St Jerome on the centre panel correspond in part to his desire for salvation (e.g. Judith slaying Holofernes), and in part to his lusts of the flesh. The fantastic rock formations behind the saint are in his imagination converted into what seems to be a hut or a kitchen, from the chimney of which smoke appears to be rising. These are vain fantasies, for in reality the chimney and the smoke look more like plants. St Giles has withdrawn into a grotto that frames his figure as in a late Gothic miniature, e. g. the *St John in*

APPX. PL. 9?

the Wilderness, Bibliothèque Nationale, Paris, MS Lat. 18014.

The *St Anthony* on the left wing is iconographically only a further development of the *St Anthony* in the Chrysler Collection and the one on the right wing of the Lisbon altarpiece.

COPIES: A copy of the *St Jerome* is on the right wing of the triptych in the Bruges Museum, no. 209.

BIBLIOGRAPHY: Dollmayr, p. 288. Th. Frimmel, *Kunstchronik*, new series, VII, 1896, p. 68, and *Kleine Gemäldestudien.* Cohen, no. 24. Lafond, p. 64. Baldass, 1917, p. 188: second period. Friedländer, pp. 98, 151, no. 98. Tolnay, 1937. Baldass, 1959, p. 237f. Combe, no. 78.

NOTES – P. 36, 25 Jan van Ruisbroeck, *Buch von der höchsten Wahrheit*, ed. F. M. Huebner, Leipzig, 1921, p. 75.

P. 37, 2 In the didactic literature of the Middle Ages beehives and honey are symbols of sensual love. See Freidank, *Bescheidenheit*, ch. 55, v. 15–18.

P. 37, 3 According to the *Speculum Humanae Salvationis* the *Beheading of Holofernes* is the prototype of the *Triumph of the Virgin over the Devil*. For the *Heretical Worshipper* of the sun and the moon, see Nicolaus de Lira Preceptorium, whose work was published by J. Geffcken, *Der Bildercatechismus des 15. Jahrhunderts*, pp. 23, 112.

P. 37, 20 *Legenda Aurea*, ed. T. de Wyzewa, pp. 490 ff.

P. 37, 22 *Legenda Aurea*, op. cit., p. 492: ... un ange lui [St Giles] apparut qui déposa sur l'autel une feuille où était écrit que, grâce à ses prières, le péché du roi se trouvait pardonné. Et l'on dit aussi que, sur cette feuille, une main céleste avait ajouté que quiconque invoquerait St Gilles pour la rémission d'un péché, obtiendrait cette rémission, pourvu seulement qu'il ne commit plus le même péché.

24a. THE TRIBULATIONS OF JOB – THE TEMPTATION OF ST ANTHONY – THE PENITENCE OF ST JEROME

PPX. PL. 20

Bruges, Musée Communal, no. 209.
Oil on wood. Centre panel: height 98.3 cm, width 72.1 cm; left wing: height 98.1 cm, width 30.5 cm; right wing: height 98.8 cm, width 30.2 cm.

PROVENANCE: The picture comes from the church of Hocke, Bruges district, Western Flanders (cf. de Bisthoven and Parmentier). The theme of Job is known in Bosch's work: Damias de Goes, the agent of Juan III, acquired a picture by Bosch with the same theme in 1523 or 1524 (cf. Bax, p. 5).

PRESERVATION: The work is in poor condition. Its surface has been painted over.

RECONSTRUCTION: It is surprising that the hermits on the wings should have their backs turned toward the centre of the triptych. Bisthoven and Parmentier are of the opinion that the wings have been interchanged and that the hermits originally had their faces turned toward one another. As I said in the first edition of this book, p. 96, under no. 24, this triptych is probably a copy of a lost work by Bosch.

BIBLIOGRAPHY: Janssens de Bisthoven and R. A. Parmentier, *Corpus: Bruges,* 1951, pp. 5 ff.

25. ST JOHN THE BAPTIST IN THE WILDERNESS

Madrid, Museo Lazaro Galdiano. PAGE 273
Oil on wood. Height 48.5 cm, width 40 cm. Unsigned.

PRESERVATION: The main motif of the huge fruit is damaged and partially restored.

The panel has been cut down at the sides. According to Baldass, 1959, it originally formed a diptych with the *St John the Evangelist* in Berlin; but this is most unlikely, in view of the differences in composition, colouring (bright in Berlin but dark here) and treatment of the forms, which indicate a later date, closer to that of the *Garden of Earthly Delights*.

DATING: This painting may be ascribed to the period between the Venice *Hermits* and the *St Christopher* in the Boymans-van Beuningen Museum, Rotterdam; incidentally, in the harmony between the dark red and light green it bears a resemblance to the latter work.

H. Devoghelaere has a very interesting article in *L'Art et la vie*, 1936, pp. 312 ff., on the *St John the Baptist in the Wilderness* in the Lazaro collection in Madrid. The fantastic flower leads him to draw a comparison with the tree of Jesse. On the other hand, he sees a source of inspiration for this picture in a German engraving of the fifteenth century, a major work by the Master of *St John the Baptist*. In actual fact, the composition of the landscape is reminiscent of Bosch, and we also find here the motif of the saint pointing out the Lamb of God.

INTERPRETATION: The saint, meditating on the Lamb, the symbol of Christ, is distracted, and his thoughts seem to digress in the direction of sexual pleasures, as indicated by the open fruits with seeds, which are being picked by birds. The substance of the fantastic fruit is transparent. The plant may well be a vision in the saint's mind, or it might be a symbol of 'Nature', rather like that in Jean Perreal's miniature, the *Dialogue of the Alchemist with Nature*, about 1495, where the inscription leaves no doubt as to the interpretation: cf. Ch. Sterling in *L'Oeil,* 1964.

According to Fraenger, the fantastic crags in the background might be the saint's prison. The same author remarks that St John is not wearing the usual animal skin, but a mantle of crimson, and sees this as an allusion to his martyrdom.

BIBLIOGRAPHY: A. L. Mayer, *Der Kunstwanderer,* February 1920. *La Colección Lazaro,* Madrid, 1926, p. 460, no. 432. Friedländer, p. 151, no. 102: 'remarkable composition, certainly by Bosch.' *Catalogue of the J. Bosch Exhibition,* Museum Boymans, 1936, no. 54 (when the picture was exhibited for the first time). Tolnay, 1937. Baldass, p. 239. Combe, no. 80.

26. ALTARPIECE OF ST JULIA

PAGES 274–277

Venice, Palace of the Doges.
Oil on wood. Height 104 cm, width 63 cm; width of each wing: 28 cm. Signed on centre panel, lower left: Jheronymus Bosch.

PROVENANCE: Mentioned by A. M. Zanetti, *Della Pittura Veneziana,* Venice, 1771, p. 491: *Nella stanza dell' Eccelso Tribunale ... la crocefissione d'un Santo o Santa martire.* Transferred in 1893 from the store-rooms of the Kaiserliche Galerie in Vienna to the exhibition rooms. Since 1919 in the Palace of the Doges, Venice.
PRESERVATION: Badly damaged (apparently by fire).
DATING: The technical and pictorial treatment is very close to that of the *Altarpiece of the Hermits,* but shows greater plasticity and monumentality, especially in the centre panel. This leads us to conclude that the work was done shortly after the *Altarpiece of the Hermits,* about 1500–5. Baldass, 1959, believes that the wings were painted by Bosch at an earlier date, and originally belonged to a different triptych. Although the composition of the wings is indeed very different from that of the centre panel, the technique is the same.
According to van Schendel (oral communication), two donors, possibly kneeling, were originally depicted on the wings. The artist himself painted them over, the one on the left with a tower, the one on the right with a rock; this suggests that Bosch must have used panels on which he had already begun another composition.
BIBLIOGRAPHY: Th. Frimmel, *Kunstchronik,* new series, VII, 1896, p. 68, and *Kleine Gemäldestudien.* Dollmayr, p. 287–8. Cohen, no. 23. Lafond, p. 65. Baldass, 1917, p. 190: a late work. Friedländer, p. 151, no. 99. Tolnay, 1937. Baldass, 1959, p. 237. Combe, no. 79.

PAGE 275

NOTES – P. 38, 24 The unconscious figure on the left, at the foot of the cross, probably represents Eusebius, the pagan protector of Julia. The pelican and owl orna-

ments on his lower garment and cloak would be references to his ambiguous character.
P. 38, 30 The gold pieces that one of the personages holds in his hand leave no doubt as to his mercantile profession.

27. ST CHRISTOPHER

PAGES 278–

Rotterdam, Museum Boymans-van Beuningen (formerly Koenigs Collection, Haarlem).
Oil on wood. Height 113 cm, width 71.5 cm. Signed, lower left: Jheronimus Bosch.

PRESERVATION: Damaged and extensively cleaned in various places. The upper edge of the picture formerly terminated in a semicircle; later (in the eighteenth or nineteenth century) it was given a flatter form.
INTERPRETATION: In contrast to his usual procedure, the artist here put the luminous warm red in the centre where it contrasts with the cool grey-beige of the hollow trees to the right and left.
Bosch has introduced into the landscape several references to the corrupt world: in the left foreground a shipwreck, in the left background a dragon in the ruins, and behind him a burning city. This idea was followed up in a triptych in Antwerp Museum. Fraenger, *Hochzeit zu Kana,* p. 127, calls attention to the fact that the staff has sprigs of foliage, a motif that appears in the *Legenda Aurea.*

APPX. PL. 10

BIBLIOGRAPHY: *Katalog der Ausstellung im Kunsthaus, Zürich,* May–June 1934, no. 95. *Verzameling F. Koenigs Schilderijen,* Museum Boymans, Rotterdam, 1935, no. 2. *Catalogue of the J. Bosch Exhibition,* Museum Boymans, 1936, no. 60. Tolnay, 1937. Baldass, 1959, p. 238. Combe, no. 81.
NOTES – P. 37, 33 The rich folds of the cloak may be related to the engraving by the Máster of *St John the Baptist* (Lehrs, 10), likewise depicting St Christopher, which probably inspired it.

APPX. PL. 100, 103

P. 37, 38 *Legenda Aurea,* op. cit., p. 363: ... *l'enfant devenait lourd comme un poids de plomb.*
P. 37, 42 *Legenda Aurea,* op. cit., p. 362.
P. 38, 6 The Bordeaux-red of the saint's cloak harmonizes with the darker red of the child's dress, the dark blue of the girdle and the landscape, the mother-of-pearl tones of the large tree on the right and the pink of the jug.

27a. ST CHRISTOPHER BEARING THE SAVIOUR ON HIS SHOULDER

Madrid, private collection.
Oil on wood. Height 45 cm, width 20 cm. Signature.

PAGE 282

A small picture, tall and narrow, which has probably been cut down on both sides. First published and reproduced by D. Angulo [Angulo Iñiguez] in *Burl. Mag.*, LXXVI, 1940, p. 3. This work, the original of which I have not been able to examine, is to be assigned, according to the reproduction, to the end of Bosch's middle period, at the time of the *Altarpiece of St Julia* (cf. drawing of the garments blown by the wind). It may be a little later than the Rotterdam *St Christopher*, in which the host of demons is still lacking. Here we see a crescent, the symbol of heresy, on the army's banner. The vanishing-point is high, and hence the horizon line as well. The eye encounters a broad lacustrine landscape of great beauty, which anticipates the landscape on the right wing of the Prado *Epiphany*.

The saint, with his body bent and twisted as he leans upon his wooden staff and shows the strain of bearing the Child, his clothes in disarray from the wind, reminds us less of the Flemish tradition in depicting St Christopher (cf. D. Bouts, Memling) than of German portrayals in woodcuts and engravings, e. g. by Schongauer. Angulo calls attention to the similarity to the *St Christopher* of the Frankfurt Master (private collection, Berlin), reproduced in Winkler, *Altniederländische Malerei*, Fig. 125; this is explained by the fact that both derive from the same source.

Here Jesus is encompassed in a crystal ball, signifying the globe and crowned with the cross and banner of resurrection, an example that shows that in Bosch the crystal ball is not always equated with transitoriness.

28. THE PRODIGAL SON

GES 283–285

Rotterdam, Museum Boymans-van Beuningen.
Oil on wood. Diameter 71.5 cm. Unsigned.

PROVENANCE: Theodor Schiff Collection, Vienna; Figdor Collection, Vienna.
DATING: Hannema, *Museum Boymans, Jaarsverlag 1931*, pp. 2–6, dates the picture around 1510 – a hypothesis that is made thoroughly credible by the similarity of the style to that of the Prado *Epiphany*: however, he sees the *Prodigal Son* as a portrait of the artist, an assertion that the lack of resemblance makes rather dubious. The reverse of the *Hay-wain* foreshadows this part of the composition. See Baldass, 1917, p. 193. We repeat that these works differ enormously in execution and palette.
INTERPRETATION: Glück, 1904, and Hannema, op.cit., see this picture as an illustration of the parable of the prodigal son in the 'moment of enlightenment'.
Baldass, 1926, and E. Sudeck, *Bettlerdarstellungen vom*

Ende des 15. Jahrhunderts bis zu Rembrandt, Strasbourg, 1931, p. 17, assume that this relates to 'some proverb of a moralizing nature'.

The author stands by his interpretation of the painting, that the hawker is probably the prodigal son – the motif of the pigs at the trough leaves no doubt as to that – returning to his father's threshold from a disorderly house (Luke xv, 11–32), representing the sorry situation of the human soul on earth. He is unable to choose between sin and virtue, because he lacks willpower and has no faith; the theme of the prodigal son is integrated into the allegory of decision by free will, a late medieval parallel to the theme of *Hercules at the Crossways*, which Panofsky has dealt with in his book of that title.

The more recent interpretation by Pigler, *Burl. Mag.*, 1950, that the figure is a child of Saturn, does not contradict our view, for the children of Saturn are likewise of the melancholic temperament. But the astrological subsidiary interpretation is not by any means certain, since the planet itself is not represented. The Florentine engraving of about 1460, with which Pigler compares the painting, shows the wandering trader, the pig and the gallows in an entirely different context.

For Brand Philip, 1958, as for Pigler, the figure is a child of Saturn, and as proofs of this she adduces the limping gait, the dog, the owl, and the thread fastened to his hat, which shows that he is a cobbler. She goes on to explain that this hawker is a weak and bad man, who 'did evil things in the tavern' and is to be punished for them, as the gallows to the right indicate. Brand Philip (p. 76) concludes from this that Bosch's picture is negative and pessimistic in its basic attitude, that it was intended as a moralizing sermon, containing a serious warning against hawkers. According to her, Bosch intended to express the following warning in his picture: 'Do not buy the goods of this hawker; he is a bad character, who will end on the gallows, and you will be sorry that you had dealings with him.'

But the actual impression that the picture makes on the viewer is entirely different. The face of the hawker shows that he is not a bad character, for we know from Bosch's other pictures how he depicted such men; he is not an old man, but a young one, whose hair has turned prematurely grey. His constrained gestures and uncertain gait do not accord with a corrupt character. The idea that he will end on the gallows is unconvincing in view of the fact that the path he is taking does not lead to the gallows but turns off to the right behind the gate. It is not he who is bad, but the world around him that is thus described, and this is why he can find no place in it. Brand Philip interprets the lattice-gate as the 'gate of death' and not as the gate of his father's house, but the

only evidence she adduces for this is an engraving done almost two hundred years later, which has no relation to Bosch's work.

ADDITIONAL NOTE: Since the revision of this book was completed, the article by D. Bax in *Nederlands Kunsthistorisch Jaarboek*, 13, 1962, pp. 1ff., has become available; Bax, too, rejects Brand Philip's interpretation, in part with identical arguments. C. Péman in *Archivo Español de Arte*, XXXIV, 1961, pp. 125ff., has derived the original of the hawker motif from a miniature in the margin of the Lutterell Psalter. See text, p. 46f.

BIBLIOGRAPHY: Glück, *J.d.p.K.*, XXV, 1904, pp. 174ff. (Reprint: *Aus drei Jahrhunderten europäischer Malerei*, pp. 8ff.). Gossart, p. 290. Cohen, no. 26. E. Heidrich, *Altniederländische Malerei*, 1910, p. 105. Lafond, p. 76. Baldass, 1917, p. 193: regards the picture as an unsolved problem and dates it with the wings of the *Hay-wain*, which likewise depict a hawker, to the last period. G. Glück, *Zeitschrift für bildende Kunst*, LXI, 1927–8, pp. 249ff. Friedländer, pp. 102, 152, no. 103. Hannema, *Museum Boymans, Jaarsverlag 1931*, pp. 2ff., detailed analysis. E. Sudeck, *Bettlerdarstellungen vom Ende des 15. Jahrhunderts bis zu Rembrandt*, Strasbourg, 1931, pp. 12ff., detailed analysis. *Catalogue of the J. Bosch Exhibition*, Museum Boymans, 1936, no. 57. Tolnay, 1937. Baldass, 1959, pp. 227f. Combe, nos. 122–5. Brand Philip, 1958.

NOTES – P. 43, 6 Sigüença (op. cit., Appendix) already stated correctly, in reference to Bosch's work in general: '... he painted them as a mirror, to guide Christians.' Jean Gerson, in his book *Der dreieckecht Spiegel*, edited by Geiler von Kaisersberg, Strasbourg, 1510, alludes to this didactic function of the mirror: 'The first function of the mirror is that in it we recognize what befits us or does not befit us.' It is not necessary, as Glück, 1904, does, to explain Bosch's frequent choice of the medallion form by his being accustomed to painting glass windows.

P. 43, 33 See Freidank's *Bescheidenheit* (op. cit., p. 18, v. 18–19):

> *Ichn weiz selbe nit ze wol*
> *Wer ich bin und was ich sol.* (Von der Sêle)

P. 44, 4 The spoon, a symbol of dissipation, is illustrated by the following two proverbial expressions:

> *De pollepel hangt hem op zijde* (Harrebomée, II, p. 16).
> *Liebe macht Löffelholz aus manchem Knaben stolz.*

The cat's skin, symbol of misfortune, is illustrated by the following expression:

Het is een vel (i. e.: a misfortune; Harrebomée, II, p. 336). It is hard to accept the suggestion of Hannema that the cat's skin here is only 'a protection against rheumatism'.

P. 44, 8 On 'allegories of the free will' in general, see Panofsky, *Herkules am Scheidewege*, Leipzig, 1930. One cannot help noting that to a certain extent the landscape of the *Prodigal Son* follows the principle of the Pythagorean 'Y', which according to Panofsky dominates the compositions of certain 'allegories of the free will' (see Panofsky, op. cit., pp. 67ff. and Plates 30, 38).

E. BIBLICAL COMPOSITIONS WITH LARGE FIGURES

29. THE CRUCIFIXION

ES 286–289

Brussels, Musées Royaux des Beaux-Arts.
Oil on wood. Height 70.5 cm, width 59 cm. Unsigned.

PROVENANCE: Franchomme Collection, Brussels, formerly Fétis Collection; cannot be identified with the *Model for a Crucifixion* mentioned in documents in 1512. See p. 407.

PRESERVATION: The picture consists of two panels joined together.

DATING: The simple, almost provincial composition and the pale colours (vermilion, pink and grey for the Virgin, black and pink for the donor) indicate the early period. The deep, brilliant tones are missing. Nevertheless, the plastic treatment of the drapery anticipates the later biblical pictures with large figures. The landscape foreshadows that of the *Christ Carrying the Cross* in the Royal Palace in Madrid (formerly in the Escorial).

BIBLIOGRAPHY: Friedländer, *Von Eyck bis Bruegel*, Berlin, 1921, pp. 79–80. Baldass, 1926, pp. 103 ff.: he dates the picture close to the Berlin *St John on Patmos. Exposition Le Paysage Flamand*, Brussels, 1926, Catalogue no. 36 bis. Winkler, *Die altniederländische Malerei*, p. 157. Friedländer, p. 148, no. 84. *Catalogue of the J. Bosch Exhibition*, Museum Boymans, 1936, no. 49a. Tolnay, 1937. Baldass, p. 245. Combe, no. 11.

NOTES – P. 20 Friedländer, *Von Eyck bis Bruegel*, pp. 79–80, sees in Bosch's *Crucifixion* the influence of Roger van der Weyden. But the only thing that could recall that master would be the broken line of the body, and this characteristic is already to be found in the 1444 fresco, which Bosch's work follows in several particulars: the closed legs and the feet nailed over one another in the place of Roger's separated legs and crossed feet.

P. 20, 17 A stained-glass window in Beauvais dated 1516, of which only the inscription is left (published in the *Mémoires de la Société académique de l'Oise*, IX, p. 145, and in E. Mâle, *L'art religieux de la fin du Moyen-Age*, p. 162–3) illustrated the same idea by means of a sort of ascending chain of prayers.

30. CHRIST CARRYING THE CROSS

GES 290, 291

Madrid, Royal Palace.

Oil on wood. Height 150 cm, width 94 cm. Unsigned.

PROVENANCE: Mentioned among the pictures that Philip II had sent to the Escorial in 1574 (see Justi, p. 142, no. 3). Formerly in the Escorial.

PRESERVATION: This large wood panel has been damaged by a vertical crack left of the centre, and has been restored.

DATING: This painting must be later than the Vienna *Christ Carrying the Cross*, since here Bosch repeats with little variation the figures of the scourger and of Simon of Cyrene.

INTERPRETATION: It is noteworthy that Bosch chose a subdued grey for the cloak of Christ in the centre of the picture and shifted the deep blue, pink and white to the left. The landscape is enveloped in a cold green. The treatment of the forms is sculptural and monumental, and thus anticipates the rendering of the figures in the Escorial *Crowning with Thorns* and the Prado *Epiphany*.

BIBLIOGRAPHY: Justi, p. 142. Cohen, no. 6. Lafond, p. 43. Friedländer, p. 147, no. 81. Tolnay, 1937. Baldass, 1959, p. 245. Combe, no. 17.

31. THE EPIPHANY
(Adoration of the Magi)

On the outer side of the wings: *Mass of St Gregory* PAGES 295–305 (grisaille).
Madrid, Museo del Prado.
Oil on wood. Height 138 cm, width 72 cm; width of each wing 33 cm. Signed on the centre panel, lower left: Jheronimus Bosch. Inscription on left panel: *een voer al* (one for all). Below this, the arms of the Bronckhorst and Bosshuyse families.

PROVENANCE: Confiscated by Philip II in 1568 from Jean de Casembroot, lord of Backerzeele (Pinchart, I, p. 276). Mentioned as *Nativity* in the inventory of pictures that Philip II had sent to the Escorial in 1574 (identified by Justi, p. 142).

DATING: This work has been dated about 1490 by Demonts, pp. 1 ff., and Baldass, 1917, p. 184; and by Friedländer about 1495. However, the style permits us to assign a later date, and it may be dated about 1510 (cf. Tolnay, 1937). Compare the costumes with those of

the *Male Portraits* by Jean Mostaert in the Brussels Museum. Later, Baldass, 1959 adopted our dating.

INTERPRETATION: When the wings are closed, the altarpiece shows the *Mass of St Gregory* in grisaille, painted across both panels. The saint is kneeling before the altar, above which is seen the sarcophagus of Christ, and at some distance from the Pope is a small kneeling figure, according to Fraenger the Roman woman who doubted the miracle of transubstantiation. The patrician to the left of the altar is not identical with the donor on the inner side of the triptych. Possibly it represents the donor's dead father.

Bosch represents directly the real presence of the Lord in the Eucharist. The scenes of the Passion, which originally formed the sculptural decorations of the altar, have been transformed into living reality by the fervent prayers of the saint. The story of the Passion is no longer presented in a continuous sequence (as on the reverse of the Berlin *St John on Patmos*), but the scenes are arranged symmetrically one above the other, in horizontal zones. The *Mass of St Gregory* heralds the *Epiphany* on the inner side of the altarpiece, which is likewise conceived by Bosch as the holy mass (see text).

On the centre panel of the inside lies the gift of King Melchior, at the feet of Mary, representing the sacrifice of Isaac as a statue in gold; it is a typological prefiguration alluding to Christ's sacrifice; but the swans on the king's helmet on the ground beside him seem to be a

PAGE 299

reference to sin. The scene of the visit of the Queen of Sheba to Solomon on the embroidered cape of King Balthasar is a prefiguration of the journey of the Three Kings to Bethlehem. The embroidered border of the cape depicts the sacrifice of Manoah (Judges xiii, 3–12), where an angel announces to the aged couple that they will have a son who will be the Saviour, the prototype of Christ (this interpretation of the scene by Fraenger is the correct one, and not our earlier idea that this was

PAGE 298

Noah's sacrifice). On the spherical casket of myrrh that the Negro king holds in his hand we see a picture of the three mighty heroes bringing water to David (a prefiguration of the Epiphany; 1 Chron. xi, 17–18). A bird is perched upon the casket of myrrh, eating a fruit and recalling the type of pelican that Bosch also uses elsewhere. However, the border of his cloak shows bird-like monsters, some with human heads, which are pecking at fruit and obviously signifying lust.

PAGE 304

The landscape in the background shows a wide panorama, which is characterized as the evil godless world by a heathen idol, an evil tavern and three hordes of wild warriors. The latter are metamorphoses of the traditional retinues of the kings. According to Brand Philip they represent the last battle at the end of the world (Rev.

xvi, 14), a rather far-fetched interpretation, especially since no fighting of any kind is depicted.

In recent times the meaning of the mysterious figure standing in the door of the hut has been much discussed. Although the man wears a scarlet cloak, he is half naked. On his head is a crown in the form of a turban decked with thorns. According to Brand Philip (*Art. Bull.*, XXXV, 1953) this figure represents the Jewish Messiah, since legend relates that he had been a captive, which would explain the golden chains; the prophet Isaiah says (liii, 3–4) that the Messiah of the Jews 'is despised and rejected of men, a man of sorrows, and acquainted with grief: ... wounded for our transgressions,' and Bosch's figure has the white skin and the large sore of a leper; Brand Philip adds that this Messiah embodies the synagogue. According to her, even the ruined hut is a symbol of the old Law. For her the entire scene (the ruined hut, the Jewish Messiah and the ass behind the second door) represents the synagogue as a symbol of evil, and the Jewish Messiah here is actually Antichrist, the false prophet. It must be recalled, however, that in the art of that time Antichrist was represented as a handsome beardless youth. For Brand Philip the crown of thorns is a reference to the deceptive imitation of the Passion by Antichrist, and the living branch with leaves and flowers projecting from a glass vase would be the magician's trick of Antichrist illustrated in *Hortus*. She regards the small bell on a ribbon as the bell of the Jewish high priest. The object in his left hand, a large metal vessel open at both sides, is the helmet of the second king, but at the same time a diagram of hell.

According to Fraenger (in *Deutsches Jahrbuch für Volkskunde*, III, 1957, p. 169), who does not seem to be acquainted with Brand Philip's article, this man is Adam as a witness to the miracle of the Epiphany, and the figure next to him is Abraham. In our opinion, the figure is most likely the figure of the Messiah of the Old Testament, as described by Isaiah (liii, 3–4) but thought of as a prefiguration of Christ and his Passion. The golden chains allude to the seizure of Christ, and the wound on his leg, which is wrapped up like a relic in a transparent gilt-edged bandage, to the entire story of the Passion of the Lord; the crown of thorns anticipates that of Christ; the living branch on it may be the symbol of the Messianic kingdom (Is. xi, 1), as Fraenger interprets it, the little bell is the Christmas bell that heralds the coming of Christ; the gentle way in which he touches the wooden door-posts is probably an allusion to the wood of Christ's Cross; the object in his left hand is not a helmet but, as Fraenger notes, the container for his crown. The ruined hut is not necessarily the symbol of the synagogue, but an expression of the humility and poverty

of the Holy Family. The man's young bearded face, unknown in the iconography of Antichrist, anticipates the face of Christ. Moreover he observes the Child Jesus with lively interest. The other figures in the hut, who with the main figure form two groups of three, seem to be the earliest prefigurations of the Wise Men. In a similar way, Roger van der Weyden, in his *St Columba Altar* in Munich, had already presented in an arched gateway, behind the adoring Magi, three figures who resembled them and may already have referred to adoration in perpetuity. Because of the ambiguity of the elements presented in Bosch's painting, the surest guide to a proper understanding of his spiritual intentions is the expressive value of his forms. If we neglect them, it is unavoidable that they will be related to traditions and texts with which they have no connexion.

COPIES: For the best known, see Friedländer, p. 144.

BIBLIOGRAPHY: Justi, p. 128: 'The types of the Holy Family and patrons are certainly derived from Roger and Bouts.' Dollmayr, p. 290. Maeterlinck, *Le genre satirique dans la peinture flamande*, p. 231f. Cohen, no. 16. Schubert-Soldern, *Von Jan van Eyck bis Bosch*, 1903, p. 108: emphasizes the influence of the altarpiece in Dijon by the Master of Flémalle. Gossart, p. 47. Lafond, p. 37: *Une des premières productions dans le genre religieux.* Baldass, 1917, p. 184: dates the work about 1490 (costumes); Tolnay, 1937. Baldass, 1959, p. 241f., adopts our later dating. Likewise Combe, nos. 115–120. Demonts, pp. 1ff.: *Il semble que Bosch ait dû commencer par des œuvres comme l'Adoration des Mages (Prado).* Friedländer, pp. 89, 144, no. 68: 'not much earlier than 1495 and hardly later.'

APPX. PL. 110–111

PX. PL. 104

NOTES – P. 29, 33 The earlier depictions of the *Mass of St Gregory* do not contain any visionary element. As a characteristic example we cite the work, dated 1486, of an anonymous master in the Utrecht Museum, Cat. no. 540.

P. 40, 19 Up to the present, and incorrectly, only the influences of Roger and Memling have been mentioned. See Justi, p. 128; Baldass, 1917, p. 185.

P. 40, 21 See Schubert-Soldern, loc. cit.

P. 41, 5 See *Biblia Pauperum*, ed. J. H. Cornell, p. 256, no. 76. The queen presents to Christ the peoples being converted. On the left panel the legend: *een voer al* (one for all).

P. 41, 17 See Smits, op. cit., pp. 88–9. The old 1421 altarpiece of the choir of Our Lady in 's Hertogenbosch likewise represented the *Epiphany* (burnt in 1463). It was replaced in 1478 by a painting by Wezel of Utrecht, and in 1509 by an *Epiphany* by Bosch.

P. 41, 25 Cf. the *Epiphany* of Master Francke in the Kunsthalle, Hamburg, which is influenced by the Burgundian school, and the *Flight into Egypt* of Melchior Broederlam in the Dijon Museum.

P. 41, 40 The transparent grey of the latter here completely takes the place of the traditional blue.

32. THE TEMPTATION OF ST ANTHONY

Madrid, Museo del Prado (formerly in the Escorial). Oil on wood. Height 75 cm, width 51 cm. Unsigned.

PRESERVATION: The upper corners of the picture were apparently covered by a semicircular frame. The painting of these, however, seems to be by Bosch's hand. Thus, the painting was rectangular also at the outset. (Baldass, 1959, p. 278, on the contrary regards the painting of the corners as a later addition.)

DATING: The palette is of the same soft, silky light beige, light green and light blue as in the Prado *Epiphany*, and for that reason we maintain our late dating. Combe accepts the late dating, and even regards this painting as Bosch's 'last work'; Baldass too rallied to our opinion in 1959.

The fire in and behind the house (which probably represents Anthony's hut) is obviously the attribute of the saint, presented dramatically. A detailed analysis, which appeared after the first edition of this book, is Fraenger's 'Hieronymus Bosch; Die Versuchung des Heiligen Antonius', in *Hessische Blätter für Volkskunde*, XLIX–L, 1958, pp. 20ff. Fraenger agrees with our late dating, and seeks to interpret the picture in accordance with Jung's conceptions, showing that Bosch represented his doctrine of the dialogue between the Ego and its inner mirror image, the Self, centuries before Jung.

BIBLIOGRAPHY: Cohen, no. 17. Lafond, p. 73. Baldass, 1917, p. 187–8: correctly emphasizes the influence of Geertgen. Friedländer, pp. 95, 150, no. 93. Id., Prado *Catalogue* 1933: about 1490. Tolnay, 1937. Baldass, 1959. Combe, 1957.

NOTES – P. 42, 2 The stylistic similarity between this picture and the Prado *Epiphany* was first observed by Baldass, 1917, p. 187–8, although at that time he regarded both pictures as works of the middle period.

P. 44, 25 Jan Ruisbroeck, *Das Buch von der höchsten Wahrheit*, ed. F. M. Huebner, p. 89. 'And although firmness and devotion of spirit in God must make way thereafter for true enjoyment of unity, nevertheless firmness and devotion always remain, as an inner attitude.'

F. PAINTINGS WITH HALF-FIGURES

33. THE CROWNING WITH THORNS

PAGE 307

London, National Gallery.
Oil on wood. Height 72.5 cm, width 58.5 cm. Unsigned.

PROVENANCE: Appeared at the Hollingwood Magniac auction, 1892. Acquired by the National Gallery in 1934. The preliminary drawing is visible through the transparent colours.

DATING: *The Crowning with Thorns* of the National Gallery is probably later than the *Christ Carrying the Cross* in the Royal Palace, Madrid, and in any case earlier than the *Crowning with Thorns* in the Escorial. The face of the thief seen at upper right in the London picture is found in all three of these paintings. This work is not very well preserved, and some parts seem to have been restored.

BIBLIOGRAPHY: Sir W. M. Conway, *The van Eyck and their Followers*, London, 1921, p. 344: doubts its authenticity. *Pantheon*, XIV, 1934, pp. 383, 387. Tolnay, 1937. Baldass, 1959, p. 243. Combe, no. 115. Treated in detail by M. Davies, *Catalogue of the Netherlandish School*, National Gallery, London, and *Corpus: National Gallery*.

34. THE CROWNING WITH THORNS

PAGE 308

Madrid, Escorial.
Oil on wood. Height 165 cm, width 195 cm. Unsigned.

PROVENANCE: Mentioned (wrongly as *Seizure of Christ*) among the pictures that Philip II had brought to the Escorial in 1574 (identified by Justi, p. 142).

PRESERVATION: The picture has recently been cleaned and the splendid quality of grisaille in the corners, representing the fall of the apostate angels, has become visible. This too is by the hand of the master.

DATING: The face of Christ is reminiscent of the Christ in the *Sepulture* by Quentin Massys in the Antwerp Museum. This observation is by Hulin de Loo, who concludes from it that Massys influenced Bosch. But the earlier works of Bosch lead up to this type so naturally that one might rather conclude that he influenced Massys, which would enable us to set the date of 1511, which is the date of the Antwerp *Sepulture*, as a *terminus ante quem* for Bosch's work.

INTERPRETATION: Mela Escherich, 'Eine politische Satire von H. Bosch', in *Zeitschrift für Kunstgeschichte*, IX, pt. 2, 1940, pp. 188ff., believes that she can recognize a portrait of Louis XI in the profile head to the left (Pilate), and of Galeazzo Maria Sforza or Chancellor Simonetta in the other onlooker. She is of the opinion that the three soldiers to the right represent Austria with the Habsburg double eagle, Lorraine and Switzerland. For her Bosch's picture is a reflection of the dissatisfaction of Burgundy, which was divided between France and Maximilian of Austria after the death of Charles the Bold in 1477. At the same time Brabant was suffering under the rule of Maximilian's governor, Albert of Saxony. Accordingly, Escherich dates the picture about 1477, a date that is in our opinion far too early. The entire political interpretation is questionable.

COPIES: For the best known ones, see Friedländer, p. 146. The copy in the Valence Museum was wrongly regarded as an original by Justi, p. 125.

BIBLIOGRAPHY: Justi, p. 125. Cohen, no. 7. Claude Phillips, *Burl. Mag.*, XVII, 1910, pp. 321ff. Lafond, p. 40: *Sans doute un des premiers tableaux de Bosch*. Demonts, pp. 1ff., says the same. Baldass, 1917, p. 194: 'The highest point in Bosch's development'. Friedländer, pp. 93, 146, no. 79. Tolnay, 1937. Baldass, 1959, p. 244. Combe, no. 112.

NOTES – P. 21, 32 Reference may be made, for example, to the *Pietà* in tondo form in the Louvre, formerly attributed to Jean Malouel and dating from about 1410. (See: *Catalogue des peintures. Ec. Fr.*, no. 996).

P. 22, 1 For studies on Leonardo, see MS W. AN., quad. V, fol. 22 r. (M. Herzfeld, *Leonardo als Denker, Forscher und Poet*, Jena, 1926, p. 91, no. XL), and SP., MS W. AN. B., fol. 13 r. (Herzfeld, op. cit., p. 92, no. XLVI).

However, mention should be made of a note in MS C.A., fol. 370 v. (Herzfeld p. 252, no. CVIII), where he gives a moral meaning to the equation of man with animal.

34a. THE VIRGIN AND CHILD and ST JOHN THE BAPTIST, STANDING

PAGE 312

Two panels of the same size.
's Hertogenbosch Cathedral. Tempera on canvas. Larger

than life-size. Inscription on reverse: *Bosch delineavit et p(in)xit*. Although this is written in Gothic letters, it is probably not a signature.

PRESERVATION: These two pictures were originally the folding cover panels of a large clock, which is dated 1513. Both are in very bad condition and were heavily restored in 1949.

The figures imitate sculpture. With the exception of the heads and hands they are painted in grisaillé; the background is red. Their colour recalls the palette of the reverse of the wings of Bosch's altarpieces. They are conceived as standing figures on painted bases, under painted Late Gothic baldachins. The folds, heavy but soft, remind us of Burgundian statues of about 1400. Because of the spatial and plastic conception, the date of 1513 is very probable, but the proportions and drawing of the work as a whole, as well as the execution of the details, are very weak. Because of the poor condition of the two pictures, I cannot say anything definite as to their authenticity; but the faces are reminiscent of Bosch, and it may be presumed that this is a work that was done in Bosch's studio, perhaps after cartoons by him.

BIBLIOGRAPHY: Discovered and first published by Jan Mosmans, *J. Bosch, Maria en Sint Jans,* 's Hertogenbosch, 1950.

35. CHRIST BEFORE PILATE

PAGE 309

Princeton, N.J., Princeton Art Museum.
Oil on wood. Height 84.5 cm, width 108 cm. On Pilate's sleeve BVS FACIEBAT, discovered by Louis Réau; in our opinion, it is dubious whether this is a signature.

PROVENANCE: Purchased by Allen Marquant from a London dealer in 1891; Allen Marquant Bequest.
ATTRIBUTION: In contradiction to Hulin de Loo (cited in Tolnay, 1937, p. 101), I consider it a genuine late work, done shortly before the Ghent *Christ Carrying the Cross*.
INTERPRETATION: The entire composition, with its half-figures, and also the grouping of the figures, recall North Italian half-figure compositions of Giovanni Bellini or the early Titian. Whether there was a direct influence here or whether Bosch arrived at this scheme by himself is a question that must remain open. The background is black, and the two brilliant red parts, namely the head-covering of the figure in profile on the left and that of Pilate contrast with the coldly glistening metal objects (silver breastplate and helmet and golden basin). Although the forms are plastically modelled with a fine *sfumato*,

they seem to be weightless, as in the Ghent *Christ Carrying the Cross*. The changing colours of the peaked cap of the figure immediately behind Christ (blue in golden-yellow) are also in line with the Ghent painting.
On possible relationship to Leonardo's caricatures, see A. Blum, loc. cit.
BIBLIOGRAPHY: Allen Marquant, *Princeton University Bulletin,* XIV, no. 11, March 1903, pp. 41 ff. Lafond, p. 41. Baldass, 1917, p. 194: later than the Ghent *Christ Carrying the Cross*. Friedländer, p. 145, no. 76. Baldass, 1943, pp. 43, 73, regards the picture as questionable, and does not mention it in his 1959 edition. Tolnay, 1937. Recently cleaned and published after cleaning by Ernest de Wald in *Record of the Art Museum, Princeton University,* 1948, no. 2, p. 4f.
NOTES – P. 42, 32 The type of painting with half-figures appears as early as the middle period; that of the Ghent *Christ Carrying the Cross*, consisting entirely of heads, occurs only once in the artist's work. It can be explained only by the assumption that it is from the end of his creative period and must be dated later than the Philadelphia *Christ before Pilate*.

36. CHRIST CARRYING THE CROSS

Ghent, Musée des Beaux-Arts. PAGES 310
Oil on wood. Height 76.7 cm, width 83.5 cm. Unsigned.

PROVENANCE: Acquired in 1902 for the Museum by Hulin de Loo.
PRESERVATION: The painting was restored in 1956–7, and on that occasion an article by Roger van Schoute, 'Le portement de Croix de Jérome Bosch au Musée de Gand', appeared in the *Bulletin de l'Institut Royal du Patrimoine Artistique,* II, 1959, pp. 47ff. On p. 49 of that publication he presented an X-ray photograph of the painting, on which the drawing is visible through the transparent colours. The painting seems to have been trimmed slightly at the edges. On possible relationship to Leonardo's caricatures, see André Blum, loc. cit.
BIBLIOGRAPHY: *Exposition à Bruges,* 1902, Catalogue no. 285. Friedländer, *Meisterwerke der niederl. Malerei auf der Ausstellung in Brügge,* Plate 84. Maeterlinck, *Revue de l'art ancien et moderne,* 1906, p. 299: *nous y constatons l'influence considérable qu'exercèrent les mystères et moralités sur l'art flamand.* Lafond, p. 44. Baldass, 1917, p. 194. Friedländer, pp. 94, 147, no. 82. Tolnay, 1937. Baldass, 1959, p. 245. Combe, nos. 110–11.
NOTES – P. 42, 36 There are few compositions prior to Bosch consisting entirely of heads: the *Mass of St Gregory,*

a Dutch miniature (about 1470) in an Amsterdam private collection, reproduced in Byvanck-Hoogewerff (Plate 14b), in which six heads appear above the altar; a painting by Dürer, *Christ among the Scribes* (1506), formerly in the Barberini Gallery in Rome, now in the Thyssen-Bornemisza Collection, Lugano. In these cases we have only a kind of abbreviation.

P. 43, 6 Freud, 'Der Dichter und das Phantasieren'. *Gesammelte Schriften,* x, pp. 230ff., and E. Kris, 'Zur Psychologie der Karikatur', *Imago,* 1934, pp. 450ff.

LOST PAINTINGS KNOWN FROM COPIES

X. PL. 2, 3

37. JESUS BEFORE THE SCRIBES

Best examples: Settignano, Weintzheimer Collection.
Paris, Musée du Louvre.
Philadelphia, Philadelphia Museum of Art,
Johnson Collection.
See Friedländer, no. 72. The model of this work may
date from the period of the *Conjuror*.
On Bosch's composition compare, by way of contrast,
the earlier conception in Appx. Pl. 71.
BIBLIOGRAPHY: Combe, no. 132.

37a. CHRIST AND THE WOMAN TAKEN IN ADULTERY

PX. PL. 10

Philadelphia, Philadelphia Museum of Art, Johnson
Collection. Published by Tolnay, *Art International*, VII/4,
1963, p. 24. This is the only copy in existence of a lost
original by Bosch, which has not previously been ment-
ioned in literature on Bosch. It was formerly regarded (by
Puyvelde) as a copy after Dirk Bouts, and only recently
has it been shown by Lucie Ninan and J. van Gelder
that it might go back to a lost work by Bosch. The paint-
erly quality of this work, with its warm red and pure
white colours, is superior to that usually found in copies
after pictures by Bosch. The artist keeps fairly close to
John viii, 1–11: Christ was teaching in the temple when
the scribes and Pharisees brought him a woman taken
in adultery. Thereupon Christ stooped down and wrote
on the ground, and said, when He stood up: 'He
that is without sin among you, let him first cast a stone
at her.' This is the very instant that Bosch has depicted:
Christ's writing is visible on the ground, but He has stood
up and is speaking. The scene was usually represented
by having the adulteress standing or kneeling before

Christ, or by Christ stooping to write on the ground.
But Bosch represented both Christ and the woman
as standing, in order to avoid any impression of humi-
liation. Still more surprising is the fact that a young,
elegantly clad Pharisee is accompanying the likewise
young and elegant adulteress, with his arm around her
slender waist and holding her tenderly, as if he were a
bridegroom presenting his bride to the Saviour. It al-
most seems as if Bosch, instead of despising the adulteress,
wanted to honour her.

The composition is articulated by the columns of the
arches in the background, which create a division into
three parts and determine the arrangement of the figures
in front of them: the largest group in the large centre
portion, Christ on the right and the smallest group in
the small parts along the side. Instead of seeking the
effect of three-dimensional space by overlapping and
linear perspective, as was the fashion in the Netherlands
at that time, Bosch's composition is bound to the two-
dimensional plane, a method that enabled him to bring
out the colour values and the splashes of pure colour
more decoratively and pictorially.

38. CONCERT IN AN EGG

Best examples: Senlis, Pontalba Collection. Lille, Musée APPX. PL. 4, 5
Wicar.
INTERPRETATION: The original drawing anticipating
this composition is in the Kupferstichkabinett, Berlin.
ATTRIBUTION: See Baldass, 1917, p. 194, who holds that
the original must stem from the last period; he sees a
certain stylistic affinity with the *Hay-wain*. Friedländer,
no. 108. We would prefer to date the model of this com-
position to the period of the *Conjuror*.
BIBLIOGRAPHY: Combe, no. 131.

39. CHRIST CARRYING THE CROSS

APPX. PL. 25
Sole example: London, Arnot Gallery. Tempera on canvas.
PRESERVATION: In very bad condition, in part repainted.
ATTRIBUTION: See Baldass, 1935, who regards the picture as an original by Bosch. *Catalogue of the J. Bosch Exhibition*, Museum Boymans, 1936, no. 63 (where the picture was exhibited for the first time).
BIBLIOGRAPHY: Baldass, 1943, p. 251, Fig. 113. Combe, no. 140.

40. THE ADORATION OF THE MAGI: two panels

PAGES 96–97
Best example: Philadelphia, Philadelphia Museum of Art, Johnson Collection.
ATTRIBUTION: Although I still have some doubts, I should like to point out that the dog overlapping the feet of the shepherd on the left panel is hardly possible in a copy, and suggests that this is an original. The poor condition of both fragments makes a final judgement difficult. A copy of the entire composition is in the Marquis Casa Torres Collection, Madrid. Cf. Tolnay, *Art International*, VII/4, 1963. See Friedländer, no. 70: 'probably an original.'

APPX. PL. 19

41. THE BATTLE BETWEEN CARNIVAL AND LENT

APPX. PL. 26
Best examples: Rohoncz, Baron Thyssen-Bornemisza Collection. Amsterdam, Rijksmuseum.
Antwerp, Museum Meyer van den Bergh.
See Glück, *Gedenkboek A. Vermeylen*, 1932, pp. 263ff.
INTERPRETATION: This painting by Bosch obviously influenced Bruegel's picture of the *Battle between Carnival and Lent* (Vienna).

42. THE TEMPTATION OF ST ANTHONY: half-figure

APPX. PL. 48, 49
Best example: Madrid, Prado. Amsterdam, Rijksmuseum (formerly Schmidt-Degener Collection).
ATTRIBUTION: See Friedländer, no. 95. Glück, *J.d.K.S.*, new series, IX, 1935, p. 151, who sees the example in the Rijksmuseum, Amsterdam as a copy of the *Temptation of St Anthony* that according to documents was in the possession of Margaret of Austria in 1516. See also Combe, no. 136.
See p. 388.

43. THE KISS OF JUDAS: half-figure

APPX. PL. 4
Examples: Amsterdam, Rijksmuseum and San Diego, California, Fine Arts Gallery.
ATTRIBUTION: See M. D. Henkel, *Pantheon*, VIII, 1931, p. 273, who regards the picture as an original. Cohen, *Pantheon*, VIII, 1931, p. 440, regards it as a copy.

44. THE CROWNING WITH THORNS: half-figure

APPX. PL. 4
Best example: Philadelphia, Philadelphia Museum of Art, (formerly London, Paterson Collection). Berne, Musée de l'Art, no. 32 (without the donor).
ATTRIBUTION: In some examples (e. g. in the Antwerp Museum) the copyist has added the portrait of the donor, in each case at lower left.
The lost original must have been done before the London *Crowning with Thorns*.
BIBLIOGRAPHY: See *Burl. Mag.*, III, 1903, p. 92. Friedländer, no. 80.

45. THE ADORATION OF THE SHEPHERDS: half-figure

PAGES 292–
Best example: Cologne, Wallraf-Richartz-Museum. Height 66 cm, width 43 cm.
Another very badly damaged copy of inferior quality is in a private collection in Holland, and yet another example in the Brussels Museum.
ATTRIBUTION: See Justi, p. 127f., who considers this example an original. Dollmayr, p. 300. Baldass, 1917, p. 194, sees the picture as a copy, the original of which is from the last period. Friedländer, no. 65. *Catalogue of the J. Bosch Exhibition*, Boymans Museum, 1936, no. 62. I now regard this painting as the original (at least so far as the main figures are concerned). The two shepherds in the left background seem to be rather foreign to Bosch's style. (It is possible that Bosch died leaving the painting unfinished, and that someone else completed the left background.) In any case, the technique of the main figures, in which the drawing is visible through the colours (e. g. Joseph's head and Mary's neck), corresponds fully to Bosch's style of the period of the London *Crowning with Thorns*.
INTERPRETATION: The composition of this scene with half-figures has a parallel in a painting by the Master of the Virgo inter Virgines. It is surprising and quite untraditional that the garment of the Virgin should be white. The fine winter landscape in the right back-

ground is in cool dull beige tones. On the motif of the magpie looking on, cf. our remarks on the Philadelphia *Epiphany;* here the motif is much more strongly brought out. It was copied elsewhere in the sixteenth century as well. Fraenger, *Hochzeit zu Kana,* pp. 114ff., thinks that he can identify the head of Joseph as a portrait of Jacob van Almangien; but his features are not known.

BIBLIOGRAPHY: Baldass, 1943, p. 246, Fig. 87. Combe, no. 133. Lerche regards the Cologne example as a copy.

46. CHRIST BEFORE PILATE

Example: Rotterdam, Museum Boymans-van Beuningen (formerly Munich, de Nemes Collection). APPX. PL. 51

INTERPRETATION: See Friedländer, no. 75. *Catalogue of the J. Bosch Exhibition,* Museum Boymans, 1936, no. 61. The lost original must be dated to the artist's last creative period. The copy shows high quality in the handling of *sfumato.*

DISPUTED WORKS

We list here works hitherto mentioned in the literature as originals or close copies of the master.

We shall not discuss again here pictures formerly attributed to the master and already rejected by Friedländer. We shall confine ourselves to listing the works regarded as genuine by Friedländer and later attributions.

47. THE EPIPHANY

New York, Metropolitan Museum (formerly Berlin, Lippmann Collection), and Rotterdam, Museum Boymans-van Beuningen.

ATTRIBUTION AND INTERPRETATION: Of the two paintings, the one in the Metropolitan Museum seems to be of superior quality. However, in my opinion neither is by the hand of the master.

In view of the ungainly style of the figures, one might be inclined to date this painting to Bosch's earliest period, say around 1480. It cannot be so early, however, since the architectural frame seems to be influenced by Dürer's Epiphany in the *Life of the Virgin* of about 1502–5, although here the prototype is simplified. This would give a *terminus post quem,* and indeed some details of the landscape in the background, e. g. the bridge and the trees on the river bank, as well as the curved line of the drapery held by angels above the principal scene, support this date. On the other hand, it is unlikely that Bosch painted such primitive figures as late as 1500.

A final reason for attributing this picture only to the atelier of the master is the brush-strokes, e.g. in the hands or body of Jesus, where it is impossible to recognize Bosch's style. Further, the treatment of the trees in the background seems to be only a feeble imitation of Bosch.

BIBLIOGRAPHY: See Baldass, 1917, p. 177. Friedländer, no. 66.

48. THE EPIPHANY (triptych)

Anderlecht, Church of Saint-Pierre.

INTERPRETATION: Inspired by the Prado *Epiphany*. The Italianizing decoration of the house on the left panel dates the picture about 1520–5. The faces of the figures were repainted in the latter half of the sixteenth century.

BIBLIOGRAPHY: See Friedländer, no. 69. *Catalogue of the J. Bosch Exhibition,* Museum Boymans, 1936, no. 63a. Another replica of this *Epiphany* is in an English private collection. My impression, on the basis of good photographs (I have not seen the painting itself), is that this work is of higher quality than the one in Anderlecht.

49. THE LAST JUDGEMENT

United States, private collection (formerly Paris, Pacully Collection).

ATTRIBUTION: Inspired by the engraving *The Last Judgement* by Allaert de Hameel, but differing in details.

BIBLIOGRAPHY: See Friedländer, no. 87.

50. THE LAST JUDGEMENT

Bruges, Musée Communal des Beaux-Arts.

Centre panel: height 99.2 cm, width 60.5 cm. Wings: height 99.5 cm, width 28.8 cm. Signed: Jheronimus Bosch.

PRESERVATION: In relatively good condition; cleaned in 1960.

ATTRIBUTION: I now consider this triptych to be an authentic work of the period of the *Garden of Earthly Delights,* viz. about 1510. The high quality of the *Crowning with Thorns* in grisaille recently discovered on the reverse, but very badly damaged, also points to its authenticity; see no. 50a. Baldass, 1943, p. 29, regards it as a pastiche.

K. PL. 32, 36

APPX. PL. 33–35

APPX. PL. 31

PAGES 188–201

BIBLIOGRAPHY: Maeterlinck, *Revue de l'art ancien et moderne*, XXIII, 1908, pp. 145ff.: work of an imitator. Friedländer, no. 86. A.Janssens de Bisthoven and R.A. Parmentier, *Corpus: Bruges,* 1951.

50a. THE CROWNING WITH THORNS

PAGE 188

Paintings in grisaille. On the reverse of the *Last Judgement* in Bruges, Musée Communal (see no. 50).
Height 98.3 cm, width 72 cm. Recently discovered and not previously published.
ATTRIBUTION: Badly preserved (the work has not yet been incorporated into the Bruges volume of the *Corpus: Bruges,* 1951). It has the high quality of an original by Bosch at the end of his middle period. After I had seen the triptych subsequent to its cleaning in 1960, I was convinced that the inner side of the wings too are by Bosch. The triptych was painted *alla prima* in silky pink and light blue on a brown and green ground. Several motifs are anticipated in the Wildenstein panels, but here they are further developed. The same motifs likewise appear in the *Last Judgement* of the Vienna Akademie and in the *Garden of Earthly Delights,* but in both these cases they are developed still further. I would be inclined to date the Bruges triptych somewhat earlier than the *Garden of Earthly Delights.*

51. VISIO TONDALY

APPX. PL. 52

Madrid, Museo Lazaro Galdiano
(formerly Amsterdam, N. Beets).
Probably by the same hand as no. 49.

52. PARADISE

APPX. PL. 53

New York, Metropolitan Museum.
Height 27.5 cm, width 40.5 cm.
PROVENANCE: Formerly P. de Boer, Amsterdam.
In this composition certain elements of the *Garden of Earthly Delights* recur, such as the fantastic crags, combined with the 'plant chimney' of the centre panel of the Venice *Altarpiece of the Hermits.* Its style dates it to about 1510–20.
BIBLIOGRAPHY: See *Catalogue of the J.Bosch Exhibition,* Museum Boymans, 1936, no. 49, where the picture appears as a genuine work and is dated 'before 1500'.

53. THE TEMPTATION OF ST ANTHONY

Lugano, Baron Thyssen-Bornemisza Collection
(formerly Munich, Drey Collection).
INTERPRETATION: The demons are possibly inspired by a sheet of sketches by the master, now lost, which was of the same period as the sheet in Oxford, on which similar motifs are found.
BIBLIOGRAPHY: Friedländer, Plate 91.

54. THE TEMPTATION OF ST ANTHONY

Haarlem, Gutman Collection.

APPX. PL.

Oil on wood. Height 27 cm, width 21 cm. Unsigned.
ATTRIBUTION AND BIBLIOGRAPHY: Friedländer, pp.95, 150. *Catalogue of the J.Bosch Exhibition,* Museum Boymans, 1936, no. 55. The execution does not seem to us to be by the hand of the master. His technique is not recognizable in the very fine brush-strokes. The palette, in which yellow and blue predominate, is not that of Bosch. Finally, the landscape in the foreground, which is entirely lacking in animation, is not in the manner of the master.

55. THE TEMPTATION OF ST ANTHONY

Berlin, Deutsches Museum.
ATTRIBUTION: A composition alien to Bosch, inspired by the Prado *Temptation of St Anthony.*
BIBLIOGRAPHY: See Friedländer, no. 94.

56. ST CHRISTOPHER

Winterthur, Reinhart Collection.
DATING: The almost monochrome palette with brown predominating dates the picture about 1540.
BIBLIOGRAPHY: See Friedländer, no. 96. Pfister, Plate 15.

57. ST JAMES OF COMPOSTELA AND THE SORCERER

On the reverse:
The Temptation of St Anthony.

APPX. PL.
108, 109

Valenciennes, Museum.
ATTRIBUTION: Inferior to Bosch; very different brush-strokes; but it is Dutch. The costumes date the picture about 1510–20.
BIBLIOGRAPHY: *Musée de Valenciennes: Catalogue,* 1909, no. 176. Friedländer, no. 10. Edouard Michel, *Bulletin*

des Musées de France, 1930, pp. 64ff. A. Cornette, *Trésor de l'art flamand*, 1932. *De van Eyck à Bruegel (Catalogue)*, Musée de l'Orangerie, 1935, no. 3. *Catalogue of the J. Bosch Exhibition*, Museum Boymans, 1936, no. 53. Baldass, 1943, p. 96: a follower of Bosch. Combe, no. 135, likewise considers it a copy.

58. HELL

APPX. PL. 54
New York, Metropolitan Museum.
DATING: The Italianizing naked figures date the picture about 1530–50.
BIBLIOGRAPHY: See Friedländer, no. 88.

59. CHRIST DRIVING THE MONEY-CHANGERS FROM THE TEMPLE

Copenhagen, Museum of Fine Arts.
BIBLIOGRAPHY: See Friedländer, no. 74. Glück, p. 36, no. 3. Tolnay, *Pierre Bruegel l'Ancien*, Brussels, 1935, p. 95, no. 51. A pastiche of elements from Bosch and Bruegel.

60. CHRIST BEFORE PILATE

New York, Jacob Heiman (1942). Formerly Amsterdam, APPX. PL. 50 Goudstikker Collection.
ATTRIBUTION: By an imitator of Bosch's last mode of painting, inspired by the Princeton *Christ before Pilate* (see no. 35). The picture also shows influences of the works of Lucas van Leyden and Dürer's woodcuts.
BIBLIOGRAPHY: *Katalog der Sammlung Goudstikker*, 1930 to 1931, no. 4.

61. THE TEMPTATION OF ST ANTHONY

Kansas City, Missouri, Gallery of Art. APPX. PL. 23
INTERPRETATION: The motif of the saint kneeling to draw water with a jug is borrowed from the left wing of the Venice *Altarpiece of the Hermits*.
BIBLIOGRAPHY: A. H. Barr, jr., *Fantastic Art, Dada, Surrealism*, New York, 1936, no. 14.

DRAWINGS

We limit ourselves here to mentioning original drawings by the artist; we group them according to the principles adopted for the Catalogue Raisonné of paintings. Nos. 2, 8 and 10 do not appear in M. J. Friedländer's catalogue; nos. 5, 11, 12, 15 and 18 of that catalogue are omitted here, as not authentic. In agreement with M. J. Friedländer (p. 127) we regard as not certainly by the master the drawing of the *Virgin and St John* in the Kupferstichkabinett of the Dresden Museum, reproduced in C. Woermann, *Die Zeichnungen im Dresdener Kupferstichkabinett*, IV, Plate 2, whose authenticity Benesch finally endorsed (*J.d.p.K.*, XLVI, 1925, pp. 181 ff.). Judging from its style and technique, this drawing seems to be too early for Bosch; it may well be that it is a work by Jan van Aken, the Master of the 1444 fresco, 's Hertogenbosch Cathedral.

1. GROUP OF EXECUTIONERS,
probably for a *Crucifixion*

PAGE 317, 1 ABOVE

New York, Pierpont Morgan Library.
Height 12.4 cm, width 12.6 cm.

PROVENANCE: F. Murray Collection.
BIBLIOGRAPHY: *A Selection from the Collection of Drawings ... formed by F. Murray*, London, 1904, no. 112. Cohen, p. 390. Baldass, 1926, pp. 109, 111. Friedländer, p. 126, no. 17. Baldass, 1959, p. 247.
DATING: A youthful work, from approximately the period of the Frankfurt *Ecce Homo*.

1a. THE ENTOMBMENT

PAGE 316, 1a BELOW

London, British Museum.

Drawn with the point of the brush and black ink and grey wash, over outlines in black chalk. Faint inscription in black chalk on the front of the sarcophagus: 'Iheromus Bossche'.
ATTRIBUTION: Attributed to Bosch and published by A. E. Popham in *British Museum Quarterly*, 1952, p. 45.
INTERPRETATION: This composition seems to be inspired by the triptych of the Master of Flémalle (London, Count Anthony Seilern Collection), which represents the same theme. This would be new evidence that Bosch knew some works of the Master of Flémalle and was influenced by them, e. g. in the *Cure of Folly* and the late *Epiphany*, as we already concluded in the 1937 edition. The drawing seems to originate from the end of the early period and may be a study for the right wing of a triptych, the left wing of which may have formed part of the Vienna *Christ Carrying the Cross* and the lost centre panel of which probably represented Golgotha (see above). These three consecutive scenes of the Passion appear in this sequence on the reverse of the Berlin *St John on Patmos*. According to Boon, *Burl. Mag.*, 1960, pp. 457 ff., this drawing is closely related to the drawings of the *Death of the Miser* and the *Ship of Fools*, both in the Louvre.
In my opinion the drawing in the British Museum is of superior quality, and both the drawings in the Louvre seem to be copies of the paintings, and not studies for the paintings.

2. TWO WITCHES

On the reverse:
The Fox and the Rooster.
Rotterdam, Museum Boymans-van Beuningen.
Pen drawing in bistre. Height 12 cm, width 8.5 cm.
Signature apocryphal.

PAGE 316 ABOVE

PROVENANCE: Rodriguez Collections; Vallardi Collection; Dr Leo Baer Collection, Bad Homburg; most recently Koenigs Collection, Haarlem.
BIBLIOGRAPHY: H. Swarzenski and E. Schilling, *Handzeichnungen alter Meister aus deutschem Privatbesitz*, Frankfurt-on-Main, 1924, no. IX. *Catalogue of the J. Bosch Exhibition*, Museum Boymans, 1936, no. 23. Baldass, 1957, p. 246.

3. THE CONJUROR:
preliminary study for the painting

PAGE 317
BELOW LEFT

On the reverse: *Burlesque Concert,* not by the master's hand.
Paris, Musée du Louvre (no. 19197).
Pen drawing in bistre.
Height 27.8 cm, width 20.2 cm.

DATING: Stylistically comparable with the table-top with the *Seven Deadly Sins* in the Prádo.
INTERPRETATION: Possibly a sketch for a tondo (judging from the arrangement of the figures).
BIBLIOGRAPHY: Lafond, reprod. p. 71, no. 3. Friedländer, p. 126, no. 14 (a, b). *Catalogue de l'Exposition de l'Orangerie: De van Eyck à Bruegel,* Paris, 1935, no. 153. *Catalogue of the J.Bosch Exhibition,* Museum Boymans, 1936, no. 24. Baldass, 1957, p. 245.

4. THE SHIP OF FOOLS IN FLAMES

PAGE 315
BELOW

Vienna, Akademie der Bildenden Künste.
Pen drawing in bistre. Upper edge trimmed. Height 17.6 cm, width 15.3 cm.

DATING: Stylistically on the same level as the Louvre *Ship of Fools.*
INTERPRETATION: Possibly a preliminary drawing for the right wing of a triptych with Ships of Fools, the left wing of which would probably have been the Louvre *Ship of Fools.*
BIBLIOGRAPHY: J.Schönbrunner and J.Meder, *Handzeichnungen aus der Albertina und aus anderen Sammlungen,* Vienna, 1896–1908, VII, no. 824. Lafond, no. 7. W. Schürmeyer, Plate 48. Friedländer, p. 124, no. 9. Baldass, 1957, p. 247.

5. THE TEMPTATION OF ST ANTHONY IN A LANDSCAPE

PAGE 318 ABOVE
AND BELOW RIGHT

On the reverse:
A Gay Company in a Giant Egg.
Berlin, Kupferstichkabinett.
Pen drawing in bistre. Height 25.7 cm, width 17.5 cm.

PRESERVATION: The sheet has been repaired by pasting on a sheet of paper on the left and in the middle.
DATING, ATTRIBUTION AND INTERPRETATION: Earlier than the *Garden of Earthly Delights* (the monster with its body in the shape of an egg, to the right, recurs, further developed, on the *Hell* panel of the *Garden of Earthly Delights*). Reverse: sketch for a lost painting, which we know from copies (e. g., in Senlis, Baron de Pontalba Collection). See Catalogue of Lost Paintings, no. 38. Two monsters, right and left, done in a rather lighter ink, may be earlier, but are likewise by Bosch's hand.
BIBLIOGRAPHY: Lafond, no. 11 and reprod. p. 76. Friedländer, p. 125, no. 6 (a, b). E. Bock, *Die niederländischen Meister. Beschreibendes Verzeichnis sämtlicher Zeichnungen,* Berlin, 1930, no. 711. *Catalogue of the J.Bosch Exhibition,* Museum Boymans, 1936, no. 15. Baldass, *Die graphischen Künste,* new series, II, 1937: an imitator of Bosch.

6. THE HEARING FOREST AND THE SEEING FIELD

PAGE 324
BELOW

On the reverse: various sketches, including *A Beggar.*
Berlin, Kupferstichkabinett (no. 549).
Pen drawing in bistre. Height 20.3 cm, width 12.6 cm.

INTERPRETATION: J.Rosenberg, in *Essays in Honor of E.Panofsky,* New York, 1961, pp. 422ff., rejects Benesch's interpretation that this is an allegorical self-portrait of Bosch, and adopts my interpretation (1937), which is based on the inscription on a woodcut of the mid-sixteenth century. Rosenberg also points to the cock at the foot of the tree, running toward a fox, a motif that he believes is an allusion to man running toward his misfortune when deceived by the Devil. Further, Boon, *Burl. Mag.,* 1960, pp. 457ff., gave a new and amended reading for the text at the upper edge of the drawing: *Miserrimi quippe est ingenii semper uti inventis et nunquam inveniendis.* The key to this enigmatic representation was provided by a woodcut of an anonymous Netherlands master, dated 1546 and reproduced in *Nederlandsche Houtsneden, 1500–50,* Plate 222, depicting the same subject, with the following legend: *Dat velt heft ogen, dat wolt heft oren, Ick wil sien, swijghen ende hooren* ('The field has eyes, the forest has ears, I will see, be silent and hear').
On the reverse, only the sick beggar is by Bosch's hand; all the rest, done in lighter ink, seems to be by a pupil. (Friedländer: 'several personages, some of whom are later and done by a weaker hand.') Last period.
BIBLIOGRAPHY: H.Eickhoff, *Amtl. Berichte der Berliner Museen,* XL, 1918–19, col. 25–26. Benesch, *J.d.p.K.,* LVIII, 1937, p. 261, points out that the owl has an egocentric character while magpies are malicious. Friedländer, p. 124, no. 4 (a, b). E. Bock, *Die niederländischen Meister. Verzeichnis sämtlicher Zeichnungen,* Berlin, 1930, no. 549. *Catalogue of the J.Bosch Exhibition,* Museum Boymans, 1936, no. 12. Baldass, 1957, p. 247.

7. THE TREE-MAN

PAGES 3 AND 331

Vienna, Albertina.
Pen drawing in bistre. Height 27.7 cm, width 21.1 cm.

ATTRIBUTION: The main figure anticipates the main motif of the *Hell* panel of the *Garden of Earthly Delights*. After further study of the original, I now consider the sheet to be an original by Bosch's hand, from his last period.

PX. PL. 56

A weak paraphrase can be found in a London drawing.
BIBLIOGRAPHY: Th. Frimmel, *Chronik für vervielfältigende Kunst*, 1891, p. 36: attributed to Bles. A. L. Romdahl, *J.d.a.K.*, XXV, 1904, p. 126: attributed to Bruegel. Bastelaer, p. 160: not by Bruegel. Friedländer, pp. 124, 125, no. 7: attributed to Bosch. Benesch, *Beschreibender Katalog der Handzeichnungen in der Graphischen Sammlung Albertina*, Vienna, 1928, II, p. 5, no. 26: attributed to Bosch. *Catalogue of the J. Bosch Exhibition*, Museum Boymans, 1936, no. 14. Baldass, *Die graphischen Künste*, new series, II, 1937, pp. 18ff.: attributed to Bosch; likewise Baldass, 1957, p. 247. Combe, no. 94.

8. OWLS' NEST ON A BRANCH

PAGE 331 BELOW

Rotterdam, Museum Boymans-van Beuningen, formerly Haarlem, Koenigs Collection.
Pen drawing in bistre. Height 14 cm, width 19.6 cm.

INTERPRETATION: The drawing was the subject of an article by J. Rosenberg in *Essays in Honor of E. Panofsky*, pp. 422ff., in which the author shows that the drawing is incomplete as it stands today, and proposes a convincing reconstruction. Rosenberg also provides an interpretation of the sheet that is new in part. He agrees with my interpretation (1937) to the effect that this is an allusion to the saying, *Das ist ein richtiges Eulennest*, and adds that the owl is a personification of sin, more specifically envy and hatred, and bases his opinion on a note by Dürer. The sheet is from the master's last period.
BIBLIOGRAPHY: *Nederlandsche Teekeningen uit de 15de, 16de, 17de Eeuw. Verzameling Koenigs*, Museum Boymans, Rotterdam, 1934, no. 2. N. Beets, *Oud Holland*, LII, 1935, p. 225: incorrectly attributes the sheet to Lucas Cornelisz. *Catalogue of the J. Bosch Exhibition*, Museum Boymans, 1936, no. 13. Baldass, 1957, p. 247. Combe, no. 121.

8a. TWO CARICATURED HEADS

PAGE 325 ABOVE RIGHT

(On the reverse of 8b). Owner not known.
Pen drawing in bistre. Height 15 cm, width 10.3 cm.

PROVENANCE: Formerly Seattle, Washington, Le Roy Bacchus Collection; Montreal, Canada, Randall Collection, sold at Sotheby's, May 10, 1961, present owner not known. Published by J. Rosenberg, *Old Master Drawings*, 1939, Plate LX.
INTERPRETATION: This is the only sheet by Bosch still extant containing studies of faces. Although ugly heads like these already appeared in earlier works of his (e. g. in the Frankfurt *Ecce Homo* and the Vienna *Christ Carrying the Cross*), the fullness of the forms and the treatment of the head-coverings are closer to the draughtsmanship of the later works, e. g. the Princeton *Christ before Pilate* (the two heads in the middle) and the Ghent *Christ Carrying the Cross* (two heads in the upper centre and on the right). To contrast a sharp profile with the full round forms of a head in three-quarter view is a device that goes back to Italian art, where it appears in the Trecento and in the works of Masaccio, Leonardo and Raphael. Leonardo's drawing in Windsor, with five grotesque heads, in which the head in profile in the middle contrasts with the symmetrically arranged heads seen frontally and diagonally, presents a solution resembling that of Bosch, but twenty years earlier. Whether there was any direct relationship between the late Bosch and Leonardo is open to question. In any case the conscious way in which the late Bosch contrasts the heads with one another in this drawing, which he did not do in his early works, suggests that he had knowledge of Leonardo's drawings featuring studies of faces. Leonardo, however, was interested in the abnormalities of nature as deviations from an ideal type, whereas Bosch accepted the ugly as a natural phenomenon. The immediate influence of Leonardo on Bosch was thought to exist by André Blum, *Revue des arts*, December 1952 and in *Atti del Convegno degli Studi Vinciani*, 1953, pp. 66ff.
BIBLIOGRAPHY: Baldass, 1957, p. 246.

8b. THE TEMPTATION OF EVE BY THE SERPENT

(On the reverse of 8a).

PAGE 325 ABOVE LEFT

INTERPRETATION: Drawn with masterly light strokes, like the rider on the sheet in a Paris private collection. J. Rosenberg, *Old Master Drawings*, 1939, Plate LXI, misinterpreted the theme as the original sin of Adam and Eve; what seems at first glance to be Adam is actually the serpent with a tail. On the left wing of the *Garden of Earthly Delights* Bosch depicted only the creation of Eve and omitted the scene of Eve's temptation, which he had featured in his earlier triptychs, as on the left wing of the

Hay-wain and the *Last Judgement* in the Vienna Akademie. This drawing may be the first version of a scene on the left wing of the *Garden of Earthly Delights* in which Bosch originally planned to relate the story in two scenes. Later he decided not to show the Temptation.

9. SCENES IN HELL and STUDIES OF MONSTERS

PAGE 318
ABOVE AND EBLOW
LEFT

On the reverse: *Monsters.*
Berlin, Kupferstichkabinett.
Pen drawing in bistre. Height 15.6 cm, width 17.6 cm.

PRESERVATION: A piece of paper has been pasted on at lower centre.
ATTRIBUTION: This drawing, the authenticity of which is not entirely certain, might be from the artist's first period (see the *Hell* of the *Seven Deadly Sins* on the Escorial table-top and the wavering lines).
BIBLIOGRAPHY: Friedländer, p. 125, no. 2 (a, b). E. Bock, *Die niederländischen Meister. Verzeichnis sämtlicher Zeichnungen*, Berlin, 1930, no. 548. *Catalogue of the J. Bosch Exhibition*, Museum Boymans, 1936, no. 21. Baldass, 1957, p. 246.

10. BEGGARS AND CRIPPLES

PAGE 320
BELOW RIGHT

Brussels, Cabinet des Estampes.
Height 26.4 cm, width 19.8 cm. The signature and date, 'Bruegel 1558', are apocryphal.

PROVENANCE: Formerly Koller and von Lanna Collections.
DATING: Judging by the style, this is a drawing of the first period.
BIBLIOGRAPHY: R. v. Bastelaer, *Les dessins de P. Bruegel l'Ancien appartenant au Cabinet des Estampes de la Bibliothèque Royale de Belgique*, Brussels, 1924: attributes the sheet to Bruegel the Elder. Benesch, *Die graphischen Künste: Mitteilungen der Gesellschaft für vervielfältigende Kunst*, 1932, Fasc. I, p. 3: the first to attribute the sheet to Bosch. *Musée de l'Orangerie: De van Eyck à Bruegel (Catalogue)*, Paris, 1935, no. 155. *Catalogue of the J. Bosch Exhibition* Museum Boymans, 1936, no. 22.

10a. A MAN STANDING, SEEN FROM BEHIND (WEARING HAT AND LONG CLOAK, ENVELOPING HIS BODY AND THROWN OVER HIS RIGHT SHOULDER)

PAGE 328
BELOW LEF

Rotterdam, Museum Boymans-van Beuningen (formerly F. Koenigs Collection, no. 174).
Black pencil gone over with fine pen. Height 13 cm, width 8.4 cm. The inscription 'Bruegel' in lighter ink seems to have been added by an early owner.

INTERPRETATION: This drawing is on the reverse of a sketch executed by another hand in the manner of Pieter Bruegel the Elder, representing a woman seen from behind, carrying a pail of water. In Rotterdam this sheet is attributed to P. Bruegel the Elder. The reverse has been tentatively attributed by us to Bosch. This is a relatively early drawing, probably from the period of the Louvre *Ship of Fools* and the Yale *Gluttony*. The drawing is a kind of anticipation of Bruegel's *naer het leven* sheets. It shows from the rear a motionless clothed figure, and the comic effect comes from the fact that the helmet-shaped hat completely covers the head and neck, forming a new and odd unity with the clothing. Such rear views recur in Bosch's work, for example in his drawings of beggars in Brussels and Vienna. This category of Bosch's drawings, of which the Rotterdam sheet is, so far as we know, the only one to have come down to us, seems to have been one of the sources of inspiration for Bruegel's *naer het leven* series, in technique and in motif. We may assume that Bruegel acquired Bosch drawings of this type for purposes of study, that they remained in his family and were used by his sons as well. Cf. no. 14a.

11. Sheet of Sketches, with THE TEMPTATION OF ST ANTHONY

PAGE 319

On the reverse: *Monstrous Animals.*
Paris, Musée du Louvre (no. 20871).
Pen drawing in bistre. Height 20.5 cm, width 26.3 cm.

BIBLIOGRAPHY: Lafond, no. 1, p. 68, reprod. p. 88. Friedländer, p. 126, no. 13. Baldass, 1959, p. 247.

12. Sheet of Sketches, with Studies of MONSTERS

PAGE 322
ABOVE

On the reverse: Studies of *Monsters.*
Oxford, Ashmolean Museum.
Pen drawing in bistre. Height 31.8 cm, width 21 cm.

INTERPRETATION: Two of these sketches served as a model for two monsters in the Munich fragment of the *Last Judgement.*
BIBLIOGRAPHY: S. Colvin, *Selected Drawings from Old*

Masters in ... Oxford, Oxford, 1903–4, IV, Plate 13. Cohen, p. 390. Lafond, nos. 15, 16. Friedländer, p. 126, no. 16 (a, b). *Catalogue of the J. Bosch Exhibition,* Museum Boymans, 1936, no. 16. A. E. Popham, *Burl. Mag.,* LXXI, 1937, II, p. 294: copy. Baldass, *Die graphischen Künste,* new series, II, 1937: copy.

13. Sheet of Sketches: BEGGARS

PAGE 320
BELOW LEFT

Vienna, Albertina.
Pen drawing in bistre. Height 28.5 cm, width 20.5 cm.

BIBLIOGRAPHY: J. Schönbrunner and J. Meder, *Handzeichnungen aus der Albertina und aus anderen Sammlungen,* Vienna, 1896–8, III, no. 345. Lafond, p. 87, no. 4, and reprod. p. 66. Friedländer, p. 127: 'seems to stem from P. Bruegel rather than from Bosch.' Benesch, *Beschreibender Katalog der Handzeichnungen in der graphischen Sammlung Albertina,* Vienna, 1928, II, p. 5, no. 24: 'The minute "miniature technique" of the drawing ... suggests dating the sheet in the first period of the master's development.' Baldass, *Die graphischen Künste,* new series, II, 1937: a copy. Winkler and Boon believe that the drawing may be by P. Bruegel the Elder.

14. WITCHES

PAGE 320
ABOVE

Paris, Musée du Louvre (no. 19721).
Pen drawing in bistre. Height 20.3 cm, width 26.4 cm. Inscription added later: *Bruegel manu propria.*

PROVENANCE: Mariette Collection.
ATTRIBUTION: The drawing, which had been classified in the Louvre among the Bruegel drawings, was attributed to Bosch for the first time by Tolnay in *Die Zeichnungen P. Bruegels,* Munich, 1925, p. 54, Plate 7. Friedländer, p. 126, no. 10: adopts our attribution. Likewise Baldass, 1959, p. 246.
DATING: Bruegel knew this drawing and used it for the main scenes of his Vienna *Battle between Carnival and Lent.* From Bosch's last period.

14a. A Sheet with a RIDER above and STUDIES FOR THREE FIGURES below, for a GOLGOTHA composition

PAGE 325
BELOW LEFT

Paris, private collection. Pen drawing in ink.

ATTRIBUTION: First attributed to Bosch by Tolnay

in *Bulletin des Musées Royaux des Beaux-Arts,* IX, Brussels, 1960, pp. 3 ff. In our opinion the upper drawing is by Bosch's hand and shows the same technique as other rapid sketches by the master, e. g. the *Temptation of Eve by the Serpent.* The attribution of the lower sketches is more difficult, since they do not completely match the style of any of Bosch's drawings that have been preserved, but they cannot be attributed to Bruegel. This question will have to be left open. All four of the figures were used later by Pieter Bruegel the Younger in his rendering of *Golgotha,* of which several versions are known, e. g. those in Antwerp and Philadelphia. Comparison shows the great superiority of the drawings, which can therefore not be regarded as copies from the painting. Like the *Man Standing* of Rotterdam (no. 10a), this sheet must have been in Bruegel's atelier where it must have been used as a model by Pieter Bruegel the Younger.

15. BEEHIVE AND WITCHES

PAGE 321
ABOVE

On the reverse: Sketch for *Witches.*
Vienna, Albertina.
Pen drawing in bistre. Height 19.2, width 27 cm. Apocryphal signature.

INTERPRETATION: Bosch employs the motif of the man in the beehive to decorate the back of the throne on the centre panel of the *Altarpiece of the Hermits* in the Palace of the Doges, Venice.
Illustrated proverbs: *Hij is door den korf gevallen. Men zou haar met geene tang anraken* (Benesch).
BIBLIOGRAPHY: Lafond, no. 6 and reprod. p. 69. Friedländer, p. 125, no. 8. Benesch, *Beschreibender Katalog der Handzeichnungen in der graphischen Sammlung Albertina,* Vienna, 1928, II, p. 5, no. 25: 'toward the end of the century.' *Catalogue of the J. Bosch Exhibition,* Museum Boymans, 1936, no. 17. Baldass, 1959, p. 246.

16. ANIMAL STUDIES

PAGE 321
MIDDLE AND
BELOW

On the reverse: *Two Monsters.*
Berlin, Kupferstichkabinett.
Pen drawing, black ink on pink ground. Height 8.5 cm, width 18.2 cm. Apocryphal signature in bistre.

INTERPRETATION: The same motif of a toad-like monster on the front, lower right, was used by Bosch for the upper tondo on the reverse of the Rotterdam *Flood,* as was pointed out by Baldass, *Die graphischen Künste,* new series, II, 1937, p. 22.

391

BIBLIOGRAPHY: Friedländer, p. 124, no. 1 (a, b). E. Bock, *Die niederländischen Meister. Verzeichnis sämtlicher Zeichnungen,* Berlin, 1930, no. 550. *Catalogue of the J. Bosch Exhibition,* Museum Boymans, 1936, no. 18. Baldass, 1959, p. 247.

17. TWO MONSTERS

PAGE 324
ABOVE

On the reverse: *Tortoise* with Death's Head on its Carapace, and *Winged Demon.*
Berlin, Kupferstichkabinett.
Pen drawing in bistre. Height 16.4 cm, width 11.6 cm.
Later signature in bistre.

DATING: Last period.

APPX. PL. 55

BIBLIOGRAPHY: Friedländer, p. 124, no. 3 (a, b). E. Bock, *Die niederländischen Meister. Verzeichnis sämtlicher Zeichnungen,* Berlin, 1930, no. 547. *Catalogue of the J. Bosch Exhibition,* Museum Boymans, 1936, no. 20. A copy of both studies on the front and both studies on the reverse is to be found in a drawing of the Lord Melchett Collection, London (cf. C. Dodgson, *Old Master Drawings,* 1931, IV, p. 52, Plate 46). R. Wittkower, *Catalogue of the Collection of Drawings by the Old Masters formed by Sir Robert Mond (Lord Melchett),* London, 1937. Baldass, 1959, p. 246.

18a. MARY AND JOHN AT THE FOOT OF THE CROSS

PAGE 315
ABOVE LEFT

Dresden, Kupferstichkabinett. Acquired before 1764.
Brush drawing in grey and black.
Height 30.2 cm, width 17.2 cm. Trimmed round at top.
Late inscription: Hieronymus Bosch. Not definitely by the master.
High quality. Perhaps a very early original work (as O. Benesch holds)? Cf. W. Schürmeyer, *Hieronymus Bosch,* Munich, 1923, Plate 1.

18b. HOLY WOMAN AT THE GRAVE

PAGE 315
ABOVE MIDDLE

Dresden, Kupferstichkabinett.
Brush drawing in grey and black.
Height 16.8 cm, width 13.7 cm (detail).
Reverse of 18a.
Fragment.

18c. STANDING RABBI OR HIGH PRIEST

PAGE 315
ABOVE RIGHT

Dresden, Kupferstichkabinett.
Pen drawing in brown.
Dubious attribution.
Height 19.7 cm, width 27.5 cm.
Later inscription: H. Bosch.

18d. SCENE IN HELL

PAGE 322
BELOW

Dresden, Kupferstichkabinett.
Pen drawing in brown.
Height 19.7 cm, width 27.5 cm.
Paraphrase of the right wing of the *Garden of Earthly Delights.*
Probably not by his hand.
Cf. Bax, 1949: An original. In our opinion, by an imitator of Bosch.
Reverse of 18c.

19. A MAN EMPTYING A TROUGH

PAGE 325
BELOW RIGHT

Paris, Musée du Louvre.
Inv. no. 19722.
Pen drawing.
Height 14.3 cm, width 9.5 cm.
Attributed to Bosch by Baldass, 1959, p. 246, Fig. 134. From the Marville Collection; at that time attributed to Bruegel: 'Possibly illustration of a proverb' (Baldass, *Die graphischen Künste,* new series, II, 1937, p. 23f.): 'from end of middle period.' Combe accepts this attribution.

20. CHRIST CARRYING THE CROSS

PAGE 327

Rotterdam, Museum Boymans-van Beuningen.
Height 23.6 cm, width 19.8 cm.
Attribution to Bosch doubtful.

21a. Sheet of Sketches with HEADS

PAGE 328
BELOW RIGHT

Rotterdam, Museum Boymans-van Beuningen.
Pen drawing.
Height 17.4 cm, width 11.8 cm.
To be attributed to Allaert de Hameel?

21b. A WARRIOR

PAGE 328
BELOW RIGHT

Rotterdam, Museum Boymans-van Beuningen.
Pen drawing.
Height 17.4 cm, width 11.8 cm.
Reverse of 21a.
To be attributed to Allaert de Hameel?

22. THE DEATH OF THE MISER

PAGE 328
ABOVE

Paris, Musée du Louvre.
Inv. no. 6947.
Drawing heightened with white.
The reverse of the sheet (much restored), reproduced here for the first time, features among other things a helmet; in the lower right corner, pasted on, the pen sketch, apparently by his hand, of an ape(?). Late Gothic inscription: 'Jeronimus Bos van Antwerpen'.

23. THE SHIP OF FOOLS

PAGE 329

Paris, Musée du Louvre.
Grisaille.
Possibly after the painting in the Louvre. The maypole is visible here in its original form, before the subsequent additions.

24. ECCE HOMO and CHRIST CARRYING THE CROSS

PAGE 326

Sacramento, California, Crocker Art Gallery.
Pen and bistre, worked over in pencil by a later hand.
Height 25.4 cm, width 20.1 cm.
Presumably by Allaert de Hameel (our attribution). Copy of a rectangular pictorial composition by Bosch. The scene at upper left, representing Christ before Pilate, is shown in a painting in the Philadelphia Museum (Hans Swarzenski).

393

ENGRAVINGS

See the catalogue of the engravings by Allaert de Hameel, compiled by Lehrs and published as an appendix to the article by Ch. C. V. Verreyt in *Oud Holland,* XII, 1894, pp. 15ff.

Of the engravings prepared by Allaert de Hameel, formerly attributed to Bosch, Winkler (*J.d.p.K.,* XLIV, 1923, p. 143) regards only three as inspired by Bosch – at most two of these engravings seem to have been taken from compositions by him. The mention of 'Bosche' on Allaert de Hameel's engravings is not the signature of the artist but a place-name: 'Bosche' is an abbreviation of 's Hertogenbosch, as is shown by the inscription on engraving B. VI, 5 (Lehrs, VII, 9): ''s Hertoghen Bosche'.

1. THE LAST JUDGEMENT

PAGE 330
ABOVE

Height 24 cm, width 34.6 cm.

BIBLIOGRAPHY: B. VI, 2. J. Renouvier, *Des types et manières des maîtres graveurs,* Montpellier, 1854, p., 145. *Oud Holland,* XII, 1894, 14, 16 (2). Lafond, 82. A.J.J. Delen, *Histoire de la gravure dans les anciens Pays-Bas,* Paris, 1924–5, I, 131. Lehrs, XII, no. 2. *Catalogue of the J. Bosch Exhibition,* Museum Boymans, 1936, no. 25.

2. A BELEAGUERED ELEPHANT

Height 20.4 cm, width 33.5 cm.

PAGE 330

BIBLIOGRAPHY: B. VI, 4. J. Renouvier, *Des types et des manières des maîtres graveurs,* Montpellier, 1854, p. 146. *Oud Holland,* XII, 1894, 21, 7. Lafond, 86. Lehrs, VII, 6. *Catalogue of the J. Bosch Exhibition,* Museum Boymans, 1936, no. 28.

The inventory of the Royal Palace in Madrid drawn up after the death of Philip II mentions a painting representing the same subject (see Justi, p. 143). This theme is probably taken (as Hannema assumes in his catalogue of the Hieronymus Bosch Exhibition, no. 28) from the Apocrypha of the Old Testament, I Maccabees vi, 28–47. The theme of the elephant with a tower on its back was first depicted on a playing card by the 'Maître de la Puissance des Femmes', about 1455. See F. Rumpf in *A. Goldschmidt: zum siebzigsten Geburtstag,* Berlin, 1935, p. 79.

LOST WORKS
BY HIERONYMUS BOSCH

Lost works by Hieronymus Bosch, mentioned in early sources but of which we have no copy.

We confine ourselves to listing the works of Hieronymus Bosch that are mentioned in early writings from the end of the fifteenth to the seventeenth century. We do not discuss the references to numerous works attributed to the artist in catalogues compiled since the beginning of the seventeenth century, which are impossible to check.

a] WORKS FORMERLY IN THE NETHERLANDS

1. Cartoons for the windows of the Chapel of the Brotherhood of Our Lady in 's Hertogenbosch, executed by master glazier Willem Lombard. See p. 412.
2. Sketch for the crucifix for the Brotherhood of Our Lady in 's Hertogenbosch. See p. 412.
3. Painting from the high altar of the church of St John in 's Hertogenbosch.
'Altaris summi Chori, et Divae Virginis superioris extant tabulae singulari arte Hieronimi Bosz delineate, referentes illud opus *Creationis Hexameron mundi,* ibidem *historiam Abigaelis,* quomodo *Davidi* supplex cum muneribus et commeatu offensam deprecata, et *Salomon Bersabeam matrem veneratus est.*' (See: J. B. Gramaye, *Taxandria,* Brussels, 1610, p. 13; our italics).
'Inde St Janskerk ... den Altaer in het hooghe choor was met Toetsteenen Pilaten cierlijck end kosterlijck toe-gestelt, ende verciert met een groote end konstighe schilder Hieronymus Bosz, vertoonende de *Scheppings des Werelts,* met de *Historie van Abigael* komende met hare gaven by *David.* Item de *Historia van Salomon Eerende Syn Moeder Bersabeam,* ende staet nu in de plaets van deselve schilderye de *Thien Gheboeden* met groote goude Letteren.' (Jacobus van Oudenhoven, *Beschryvinge der Stadt ende meyereye van 's Hertogenbosche,* Amsterdam, 1649).
4. Altarpiece of the Chapel of Our Lady in the church of St John in 's Hertogenbosch.

Altari D. Virginis inferioris exhibetur eodem auctore, oblatio munerum trium regum (see Gramaye, loc. cit.).
Op den Altaer van de lughe lieve Vrouwe stout een schilderye van de offerhande van de Drie Conighen, van den selven schilder (see Oudenhoven, loc. cit.).
5. Painting from the St Michael altar in the church of St John in 's Hertogenbosch.
Altari S Michaelis Archangeli, obsidio Bethuliae, Caedes Holofernis, fuga et strages exercitus Assyriorum, Victoria per Juditham obtenta, Madrochaei et Hesterae, libertataeque Judaeorum triumphus (see Gramaye, loc. cit.).
Op St Michiels Alater de Historie van de Belegeringhe ende't Ontset van Bethuliae mede van den selven gheschildert (see Oudenhoven, loc. cit.).
6. Carel van Mander (ed. H. Hymans, p. 169f.) saw the following pictures in various Dutch collections:
a) *The Flight into Egypt* (Joseph asking a peasant the way); b) *Christ in Swaddling Clothes;* c) *Christ Carrying the Cross;* d) *A Monk Disputing with Heretics;* e) *A Miracle.*

b] WORKS FORMERLY IN FLANDERS

7. Collection of William the Silent, Prince of Orange, in Brussels – inventory of 1568: *un grand tableau de Jeronimus Bosch* (see Pinchart, I, p. 185).
8. In 1595 the following paintings by Bosch were in the palace of Archduke Ernst in Brussels: a) The *Cure of Folly* (Inv. no. 9); b) *Sic erat in diebus Noe* (Inv. no. 29); c) *Crucifix* (in the predella, depicting Christ in swaddling clothes). (See *Compte-rendu des séances de la Commission Royale d'Histoire,* pt. 13, Brussels, pp. 115, 119, and Pinchart, I, p. 276).
9. *Christ Carrying the Cross,* in the church of St Pharaïlde in Ghent and mentioned by Marc van Vaernewijck, *Troubles en Flandres et dans les Pays-Bas au XVIe siècle.* 'Je ne suis pas en mesure de spécifier les ravages exercées a Sainte-Pharaïlde. On y voyait notre Seigneur portant sa Croix, travail du maître peintre Jérôme Bosch, que

l'on appelait le faiseur de Diables, parce qu'il n'eut pas de rival dans l'art de représenter les démons.' (Ed. H. van Buyse and P. Bergmans, Brussels, 1905, II, p. 137).

10. The inventories of the art galleries of Antwerp in the sixteenth and seventeenth centuries mention the following paintings: a) Michiel van der Heyden, June 24, 1552: *een groot tafereel op lijnwaet in een raeme, gemaect van Hieronimus Bosch;* b) *een personnagie van een groot hoot met andere phisolomeyen van Jheronimus Bosch op doeck gemact;* c) Margaretha Boge, 1574: *een tafereel van Jheronimus Bosch wesende van de VII dootsonden;* d) Jan van Kessel, 1583: *een oude schildereye op doeck van Jeronimus Bosch;* e) Marco Munez Perez, 1603: *Tres pinturas in madera con sus listas, la un del excmo Bosch en que ay un hombre que con cierta folles y lanternas y otra de Frans Floris . . . ;* f) Herman de Neyt, 1642: *een Temptatie van Bosch, in vergulde lyst, no. 17;* g) *eenen herder voor zyn schaepen, lantschap van Bosch, get. no. 659;* h) *een Helleken van Bosch, op paneel, get. no. 659;* i) *eenen voesterheer van Bosch op paneel, met binnenlyst, no. 159 get.;* j) Sara Schut, 1644: *een St Anthonis temptatie van Jeronimus Bosch;* k) Jan van Meurs, 1652: *item een sint Anthonis temptatie van Jeronimus Bosch;* l) Susanna Willemsens, 1657: *een stucken van Jeronimus Bosch op pinneel;* m) Jean Petit, 1660: *item een schilderye wesende een oordeel met twee deuren van Jeronimus Bosch.*
(See J. Denucé, *Les galeries d'Anvers aux XVIe et XVIIe siècles,* Antwerp, 1932, pp. 3, 4, 6, 12, 14, 95, 97, 98, 110, 116, 134, 199, 277).

11. The inventory of Rubens' estate mentions: a) *The Temptation of St Anthony;* b) *Heads: deux peintures estant de testes, des grandes figures faisant des grimazes;* c) *Heads: deux peintures estant de testes, des grandes figures faisant des grimazes;* d) *Wedding Feast: à la façon de Jeronimus Bosch.*
(See Pinchart, *Messager des Sciences de Gand,* 1858, p. 165.)

c] WORKS FORMERLY IN GERMANY

12. Canon Gerhard von Haen bought a triptych for Bonn Cathedral in 1585, *opus quondam Hieronimi Buschii, celebris nostri temporis eo loco pictoris, exquisti artificis depictum.* The centre panel showed *Christ's Entry into Jerusalem;* the wings the *Birth and Resurrection of Christ* (picture burned in 1590).
(See Meyer, *Künstlerlexikon,* I, p. 94, who makes reference to the account books of Bonn Cathedral for 1589.)

d] WORKS FORMERLY IN SPAIN

13. The Don Felipe de Guevara Collection contained, in addition to the *Cure of Folly* and the *Hay-wain,* the following four paintings (see Justi, p. 141–2): a) *Dos ciegos;* b) *Una danza a modo de Flandes;* c) *Unos ciegos andon a caza de un puerco javali;* d) *Una bruja.*

14. In 1574 Philip II had sent to the Escorial, in addition to the paintings that have come down to us and the four paintings of Don Felipe de Guevara mentioned above, a *Christ in Swaddling Clothes* and three *Temptations of St Anthony* (see Justi, p. 142).

15. The inventory of the Royal Palace in Madrid drawn up after the death of Philip II mentions the following paintings (see Justi, p. 143): a) *Crucifixion;* b) *Christ in Swaddling Clothes;* c) *St Martin;* d–e) *Two Sketches;* f) *An Elephant.*

16. Argote de Molina, *Libro dela Monteria,* Seville, 1582, chap. 47, informs us that the hunting pavilion of the Prado contained the following paintings: a) *Lent and Carnival;* b) *The Organ Blower;* c) *Monster;* d) *Man on Ice.*

17. Siguença (see Appendix) informs us of the existence of a painting representing the Seven Sacraments, at that time in the Escorial.

e] WORKS FORMERLY IN VENICE

18. According to the Anonymous Morelli (Marcantonio Michiel) the following three paintings were in the house of Cardinal Grimani in Venice in 1521: a) *La tela del inferno cun la gran diversità de' mostri fu de mano de Hieronimo Bosch;* b) *La tela delli sogni fu de man dell' istesso;* c) *La tela della fortuna con el ceto che ingiotte fu de man de l'istesso.* (See *Notizie d'opere del disegno,* ed. Th. Frimmel, Vienna, 1888, p. 102.)

Sources of the Work of Hieronymus Bosch

LITERARY SOURCES

(The Spanish texts are given in translation)

1] About 1560. Don Felipe de Guevara, *Comentarios de la Pintura* (ed. Ant. Ponz, Madrid, 1788, pp. 41–44): 'I recently found a new manner of painting, that people called 'grillo'. The name was given it by Antifilo, who painted a man whom he jokingly called Grillo. Since that time this sort of painting has been called 'grillo'. Antifilo was born in Egypt and learned this way of painting from Ktesideno; it seemed to resemble the kind that our age praises so much in Bosch, or Bosco, as we say; Bosch was always a little peculiar in that he painted wondrous persons and strange situations... That will be one reason for distinguishing him from the people, and also from other men not of the people, who have a mistaken opinion of his pictures and [regard them] as a monstrosity, as something outside the rules of what is taken as natural ..., which is attributed to Bosch, by making him out to be the inventor of monsters and chimeras. I do not deny that he painted strange persons and things, but he only did this because he set his theme in Hell, for which, since he wanted to represent devils, he devised compositions of unusual things. What Bosch did with care and restraint, others have done and are doing without measure or judgement, because they saw how Bosch's mode of painting was received in Flanders; they decided to imitate him by painting monsters and fabulous inventions, and hoped that people would believe that there was no more than this to the imitation of Bosch. For this reason there are innumerable pictures of this kind, falsely signed with the name of Hieronymus Bosch, which he never painted.'

(The rest of this text is in Dollmayr, pp. 294ff. Schmidt-Degener, p. 150, note 4, calls attention to the following error in Dollmayr's translation: Don Felipe de Guevara attributes the *Seven Deadly Sins* to Bosch himself and not, as Dollmayr translates this passage, to an imitator of the artist.)

2] L. Guicciardini, *Description de tous les Païs Bas,* Antwerp, 1567, p. 132: *Jerosme Bosch de Boisleduc inventeur trèsnoble & admirable de choses fantastiques, & bizares...*

3] 1566–8. Marc van Vaernewijck, *Troubles religieux en Flandre et dans les Pays-Bas au XVIe siècle,* ed. H. van Duyse and P. Bergmans, Brussels, 1905, II, p. 137, says of the *Christ Carrying the Cross* that was in the church of Sainte-Pharaïlde: 'Work of the painter Master Bosch, who was called the inventor of devils, because he had no rivals in the art of depicting demons.'

4] 1568. Vasari, *Le Vite de' piu eccellenti Pittori, Scultori e Architetti* (ed. G. Milanesi, V, p. 439), says of Bruegel's engravings, which he takes to be works by Bosch: *Fantastiche e capricciose invenzioni che sarebbe cosa fastidiosa a volere di tutte ragionare.*

5] 1582. Argote de Molina, *Libro dela Monteria,* Seville, 1582, chap. 47, 'Descricion del Bosque y Casa Real de Pardo,' fol. 20 v.: 'By the hand of J. Bosch, the painter from Flanders famous for his fantasies ['disparates']: eight paintings are to be seen, one of them the picture of a *Strange Child,* born in Germany, apparently three days old and looking as though it were seven years old. Ugly in aspect and form, it has an astounding face; its mother is holding it in its swaddling clothes. The other paintings are *Temptations of St Anthony.*'

6] 1584. G. P. Lomazzo, *Trattato dell'Arte della Pittura, Scultura ed Architettura,* Rome, 1844, II, pp. 201–2: '*Girolamo Bosch fiammingo, che nel rappresentare strane apparanze, e spaventevoli ed orridi sogni, fu singolare e veramente divino.*'

7] 1604. Carel van Mander, *Het Schilder-Boeck,* Haarlem, 1604 (ed. H. Hymans, I, p. 169–70): *Comment décrire, par exemple, les étranges conceptions nées de la fantaisie de Jérôme Bosch...* There follows a description of his mode of painting and a short list of paintings, but in no systematic order. *On voit là les monstres les plus curieux et il faut vraiment admirer l'habilité du peintre à rendre les flammes et la fumée.* The praise also extends to the subjects and his naturalistic manner of painting.

8] 1605. Fray Joseph de Siguença, *Tercera parte de la Historia de la Orden de S. Geronimo,* Madrid, 1605, pp. 837 to 841. 'Of German and Flemish paintings which, as I emphasize, are numerous, there are many paintings by Hieronymus Bosch scattered throughout the house [the Escorial]; for various reasons I should like to speak at somewhat greater length of this painter, since his great genius merits it, although people in general call his paintings the *disparates* [fantasies] of J. Bosch, people who look inattentively at what they see, and I believe for that reason call him unjustly a heretic, and I have – to begin with this point – so high an opinion of the piety and religious zeal of the king, our founder [that I believe], if this were the case, he would not have permitted the paintings to be in his house, in his monasteries, in his bedchamber, in the chapter-houses of the Order, in the sacristy, whereas in fact all these rooms are adorned with them: In addition to this argument, which seems

to me of great weight, there is yet another, which I derive from his pictures, for in them are to be seen almost all the sacraments and orders of rank and classes of the Church, from the Pope down to the least, two points on which all heretics go astray, and he painted them with all his zeal and with great accuracy, which as a heretic he would not have done, and he has done the same with the mysteries of our salvation. And now I should like to point out that these pictures are by no means farces, but books of great wisdom and art, and if foolish actions are shown in them, they are our follies, not his, and, let us admit it, they are a painted satire on the sins and fickleness of men. As the theme of many of his paintings, one could cite the verses of the famous critic of Roman sins, who sings at the outset: "Whatever holds man enslaved, swearing, horror, anger, lust: pleasure, distraction make up the medley of our book. And if the number of sins grows..." etc. as, translated into Spanish, Bosch too could say: As far as men act, their wishes, cares, their anger, their vain desires, longings, distractions are the content of his pictures. But when did he [man] show such a fullness of sins? In my opinion, the difference between the paintings of this man and those of others is that the others try as often as possible to paint man as he looks from the outside, while this man has the courage to paint him as he is inwardly: an act that arises from a strange motive, and which I should like to explain by the following example: Poets and painters are, in their own judgement, related to each other: the sisterly properties, that are no further apart than brush and pen, so that they are one and the same thing, – the subjects treated, the aims, the colours, the liberties and other integral parts are so much the same that they can hardly be distinguished, and only in the form of our metaphysical substances. Among Latin poets there is one (and no one else deserves the name to the same degree) who, since it seemed to him he could not equal Vergil in his heroic poetry, nor Terence nor Seneca in comedy or tragedy, nor Horace in lyric poetry, and although he was greatly gifted and had everything required to make him one of the foremost: – he decided to embark on a new path, and invented a comical poetry that he called the "macaronic": thus he was the first to invent all this, both through his fantasy and his intelligence, and he was always the master and leader of this style, and all noble spirits read him so, and none of them despised him, as I have said: "Let him read me who reads everything." And since his rank and calling, as it appears, did not allow him this occupation (he was a clergyman; I cannot give his name, since he kept it secret), he adopted a comical name and called himself Merlin Cocayo, which corresponds very well to the

aspect of his work, as with that other man who called himself Ysop [sic] in his poems, and showed with a particular art how one can recognize and understand the best in the most valuable of poems on subjects both moral and inspired by nature, and how, if one had to act the critic, one can show the truth by comparing and contrasting many passages. I am of the opinion that the painter Hieronymus Bosch certainly wished to resemble this poet, not because he knew him, (for, as I believe, he painted his fantasies before him), but because the same thinking and the same motive impelled him: he knew that he had great gifts for painting and that in regard to a large part of his works he had been considered a painter who ranked below Dürer, Michelangelo, Raphael (Urbino) and others, and so he struck out on a new road, on which he left all others behind him, and turned his eye on everything: a style of painting, satirical and macaronic, devoting much skill and many curiosities to his fantasies, both in innovation and execution and often proved how able he was in this art, as Cocayo too did, when he spoke seriously.

The pictures and paintings to be found here are very diverse. He painted pious matters, such as scenes of Christ's life and passion: the *Adoration of the Magi*, and *Christ Carrying the Cross* in the former he conveys the pious and honest action of the wise and just, in which one sees no strangeness and no extravagance; in the latter he shows the envy and rage of false doctrine, that knows no rest until it has annihilated the life and the innocence that is Christ: thus we see the Pharisees and scribes with furious faces and disputing, so that we may infer, from their attitudes and actions, the tumult of their feelings. He painted the *Temptation of St Anthony* several times (this is the second genre of paintings), and used this subject to achieve strange effects. We see on the one hand the saint, the first hermit, with a serene countenance, humble, in rapt contemplation, calm and with his soul entirely at peace; on the other hand the unbounded fantasies and monstrosities that the enemy devises in order to confuse his imperturbable soul and distract his fervent love: to this end he conjures up living beings, wild animals, chimeras, monsters, fire, death, roaring, threats, vipers, lions, dragons and fearful birds of all kinds, so that one asks in astonishment how it was possible for him to give shape to all his ideas: and all this seems to show that a soul sustained by the grace of God, elevated by His hand to such a life, cannot be shaken or deflected by whatever the enemy may bring forth in fantasy as before the bodily and spiritual eye, whatever may induce laughter, vain pleasure or dissoluteness. He has made frequent variations upon this subject and this concept, and devised so many new ideas

that it arouses my admiration [to see] that he could invent so many things, and I am compelled to contemplate my own wretchedness and weakness, and to recognize how far I am from this perfection, because I am overwhelmed by persons imitated so simply and by small trifles, because I feel myself confused and lack solitude, tranquillity, concentration and patience; and the art of the Evil One and of Hell could not bring about the fall of this saint: and the Lord is ready to help me too, as He did him, and now I go out with courage to do battle. This painting is seen often: one picture is in the chapter-house of the Order; another in the cell of the prior; two in the Gallery of the Infanta; some in my cell, which I often read and immerse myself in; in the bedchamber of His Majesty, in which there is a case with books like those of the monks, is a splendid picture in a frame, hanging in the middle and as it were the central point, framed in light and an aureole, with our Saviour surrounded by seven circles in which we see the *Seven Deadly Sins*, by which all the creatures that He delivered affront Him, without thinking that He observes them and sees everything. In seven other circles he depicts the Seven Sacraments with which He endowed the Church and in which, as in precious vessels, He placed the remedies for so many sins and sorrows to which mankind is addicted; and this is certainly the contemplation of a good and pious man, so that all of us here can observe ourselves, for he painted a mirror, whereby the Christian may better know himself; he who painted this did not understand our religion falsely. Here we see the Pope, the bishops and the priests, some teaching us, others baptizing, yet others converting and giving sacraments. In addition to these paintings there are still others of great artistry and no less considerable benefit, although they seem more macaronic, which is the third manner of his invention. The idea and the art of this manner are based on the passage in Isaiah, where the messenger of God says: "All flesh is grass, and all the goodliness thereof is as the flower of the field." And on this theme David says: "Man is like grass and his goodliness like the flower of the field." One of these pictures contains as its basic idea and principal motif a *Hay-wain* and sitting thereon the lusts of the flesh, fame and those that signify glory and power, represented by some naked women who play and sing; and glory by a demon beside them with his wings and his trumpet, proclaiming his own greatness and joy. The other has as subject and basic idea a flower and a fruit of those flowers that we call strawberries, that belong to the strawberry plant, and that are called elsewhere *maiotas,* that hardly leave any taste behind when one has eaten them. So that his idea may be understood, I will set it forth in the order in which he

has presented it. Between the two pictures is hung a large painting with two wings, by which it can be closed. On the first of these wings he painted the *Creation of Man* and how God set him in Paradise, a wondrous place, full of green and very lovely, as lord of all the creatures of earth and birds of heaven; and how He admonished him to obey Him and keep His faith, and not to eat of a certain tree, and how the Evil One tempted him in the form of a serpent, how he despised the command of God, and how He drove him from this wondrous place and took from him his high dignity, for which he was created and with which he had been clothed. The picture, which is called the *Hay-wain*, is painted with much feeling, and that of the *Strawberry Plant* is done with a thousand fantasies and observations, which are admonitions; it is on the first part and on the wing. Then on the large picture are painted: the pursuits of man once expelled from Paradise and set in the world; and he shows him following after a glory that is like hay and straw, or like a plant without fruit, of which one knows that it will be cast into the oven the next day, as God Himself says: and he shows the life, the concerns and the thoughts of these children of sin and wrath who, forgetting the commandments of God, namely repentance for sins and reverence for the faith, strive to obtain glory of the senses, which is like the transient, useless and short-lived hay, as are the pleasures of the senses, differences of caste, pride and fame. This hay-wain, like fame, is drawn by seven wild beasts and frightful monsters; we see men painted among lions, others among dogs, others among bears, fishes, wolves – all images and symbols of arrogance, lust, avarice, ambition, stupidity, tyranny, animal instinct and brutality. Around this circle move men of all ranks, from Pope and Emperor and other princes down to those in the lowest rank who do the humblest work on earth; for all flesh is as grass, and all this governs the children of the flesh, and they need all this in order to attain this vain and transitory fame; and all this shows how this fame is sought – some set up ladders, others seize hooks, others clamber upon it, still others leap and try to reach it with any and all means and instruments; some, who have already climbed on top, fall off again, others are run over by the wheels, others enjoy these distinguished honours and names. Thus there is no order, no calling and no occupation, however high or low it be, divine or human, that does not transform the sons of this earth and lead them astray in order to attain this glory, which is a grass, and to enjoy it. All hasten, and the animals that draw the wagon put forth their strength, for it is heavy-laden, and they draw it in order to finish their daily work early and be free of this task and go elsewhere, whereby is very

well expressed the short duration of this wretched century, how short a time it takes until it comes to its end, and how much all times are alike in the Evil One. The end and goal of all this are painted on the last panel, on which we see a fearful *Hell* with horrible tortures, with dreadful monsters, all steeped in darkness and everlasting fire. And to show the number of those that enter here and find no place left, he depicts how new rooms and houses are being built, and the stones that are brought there to use in this building work are the souls of the wretched damned, who elsewhere have been transformed into instruments of their punishment, the same instruments that they employed in order to attain that glory. But so that it may be understood that nothing in this life, wherever it be, is excluded from the help and goodness of God, not even the greatest of sinners, when they are in the state of sin: we see the guardian angel alongside those sitting on the very top of the hay-wain, in the midst of these evildoers, and he prays to God for them, and Our Lord Jesus Christ with outstretched arms and visible stigmata awaits those who repent. I acknowledge that I saw more in this picture in the short time that I looked at it than I did in many books over many days. The other picture of the vanity and glory and transient taste of strawberries or the fruit of the *Strawberry Plant* and its fragrance, which one can hardly smell when it passes: it is the most wonderful and best-invented thing that one can imagine. I say indeed that if one took it as a model and a great mind described it, he could make a very useful book out of it, for in it one sees, in a clear and vivid manner, innumerable passages from the Scriptures, relating to the evil nature of man, for there are many allegories and images to express this in the Psalms and Prophets in the form of tame, brave, wild, lazy, wily, cruel, carnivorous draught and riding animals, destined for the pleasure, recreation and ostentation that men seek, and which they subject to themselves for their wishes and customs, and the crosses that are made between them – all are depicted here with wondrous likeness. The same applies to the birds, the fishes and the reptiles, of which there is such an abundance in the divine Books. And then too one understands the transmigration of souls in the imagination of Pythagoras and Plato and other poets, who wrote learned fables on their metamorphoses and transformations, and whose aim was only to show the bad habits and morals and corrupt views with which the miserable souls of men adorn themselves, who for their pride are turned into lions, for their vengefulness into tigers, for their lust into mules, horses and swine, for their tyranny into fishes, for their vanity into peacocks, for their slyness and falsity into wolves, for their licentiousness into apes and wolves,

for their callousness and evil into asses, for their stupidity into foolish sheep, for their rashness into goats and other such creatures and forms, which they amass and build up on human existence; and so these monsters arise and these grimaces, and all this for so low and vulgar a purpose as revengefulness and covetousness and fear of men and the wish to seem and to be respected and other similar desires, that hardly reach the gums or moisten the tongue, as with the taste or the use of a strawberry or the fruit of the strawberry plant or the fragrance of its flower. I wish that the whole world were full of copies of these pictures, as it is full of this truth and the simple models after which Bosch painted his "fantasies": for if one leaves aside the great originality and art and strangeness and thoughts that are in every picture (one is astounded that a single head could accomplish so much), there would be a great deal to be gained if everyone would go to them entirely absorbed in his inner life, as if he did not know what was in him, or were so blind that he did not know the passions and sins that make one an animal or even several animals. And man would also see in this last picture the wretched goal and end of his pains, efforts and pursuits, into which this infernal habitation is transformed. He who puts all his happiness in music and vain and obscene songs, in dancing and gaming, in hunting, feasting and ostentation, on domination, revenge and the worship of his own holiness and hypocrisy, that man will see a contradiction between this way of life and that brief enjoyment, that is transformed into eternal wrath without help and grace.

I will say no more about Bosch's pictures, but only point out that in almost all of them – that is, in all those that manifest this art (which, as we have seen, are of another kind and sacred), he depicts fire and an owl. By the former he gives us to understand that we must always be thinking of this everlasting fire, and then we shall do all our work more easily, as we see in all the pictures that he has painted of *St Anthony*. And by the latter he says that his paintings are works of thought and reflection, and that they must be looked at in contemplative spirit. The owl is a nocturnal bird, sacred to Minerva and wisdom, the symbol of Athens, where philosophy flourished, which grows in the stillness and silence of night, using more oil than wine.'

9] 1645. Francisco Quevedo, Sueños. Justi (p. 137) notes that Quevedo, in his visions of hell, meets Bosch among the godless. However, the name of Bosch is nowhere cited in the French edition, *Les Visions de F. Quevedo*, Paris, 1634, the only one available to the author.

10] 1649. Francisco Pacheco, *Arte de la Pintura*, Seville, 1649, pp. 431–2: 'There are documents enough to speak of higher and more difficult things, of personalities, if

one finds time for such pleasures, which have always been condemned by the great masters. Nonetheless some seek these pleasures: this is the case with the ingenious fancies of Hieronymus Bosch for the diverse forms he has given his demons, for the inventiveness of which our King Philip II was so fond, as is shown by the great number of paintings that he collected. But Father Siguença praises him beyond all measure and makes these fantasies into mysteries, which we do not recommend to our painters. And now we pass to more agreeable subjects of painting...'

11] 1657. Francisco de los Santos, *Descripcion breve del monasterio de S.Lorenzo del Escorial,* Madrid, 1657.
Fol. 66 v. *Christ Carrying the Cross* and the *Temptation of St Anthony* (in the great monastery); on this is the remark: 'In the strange manner for which he [Bosch] was famous.'
Fol. 68 v. – 69 r.: The *Temptation of St Anthony,* the *Haywain,* the *Adoration of the Magi* (in the prior's cell); the first two pictures described in more detail; the third only mentioned. This is an abbreviated repetition of Siguença's description; the remark that Bosch *'fue entre los Pintores, como Merlin Cocayo entre los Poetas'* is likewise from Siguença.
Fol. 80. The *Garden of Earthly Delights* (in the Gallery of the Infanta). Likewise follows Siguença: the wish to see the whole world full of copies of this picture also comes from the same source.
Fol. 107 v. The name of Bosch is given, without further details, among the names of the various painters of the pictures hanging in the sacristy.

12] Mid-seventeenth century. Jusepe Martinez, *Discursos practicables del nobilissimo arte de la pintura,* new edition, Madrid, 1866, pp. 184ff.
'In this same city of Toledo there was a painter, native to the city, of whom it is said that he studied long in Flanders, and when he returned to his home town, since many painters excelled him in historical painting and portraits, he devoted himself to very strange and unheard-of themes and things, and so well indeed that people became accustomed to say: *el disparate* of Hieronymus Bosch; that is what they called [his pictures], not that they were lacking in high judgement and high morality. It would take an entire book to recount and comment on everything he painted: I shall only speak of three [pictures], so that an idea may be gained of his strange fancy and fertile mind – and there was a picture of the *Temptation of St Anthony,* in which he depicted a Hell in the form of a very broad landscape, full of flames, which torture a great number of the damned, seen both near at hand and from afar, with great precision and originality: the most important place in this picture is taken by the saint, who is so tormented that he expresses great pain, and is surrounded by an enormous number of demons tormenting him and by forms and monsters so strange that any one of them would suffice to frighten a stout heart; in addition I have seen, both painted and engraved, the *Seven Deadly Sins,* expressed so vividly that it is a wonder and a fine example; in addition there is to be found there a terrible sort of demon torturing the damned according to their sins, with weird instruments that no one has ever seen before; and in this way he made himself unique, and succeeded in earning great honour, and many agree that our D.Francesco Quevedo, in his visions, was inspired by the pictures of this man of genius, for he created innumerable pictures and painted them in oil and tempera. Some painters in Italy and France, Flanders and Germany, have followed him along this path; although they were not so exuberant in their imagination as this creative artist was, they were gifted with great mastery...'

13] 1681. F.Baldinucci, *Notizie de' professori del disegno,* ed. S.Franchi, Florence, 1846, II, p. 139f., regards Bosch as a visionary: *e valente assai nell'inventar capricci di cose extremamente terribili e spaventose, come larve, spiriti, stregherie, malefici, ed altre rappresentazioni infernali e diaboliche...* (The rest is a shortened translation of Carel van Mander.)

DOCUMENTS

The most important documents containing information on the artistic activity of Hieronymus Bosch are:

1] The account books of the Brotherhood of Our Lady in 's Hertogenbosch, entitled: Rekeningen van St Jan (see *a, b, c, d, e, g, h*), which were probably copied about 1519, the date at which the accounts end.

2] The register of the Brotherhood, entitled: *Lyst van levende en overleden bruders van 1330 tot 1640*. In these registers, which are in several hands, the same hand can be seen for the years from 1330 to 1567. From this it must be inferred that it was only at this last date that the entry was made which is of interest to us (see *j*).

3] The register of names and coats of arms, entitled: *Namen ende Wapenen der Heeren beeidigde Broeders soo geestlijke als wereltlijke van de seer oude ende seer doorlugtige Broederschap van Onse Lieve Vrouw birme de Stad 's Hertogenbosch*. On the first page of the volume that concerns us there is a note showing that it was written in 1606 *(Dit boek is van het jaar 1606)* (see *k*).

There follow below in chronological order the documents that have come down to us:

a) 1480-1: 'Ontvangen van Jeroen die maelre van de doeren van onser liever vrouwen alde taeffel die die voirscr. proesten denselven vercoft hebben voer V Rynsgulden VIII St. Rek.' 1480-1 (cf. Mosmans, p. 207, note 8).

b) 1488-9: 'Itam, ter ierster vergaderingen tot Jeronimus, die scilder, voer XXiiij pont runtvlees, 'pont: eene Philippus penninck; item, voer iiij loet genybers, ij loet pepers, 1/2 loet soffraens: V. st.; item, voer wortelen, ij.; item den weert een mengele wyns,' etc. (Pinchart, I, p. 269, note 5c).

c) 1493-4: 'Willem Lombard, glaesmalder: iii orten stuivers voer een Gots-penninck hem gegeven by den proesten, doe zy met hem over quamen van een nyenwen ghelaese dat hy maken sal nae den patroen dat Joen, die maelder, hem soude maken, 't welk staen soude in onser nyeuwe capelle.

Joemen, den maelder, geschenken ii 1/2 st., tod dien ijnde day hy denselven Willem Lombart soude willen te wege helpen dat 't voirschreven gelas mocht wael wesen gemaeckt.

Voor een paar oude slaeplakens daer Jeroen de Maelder, op soude malen een patroen van een gelaes, dwelck Willem Lombart soude maken (wonende) in die Thoerenstraet: XX st.' (Pinchart, p. 273, note 3, and Mosmans, p. 215, note 6).

(It is not possible to attribute with certainty to Hieronymus Bosch the stained-glass window done by Henricken Bueken in the choir of Our Lady in the Cathedral of St John in 's Hertogenbosch; its designer is not mentioned in any document.)

d) 1498-9: 'Item, ter Vter vergadering, doe men den swaen att tot Wouters van der Rullen daer Jheronimus Van Aken, schilder, dat laken lede, behalve den swaen gecomen en gescenckt van den rentmeester van wegen ons genedige heer; daertoe noch gecocht tegen Rutger Van Erpe eene andere swaen voir Viij stuvers, ende den knecht die de swaen bracht voer zyn drincgelt, ij 1/2 st.' ('Rekeningen van St Jan', accounts of the Brotherhood of Our Lady; Pinchart, p. 270, note 2.)

e) 1503-4: 'Item gegeven Iheronimus knechten schilder van den drie schilden te maken te weten van Heeren Jannen van Baex ridder, Henrich Massereels ende Lucas van Erpe hangende aen die metalen pylernen.' (Accounts of the Brotherhood of Our Lady, communicated by M. J. Mosmans, archivist of 's Hertogenbosch Cathedral.)

f) 1504: 'A Jéronimus Van Aeken, dit Bosch, paintre, demourant à Bois-le-Duc, la somme de XXXVJ livres, à bon compte sur ce qu'il pourroit estre deu ung grant tableau de paincture, de IX pieds de hault et XI de long, où doit estre Le Jugement de Dieu, assavoir paradis et enfer, que Monseigneur lui avoit ordonné faire pour son très-noble plaisir.' Archives du Département du Nord, Lille, NF.190 (Office of accounts, fol. IIc XXXVo; see Pinchart, I, p. 268).

g) 1508-9: 'In de yersten tot Wouters Van der Rullen, by een deel gezwoeren brueders, omme Jheromme ende meester Jan Heyns, te willigen ende raet nemen omme Onser-Lieve-Vrouwen taefel te Stofferen' etc. (Pinchart, loc. cit.).

h) 1512: 'Jeronimo die maelder, want hy 't patroen van den cruse heeft gemaeckt: XX st.' (Pinchart, loc. cit.).

i) 'Ung moyen tableau de Sainct-Anthoine, qui n'a couverture ne feullet, qui est fait de Jheronimus Bosch, et a esté donné à Madame par Jhoane, femme de chambre de Madame Lyonor' (Inventory of Margaret of Austria, 1516; see Pinchart, I, p. 275).

j) 1516: 'Obitus fratrum: A° 1516, Hieronimus Aquen als Bosch insignis pictor' (Register of the Brotherhood of Our Lady; see Pinchart, I, p. 268).

k) 1516: 'Hieronimus Aquens alias Bosch seer vermaerd schilder. Obiit. 1516' (See: *Namen ende Wapenen der Heeren beeidigde Broeders soo geestelyke als wereltlyke van de seer oude*

ende seer doorlugtige Broederschap van Onse Lieve Vrouw birme de Stad 's Hertogenbosch. Pinchart, loc. cit.) This note is on fol. 76 r., lower right, under a blank coat of arms. It is not without interest to see the list of Hieronymus Bosch's fellow-members on the same page: 1. Franco van Langel, Secretaris en Raed deser Stad. 1514. 2. Hr. Joannes Spijkers, Priester. 3. Hr.Arnoldus van Malsen, Praelat van 't Abdij e van Berne, Obiit 1515. 4. Hr. Joannes van der Hoeven van Lierop. Obiit 1515. 5. Hr. Joannes Heijens die de fondamente gelegt heeft van·Ons. Lieve Vrouwe Choor, 1515. 6. Rutgeris van Erp, van Lieshout. Raed deser Stad. 1516.

The name of the van Aken family is mentioned in certain documents, unpublished for the most part, which can be seen in 's Hertogenbosch:

l) In 1399 a certain Jan van Aken, furrier *(bontwerker)*, acquires rights of citizenship (Stadsrekening no. 1).

m) Jan van Aken, owner of a house opposite the tower of the church of St John and next to the house of Conradus Herman Conensven, *tinctor,* who died in 1418. In the letter preserved in the church archives we read: *inter hereditatem quondam Johes dti de Aken.*

n) 1424: Mention is made of a certain 'Petrus dictus de Aken, filius quondam gerardi dicti de Aken' in a letter preserved in the archives of the 'Godshuizen' of 's Hertogenbosch.

o) 1423–4: Mention is made in the archives of the cathedral of a Meister Jan van Aken (Mosmans p. 206, note 2); he is also mentioned in 1430 (ibid., p. 204, note 1), 1431–2 (ibid., p. 206, note 7) and 1433–4 (ibid., p. 204, note 7). This Jan van Aken must have been the grandfather rather than the father of Hieronymus van Aken – an opinion shared by Friedländer (p. 80) and Mosmans. He is very probably the author of the fresco in the cathedral, dated 1444, that must have had a decisive influence on our artist.

p) 1464: A certain Laurent van Aken is mentioned as a citizen of 's Hertogenbosch (Pinchart, 1, p. 270).

q) 1531: The estate of Aleid, daughter of Goyart van Merverme alias Brants, widow of Jeronimus van Aken, is probated. (See van Gasse van Ysselt, *Voorname Huizen te 's Hertogenbosch,* pt. 2, p. 265).

(Items *l, m, n* and *q* are from Mr Mosmans.)

Bosch Research since 1937

A review of Bosch research since the first edition of this book, 1937

1. DOCUMENTS IN ARCHIVES

Archival studies in the last quarter-century, especially those of H.J.M.Ebeling, in *Miscellanea Gessleriana*, Antwerp, 1948, and of F.W.Smulders, in *De Brabantsche Leeuw*, 1955, 1957 and 1959, have yielded some interesting facts about the family, social status, marriage and artistic activity of the master. We present a critical summary of these findings.

As regards the van Aken family, it is now established that their name appears in documents of 's Hertogenbosch from the thirteenth century onward.

Hieronymus Bosch's grandfather was the painter, Master Jan van Aken, who died between March 14 and August 8, 1454. He had five children: Jan the Younger; Hubert, mentioned in 1447, 1451 and 1488; Goossen, a painter, mentioned in 1448-9; Anthonis, Bosch's father; and Thomas, likewise a painter, mentioned in 1447 and 1451 (Smulders).

Bosch's father was the painter, Master Anthonis van Aken, who is mentioned in 1472, 1474, 1476 and 1481. His children were: Jheronimus (Hieronymus), who took the name Bosch and always signed himself 'Jheronimus Bosch' (it is assumed that he took his name from the name of his town); Heberta; Goossen, who was a painter and inherited his father's house, for which reason it is thought that he continued his father's atelier, since he delivered two panels for an altar in the church of St John, which are mentioned in 1481; Anthonis the Younger; Jan; Katherine, mentioned on April 5, 1474 (Smulders).

Bosch's mother was the daughter of a tailor.

Bosch's birthplace is in all probability 's Hertogenbosch; his name does not appear in the list of citizens, but these lists are not complete (Ebeling).

According to a hitherto unpublished discovery by Mosmans, reported in a note in *G.d.B.A.*, LIII, 1959 (Chronique des Arts, p. 13f.), Bosch's date of birth is October 2, 1453. Bosch's portrait in the 'Recueil d'Arras' would correspond to this date. On the other hand, Ebeling regards it as likely that Bosch was born between 1460 and 1462, since, he says, Bosch became a free master painter in 1487-8 and this usually took place at the age of 25 to 27. As we shall show, however, there is no definite evidence that he actually became a free master painter in those years.

In 1486-7 Bosch became a member of the Brotherhood of Our Lady in 's Hertogenbosch.

The books for 1487-8 of the Brotherhood mention 'Jeroen, the painter' as donor of a sum to the Brotherhood, probably in order to raise his status. The document does not mention the specific occasion of this benefaction. Ebeling, who brought this document to light, believes that Bosch made the donation on the occasion of his attaining the rank of free master, which took place in these years. But this is most improbable, since Bosch is already mentioned as 'Jeroen die Malere' in the documents of 1480-1. On June 15, 1481 Bosch appears for the first time as the husband of Aleyt, daughter of Goyart van der Mervenne, alias Brant, son of Goyart the Elder; in 1484 he is mentioned as 'husband and guardian' of Aleyt, and this may explain why he so often acted for his wife in financial transactions.

The property of his wife lay in Oirschot, in the vicinity of 's Hertogenbosch.

Disputes arose between Bosch and his wife, on the one hand, and Aleyt's father, Goyart Goyarts van der Mervenne, on the other. Bosch's mother-in-law, who must have died prior to November 1472, was named Postellina. Her mother, Aleyt's grandmother, was the daughter of an apothecary.

Bosch and his wife gave alms on February 7, 1492. Transactions, in which Bosch acted mainly for his wife, took place on the following dates: April 11, 1482; January 3, 1483; March 21, 1483; December 29, 1487; February 26, 1488; October 1, 1488; March 6, 1494; March 17, 1498; July 30, 1498.

As regards Bosch's artistic activity, we learn that in 1480-1 he bought the side panels of the old altarpiece of the Brotherhood. He painted the outer side of the wings

of the high altar of the Brotherhood of Our Lady between 1488–9 and 1491–2, and probably the inner side as well. The latter were painted (probably repainted) in 1521–2 and 1522–3 by Gielis van Hedel, also called van den Bossche, of Brussels. The centre panel of this altarpiece was originally done in 1476 by Adriaan van Wezel and at that time seems to have had no wings. The latter were first added in 1488–9 by Goyart Cuper and were probably painted by Bosch. According to entries made in 1565 by three officials of 's Hertogenbosch, the front and reverse of both wings were painted by Bosch himself, and the same is reported by Gramaye, *Taxandria*, 1608–9. (Ebeling, however, on the basis of 1521 documents, believes that only the outer sides were painted by Bosch, but it is unlikely that the inner sides remained unpainted until 1521–2, and hence the data given by the officials and Gramaye seem to be reliable.) Gielis van Hedel, alias van den Bossche, was apparently a pupil or follower of Bosch, according to Ebeling. He seems to have come from 's Hertogenbosch (this would explain why he took the name van den Bossche when he lived in Brussels).

The records mention a design *(patroen)* for a coloured stained-glass window in the chapel of the Brotherhood, which Willem Lombard was to execute in 1493–4. Bosch drew this design on two old bed-sheets.

There is also mention of a cross, probably a crucifix, for a surplice commissioned by the Brotherhood in 1511–12, and a design for a candlestick, likewise for the Brotherhood.

In 1508–9 the priors of the Brotherhood asked Jan Heyns, the architect of the chapel, and Bosch for advice on a carved altar, altarpiece or panel.

Ebeling's assumption that an artist of the stature of Hieronymus Bosch, who had also married into one of the best families of the city, could not have executed such insignificant work and for the low prices mentioned in the documents is unconvincing, for even the greatest artists of that period (Dürer, Michelangelo, Titian etc.) did such work. As for the low prices, it is possible that, just because he was rich, he asked for them only as a nominal honorarium to cover costs.

Ebeling's conclusion that around this time one or even two other painters named 'Jeroen, the painter' must have been living in the city, and his attribution of these works to them, is far from convincing.

To conclude: the documents show that the van Aken family was a dynasty of painters in 's Hertogenbosch, since Bosch's grandfather, two uncles, father and two brothers were master painters.

Our hypothesis that Bosch's art grew out of local tradition is reinforced by this fact, and we can assume that he was initiated into his calling by a member of his family, probably his father. The 1444 fresco in the cathedral may have been the work of Bosch's grandfather, Jan van Aken (who died ten years later), or one of his two uncles, the painters Thomas and Goossen. Although there is no painting, apart from the four frescoes in the cathedral, that can definitely be attributed to the 's Hertogenbosch school, we can state, on the basis of the documents, that there was such a local school. It may be the source of the triptych, dating from about 1400, now in the Chicago Art Institute, which I published in the *Miscellanea Léo van Puyvelde,* Brussels, 1949, pp. 49 ff., and attributed tentatively to the 's Hertogenbosch school. It presents some striking similarities to Bosch's works.

If our hypothesis is correct, new light is shed on the origins of Bosch's style. In no other Dutch local school, neither in Utrecht, Delft, Gelderland nor Haarlem, do we find any such monstrous faces, nor the juxtaposition of a beardless profile with a bearded three-quarter profile; even certain details of costume and ornament (earrings) anticipate motifs used by Bosch. None the less this triptych was attributed to the Westphalian School by H. Huth, *Bulletin of the Art Institute of Chicago,* XLII, 1948, pp. 18 ff.; E. Panofsky, *Early Netherlandish Painting,* Cambridge, Mass., 1953, p. 97, attributed it tentatively to the School of Bruges, an opinion that was adopted by H. Bober in *Miscellanea D. Roggen,* Antwerp, 1957, pp. 35 ff.; and finally, J. Duverger in *Bulletin des Musées Royaux de Bruxelles, Miscellanea Panofsky,* 1955, pp. 92 ff., suggested that the triptych was painted by a master who moved from 's Hertogenbosch to Bruges.

Of all the works we know in the international style, this one anticipates most directly the art of Bosch. Many writers have pointed out that Bosch was inspired by the international style; the examples they give, however, are not as close to Bosch as is the Chicago triptych; thus, for example, Baldass, 1959, p. 36, has published a small Dutch *Epiphany* of the mid-fifteenth century, which according to him could be by Bosch's teacher; Jacques Combe, 1957, indicated the Roermond painting in this sense; Benesch, 1957, mentioned the *Last Judgement* in the church at Diest, now in the Brussels Museum; and Bax, 1949, found similarities between Bosch and Pisanello's animal drawings. In any event Bosch adopted the international style, and in that he stood alone in his era. The attraction of this style for Bosch lay in the fact that it did not stress the characteristics of the media, and so permitted greater freedom and fluidity of brushwork. Bosch seems to have gone over to the international style in the second phase of his youth.

On 's Hertogenbosch as a commercial centre in the fifteenth century, cf. L. Pirenne and W. Formsma,

Koopmangeest te 's Hertogenbosch in de 15e and 16e eeuw, Nijmegen, 1962. (I take this occasion to express my thanks to Dr L. Pirenne, Municipal Archivist of 's Hertogenbosch, for calling my attention to recent local publications on Bosch that would otherwise have escaped me.)

Bosch's mother, as the daughter of a tailor, belonged to the artisan class. Bosch's marriage to a rich patrician woman raised him far above the social level of his own class. He must have been very well off after his marriage, since he paid very high taxes (Ebeling). The material independence he achieved may have made it easier for him to express his not always orthodox views on the institutions (e. g. the Church) and the mighty of this world, including the clergy, and to give free rein to his criticism of the world.

The fact that Bosch made designs for minor works of art (coloured stained-glass windows, candlesticks, a cross for a surplice) shows that he was more versatile than might have been presumed on the basis of the paintings that have come down to us.

2. LITERARY SOURCES

The early literature in Spain on Bosch was collected and published by Don Xavier de Salas, *El Bosco en la literatura española,* Barcelona, 1943. This work was supplemented by the same author in his article, 'Mas sobre el Bosco en España' in *Homenaje a J. A. van Praag,* Amsterdam, 1957.

An early Italian translation of Sigüença's description of Bosch's paintings in the Escorial is in Ilario Mazzolari da Cremona, *Le reali grandezze dell'Escuriale di Spagna,* Bologna, 1648, pp. 242–8. (This work is cited by A. Blunt in the *Journal of the Warburg and Courtauld Institutes,* 1939–40, p. 61, but he overlooks the fact that this is only a translation of Sigüença.)

3. BOSCH CATALOGUE

We make some additions here to the paintings and drawings discussed in the text of the first edition and described in its catalogue. Paintings and drawings not treated in the first edition of this book have been inserted in the catalogue and are indicated by the letter 'a' or 'b' after the relevant number.

The corpus of Bosch's paintings has been enlarged since 1937 by the following items, some originals, others works of his school:

1. *Two Heads,* possibly of *High Priests.* Rotterdam, Boymans-van Beuningen Museum. Cat. no. 3a.

2. *Ecce Homo.* Boston, Museum of Fine Arts. Cat. no. 5a.

3. *Paradise* and *Hell:* two panels. New York, Wildenstein Galleries. Cat. no. 6a.

4. *Head of a Woman* (fragment, seen in profile). Rotterdam, Museum Boymans-van Beuningen. Cat. no. 9a.

5. *Ecce Homo* (replica). Indianapolis, Cloves Collection. Cat. no. 12a.

6. *The Temptation of St Anthony.* New York, W. P. Chrysler Collection. Cat. no. 21a.

7. *The Tribulations of Job – The Temptation of St Anthony – The Repentance of St Jerome.* Bruges, Musée Communal. Cat. no. 24a.

8. *St Christopher, bearing the Saviour on his Shoulder.* Madrid, Private Collection. Cat. no. 27a.

9. *The Virgin and Child* and *St John the Baptist, standing:* two panels. 's Hertogenbosch, Cathedral. Cat. no. 34a.

10. *Christ and the Woman Taken in Adultery.* Philadelphia Museum of Art, Johnson Collection. Cat. no. 37a.

11. *The Crowning with Thorns,* grisaille, on the outer side of the wings of the *Last Judgement.* Bruges, Musée Communal. Cat. no. 50a.

The corpus of Bosch's drawings has been enlarged since 1937 by the following entries:

1. *The Entombment.* London, British Museum. Cat. no. 1a.

2. *Two Caricatured Heads.* Formerly Seattle, Washington, Le Roy Bacchus Collection. Cat. no. 8a.

3. *The Temptation of Eve by the Serpent* (on the reverse of 8a). Cat. no. 8b.

4. *A Man Standing, Seen from Behind* (wearing Hat and Long Cloak). Rotterdam, Museum Boymans-van Beuningen. Cat. no. 10a.

5. A sheet with a *Rider* above and *Studies for Three Figures* below, for a *Golgotha* composition. Paris, Private Collection. Cat. no. 14a.

Advances have been made in the exact critical description of Bosch's paintings by publication of several volumes of the *Corpus de la peinture des anciens Pays-Bas,* the following volumes of which were available to us: Madrid, by J. Lavalleye; London, National Gallery, by M. Davies; Le Musée Communal de Bruges, by A. Janssens de Bisthoven and R. A. Parmentier; New England Museums, by Colin Eisler; Paris, Louvre, by Hélène Adhémar.

Also of importance are the catalogues in the recent monographs of Baldass, 1959, and Combe, 1957, which agree with our catalogue of 1937 in the main points so far as authenticity and chronology are concerned.

However, a definite tendency has become evident in some publications to reject paintings by Bosch which are of high quality, e. g. in Brand Philip, 1948, who declares the *Cure of Folly* unauthentic, and in Boon, *Burl. Mag.,*

1960, pp. 457ff., who rejects the *Cure of Folly*, the Philadelphia *Ecce Homo*, the *Conjuror* and the *Marriage at Cana*. At the same time Boon attributes to Bosch such copies as the drawings of the *Ship of Fools* and the *Death of the Miser*, both in the Louvre. An attempt was made by Poch-Kalous, in the 1961 catalogue of the Vienna Akademie, to rehabilitate the *Last Judgement* in that collection.

APPX. PL. 106, 107 Two pictures, privately owned in Austria, have recently appeared which seem to be by a Dutch master of 1510–20; in the faces and elsewhere they are clearly reminiscent of Bosch and may be copies of one of the lost altarpieces by him in 's Hertogenbosch Cathedral.

4. CHRONOLOGY

The major periods of Bosch's artistic development and the approximate chronology of his paintings were elucidated for the first time in the first edition of this book, and its data have been adopted in all essential points in later books by other authors, in particular Baldass and Combe. W. Fraenger, L. Brand Philip, C. Linfert and R. L. Delevoy also follow this chronology. However, Boon, *Burl. Mag.*, 1960, seeks to ascribe some early works of the master to a later period, although his arguments do not carry much conviction.

5. PROVENANCE

The opinion put forward in the 1937 edition of this book, to the effect that Bosch's style had its origin in the local school at 's Hertogenbosch, has received strong support from recently published documents, which revealed that Bosch came from a regular dynasty of painters (see above, p. 412). It is highly probable that he learned his calling from his father, uncles or grandfather, who were all painters.

An attempt to reconstruct the origin of the school of 's Hertogenbosch was undertaken by Tolnay in *Miscellanea Leo van Puyvelde*, Brussels, 1949, pp. 49ff., in which the triptych now in Chicago, and dating from about 1400, was attributed hypothetically to a master from 's Hertogenbosch.

6. STUDY OF MOTIFS

The origins of many of the motifs employed by Bosch have been investigated by several authors since 1937. Of particular importance for elucidation of the sources of the demoniac and fantastic elements in Bosch are the works of Jurgis Baltrusaitis: *Le Moyen Age fantastique*, Paris, 1955, pp. 42ff.; 'Le paysage fantastique au Moyen Age', in *L'Oeil*, 1955, no. 10, pp. 18ff.; and *Réveils et prodiges*, Paris, 1960. Baltrusaitis shows that many of the fantastic motifs in Bosch go back to medieval miniatures and often present analogies to work far removed in time and space, especially that of the Far East.

The origin of the motifs of the Vagabond and the Acrobats in the *Garden of Earthly Delights* has likewise been traced back to medieval miniatures by two Spanish authors: C. Péman in *Archivo Español de Arte*, XXXIV, 1961, pp. 125ff. (Vagabond), and I. Mateo in *Archivo Español de Arte*, XXXIII, 1960, pp. 427ff. (Acrobats). Further contributions to the study of motif origins are found in the works of D. Bax: *Ontcijfering van Jeroen Bosch*, The Hague, 1949; 'Bosschiana', in *Oud Holland*, LXVIII, 1953, pp. 200ff.; and *Beschrijving en poging tot verklaring van het Tuin der Onkuisheiddrieluik van J. Bosch*, Amsterdam, 1956.

7. INTERPRETATION

Exegesis of Bosch's works in the last two and a half decades has paid less and less attention to analysis of formal artistic qualities and concentrated almost exclusively on the 'iconology' of the works, giving symbolic explanations for every detail. The meagre findings show, however, that without artistic empathy the iconological method cannot lead to positive results. These analyses do not take into account subconscious impulses and artistic freedom, without an understanding of which it is impossible to comprehend the spirit of the master.

Nevertheless, recent studies of popular expressions and proverbs depicted by Bosch have in some cases shed light on the master's thinking: cf. J. Grauls, *Gentsche Bijdragen*, V, Antwerp, 1938, p. 156; L. Lebeer, ibid., pp. 152ff., and in *Trésors de la Bibliothèque Royale de Belgique*, 1958, pp. 134ff.; and the works by Bax mentioned above. The influence of astrological illustrations on Bosch's art was studied for the first time by Pigler, *Burl. Mag.*, 1950, and after him by Fraenger, Cuttler and Brand Philip, but none of them arrived at any definitive conclusions. Combe, op. cit., adduces alchemistic symbols as sources for Bosch.

8. GENERAL WORKS

As regards the question of Bosch's spiritual personality and development, the findings of two important mono-

graphs by Baldass and Combe are in accord with the first edition of this book. The monograph of the former, *Hieronymus Bosch*, Vienna, 1943 (2nd ed., 1959), is based on a long study of the artist, and was preceded by a number of articles. The book contains valuable observations on the state of preservation, technique and interpretation of the paintings, as well as a detailed catalogue prepared in collaboration with Günther Heinz. (Boon's sharp criticism of Baldass in *Burl. Mag.*, CII, 1960, pp. 457 ff., seems to us to do less than justice to the qualities of Baldass' monograph.)

Jacques Combe's *Jérôme Bosch*, Paris, 1946 (2nd ed., 1957), is distinguished for the clarity and elegance of its exposition. The aim of the author is to present an overall picture of the artistic and spiritual personality of Bosch.

O. Benesch's article, 'Hieronymus Bosch and the Thinking of the Late Middle Ages', in *Konsthistorisk Tidskrift*, XXVI, 1957, contains an interpretation of Bosch's thinking in its historical context, which in its essential points agrees with that of the first edition of this book.

Among the lesser monographs that have appeared during this period, mention should be made of those by Marcel Brion, Paris, 1938; Jean de Bosschère, Brussels, 1947; Jean Leymarie, Paris, 1949; Carl Linfert, London, 1959; R. L. Delevoy, Geneva, 1960 (with a brief narrative and an excellent bibliography); and finally, Jean de Bosschère, *Jérôme Bosch et le fantastique*, Paris, 1962.

On the other hand, Wilhelm Fraenger, *Das Tausendjährige Reich*, Coburg, 1947 (English translation: *The Millennium of H. Bosch*, Chicago, 1951, London, 1952); 'H. Bosch: Johannes der Täufer', *Ztsch. für Kunst*, II, 1948, pp. 163 ff.; 'Johannes auf Patmos', *Ztsch. für Religions- und Geistesgeschichte*, II, 1949–50, pp. 327 ff.; *Hochzeit zu Kana*, Berlin, 1950; *Der Tisch der Weisheit*, Stuttgart, 1951; 'H. Bosch in seiner Auseinandersetzung mit dem Unbewussten', *Du*, Schweizerische Monatsschrift, X, Zurich, 1951; 'H. B., The Prodigal Son', *Cristianesimo e ragion di stato*, Rome, 1952; and finally, 'The Temptation of St Anthony (Prado)', *Archivio di Filosofia*, Padua, 1957, gives too fanciful an interpretation, the conclusions of which often seem arbitrary and contrary to the written sources that have come down to us. Fraenger's interpretation has been criticized and in part rejected by D. Bax, op. cit., and by H. Van de Waal in *Bibliotheca Orientalis*, Leyden, 1957, pp. 110 ff. Fraenger assumes that Bosch was a supporter of the heretical sect of the 'Brethren of the Free Spirit', and that many of his most significant works were commissioned, and their themes influenced, by the presumptive head of the sect, Jacob van Almangien. In point of fact Bosch was a member of the Brotherhood of Our Lady at 's Hertogenbosch, and it is not established that the sect existed during the artist's lifetime or that Jacob van Almangien belonged to it.

In Fraenger's beautifully written analyses the methods of Jung's depth psychology and modern sociology are applied in a way that is often interesting, but usually arbitrary. Although Fraenger's writings contain interesting observations on points of detail, on the whole the figure of Bosch appears as a passive transmitter of the ideas of his presumed patron, Jacob van Almangien, and inadequate justice is done to the creative originality of the master. (Further criticisms of Fraenger's theories about individual works by Bosch will be found in the catalogue.)

Notes to Introduction

P. 10, 12 Hieronymus Bosch's birthplace, 's Hertogen-bosch, is mentioned by Carel van Mander, ed. Hymans, I, p. 169, and Floerke, I, pp. 140ff.; incidentally, he adds, 'but I could not learn either the date of his birth nor that of his death.'

We do not know the date of the artist's birth. His portrait in the Arras Codex (fol. 275), which shows him well advanced in years, leads to the general assumption that he was born about 1450 (see, e.g., Friedländer, p. 80). Cf. Mosmans' discovery quoted on p. 411.

P. 10, 14 'C'est une grande ville, belle & forte, peuplée et riche, avec bons & aisibles édifices...L'on y faict... beaucoup de draps...& s'y faict somme inestimable de couteaux de très-bonne trempe & somme innombrable d'épingles...Bolduc tient le quatrième et dernier degré des quatre villes capitales de Brabant,' writes Guicciardini in his description of all the Low Countries, Antwerp, Silvius, 1567, p. 172. – A hundred years later Jacobus van Oudenhoven in his book, *Beschryvinge der Stadt ende meyereye van 's Hertogenbosch*, Amsterdam, 1649, writes: 'Een Plaetse seer groot, bestaende uyt meer als hondert Parochie-Kercken, onder dewelcke vele Parochien zijn, daer duysenden Communicanten plachten te Zyn.'

P. 10, 17: It has not yet been considered that Bosch's art may have developed from local tradition. Friedländer (p. 119) writes about 's Hertogenbosch that it is impossible for Bosch's art to have been derived from this town. Justi, p. 112, favours Brussels and Antwerp; Baldass, 1917, p. 184, and *J.d.k.S.*, XXV, 1919, pp. 10ff., relates the art of Bosch directly with the van Eyck milieu and suggests, as the connecting link between their style and that of our artist, a *Crucifixion* of the Traumann Collection in Madrid, which he dates about 1460. But this picture, judging by its style, cannot be dated prior to 1490; it is therefore from Bosch's period and cannot have served as a bridge between the two epochs.

H. Hymans, *G.d.B.A.*, x, 1893, p. 384; H. von Tschudi, *J.d.p.K.*, XIX, 1898, p. 114; and Schubert-Soldern, p. 108. All three recognize certain affinities between the *Nativity* of the Master of Flémalle in Dijon and the works of Hieronymus Bosch.

Dollmayr, p. 290, assumes an influence of the school of Haarlem (Ouwater and Geertgen). W. Cohen and Winkler, p. 143, see an influence of the Master of the Virgo inter Virgines. But since this master lived at the same time as Bosch, the influence would have been rather in the opposite direction. Winkler, *Die altnieder-ländische Malerei*, p. 159, and Friedländer, p. 119, explain Bosch's style by means of biblical illustrations, but fail to give any precise sources.

Dvořák, *Kunstgeschichte als Geistesgeschichte*, pp. 174ff., refers to the influence of Schongauer, whom he holds to have been the true inspirer of the demoniac element in the art of Bosch. Actually, so far as this aspect of their art is concerned, both these painters drew on the same sources, namely the art of the old Netherlands. Consider, e. g., the *Last Judgement* miniature in Barcelona Cathedral (Solier, *Die Kathedrale von Barcelona*, Plate 13) and the *Last Judgement* attributed to Hubert or Jan van Eyck, formerly in the Hermitage, now in the Metropolitan Museum. The hypothesis most widespread today, first formulated by E. Bertaux, *Revue de l'art ancien et moderne*, XXIII, 1908, pp. 345ff., and repeated by Benesch, *J.d.p.K.*, XLVI, 1925, pp. 181ff. and in *Mélanges Hulin de Loo*, pp. 36ff., and Baldass, 1926, p. 110, is the following: The art of Bosch is said to derive from the particular style of the end of the fourteenth and the beginning of the fifteenth centuries, which German scholarship calls the 'soft style'. In their judgement the three historians base themselves on the series of paintings by the Master of St George in the Louvre. But we need not search for the influence of the 'soft style' on Bosch by way of the Catalan School: the frescoes in the cathedral of 's Hertogenbosch explain it. Let us recall that Mosmans, op. cit., has referred in this connection to the gargoyles of this cathedral.

P. 10, 30 For the cathedral, see F. X. Smits: *De kathedral van 's Hertogenbosch*, Brussels, 1907, and in particular Jan Mosmans, *De St Jans-kerk te 's Hertogenbosch, Nieuwe Geschiedenis*, 's Hertogenbosch, 1931.

P. 10, 32 The iconography of the 'tree of Jesse', the apex of which is no longer Christ but Mary, because of the Marian cult widespread in the fourteenth century, is already to be seen in a miniature in the song book of Richard of Canterbury, which dates from about 1300. (See E. Mâle, *L'art religieux du XIIe siècle en France*, Paris, 1922, p. 169.) Since, according to the documents, the fresco of the 'tree ef Jesse' was cleaned ('washed') for the first time in 1422–3 (see Mosmans, p. 201), the date 1390–1400 very probably could be the date of its execution.

P. 11, 10 The inscription tells us that the donors are Katharina Jordensdochter van Driel and Willem Jacobszoon van de Wiel. The rarity of paintings of definitely Dutch origin in the first half of the fifteenth century makes this fresco significant.

P. 15, 27 In Freidank's *Bescheidenheit* the peculiarities of man are often symbolized by 'fools'. F. Zarncke, *Sebastian Brants Narrenschiff*, Leipzig, 1854.

P. 23, 4 Some data on the ratio of laymen to clergy in the Brotherhood at the time of Bosch:

> 1385–6, 35 clergy out of some 310 new members;
> 1495–6, 20 clergy out of some 790 new members;
> 1517–18, 20 clergy out of some 500 new members.

M. Mosmans, to whom we are indebted for these valuable data, adds that women were admitted to the Brotherhood. Often entire families joined on the same day.

P. 23, 4 In the 1518 statutes, published by J. C. A. Hezenmans, op. cit., p. 122, we read: 'Immensa summi Patris largitas...unigenitum suum de supernis mittens ...paraturum redemptis ibidem...perpetuas mansiones, ut hominem perditum sibi novae adoptionis gratia reformaret...Quapropter Christi fideles universi et specialiter clerici...in laudes ipsius Christi, gloriosaeque genitricis suae...devotius tenentur prorumpere, jubilationis, laetitiae et honoris cantica persolventes, ut laicos, quibus ipsi clerici proponuntur in exemplum, discretius inducere valeant suo Creatori qui Christus est, Mariaeque Sanctissimae suae matri devotius, ac humilius obedire pariter et orare...His igitur nos, clerici et scolares praedicti, circumducti...summis desideriis implorare volentes, quamdam confraternitatem...legendi, cantandi, et divina celebrandi officia...in choro collaterali...certis temporibus, diebus ac festis quibusdam solempnibus... duximus statuendum...' (Communicated by M. Mosmans).

P. 23, 6 Regarding the charitable work of the Brotherhood, the statutes state: 'In octavis omnium Sanctorum ...socii ad chorum conveniunt...pro defunctis dictae confraternitatis...qui suas eleemosinas et beneficia caritatis dictae confraternitatis in extremis aut alias legaverint'...'Item ordinatum est...quod, quam cito facultates ejusdem confraternitatis ad hoc suppetent, ementur quique cerei et unus pannus theutonice dictus Raudec (black gown) quibus utetur communiter in exequiis pauperum sociorum' (Communicated by M. Mosmans).
During the fifteenth century the 'Spynden', the distribution of bread and money to the poor of the city, who assembled in front of the door of the Brotherhood of Our Lady, became more and more frequent. See *Namen ende Wapenen der Heeren Beeidigte Broeders...*, in the chapter entitled: 'Van de Aelmissen der Broederschap'.

P. 23, 10 See Erasmus: *Epist.*, lib. 24, no. 1284. No document gives us precise information on the relationships between the Hieronymites and the Brotherhood of Our Lady. M. Mosmans mentions some contracts entered into between the church of St John and the Brethren of the Common Life between 1500 and 1550 concerning calligraphic work done for the church.

P. 23, 19 Bibliography on the Brethren of the Common Life: G. H. M. Delprat, *Verhandeling over de Broederschap van G. Groote* (2nd ed.), Arnhem, 1852. On 's Hertogenbosch, see pp. 126ff. L. Schulze, 'Die Brüder des gemeinsamen Lebens' in *Realenzyklopädie für protest. Theologie und Kirche*, III, pp. 475ff. Ernst Barnikol, *Studien zur Geschichte der Brüder vom gemeinsamen Leben*, Tübingen, 1917.

P. 29, 13 See Ph. M. Halm, 'Ikonographische Studien zum Armen-Seelen-Kultus', *Münchener Jahrbuch*, XII, 1921–2, pp. 1ff. A. Pigler, 'Evagationes Spiritus' in *Archeologiai Értesitö*, XXXIX, 1922–3, pp. 121ff. Incidentally, Pigler publishes, in this article, a very interesting painting of the Austrian school dealing with the same theme, and now in the Esztergom Museum (Hungary).

P. 29, 14 A similar representation – a vision in light blue against the dark-blue heaven – is to be found in the 'Livre des Merveilles du Monde', Paris, B.N. fr. 2810, fol. 209 v.

P. 32, 24 *La clef des songes de Daniel* (p. 58) informs us that the hare is the symbol of the fear of death. On the other hand, the devouring by an infernal monster of sinners guilty of lust is taken from the *Vision of Tondalus*, op. cit., pp. 40, 81. The bed on which a woman lies stretched out, behind the hare, symbolizes punishment for lust, as M. Roggen (op. cit.) notes; he found the origin of this motif in *Dat Boek van der Voirsienicheit Godes,* a book of the mid-fifteenth century (Brussels, 1930).

P. 32, 25 Artemidorus (op. cit., p. 12): *les oreilles battues et frappées président mauvaises nouvelles.* According to modern psychoanalysis, ears are symbols of the female organs. See Freud, *Traumdeutung*, op. cit., p. 316.

P. 32, 25 Artemidorus (op. cit., p. 12): *La clef vue par Songe à celui qui voudroit se marier.* According to modern psychoanalysis, the key is a phallic symbol. See Freud, op. cit., p. 316.

P. 32, 28 See Jacob van Oestvoren's poem 'De blauwe Schuit', dating from 1413.

P. 32, 34 Compare this face with the portrait of the artist in the Arras Library drawing and Lampsonius' engraving. This self-portrait of Bosch in Hell recalls

Teophilo Folengo, who is his epic poem 'Baldus' takes part in an assembly of poets and astrologers in Hell, in a giant pumpkin. See C. S. Gutkind, 'Die Sprache des Folengo', *Archivum Romanicum*, VI, 1922, pp. 425 ff.

P. 45, 8 For this interpretation of the work of Jan van Eyck, see the author's article 'Zur Herkunft des Stiles der van Eyck' in *Münchener Jahrbuch*, new series, IX, 1932, pp. 320 ff.

P. 46, 8 Bosch's monochrome painting is not, as in his predecessors, a procedure intended to produce the illusion of a sculpture in the round: it is essentially pictorial as regards both media and purpose.

P. 46, 15 See Carel van Mander, *Le Livre des Peintres*, ed. Hymans, 1884, p. 169: *Son procédé était large et ferme et il peignait souvent du coup, ce qui n'a pas empéché ses œuvres de rester très belles...*

P. 46, 16 See Carel van Mander, op. cit., p. 169: *Comme nombre d'anciens peintres, il avait coutume de tracer complètement ses compositions sur le blanc du panneau et de revenir ensuite par une teinte légère et transparente pour ses carnations, attribuant, pour l'effet, une part considérable au dessous.*

P. 46, 41 The same phenomenon appears simultaneously in Italy, in Leonardo's calligraphic drawings, and in Germany, in Dürer's handwriting.

P. 47, 1 In the catalogue of drawings these are given in approximate chronological sequence in each group.

P. 47, 4 E. Sudeck, op. cit., gives a detailed analysis of the sheet 'The Legless Cripples' in the Vienna Albertina.

P. 48, 3 See the document reproduced on p. 407, left column, line 16.

P. 48, 4 There are two references to this painting in the 1516 and 1524 inventories of the House of Habsburg (see *J.d.a.K.*, III, 1885, p. xcix and note 49). *Ung moyen tableau de Sainct-Anthoine, qui n'a couverture ni feuillet, qui est fait de Jheronimus Bosch, et a esté donné à Madame par Jhoane femme de chambre de Madame Lyonor* (1516 Inv.); *item un aultre tableau de Monseigneur Sainct-Anthoine tenant ung livre et une besicle en sa main et ung baston soubz son bras, le fond de bocaige es estranges figures de personnaiges...* (1524 Inv.). This *Temptation of St Anthony*, on which the saint was shown with a stick under his arm and holding a

book and eye-glasses, would be identical in composition, according to Glück, *J.d.k.S.*, new series, IX, 1935, p. 151, with the copy in the Rijksmuseum.

P. 48, 5 See *L'Anonimo Morelliano*, ed. Grizzoni, Bologna, 1884, pp. 196, 197, who mentions three works by Bosch in his inventory of Cardinal Grimani.

P. 48, 6 See J. Denucé, *Les Galeries d'Art à Anvers aux XVIe et XVIIe siècles. Inventaires*, Antwerp, 1932. Paintings by Bosch in the collections of: Michiel van der Heyden (1552); Margarethe Boge (1574); Jan van Kessel (1583); Marco M. Perez (1603); Herman de Neyt (1642); Sara Schut (1644); Jan van Meurs (1652); Susanna Willemsens (1657); Jean Petit (1660). Cf. also under lost works.

P. 48, 17 For the inventory of Philip II's collection, see Justi, p. 122f.

P. 48, 25 For the influence exerted by Bosch, see Baldass, 1926, pp. 120 ff. For his influence on Jan de Cock (according to N. Beets, *Oud Holland*, LII, 1935, pp. 49 ff. and op. cit., LIII, 1936, pp. 55 ff., Lucas Cornelisz de Kock) and on the Antwerp Mannerists, see Friedländer, *Zeitschrift für bildende Kunst*, new series, XXIX, p. 67, and Cohen in *Genius*, 1921.
Two youthful works of El Greco, the *Dream of Philip II* and the *Martyrdom of St Maurice*, both in the Escorial, enable us to evaluate Bosch's influence on this artist – the colouring of the *Martyrdom of St Maurice* in particular recalls that of the *Garden of Earthly Delights*.
In his two engravings, 1617 and 1634, representing the *Temptation of St Anthony*, Callot was certainly inspired by Bosch's *Temptation*.
We note further that Flaubert, when he was writing his *Tentation de St Antoine*, drew his inspiration from a work of the school of Hieronymus Bosch, which at that time was in the Doria Palace in Genoa. See Th. Reik, *Flaubert und seine 'Versuchung des Antonius'*, Munich, n.d.
The copy of Bosch's *Last Judgement* executed by Cranach the Elder is in the Deutsches Museum, Berlin.

P. 48, 31 The appendix to this book (p. 413 ff.) cites the most important statements of Italian and Spanish authors concerning Hieronymus Bosch.

P. 49, 2 Surrealism: *Automatisme Psychique pur, par lequel on se propose d'exprimer...le fonctionnement réel de la pensée ...en dehors de toute préoccupation esthétique et morale.* See A. Breton, *Manifeste du Surréalisme*, 2nd ed., 1929.

P. 49, 30: See the text of Siguença, pp. 401–4.

Notes – p. 50, 6 Lampsonius, *Pictorum aliquot celebrium Germanicae inferioris effigies*. Antwerp, 1572.

> Quid sibi vult, Hieronyme Boschi,
> Ille oculus tuus attonitus? quid
> Pallor in ore? velut lemures si
> Spectra Erebri volitantia coram
> Aspiceres? Tibi Ditis avari
> Crediderim patuise recessus
> Tartaresque domos: tua quando
> Quicquid habet sinus imus Averni,
> Tam potuit bene pingere dextra.

Carel van Mander, *Het Leven der Doorluchtighe Nederlandtsche en Hooghduytsche Schilders,* Amsterdam, 1614, ed. H. Hymans, Paris, 1884, pp. 169ff., and ed. Hanns Floerke, Munich, 1906, pp. 140ff.
Jules Renouvier, in his *Des types et des manières des maîtres graveurs,* Montpellier, 1853–6, pp. 144ff., still terms Hieronymus Bosch the founder of the 'school of drôleries'.

p. 50, 10 The works of Louis de Fourcaud, *Hieronymus van Aken, dit Jérôme Bosch,* Paris, 1912; Kurt Pfister, *Hieronymus Bosch,* Potsdam, 1922; and Walter Schürmeyer, *Hieronymus Bosch,* Munich, 1923, are writings without scholarly pretensions.
In Max J. Friedländer, *Geertgen van Haarlem und Hieronymus Bosch,* Berlin, 1927, there is an interesting catalogue of the works of the artist with a number of new attributions. Our views deviate from those of Friedländer in several points. See the introduction to the catalogue, above, p. 335.

p. 50, 14 Baldass, 1917, pp. 177ff.
In an article in *G.d.B.A.,* xv, 1919, pp. 1ff., Louis Demonts also attempts to present a development of Hieronymus Bosch: '...d'abord traditionaliste et considérant, comme l'église, que la peinture est un moyen d'instruire grâce à des symboles et à des allusions, Jérôme Bosch évolue du tableau théologique au tableau moral, pour aboutir vers la fin de sa carrière au véritable tableau de genre.' This conception of the artist's development, which is based, not on an analysis of the style, but on the subject, suggests the author to date the *Cure of Folly,* the *Conjuror* and the *Ship of Fools,* which are works from the beginning of Hieronymus Bosch's career, as late works, and such works as, for example, the Prado *Epiphany,* which are of the last period, as youthful works.

p. 50, 17 Dollmayr, pp. 282ff. and Gossart, *J. Bosch,* Lille, 1907. Despite their scholarly character, these two works do not give any true explanation of Bosch's ideas, which are, for both authors, mere illustrations of current conceptions.

p. 50, 18 Cohen, in: Thieme-Becker, *Künstlerlexikon,* iv, 1910, pp. 386ff. Baldass, 1926, pp. 103ff.

BIBLIOGRAPHY

This list is confined to the works most frequently cited and referred to by abbreviations in the text.

Adhémar – See: *Corpus.*

Baldass, 1917 – L. von Baldass, 'Die Chronologie der Gemälde des Hieronymus Bosch', in: *J.d.p.K.,* XXXVIII, 1917, pp. 177ff.

Baldass, 1926 – L. von Baldass, 'Betrachtungen zum Werke des Hieronymus Bosch', in: *J.d.k.S.,* new series, I, 1926, pp. 103ff.

Baldass, 1935 – L. von Baldass, 'Ein Kreuzigungsaltar von Hieronymus Bosch', in: *J.d.k.S.,* new series, IX, 1935, pp. 87ff.

Baldass, 1943 – L. von Baldass, *Hieronymus Bosch,* Vienna, 1943.

Baldass, 1959 – L. von Baldass, *Hieronymus Bosch,* 2nd ed., Vienna, 1959.

Bastelaer – R. van Bastelaer and G. Hulin de Loo, *P. Bruegel l'Ancien: son œuvre et son temps,* 2 vols., Brussels, 1907.

Bax, 1949 – D. Bax, *Ontcijfering van Jeroen Bosch,* The Hague, 1949.

Bax, 1956 – D. Bax, *Beschrijving en poging tot verklaring van het Tuin der Onkuisheiddrieluik van Jeroen Bosch, gevolgd door kritiek op Fraenger,* Amsterdam, 1956.

Benesch, 1931 – O. Benesch, 'Ein Spätwerk von Hieronymus Bosch', in: *Mélanges Hulin de Loo,* Brussels – Paris, 1931, pp. 36ff.

Benesch, 1937 – O. Benesch, 'Der Wald der sieht und hört', in: *J.d.p.K.,* LVIII, 1937, pp. 258ff.

Benesch, 1957 – O. Benesch, 'Hieronymus Bosch and the Thinking of the Late Middle Ages', in: *Konsthistorisk Tidskrift,* XXVI, 1957, pp. 21ff.

Blum – A. Blum, in: *Atti del Convegno di Studi Vinciani,* 1953, pp. 66ff.

Boon, 1960 – K. G. Boon, 'Hieronymus Bosch' [review of Baldass, 1959], in: *Burlington Magazine,* CII, 1960, pp. 457ff.

Brand Philip, 1953 – L. Brand Philip, 'The Prado *Epiphany* by Jerome Bosch', in: *Art Bulletin,* XXXV, no. 4, 1953, pp. 267ff.

Brand Philip, 1958 – L. Brand Philip, '*The Peddler* by Hieronymus Bosch: a Study in Detection', in: *Nederlands Kunsthistorisch Jaarboek,* IX, 1958, pp. 1ff.

Brion – M. Brion, *J. Bosch,* Paris, 1938.

Burl. Mag. – *Burlington Magazine,* London.

Byvanck-Hoogewerff – A. W. Byvanck and G. J. Hoogewerff, *Noord-Nederlandsche miniaturen in handschriften der 14e, 15e en 16e eeuwen,* The Hague, 1922, II.

Cohen – W. Cohen, 'Hieronymus Bosch', in: Thieme-Becker, *Künstlerlexikon,* IV, 1910, pp. 386ff.

Combe, 1946 – J. Combe, *Jérôme Bosch,* Paris, 1946. English translation by E. Duncan, London, 1946.

Combe, 1957 – J. Combe, *Jérôme Bosch,* 2nd. ed., Paris, 1957.

Corpus: Bruges – Les Primitifs Flamands. I. *Corpus de la peinture des anciens Pays-Bas méridionaux au quinzième siècle. Le Musée Communal de Bruges.* By A. Janssens de Bisthoven and R. A. Parmentier. Antwerp, 1951.

Corpus: Louvre – Les Primitifs Flamands. I. *Corpus de la peinture des anciens Pays-Bas méridionaux au quinzième siècle. Le Musée National du Louvre, Paris,* I. By H. Adhémar. Brussels, 1962.

Corpus: National Gallery – Les Primitifs Flamands. I. *Corpus de la peinture des anciens Pays-Bas méridionaux au quinzième siècle. The National Gallery, London.* 2 vols. By M. Davies. Antwerp, 1953, 1954.

Corpus: New England – Les Primitifs Flamands. I. *Corpus de la peinture des anciens Pays-Bas méridionaux au quinzième siècle. New England Museums.* By C. T. Eisler. Brussels, 1961.

Cuttler, *Art Bull.* – C. D. Cuttler, 'The Lisbon *Temptation of St Anthony* by Jerome Bosch', in: *Art Bulletin,* XXXIX, 1957, pp. 109ff.

Cuttler, *Art Quarterly* – C. D. Cuttler, 'Witchcraft in a Work by Bosch', in: *Art Quarterly,* XX, 1957, pp. 129ff.

Davies – See: *Corpus.*

Delevoy – R. L. Delevoy, *Jérôme Bosch,* Geneva, 1960.

Demonts – L. Demonts, 'Deux primitifs néerlandais au Musée du Louvre', in: *G.d.B.A.,* XV, 1919, pp. 1ff.

Dollmayr – H. Dollmayr, 'Hieronymus Bosch und die Darstellung der vier letzten Dinge in der niederländischen Malerei des 15. und 16. Jahrhunderts', in: *J.d.a.K.,* XIX, 1898, pp. 284ff.

Dvořák – M. Dvořák, *Kunstgeschichte als Geistesgeschichte,* Munich, 1924.

Eisler – See: *Corpus.*

Fraenger, *Die Hochzeit zu Kana* – W. Fraenger, *Die Hochzeit zu Kana: ein Dokument semitischer Gnosis bei Hieronymus Bosch* (Kunstwerk und Dichtung, fasc. 6), Berlin, 1950.

Friedländer – M. J. Friedländer, *Geertgen und Bosch*, Berlin, 1927. (Vol. v of *Die altniederländische Malerei*, 14 vols., Berlin (vols. x–xiv Leyden), 1924–37).

G. d. B. A. – *Gazette des Beaux-Arts*, Paris.

Glück, *J.d.p.K.*, 1904 – G. Glück, 'Zu einem Bilde von Hieronymus Bosch in der Figdorschen Sammlung in Wien', in: *J.d.p.K.*, xxv, 1904, pp. 174ff.

Gossart – M. G. Gossart, *Jérôme Bosch, 'Le faizeur de dyables' de Bois-le-Duc*, Lille, 1907.

Harrebomée – P. Harrebomée, *Spreekwoordenboek der Nederlandsche Taal*, Utrecht, 1853–70, iii.

Janssens de Bisthoven-Parmentier – See: *Corpus*.

J.d.a.K. – *Jahrbuch der kunsthistorischen Sammlungen des Allerhöchsten Kaiserhauses*, Vienna–Leipzig–Prague.

J.d.k.S. – *Jahrbuch der kunsthistorischen Sammlungen in Wien*, Vienna.

J.d.p.K. – *Jahrbuch der königlich-preußischen Kunstsammlungen*, Berlin.

Justi – C. Justi, 'Die Werke des Hieronymus Bosch in Spanien', in: *J.d.p.K.*, x, 1889, pp. 121ff. (reprinted in *Miscellaneen aus drei Jahrhunderten spanischen Kunstlebens*, Berlin, 1908).

Lafond – P. Lafond, *Hieronymus Bosch: son art, son influence, ses disciples*, Brussels – Paris, 1914.

Leymarie – J. L. Leymarie, *Jérôme Bosch*, Paris, 1949.

Maeterlinck, 1906 – L. Maeterlinck, 'A propos d'une œuvre de Bosch au Musée de Gand', in: *Revue de l'art ancien et moderne*, xx, 1906, pp. 299ff.

Maeterlinck, 1914 – L. Maeterlinck, *Le genre satirique dans la peinture flamande*, Brussels, 1914.

Michel – E. Michel, *Peintures flamandes du 15e et 16e siècle.*

Catalogue raisonné des peintures du moyen-âge, de la renaissance et des temps modernes. Musée National du Louvre, Paris, 1953.

Mosmans – J. Mosmans, *De St Jans-kerk te 's Hertogenbosch*, 's Hertogenbosch, 1931.

Pfister – K. Pfister, *Hieronymus Bosch*, Berlin, 1922.

Pigler – A. Pigler, 'Astrology and Jerome Bosch', in: *Burlington Magazine*, xcii, 1950, pp. 132ff.

Pinchart – A. Pinchart, *Archives des Sciences, Lettres et Beaux-Arts: documents inédits*, Ghent, 1860, I, p. 268.

Roggen, 1936 – D. Roggen, in: *Nieuw Vlaanderen*, March 7, 1936.

Roggen, 1939 – D. Roggen, 'J. Bosch: Literature and Folklore', in: *Gentsche Bijdragen tot de Kunstgeschiedenis*, vi, 1939–40, pp. 107ff.

Schmidt-Degener – F. Schmidt-Degener, 'Un tableau de Jérôme Bosch au Musée Municipal de Saint-Germain-en-Laye', in: *G.d.B.A.*, xxxv, 1906, pp. 147ff.

Schubert-Soldern – F. von Schubert-Soldern, *Von Jan van Eyck bis Hieronymus Bosch: ein Beitrag zur Geschichte der niederländischen Landschaftsmalerei*, Strasbourg, 1903 (see also id., 'Hieronymus Bosch und Pieter Brueghel der Ältere', in: *Studien zur deutschen Kunstgeschichte F. Wickhoff gewidmet*, Vienna, 1903, pp. 73ff.).

Tolnay, 1937 – C. de Tolnay, *Hieronymus Bosch*, Basle, 1937.

Winkler – F. Winkler, 'Unbeachtete holländische Maler des 15. Jahrhunderts', in *J.d.p.K.*, xliv, 1923, pp. 136ff.

APPENDIX OF PLATES

1. *The Cure of Folly*. Copy after H. Bosch. Amsterdam, Rijksmuseum.
2. *Jesus among the Scribes*. Copy after H. Bosch. Paris, Musée du Louvre.
3. *Jesus among the Scribes*. Copy after H. Bosch. San Domenico, near Florence, Weinzheimer Collection.
4. *Concert in an Egg*. Copy after H. Bosch. Lille, Museum.
5. *Allegorical Concert*. Senlis, Pontalba Collection.
6. *The Blue Ship*. Engraving by Hieronymus Cock, after a composition by Hieronymus Bosch.
7. *Company at Table in a Floating Conch*. Engraving by Hieronymus Cock, after a composition by Hieronymus Bosch.
8. *The Conjuror*. Copy after H. Bosch. Philadelphia, Philadelphia Museum of Art, Wilstach Collection.

9. *The Conjuror*. Engraving after Hieronymus Bosch. Munich, Graphische Sammlung.
10. *Christ and the Woman Taken in Adultery*. Copy after H. Bosch. Philadelphia, Johnson Collection.
11. *The Mariage at Cana*. Copy ofter H. Bosch. Location unknown.
12. *The Marriage at Cana*. Drawing after Hieronymus Bosch. Paris, Musée du Louvre, Rothschild Collection.
13-18. *Ecce Homo:* altarpiece. Sixteenth-century School of H. Bosch. Boston, Museum of Fine Arts.
 13. Left wing, outer side: *The Donor and St John*.
 14. Right wing, outer side: *The Donor and St Mary Magdalene*.
 15. Left wing, inner side: *The Donor and St Peter*.
 16. Centre panel: *Ecce Homo*.
 17. Right wing, inner side: *The Donor's Wife with St Catherine of Alexandria*.
 18. Predella: *Veronica's Veil with Instruments of Torture and Heads from the Passion Cycle*.
19. *The Adoration of the Magi*. Madrid, Casa Torres Collection.
20. *Altarpiece of the Hermits*. Copy after H. Bosch. Brussels, Musées Royaux des Beaux-Arts.
21. *The Temptation of St Anthony*. Copy after H. Bosch. New York, Knoedler Collection.
22. *The Temptation of St Anthony*. Merion (Montgomery County, Pennsylvania), Barnes Foundation.
23. *The Temptation of St Anthony*. Kansas City, Missouri, Atkins Museum of Fine Arts, Nelson Fund.
24. *The Temptation of St Anthony*. Haarlem, Gutman Collection.
25. *Christ Carrying the Cross*. London, Arnot Gallery.
26. *The Battle of Carnival and Lent*. Lugano, Baron Thyssen-Bornemisza Collection.
27-28. *The Adoration of the Magi*. Altarpiece with wings closed and open. London, Viscount Bearsted Collection.
29. *The Adoration of the Magi*. Aachen, Suermondt Museum.
30. *The Adoration of the Magi*. Philadelphia, Johnson Collection.
31. *The Last Judgement*. Replica of Hieronymus Bosch by Allaert de Hameel? New York, Private Collection.
32. *The Adoration of the Magi*. Rotterdam, Museum Boymans-van Beuningen.
33-35. *The Adoration of the Magi*. Anderlecht, Museum.
36. *The Adoration of the Magi*. New York, Metropolitan Museum of Art, Kennedy Fund.
37-38. *The Last Judgement:* triptych. Engraving by Hieronymus Cock.
 37a. Left wing: *The Paradise with Floating Church*.

37b. Right wing: *The Torments of Hell*.
38. Centre panel: *The Resurrection of the Dead and Separation of Good from Evil*.
39. *The Garden of Earthly Delights*. Copy after Hieronymus Bosch. Budapest, Museum of Fine Arts.
40-41. Details of no. 39.
42-43. *Heaven and Hell*. Drawing after Hieronymus Bosch (cf. 37a, 37b). Princeton, N.J., Princeton University, Art Museum.
44. *Christ Mocked*. Philadelphia, Johnson Collection.
45. *Christ Mocked*. Berne, Kunstmuseum.
46. *The Kiss of Judas*. Amsterdam, Rijksmuseum.
47. *The Kiss of Judas*. San Diego, Fine Arts Gallery.
48. *St Anthony*. Amsterdam, Rijksmuseum.
49. *St Anthony*. Madrid, Museo del Prado.
50. *Christ before Pilate*. New York, Jacob Heimann Collection.
51. *Christ before Pilate*. Rotterdam, Museum Boymans-van Beuningen.
52. *The Vision of Tondalus*. Madrid, Museo del Prado.
53. *Paradise*. New York, Metropolitan Museum of Art.
54. *Landscape of the End of the World*. New York, Metropolitan Museum of Art.
55-57. Copies after drawings by Hieronymus Bosch.
 55. London, Lord Melchett Collection.
 56. London, formerly Oppenheimer Collection.
 57. Erlangen, University Library.
58. *Crucifixion Group with Donors*. For Katharina Jordansdochter van Driel and Willem Jacobszoon van de Wiel. 's Hertogenbosch, St Janskerk.
59. *The Tree of Jesse*. Fresco on the second pillar in the second row of the choir. 's Hertogenbosch, St Janskerk.
60. *SS Peter and James*. Upper portion of fresco in the St Nicholas choir of St Janskerk, 's Hertogenbosch.
61. *St Nicholas*. Lower portion of fresco in the St Nicholas choir of St Janskerk, 's Hertogenbosch.
62. *The Crucifixion*. Altarpiece, 's Hertogenbosch School. Chicago, Art Institute.
63. *St John as a Child*. Florentine School, 1428. The New York Historical Society.
64. *The Resurrection of Christ and Ascension*. About 1520. 's Hertogenbosch, St Janskerk.
65. *The Gate of Hell*. Miniature from the Book of Hours of Catherine of Cleves. New York, Private Collection.
66. *Christ Carrying the Cross,* by Allaert de Hameel. Brussels, Musées Royaux des Beaux-Arts.
67. The Planet Luna from the Master of the Family Book. Waldsee, Prince von Waldburg-Wolfegg Collection.
68. The Planet Luna. From a Tübingen manuscript.
69. From the *Ars moriendi* of Master E. S. (Lehrs 184).

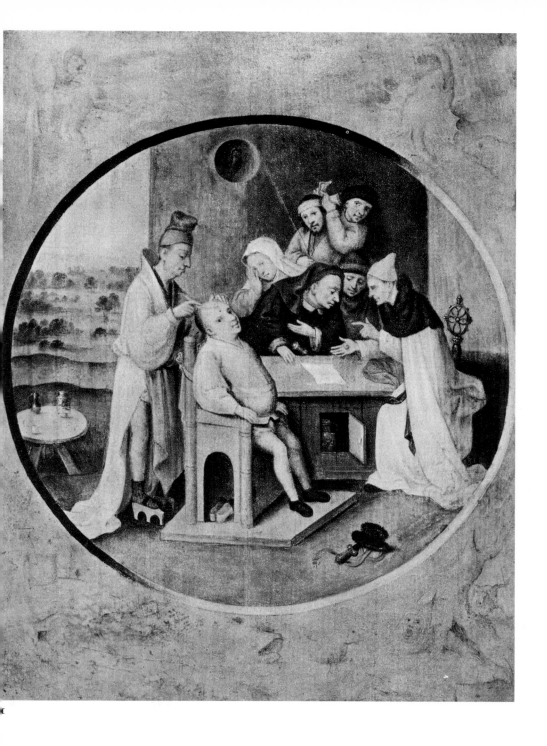

2

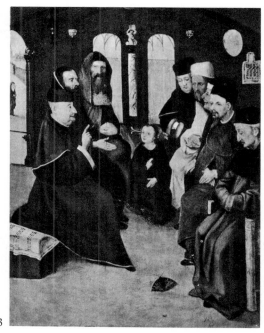

3

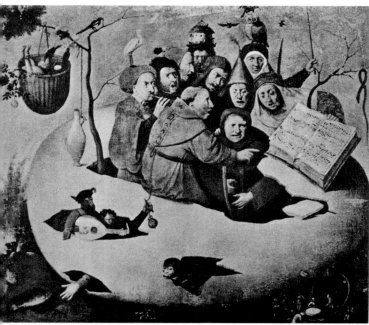

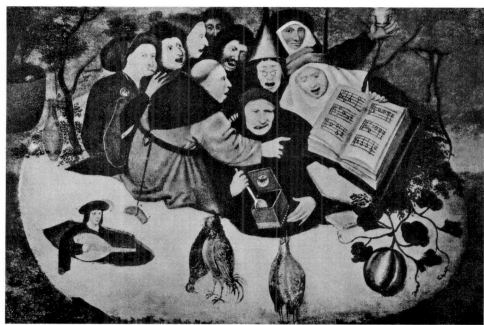

5

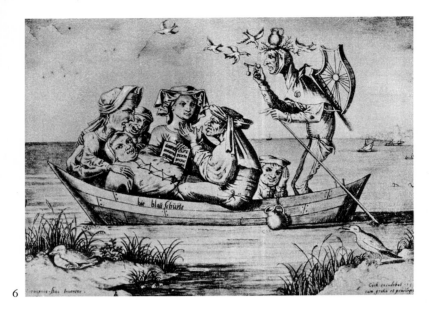

6

7

8

9

10

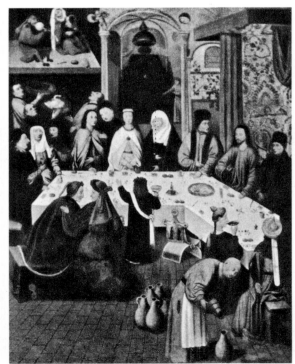

11

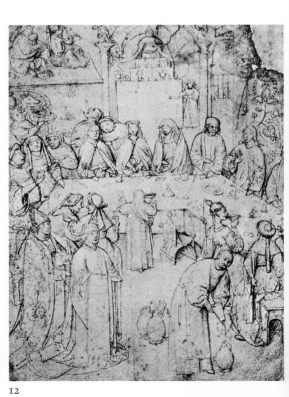

12

13 14

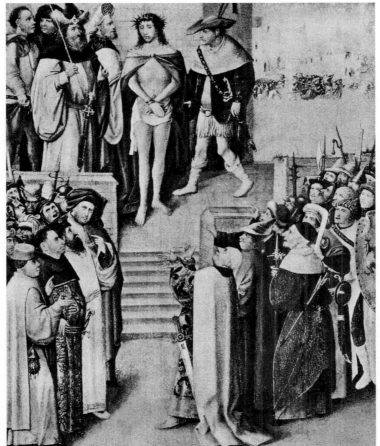

15 16 17

18

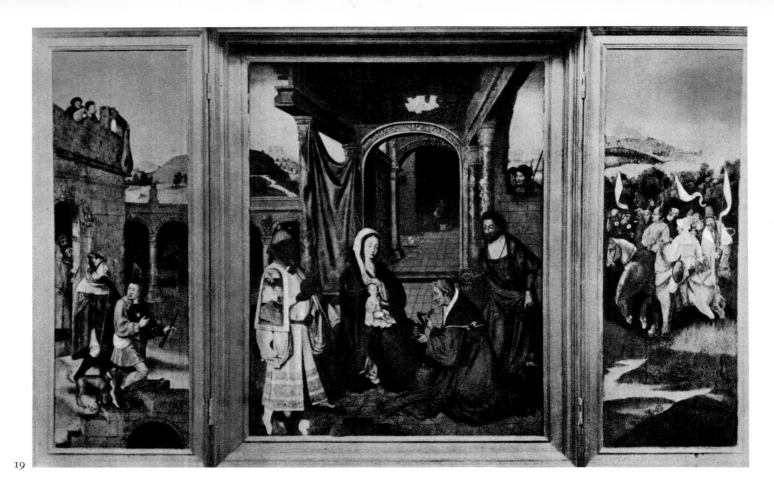

19

20

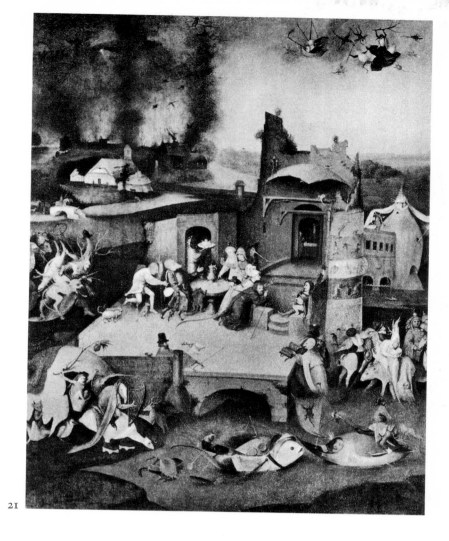

21

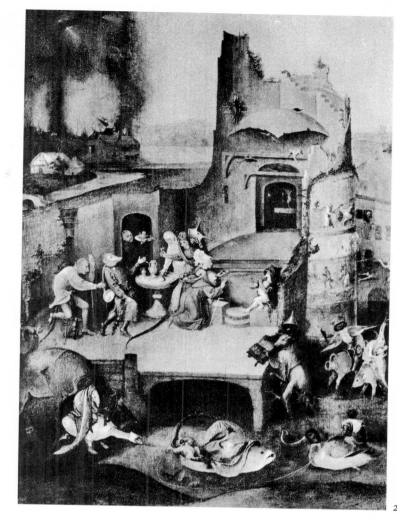

22

23

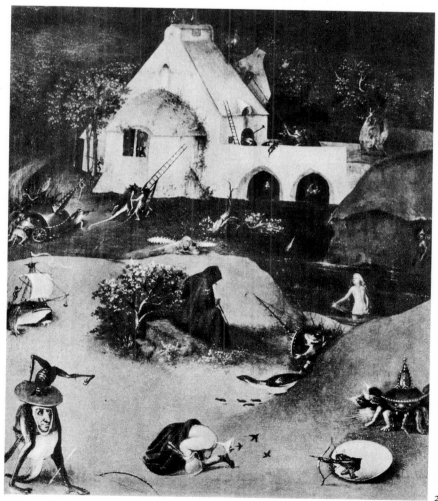

24

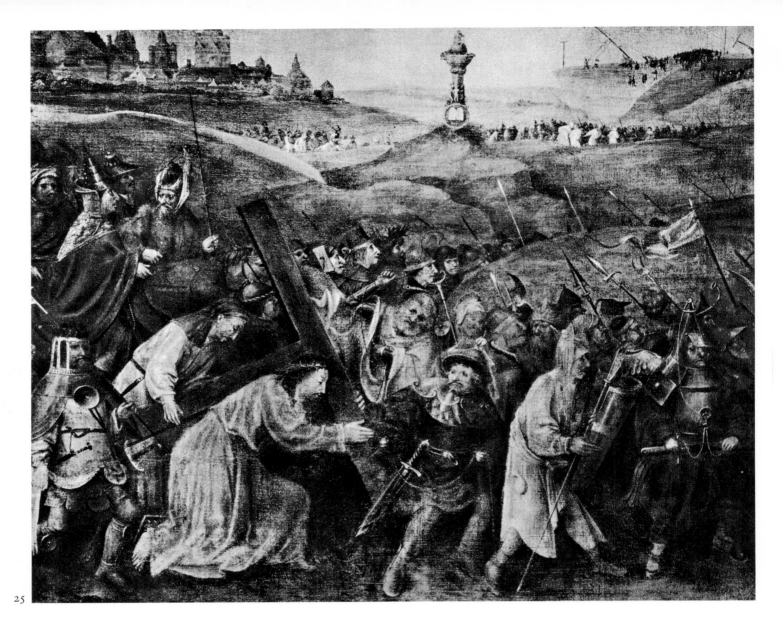

25

26

27

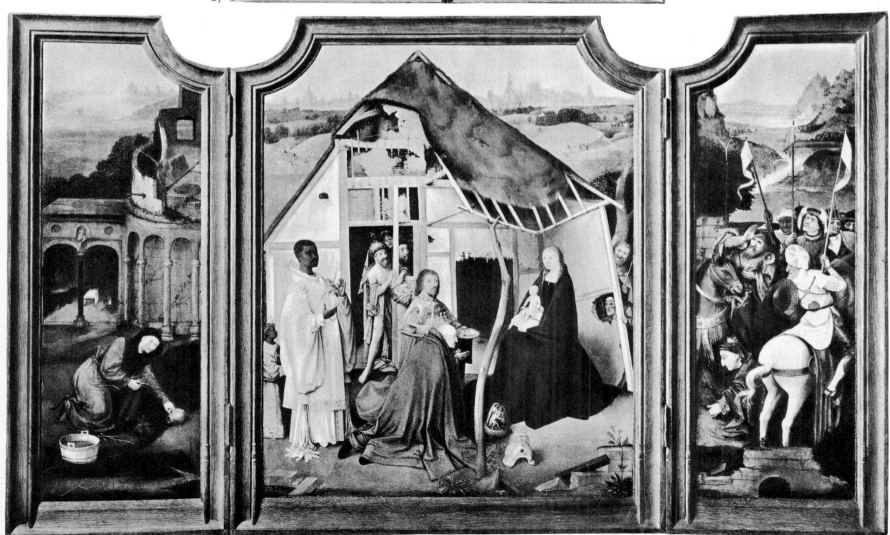

3

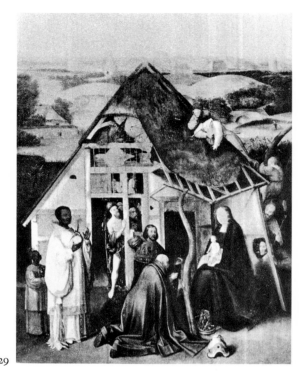

29

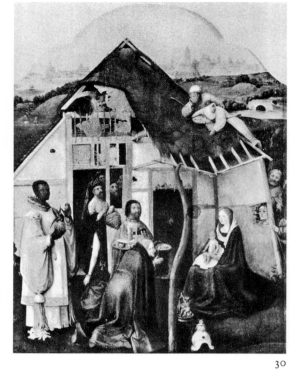

30

3

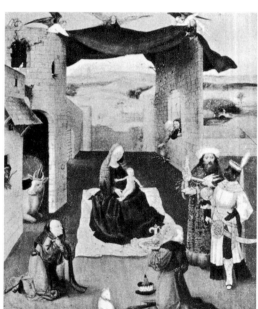

32

33

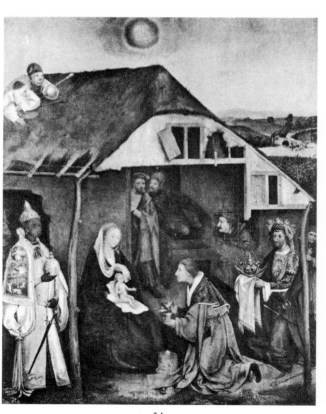

34

3

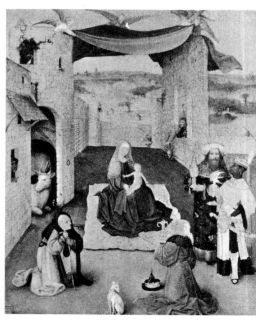

36

4

37 a

38

37 b

41

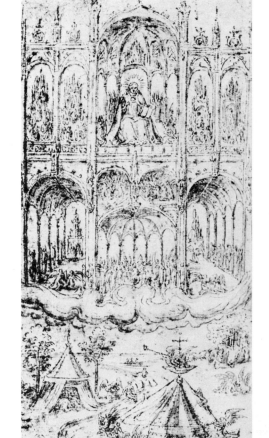

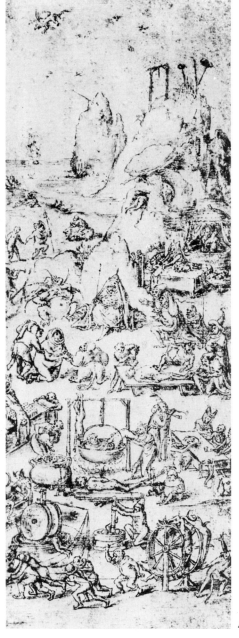

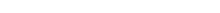

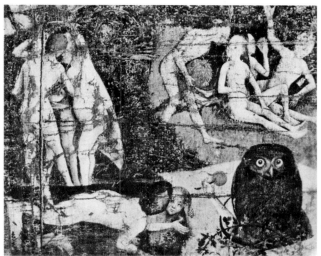

40

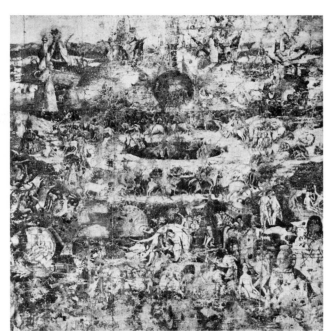

39

5

42

43

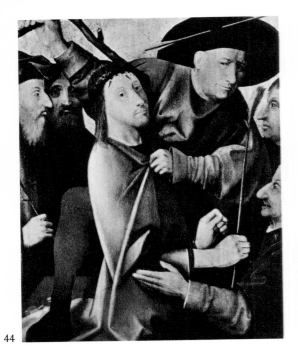

44

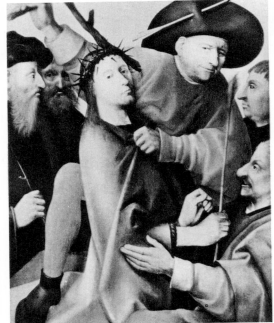

45

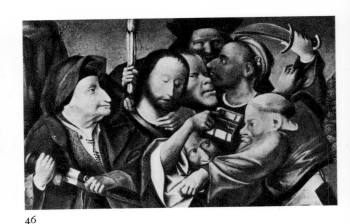

46

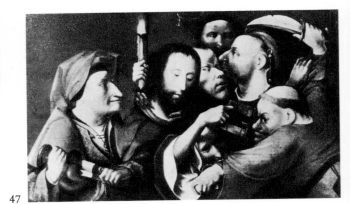

47

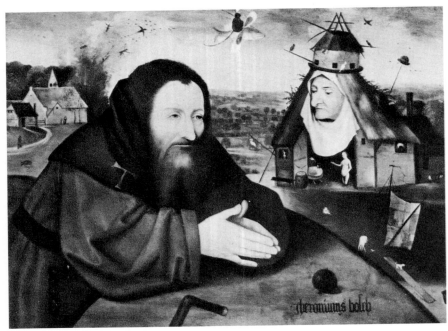

48

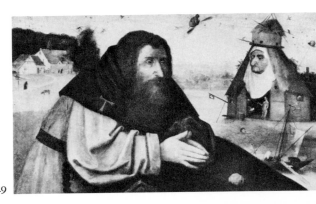

49

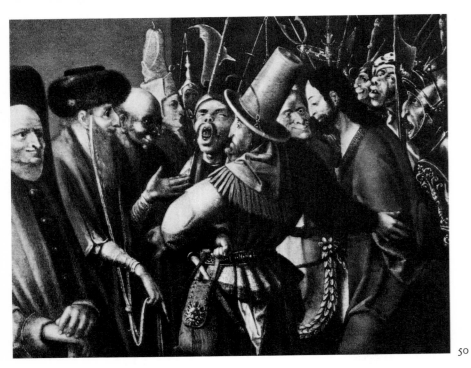

50

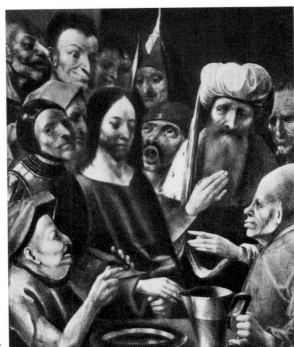

51

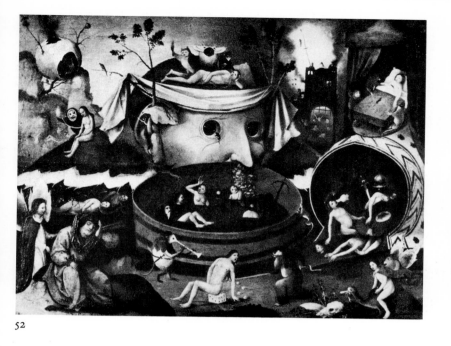

52

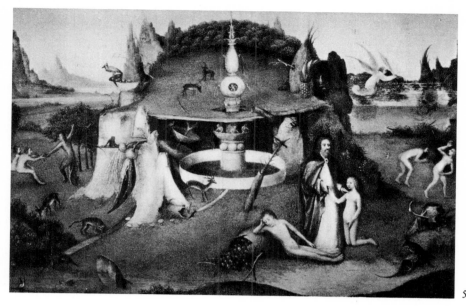

53

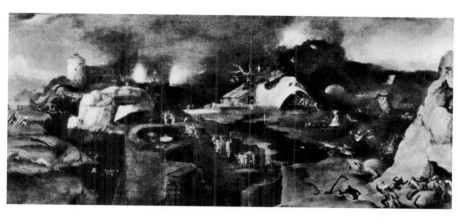

54

55

56

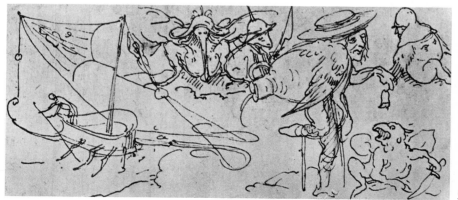

57

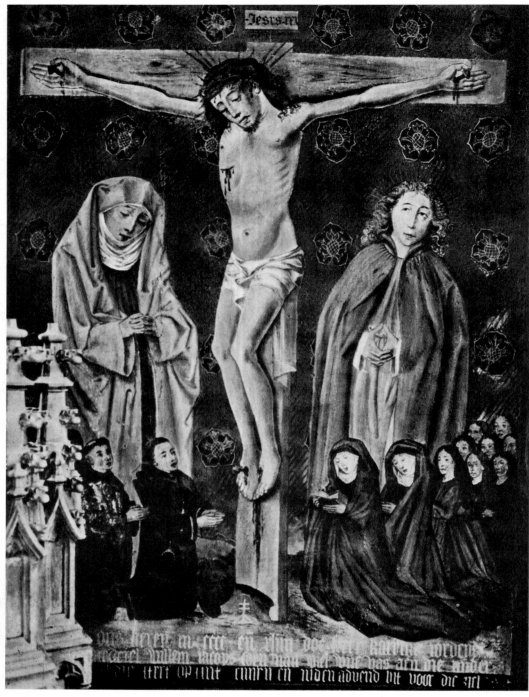

58

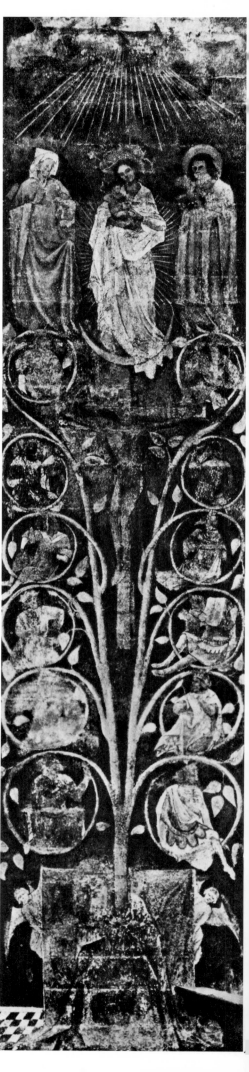

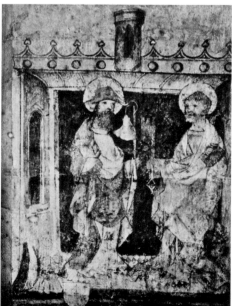

60

61

59

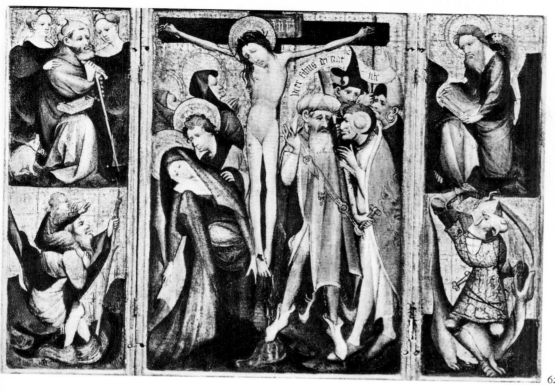

63

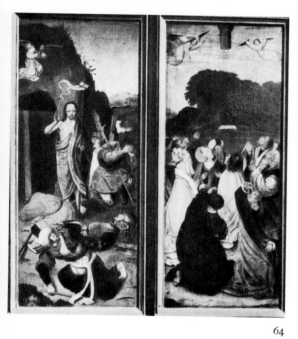
64

65

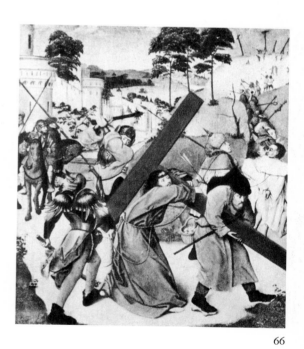
66

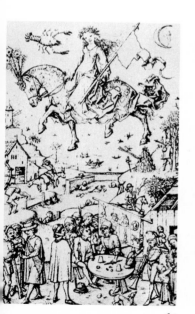
67

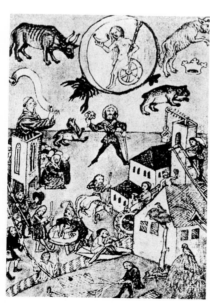
68

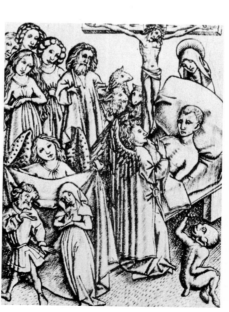
69

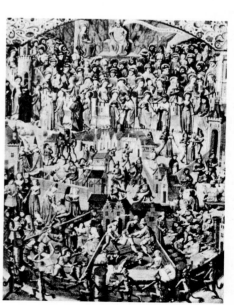
70

71

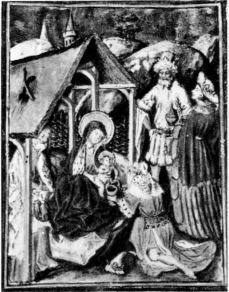

72

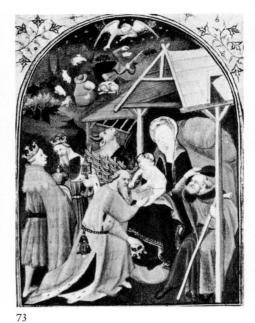

73

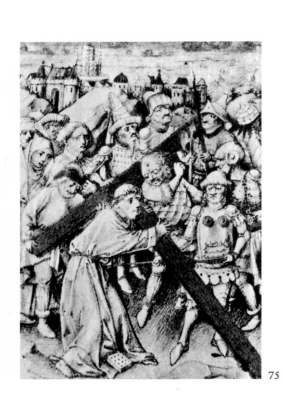

75

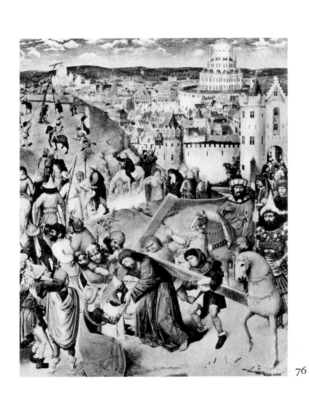

76

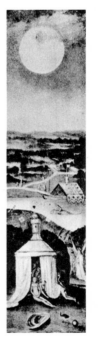

77

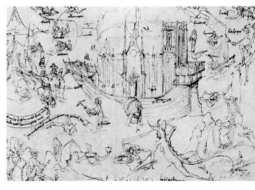

78

79

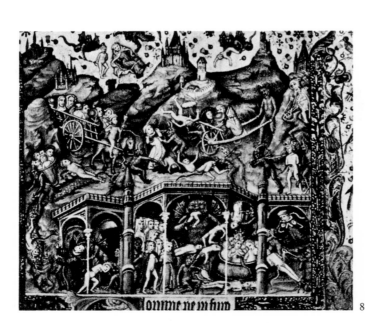

80

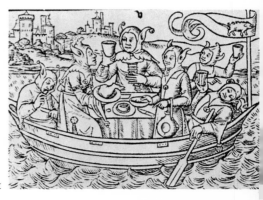

81

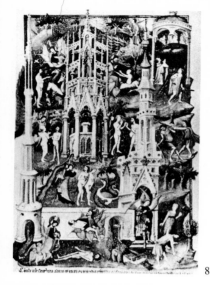

82

83

84

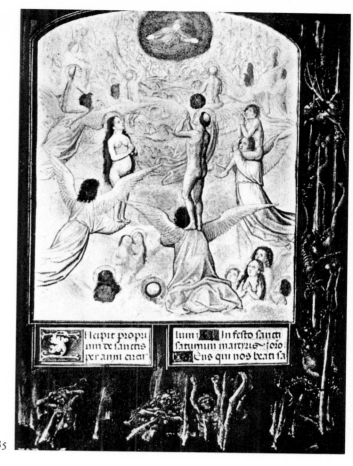

85

86

87

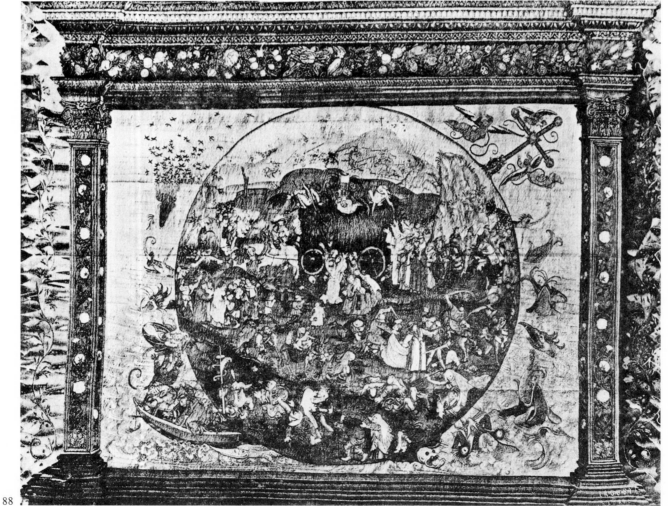

88

4

89

90

91

92

93

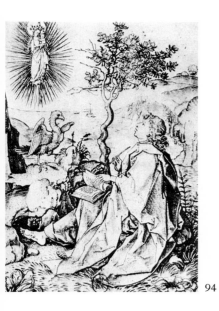

94

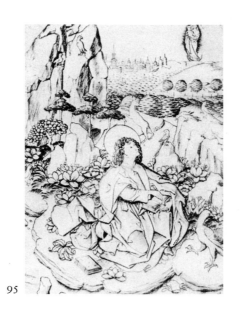

95

96

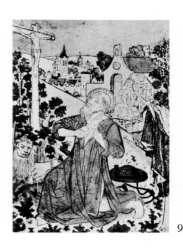

97

98

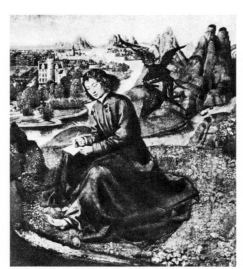

99

100

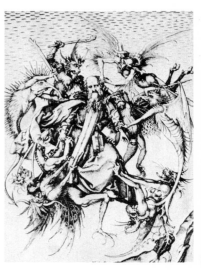

101

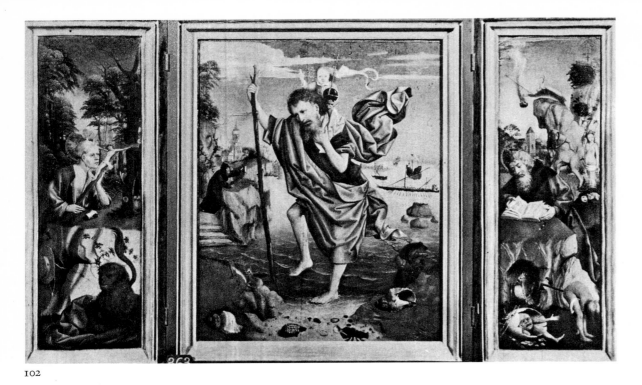

102

103

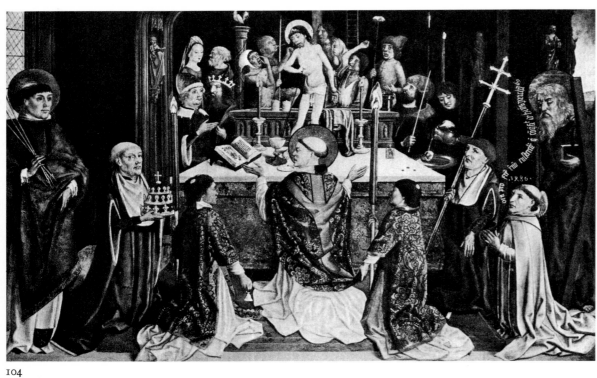

104

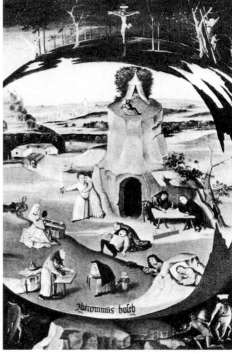

105

106

107

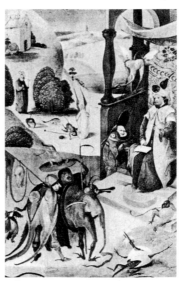

108

109

110

III

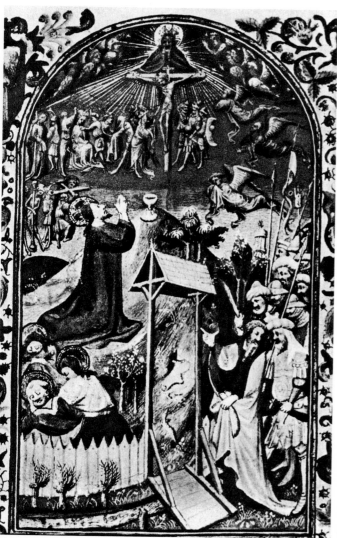

112

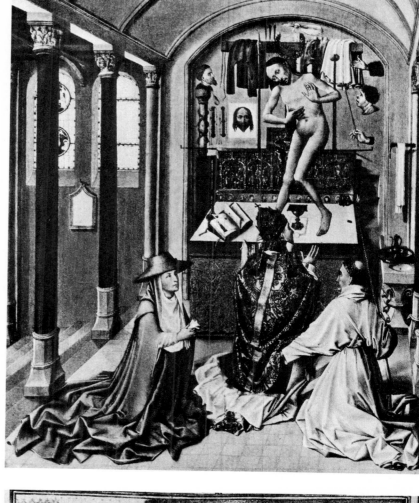

113

In endroit vo
lons ferraire
lauision que
nous auons
promise · vu
ans apreo ce

que le corps charle le chauf or
treu a verinaus en lenlise sant
eusebe le martir apaint par la
voulente uresumeur a vint
mestue de sant denis en france
qui par mut hardiv lenlise au

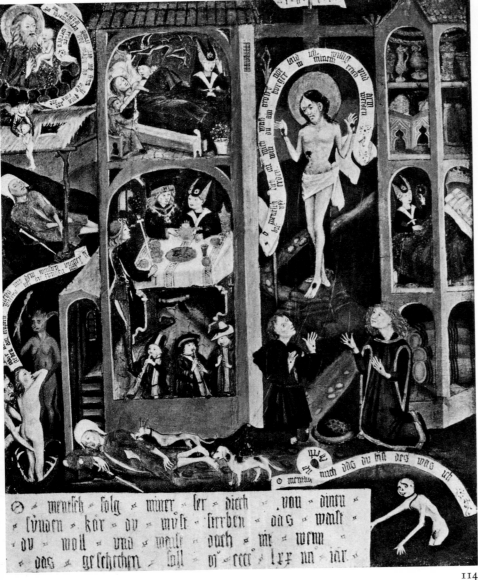

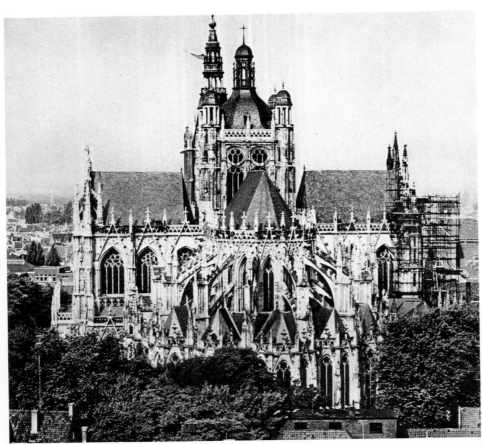

114

115

116

THE GOTHIC CATHEDRAL
OF 's HERTOGENBOSCH

Straddling the stone buttresses that support the vaulting
of the choir are sculptured likenesses of the artisans who
built the cathedral, and between them chimeras resembling
Bosch's figures.

Pages 447–449

LIST OF PAINTINGS

SOURCES OF ILLUSTRATIONS

The illustrations on pages 79–80, 90, 91, 94, 96–97, 104, 254, 282, 307, 309 were kindly made available by the museums concerned.
The publishers thank the following museums and collections for their cooperation and support in the preparation of new photographs of works by Hieronymus Bosch: Museo Nacional del Prado, Madrid; Museum Boymans-van Beuningen, Rotterdam; Städelsches Kunstinstitut, Frankfurt-on-Main; Kunsthistorisches Museum, Vienna; Galerie der Akademie der Bildenden Künste, Vienna; Museu Nacional del Arte Antiga, Lisbon; Gemäldegalerie, Berlin-Dahlem; Musée des Beaux-Arts, Ghent; Wallraf-Richartz-Museum, Cologne.